The Preston Morton Collection of American Art

The Preston Morton Collection of American Art

Katherine Harper Mead, Editor

Santa Barbara Museum of Art

THE PRESTON MORTON COLLECTION OF AMERICAN ART

Santa Barbara Museum of Art
1130 State Street
Santa Barbara, California 93101

This project is supported by a grant from the National Endowment for the Arts.

Library of Congress Catalogue Card Number 81-52029
ISBN 0-89951-043-4

Design by Margaret Dodd
Production by Margaret Dodd/Shelley Ruston

Text set in Meridien and Cochin Italic by Friedrich Typography, Santa Barbara
Printed in an edition of 5000 by Haagen Printing & Offset, Santa Barbara

(Cover) The Manhattan Club, Childe Hassam (See text, page 180)

Contents

Acknowledgments 9

Foreword 11

Introduction 15

Essay: Art for the New Continent 17

List of Artists 26

List of Contributors 27

About this Catalogue 28

Glossary of Conservation Terms 29

List of Abbreviations 30

The Catalogue 31

List of Color Plates 32

Color Plates 33-48

Eighteenth and Early Nineteenth Centuries 49

1 *Lieutenant Joshua Winslow*, John Singleton Copley 50
 Biography and Essay by Michael W. Schantz

2 *Portrait of Stephen Carmick*, Benjamin West 54
 Biography by Richard G. Carrott and Jon A. Carstens
 Essay by Michael W. Schantz

3 *Study for Edward III Forcing the Passage of the Somme*, Benjamin West 58
 Essay by Richard G. Carrott and Jon A. Carstens

4 *Elizabeth Coats Greenleaf*, Christian Gullager 62
 Biography and Essay by Ellen G. Miles

5 *Woodlands, the Seat of William Hamilton, Esq.*, William Groombridge 65
 Biography and Essay by Patricia Trenton

6 *Portrait of Edmund Rouvert*, James Peale 68

7 *Portrait of Jane Rouvert*, James Peale 70
 Biography by William H. Gerdts
 Essay by Ellen G. Miles

8 *Still Life, Wicker Basket of Mixed Grapes*, James Peale 73
 Essay by William H. Gerdts

9 *Louise Caroline de Toussard, Mrs. John Clements Stocker*, Thomas Sully 77
 Biography and Essay by Ellen G. Miles

Nineteenth-Century Landscapes 81

10 *The Meeting of the Waters*, Thomas Cole 82
 Biography and Essay by J. Gray Sweeney

11 *Janetta Falls, Passaic County, New Jersey*, Jasper Francis Cropsey 90
 Biography by Lynn Federle Orr
 Essay by William S. Talbot

12 *View of the Beach at Beverly, Massachusetts*, John Frederick Kensett 95
 Biography and Essay by J. Gray Sweeney

13 *Scene on the Upper Delaware: State of New York, Autumn*,
 Thomas Worthington Whittredge 98
 Biography by Lynn Federle Orr
 Essay by Anthony F. Janson

14 *Mirror Lake, Yosemite Valley*, Alfred Bierstadt 104
 Biography and Essay by Paul Chadbourne Mills
15 *The Sun Shower*, George Inness 110
16 *Morning, Catskill Valley*, George Inness 115
 Biography by Kathleen Monaghan
 Essay by Nicolai Cikovsky

Nineteenth Century (1840s to 1880s) 119
17 *Study for the Portrait of François Pierre Guillaume Guizot,*
 George Peter Alexander Healy 120
 Biography and Essay by Ellen G. Miles
18 *Portrait of a Child in Fancy Costume*, William Morris Hunt 124
 Biography and Essay by Peter Bermingham
19 *Ruth Gleaning*, Randolph Rogers 128
 Biography and Essay by Penny Knowles
20 *Still Life*, Severin Roesen 133
 Biography and Essay by William H. Gerdts
21 *The Secretary's Table*, William Michael Harnett 139
 Biography by Lynn Federle Orr
 Essay by Alfred Frankenstein
22 *My Studio Door*, John Frederick Peto 143
 Biography by Lynn Federle Orr
 Essay by Alfred Frankenstein
23 *Passion Play, Oberammergau*, Edward Lamson Henry 146
 Biography and Essay by Michael A. Quick
24 *Woman in Autumn Woods*, Winslow Homer 149
 Biography and Essay by Michael W. Schantz
25 *Pull for the Shore*, John George Brown 153
 Biography and Essay by Linda S. Ferber
26 *Bull Fight in Mexico*, Frederic Sackrider Remington 158
 Biography by Kathleen Monaghan
 Essay by Maria Naylor

Late Nineteenth and Early Twentieth Centuries 163
27 *Portrait of Master Douty*, Thomas Eakins 164
 Biography by Gerald M. Ackerman
 Essay by Ruth Bowman
28 *Dorothy in Pink*, William Merritt Chase 168
 Biography and Essay by Gerald M. Ackerman
29 *The Statue of Perseus by Night*, John Singer Sargent 172
 Biography and Essay by Donelson F. Hoopes
30 *Interior of His Brother's House in Boston*, Walter Gay 176
 Biography and Essay by Lynn Federle Orr
31 *The Manhattan Club*, Childe Hassam 180
 Biography and Essay by Patricia Gardner Cleek

Twentieth Century—The Urban and Rural Scene 187

32 *Summer in the Park*, Maurice Prendergast 188
 Biography and Essay by Ruth Bowman

33 *Sideshow*, Gifford Beal 192
 Biography and Essay by Dean Jensen

34 *Royal Gorge, Colorado*, Ernest Lawson 196
 Biography and Essay by Adeline Lee Karpsicak

35 *Derricks on the North River*, Robert Henri 200
 Biography by Kathleen Monaghan and Katherine Harper Mead
 Essay by William Innes Homer

36 *Portrait of Mrs. Edward H. (Catherine) Bennett*, Robert Henri 204
 Essay by Katherine Harper Mead

37 *East River from Brooklyn*, William J. Glackens 206
 Biography and Essay by Grant Holcomb III

38 *City from the Palisades*, John Sloan 210
 Biography and Essay by Grant Holcomb III

39 *Sixth Avenue Shoppers*, Everett Shinn 214
 Biography and Essay by David W. Steadman

40 *Steaming Streets*, George Wesley Bellows 218
 Biography and Essay by Michael A. Quick

41 *Children*, Jerome Myers 221
 Biography and Essay by Grant Holcomb III

42 *November, Washington Square*, Edward Hopper 225
 Biography by Kathleen Monaghan
 Essay by Gail Levin

43 *Early Winter Twilight*, Charles Burchfield 230
 Biography and Essay by David W. Steadman

Twentieth Century—*Modern Currents* 235

44 *Still Life with Two Pears*, Alfred Henry Maurer 236
 Biography and Essay by Sheldon Reich

45 *Alspitz-Mittenwald Road*, Marsden Hartley 240
 Biography and Essay by Gail R. Scott

46 *Composition, Cape Split, Maine, No. 3*, John Marin 244
 Biography and Essay by Patricia Gardner Cleek

47 *Crucifixion in Blue (Composition II)*, Abraham Rattner 249
 Biography and Essay by Melinda Lorenz

48 *Violin*, Karl Knaths 253
 Biography and Essay by Melinda Lorenz

Appendix 257

49 *The Embarcation of Regulus*, Unknown Artist 258
 Essay by Corlette Walker

50 Copy after Jules Bréton, *Le Départ pour les champs*, Unknown Artist 262
 Report by Patricia Hills

Selected Bibliography 267

Santa Barbara Museum of Art

Acknowledgments

This catalogue of the Preston Morton Collection has been, from its beginning five years ago, a collaborative enterprise involving the efforts of many. Suzette Morton Davidson, daughter of Sterling and Preston Morton and Trustee of the Santa Barbara Museum of Art, has, especially, provided at all times invaluable, informed support and encouragement. The impetus for this undertaking came from Paul C. Mills, Director of the Santa Barbara Museum of Art, and his determination that the Preston Morton Collection receive a catalogue is responsible for the project's realization. I am also grateful to him for releasing me over a period of several months from my regular duties as Curator of Collections that I might complete this work without interruption. My thanks go to the Board of Trustees for placing the quiet space of their board room at my disposal in order to work on the manuscripts which overflowed the capacity of my own office.

James W. Foster, Jr., present Director of the Honolulu Academy of Fine Arts and former Director of the Santa Barbara Museum of Art, has generously shared his knowledge of the Preston Morton Collection he helped to form, and his role has been further acknowledged by Paul Mills in the Foreword to this catalogue.

I want to express my immense gratitude to Ron Crozier, Librarian of the Santa Barbara Museum of Art. Without his efficient and unstinting assistance, his careful research and checking of bibliographical data for the catalogue raisonné, the footnotes, and selected bibliographies, it would not have been possible to complete this publication within the allotted time. Margaret Dodd, an accomplished designer, has created the handsome and elegant visual form of the catalogue. Moreover, she has acted as a tactful, yet firm, manager and assumed the major production responsibilities for this work. Judyl Mudfoot, as copy editor, established consistent usage throughout the text, meticulously corrected the manuscripts and gave them the benefit of her professional expertise. Peggy Dahl, Curatorial Assistant, has typed more letters than any of us wish to recall, pursued parties slow to answer, checked data, tidied up loose ends, and assisted in proofreading. Susan Palmer typed the manuscript, cheerfully coping with its numberless revisions. David Dahl acted as proofreader and in the process caught many slips. Patricia Farmer kindly edited the essay, "Art for the New Continent," by Corlette Walker, and the original material written by me.

There is no department within the museum that at some point in the course of the past five years has not been involved in the progress of the catalogue. The collaboration of the registration department has been crucial to a requisite systemization of the files on the Preston Morton Collection. For this essential phase of the project, much credit is due Elaine Dietsch, Registrar, and Merrily Peebles, Assistant Registrar. Elaine Dietsch likewise played an active role in the extensive conservation program planned for the Preston Morton paintings, a program paralleling the work on the catalogue itself. Initial assistance in the systematic ordering of the existing files and documentation on the Preston Morton Collection was provided by Caroline Black and Edward Quick. Much of the material in the catalogue raisonné is based upon information gathered and collated by Melinda Lorenz, former Assistant Curator. Terrell Hillebrand, former Registrar, Nancy Voss, former Curatorial Secretary, Kirk Robertson, former Grants Coordinator, Diane Roby, and Diane Gregory also aided during the early phases of the catalogue.

The following members of the Santa Barbara Museum of Art staff deserve special mention for help provided by their respective administrative acumen: Anne Bomeisler, Grants Coordinator, Shelley Ruston, Assistant Director for Publications, Public Information, and Events, and Carl Vance, Deputy Director.

I tender my appreciation to art historians of the University of California, Santa Barbara — Corlette Walker, Beatrice Farwell, Henri Dorra, and Burr Wallen. Likewise, I extend my thanks to William Treese and Felipe Cervera of the University's Arts and Music Library, who provided me with much of the needed research material.

Beyond the confines of Santa Barbara, advice and help were given by E. Maurice Bloch, Grunwald Center for Graphic Arts, University of California, Los Angeles; Otto Wittman, J. Paul Getty Museum; Michael Quick, Los Angeles County Museum of Art; and David W. Steadman, The Chrysler Museum, Norfolk.

Although acknowledged later in the catalogue proper, I also wish to thank Lloyd Goodrich and Ronald G. Pisano here for generously sending information from their files, as well as Ira Glackens, Edward H. Bennett, Jr., and Elizabeth de Forest, who kindly shared their knowledge.

Particularly helpful in providing information regarding provenance and exhibition histories for specific paintings were Nancy C. Little, Library, M. Knoedler & Co., Inc.; Michael St. Clair, Babcock Galleries; Robert C. Vose, Vose Galleries; and Antoinette Kraushaar, Kraushaar Galleries, who also gave much biographical information on Gifford Beal and graciously made material available from the files of the Kraushaar Galleries.

I also wish to acknowledge the many individuals who answered our queries and otherwise helped: Ann B. Abid, The Saint Louis Art Museum; William G. Allman, The White House; Nancy Andrews, San Diego Museum of Art; Joseph Baillio, Wildenstein & Co., Inc.; Richard J. Betts, University of Illinois at Urbana-Champaign; Larry Bevan, Haagen Printing & Offset; Arthur Breton, Archives of American Art, New York; Dan Card, National Park Service; Martha Carey, Phillips Collection; Frank J. Carroll, Library

of Congress; Laura M. Carson, The Treat Gallery, Bates College; Ed Chelini, Haagen Printing & Offset; John Clancy, Frank K. M. Rehn Gallery, Inc.; Phemie Conner, Des Moines Art Center; Edith Duane, The High Museum of Art; Stuart Feld, Hirschl & Adler Galleries; Mary Fitzgerald, Whitney Museum of American Art; Mike Flory, Haagen Printing & Offset; Tom Franotovich, Haagen Printing & Offset; Hildegard and Achilles Friedrich, Friedrich Typography; Lynne Garza, The Detroit Institute of Arts; Catherine Glascow, Columbus Museum of Art; Marion L. Grayson, Museum of Fine Arts, St. Petersburg; Richard Green, London; Paul Griswold, Haagen Printing & Offset; Jack Gyer, National Park Service; James L. Hansen, The State Historical Society of Wisconsin; Barbara M. Huggins, The Brearley School; Stephen B. Jareckie, Worcester Art Museum; Peggy Jo D. Kirby, North Carolina Museum of Art; Lisa Kirwen, Archives of American Art, Washington Center; Len Klekner, The Renaissance Society at The University of Chicago; Pamela Koe, The University Art Museum, University of California, Santa Barbara; Nancy Koeningsberg, New York; Katherine M. Kovacs, Archivist, The Corcoran Gallery; Barbara S. Krulik, National Academy of Design; Norm Littlejohn, Friedrich Typography; William A. Lucking, Jr., Ojai, California; Paul Magriel, New York; Annette Masling, Albright-Knox Art Gallery; Melissa Meighan, The American Federation of Arts; Howard Merritt, University of Rochester; Cheryl L. Mervine, Institute of Contemporary Art, Boston; Roger Mohovich, The New York Historical Society; Katherine Moore, Library, M. Knoedler & Co., Inc.; Mary Muller, National Museum of American Art; M. P. Naud, Hirschl & Adler Galleries; Linda Nelson, Museum of Fine Arts, Houston; Maurine F. Newell, Brooks Memorial Art Gallery; Helen L. Pinckney, The Dayton Art Institute; Donna E. Rhein, Dallas Museum of Fine Arts; Jane L. Richards, formerly Hirschl & Adler Galleries; Esther Robles, Esther Robles Gallery, Los Angeles; Millard F. Rogers, Cincinnati Art Museum; Alexandre Rosenberg, Paul Rosenberg & Co.; Charles A. Ryskamp, The Pierpont Morgan Library; Helen Sanger, The Frick Art Reference Library; Patricia Scheidt, The Arts Club of Chicago; Carole Schwartz, Cincinnati Art Museum; Cynthia Seibels, Kennedy Galleries, Inc.; Thomas T. Solley, Indiana University Art Museum; Victor D. Spark, New York; Suzanne K. Stenson, The Corcoran Gallery; Catherine Stover, Pennsylvania Academy of the Fine Arts; Carol Taylor, Santa Barbara; Elizabeth S. Telford, John & Mabel Ringling Museum of Art; Fearn C. Thurlow, The Newark Museum; Joyce Ann Tracy, American Antiquarian Society; Nicholas B. Wainwright, The Historical Society of Pennsylvania; Richard Wattenmaker, Flint Institute of Fine Arts; William E. Woolfenden, Archives of American Art, New York; Rudolf G. Wunderlich, Kennedy Galleries, Inc.

Gary Alden, Sarah Fisher, and the other conservators of the Balboa Art Conservation Center, San Diego, have provided exemplary documentation for the Preston Morton paintings they have inspected and worked on during the past years. Likewise, William Leischer and James Greaves have prepared detailed reports of work done on the Preston Morton Collection by the Conservation Center, Los Angeles County Museum of Art. The majority of the condition and technique reports included in the catalogue for each work is based on those submitted by these two outstanding laboratories.

I have kept to the last those most deserving of greatest thanks — the authors contributing to this catalogue. The Santa Barbara Museum of Art is deeply grateful to each and every one of these scholars who, in the essays they have written for this catalogue, have done so much to increase knowledge of the works in the Preston Morton Collection.

Katherine Harper Mead
Editor

Foreword

Today, American Art seems like a perfectly proper field for art museums to take special interest in. This was not the case at the time the Preston Morton Collection was formed two decades ago; to the contrary, this was an era in which American art suffered a surprising amount of resistance, opposition and neglect, an era when it was necessary to make a valiant, pioneering effort to be involved with American art at all.

This had not always been so. Earlier, our nation had taken a proper interest in its artists — in between its responses to those of Europe — until roughly the period following World War I and the 'twenties, when the tastes of Duveen and Berenson and the patronage of men such as Mellon began bringing European ''Old Masters'' in quantity to this country, pushing our seemingly more parochial art off our museum walls, and when the new modern European movements introduced in this country in the 1913 Armory Show left American painters scrambling to catch up.

The vastly altered circumstances of the Depression and the 'thirties radically shifted attention in the arts. The Works Progress Administration was concerned about the welfare and employment of American artists and about the general public's exposure to art in public buildings. Also, modern tastes of the day melded with historicizing inclinations to produce a new interest in historic American primitive and folk art.

Another World War occurred before American artists were to take the lead of the avant-garde for the first time, and before scholars and collectors in this country really began to spur the growth of interest in American art we take for granted today. At a time when Mellon's new heroine on the Mall, the National Gallery of Art, had only a Copley here and a Cassatt there, at a time when the country's principal federal collection of American art (now most handsomely housed at the National Collection of Fine Arts — just recently renamed the National Museum of American Art — and the National Portrait Gallery) was languishing in the old Smithsonian, fighting for space with boat models and Civil War cannons, the tide started to turn. Central to this, as I recall it, were Maxim Karolik, whose collection of American art is now in the Museum of Fine Arts, Boston; Edgar William and Bernice Chrysler Garbisch, whose collection of American naive paintings is now at the Chrysler Museum at Norfolk, Virginia; the construction of a special building at Williamsburg, Virginia in 1957 to house the Abby Aldrich Rockefeller Folk Art Collection (the collection itself dating to the early 'thirties); and the continued efforts of the Whitney Museum of American Art. On the West Coast, the development of the Oakland Museum's California Collection and the formation of the Preston Morton Collection were likewise events of national importance.

One of the champions of American art history who helped turn the tide was Edgar Preston Richardson, director of The Detroit Institute of Arts, whose *American Painting: The Story of Four Hundred and Fifty Years*, published in 1956, is the first broadly scholarly history of American art written in our time. Richardson also founded the Archives of American Art at the Institute, thus initiating a nationwide program to find and preserve the records of American artists. In large part inspired by his example, in 1956, we then at the Oakland Museum, to celebrate its fortieth anniversary, founded a collection of California art and a supporting Archive.

Certainly the dean of the embattled Americanists in California has been Alfred Frankenstein, an unusually able critic, writer, teacher, lecturer and general gadfly. His book on William Harnett and his circle, *After the Hunt*, published in 1953, became one of the first successful and widely-read books on American art. Frankenstein has preached, damned, charmed, seduced and generally enlightened in behalf of American art not only in California and throughout the United States but elsewhere in the world.

The Santa Barbara Museum of Art, although it has never really thought of itself as specializing in American art (or in any other specific corner of the arts, for that matter) has continually made significant efforts in this area. Its founding director, Donald Bear, himself an artist as well as a museum man, had evolved in the Americanist atmosphere of the 'thirties at the Denver Art Museum and had been responsible for assembling an exhibition of American art for the 1939 New York World's Fair. He was dedicated to showing the work of living American artists and he shared with other sophisticated admirers of contemporary art in his age a special affection for American primitive painting. In fact, he agreed to accept the post of director of the museum only on the condition that the president of the museum board, Buell Hammett, purchase for the museum the celebrated American primitive painting, *The Buffalo Hunter*. For the museum's inaugural show held the summer of 1941, Bear organized an exhibition entitled ''Painting Today and Yesterday in the United States.'' Bear's exhibition laid the foundation for the future of American art at the museum.

''Inasmuch as this new institution will function as a living art center in the community, as well as a true museum, nothing could be more fitting than making its initial presentation to the public of the art of our own country,'' wrote Bear and Janet H. Lineberger in their introduction. '' . . . throughout its development American art reflects constantly changing influences of changing environments, as the frontiers of the country expand, and its ambitions mount and become more diversified. When we trace the course of American painting, we do not expect to find the slowly consistent and nurtured growth of a tradition. But we do find the brilliant sporadic flourishes, the swift changes, and cross-current influences which mark the path of a rising civilization.'' Bear was

always an especially dedicated supporter of living American artists. "It is the duty of the American museum . . . to help create an audience, not only for the artist of national prominence, but for those of local importance too. The museum does not make the artist. Quite to the contrary, the artist makes the museum."

Following Bear's untimely death in 1952, the museum, under Director Ala Story, began to purchase an excellent group of modern American paintings as a memorial to him and presented a series of Pacific Coast Biennials from which it regularly selected purchases for its American collection. It was during this period, from 1948 to 1958, that Sterling Morton of the well-known Chicago family served as a trustee of the museum. Ever since the late 1930s he and his wife, Preston, had been dividing their time between Chicago and Santa Barbara, and in 1962 Preston Morton joined the board of the museum, to remain on it until her death in 1969.

The Preston Morton Collection was the result of the efforts on one hand of Preston Morton, encouraged by her husband, Sterling, and on the other of James W. Foster, Jr., the museum's third director. The collection was conceived and acquired in a remarkably short time in the late 'fifties and opened in February, 1961 in celebration of the twentieth anniversary of the museum. Mrs. Morton composed a few words on how the collection came to be formed, which she planned to give at a dinner preceding the premiere showing of the collection and the inauguration of the new Preston Morton Wing given to house it. Sadly and suddenly, on February 24, Sterling Morton died and the dinner was cancelled. Mrs. Morton's proposed remarks, which have fortunately been preserved, included the following:

For some years, I had been considering various projects for Santa Barbara which might in a measure reflect the good life and happiness we have had in the eighteen years we have been coming out here. It wasn't, however, until I met James Foster, who expressed himself with such vigor and enthusiasm on both the accomplishments and needs of the museum, that my attention became focused in this direction.

There were two other factors, however, that influenced me in my decision to undertake the addition to the museum. First, my husband's understanding, enthusiasm and encouragement. Second, my very art-minded daughter. She is not only a collector but has been associated with the Art Institute of Chicago for many years. During this time she has talked to me a great deal about her work and aspirations and it is through her influence that I became so interested in the visual arts and what they mean to a community. I am sorry I didn't learn my lesson sooner. Already my brief association with the art world has been extremely rewarding.

My first conversations with James Foster contemplated only more space for children's classes. To do this it was apparent a large room was necessary. It could also serve as a lecture hall equipped for informal illustrated talks on related subjects.

One thing led to another; why not have a lower gallery and a picture gallery above? As time passed our director became ever more

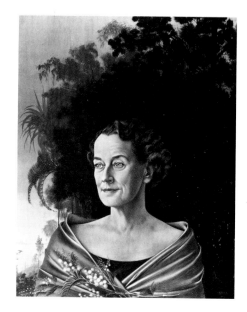

Brian Connelly, *Portrait of Preston Morton*, 1955. Collection of Suzette Morton Davidson.

persuasive and ere long we found ourselves winging our way across the continent, me from Chicago and Jim from here, to converge on New York, the art center of the United States. We visited most of the dealers and our success far surpassed our expectations. The results you see . . . "

James Foster was born in Baltimore in 1920, studied at Johns Hopkins University (his fourth year interrupted by Naval assignment), George Washington University, the Corcoran School of Art and the American University in Washington, D.C., from which he received his B.A. in 1947. He then joined the staff of the Baltimore Museum of Art in his home town as Executive Assistant until 1952, then as Assistant Director to Director Adelyn Breeskin until 1957, when he became director of the Santa Barbara Museum of Art.

The vision of American art history which he brought with him and which he embodied, with Preston Morton's participation and support, in the Morton Collection, owes something to his native environment on the East Coast, to family interests, and to his training as an artist for whom appreciation of American painting was nurtured in the many museums in the area.

In 1977, when the concept of doing a catalogue of the Preston Morton Collection was in its early stages, Jim Foster wrote me and described how the collection came about. He said, "I cannot write about myself for publication" and that "Preston's generosity is paramount to other considerations," but nevertheless his words about how the collection was formed seem to me of importance, and I am including them here, with his reluctant approval, edited only slightly.

12

The Preston Morton Collection will always be one of the nearest and dearest memories in my professional life. Nothing has been more exciting or personally rewarding than the opportunity given me in the formation of that collection. The concept of the collection was mine, and, with few exceptions, the selections were essentially mine, albeit with her approval on them, in a few cases given grudgingly. Indeed, Preston knew little about American art at the time and preferred the French school, although she had bought a Mary Cassatt for herself, which is almost saying the same thing. She wanted to do something for the museum, their friends and the community. Somehow we had hit it off well and a very warm relationship developed, with Page (Mrs. Foster) included, so I guess she put faith in me and my proposal. The strength of the museum's collection then was its American holdings, however limited, and I wanted to develop it as an important West Coast resource which no other museum in the area was particularly interested in doing at that time.

Preston was individualistic and an impulsive nature was central to her personality. She wanted the collection to be formed the day before yesterday. I had a rough plan of action and we spent some two weeks in New York together, occasionally joined by Sterling, who personally chose to buy the Remington. Suzie Morton Zurcher, now Davidson, took an interest and shortly found and gave the nice Cole. We were in the right place at the right time, for the American market was slow and the paintings were there. We went at a furious pace and the dealers turned themselves inside out for us. I remember that at Knoedler's, then on 57th in their wonderful old building, they hung our initial selection in the gallery at the back on the main floor so that we could better review them on returning for our second look. And so it went, from gallery to gallery all over town where there might be something of interest in building a modest survey collection, remembering, of course, what the museum already had or could expect from other sources.

The Copley was one of the surprises. It was shown to us by Bill Davidson and Elizabeth Clare, whom I'd known and much respected for a number of years, at Knoedler's. In an uncleaned state and with only family documentation as to its provenance, there was no absolute proof of its being a Copley. Bill and Elizabeth were convinced and Jules Prown (the Copley specialist and writer in American art) agreed. I had an instinctive feeling it was okay, so we said, "Send it out to us, but please clean it first." In the cleaning the signature and date appeared! And we had been quoted an unsigned price, what's more, thereby getting a real bargain.

Arrangements were made for shipment of our final selections on an approval basis, for there was the Acquisitions Committee whose approval had to be obtained. In a relatively short time, the McCormick Gallery was installed with Preston's proposed gift collection, and I was one nervous director when ushering in the trustees for a review. There were a few remarks, but all in all the day was ours and the museum the better for it. It was, as you see, a remarkable experience in many ways. As a young and "undaunted" (though often tried) director, I screwed up my nerve and, though I knew that, given more time, we might have arrived at a somewhat different selection, urged the trustees to accept. The new wings added to the museum subsequently followed, one by one. The opening of the Preston Morton Wing with the first viewing of her collection was a sad occasion, for Sterling suddenly died a day or two before and the celebrating was called off, of course.

In his foreword to the catalogue, *Two Hundred Years of American Painting*, published on the occasion of the first showing of the Preston Morton Collection with the museum's other American holdings, Foster referred to the museum's inaugural American exhibition and said,

> "On this occasion, twenty years later, it is equally fitting to mark the museum's anniversary and reaffirm its original objectives . . . The Preston Morton Collection now provides many of the missing links in the story of American painting since the latter half of the eighteenth century, and the Museum's total American holdings became a readable ensemble with art-historical sequence. Treatments of portraiture, landscape and still life as they developed from period to period over the last two centuries may be traced in representative and sometimes outstanding examples of artists who have both reflected and influenced their times. Here, as we study these artistic accomplishments dating back to Revolutionary days, we have the affirmation of a true American art, a cultural heritage which, though evidencing its European antecedents, is undeniably of this continent, of those forces and circumstances which created our United States. We take pride not only in our past achievements but also, with ever more conviction, in the vital, creative leadership American art enjoys today throughout the world.
>
> In a museum which embraces the art of all times, it is not amiss to concentrate major attention where its strength lies. Hence this publication and the exhibition prompting it, and hence the ambitious hope here expressed: that Santa Barbara may be the West Coast center for the collection, study and appreciation of the art of our country.
>
> To Mrs. Sterling Morton, for whom the new wing and its collection are named, we affectionately dedicate this catalogue. Her understanding and sympathetic attitude, her perception and vision, her effort and determination, and her remarkable generosity have brought together notable resources of enduring influence on this community, for which all of us can be deeply grateful.

Foster left in 1963 to become director of the Honolulu Academy of Arts, a post he has held since, and from which he has announced he will retire in about a year.

The perceptive comments of scholars and art critics upon the advent in California of the Preston Morton Collection reveal much about how the creation of such a collection of American art was viewed at the time.

E. Maurice Bloch, then and still today in the Department of Art at the University of California, Los Angeles, and, since 1954 director and curator of the Grunwald Center for the Graphic Arts, wrote in his Introduction to the catalogue, *Two Hundred Years of American Art*:

> In an age when collecting is so largely dominated by a prevailing taste for European painting, at times displaying a somewhat questionable connoisseurship, it is both refreshing and heartening to observe the wealth of material which yet remains to be discovered at our very doorstep. . . . the high quality of the pictures in this collection should serve as a pattern for further exploration by young museums elsewhere through the country, and for collectors seeking fresh and vital areas of collecting investigation.

Henry J. Seldis, who always treasured and cultivated his Santa Barbara associations, had become the art critic for the *Los Angeles Times*. He wrote on March 26, 1961:

It is doubtful that a more important survey of American painting has ever been assembled in the West Coast than the current 20th Anniversary Exhibition of the Santa Barbara Museum of Art. It is astonishing that this small museum in a small city has been able to establish such a fine permanent collection so quickly.... At first view, the Preston Morton Collection is overwhelming in its daylight splendor, its stellar list of artists and its considerable number.

During the ensuing years, the Morton Collection has continued to be one of the centers of focus in the museum, on display in the Preston Morton Gallery, in accordance with the terms of the gift, six months of the year. Although the emergence of other American collections in San Francisco, Oakland, Los Angeles and elsewhere has meant that Santa Barbara is no longer, as envisioned by Foster, "*the* West Coast center for the collection, study and appreciation of the art of our country" (italics mine), it has intermittently undertaken distinguished projects in the field. Thomas Leavitt, the fourth director of the museum, a good Americanist, presented such exhibitions as the Albert Bierstadt exhibition in 1964, a landmark in the revival of Bierstadt's work and in the new look at American nineteenth-century painting. Occasionally, other important American works have been added to the collection and, in the last decade, we have held other major exhibitions of American painting.

The concept of a scholarly catalogue for the Preston Morton Collection began to emerge in my mind in the early 'seventies as we approached the Bicentennial of the American Revolution. Nothing much came of that, however, until Katherine Harper Mead joined our staff in 1975. Her special field had been in French Impressionism but, as our holdings in this period were quite small and well documented, she chose to concentrate on the Morton Collection and the catalogue proposed for it. Scholars and students of American art throughout the country were invited to contribute entries on works by artists of special interest to them. Katherine discusses this herself in her Introduction, but I want to say here how grateful we are to her and to all the contributors to this catalogue for this distinguished piece of work, and to her for personally overseeing its completion, even though she has since left her position as Curator of Collections for our museum to become the director of the Elvejem Museum of Art at the University of Wisconsin-Madison.

Funding for the catalogue came from three major sources: a grant from the National Endowment for the Arts, The Sterling Morton Charitable Trust, and income from the Santa Barbara Museum of Art's Elizabeth A. Chalifoux Fund.

The Preston Morton Collection was formed in part to celebrate the museum's twentieth anniversary. Appropriately enough this publication comes off the press another twenty years later, in time to celebrate the museum's fortieth anniversary. This year is also the year when the decision has finally been made to proceed with another major addition to the museum. Both are happy occasions, indeed.

May we hope that, in future years, these long awaited accomplishments behind us, we can continue to expand and enhance our efforts in behalf of American art by developing print and drawing and sculpture collections which parallel the Morton paintings, and acquiring more furniture and decorative arts to extend our understanding of the various eras represented by the collection. The opportunity for further scholarly and interpretive efforts, for further additions and presentations in the field of American art, are many.

Certainly we could not look with such optimism to what the museum can accomplish between now and its next twentieth anniversary, which will take place in the year 2001, without the inspiration of those who have contributed so much before us.

Paul Chadbourne Mills
Director
Santa Barbara Museum of Art

14

Introduction

Preston Morton's desire "to do something" for the community she and her husband Sterling Morton enjoyed during Chicago's winter months brought a remarkable gift to Santa Barbara and its museum. The collection Preston Morton gave the Santa Barbara Museum of Art was remarkable not only because, as Paul Mills has pointed out in the Foreword, it antedated the high fashion for American art but also, and perhaps more significantly, because it was specifically created for a museum, with a clear, didactic purpose in mind and with the advice of a museum professional and art historian. This collaboration between Preston Morton and James W. Foster, Jr., then director of the Santa Barbara Museum of Art, culminated at the 1961 opening exhibition of the Preston Morton Collection with forty-six works that offered a representative spectrum of American painting from the mid-eighteenth century through the early decades of the twentieth century. Preston Morton acquired almost all of the paintings in the collection bearing her name. Only nine works are gifts of other donors. Two of these (cat. nos. 26, 31) came from Sterling Morton and two more (cat. nos. 10, 49) from Suzette Morton Zurcher (now Davidson); the others are the portrait by Healy (cat. no. 17), the two landscapes by Whittredge (cat. no. 13 and fig. 1), Henry's genre scene (cat. no. 23), the small portrait by Hunt (cat. no. 18), and Gay's interior (cat. no. 30).

The 1961 premiere of the Preston Morton Collection presented eloquent proof for the claim Foster made at the time: "Newly acquired, The Preston Morton Collection now provides many of the missing links in the story of American painting since the second half of the eighteenth century, and the Museum's total American holdings become a readable ensemble with art-historical sequence."[1]

The Preston Morton Collection, however, did far more than provide "missing links" to the museum's existing body of American art. As a distinctive and coherent entity in itself, the collection gave focus to the museum's other American holdings and constructed a solid armature — impossible to build today — for shaping the history of American painting from 1750 to modern times.

Beginning chronologically with Copley and West, the collection endowed the museum with an impressive roster of American masters — Inness, Homer, Eakins, Sargent, Sloan, Glackens, Bellows, Hopper, and Marin, to mention only the most obvious; some major works — Inness's *Morning, Catskill Valley* (cat. no. 16), Bellows's *Steaming Streets* (cat. no. 40), and Burchfield's *Early Winter Twilight* (cat. no. 43); and a rich array of minor masterpieces — Cropsey's *Janetta Falls, Passaic County, New Jersey* (cat. no. 11), Kensett's *View of the Beach at Beverly, Massachusetts* (cat. no. 12), Harnett's *The Secretary's Table* (cat. no. 21), Hassam's *The Manhattan Club* (cat. no. 31), Sloan's *City from the Palisades* (cat. no. 38),

Glackens's *East River from Brooklyn* (cat. no. 37), Shinn's pastel, *Sixth Avenue Shoppers* (cat. no. 39), and Hartley's *Alspitz-Mittenwald Road* (cat. no. 45).

One of the strengths of the Morton Collection resides in a series of small constellations of paintings related in time and theme. The gallery of portraits ranging from Copley to Sully that dominated the collection's chronological beginning bore witness to the dominion of portraiture in America during colonial times and the early decades of the Republic. Likewise, the panoply of landscapes occupying the center of the collection's nineteenth-century paintings reflected the magnificent flowering of the genre in that century. The group of paintings by the so-called Ashcan artists — each work created within the first decade of this century and with New York as its subject — captured the essence of this school during its finest moment.

The Preston Morton Collection had been restricted to painting until 1969, when, under the directorship of Goldthwaite H. Dorr III, the museum acquired Randolph Rogers's *Ruth Gleaning* (cat. no. 19) specifically to fill the architectural niche in the Preston Morton Gallery. As the only sculpture in the collection, the Rogers marble remains an anomaly. Equally untypical of the tenor of the collection is the figure's overtly sentimental character, illustrative though it may be of Victorian taste.

During the course of Paul Mills's directorship and my service at the Santa Barbara Museum of Art, between 1977 and 1979 four more paintings were added to the collection, in consultation with Suzette Morton Davidson. The first of these was Robert Henri's *Derricks on the North River* (cat. no. 35) of 1902, which brought into the collection a work by the dominant member of the "Ashcan" artists, an acquisition that also complemented the river scenes by Sloan and Glackens. Henri's painting was followed by J. G. Brown's *Pull for the Shore* (cat. no. 25), a major example of nineteenth-century genre painting otherwise sparsely represented in the collection. Brown's painting was transferred from the museum's general collection in replacement for a landscape by Whittredge (see cat. no. 13, fig. 1), which had been de-accessioned from the Preston Morton Collection several years prior (1971) in partial exchange towards the acquisition of *Pull for the Shore*. The third acquisition, Robert Henri's *Portrait of Mrs. Edward H. (Catherine) Bennett* (cat. no. 36) came as a welcome surprise from Edward H. Bennett, Jr., the son of the sitter, who in her lifetime had been a friend of Preston Morton. Thomas Cole's *The Meeting of the Waters* (cat. no. 10), purchased by Suzette Morton Davidson, represents the most important of the collection's recent additions, providing a significant work by America's most influential landscape painter of the nineteenth century.

Although the Preston Morton paintings form a model study

collection, to date the only publication to present the collection in its entirety has been the 1961 handbook and catalogue, *Two Hundred Years of American Painting*, out of print for many years. In this handbook, moreover, the collection was only discussed briefly and was listed together with the museum's other American holdings. Paul Mills's objective has been to give the collection a publication of its own and mine to provide an accompanying catalogue raisonné. We decided to solicit the essays on individual works from a broad spectrum of scholars — established experts in the field as well as graduate students at the outset of their careers. Such treatment, we realized, would of course lead to a disparity of style and approach, yet we believed the variety of these points of view would be of value.

In keeping with the didactic character of the Preston Morton Collection, it seemed important for its catalogue to be of interest to the layman as well as to the specialist and student. In addition to documenting the collection, we also wished to present it within an art historical context. For this reason, we asked Dr. Corlette Walker, lecturer in the history of art at the University of California, Santa Barbara, and a scholar long familiar with the collection, to write a special essay for the catalogue. In the illuminating overview that follows this introduction, Professor Walker has chosen to discuss the collection in terms of painting's traditional categories; history painting, portraiture, genre, landscape, and still life as they evolved in this country. The decision to preface the discussion of the works proper with short biographies of their respective artists was again premised on the broader informative purpose of the catalogue.

A particular concern over the past years — one complementary to scholarly research on the Preston Morton Collection — was that of its conservation. The examination and work by conservators of the Balboa Art Conservation Center in San Diego and the Conservation Center, Los Angeles County Museum of Art, recorded in detailed reports, has provided invaluable documentation that we considered equal in importance to those other forms of documentation — provenance, exhibition history, references — usually found in a catalogue raisonné. My decision to include the conservators' findings was influenced by *The Guggenheim Museum Collection: Paintings 1880–1945*.[2] Cleaning, lining, and repairs in painting represent interventions to the original state of the works and are thus central to their history.

In the sequence chosen for the presentation of works in this catalogue, there has been no recourse to any fixed system. The arrangement is neither alphabetical, nor according to genre; it does not depend on stylistic or historical labels such as Neo-Classicism, Romanticism, Realism, Impressionism, Post-Impressionism, and so on. Predictably, the earliest paintings in the collection open the list, which then ends with the latest works, yet rather than forcing any

metronomic succession of dates, I have tried to follow the historical logic of the collection itself. As a result, certain sections overlap in time and a fair number of works are out of strict chronological order. Sections such as *Nineteenth-Century Landscapes* and *Twentieth Century—The Urban and Rural Scene* reflect the clustering of works within a given period into identifiable entities, the latter section, for example, not only displays thematic affinities among the works, but also embraces a complement of the independent artists' group called The Eight (Prendergast, Lawson, Henri, Sloan, Glackens, Luks, Davies, Shinn) providing the nucleus of the "Ashcan" School as well. In similar fashion, to avoid separating works by styles related to one another, I have occasionally placed single works out of chronological sequence. Thus three paintings, Impressionist and Post-Impressionist in their inspiration, Prendergast's *Summer in the Park* of circa 1905–1907, Beal's *Sideshow* of 1910, and Lawson's *Royal Gorge, Colorado* of ca. 1927 come before Henri's *Derricks on the North River* of 1902 and the attendant group of "Ashcan" views of New York, all executed before 1910. The placement of Eakins's *Portrait of Master Douty* of 1906 in the beginning of the section, *Late Nineteenth and Early Twentieth Centuries*, is predicated on the fact that this late work by the Philadelphia master is firmly rooted in the sensitivity informing his Realist portraits of the 1870s. Hassam's *The Manhattan Club* of 1891, on the other hand, reflects the impact of French Impressionism on American painting during the 1880s. Its position in the catalogue, moreover, as the concluding work for that section (rather than the paintings by the expatriates Gay and Sargent) was largely dictated by its subject matter: Hassam's painting of urban life, prefiguring The Eight's fascination with city scenes, so clearly demonstrated in the following section.

The proof of any catalogue, however, is in the reading. The authors and editor of this publication hope that its readers will experience the same instruction and delight in these pages so eloquently conveyed by the collection itself.

Katherine Harper Mead
Curator of Collections from 1975-1980
Santa Barbara Museum of Art
now Director, Elvehjem Museum of Art
University of Wisconsin-Madison

Notes
1. Foreword to *Two Hundred Years of American Painting, A handbook listing the Museum's holdings, including the newly acquired Preston Morton Collection. Commemorating the opening of the Preston Morton Wing and the Museum's twentieth anniversary 1941–1961*, Santa Barbara Museum of Art, 1961.
2. *The Guggenheim Museum Collection: Paintings 1880–1945*, Angelica Zander Rudenstine, ed. (New York: The Solomon R. Guggenheim Museum, 1976).

Essay: Art for a New Continent

Portraits by John Singleton Copley, Benjamin West, Thomas Sully, Thomas Eakins, William Merritt Chase, and Robert Henri; still lifes by James Peale, Severin Roesen, William Harnett, John Peto, Alfred Maurer; landscapes by Thomas Cole, Jasper Francis Cropsey, John Frederick Kensett, Albert Bierstadt, George Inness, William Glackens, John Sloan, John Marin, and many other major names in American art from the eighteenth, nineteenth, and early twentieth centuries hang on the walls of the Santa Barbara Museum of Art, in the Preston Morton Wing. Unlike the grand regional collections in New York or Philadelphia, for example, the Preston Morton Collection was largely formed at one time by a single collector with the expressed aim of representing American art as a whole. Fortunately for Santa Barbara, Preston Morton was ahead of her time; as Maurice Bloch noted in his introduction to the 1961 catalogue, *Two Hundred Years of American Painting*, most collectors of that period were "largely dominated by a prevailing taste for European painting." Now that the situation has reversed itself and the taste for American art in this country appears to be dominant, Santa Barbara is exceptionally fortunate to possess a uniquely balanced collection that fulfills the dual requirements of aesthetic beauty and representation.[1]

The ordinary gallery goer as well as the scholar nowadays focuses on characteristics that scarcely interested the viewer twenty years ago. The art world in general has been permeated by a new critical doctrine described for want of a better name as "pluralism."[2] In contrast to previous art theory, pluralism does not refer to stylistic characteristics or to group movements, but implies a willingness to take each work of art on its own merits. What amounted to belief in the ultimate triumph of American Abstraction in the 1940s, 50s and 60s, often led to approaching American art history in terms of a single stylistic evolution beginning with Modernism in France and culminating in the New York School of the 1940s and 50s. This attitude was related to the avant-garde theory that each new generation must rise against the establishment and create new forms in order to push the frontier of art further and further out. In that atmosphere, nineteenth- and early twentieth-century art was seen as conservative, historically interesting but artistically important only when it presaged some aspect of this evolution, as when the Sublime landscape style and the nineteenth-century landscapes of Frederic Church and Albert Bierstadt were linked to the enormous size of Abstract Expressionist painting.

Now that scholars and even members of the general public are viewing the past with a more dispassionate historicism, every artist is considered as potentially interesting as another. Once famous and influential artists who had disappeared from view or had been seen by viewers of the 1920s, 30s, and 40s as fusty — even ridiculous — are now treated to extensive exhibitions and monographs.[3] No longer can any one scholar master the wide spectrum of research and knowledge necessary for an understanding of American art during the past two centuries: therefore, the editor of this catalogue, Katherine Harper Mead, has asked a number of art historians in that field to write the entries. The scholar's new desire to put the work of art in historical perspective demands consideration beyond the stylistic and biographical aspects of a work of art, to include the political, social, and cultural context that produced it as well.

Since this pluralistic approach is apt to be intensive and detailed, there is a danger of overlooking the remarkable way this collection reflects the overall style, genre, and subject matter of eighteenth-, nineteenth-, and early twentieth-century American art; it reflects — in a way that not even its collector may have imagined — the most prominent artistic concerns and underlying meanings of the various periods and schools.

Today, where the late twentieth-century museum visitor looks for style and subject in a work of art, the eighteenth- and nineteenth-century patron and viewer would have seen these works in terms of genre. This dogma presented painting as a hierarchy of types, with history at the highest level consisting of classical and religious subject matter, followed on a descending scale by the mythological portrait, the ideal landscape, the quotidian scene — genre itself — and finally at the bottom, still life. Each category conformed to definite rules of scale, subject, and interpretation. From the mid-seventeenth century on, when this hierarchy was established, classifications of paintings and the artists who produced them were graded in value. In order to understand the intentions of the American artist and the wishes of his patron, it is necessary to determine where the painter conformed to European evaluation and where he broke with that tradition to create his own standards.

From the moment America became independent in the 1780s, its artists struggled between the urge to create an art worthy of their new country, the politically unique United States, and the knowledge that they were, culturally at least, European. During the new nation's first years, the greatest American painters of the eighteenth century, Benjamin West and John Singleton Copley, ultimately (and ironically) became English — leaders of the London art world, West actually assuming the mantle of Sir Joshua Reynolds as elected President of the Royal Academy. American artists accepted the structure of the English art world, its training, its patronage, and its views on what was proper for the artist to paint. Yet, while American painters of the late eighteenth and early nineteenth century all studied abroad, and most of them with Benjamin West,[4] they were able neither to use that training nor to

17

fulfill their professional aspirations unless they remained in Great Britain. In the Preston Morton Collection, only the sketch for the history painting by Benjamin West, *Edward III Forcing the Passage of the Somme* (cat. no. 3), of 1788, belongs to the highest level of academic genre, *Istoria*, or history painting.[5] Subjects taken from classical antiquity, from Greek and Roman history, from national history, and from the Bible were seen as the summit of artistic invention. This view of the role of painting insured that government buildings, palaces, and churches would have a cadre of artists capable of decorating them with suitable works of art; originally a seventeenth-century French tradition, it was resurrected in England by Sir Joshua Reynolds when he created the Royal Academy of Art in 1768. It had not, to tell the truth, very profound roots in Great Britain itself. Reynolds saw the academic tradition as a means of raising the artist's social position and financial status, but in Great Britain it had only a modest measure of success from the 1780s to the 1830s, when it disappeared again.

During the eighteenth and nineteenth centuries, because of the Puritan prejudice versus religious art and the absence of palaces, portrait painting was the only sure way of making one's living as an artist in America. If an eighteenth-century American had any art to hang on the walls of his home it was quite likely to be a portrait. Even lack of artistic training could not suppress the market for likenesses, and many of the portraits of this period still resembled seventeenth-century limner works — assumed by many historians to have been prepared paintings of faceless figures that the transient artist took from place to place, to complete by filling in the features of the sitter. In this collection, the paintings of John Singleton Copley and Benjamin West, *Lieutenant Joshua Winslow* (cat. no. 1) of 1755 and the *Portrait of Stephen Carmick* (cat. no. 2) of ca. 1756, were created early in their careers before they had encountered the great late eighteenth-century schools of portraiture in Italy and England. They may never have had an opportunity to see a competent portrait firsthand in America; their contemporaries in art were often emigrant painters — "drapery painters" or assistants to portraitists in London, able to reproduce satin with marvelous fidelity but the face and figure not at all. For these reasons both young painters exhibited a reliance on engraving: poses, costumes, and especially the setting — as seen in the background drapery and column of the Stephen Carmick picture — are either French in origin, derived from graphics like those of Rigaud and Natoire, or closer to home in engravings after the works of Kneller or Hudson.[6] In the days before easy travel, and before photography, all American artists depended upon prints for their knowledge of the European art world, and it is no accident that they often began their careers as engravers.

By the late eighteenth century after Copley and West were established as two of the most prominent painters in London, American artists were encouraged to study there, even if they did not intend to follow in the footsteps of their mentors by remaining in Great Britain. Fortunately for America, two of West's most promising pupils, Gilbert Stuart and Charles Willson Peale, chose to return to their native land despite success in London. We owe the definitive images of the fathers of our country to Stuart — not only of George Washington, whose portrait he painted many times, but also of Jefferson, Madison, Monroe, Adams, and others. Both Stuart and Philadelphia's Peale rejected the stately full-length English portrait, symbolic of royal and aristocratic values, for the more informal three-quarter view, seated figure used by Joshua Reynolds in his most intimate likenesses, and for the portrait bust. Charles Willson Peale, who had studied with West before the Revolution, founded a more prosaic but equally informal school of painting in Pennsylvania. More importantly, he established a dynasty of artists that perpetuated his style and influence far into the nineteenth century. The portraits of *Edmund* and *Jane Rouvert* (cat. nos. 6, 7) by Peale's younger brother James are charming examples of the type of portraiture practiced by Charles Willson Peale, his brother, his sons, and his daughter. Thomas Sully, whose portrait of *Mrs. John Clements Stocker* (cat. no. 9) of 1814 is in this collection, was also a Philadelphian and the most prolific portraitist of the early nineteenth century. He turned once more to England for his models, basing his bravura style on that of Sir Thomas Lawrence in pose and physical type as well as in his flashing brushstrokes.

Late eighteenth- and early nineteenth-century American portrait style, therefore, often emulated the provincial English manner and actually resembled work by artists like Joseph Wright of Derby, who in the late eighteenth century painted many rising industrialists in Derbyshire. Both sorts of portraiture reflect the influence of middle class attitudes in England and the United States, through informality and their psychological penetration of its more open society.

Beginning in the 1830s, and dating roughly from the time when Samuel Morse introduced the daguerreotype on this continent, portraiture began to decline as the major American genre. Moreover, American taste turned away from English models and looked to France instead: George Healy's *Study for the Portrait of François Guillaume Guizot* (cat. no. 17) has broken with the English style and reflects its photographic origins.[7] By this time most portrait painters, as they do even today, often used the daguerreotype and the photograph as *aides-mémoire* in place of preparatory drawings. Early belief in the absolute truth of the camera's eye led to a loss of spontaneity in the pose, and the smooth, "licked" surface of M. Guizot's portrait derives not only from French practices in oil

painting but from this relationship with the photographic image.

Although, by the end of the Civil War, portraiture had lost its preeminence and function as mainstay of the artistic profession, many major artists continued to choose it as their primary means of expression. Thomas Eakins — perhaps America's greatest native painter in the nineteenth century (as opposed to the important expatriates James McNeill Whistler, John Singer Sargent, and Mary Cassatt) — following the loss of his professorship at the Philadelphia Academy, painted almost nothing but portraiture. The difference between the society or family portrait in the early nineteenth century and a work like the sad little boy, *Portrait of Master Douty* of 1906 (cat. no. 27), is very great. The child's intent, inward, dreaming look reflects the subjectivity and pessimism so notable in turn-of-the-century America. This portrait is comparable to Eakins's splendid self-portrait of 1902, which rivals his model, the seventeenth-century Spanish painter Velasquez, while also plumbing tragic subjective depths unexplored by the earlier painter. William Merritt Chase's *Dorothy in Pink* (cat. no. 28) and William Morris Hunt's *Portrait of a Child in Fancy Costume* (cat. no. 18) evince a taste for the silvery tones and revealed brushwork of seventeenth-century realists, whether Dutch or Spanish. This preference was increased by late nineteenth-century practices and the influence of French tonalists and the Munich school; elegance and subtlety as found in English academic style was abandoned for the broad brushwork and uncompromising realism of the continental model. Sitters painted in this style are often in costume, as is *Dorothy in Pink*, who wears eighteenth-century dress. This meant that the once clearly expressed function of portraiture — recreating the likeness — began to blur with what used to be called genre proper and now is sometimes referred to as narrative painting.[8] Winslow Homer's *Woman in Autumn Woods* (cat. no. 24), for instance, is neither a portrait nor merely a picture of a pretty girl in a landscape.

The widespread nineteenth-century admiration for realism, and the influence of the Düsseldorf school, reinforced an American proclivity for story telling and depictions of popular life: Edward Lamson Henry's *Passion Play, Oberammergau* (cat. no. 23), John George Brown's *Pull for the Shore* (cat. no. 25), or Frederic Remington's *Bullfight in Mexico* (cat. no. 26) share the kind of subject matter and style that twenty or thirty years ago would have seemed too popular to be worthy of interest or study. With today's renewed interest in realism and subject matter, however, the earlier attraction for this type of painting is more easily appreciated.

Nineteenth-century still-life painting in the Preston Morton Collection also represents an American predilection for the particular and the real, a taste conforming to the traditions of seventeenth-century *nature morte*.[9] Although still life since the time of Cézanne has become a major modernist mode, in the eighteenth and early nineteenth century it was considered a low genre and wherever it occurred one suspected sympathy for Dutch art. Citizens of America's early Republic with their dependence on trade, interest in science, and belief in thrift and hard work were disposed to see the world with much the same vision as the seventeenth century Dutch. In Philadelphia, the many members of the Peale family, while painting obsessively detailed baskets of fruit and flowers like James Peale's *Still Life: Wicker Basket of Mixed Grapes* (cat. no. 8), were interested in more than just the formal components of art. Because the patriarch of their clan, Charles Willson Peale, was not only the founder of a museum but also involved with scientific expeditions into the American wilderness, his relatives were appropriately concerned with botanical truth and optical illusion in their pictures.

Severin Roesen's *Still Life* (cat. no. 20) also reveals the continuing popularity of this type of painting in mid-nineteenth century, clearly displaying that minute realism so delighted in by members of the Düsseldorf School — in particular (as William Gerdts has noted in this catalogue), the painter Johann Preyer. Finally, in the 1880s and 90s, William Michael Harnett brought two traditions together, one stemming from the Peales and the other from Germany.[10] Influenced by Raphaelle Peale in Philadelphia and by his training in France and Germany, Harnett painted in the *trompe l'oeil* style of still life that harked back to the Baroque period. His manner is a playful extension of the period's optical realism, attempting to achieve such extreme fidelity to nature that the viewer is deceived into mistaking the painting for reality. However, by the twentieth century, pictures like William Harnett's *The Secretary's Table* (cat. no. 21) and John Peto's *My Studio Door* (cat. no. 22) had disappeared so completely from the public consciousness and museum walls that Alfred Frankenstein, whose entries on Harnett and Peto are included in this catalogue, had to rediscover both artists — especially Peto, who was usually labeled as Harnett.

The still life in modern American painting no longer descends from an admiration for realism and illusionism, but from the French school of the late nineteenth and early twentieth century. Cézanne, Van Gogh, Picasso, and Matisse all used elements from the older still-life compositions as motifs, but transformed them in order to analyze space and form, by breaking down and then reassembling the object as they perceived it. These "abstractions" from reality were subjective and also based on previous experiments by other artists, not on the mid-nineteenth-century view of "Truth to Nature." It was an art based on art. Such works as Alfred Maurer's *Still Life with Two Pears* (cat. no. 44) and *Violin* by Karl Knaths (cat. no. 48) reflect the situation in American art after the Armory Show of 1913, when the various versions of European Modernism appeared all at once, threatening American art's self-

confidence by fragmenting its singleness of vision and belief in nature. Certain artists represented in the Preston Morton Collection followed the Fauvist and Cubist vision, transposing it into their own versions of these styles. Some, like Alfred Maurer, who ended his life in suicide, suffered in this struggle to relate to European Modernism. Karl Knaths, however, continued to work more or less in the European tradition until his death in 1971.

In this overview of the different painting genres assembled for the Preston Morton Collection, I have saved the category of landscape and its twentieth-century counterpart, the cityscape, until last, because it became the means through which Americans finally succeeded in creating an art indigenous to their unique homeland. Today our eyes are charmed by these glimmering waters, rocky shores, and rosy sunsets in nineteenth-century landscapes, but their surface beauty alone will not suffice to explain the overwhelming attraction they held for the previous century. It is difficult for us to comprehend the importance they once had unless we realize what a profound degree of meaning landscape carried for both the nineteenth-century artist and spectator; not just a single meaning, but a great variety of interpretations. Landscape, not history painting, was the dominant genre in America's art, and it was on the battleground of landscape that our native artists fought the war between the real and the ideal. Early nineteenth-century attempts by Washington Allston, John Vanderlyn, and Samuel Morse to import the varying modes of *Istoria* from England and the continent were unsuccessful.[11] Not until Thomas Cole returned from Europe in 1832, with a firm grounding in the British landscape school, were Americans ready to embrace a classification of painting that responded to their need for new themes, equal and analogous to the great new political experiment of the United States. In painting, these themes were found in landscape, most spectacularly in America's vast and virginal wilderness.

This American Wilderness theme was not based purely on the image of untamed nature; the nineteenth-century viewer recognized its significance as originating in the older landscape tradition of the Ideal, the Picturesque, and the Sublime. That landscape, inanimate nature, seemingly the most bland of all the genre, should possess meaning at all seems like a contradiction in terms. But if we accept the hierarchy of genre, the highest having the most philosophical, religious, and literary meanings, the real or topographical view performing a very low, pragmatic role close to map-making and military surveys, then it is understandable why the seventeenth- and eighteenth-century landscape painter in creating the ideal landscape subscribed to the theory of *Ut Pictura Poesis* (As is Poetry so is Painting). In the Ideal landscape it is always late afternoon: a golden twilight on a summer's day, the fields and buildings of the Roman campagna, as freely interpreted by the seventeenth-

century French painters Claude Lorraine and Nicolas Poussin, stand as poetic metaphors for Virgilian pastoral poetry or the Hellenistic idylls, a land of milk and honey where nymphs and satyrs and rustic peasants disport themselves. It is not, however, paradise. The mood is indeed often elegaic, suggesting that this innocence shall pass away. Claude, "the Divine Claude" as he was called, also established formal conventions for this idealized subject matter, probably taken from stage machinery of the day — a tree at one side in the front plane, framing the view and establishing the scale, diagonal movement into the middle distance, and the recession of planes to distant hills or mountains that sometimes actually do resemble stage flats. A hundred years later, in the eighteenth century, the development of the Picturesque and Sublime landscape was still based on these conventions, but the meaning that accrued to them had an added dimension, that of associationalism. No longer did the rules ensure a contemplation of poetic mood inspired solely by literary allusion. In the Picturesque and the Sublime landscape the artist's interpretation of the scene was intended to arouse a series of responses in the spectator. The meaning was now more emotional than contemplative, and the viewer's pleasure in these two pictorial types resulted from the artist's manipulation of configurational elements in the scene itself instead of emanating from humanistic learning, Latin inscriptions or a knowledge of Greek mythology. Thus, the Picturesque was associated in a roundabout way with the natural, or English, garden, called picturesque because its vistas were based not on the geometry of a French seventeenth-century formal garden but on the vistas in Claude Lorraine's paintings. The Picturesque landscape — even of wild nature — tends to resemble a garden; the Sublime, on the other hand, especially as defined by Edmund Burke in his *Inquiry into the Origin of Our Ideas of the Beautiful and the Sublime* (1757), developed the associational characteristics of landscape painting even further. Sublime characteristics, however, are those that excite awe and terror in the viewer, achieving this effect through attributes that are dimensional and spatial, not moral. Obscurity, where all is dark, uncertain, and confused; vastness, whose great dimensions are most moving when expressed in height; and infinity, which, tending to fill the mind with delightful horror, is the most genuine effect and the purest test of the Sublime, all played their roles in Sublime landscape. This association of shapes with emotions was, in the end, extended to the Picturesque. By the 1790s, Uvedale Price had included attributes of roughness, sudden variation, and irregularity for the Picturesque.

Added to these categories of landscape (whose significance was clear to every viewer in the early eighteenth century, whether professional or amateur), was a renewed interest in the topographical. Increased interest in exploration, both at sea and in the un-

charted wilderness of the United States, stimulated America's curiosity about its virgin land filled with new species of birds and animals as well as new geological formations. These interests proved more compelling than the genteel, theatrical tradition of the Ideal and the Picturesque and raised the topographical tradition to a level equal with that of the literary.

Meaning in topographical art was deepened in the early nineteenth century by its association with the transcendental view of Science and Art, given its greatest expression by Baron Alexander von Humboldt, the German traveler and scientist, and by the English art critic John Ruskin. Both men had a profound effect on American art. Humboldt's vision of the world, in his scholarly writings and in his more popular book *Cosmos*, transferred the study of geology and botany from the scientific to the metaphysical plane — to know the universe was to master it, and what better way to know it than to record it. Ruskin named this moral imperative "Truth to Nature"; henceforth, it became an essential part of the American landscape aesthetic.

Thomas Cole was without doubt the first artist to synthesize past traditions in order to find a new meaning for American Art. His great unfinished painting *The Meeting of the Waters* (cat. no. 10), one of the masterpieces of the Preston Morton Collection, relates not only to the Ideal, the Sublime, and Romantic Scientism, but also embodies some of the allegorical and symbolic conventions found in Romantic landscape from England and Germany. As we shall see, Cole was able to transform all these meanings into a single, unique vision. His years of study in London coincided with those in which Sublime landscape, as seen in the works of J. W. M. Turner and John Martin, were at the height of their acceptance. The great size of these paintings, embellished by the awe-inspiring literary significance of Sublime subject matter, proved influential. At this period, a particular kind of Sublime subject, called "cataclysmic" by modern scholars, was in favor. It can be seen in Turner's *Seven Plagues of Egypt*, John Martin's *Pandemonium*, or Cole's own series, *The Course of Empire*, which demonstrated in five canvases the rise of the Roman Empire from barbarism and its descent into ruin; all subjects dealing with vast and striking cataclysms that did indeed impress the viewer with awe and terror. It is also possible that, given the passion for geology held by the most influential art theorists of the time, especially Humboldt and Ruskin, a then current scientific view of evolution known as "catastrophism" underlay such apocalyptic scenes.[12] It must not be forgotten either that the early nineteenth century was the great age of evolutionary theses and disagreement, Darwin's theory being only one among many. *The Meeting of the Waters* with its calm, elegiac character would not appear at first glance to belong to this tradition, but if one examines the symbolism of the painting and views the work in

conjunction with Cole's own writings, particularly the *Essay on American Scenery* of 1835, it would not be assuming too much to suggest that the cave which Cole had designated elsewhere as symbolic of a "mysterious past" and barrenness of the landscape might both be associated in a very general way with these prevailing "catastrophic" notions.

The Meeting of the Waters also shares some of the more obvious symbolic and allegorical conventions of the Romantic landscape in both England and Germany. The mysterious cavern, stream of life, and light gleaming through the clouds are all motifs that can be found, for example, in John Martin's *The Expulsion of Adam and Eve from Paradise* (1813). More notably perhaps, Cole shares with German Romantics, like Caspar David Friedrich, the transcendental view in which Nature and Religion, as well as Nature and Human Nature, are confounded. All natural elements are treated allegorically: the water as the river of life, the trees as noble souls buffeted by fate, the cavern as "the darkness from which we come," the clouds as a setting wherein one sees a vision of the Heavenly City. Related to this type of landscape, and also important for *The Meeting of the Waters*, was the Romantic association of landscape with nationalism. Americans, in company with the German painters, often produced allegorical landscapes with conspicuous symbols like the flowing waters of life, which could be identified as nationalist themes. The dense German forest of Friedrich's *Chasseur in the Forest* (1812) refers, for instance, to the defeat of the Roman legions of Varus by the Teutonic chieftan Arminius, an oblique reminder of the Napoleonic invasion of Germany.[13] We know from Cole's writings that he, too, envisioned the American land and its untamed territories in nationalistic terms. This sort of wilderness, he assumed, existed nowhere else on earth, and was consequently an exclusively American theme. In his *Essay on American Scenery*, he not only denoted the wilderness as "yet a fitting place to speak of God," but also associated it with Eden: "We are still in Eden, the wall that shuts out the garden in our own ignorance and folly." Beyond this conjoining of wild nature with religion, he also speaks of decline and ruin: "my sorrow that the beauty of such landscapes are quickly passing away, the savages of the axe are daily increasing, the most noble scenes are made desolate and oftentimes with a wantoness and barbarism scarcely credible in a civilized nation."[14] In his essay he also discusses the different sections of the United States and their variety in landscape, dwelling on descriptions of rivers and lakes more than on any other feature. It is tempting to think that in *The Meeting of the Waters* Cole intended to project, beyond his religious interpretation (the passage from earthly existence to the sea of Eternity and Heavenly Salvation), the added symbolism of a great uncharted land in the process of being discovered, signifying not only a confluence of the waters of life but the

waters of the American continent as well.[15]

The complexities of meaning inherent in the Thomas Cole painting are present to a greater or lesser degree in all nineteenth-century American landscapes from the Preston Morton Collection. After Cole, the pure Sublime or Picturesque landscape no longer sufficed — the artist wanted now to exploit some aspect of landscape that was uniquely American, and so he added to the older symbolism the various metaphysical and scientific elements described.

Janetta Falls, Passaic County, New Jersey (cat. no. 11) by Jasper Cropsey is representative of the mid-nineteenth century Hudson River School. In many respects *Janetta Falls* is a Picturesque landscape, conforming to the late eighteenth- and early nineteenth-century passion for travel and derived from views offered in the many illustrated books of the period that accompanied voyages to the English Lake country and other parts of Great Britain, or to Niagara Falls, the Great Stone Face, or Watkins Glen in the United States.[16] But in many other ways *Janetta Falls* is anti-Picturesque. In Cropsey's view, the spectator is placed up against the rocks; no receding planes or trees frame his view. Nevertheless, the thick undergrowth, the rocks, and the woodland untouched by civilization conveyed his special message. In attempting to rid himself of the Picturesque *schemata*, Cropsey has substituted this intense vision of a new aesthetic close to Ruskin's "Truth to Nature."[17] Consequently, the preparation of each picture required a fresh investigation of the subject, and this close observation of natural detail coincided with the transcendental tradition identifying Nature and God. "Truth to Nature" originated in the mind of the artist who wandered freely through a landscape made by the hand of God. Every tree, every rock was God-given, since perfection could exist in every one of God's creations no matter how deformed, even in a shattered rock, a weed, or a rotten tree. And so, by extension, the yet uncultivated land that was America was closer to God than the carefully tended gardens and parks of Europe. Furthermore, in his depiction of this hallowed wilderness, the artist was enjoined from expressing his personality through any brilliance of execution. The graceful recipes for creating the Picturesque style, reproduced in so many nineteenth-century drawing manuals, were exchanged for an intense view of nature expressed most ideally in a crystalline style.

John Frederick Kensett's *View of the Beach at Beverly, Massachusetts* (cat. no. 12) is a good example of this intense style of painting, termed Luminism by twentieth-century art historians. Unlike the designations of Picturesque and Sublime with their special interpretations known and shared by the artists involved, Luminism was applied after the fact, by critics and scholars to describe a mid-nineteenth-century American landscape technique

and artistic theory, particularly the work of Kensett, Fitz Hugh Lane, and Martin Heade. Its most ardent present-day adherent, Barbara Novak, speaks of a "smooth mirror-like surface that shows barely a trace of the artist's hand," which demonstrates to her that, " . . . In removing his presence from the painting, the artist acts like a clarifying lens allowing the spectator to confront the image more directly and immediately. Perhaps in absence of stroke, time stops and the moment is locked in space."[18] Novak's approach to meaning is made through the physical components of brushwork and finish. Now the artist's intention no longer lies in his choice of subject matter but in the way he interprets Nature through his manner of painting.

Luminism would appear to differ from "Truth to Nature" because of its specific interest in light, but neither Worthington Whittredge in his *Scene on the Upper Delaware: State of New York, Autumn* (cat. no. 13), nor Albert Bierstadt's *Mirror Lake, Yosemite Valley* of 1864 (cat. no. 14) seem to satisfy either criteria, nor would either artist have known or considered himself a member of any group. Their landscapes superficially resemble works by earlier members of the Hudson River School, but their training in Düsseldorf and other European centers often resulted in a formula quite different from the Picturesque or "Truth to Nature." The *schemata* used by many German and Scandinavian painters of this period is most often characterized by a dark middle distance and a rosy horizon. While their identification with the American landscape as wilderness conformed to notions of the Sublime, their preference for the Far West, the Rocky Mountains, the plains, the High Sierras, or California as their themes singled out regions of the United States that are above all naturally sublime. Although light in these paintings resembles the one found in the earlier Sublime employed to render immensity and infinity, the intention here may not be merely to evoke fear and wonder but also to describe the incredible space of the American West. Both Whittredge and Bierstadt traveled to the western reaches of the continent on government surveying expeditions. Their subsequent works were helpful to Frederick Law Olmstead and others who strove to create state and national parks and to have wilderness tracts set aside for posterity. With Thomas Moran and other artists, they became instrumental in perpetuating the natural theater of the Sublime in the American consciousness.

The nineteenth-century landscape painters continued to infuse their landscapes with romantic symbolism. One is made immediately aware of such obvious examples as the cross found in the foremost plane of Kensett's *View of the Beach at Beverly, Massachusetts.* As Gray Sweeney has pointed out in this catalogue, given the religious implication in every "choice" made by the Hudson River School, it is unlikely that Kensett was unaware of the implicit

symbol formed by the seemingly fortuitous meeting of two pieces of driftwood. Caspar David Friedrich's paintings of crosses as shrines in the German forests would surely have been known to American artists, and the resultant new interpretations by Kensett and other Hudson River School painters suggested the random significance of Nature itself. Motifs like Kensett's driftwood crucifix accord with the Hudson River aesthetic that encouraged original, even chance, arrangements rather than deliberately planned compositions.

It is much more difficult for us to recognize, nearly one hundred years later, the symbolism existing in paintings by George Inness. In his early work *Sunshower* (cat. no. 15) of 1847 we can see a resemblance to the Hudson River painters of the 1830s and 40s; it is a charmingly straightforward work in the Picturesque mode. However, his late work, the great *Morning, Catskill Valley* (cat. no. 16) does not, as might at first be assumed, result completely from the influence of French art — Corot and the Tonalists. Inness's mist is not just a response to the atmospheric conditions of the forest; the color of the trees exists not simply because the expected brilliance of Autumn inflames their leaves; it is, of course, all these things, but it is also more. As Nicolai Cikovsky (both in this publication and in his book on George Inness) has demonstrated, Inness's belief in the philosophy and symbolism of Emmanuel Swedenborg imbued this painting with a more than ordinary meaning.[19] Red, in the oak trees, for instance, corresponds to love because of its origins in the fire of the spiritual sun. Swedenborg believed the natural world to be a reflection of the spiritual realm. All aspects of this landscape, therefore, contain spiritual truths: trees, cattle, color, and light all have a transcendental meaning. Theoretical applications of correspondence, found for the first time in American painting in Inness's late work (1888–1894), had existed in Europe since the late eighteenth century. In Goethe's theories, colors were assigned different meanings connected with mood, and soon the idea of relationships between color, words, and tones was an underlying element in all Romantic and Symbolist art. It must be said, however, that while Inness's interpretations of nature are undeniably symbolic, they demonstrate no specific alliance to any European school.

And yet the Sublime approach to American landscape lingered on, reappearing in one form or another at the beginning of the twentieth century. Because American *fin-de-siècle* painters and their followers in the next decades were prone to blend the broken brushstrokes and optical experimentation of the French Impressionists with the gentler charms of the native genteel tradition, the Sublime landscape's preference for infinity, drama, and associated symbolism survived in the twentieth century. Marsden Hartley's landscape of the Bavarian Alps *Alspitz-Mittenwald Road* (cat. no. 45) of 1933 recalls the German romantics; surging, modern brushwork

reanimates the inheritance of an anthropomorphic mysticism incorporated in this scene. Quite as much as in Caspar David Friedrich's *Der Watzmann* (1824), Hartley expresses the symbolic presence of the mountain. Similarly, John Marin's *Composition, Cape Split, Maine, No. 3* (cat. no. 46) of the same year has transformed the formal elements learned from his study of Cézanne in Paris into an electrically explosive drama of the New England sea coast. Even as late as 1958, in Charles Burchfield's great painting *Early Winter Twilight* (cat. no. 43), lowering clouds and gnarled trees evoke the mood of an impending storm; the whole freight of symbolism implicit in the trees and the time of year recalls both the mood and mysticism generated by nineteenth-century landscape.

By the end of the nineteenth century, however, the once vital tradition of the Sublime had generally faded away. The nationalistic impulse to discover America's destiny as manifest in her land — especially in the wilderness tracts — had given way during the early twentieth century to buoyant confidence in America's technological might, its industry, and its cities filled with millions of emigrants streaming in from Europe; the world of the American cityscape.

The cityscape figured only rarely in American painting until the last decades of the nineteenth century.[21] Around 1900, when the cityscape appeared in paintings by a group calling themselves The Eight, but also known as the "Ashcan" School, it was not the placid perspective views of the Venetian painter Canaletto, nor the teeming morass recorded by William Hogarth that they sought to emulate. Closer in its joyful sense of freedom to Impressionist scenes of Paris in the 1860s, 70s and 80s, although without their color experimentation, this school elicits an underlying optimism, marking the shift from wilderness to city, yet still preserving a faith in America's destiny. The late Amy Goldin noted in writing about The Eight, "Just as our landscape painters had portrayed the wilderness as an untamed but fertile garden, these urban scenes offer the city as a social garden, a human wilderness unpruned and crude but essentially undestructive, life enhancing, strong."[22]

This is not to say that the "Ashcan" School was linked to any ideas pertaining to the avant-garde, or to any notion directly concerned with radical politics or the class struggle. Led by Robert Henri, this group was formed in Philadelphia where their teacher Thomas Anschutz had been a pupil of Thomas Eakins. They shared a conviction that the artist must be involved in the life around him, deeply committed to partaking of humanity in all its aspects, but it was their background as newspaper artists — rather than any desire to depict the despair of the working class environment — that led them to urban subjects. Each of them was familiar with, and loved, the vital, growing, city environment; the paintings of this period in the Preston Morton Collection must surely have been assembled

with this special theme in mind. Except for Robert Henri, who is represented as well by *Portrait of Mrs. Edward H. (Catherine) Bennett* (cat. no. 36), all of the "Ashcan" School works included in this collection are views of New York. Writing on this period, most scholars note a lack of cohesion in the styles of The Eight. While Robert Henri, John Sloan, George Luks, William Glackens, and Everett Shinn exhibit certain broad characteristics in common, like rough brushwork, there seems to be no important unifying element either among those five, or the remaining three members of the group, Maurice Prendergast, Ernest Lawson, and Arthur Davies. Prendergast and Lawson, for example, are close to European Impressionism and Post-Impressionism and to the work of Childe Hassam, who is represented here by his own cityscape *The Manhattan Club* (cat. no. 31). Notwithstanding their stylistic divergences, these artists, together with George Bellows, Jerome Myers, and Edward Hopper, were all artistically motivated by a particular vision of New York. Their works are filled with the teeming streets, the windswept harbor, and new skyscrapers of Manhattan — in Henri's *Derricks on the North River* (cat. no. 35), and in William Glackens's *East River from Brooklyn* (cat. no. 37), both of 1902, George Bellows's *Steaming Streets* of 1908 (cat. no. 40), and John Sloan's *City from the Palisades* of the same year (cat. no. 38). *Sideshow* by Gifford Beal (1910, cat. no. 33) and the Jerome Myers's *Children* (1926, cat. no. 41) depict a gentler side of urban life, while the stark emptiness of Edward Hopper's *November, Washington Square* (1932, cat. no. 42) reveals the loneliness of New York in the throes of the Depression.

The energy and excitement embodied in the first three decades of the twentieth century jumps out at the viewer of these pictures. Lacking in finesse or subtlety, they are works that capture America's spirit in the industrial age, as much as landscape paintings of the wilderness had registered it for the nineteenth century. Thus, while the landscapes and cityscapes form the single largest continuous block of American paintings and constitute perhaps the most striking and outstanding portion of the Preston Morton Collection as a whole, the broad choice of portraits, still lifes and genre are also representative of the overall vitality and uniqueness of the eighteenth-, nineteenth- and early twentieth-century art in America. In the forms and meaning of past art are found the sources of our present. By recognizing ourselves in the search of past American artists for uniquely American meaning, in the Sublime, the Transcendental, the Symbolic, we can in this period of revisionism find the alternative to the derivative concerns of European modernism, a twentieth-century art for the new continent.

Corlette Walker

Notes

1. The enlargement of the various Smithsonian galleries of American Art in Washington, the enormous collection in the new wing of the Metropolitan Museum in New York, where many works long relegated to the basement were refurbished and given separate galleries, the recent installation of the American collection at the De Young Museum in San Francisco, now with the addition of the Rockefeller Collection of American Art, are but a few indications of the renewed interest among Americans in their native art.

2. See *College Art Journal,* XL (Fall / Winter 1980), no. 1/2, with an essay by guest editor Irving Sandler on "Modernism, Revisionism, Pluralism and Post-Modernism," pp. 345–348, and "Pluralism in Art and Art Criticism, a Roundtable Discussion," pp. 377–379. While Post-Modernism is sometimes equated with the same ideas as pluralism, it is (in my opinion) too strongly associated with architecture to apply to painting.

3. Such artists as George Loring Brown or Theodore Robinson come to mind, or, in the twentieth century, Guy Pène du Bois. There is also a renaissance of interest in American nineteenth-century sculpture fostered by the scholars William Gerdts and Horst Janson.

4. Among those who studied with Benjamin West in London from 1764 until his death in 1826 were Matthew Pratt, Mather Brown, William Dunlap, Charles Willson Peale, John Trumbull, Washington Allston, Robert Fulton, Samuel Morse, Rembrandt Peale, and Charles Bird King.

5. Unless one includes *The Embarcation of Regulus,* a work that belongs to a sub-genre of *Istoria,* "the historical landscape," a classification accepted after it had been developed by Philippe De Routherbourg, J. W. M. Turner, and John Martin in the early nineteenth century.

6. See Trevor Fairbrother, "John Singleton Copley's Use of British Mezzotints for his American Portraits; a Reappraisal Prompted by New Discoveries," *Arts Magazine,* LV (March 1981), no. 7. The article also includes a reproduction of *Lt. (General) Joshua Winslow* (fig. 1, p. 122).

7. See Barbara Novak, *American Painting in the Nineteenth Century* (New York: Praeger, 1969), p. 199, or James Thomas Flexner, *That Wilder Image* (New York: Bonanza Books), pp. 212–216.

8. See, for example, Donelson Hoopes, *American Narrative Painting* (exhibition catalogue, Los Angeles County Museum of Art, 1974).

9. See William H. Gerdts and Russell Burke, *American Still-Life Painting* (New York: Praeger, 1974).

10. Before Harnett and Peto, the most famous examples of *trompe l'oeil* in American art were Charles Willson Peale's *Staircase Group* (1795, Philadelphia Museum of Art) and Raphaelle Peale's *After the Bath* (1823, Nelson Gallery-Atkins Museum, Kansas City).

11. Upon his return from Europe in 1917, Washington Allston brought with him an unfinished canvas, his large history painting, *Belshazzar's Feast.* Apocryphal tradition had it that immediately upon his return to Boston, Allston showed the nearly complete canvas to the aged Gilbert Stuart, who noted that some of the perspective in the background needed correcting. Allston began to repaint. From that time until his death in 1843, he never ceased working on the canvas. It was not that Allston was unappreciated or that he was a failure. Quite to the contrary, Boston thought him the greatest painter in America. It was, rather, the fact that there was no other artist or group to help him with the perspective, tell him when to stop, or demand the canvas for exhibition, there being no salon nor any art dealers in Boston at that time.

John Vanderlyn's *Ariadne Asleep on the Island of Naxos* (1812) was completed before he left Paris. In Paris he had won a gold medal at the French Salon for his *Marius in the Ruins of Carthage,* and he hoped to introduce New Yorkers to this type of painting. But *Ariadne,* besides being a history piece, also fell afoul of the Puritan proscription against the nude — no matter how idealized and Greek she may have been. Vanderlyn, in his later years, made his living in portraiture and landscape.

Samuel Morse's major efforts, the gigantic *Old House of Representatives* (1822) and, ten years later, the *Exhibition Gallery at the Louvre* did not make the reputation he had hoped for while a student in Europe. When his invention of the Morse code made him a millionaire, he consequently abandoned all aspirations to be America's foremost history painter.

12. Catastrophism was an early nineteenth-century response to the antibiblical implications of geological science. It dealt with phenomena like the shell fossils found on mountain peaks by theorizing that they had been deposited there in a worldwide catastrophe such as a flood or an earthquake (Neptunism versus Volcanism). The American scientific establishment, and Louis Agassiz in particular, continued to believe in catastrophism long after British scientists had accepted Darwin's findings on the extreme antiquity of the earth and the thesis of natural selection. Most religious interpretations of catastrophism suggested that the renewal of life after catastrophe came through God's dispensation and not through the survival of the fittest or random selection. God's will, not change, accounted for the history of the earth and its different species.

13. See Victor Maisel, "Philip Otto Runge, Caspar David Friedrich and Romantic Nationalism," *Yale University Art Gallery Bulletin*, XXXIII (Oct. 1972), pp. 37–51.

14. Thomas Cole, *Essay on American Scenery, American Monthly Magazine*, vol. 7, 1836; reprinted in John W. McCoubrey, *American Art, 1700–1960; Sources and Documents* (Englewood Cliffs, N.J.: Prentice-Hall, 1965), pp. 100, 109.

15. Cole's religious symbolism has been investigated in this catalogue by Gray Sweeney, and elsewhere by Alan Wallach, "The Voyage of Life as Popular Art," *Art Bulletin*, LIX (June 1977), no. 2, pp. 234–251.

16. William Gilpin, *Observations relative chiefly to Picturesque Beauty in Several Parts of Great Britain* (1770), or his *Three Essays On Picturesque Beauty; on Picturesque Travel; and on Sketching landscape: to these now are added two essays, giving an account of the principles and mode in which the author executed his own drawing*, 3rd ed. (London, 1808), p. 747.

Alexander Jackson Downing, who was the American tastemaker of the early nineteenth century, emulated the Rev. William Gilpin's choices for picturesque views in America, including Niagara Falls, the Great Stone Face, Watkins Glen, and other sites where one might walk to experience a Picturesque view.

17. Ruskin's ideas were well known in America by mid-nineteenth century. While his theories bore some resemblance to the transcendentalism of Emerson and Thoreau, most scholars admit that Ruskin is often inconsistent and contradicts himself. In the 1850s, a journal titled *Crayon* and, in the 1860s, a group calling itself *The Society for the Advancement of Truth in Art*, which published a journal called *The New Path*, were devoted to Ruskin on landscape. The foreword to the first issue of *The New Path* stated, "We believe that all Nature being the perfected work of the Creator should be treated with the reverence due to its Author, and by Nature they do not mean only the great mountains and wonderful land effects, but also every dear weed that daily gives forth its life unheeded to the skies." See Joshua C. Taylor, *The Fine Arts in America* (Chicago: University of Chicago Press, 1979), p. 96.

18. Barbara Novak, *American Painting of the Nineteenth Century* (New York: Praeger, 1969), p. 97.

19. Emmanuel Swedenborg, Swedish scientist, theologian (1688–1772), founder of the Swedenborgian Church. William Blake, John Flaxman, William Rimmer, William Page, and William Keith were all artists interested in Swedenborgianism and its symbolism and religion. See Nicolai Cikovsky, *The Life and Work of George Inness* (New York: Garland Publishing Inc., 1977).

20. Inness was one of the last American painters in the nineteenth century to seek out deeper meanings in nature in terms of color. However, both Albert Pinkham Ryder and Albert Blakelock were interested in literary subjects and in different types of literary symbolism — in the case of Ryder symbolism close to the Wagnerian. But they were less interested in the American wilderness and harked back to the early nineteenth-century "gothic" subjects — *Death at the Racetrack* invokes the *Death on a Pale Horse* of Benjamin West and Turner. Late in the century, the strain of mysticism disappears altogether, and painters like Theodore Robinson and Childe Hassam found their subject matter and technique ready-made in the French Impressionism movement.

21. There are two types of cityscapes, the Real, as in Francis Guy's *A Winter Scene in Brooklyn* (1817–1820) or Ideal, as in Thomas Cole's *The Course of Empire* series (1833–1836).

22. Amy Goldin, "The Eight: Laissez Faire Revolution," *Art in America*, July–Aug. 1973, p. 47.

List of Artists

Gifford Beal 192
George Wesley Bellows 218
Albert Bierstadt 104
John George Brown 153
Charles Burchfield 230
William Merritt Chase 168
Thomas Cole 82
John Singleton Copley 50
Jasper Francis Cropsey 90
Thomas Eakins 164
Walter Gay 176
William J. Glackens 206
William Groombridge 65
Christian Gullager 62
William Michael Harnett 139
Marsden Hartley 240
Childe Hassam 180
George Peter Alexander Healy 120
Robert Henri 200
Edward Lamson Henry 146
Winslow Homer 149
Edward Hopper 225
William Morris Hunt 124
George Inness 110
John Frederick Kensett 95
Karl Knaths 253
Ernest Lawson 196
John Marin 244
Alfred Henry Maurer 236
Jerome Myers 221
James Peale 68
John Frederick Peto 143
Maurice Prendergast 188
Abraham Rattner 249
Frederic Sackrider Remington 158
Severin Roesen 133
Randolph Rogers 128
John Singer Sargent 172
Everett Shinn 214
John Sloan 210
Thomas Sully 77
Benjamin West 54
Thomas Worthington Whittredge 98
Unknown 258
Unknown 262

List of Contributors

Gerald M. Ackerman, *Pomona College, California* 164, 168, 170
Peter Bermingham, *University of Arizona Museum of Art* 124, 127
Ruth Bowman, *Los Angeles* 166, 188, 191
Richard G. Carrott, *University of California Riverside* 54, 58
Jon A. Carstens, *University of California Riverside* 54, 58
Nicolai Cikovsky, *University of New Mexico* 112
Patricia Gardner Cleek, *Santa Barbara* 180, 182, 244, 246
Patricia Hills, *Boston University* 262
Linda S. Ferber, *Brooklyn Museum* 153
Grant Holcomb III, *SUNY at Stony Brook* 206, 208, 210, 212,
 221, 222
William Innes Homer, *University of Delaware* 202
Donelson F. Hoopes, *Los Angeles* 172, 174
Alfred Frankenstein, *Stanford University* 142, 144
William H. Gerdts, *City University of New York* 68, 73, 133
Anthony F. Janson, *Indianapolis Museum of Art* 100
Dean Jensen, *The New Milwaukee Art Center* 192, 194
Adeline Lee Karpsicak, *University of Arizona Museum of Art* 196, 199
Penny Knowles, *Santa Barbara Museum of Art* 128, 131
Gail Levin, *Whitney Museum of American Art* 226
Melinda Lorenz, *Shwayder Art Gallery, University of Denver*
 249, 250, 253
Katherine Harper Mead, *Curator of Collections from 1975-1980,*
 Santa Barbara Museum of Art, now Director,
 Elvehjem Museum of Art, University of Wisconsin-Madison 200, 204
Ellen G. Miles, *National Portrait Gallery* 62, 70, 77, 120
Paul Chadbourne Mills, *Santa Barbara Museum of Art* 104, 107
Kathleen Monaghan, *Santa Barbara Museum of Art* 110, 158,
 200, 225
Maria Naylor, *New York City* 160
Lynn Federle Orr, *University of California, Santa Barbara*
 90, 98, 139, 143, 176, 178
Michael A. Quick, *Los Angeles County Museum of Art* 146, 218
Sheldon Reich, *University of Arizona* 236, 238
Gail R. Scott, *University of Maine-Presque Isle Extension* 240, 242
Michael W. Schantz, *Grunwald Center for the Graphic Arts,*
 University of California, Los Angeles 50, 56, 149
David W. Steadman, *Chrysler Museum, Norfolk* 214, 216, 230, 232
J. Gray Sweeney, *Grand Valley State College, Michigan* 82, 95
William S. Talbot, *Cleveland Museum of Art* 92
Patricia Trenton, *Union League Club, Chicago* 65, 66
Corlette Walker, *University of California, Santa Barbara* 17, 258

About this Catalogue

Title—Whenever possible, the title given is the one under which the painting was originally recorded or mentioned. Several of the paintings in the Preston Morton Collection were acquired with titles different from those given in the present catalogue. If these titles appear in the first publication of the Preston Morton Collection, *Two Hundred Years of American Painting*,[1] 1961 (see Exhibitions) or are otherwise in common use, they are included in parentheses below the title proper.

Date—A date, given alone, indicates it is recorded on the painting itself or is otherwise securely documented. A date preceded by circa (ca.) is one established quite precisely in time by circumstantial evidence.

Measurements—They are given in inches followed by centimeters in parentheses. Height precedes width. Each work was remeasured for the purposes of this catalogue and therefore the measurements recorded here may vary slightly from those found in earlier publications. Dimensions given are those of the painted surfaces.

Inscriptions—Any inscription on the stretcher or reverse of the support known to be in the artist's hand is recorded, unless a signature on the reverse is in characters similar to those found in the signature on the front of the painting. Other inscriptions on the reverse of the support are recorded if the information they contain is of material value.

Provenance—Dealers, auctions, and sales are given in parentheses. When clearly substantiated, direct transfer from one owner to the other is indicated; otherwise only the owner's name, with dates or a date of ownership if known, is indicated within semicolons. Conflicting sources of information regarding ownership and/or transfer are covered in footnotes. Probable, but unsubstantiated, ownership is indicated by a question mark.

Condition and Technique—If known, earlier condition history is given. Summaries of condition and, if applicable, of treatment are given for each painting on canvas, panel, or board that has been inspected and/or treated by the Balboa Art Conservation Center, San Diego, and the Conservation Center, Los Angeles County Museum of Art. Many of the chemical compounds and materials used in the treatment are given in their abbreviated forms, and are listed more fully in the *Glossary* on page 29. If included in the report of the conservation laboratory, technique is given.

Exhibitions—The exhibition histories are as complete as possible. When an exhibition could not be verified by the editor, the source of information is indicated. Exhibitions are listed in chronological order; data given include place, institution where first shown, title of exhibition, dates of first showing, and if accompanied by a catalogue, with catalogue references following. If a particular exhibition traveled, participating institutions are also listed. Mentions of two exhibitions held at the Santa Barbara Museum of Art in 1961 and 1966 respectively, *Two Hundred Years of American Painting* and *American Portraits In California Collections*,[2] are given in shortened form.

References—These include only specific mention and/or reproduction of the work in question in publications, exclusive of exhibition catalogues. References are listed in chronological order.

Selected Bibliographies—These are intended to be of general interest and to provide a guide to further reading on the individual artists presented in the biographical essays. The bibliographies are placed at the back of the catalogue (beginning on page 267) under names (alphabetically listed) of the individual artists to whom they refer.

Left and Right—These references, unless otherwise specified, indicate the spectator's left and right.

Notes

1. *Two Hundred Years of American Painting*, Santa Barbara Museum of Art, Mar. 4–Apr. 5, 1961. Catalogue text by E. Maurice Bloch.
2. *American Portraits In California Collections*, Santa Barbara Museum of Art, Apr. 6–May 8, 1966. Catalogue introduction by Thomas W. Leavitt.

Glossary of Conservation Terms

B67:	Acryloid B67 (polyisobutyl methacrylate)
B72:	Acryloid B72 (methyl methacrylate-ethyl acrylate copolymer)
Calgon:	sodium hexametaphosphate, trisodium phosphate and sodium carbonate
DMF:	dimethyl formamide
EDC:	ethylene dichloride
Elvacite 2044:	poly n-butyl methacrylate
Magna:	bocour magna (proprietary acrylic resin paints, probably poly n-butyl methacrylate)
MEK:	methyl ethyl ketone
Multiwax W835:	microcrystalline wax
Multiwax X-145-A:	microcrystalline wax
PVA:	Polyvinyl acetate
PVA-AYAA:	Bakelite PVA-AYAA (polyvinyl acetate)
PVA-AYAC:	Bakelite PVA-AYAC (polyvinyl acetate)
PVA-AYAF:	Bakelite PVA-AYAF (polyvinyl acetate)
PVA heat seal:	polyvinyl acetate heat seal adhesive (PVA-AYAA and PVA-AYAC, 1:1, dissolved in toluene with a small proportion of multiwax W445)
Rhoplex A234:	methyl methacrylate-ethyl acrylate copolymer emulsion
Ross wax:	4 parts beeswax, 1½ parts multiwax W445, 1½ parts paraffin, 2 parts Zonarez B85 polyterpene resin
Solivar:	proprietary acrylic resin, probably n-butyl methacrylate and n-butyl acrylate copolymer
Tergitol:	tergitol 7 (anionic wetting agent)
Vance wax:	1½ parts beeswax, 1½ parts multiwax X-145-A, 1 part Zonarez B85 polyterpene resin
Zonarez B85:	polyterpene resin

List of Abbreviations

attr.	attributed
Allison	H.V. Allison & Co., Inc., New York
Babcock	Babcock Galleries, New York
BACC	Balboa Art Conservation Center, San Diego
ca.	circa
cat.	catalogue
chap.	chapter
Coll.	Collection
comp.	compiled
Downtown	Downtown Gallery, New York
ed.	edited
(Ed.)	Editor
fig.	figure
Hirschl & Adler	Hirschl & Adler Galleries, Inc., New York
ill.	illustrated
Kennedy	Kennedy Galleries, Inc., New York
Knoedler	M. Knoedler and Co., Inc., New York
Kraushaar	Kraushaar Galleries, New York
LACMA	Los Angeles County Museum of Art Conservation Center
l.c.	lower center
l.l.	lower left
l.r.	lower right
Levy	John Levy Galleries, New York
n.d.	no date
Nicholson	John Nicholson Gallery, New York
no.	number
n.p.	not paginated
Ortgies	Ortgies & Co., New York
p.	page
PMC	Preston Morton Collection
pl.	plate
pp.	pages
repr.	reproduced
rev. ed.	revised edition
Robles	Esther Robles Gallery, Los Angeles
Rosenberg	Paul Rosenberg & Co., New York
SBMA	Santa Barbara Museum of Art
Spark	Victor D. Spark, New York
u.c.	upper center
u.l.	upper left
u.r.	upper right
vol.	volume
Vose	Vose Galleries of Boston, Inc.
Wildenstein	Wildenstein and Co., Inc., New York

The Catalogue

List of Color Plates

31 *The Manhattan Club*, Childe Hassam Cover
(See text, page 180)

1 *Lieutenant Joshua Winslow*, John Singleton Copley 33
(See text, page 50)

6 *Portrait of Edmund Rouvert*, James Peale 34
(See text, page 68)

7 *Portrait of Jane Rouvert*, James Peale 35
(See text, page 70)

10 *The Meeting of the Waters*, Thomas Cole 36
(See text, page 82)

12 *View of the Beach at Beverly, Massachusetts*, John Frederick Kensett 37
(See text, page 95)

16 *Morning, Catskill Valley*, George Inness 38
(See text, page 115)

21 *The Secretary's Table*, William Michael Harnett 39
(See text, page 139)

32 *Summer in the Park*, Maurice Prendergast 40
(See text, page 188)

33 *Sideshow*, Gifford Beal 41
(See text, page 192)

36 *Portrait of Mrs. Edward H. (Catherine) Bennett*, Robert Henri 42
(See text, page 204)

38 *City from the Palisades*, John Sloan 43
(See text, page 210)

39 *Sixth Avenue Shoppers*, Everett Shinn 44
(See text, page 214)

42 *November, Washington Square*, Edward Hopper 45
(Photograph taken before 1981 conservation work)
(See text, page 225)

44 *Still Life with Two Pears*, Alfred Henry Maurer 46
(See text, page 236)

46 *Composition, Cape Split, Maine, No. 3*, John Marin 47
(See text, page 244)

43 *Early Winter Twilight*, Charles Burchfield 48
(See text, page 230)

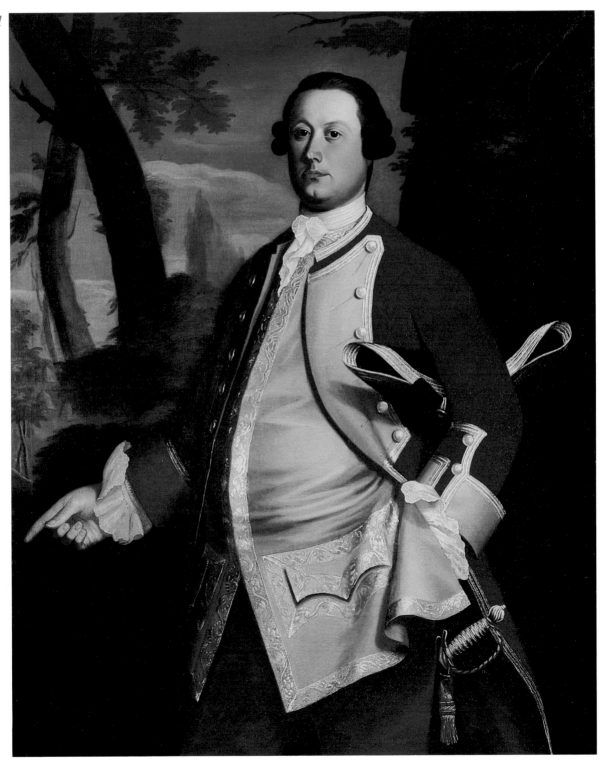

Lieutenant Joshua Winslow, John Singleton Copley

6

Portrait of Edmund Rouvert, James Peale

7

Portrait of Jane Rouvert, James Peale

35

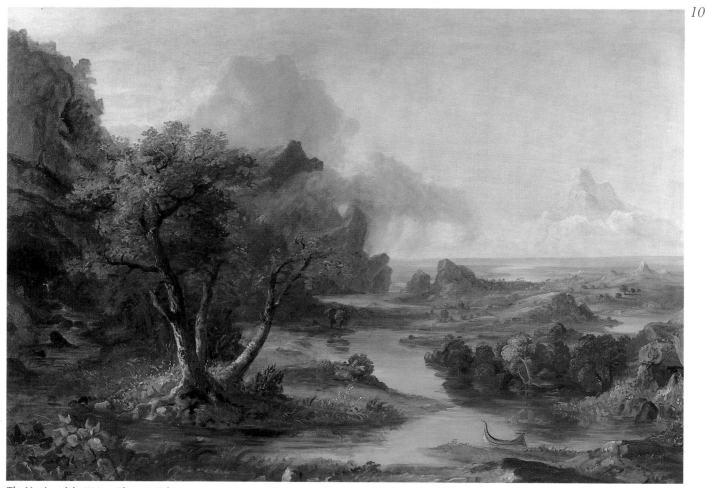

The Meeting of the Waters, Thomas Cole

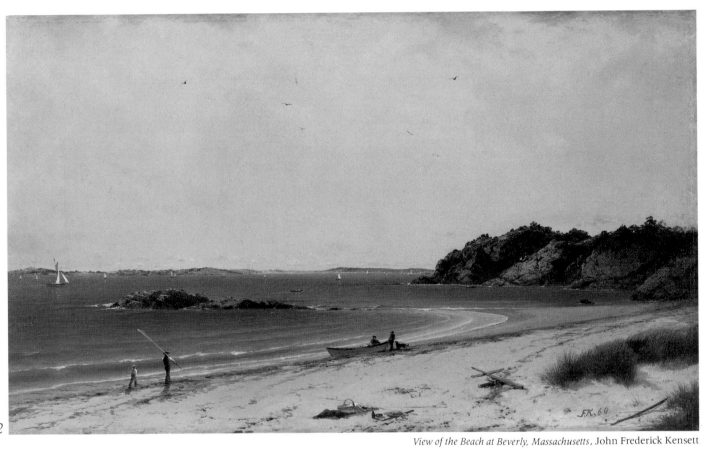

12

View of the Beach at Beverly, Massachusetts, John Frederick Kensett

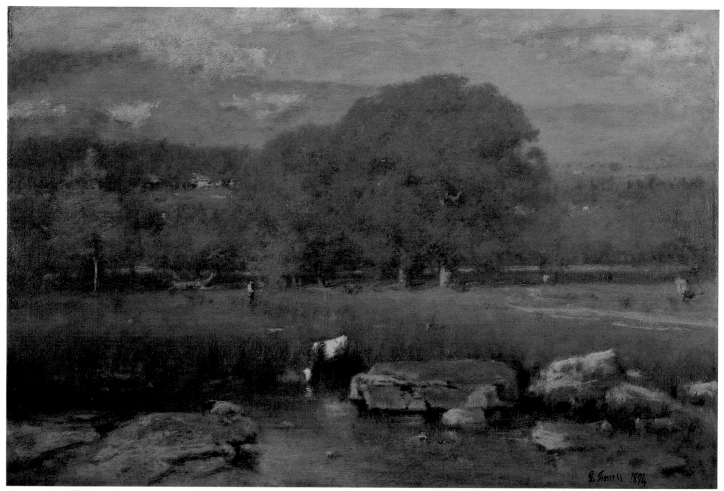

Morning, Catskill Valley, George Inness

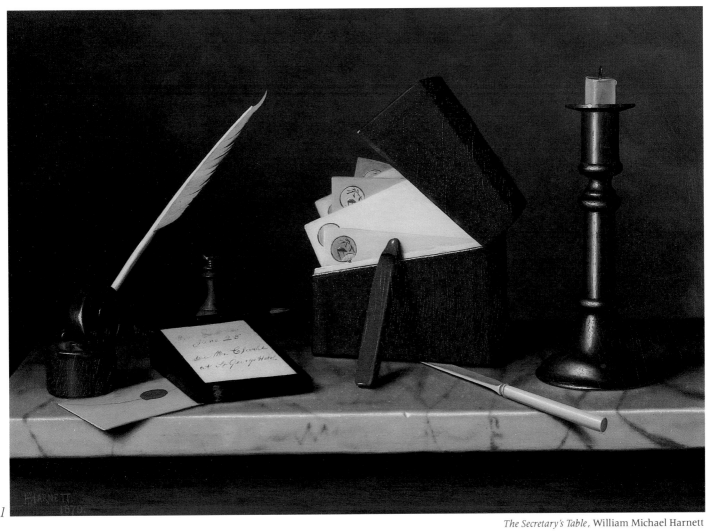

The Secretary's Table, William Michael Harnett

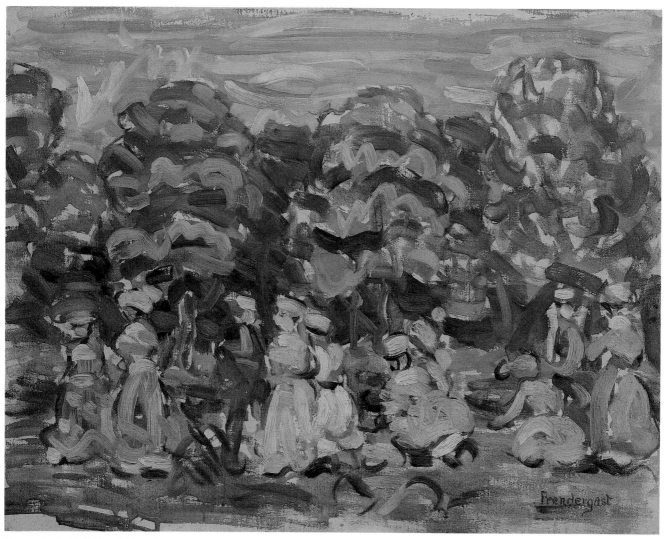

Summer in the Park, Maurice Prendergast

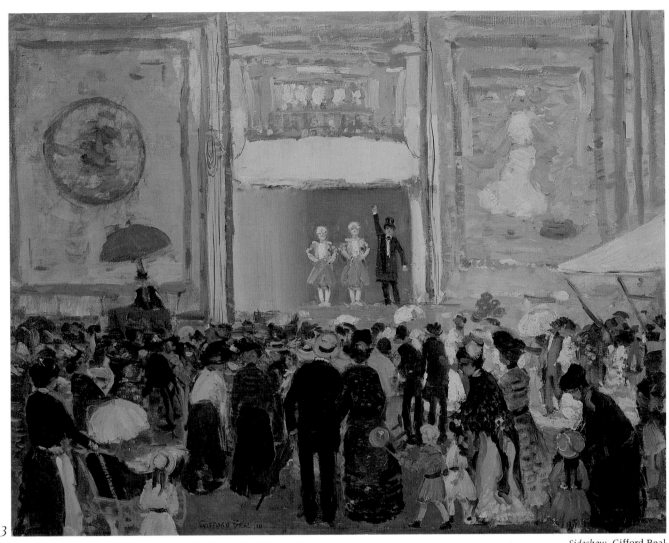

33

Sideshow, Gifford Beal

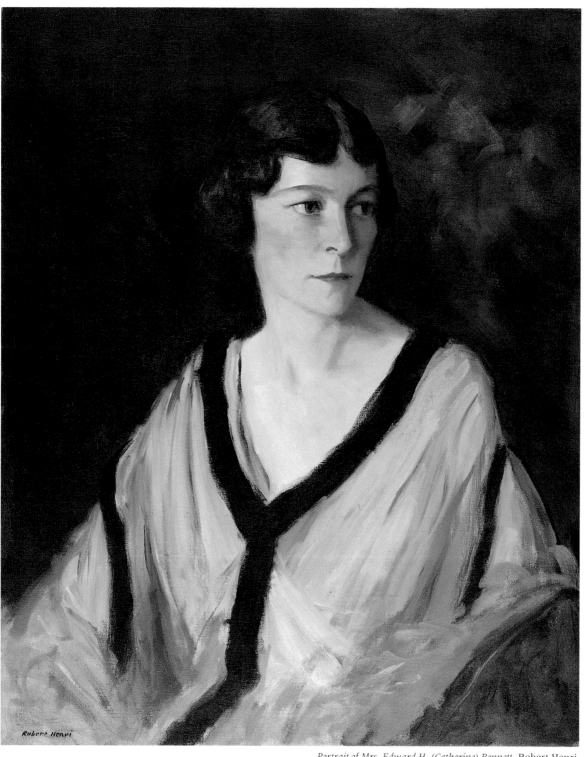

Portrait of Mrs. Edward H. (Catherine) Bennett, Robert Henri

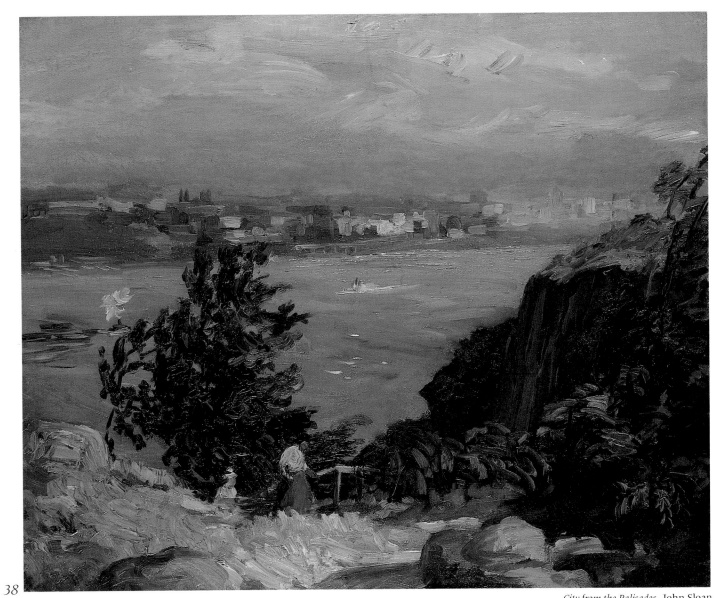

38

City from the Palisades, John Sloan

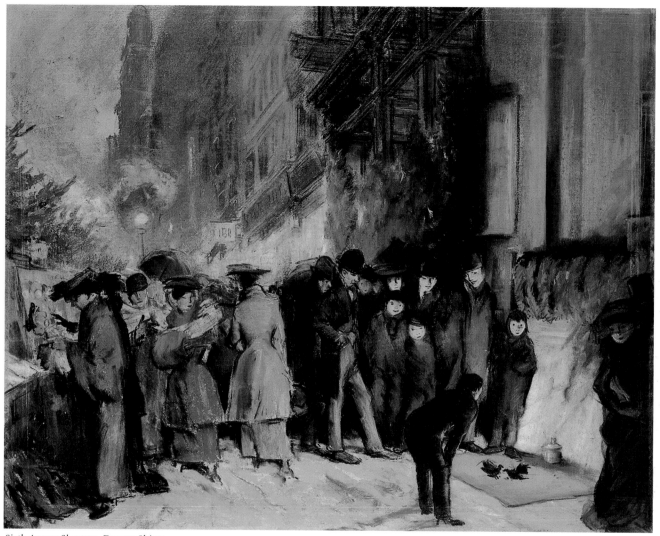

Sixth Avenue Shoppers, Everett Shinn

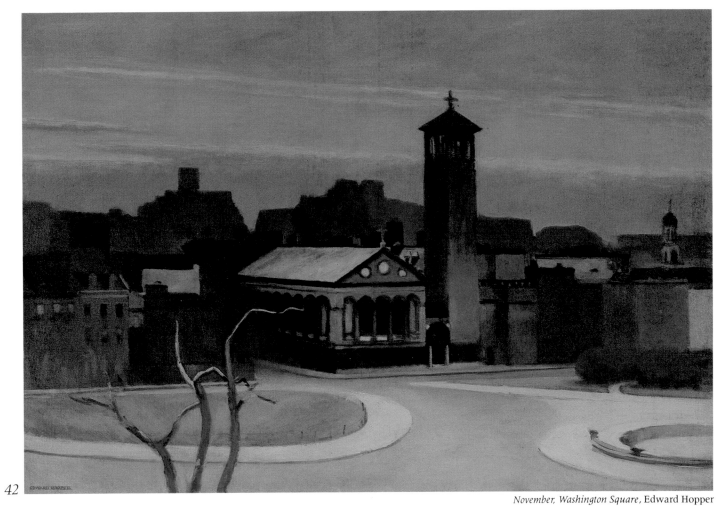

42

November, Washington Square, Edward Hopper

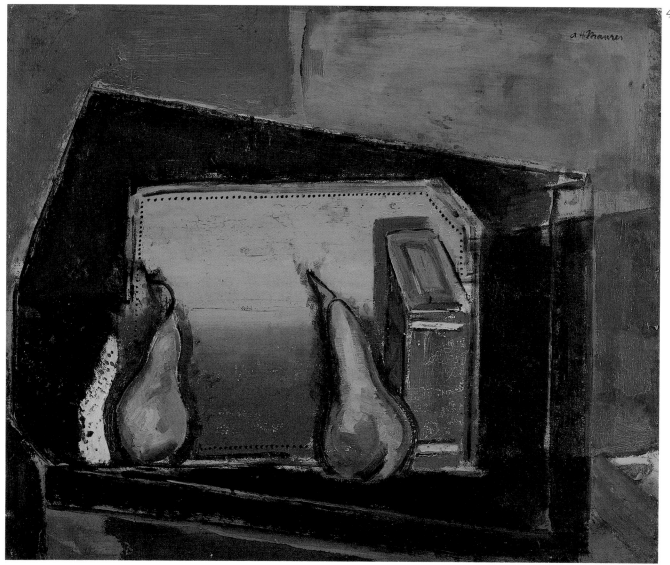

Still Life with Two Pears, Alfred Henry Maurer

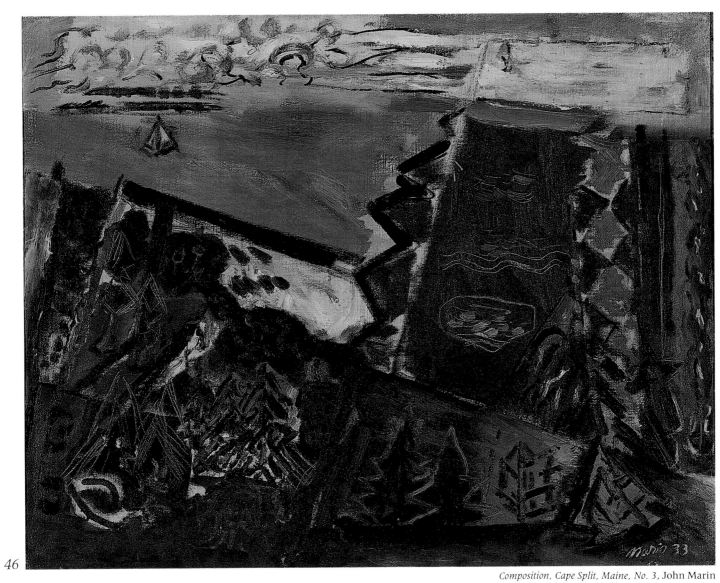

46

Composition, Cape Split, Maine, No. 3, John Marin

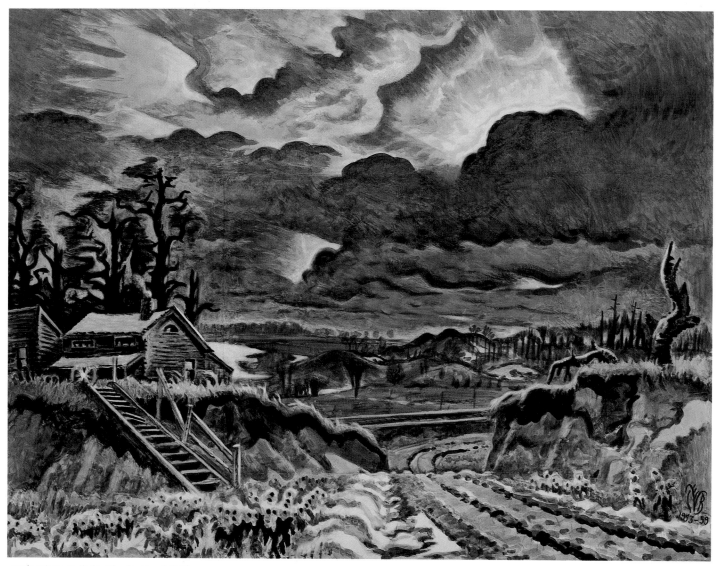

Early Winter Twilight, Charles Burchfield

Eighteenth and Early Nineteenth Centuries

John Singleton Copley
1738-1815

John Singleton Copley was born in Boston on July 3, 1738. His parents, Richard and Mary Singleton Copley, were of Irish stock and proprietors of a tobacco shop on Boston's busy Long Wharf. By the time Copley was nine or ten his father had died, leaving his mother to continue the family business. In May of 1748, however, Mary Copley chose to remarry. Her decision to do so proved crucial to Copley's future career as an artist. His stepfather was one Peter Pelham (1697–1751), a talented mezzotint engraver from England. It was through Pelham that Copley first became acquainted with artistic endeavors. Perhaps even more important was his stepfather's friendship with John Smibert (1688–1751), a Scottish artist who had become America's foremost portrait painter. Pelham made several engravings after portraits by Smibert, and it seems likely that young Copley had direct contact with this outstanding artist.

Copley's first documented artistic productions appear not long after the death of his stepfather in December 1751. He began by trying a mezzotint engraving, some history paintings copied from European prints, and a number of portraits in oil. These early attempts at painting occurred at the tender age of fifteen. By 1755 he was putting out very competent likenesses, every bit as good as his older competitors. In a few more years he would eclipse all rivals as the premier portrait painter in America.

Despite the success and prosperity that accrued to John Copley as a portrait painter, the young artist nurtured an inspiration to be a history painter in the Grand Manner. These notions of high art were to be found in printed treatises imported to America and available to Copley. His desire to paint grander images was reinforced by the enthusiastic encouragement of Sir Joshua Reynolds (1723–1792), the first President of the Royal Academy, and above all by Benjamin West (1738–1820), the American expatriate and preeminent history painter in England. These forces convinced Copley to leave his homeland. On June 10, 1774, at the age of thirty-six, he set sail for Europe and the Grand Tour, a sojourn that would give Copley firsthand exposure to antiquity and the Old Masters.

At the end of his Continental journey, the artist took up residence in London, never to return to America. His English career is markedly different from that in Boston. The creative outpouring of his British years is epitomized by monumental history paintings that rivaled the work of his English contemporaries. Indeed, in a unique display of dramatic showmanship Copley displayed such works as his *Siege of Gibraltar* in a large tent in direct competition with the annual exhibition of the Royal Academy. Such acts did not endear him to his fellow Academicians. John Copley's later years were characterized by an irascible personality and declining proficiency. He died in London, September 9, 1815.

Michael W. Schantz

Lieutenant Joshua Winslow

(See color reproduction, page 33)

After a brief business career with his brother Isaac, Joshua Winslow (1727–1801) chose to enlist in the British army. He did so just in time to participate in Sir William Pepperell's successful campaign against the French stronghold of Louisburg on Cape Breton Island, Nova Scotia. He remained in active military service for a period of fourteen years, rising in rank from Lieutenant to Captain, and eventually becoming the Chief

1 Lieutenant Joshua Winslow

(previously titled *General Joshua Winslow*)
1755
Oil on canvas
50 x 40 in. (127 x 101.6 cm)
Signed and dated l.r.: J Copley 1755
Gift of Mrs. Sterling Morton
60.54

Provenance

General Joshua Winslow; John Winslow, nephew of the sitter; Mary Ann Winslow, daughter of the latter; James Fullerton Trott, her son; John Winslow Trott; Mrs. John Winslow Trott, Niagara Falls, N.Y.; (consigned by Mrs. Trott to Knoedler, 1936); (purchased from Mrs. Trott by Knoedler, 1956); purchased from Knoedler by Mrs. Sterling Morton for the PMC, 1960.

Condition and Technique

In 1960 prior to entering the SBMA, at the request of James W. Foster, Jr., Director (letter of Jan. 28, 1960), the painting was cleaned and lined with wax-resin while still at Knoedler. According to a letter of March 28, 1961, from Foster to Bartlett H. Hayes, Jr., Director, Addison Gallery of American Art, the painting was cleaned by Morton Bradley "who uncovered the signature and date."

In 1978 examination by the BACC noted that the support was in good condition and the lining still adequate. The ground and paint layers showed moderate cupping, severely raised stretcher creases, and overall age crackle. The numerous areas of overpaint had discolored, and the fills had been incompletely applied. The surface coating had an even overall gloss except for the matt overpaintings.

In 1981 the painting was treated by the BACC. The surface coating was removed with Benzine B264, and the overpainting with acetone. An isolating layer of Acryloid B72, 10% in xylene was applied. Losses were filled with wax-dammar filling putty (2½ parts beeswax, 1 part dammar), the fills were textured with metal implements and the fills were sized with Bakelite PVA-AYAA, 10% in ethyl alcohol. Inpainting was done with dry pigments hand ground in Acryloid B72. Several spray coats of B72, 10% in xylene were applied as a final protective surface coating.

The support is a moderately heavy weight, slightly loosely woven plain and single weave fabric. The ground, which is not readily visible, is

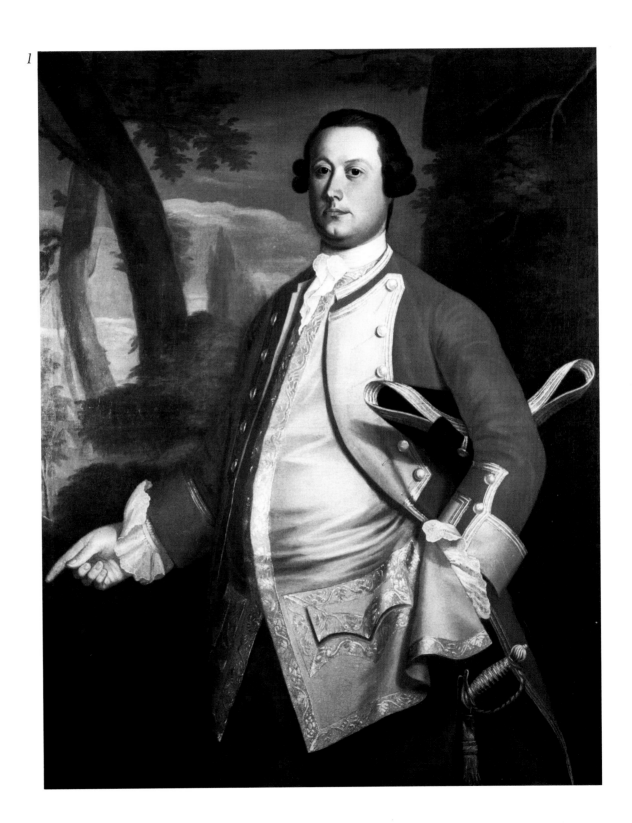

Commissary Officer, first at Fort Lawrence and later at Fort Cumberland. In 1759 he left the army and married his cousin, Anna Green, in Boston. At this time he renewed his business career, taking up residence in Marshfield, Massachusetts, and in 1773 was one of the consignees (along with Copley's father-in-law, Richard Clarke) chosen by the East India Company to sell tea and collect import duties. His were among the cargoes of tea that were so rudely thrown into the Boston harbor during a very famous Tea Party. Winslow's continued allegiance to George III forced him to flee the colonies shortly before the Revolution. He went first to Halifax, where he was made Paymaster of the British Forces. At the conclusion of the hostilities with the colonies, he went to England, and somewhat later to Quebec, where he remained until his death.[1]

At the time the portrait of Joshua Winslow was painted, in 1755, Copley was only seventeen years of age.[2] It stands as a precocious effort for one so young, and, considering Copley had only begun his professional painting career two years earlier, his talent is evident. The *Winslow* portrait also represents Copley's *entrée* into the patronage of social notables and, in this case, one of the heroes of Louisburg; John Copley had very much "arrived" as a competent and sought-after portrait painter. From this time forward, commissions would come from the upper ranks of Boston society. And, while Joshua Winslow was an ardent loyalist, a list of Copley's clientele shows he was equally comfortable painting Tory or Whig.[3]

Fortunately for the young Copley, the first two years of his professional practice were made easier by the fact that the most important portraitists of the first half of the eighteenth century had either died or left Boston. These included Robert Feke (1705/10–after 1750), John Greenwood (1727–1792), and John Smibert (1688–1751). With these formidable painters out of the way, competition was greatly depleted. The paintings by these worthies, however, did not escape Copley, and their influence is evident in his early work. Indeed, Copley had apparently learned so well from his observation of his fellow artists that this portrait of *Joshua Winslow* was for a very long time attributed to John Greenwood. Not until fairly recent times did cleaning reveal Copley's signature and the date 1755.

While the pose of *Joshua Winslow* has been traced to other American portraits, most notably Robert Feke's *Isaac Winslow* (ca. 1748–1750),[4] the original sources for such portraits are the British paintings of artists like Sir Godfrey Kneller (1646–1723), Thomas Hudson (1701–1779), and Joseph Highmore (1692–1780). These artists had formalized postural conventions that they repeated again and again in their portraits of British elite. Hudson in particular produced several poses where the tricorn hat is placed comfortably under one arm and the other thrust under the sitter's vest, with saber handle protruding. It was, in fact, a very fashionable pose in mid-century England. These images of English notables were transmitted to the colonies with the proliferation of mezzotint engravings. For this reason many early American portraits, from many varying locations, have similar gestures. Such similarities, therefore, were not necessarily due to one artist's copying the painting of another. It is now well known that artists possessed engravings as pictorial aids.[5] It is obvious that Copley owned such prints, since printmaking was the business of his stepfather, Peter Pelham (1697–1751). It seems very likely also that the young artist utilized one of these prints as a guide for the formal pose of *Joshua Winslow*; the lieutenant might personally have chosen the pose from an assortment of possibilities, selecting a print much like James McArdell's (ca. 1729–1765) engraving after Thomas Hudson's *Lord Townshend*.[6] John Copley would use virtually the same pose for at least two subsequent portraits, *William Brattle* (1756)[7] and *Theodore Atkinson* (1757–1758).[8]

probably a greyish layer of medium thickness. The paint, an oil type, is applied as a rich vehicular paste, with some pigmented glazes, and heavily localized impasto in the whites, highlights, and braid.

Notes

1. Biographical information from *Appleton's Cyclopaedia of American Biography*, J. G. Wilson and J. Fiske, eds. (New York, 1899), VI, p. 570; J. C. Webster, *The Journal of Joshua Winslow* (St. John, New Brunswick, 1936), pp. 11–12.
2. A label formerly affixed to the back of the stretcher, now lost but recorded, read: "A pt. of Joshua Winslow born in Boston, January 23, 1727, painted by John Singleton Copley, in 1755. J. W. was a lieutenant in Col. Moore's Regiment at Louisburg in 1745. Commissary in the British army in 1755 — died in Quebec in 1801.
"Paul Revere designed almost all of the frames for Copley's portraits. The heads of Copley's are too small."
Also signed by Copley is a miniature representing Joshua Winslow *en buste*, which is identical in features, position, and detail of costume with the SBMA painting. See Jules David Prown, *John Singleton Copley: In America 1738–1774* (Cambridge, Mass.: Harvard University Press, 1966), pp. 21–22. (Ed.)
3. See Prown's computerized analysis of Copley's patrons. Prown, pp. 97–137.
4. Museum of Fine Arts, Boston, gift of Russell Wiles; Prown, fig. 33.
5. The whole question of mezzotint prototypes was first introduced and discussed by Waldron Phoenix Belknap, Jr.; included in his work are many comparisons between American poses and those found on imported prints. See Belknap, *American Colonial Painting: Materials for a History* (Cambridge, Mass.: The Belknap Press of Harvard University Press, 1959), Part VI, "The Discovery of the English Mezzotint as Prototype of American Colonial Portraiture," pp. 273–329. See also Trevor Fairbrother, "John Singleton Copley's Use of British Mezzotints for his American Portraits; a Reappraisal prompted by New Discoveries," *The Arts Magazine*, LV, no. 7 (March 1981).
6. Belknap, pl. XIX.
7. Coll. Thomas Brattle Gannett, Wayland, Mass.; Prown, fig. 36.
8. Museum of Art, Rhode Island School of Design, Providence; Prown, fig. 53.

References

Augustus Thorndike Perkins, *A Sketch of the Life and a List of Some of the Works of John Singleton Copley*, (Boston: privately printed, 1873), p. 123.

James Grant Wilson and John Fiske, ed., *Appleton's Cyclopaedia of American Biography* (New York: Appleton & Co., 1889), VI, p. 570.

Frank W. Bayley, *The Life and Works of John Singleton Copley* (Boston: Founded in the Taylor Press, n.d.), p. 258.

J. C. Webster, *The Journal of Joshua Winslow* (St. John, New Brunswick, 1936), p. 12 (as belonging to John Winslow Trott).

We are fortunate to have in the Preston Morton Collection an early portrait by Benjamin West, dating from approximately the same time as Copley's work. It is important to keep in mind that West and Copley were exact contemporaries, born the same year. Because of West's ascendancy to the top of the international art community of his day, his attainment of the presidency of the Royal Academy, and most of all his role as advisor and mentor to Copley, it is often incorrectly assumed that West was older. Comparison of West's *Stephen Carmick* portrait with Copley's *Joshua Winslow* reveals that Copley possessed a native ability at least equal to that of West. Certainly, in his simulation of the satin and brocade detailing of Winslow's waistcoat, as well as the silvery piping of his hat and coat, and the luster of his sword hilt, Copley shows every bit as much technical skill as West. As fate would have it, however, it was Benjamin West, and not John Copley, who was first afforded the opportunity to experience and participate in art activities and opportunities abroad. Not until 1774 did Copley get his chance at European study. By then, the artist had produced one of the most formidable portrait oeuvres in the history of American art.

Michael W. Schantz

Exhibitions

N.Y., Knoedler, *Exhibition of Masterpieces of American Historical Portraiture*, no. 14, p. 21.[1]
N.Y., Knoedler, *Portraits of George Washington and Other Eighteenth Century Americans*, Feb. 13–March 4, 1939 (?).[2]
N.Y., Knoedler, Summer 1940.[1]
Andover, Mass., Addison Gallery of American Art, Sept. 18–Nov. 1, 1942, no. 24.
N.Y., Syracuse Museum of Fine Arts, *American Old Masters: Portraits and Landscapes 1737–1925*, Jan. 16–Feb. 10, 1944, repr. cover.[3]
Atlanta, The High Museum of Art, *Eighteenth Century American Paintings*, March 1945.
Memphis, Tenn., Brooks Memorial Art Gallery, *A Loan Exhibition of American Paintings* (lent by Knoedler), Oct. 5–Oct. 29, 1945, no. 1 (as *General Joshua Winslow*).[3]
N.Y., Duveen Galleries, *A Loan Exhibition of Portraits of Soldiers and Sailors in American Wars, For the Benefit of The Soldiers and Sailors Club of New York*, Nov. 17–Dec. 15, 1945, no. 3 (as *General Joshua Winslow, 1727–1801*), p. 33, repr. p. 15.
Chapel Hill, University of North Carolina, Person Hall Art Gallery, Apr. 12–28, 1946, no. 1.[3]
Colorado Springs Fine Arts Center, *21 Great Paintings*, July 20–Aug. 30, 1947, no. 1, repr.
N.Y., Knoedler, *American Paintings of the 18th and Early 19th Century In Our Current Collection*, Jan. 5–31, 1948, no. 10, repr.
N.Y., Kennedy Galleries, Inc., *A Nation is Born: An exhibition to commemorate the 165th Anniversary of the Inauguration of GEORGE WASHINGTON as the first President of the United States April 30th, 1789*, Apr. 30–June 5, 1954, no. 16, p. 7 (as *Portrait of General Joshua Winslow 1727–1801*), repr. p. 28.
N.Y., Knoedler, *Exhibition of American Portraits* (1755–1815), June 16–July 31, 1958, no. 7.
SBMA, *Two Hundred Years*, 1961, no. 1 (as *General Joshua Winslow*), repr. color frontispiece, mentioned "Introduction," n.p.
SBMA, *American Portraits*, Apr. 6–May 8, 1966, no. 3 (as *General Joshua Winslow*), repr., n.p.
Calif., The Oakland Museum, *Art Treasures of California*, Nov. 29–Dec. 31, 1969, repr., n.p.
Brunswick, Maine, Bowdoin College Museum of Art, *The Winslows: Pilgrims, Patrons, and Portraits*, Sept. 15, 1974–Feb. 1, 1975, no. 15 (as *Joshua Winslow*), repr. p. 35, mentioned pp. 6, 9 (a joint exhibition with the Museum of Fine Arts, Boston).

1. From information provided in the catalogue for *A Loan Exhibition of Portraits of Soldiers and Sailors in American Wars*, Duveen Galleries, N.Y., Nov. 17–Dec. 15, 1945, no. 3, p. 33.
2. The painting is not listed in the catalogue, nor is the exhibition included in the exhibition history provided by Knoedler. However, Frederic F. Sherman in "Exhibitions — American Eighteenth Century Portraits," *Art Quarterly*, XXVII (Apr. 1939), p. 98, noted: "The exhibition of portraits of Washington and other eighteenth century Americans at the Knoedler Galleries was distinguished by the first appearance in a public showing of Copley's exceptionally attractive three-quarter length of General Joshua Winslow painted in 1755 when the artist was eighteen [sic] years of age."
3. From information provided by Knoedler.

Alfred M. Frankfurter, "Portraits of American History," *Art News*, XXV (Nov. 7, 1936), pp. 11–12.

Barbara Neville Parker and Anne Bolling Wheeler, *John Singleton Copley: American Portraits in Oil, Pastel and Miniature with Biographical Sketches* (Boston: Museum of Fine Arts, 1938), p. 257.

Frederic F. Sherman, "Exhibitions — American Eighteenth Century Portraits," *Art Quarterly*, XXVII (Apr. 1939), pp. 95, 98.

Alan Burroughs, "Young Copley," *Art in America*, XXXI, no. 4 (Oct. 1943), pp. 160–171, no. 13, p. 163 (as *Lt. Winslow*, J. W. Trott Collection), repr. fig. 5, p. 166, mentioned pp. 169–171.

Alan Burroughs, *John Greenwood in America 1745–1752* (Andover, Mass., Addison Gallery of American Art, Phillips Academy, 1943), cat. p. 73, fig. 3, mentioned pp. 21, 42.

Charles Coleman Sellars, "Mezzotint Prototypes of Colonial Portraiture. A Survey Based on the Research of Waldron Phoenix Belknap, Jr.," *Art Quarterly*, XX, no. 4 (Winter 1957), no. 15B, p. 426, repr. p. 428.

Waldron Phoenix Belknap, Jr., *American Colonial Painting: Materials for a History* (Cambridge, Mass.: Belknap Press of Harvard University Press, 1959), no. 15B, pp. 291–292 (as *Lt. Joshua Winslow*), repr. Pl. XIX, fig. 15B.

Louis B. Wright, George B. Tatum, John W. McCoubrey, and Robert C. Smith, *The Arts in America: The Colonial Period* (New York: Charles Scribner's Sons, 1966), repr. p. 200.

Jules David Prown, *John Singleton Copley: In America 1738–1774* (Cambridge, Mass.: Harvard University Press, 1966), cat. p. 234, Pl. 31, mentioned pp. 21, 22, 25, 27, 116, 120, 122, 125, 127, 141, 162, 163.

Alfred Frankenstein, *The World of Copley 1738–1815* (New York: Time-Life Books, 1970), p. 31, repr.

John Wilmerding, ed., *Genius of American Painting* (New York: Morrow, 1973), p. 68, repr.

Trevor Fairbrother, "John Singleton Copley's Use of British Mezzotints for his American Portraits; a Reappraisal prompted by New Discoveries," *The Arts Magazine*, LV, no. 7 (March 1981), pp. 122–130, repr. p. 122.

Benjamin West
1738-1820

Benjamin West was born to John and Sarah Pearson West on October 10, 1738, in Springfield Township, Pennsylvania, some ten miles from Philadelphia. (The site still stands on the present campus of Swarthmore College.) After showing considerable natural talent at the early age of nine, West was taken to Philadelphia by an uncle and subsequently introduced to William Williams, a British artist from Bristol then working in the city. From Williams the young West learned the basic techniques of painting. He studied artistic theory by Jonathan Richardson and Charles de Fresnoy. Before he was twenty West had established himself as a successful portrait painter—his earliest successes beginning in 1755–1756 with the portraits of the George Ross and William Henry families of Lancaster, Pennsylvania.

Recognizing his talent and promise, a group of Philadelphia businessmen headed by William Allen arranged in 1760 to send the painter to Rome, the artistic and intellectual center of Europe at the time. There he met Pompeo Battoni, impressed Anton Raphael Mengs and charmed Cardinal Albani. He copied works by Correggio, Raphael, and Titian, as well as making studies after the antique.

West traveled through Northern Italy and France to London, bringing with him the new artistic theories of the Winckelmann-Mengs circle. His *Agrippina Landing at Brindisium with the Ashes of Germanicus* (1768) brought him instant success as the quintessential neoclassicist in Britain, and placed him in the international vanguard of the movement. He was presented to George III, who befriended him and later appointed him court painter (1772).

West went on to pioneer other styles equally important for later nineteenth-century art. Using contemporary costumes, he painted his famous *Death of General Wolfe* in 1770 thereby establishing a "realist" genre of history painting. With his *Saul and the Witch of Endor* (1777) he embarked upon a new path of increased emotional subject matter expressively executed. This interest in "Gothick" iconography culminated in his proto-Romantic *Death on a Pale Horse* (ca. 1787–1817, several versions), which in its time was considered a prime example of the Sublime. The loose, free brushstroke and murky colors were a far cry from his earlier work and prefigure the style and iconography of Delacroix. Throughout West's career, however, the greatest acclaim was accorded to his history paintings. Toward the end of his life, he concentrated on religious subject matter.

A founding member of the Royal Academy (1768), West was its president after the death of Reynolds until his own death, save for one year (1792–1804, 1805–1820).

Even without considering his official honors or his remarkable artistic trailblazing, West would deserve a special niche in the history of American art as teacher, advisor, and host to countless artists who came from the United States to study in London, among them Washington Allston, Ralph Earl, Samuel F. B. Morse, Charles Willson Peale, Gilbert Stuart, Thomas Sully, John Trumbull, and, in a sense, John Singleton Copley.

Richard G. Carrott and Jon A. Carstens

2 Portrait of Stephen Carmick

ca. 1756
Oil on canvas
47⅛ x 37⅛ in. (119.7 x 94.3 cm)
Not signed or dated
Gift of Mrs. Sterling Morton
60.84

Provenance

By descent in the Carmick family; Louis Carmick, 1876; Louis G. Carmick, a great-great-grandson of the sitter, Washington, D.C., by 1934 or 1935;[1] still in collection in 1938 (see Sawitzky, References); (consigned by a descendant of the sitter on a joint account to Hirschl & Adler Galleries and M. Knoedler and Co., Inc., N.Y., Sept. 1958); (bought out by Hirschl & Adler, 1960); purchased from Hirschl & Adler by Mrs. Sterling Morton for the PMC, 1960.

1. The painting is mentioned by Burroughs (see References) as being on loan to the Corcoran Gallery of Art. This loan is corroborated by a letter of Feb. 24, 1981 from Katherine M. Kovacs, Archivist, The Corcoran Gallery.

Condition and Technique

In 1978 and 1980 examination by the BACC noted the painting had been lined at an unknown date with a wax-resin adhesive (estimated). The tacking margins were missing on all four sides and the edges had been cut irregularly. The painting may have been reduced in size slightly. The original support was moderately brittle and had numerous repaired damages including a ca. 5 in. horizontal tear in the background near the right edge, a loss and tear on the base of the pillar in the background r., and a tear and loss on the cuff of the figure's proper right arm. At the time the BACC noted that there might be additional tears and losses revealed when the lining fabric is removed. Optical and ultraviolet excited/visible fluorescence examination, and X-ray radiographs indicated extensive paint and ground losses throughout and extensive overpaint in the u.r. corner, in the background above the figure's head and near the right edge, in the l.l. corner and on the coat, with smaller areas of overpaint scattered throughout. A fine branched and linear fracture crackle pattern with a narrow aperture was visible throughout. There was moderate cupping in all areas of the crackle. Moderate to marked abrasion was scattered throughout. The extensive areas of overpaint may have concealed additional abra-

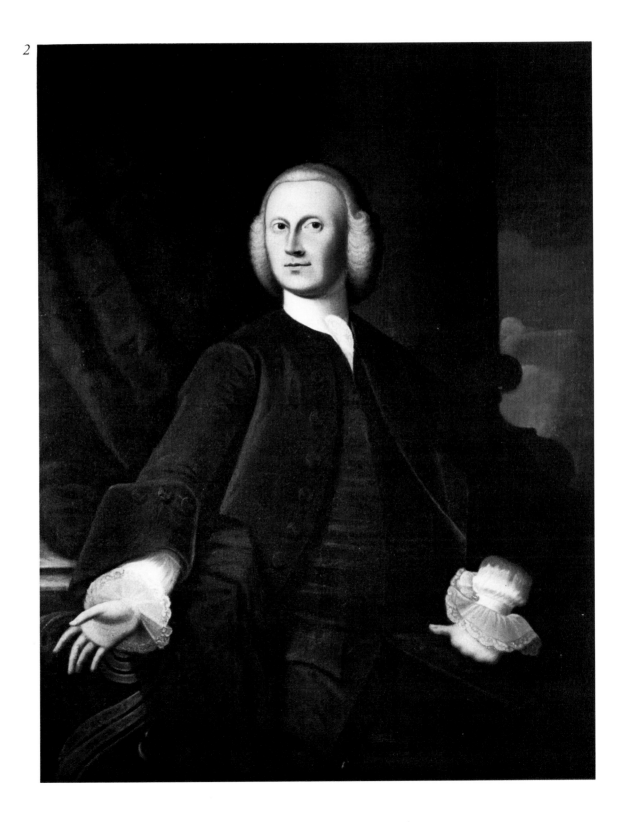

Portrait of Stephen Carmick

Stephen Carmick (1719–1774) was a Philadelphia merchant and importer of Scottish descent. He assumed an important role in the colonies' early efforts for independence as evidenced by his membership in the "Sons of Liberty," a radical group organized to protest the British imposition of the infamous Stamp Act of 1765. His participation in the cause of colonial freedom and self-government is also indicated by his signing of the Nonimportation Agreements, the colonies' chief weapon against oppressive taxation by Great Britain. He has the further distinction of being laid to rest in Christ Church cemetery, not far from the grave of Benjamin Franklin.[1]

Benjamin West's portrait of this patriotic Philadelphian descended in the Carmick family well into the present century. By family tradition, the portrait was painted during the young artist's residence in Philadelphia, from August 1756 to April 1760. Nevertheless, at least one scholarly suggestion has been made that West painted the portrait in Lancaster, Pennsylvania, some seventy miles from Philadelphia, during a visit there in 1755 to paint the William Henry family.[2] The decided grace and sophistication of pose and the more mature sense of proportion of the Carmick portrait, however, shows greater confidence than the juvenile handling of West's Lancaster efforts. Furthermore, it was not customary for important sitters, which Stephen Carmick surely was, to travel to have their portraits done. The opposite was true, not only in West's day, but throughout much of American art history; itinerancy was a fact of life for budding artists.

It also seems unlikely that the Carmick portrait was produced during the period when the susceptible young artist came under the heavy-handed influence of John Wollaston, an English artist working in America (1749–1758, 1767). The influence on West is seen in such paintings as *Ann Inglis* (ca. 1757) and most notably in his portrait *Elizabeth Peel* (ca. 1757–1758). These portraits reveal a fleshiness and facial roundness, as well as an attempt at rococo showiness, characteristic of Wollaston. Stephen Carmick's features, on the other hand, particularly his fine aquiline nose, are more generalized and taut, quite in contrast to the consistent plumpness seen in the work of the older artist. Considering the paucity of information concerning West's early endeavors, it would seem, then, that the date of 1756 for the execution of the painting is as certain as can be established at the present time.

In addition to Wollaston, there were other noteworthy painters whose work was in evidence in Philadelphia during the mid-century. Most frequently mentioned are Gustavus (1682–1755) and John (1728–1778) Hesselius and above all, the native-born Robert Feke (active ca. 1741–1750), one of the finest of the early portraitists. Feke is known to have executed numerous portraits of Philadelphia's elite, among them several members of the Shippen family, as well as a three-quarter-length portrait of Thomas Hopkinson, Judge of the Admiralty Court.[3] Two of West's early acquaintances in Philadelphia were the young Francis Hopkinson, the son of the Judge, and Joseph Shippen, who some years later would sail to Europe with West.[4] In each case, the artist would surely have been afforded access to the painted examples of Feke. Exposure to these paintings may have helped West capture the feeling for velvet fabric in the Carmick portrait, something Feke did remarkably well.

Although the influence of contemporaneous painting on the portraits of the young West cannot be determined with certainty, the importance of European engravings as models can be established with considerable accuracy. Thanks to the pioneering efforts of Waldron Phoenix Belknap,[5] it is now common knowledge that American colonial pain-

sion. Small areas of fabric texture had been impressed in the paint film, probably during a previous lining process.

In 1981 the painting was treated by the BACC. The surface coating and overpaint were removed with acetone. Overpaint and old fills were removed with acetone, water, mechanical action (using a scalpel under the binocular stereomicroscope), and dimethyl formamide. A protective temporary brush coating of Soluvar gloss varnish, 30% in Benzine B264 was applied. The old lining was removed with moderate heat. Wax residues were removed with Benzine and micro-spatula. Tears in the support were realigned, and linen inserts were attached into the lacunae, which were patched with long-fibered Japanese tissue as necessary. The painting and an interliner of satin-weave fiberglass infused with Ross wax were placed face down on the cushioned vacuum hot table and lined with Ross wax adhesive to a prepared aluminum honeycomb hexcel panel. The excess lining adhesive was removed with benzine. A brushcoat of Acryloid B72, 10% in xylene was applied as a protective isolating layer. Losses were filled with wax-dammar filling putty (2½ parts beeswax, 1 part dammar), fills were textured and then sized with Bakelite PVA-AYAA, 10% in ethyl alcohol. Inpainting was done with dry pigments ground in B72. Several spray coats of B72, 10% in xylene were applied as final protective coating with an interlayering of PVA-AYAA, 7-10% in ethyl alcohol, and Soluvar, stock solution diluted 1:1 in benzine.

The support, a medium-weight, plain weave linen (estimated) with threads varying in thickness, is covered with a white oil-type (estimated) ground of moderate thickness that partially conceals the fabric texture. It was probably applied by the artist. The degree of density seen in the X-ray radiographs suggests that it is largely composed of white lead. The oil-type paint (estimated) is generally thin and opaque and ranges from a thin fluid to a soft paste of moderate thickness. The basic form of the figure and background drapery appears to have been sketched in with thin, semi-transparent fluid paint with brushmarks that partially cover the ground. The darker modeling was built up over this with a thicker fluid paint. The flesh tones, hair, and shirt cuffs were done in paint ranging from a thick fluid to a thin soft paste with brushmarks. Details were added with a soft paste of moderate thickness. The X-ray radiographs reveal several changes by the artist in the composition. The shirt front appears to have a somewhat different form in the earlier stages of work. There are also several faint curving horizontal forms in the u.r. portion of the background that do not relate to the present composition.

ters frequently used popular mezzotint engravings, imported from England, as up-to-date guides to current fashions and notable personalities among British royalty and society. These engravings also provided the artists with ideas for formal poses and pictorial props. It was customary for an artist to have a selection of such prints from which a potential client might choose a desired pose or even costume. We know through West's biographer John Galt[6] that he was first acquainted with European prints at a very early age and that in the execution of his famous history piece *Death of Socrates*[7] he copied an engraving after a Hubert Gravelot (1699–1773) drawing. We also know that West's brother-in-law, John Levenus Clarkson, was a dealer in engravings.[8] It seems evident, therefore, that West was well aware of the practical uses of prints and very likely had his own collection during these formative years. What may appear today as affected gestures and poses, such as the outstretched arm of Stephen Carmick, were copied from pictorial modes popular in England. These conventions had a long tradition in English portraiture, beginning with Anthony Van Dyck (1599–1641), formalized by Peter Lely (1618–1680) and Godfrey Kneller (1646–1723), and continued in West's day by Joseph Highmore (1692–1780) and Thomas Hudson (1701–1779). Prints after these popular artists were eagerly sought by the American public and were imported in considerable numbers, providing the curious American colonists with a much-wanted glimpse of English celebrities. In this *Portrait of Stephen Carmick*, the hand on hip, the background with column, and the heavy drapery are all conventions frequently used in British portraiture and can be traced back at least to the first half of the seventeenth century. *Portrait of Stephen Carmick* therefore is important for establishing the sources that helped shape the art of the young West.

Establishing the desired pose for *Stephen Carmick* was, therefore, a task for which West had ready assistance. The duplication of that pose on canvas was another matter entirely. Nevertheless, he shows here considerable technical facility for one so young. Certain areas in particular are noteworthy as demonstrations of West's handling of pigment. In the face of Stephen Carmick, West captured a sufficient feeling of flesh by very subtly graduating the intensity of color. He further integrated a hint of hair growth, most notably on the upper lip. These facial areas are in general achieved with a very smooth application of paint, with brushstrokes virtually unnoticeable. The sitter's wardrobe also reveals West's talents. Both in the jabot under the neckband and in the ruffle of lace on the shirt sleeve, he successfully simulated the transparency of the delicate fabric. And in Carmick's coat, waistcoat, and breeches, he rendered the feeling of velvet by judicious placement of lighter areas of color. In the waistcoat, these highlighted areas suggest not only the softness of the fabric but the tightness of the vest on Carmick's rather substantial girth. All things considered, *Portrait of Stephen Carmick* is a rather fine performance for a seventeen-year-old.

Michael W. Schantz

References

Alan Burroughs, *Limners and Likenesses* (Cambridge, Mass.: Harvard University Press, 1936), pp. 72–73 (as owned by Louis G. Carmick, Washington, D.C.).

William Sawitzky, "The American Work of Benjamin West," *Pennsylvania Magazine of History and Biography*, LXII (Oct. 1938), cat. p. 452 (as owned by Louis G. Carmick, great-great-grandson of the sitter), Pl. 13.

James Thomas Flexner, *American Painting: First Flowers of Our Wilderness* (Boston, Mass.: Houghton Mifflin Co., 1947), p. 187.

Notes

1. Biographical information from William Sawitzky, "The American Work of Benjamin West," *The Pennsylvania Magazine of History and Biography*, LXII, no. 4 (Oct. 1938), p. 452; *Official Catalogue, International Exhibition 1876*, Part II, Art Gallery, Annexes and Out-Door Works of Art, Department IV (Philadelphia: United States Centennial Commission, 1876), p. 50.
2. Sawitzky, p. 452.
3. For discussion of Feke's Philadelphia works, see Henry Wilder Foote, *Robert Feke: Colonial Portrait Painter* (Cambridge, Mass.: Harvard University Press, 1930), "Catalogue of Portraits," pp. 122–214.
4. Benjamin West's associations in Philadelphia in the years leading up to his departure for Europe are discussed in Robert C. Alberts, *Benjamin West: A Biography* (Boston: Houghton Mifflin Co., 1978), pp. 19–28.
5. Waldron Phoenix Belknap, Jr., *American Colonial Painting: Materials for a History* (Cambridge, Mass.: The Belknap Press of Harvard University Press, 1959), Part VI, "The Discovery of the English Mezzotint as Prototype of American Colonial Portraiture," pp. 273–329.
6. Nathalia Wright, *The Life of Benjamin West by John Galt: A Facsimile Reproduction* (Gainesville, Fla.: Scholars' Facsimiles & Reprints, 1960), pp. 22–23.
7. Ann C. Van Devanter, "Benjamin West's *Death of Socrates*," *Antiques*, CIV, no. 3 (Sept. 1973), pp. 437–439.
8. Alberts, p. 15.

Exhibitions

Philadelphia, *International Exhibition*, 1876, Official Catalogue, Part II, Department IV, no. 1164 (as *Portrait—Stephen Carmick, Signer of the Non-Transportation Act*; owner, Louis Carmick), p. 50.

SBMA, *Two Hundred Years*, 1961, no. 11, repr., mentioned "Introduction," n.p.

SBMA, *American Portraits*, 1966, no. 7, n.p.

Honolulu Academy of Arts, *Vignettes of American Art and Life*, Sept. 10–Nov. 7, 1976, no. 1 (under "Queen Anne 1730–1760").

Tuscon, University of Arizona Museum of Art, *First Flowers of Our Wilderness*, 1976, no. 75 (as ca. 1759), Pl. 75, opened SBMA Jan. 11–Feb. 15, 1976; traveled University of Arizona, Feb. 29–March 28, 1976, and to the following not listed in the catalogue, Kansas, Wichita State Museum, Apr. 11–May 9, 1976, Athens, Georgia Museum of Art, May 30–June 27, 1976.

Study for Edward III Forcing the Passage of the Somme

West's contemporary, John Galt, tells us that one day, in a casual conversation with the King, the artist remarked that despite the great talents of Italian painters, the noblest "events in the history of their country were but seldom touched." George III apparently agreed with West's "disgust" at such a void in the artistic heritage of a nation, for he decided to commission his American court painter to decorate the Audience Hall of Windsor Castle with a series of works illustrating events in the life of Edward III (1312–1377), the builder of that castle. The subjects chosen consisted of: (1) *Edward III Embracing the Black Prince after the Battle of Crécy*, (2) *The Installation of the Order of the Garter*, (3) *The Black Prince Receiving the King of France and his Son as Prisoners at Poitiers*, (4) *St. George Vanquishing the Dragon* (hardly an event in the life of Edward III, but the Saint was the patron of the Order of the Garter), (5) *Queen Philippa Defeating King David of Scotland in the Battle of Neville's Cross*, (6) *Queen Philippa Interceding with Edward for the Burgesses of Calais*, (7) *King Edward Forcing the Passage of the Somme*, (8) *King Edward Crowning Sir Eustace de Ribaumont at Calais*.

These events fell within the period of the greatest successes and accomplishments of Edward III's long reign (1327–1377): the decade between the battles of Crécy (1346) and Poitiers (1356).[1] The series for the Audience Hall ended chronologically with the scene depicting the Black Prince receiving the King of France and his son (John the Good), and the future Philip the Bold of Burgundy as prisoners after the battle of Poitiers, in which 8,000 English soldiers defeated an army of 60,000. The initial event was *King Edward Forcing the Passage of the Somme*. Prior to the Battle of Crécy, Edward's march north to Calais was blocked by the Somme River, which runs deep through marshy ground to the sea. By threats and bribes he induced a peasant to lead the army to a ford at the mouth of the river where a passage could be effected at low tide. Blocked by a body of horsemen, the English nonetheless fought their way across just before the tide turned to render the ford useless to the pursuing French troops.

Although the date of the concept of this series is unclear, West executed the paintings in the late 1780s and 1790s. It might also be remarked that the historical logic of the choice of the protagonist not withstanding, there must have been some satisfaction on the part of the King in memorializing the feats of his distant ancestor who had successfully defeated France — the nation currently troublesome to the British Crown.

The iconographic sources for these events ultimately can be traced to the first book of Jean Froissart's *Chronicles* (ca. 1370; standard English translation by John Bourchier, 1523–1525), although West probably favored David Hume's more recent four-volume *History of England* (1754–1761). George III may have disapproved of Hume's ideas on religion and current political theory, but he could hardly have taken issue with the anti-Whig polemical tone of the *History*.

The Santa Barbara painting is a sketch for no. 7 of the Windsor cycle, *King Edward Forcing the Passage of the Somme* (fig. 1, now at Kensington Palace, London). It is listed in Galt's catalogue of the works of West along with the finished product. There is also a drawing of a detail of one of the horses at The Pierpont Morgan Library in New York (fig. 2),[2] which in the careful execution of the details of the caparisoned head indicates West's devotion to archaeological exactitude, for it is known that he copied items in the royal

3 Study for Edward III Forcing the Passage of the Somme

(Previously and incorrectly titled *Study for the Black Prince Crossing the Somme*)
1788
Oil on canvas
17⅛ x 21¾ in. (43.5 x 55.2 cm)
Signed and dated l.r.: B. West 1788
Gift of Mrs. Sterling Morton
60.85

Provenance

Benjamin West, Windsor, England, 1788; (George Robins, London, West estate sale, May 22–25, 1829, no. 103); purchased from estate sale by Mr. Pickering; (Spink and Son, London, June 1951); (Charles Childs, Boston); (from Childs to M. Knoedler and Co., Inc., Feb. 1952); purchased from Knoedler by Mrs. Sterling Morton for the PMC, 1960.

Condition and Technique

In 1978 examination by the BACC noted the painting had been lined with wax-resin to fiberglass. The original tacking margins had been removed. The impasto had been crushed during lining. Past cleaning had resulted in overall abrasion and in the increase of pebbling in the dark washes. The surface coating was estimated to be a recent, thin layer of moderately glossy, polymer synthetic resin.

The support, a light-weight plain weave linen, is covered with a light warm grey ground, thinly applied, that does not obscure the fabric weave. The paint, an oil type of rich vehicular paste, is very thinly applied as dilute washes of colors with transparent glazes and translucent scumbles. The ground color is visible throughout. There are slight peaks of impasto in the white highlights.

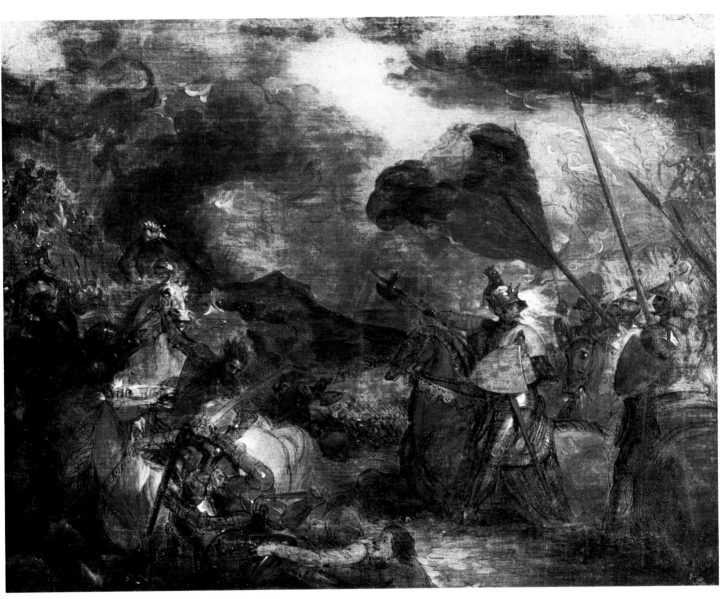

3

collections of armour and seals.³ The Santa Barbara study, which is unfinished, does not include the figures found at the far right of the final version. As the King turns in that direction and as the Black Prince is among these figures, one must assume either that the sketch has been cropped, which seems unlikely, or that the sketch was simply intended as a working drawing rather than as a final preparatory design.

Although Galt correctly identified the subject of this incident as *Edward III Forcing the Passage of the Somme*, the Santa Barbara study was titled by a London dealer in 1951 as *Black Prince Crossing the Seine* (*Connoisseur*, 1951, p. 51), and by Knoedler in 1960 as *The Black Prince Crossing the Somme*. A further confusion was contributed by the Lord Chamberlain's Office, St. James' Palace, which supplied Grose Evans with the title *The Battle of Crécy*.⁴ But the incident is clearly based on Hume's assertion that Edward III led the charge. Furthermore, one can note from the finished painting that the central figure of a mature man wears a crown-like helmet, carries a shield with the King's arms and the quartered surcoat of Edward III, whereas the younger figure highlighted at the extreme right carries the arms of the Prince of Wales. There can be no doubt that the proper title should be the one handed down to us by Galt.

The painting is executed with considerable verve. It is very loosely painted and drawn, although the paint itself is thinly applied. The artist initially seems to have used a brown undercoating with a grey-blue oil wash over it. He then drew in the principal

figures and lastly built up selected individual parts (especially round the King to the right, and the group of struggling soldiers at the left) with a more linear style than the rest of the painting and splotches of red, pink, and white set off against areas of dark blue clouds and grey-brown smoke and steam.

In the churning atmosphere, the violent gestures, the wrenched awkwardness of the poses, the ungraceful forms, the spontaneous application of paint, and the almost brutal drawing, we have a clear prefiguration of the artist's final stylistic phase. Indeed, the two horses and the warrior between them are to appear again in versions of West's final *magnum opus*, *Death on a Pale Horse* (ca. 1787–1817), a project upon which the artist had already embarked. It would seem that he had realized the artistic validity of the immediacy of a sketchy ''impressionistic'' style through preliminary quick studies such as this one. (It may be noted that West's drawing style similarly developed from neoclassical controlled precision to proto-Romantic spontaneous sketchiness.) Thus, the Preston Morton painting is a significant work in the oeuvre of the artist, as it clearly indicates a point of departure for West's final stylistic phase: a phase that represents, once again in his career, a new aesthetic that announced a major trend in a future which was to include Turner and Delacroix, and reverberates down into our own time.

Richard G. Carrott and Jon A. Carstens

The authors wish to thank Professor Allen Staley of Columbia University for his generous assistance in the documentation of this essay.

Notes

1. In both of these battles numerically superior French forces using traditional feudal tactics were decisively defeated by the well-disciplined, professional foot-soldiers of the English, thus ushering in not only the Hundred Years' War, but also an entirely new mode of warfare. The successful leadership of Edward III and his son the Black Prince, which carried the day at Crécy, was duplicated two months later by Edward's consort Queen Philippa and their second son, Lionel, Duke of Clarence, at Neville's Cross in the north of England against the ally of the French, David King of Scots. Meanwhile Edward had laid siege to Calais, which stubbornly held out for eleven months. His decision to spare the city and its inhabitants if he could have the lives of six of its most prominent citizens was further softened by the entreaties of Queen Philippa, who successfully pleaded for the lives of Eustache de St. Pierre and his five fellow burghers. It was apparently at this time that Edward conceived the idea of establishing an order of chivalry recalling King Arthur's Knights of the Round Table. Indeed, the legend of his saying to his smirking courtiers, upon retrieving the fallen garter of Joan the Fair Maid of Kent (afterwards the wife of the Black Prince), ''Honi soit qui mal y pense'' (''Shame to him who thinks evil'') places the incident at Calais during a ball celebrating the capitulation of the city. In any case, the Order of the Garter seems to have been established in 1347, and its chapel, significantly enough, was situated in Windsor Castle (St. George's Chapel) adjacent to the hall in which West's series was to hang. Edward's sense of chivalry was further manifested in 1349 when, following an unsuccessful attempt by the French to recapture Calais, he presented his own battle crown to Eustace de Ribemont (Ribaumont), who had been his valiant opponent in battle, thus both honoring and freeing his prisoner.
2. Ruth S. Kraemer, *Drawings by Benjamin West and His Son Raphael Lamar West*, New York, Pierpont Morgan Library (exhibition catalogue), 1975, p. 29, no. 42.
3. David Irwin, ''Unclassical Neo-Classicism: Sentiment and Gothic,'' *Connoisseur*, CLXXXI, no. 727 (Sept. 1972), p. 24.
4. Grose Evans, *Benjamin West and the Taste of His Times* (Carbondale, Ill.: Southern Illinois University Press, 1959), p. 122, no. 31.

Exhibitions

London, 14 Newman Street, posthumous exhibitions of Benjamin West's works, 1821 and 1828.
SBMA, *Two Hundred Years*, 1961, no. 12 (as *Study for ''The Black Prince Crossing the Somme''*).
Riverside, University of California, Picture Gallery, special loan to supplement The American Federation of Arts, *The Philadelphia Tradition*, Jan. 1964.
Riverside, University of California, Picture Gallery, *Problems in Connoisseurship*, Apr. 1965, no cat.
Santa Barbara, University of California, University Art Galleries, *William Blake in the Art of His Time*, Feb. 24–March 28, 1976, no. 17 (entry by Janice Lyle, as *Study for ''Edward III Crossing the Somme,''*), pp. 30–31, repr. p. 30, mentioned p. 10.

References

John Galt, *The Life, Studies and Works of Benjamin West, Esq.* (London: T. Cadell and W. Davies, 1820).
List of works offered by the artist's sons to the United States in 1826, no. 103.
Connoisseur, CXXVII, no. 521, supplement (June 1951) (incorrectly as *Black Prince Crossing the Seine*), repr. p. 51.
Grose Evans, *Benjamin West and the Taste of His Times* (Carbondale, Ill.: Southern Illinois University Press, 1959), pp. 69–70, 120 n. 31, Pls. 50–52.
Oliver Millar, *The Later Georgian Pictures in the Collection of Her Majesty the Queen* (London: Phaidon Press, 1969), I, p. 132, no. 1158; II, Pl. 125.
David Irwin, ''Unclassical Neo-Classicism: Sentiment and Gothic,'' *Connoisseur*, CLXXXI, no. 727, vol. 181 (Sept. 1972), p. 24.
Ruth S. Kraemer, *Drawings by Benjamin West and his son Raphael Lamar West*, New York, Pierpont Morgan Library (exhibition catalogue), 1975, no. 42, p. 29, Pl. 25 (study for the *Head of The Caparisoned Horse*).
John Dillenberger, *Benjamin West: The Context of His Life's Work* (San Antonio, Texas: Trinity University Press, 1977), p. 119, p. 134; p. 165, no. 268; p. 201, no. 106, p. 206; no. 103.
Roy C. Strong, *Recreating the Past: British History and the Victorian Painter* (London: Thames and Hudson, 1978), pp. 78–85.

Christian Gullager
1759–1826

Gullager, a Danish portrait painter, was trained at the Royal Academy of Fine Arts in Copenhagen, where he won a silver medal in 1780. His distinctive painting style was well formed by the time of his arrival in the United States, where he is first recorded in Newburyport, Massachusetts, in 1786. In 1789 Gullager moved to Boston. His earliest (and only signed American) portrait, of Colonel John May (American Antiquarian Society), apparently delighted both the painter and the sitter's wife, who wrote in her diary, "Much praise is due to the painter. He has done his work well, and I don't wonder he says his hall is stripped of its greatest ornament."[1]

By the fall of 1797 Gullager had left Boston and was advertising as a portrait and theatrical painter in New York City. He quickly moved on to Philadelphia, where he advertised through 1805. Returning to New York City for two years, he then disappeared for almost two decades, returning to his daughter's house in Philadelphia in 1825, where he died the following year.

Gullager was a talented painter, and often worked rapidly, giving his portraits a liveliness and robust healthy vigor that at times transfer to the sitters an air of rococo sensuality. Most of his known portraits were painted in Massachusetts, where his success suggests he must have pleased and flattered many sitters. Because his style changed as he came under the influence of his contemporaries, and because he signed few of his pictures, his impact on other artists is often difficult to measure. One is uncertain of authorship when portraits show both his characteristics and those of other artists. His was, also, an unpredictable temperament. While important in his lifetime, especially in Massachusetts, where he had little competition, Gullager seems to have had no imitators or followers among American portrait painters of the next generation.

Ellen G. Miles

Notes
1. Quoted in Marvin Sadik, *Christian Gullager: Portrait Painter of Federal America* (exhibition catalogue), National Portrait Gallery, Smithsonian Institution, 1976, p. 17.

Elizabeth Coats Greenleaf

This charming image of Elizabeth Coats Greenleaf (1766–1793), painted in Newburyport, Massachusetts, in about 1787, is one of Gullager's first American portraits. Miss Coats (she married John Greenleaf on November 2, 1791) was probably painted at the same time as her parents, Captain David Coats and Mehitable Thurston Coats (these portraits are now in the St. Louis Art Museum, figs. 1 and 2). While her parents are depicted as substantial, sober middle-class citizens, Miss Coats has the air of youth, matching in season of life the season of the year, "Spring," printed on the open page of the book she holds. Her blue dress with its pink highlights is edged in white lace. She wears a ring on her wedding-ring finger, and a feather decorates her brown hair. (Whether the ring indicates she was already engaged to be married is not clear.)

Miss Coats was described at about this time by young John Quincy Adams, who was studying law with Theophilus Parsons in Newburyport in 1787–1788. He met Miss Coats at a party, and was glad to have her as a dancing partner, instead of "Miss Fletcher,"

4 Elizabeth Coats Greenleaf

ca. 1787
Oil on canvas
36½ x 32½ in. (92.7 x 82.6 cm)
Not signed or dated
Inscribed l.l. upside down on book: SPRING
Gift of Mrs. Sterling Morton
60.59

Provenance

By descent in the Jacques family, Newbury, Mass., through the sitter's uncle John Thurston[1]; Joseph Brown Jacques, Newbury, Mass.[1]; given by J. B. Jacques to his cousin Caroline Elizabeth Jacques, Newbury, Mass.[1]; (House of Flayderman Galleries, Boston, by 1930)[1]; purchased by George N. Northrop, West Roxbury, Mass., 1938[1]; (acquired jointly by Hirschl & Adler Galleries and M. Knoedler and Co., Inc., Jan. 1948); purchased from Knoedler by Mrs. Sterling Morton for the PMC, 1960.

1. Provenance established by Louisa Dresser in Worcester Art Museum, *Christian Gullager*, 1949 (see Exhibitions), pp. 131, 133.

Condition

In 1966 the painting was sent to Helmer Ericson, conservator in Santa Barbara, for conservation work.

In 1975 examination by Philip Vance of the LACMA Conservation Center revealed the painting had been wax-lined but that the treatment had had no effect on the paint or ground. The painting had suffered extensive damage and a few small losses, and there were many instances of cleavage with the paint layer separating from the pink ground.

The painting will be sent to the BACC for treatment in the near future.

who was, he wrote, in love and "unless the object of her affection is present she loses all her spirits, grows dull and unsociable, and can be pleased with nothing. . . . And, as I found she could only talk in monosyllables, I was glad to change my partner. Miss Coats is not in love, and is quite sociable. Her manners are not exactly what I should wish for a friend of mine; yet she is agreeable. I am not obliged with her both to make and support the conversation; moreover, what is very much in her favour, she is an only daughter and her father has money."[1]

Elizabeth Coats married John Greenleaf in 1791. Their son David Coats Greenleaf was born on October 18, 1792. The following August, Elizabeth died, at the age of twenty-seven. Their son died that September. John Greenleaf then married Mrs. Elizabeth Greenleaf, widow of Captain Thomas Greenleaf, in 1794.[2]

Ellen G. Miles

Exhibitions

Mass., Worcester Art Museum, *Christian Gullager: An Introduction to His Life and Some Representative Examples of His Work* (catalogue by Louisa Dresser, published in *Art in America*, XXXVII, no. 3 [July 1949]), June 18–Sept. 6, 1949, no. 8, p. 135, repr. p. 134 (as *Miss Polly Coats*, from the Knoedler Galleries).
SBMA, *Two Hundred Years*, 1961, no. 3.
SBMA, *American Portraits*, 1966, no. 14, n.p.
Washington, D.C., National Portrait Gallery, Smithsonian Institution, *Christian Gullager, Portrait Painter to Federal America* (catalogue by Marvin Sadik), 1976, no. 4, pp. 16–17, 54, repr. p. 55.

References

J.E. Greenleaf, *Genealogy of the Greenleaf Family* (Boston, 1896), p. 247.
Vital Records of Newburyport, Mass., 1911, I, pp. 80, 166; II, pp. 96, 648, 649.
International Studio, XCVI, no. 399 (Aug. 1930), repr. p. 78 (as *Mehitabel Coats* by Smibert).
Historical Records Survey, Works Progress Administration, *American Portraits, 1620–1825, Found in Massachusetts* (Boston, 1939), I, no. 445 (as *Mehitabel Coats* by Smibert).
Louisa Dresser, "Christian Gullager; an Introduction to His Life and Some Representative Examples of His Work," *Art in America*, XXXVII, no. 3 (July 1949), no. 8, p. 135, repr. p. 134 (as *Miss Polly Coats*, from the Knoedler Galleries).
"Shop Talk; Old Prints and Paintings for Collectors," *Antiques*, LXVI, no. 5 (Nov. 1954), mentioned and repr. p. 344 (as *Miss Polly Coats*, from the Knoedler Galleries).

Notes

1. *Life in a New England Town, 1787–1788: The Diary of John Quincy Adams* (Boston, 1903), p. 87; see also Marvin Sadik, *Christian Gullager: Portrait Painter of Federal America* (exhibition catalogue), National Portrait Gallery, Smithsonian Institution, 1976, p. 54.
2. Essex Institute, Salem, Massachusetts, *Vital Records of Newburyport, Massachusetts*, 1911, I, pp. 80, 166–167; II, pp. 96, 199, 648, 649. James Edward Greenleaf, *Genealogy of the Greenleaf Family* (Boston, 1896), p. 427.

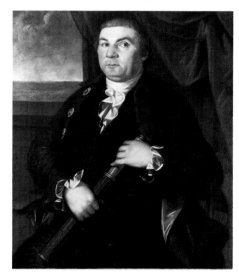

fig. 1 Christian Gullager, *Captain David Coats*. Reproduced by permission of The Saint Louis Art Museum.

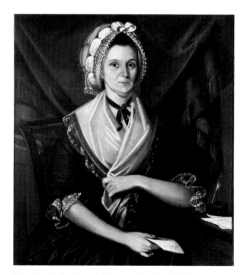

fig. 2 Christian Gullager, *Mrs. David Coats*. Reproduced by permission of The Saint Louis Art Museum.

William Groombridge
1748-1811

The life and career of William Groombridge is not very well documented. We do know, however, that he was born in Kent, England, on May 24, 1748, and began his artistic training under the tutelage of the provincial English topographer James Lambert of Lewes.[1] From 1773 to 1790 he exhibited regularly at the Royal Academy of Arts, the Society of Artists of Great Britain, and the Society of Free Artists; he was listed at various addresses.[2] Sometime in the early 1790s Groombridge immigrated to America, presumably traveling as an itinerant artist during the first several years after his arrival. His *Woodlands* painting is the earliest recorded evidence of his arrival in America known. In 1794 he was among the thirty professional and amateur artists who founded the Columbianum, an art academy modeled after the Royal Academy in London and spearheaded by Charles Willson Peale.[3] Groombridge's name first appears in the Philadelphia city directory for 1800, which lists the artist as a portrait and landscape painter.[4] Shortly thereafter he and his wife, an amateur artist, moved to Baltimore, where the latter "opened a boarding school for young ladies."[5]

It is reported that the artist executed some hundred and twenty-three landscapes. Only a small number have come to light, however, suggesting that many of them have perished over the years. Many of these landscapes were presumably sold at lotteries. Though the critics of his day recognized his work as being "meritorious," they were quick to point out that he "endeavoured, without success, to introduce the brilliant and gorgeous tints" of autumn.[6] The critic William Dunlap, who knew the artist, remarked that "the blending of nature was not found in Groomrich's [sic] imitations, nor that harmony which she always throws over her most vivid colouring."[7] Despite these deficiencies, Groombridge, like his fellow English migrant artists George Beck, William Winstanley, and Francis Guy, undoubtedly left his mark on later Philadelphia landscapists such as Thomas Doughty and Alvin Fisher.

Patricia Trenton

Notes

1. J. Hall Pleasants, *Four Late Eighteenth Century Anglo-American Landscape Painters* (1942; reprint, Worcester, Mass.: American Antiquarian Society, 1943), p. 31.
2. Pleasants, p. 31, no. 14.
3. Frank H. Goodyear, Jr., "A History of the Pennsylvania Academy of the Fine Arts, 1805–1976," In *This Academy: The Pennsylvania Academy of the Fine Arts, 1805–1976* (Pennsylvania Academy of the Fine Arts, 1976), p. 15.
4. Pleasants, p. 33.
5. William Dunlap, *A History of the Rise and Progress of the Arts of Design in the United States*, newly ed. by Rita Weiss (1834; reprint, New York: Dover Publications, Inc., 1969), vol. II, pt. 1, p. 48.
6. Dunlap, p. 47.
7. Dunlap, p. 47.

5 The Woodlands, the Seat of William Hamilton, Esq.

1793
Oil on canvas
45⅝ x 58⅛ in. (147.6 x 155.9 cm)
Signed and dated l.l.: W. Groombridge Pinx 1793
Gift of Mrs. Sterling Morton
60.58

Provenance

Estate of the artist, 1811?; subsequent history unknown; (Victor D. Spark, N.Y., 1954); purchased from Spark by Mrs. Sterling Morton for the PMC, 1960.

Condition and Technique

The painting was cleaned, restored, and lined with an aqueous adhesive, probably upon its acquisition by Spark in 1954 (letter of March 30, 1954, from J. Hall Pleasants to Spark: "I am quite enthusiastic about the photograph after the cleaning and restoration of the Groombridge landscape").

In 1977 examination by the BACC found the support and lining to be intact and adequate. It noted a general but irregular disruption of paint and ground by fine crevices largely of a jag-fork and arc pattern at an interval of 1 to 5 mm. The painting had suffered extensive general erosion, largely as scalps over the threads of the fabric support. The lacunae had been inpainted and overpainted. A surface coating had been removed at least once, possibly more. The surface coating was darkly discolored. The present stretcher replaced an earlier, slightly smaller one, as there appeared to be no original paint along the bottom edge of the canvas for a height of ca. 1 in.

In 1978 the painting was treated by the BACC. The yellowed varnish and overpaint were removed with acetone-xylene ca. 1:1, using dimethyl formamide on overpaint in some areas. Two brush coats of Acryloid B72, 10% in xylene were applied as isolating layer. At that stage the BACC decided not to remove varnish and overpaints from the bottom edge as damage and overpaint in this area were very extensive. Losses were filled with a wax putty with dry pigment added for color and mass. The fills were isolated with PVA-AYAF, 30% in ethanol; one layer of B72, 10% in xylene was applied and inpainting done with B72/B67 (3:1) palette, with xylene. Two spray coats of B72, 10%

The Woodlands, the Seat of William Hamilton, Esq.

Groombridge's *Woodlands* is of particular historical significance as it belongs to a group of early American landscape paintings, rooted in English tradition, that provided the impetus for an emerging American landscape tradition. Its growing prominence in American art paralleled the growth of the country's self-conscious nativism.

With general political unrest throughout Europe in the last decade of the eighteenth century, America became a haven for a number of migrant artists whose various skills broadened the country's taste in landscape painting. Among the four semiprofessional landscapists who descended upon America at this time was William Groombridge. He is considered one of the first professional landscapists in America because, contrary to the custom at the time, he devoted his career almost exclusively to this particular genre. The artist practiced in New York, Philadelphia, and finally Baltimore, where he spent the last decade of his life.

Typifying public taste at the time, Groombridge specialized in portraits of specific places, reflecting his provincial training in the topographical tradition. The simplified and symmetrical disposition of his subject matter, typically framed by trees and featuring a centrally placed glow on the distant horizon, reflects the influence of Claude Lorraine's pictorial formula. The addition of a few decorative and picturesque motifs (for example, a small group of figures viewing the scene), on the other hand, harks back to provincial British topographical painting, the predominant influence in American landscape art of the early nineteenth century. These characteristic features are evident in the Santa Barbara painting, a fine example of the artist's early work in America.

Groombridge's *Woodlands*, depicting the country estate of prominent Philadelphian William Hamilton,[1] is essentially a product of the artist's imagination combined with recollections of specifics associated with this place. The artist has taken certain liberties here, not particularly striving for topographical accuracy but seemingly more concerned with presenting an idyllic landscape. The house, with its commanding view of the Schuykill, is placed further from the river than it actually is. (Its Adamesque detailing and curvilinear forms, typical of the latest English fashion and innovative for America at that time, are barely described by the artist's brush.) Even the broad Schuylkill River has been narrowed to convey the pastoral effect of Hamilton's garden.

It is interesting to note that the subject of this picture "profoundly changed the character of American architecture,"[2] like the work itself, which left its imprint on later American landscapists.

Patricia Trenton

in xylene were applied and inpainting continued. On recommendation from Katherine Mead, Curator of Collections, SBMA, the BACC proceeded to remove varnish and overpaint along the bottom edge to reveal more of the remnants of original paint and to soften transition to dark brown along bottom edge. The varnish and overpaint were removed with isopropyl alcohol and scalpel. Acryloid B72, 10% in xylene was applied locally to cleaned area to bring gloss up to match the rest of the painting. One more layer of B72, 10% in xylene was applied. The bottom edge and abraded portions of the sky were inpainted with same palette as before. Two coats of Acryloid B72, 10% in xylene were applied. Inpainting was completed and four spray coats of Acryloid B72, 10% in xylene were applied, going over the new inpainting along the bottom edge more times to bring up gloss of the final coat.

The support is a moderately coarse fabric. The ground and paint are presumed to be oil, and the paint is rich in the dark areas.

Exhibitions

Philadelphia, Pennsylvania Academy of The Fine Arts, *First Annual Exhibition of the Society of Artists of the United States*, 1811, no. 5.

SBMA, *Two Hundred Years*, 1961, no. 2 (as *Woodlands, the Seat of William Hamilton*), mentioned "Introduction," n.p.

Tucson, University of Arizona, Museum of Art, *First Flowers of Our Wilderness*, no. 24, Pl. 24, opened SBMA, Jan. 11–Feb. 15, 1976, traveled University of Arizona, Feb. 29–March 28, 1976, and to the following not listed in catalogue, Kansas, Wichita State Museum, Apr. 11–May 9, 1976, Athens, Georgia Museum of Art, May 30–June 27, 1976.

References

Martin P. Snyder, *City of Independence: Views of Philadelphia Before 1800* (New York: Praeger Publishers, 1975), pp. 176-177, fig. 103.

Richard J. Betts, "The Woodlands," *Winterthur Portfolio*, XIV, no. 3 (Autumn 1979), pp. 214, 217, fig. 6.

Notes
1. For a complete discussion of the architecture and construction of *The Woodlands*, see Richard J. Betts, "The Woodlands," *Winterthur Portfolio*, XIV, no. 3 (Autumn 1979), pp. 213–234; see also Fiske Kimball, *Domestic Architecture of the American Colonies and of the Early Republic* (New York: C. Scribner's Sons, 1922), p. 163; John Fabian Kienitz, "Basic Phases of Eighteenth-Century Architectural Form," *Art in America*, XXXV, no. 1 (Jan. 1947), pp. 35–37.
2. Betts, p. 230.

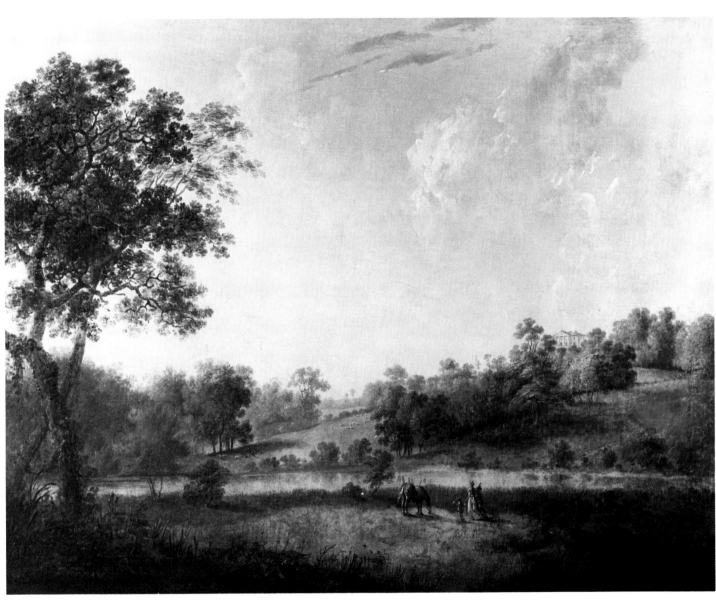

5

James Peale
1749-1831

James Peale was the fifth and youngest son of Charles and Margaret Peale. His father, born in England, came to the American colonies and taught school in Maryland, where he died in 1750. The family moved to Annapolis, and some years later James learned the trade of saddlery from his older brother, Charles Willson Peale. After Charles Willson abandoned that profession to become a painter, James followed him in that profession as well. Indeed, James Peale's artistic career was pursued in the shadow of his far more famous brother, and this, together with the paucity of manuscript documentation in contrast to the abundance remaining from Charles Willson Peale, accounts in part for the limited knowledge of James Peale's art and career that presently survives, despite a generally satisfactory outline of his life and the identification of a good many of his works.[1] Like his brother, James Peale served in the Revolutionary army. With Smallwood's Maryland regiment in 1776, he later was commissioned as captain in the 1st Maryland on March 1, 1778; he resigned his commission the following year. After the war he joined Charles Willson in Philadelphia. In 1782 he married Mary Claypoole, daughter and sister respectively of the painters James Claypoole and James Claypoole, Jr. About that time, James Peale seems to have become regularly employed repairing miniatures, though the years immediately following the Revolution were difficult ones for artists.

In 1786 James and his brother formally agreed to divide the field of portraiture, Charles Willson to paint the oil portraits "in large" and James to paint miniatures. A large number of James's miniatures have been identified from the late 1780s to about 1810. James, however, was a relatively versatile artist. Numerous oil portraits by him are also identified, some copies after his brother's work, especially Charles Willson Peale's likenesses of George Washington, but also a good many original portraits, for the most part from the early years of the nineteenth century. He also painted a number of historical pieces relating to the American Revolution, as well as some landscapes, the latter apparently an early interest, although his surviving landscapes date primarily from the last years of his life. Frequently in poor health, he is believed to have abandoned miniature painting because of the strain upon his eyes caused by such minute work, and thus turned to other "life size" themes, oil portraiture, and then still-life painting.

James Peale emulated his brother Charles Willson in another fashion. Just as a number of Charles's children became outstanding artists in their own right, so also did several of James's. Although James's children did not receive the artistic nomenclature bestowed on their cousins — Raphaelle, Rembrandt, Rubens, and Titian — Margaretta, Anna Claypoole and Sarah Miriam Peale all became able and professional artists, Maria and James, Jr., painted at least occasionally, while Jane Ramsey Peale, James's oldest child, was the mother of Mary Jane Simes, also a professional artist. James's descendants followed the several directions of his art: Anna Claypoole Peale and Mary Simes became miniature painters; Margaretta specialized in still lifes; Sarah Miriam Peale became a well-recognized oil portraitist; and all of James's artist-daughters painted an occasional still-life painting. They were among the earliest professional women artists in America.

William H. Gerdts

6 Portrait of Edmund Rouvert

1803
Oil on canvas
30⅛ x 24⅞ in. (76.5 x 63.2 cm)
Not signed or dated
Inscribed on reverse: Mr. T.[?] P. Edmund
 Rouvert
Gift of Mrs. Sterling Morton
60.73

Provenance

Mark W. Collet, great-grandson of the sitter, Philadelphia; Jesse Collet, Philadelphia; (on consignment from the estate of Jesse Collet to M. Knoedler and Co., Inc., 1943); (purchased by Knoedler, 1955); purchased from Knoedler by Mrs. Sterling Morton for the PMC, 1960.

Condition and Technique

According to a letter of Dec. 11, 1959, from Elizabeth Clare of Knoedler, to James W. Foster, Director, SBMA, the painting received "a superficial cleaning" in 1956. Prior to its being sent to the SBMA, the painting, at the request of Foster, who found the canvas "brittle" (letter of Jan. 28, 1960), was lined with a wax-resin adhesive to a fiberglass fabric.

In 1978 examination by the BACC noted that the paint surface had suffered slight general abrasion and the inpainting had darkened noticeably in the jawline and sky. The surface coating was in general even except where matt over the discolored inpainting and had suffered two small superficial scratches, one in u.r. of blue sky, the other near the top of the tree trunk at l. The surface coating was estimated a synthetic resin.

The support, a medium-weight, single and plain weave fabric, is covered with a white ground of medium thickness that allows the weave texture to show through. The paint is an oil type, applied as a thin vehicular paste, with some pigmented glazes and slight impasto in the highlights.

Notes

1. James Peale's life and career have not been studied independently of the fortunes of the Peale family as a whole. Charles Coleman Sellers, a Peale descendant and the biographer and cataloguer of Charles Willson Peale (see Selected Bibliography), has evinced the greatest interest in James Peale, and the several items in the bibliography by him are the most useful and interesting in print. See also the catalogue of the 1967 exhibition at The Detroit Institute of Arts (under Elam in Selected Bibliography).

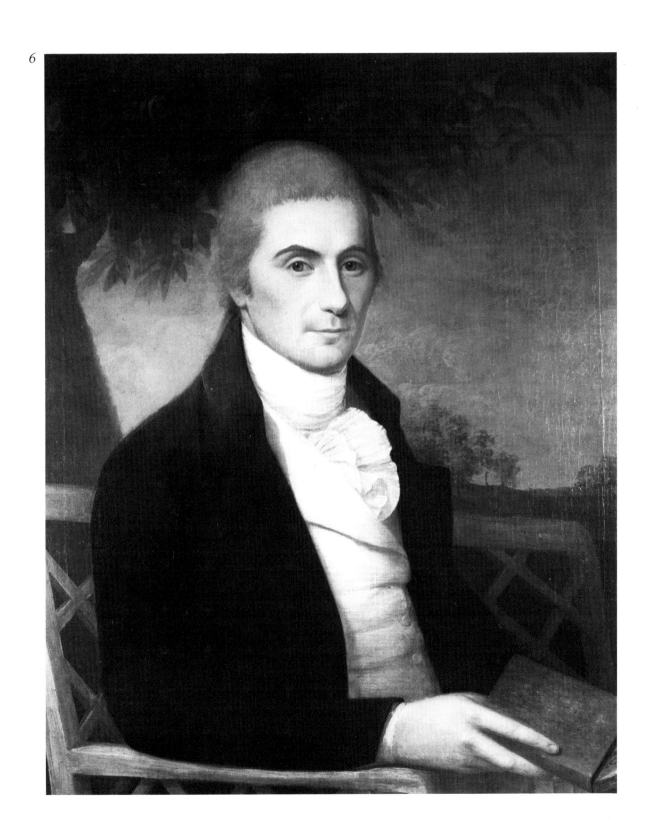

Portrait of Edmund Rouvert

(See color reproduction, page 34)

Portrait of Jane Rouvert

(See color reproduction, page 35)

James Peale painted his portraits of Mr. and Mrs. Rouvert in 1803. Whether these portraits commemorate the couple's marriage is not known. In fact, very little is known about the Rouverts. Edmund Rouvert was a Frenchman who became a successful shipping merchant in Philadelphia. He changed his name from des Brosses to Rouvert on coming to the United States as a refugee during the French Revolution. Perhaps he came at the height of the French immigration in the early 1790s. He was apparently naturalized under the name Edmond Rouvert in 1805.[1] From the inscriptions on the portraits, we know that by or in 1803 he had changed his name and had married Jane Loge, a member of a prominent Southern family.

James Peale composed his portraits of the Rouverts to balance and complement each other. When hung together, the paintings form a visual unit. Edmund Rouvert, on the left, turns slightly to our right. Mrs. Rouvert, on the right, turns to the left. Each sitter looks out at the viewer. Both are seen in garden settings, just as the evening sky turns a deep blue, and the clouds become a rosy pink. Edmund Rouvert, wearing a dark coat and a white vest, sits comfortably on a garden bench beneath a tree. He holds a book in his right hand. His right arm, resting on the arm of the bench, forms the outer left edge of the double composition. Mrs. Rouvert mirrors his pose. Her left arm marks the right edge of the composition. She wears a white Empire dress decorated with a blue ribbon, and her brown hair is held in place with a plaid scarf. Her arms lie crossed in her lap. In her right hand she holds a miniature that seems to be a portrait of her husband.

The portraits of the Rouverts were painted in a year marked by James Peale's struggle to earn enough income to support his family, and in a period when James was gradually turning from miniature painting because of the strain on his eyes.[2] Charles Willson Peale wrote about his brother in this year that James had "one miniature on hand and two portraits to be paid for in Grocery. I know not how other artists prosper, but suspect little is done."[3] From the small number of miniatures and portraits painted by James Peale in the first years of the new decade, we can see that his brother had reason to worry. Although James Peale was painting larger portraits at this time, some of them — some of the finest — were not commissions, but were of members of his immediate family, including the double portrait of his daughters Anna and Margaretta Peale (The Pennsylvania Academy of the Fine Arts) and that of a third daughter, Jane Ramsay Peale (fig. 1, Addison Gallery of American Art). That of Jane Peale is very similar to that of Mrs. Rouvert. Both sitters wear the light gauze-like gown popular with the neoclassical taste of this period, and both wear their hair in wispy, romantic ringlets tied loosely with plaid scarves. Since the portraits of the Rouverts are among the few painted in this period, one wonders if these are the portraits "to be paid for in Grocery."

Ellen G. Miles

7 Portrait of Jane Rouvert

1803
Oil on canvas
30⅛ x 24⅞ in. (76.5 x 63.2 cm)
Signed and dated l.l.: JP/1803
Inscribed on reverse: D [r?] V[?] Yancy
L[?] ing/Mrs Jane Rouvert[1]
Gift of Mrs. Sterling Morton
60.74

1. The first half of the upper line of the inscription is barely visible through the fiberglass and wax-adhesive lining. The second half is faintly visible under infrared reflectance. The lower of the two lines is clearly decipherable. The fact that different sections of the inscription react differently on exposure to different light sources may indicate, but without certainty, that they were written in different inks at different times. (From information provided by the BACC after inspection of the reverse in 1980.)

Provenance

Mark W. Collet, great-grandson of the sitter, Philadelphia; Jesse Collet, Philadelphia; (on consignment from the estate of Jesse Collet to M. Knoedler and Co., Inc., 1943); (purchased by Knoedler, 1955); purchased from Knoedler by Mrs. Sterling Morton for the PMC, 1960.

Condition and Technique

According to a letter of Dec. 11, 1959 from Elizabeth Clare of Knoedler, to James W. Foster, Director, SBMA, the painting received "a superficial cleaning" in 1956. Prior to its being sent to the SBMA, the painting, at the request of Foster, who found the canvas "brittle" (letter of Jan. 28, 1960), was lined with a wax-resin adhesive to a fiberglass fabric.

In 1978 examination by the BACC noted that the overall scattered inpainting had darkened and become matt; abrasion following the canvas weave was noticeable in the drapery. A fine age crackle covered the paint surface. The surface coating was in general even except where matt over the discolored inpainting. The surface coating was estimated a synthetic resin. The general condition was good.

The support, a medium-weight, loosely woven, single and plain weave fabric, is covered with a thin white ground. The paint is an oil type, applied as a thin vehicular paste, with some impasto in the highlights.

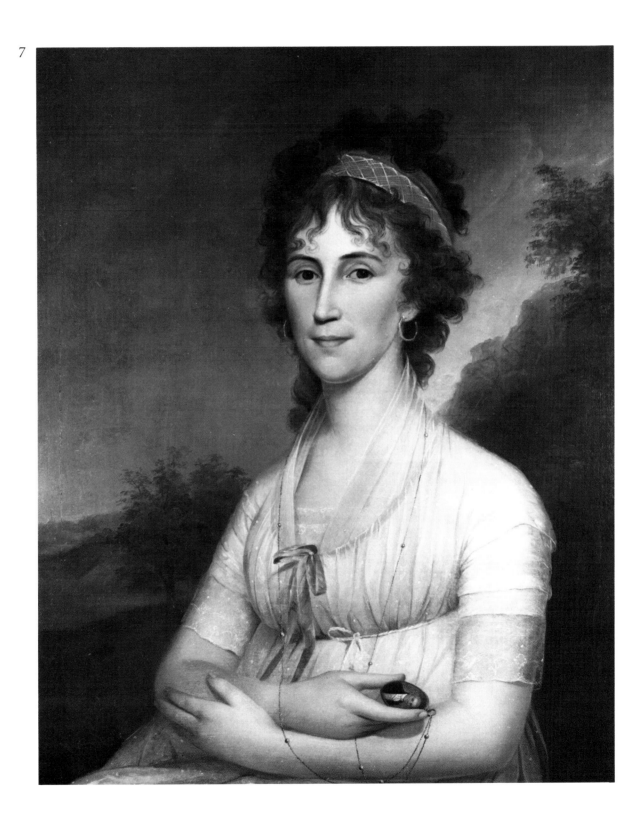

Exhibitions

Portrait of Edmund Rouvert:

Philadelphia, Pennsylvania Academy of the Fine Arts, on loan Apr. 29, 1909–Feb. 1, 1917 (information provided by Knoedler).

Philadelphia, The McLees Galleries, *Exhibition of Paintings and Watercolors by the Peale Family*, Feb. 11–March 4, 1944, no. 21, repr. (information provided by Knoedler).

Raleigh, North Carolina State Art Society, *The American Scene From 1750*, Dec. 12, 1945–Jan. 3, 1946, no. 15.

Ohio, Columbus Gallery of Fine Arts, *Colonial America*, Oct. 9–Nov. 15, 1947, no. 19 (as *Edmond Rouvert*, same no. as *Jane Rouvert*) p. 12, exhibition catalogue published in *Monthly Bulletin*, XVIII, no. 1 (Oct. 1947).

Ohio, Cincinnati Art Museum, *Paintings by The Peale Family*, Oct. 1–Oct. 31, 1954, no. 87 (as *Edmond Rouvert*).

Ohio, Columbus Gallery of Fine Arts, *Sir Joshua Reynolds and His American Contemporaries*, Jan. 30–March 2, 1958, no. 41 (as *Edmond Rouvert*, Ex. Mark W. Collet, Philadelphia).

Ohio, Cincinnati Art Museum, *Two Centuries of American Painting*, Oct. 4–Nov. 4, 1958, no. 8.

Greensburg, Penn., The Westmoreland County Museum of Art, *Two Hundred and Fifty Years of Art in Pennsylvania*, 1959, no. 91, Pl. 14 (information provided by Knoedler).

SBMA, *Two Hundred Years*, 1961, no. 4, mentioned "Introduction," n.p.

SBMA, *American Portraits*, 1966, no. 10, repr., n.p.

Michigan, The Detroit Institute of Arts, *The Peale Family: Three Generations of American Artists*, March 5, 1967, no. 91, repr. p. 82; traveled Utica, Munson-Williams-Proctor Institute, March 28–May 7, 1967.

Portrait of Jane Rouvert:

Philadelphia, Pennsylvania Academy of the Fine Arts, on loan Apr. 29, 1909–Feb. 1, 1917 (with *Edmund Rouvert*) (information provided by Knoedler).

Philadelphia, The McClees Galleries, *Exhibition of Paintings and Watercolors by the Peale Family*, Feb. 11–March 4, 1944 (with *Edmund Rouvert*), (information provided by Knoedler).

Raleigh, North Carolina State Art Society, *The American Scene from 1750*, Dec. 12, 1945–Jan. 3, 1946 (with *Edmund Rouvert*), no. 14.

Ohio, Columbus Gallery of Fine Arts, *Colonial America*, Oct. 9–Nov. 15, 1947 (with *Edmund Rouvert*, same no.), no. 19 (as *Mrs. Jane Rouvert*), p. 12, exhibition catalogue published in *Monthly Bulletin*, XVIII, no. 1 (Oct. 1947).

Sarasota, Fla., John and Mable Ringling Museum of Art, *American Painting, 3 Centuries: A Loan Exhibition*, Apr. 3–24, 1949, no. 3.

Ohio, Cincinnati Art Museum, *Paintings by the Peale Family*, Oct. 1–31, 1954 (with *Edmund Rouvert*), no. 88 (as *Mrs. Edmond Rouvert*).

Ohio, Columbus Gallery of Fine Arts, *Sir Joshua Reynolds and His American Contemporaries*, Jan. 30–Mar. 2, 1958 (with *Edmund Rouvert*), no. 42 (as *Mrs. Jane Rouvert*).

N.Y., The Knoedler Gallery, *Exhibition of American Portraits*, June 16–July 31, 1958, no. 9.

Ohio, Cincinnati Art Museum, *Two Centuries of American Painting*, Oct. 4–Nov. 4, 1958 (with *Edmund Rouvert*), no. 9 (as *Mrs. Edmond Rouvert*).

Greensburg, Pennsylvania, The Westmoreland Museum of Art, *Two Hundred and Fifty Years of Art in Pennsylvania*, 1959, no. 90, Pl. 15 (information provided by Knoedler).

SBMA, *Two Hundred Years*, 1961, no. 5, repr., mentioned "Introduction," n.p.

SBMA, *American Portraits*, 1966, no. 9, repr., n.p.

Michigan, The Detroit Institute of Arts, *The Peale Family: Three Generations of American Artists*, Jan. 18–March 5, 1967 (with *Edmund Rouvert*), no. 92, repr. p. 83.

Chapel Hill, University of North Carolina, William Hayes Ackland Memorial Art Center, *Arts of the Young Republic: The Age of Dunlap*, Nov. 2–Dec. 1, 1968, no. 66, repr., pp. 28, 40.

Tucson, University of Arizona Museum of Art, *First Flowers of Our Wilderness*, 1976, no. 45, Pl. 45, opened SBMA Jan. 11–Feb. 15, 1976; traveled University of Arizona, Feb. 29–March 28, 1976, and to the following not listed in the catalogue, Kansas, Wichita State Museum, Apr. 11–May 9, 1976, Athens, The University of Georgia, Georgia Museum of Art, May 30–June 27, 1976.

Notes

1. Edmond Rouvert was naturalized before the United States District Court on April 25, 1805. He was described as a Frenchman, but no occupation was listed. There is no proof that this is our sitter. (Information courtesy of Peter Parker, Historical Society of Pennsylvania.)

2. It was as a miniaturist that Charles Willson Peale chose to memorialize his brother in two portraits, *James Peale Painting a Miniature* (Amherst College) and *The Lamplight Portrait* (The Detroit Institute of Arts).

3. Charles Coleman Sellers, "James Peale," *Four Generations of Commissions, The Peale Collection of the Maryland Historical Society* (Baltimore, 1975), p. 30.

fig. 1 James Peale, *Portrait of Jane Ramsey Peale*. Reproduced by permission of Addison Gallery of American Art.

Still Life, Wicker Basket of Mixed Grapes

Although about forty or so still lifes by James Peale have been located, they present a problem for study, as most scholarly attention in the past has been directed almost exclusively toward his miniatures.[1] Furthermore, as so many members of the Peale family were involved with still-life painting, including four of James's own daughters, there has been understandable confusion concerning the attribution of works in this genre to one or another of the Peale family. That confusion has been exacerbated by the acknowledged fact that members of the Peale family occasionally copied one another's still-life paintings; James's nephew, Rubens Peale, for instance, indicated in his painting record list that he had copied fourteen of his uncle's still lifes. Given the particular ability of different members of the clan in effectively rendering certain forms or effects, it has even been suggested that some still lifes by one or another member of the family may actually be collaborative efforts, a hypothesis supported to a certain extent by the varying quality and styles of signed works by individual painters of the group.

Generally speaking, however, almost all the still-life paintings by members of the Peale family reveal certain similarities.[2] Subject matter is nearly always edibles, primarily fruit, sometimes placed in containers and accompanied by ceramics, glassware, and metalware. Backgrounds tend to be neutral, with no more than a variation from light to dark to conform to the source of light, a contrast that is often quite dramatic in the work of Raphaelle Peale, more subdued in James's still lifes. Likewise, the still-life arrangements rest on a neutral surface, and while these would generically be referred to as "tabletop" still lifes, the supporting surface is so undistinguished that it may be a shelf, ledge, or board. That support is almost always parallel to the picture plane with no indication of termination at either end, and the arrangement of fruit is also parallel to the picture plane and almost totally contained within the viewing area — little of it protruding beyond the viewing surface to either left or right.

Although still lifes are known to have been imported into America in Colonial days, the Peale family is generally credited with having introduced the genre professionally into American art, notwithstanding the fact that such painting, at the time (and later), was critically disdained as merely transcriptual painting, which offered neither a great challenge to the artist nor inspiration to the viewer. Consequently, still lifes were seldom noticed in exhibitions, were poorly patronized, and were often sold for very small sums or merely traded or bartered for goods and services; both James and Raphaelle, for instance, traded their work for groceries. These two members of the Peale family are generally thought of as the earliest professional still-life painters in this country, and since James is of an earlier generation than his nephew, he is often given precedence. However, in the first public art exhibition held in the new Republic, the Columbianum show of 1795 in Philadelphia, James exhibited one still life and Raphaelle eight. Subsequently, after the institution of regular annual exhibitions at the Pennsylvania Academy of the Fine Arts in 1811, Raphaelle exhibited still lifes until his death in 1825, while James only resumed showing them in the 1820s, the majority exhibited after Raphaelle's death. Located still lifes by Raphaelle, furthermore, date from as early as 1802, while all known examples by James are from the 1820s. It is probably safe to conclude, therefore, that James painted the theme only occasionally until the last decade of his life and that Raphaelle had preceded him by a good number of years in establishing the genre as a specialty. Certainly

8 Still Life, Wicker Basket of Mixed Grapes

ca. 1828
Oil on canvas
15^{15}/$_{16}$ x 21⅞ in. (40.4 x 55.5 cm)
Signed l.r.: J. Peale
Not dated
Gift of Mrs. Sterling Morton
60.75

Provenance

Private collection, Texas (information provided by Knoedler); A. M. Adler, N.Y.;[1] (on consignment from Adler at M. Knoedler and Co., Inc., N.Y., 1952);[1] purchased by Norman Woolworth, 1956;[1] (purchased from Woolworth by Knoedler, 1958);[1] purchased from Knoedler by Mrs. Sterling Morton for the PMC, 1960.

1. Information provided Jan. 16, 1980, by Nancy C. Little, Librarian, Knoedler.

Condition and Technique

In 1952 while on consignment at Knoedler the painting was lined with an aqueous glue to a plain weave linen. The painting at this time was placed on a new stretcher, and the old varnish was removed. The painting was cleaned and given a new coat of varnish. While with Knoedler the painting was given a superficial cleaning in 1954 and again in 1959.

In 1978 inspection by the BACC noted that the original tacking margins had been removed. The surface coating, a moderately thin spirit varnish, had slightly yellowed, and there were three gold leaf spatters c.r. The general condition was good.

The support, a light-weight, plain weave fabric (estimated linen), is covered with a thinly applied, light beige-white ground, which only partially obscures the fabric texture. The paint, an oil type, has a vehicular structure and is thinly applied in dry, smooth even layers, with some slight scumbling.

Raphaelle's poor reception and patronage, despite his great ability at still-life painting, would have given little incentive for James to abandon the much more rewarding field of portraiture.

Despite the similarities between the work of James and Raphaelle Peale in still life there are significant differences. In purely technical terms, many of Raphaelle's still lifes are painted on panel, while very few of James's are. Raphaelle usually signed his work on the front, James on the back. Thematically, Raphaelle displayed a wider range of subject matter, a more extensive range of edibles including cakes, nuts, and meats, and more varied decorative objects than his uncle. But fruit was their primary subject, and both artists also occasionally painted vegetable arrangements.

It is in their interpretation of fruit that the two vary the most. Raphaelle's forms are almost always clearly defined, sharply outlined, and "crisp"; color is strictly local, without any mixed, variegated tones. Forms tend toward perfection: globular peaches and oranges, perfect ellipses of grapes and watermelons, evenly serrated leaf edges. In their geometric precision the forms verge on abstraction: Raphaelle's are truly neoclassic still lifes. In contrast, James in his still lifes, as in his portraits compared to those of Charles Willson Peale, is a more romantic figure. In formal terms he revealed more brushwork and enjoyed mixing colors, reflected from object to object. Grapes would share several different hues, and individual leaves would age from green to yellow to brown. James's deployment of colors is related to a significant aspect of his romantic turn of mind; change and age figure prominently in his still lifes, unlike those of Raphaelle. Age spots, worm holes, and irregularities mark his fruit; leaves age, wrinkle, curl up, and decay. Raphaelle's still lifes are timeless; James's display transience.

Outside of the relatively rare vegetable still lifes by James, his pictures of fruit, depending on their compositional scheme, can be divided into subcategories. A few consist of fruit resting directly upon the tabletop support. The majority utilize either several varieties of ceramic, or a wicker basket; the Santa Barbara picture falls into this last category. However, an attempt to establish a chronology according to the various containers used has been so far unsuccessful — James does not seem to have used one container one year, a different one a second year, and so forth. Furthermore, James made replicas of some of his works a number of times, a procedure that contributes to the chronological confusion.[3] In similar fashion, although there appear to be several compositional and formal approaches involved in James Peale's still lifes, including those from the short period of dated still lifes (1821–1830), the works do not divide conveniently into "periods" of looser versus more controlled brushwork, simpler versus more complicated compositions, and so forth.[4]

Both stylistically and in regard to subject matter, the Santa Barbara picture is particularly close to one by James Peale in The Newark Museum, also undated. Most of the artist's still lifes contain grapes combined with other, larger fruit, particularly apples, peaches, and pears, but the Newark picture consists of grapes only, though these rest directly upon the support surface, rather than in a wicker basket as in the Santa Barbara picture. Even closer is the *Still Life No. 3* (fig. 1), formerly in the collection of the Pennsylvania Academy of the Fine Arts where, as in the Santa Barbara example, a variety of different-colored grapes pour out of a wicker basket. In all three of these paintings, Peale eschewed the fruit of the orchard and, focusing exclusively on the product of the vineyard, was interested in contrasting the grapes solely with their leaves, and in creating effective variety in the juxtaposition of blue, red, or purple, and green or white grapes. *Still Life No. 3*

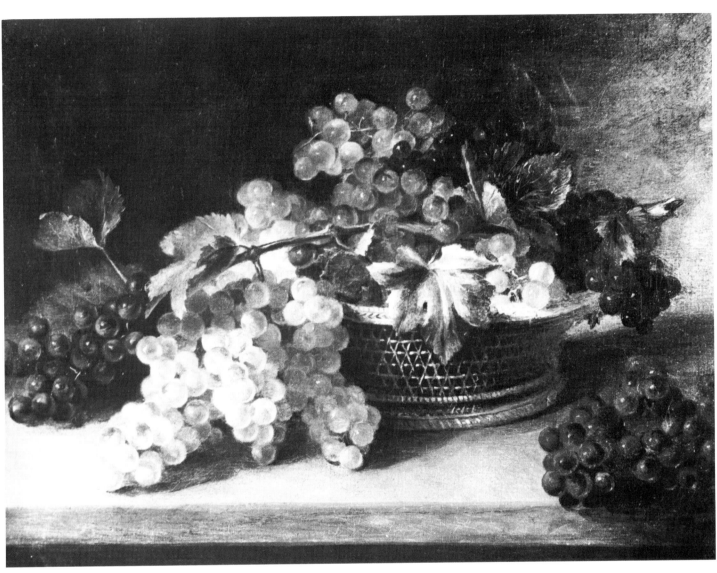

8

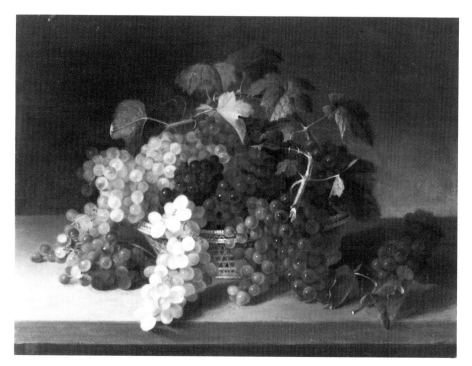

Notes

1. See, for instance, the several articles by Jean Brockway and Frederic Fairchild Sherman on Peale's miniatures listed in the Selected Bibliography.
2. The most significant studies of Peale still lifes and individual characteristics are Edward H. Dwight, "Still-Life Paintings by the Peale Family," in Charles Elam, ed., *The Peale Family: Three Generations of American Artists* (exhibition catalogue), The Detroit Institute of Arts, 1967, pp. 35–38, 118–119; William H. Gerdts, *American Still-life Painting* (New York: Praeger Publishers, 1971), pp. 24–40. The pioneer article on the subject was John I. H. Baur, "The Peales and the Development of American Still Life," *The Art Quarterly*, III, no. 1 (Winter 1940), pp. 81–92.
3. Dwight, p. 36. See also the three still lifes by James Peale at The Fine Art Museums of San Francisco and the Corcoran Gallery of Art, and one sold at Christie's, New York, in April of 1981, which are almost identical, as are also those in the Baltimore Museum of Art, the Library Company of Philadelphia and a New York private collection; Kennedy Galleries, Inc., New York City had a still life by James Peale almost identical to one now in the collection of the Museum of Fine Arts, Boston.
4. Particularly noticeable are a group of still lifes such as the Baltimore-Philadelphia-New York trio mentioned above, and a still life of peaches in The Newark Museum, which, in their smooth surfaces, rhythmic compositions and simplified coloration differ greatly from the usual more painterly, coloristic, and realistic treatment employed by James Peale; yet at least one of that group is dated 1828, while the dated works in the alternate style are both earlier and later.

is dated 1829, and this would seem to be also a reasonable, if approximate, date for the Santa Barbara painting. The Newark picture bears, moreover, some similarity with the Pennsylvania Academy's *Still Life No. 1*, dated 1827, so that an attribution to 1828 would seem justified for our example. In support of this date is the fact that in 1828 Peale exhibited at the Academy a *Still Life—Red, White, and Blue Grapes*, which could not be the picture of 1829 but could well be the Santa Barbara picture.

William H. Gerdts

Exhibitions

Houston, Texas, The Museum of Fine Arts, Oct. 26, 1954.[1]
SBMA, *Two Hundred Years*, 1961, no. 6, repr., mentioned "Introduction," n.p.
N.Y., The American Federation of Arts, *A Century of American Still-Life Painting* (selected by William H. Gerdts), 1966, no. 36 (as *Still Life—Wicker of Mixed Grapes*), circulated.
Tucson, University of Arizona Museum of Art, *First Flowers of Our Wilderness*, 1976, no. 46, Pl. 46, opened SBMA, Jan. 11–Feb. 15, 1976, traveled University of Arizona, Feb. 29–March 28, 1976, and the following not listed in the catalogue, Kansas, Wichita State Museum, April 11–May 9, 1976, Athens, The University of Georgia, Georgia Museum of Art, May 30–June 27, 1976.

1. Information from a label on the back. The registrar's office of The Museum of Fine Arts, Houston, was not able to provide any further information (letter of Dec. 3, 1980).

Thomas Sully
1783-1872

Thomas Sully was one of the predominant American portrait painters of the first half of the nineteenth century, not only because he painted over two thousand portraits, but also because he trained many younger artists and influenced the work of numerous others. His soft, flowing style and elegant compositions have come to represent the period between the War of 1812 and the 1850s. Sully, born in England, came to the United States with his parents in 1792. Here he received his early lessons in painting from several European-trained artists, including Henry Benbridge and Gilbert Stuart. His easily recognizable mature style derives, however, from his study in England in 1809–1810 with Sir Thomas Lawrence, the leading English portrait painter of the Regency period.

Sully returned to Philadelphia in 1810 to become that city's leading portrait painter. He is also remembered for his subject pictures, historical compositions, and "fancy pieces" of imagined or literary subjects. Long a member of the Pennsylvania Academy of the Fine Arts (from 1812), Sully was offered its Presidency in 1843, but declined. He was the first artist offered this important position. Sully's *Hints to Young Painters and the Process of Portrait Painting*, written in 1851 and published in 1873, summarizes his studio methods and advice to his pupils. Sully's technique was that of broad, flowing brushstrokes, a technique that often gave vertical emphasis to his compositions and a generalized air to the features of his sitters. He often placed his figures against monochrome backgrounds, thus calling attention to the soft coloring of their clothing and skin tones. Never harsh, his portraits are graceful images from a period noted also for its extraordinary political and economic changes.

Ellen G. Miles

Louise Caroline Françoise de Tousard, Mrs. John Clements Stocker

Louise de Tousard (1788–1877) was the daughter of Anne Louis de Tousard (1749–1817), a Frenchman who first came to the United States as an aide to Lafayette during the American Revolution. He returned to the United States as a refugee during the French Revolution and was later made a Colonel in the United States Army (1800). After another brief period in France, Tousard was sent to New Orleans in 1805 as a representative of the French government. Later, after several years as French Vice-Consul in Philadelphia and Baltimore, Tousard returned to New Orleans (1811–1816).[1]

Louise de Tousard married John Clements Stocker, a Philadelphian, in 1808.[2] Stocker, son of John Clements and Mary Katharine Butler Stocker, became a prosperous merchant who also served as Director of the Bank of North America and the Mutual Insurance Company.[3] In 1814, six years after their marriage, Stocker and his wife were painted by Thomas Sully, who recorded the sittings and payments in his portrait register.[4] Stocker's portrait, begun May 12 and finished on July 5, was sent to Colonel de Tousard in New Orleans, according to the register. Mrs. Stocker's portrait, the same size and price ($100), was begun on November 14 and finished on December 29. Although the register does not state this, it is possible that her portrait was also sent to Tousard; the portraits, at any rate, were recently owned as a pair by the Stockers' descendant, Mrs. Arthington Gilpin of Philadelphia.

9 Louise Caroline Françoise de Tousard, Mrs. John Clements Stocker

November 14–December 29, 1814
Oil on canvas
36 x 28 in. (91.4 x 71.1 cm)
Not signed or dated
Gift of Mrs. Sterling Morton
60.83

Provenance

Mrs. Arthington Gilpin, a granddaughter of the sitter, Philadelphia, by 1922; (John Levy Galleries, N.Y.); (acquired from Levy by M. Knoedler and Co., Inc., N.Y., 1950); purchased from Knoedler by Mrs. Sterling Morton for the PMC, 1960.

Condition and Technique

A possible cleaning executed after 1922 may have removed the "shawl" or "stole" shown in a photograph, probably taken in 1922.[1] At the time the painting entered the SBMA, two small scratches l.r. were noted.

In 1978 examination by the BACC noted the painting had been lined with an aqueous adhesive to a single weave fabric and the tacking margins of the support cut. There were scattered areas of discolored overpainting along the edges, in the whites and the background. The whites of the dress revealed localized areas of traction crackle. Slight loss at u.r. edge was due to abrasion from the rabbet. The surface coating, a natural resin varnish (estimated), was moderately discolored.

The support, a medium-weight, loosely woven, plain and single weave fabric, is covered with a creamy white-beige ground of medium thickness that does not hide the fabric texture. The oil-type paint is applied wet into wet, with some pigmented glazes, a general smooth application with some impasto in the highlights.

1. Letter of Sept. 11, 1961 to the SBMA from Mildred Steinbach, Frick Art Reference Library: "We are writing to ask whether the Sully portrait of Mrs. John Clements Stocker is the same as that which we list as owned in 1922 by Mrs. Arthington Gilpin, Philadelphia (Biddle and Fielding, "The Life and Works of Thomas Sully," 1921, p. 280 (1653)). The reason we ask is that our photograph, which evidently came from the Sully Memorial Exhibition of 1922, shows a black lace shawl or stole covering the subject's right arm, whereas the reproduction on your Calendar does not. If this is the same portrait, we presume that the portrait has been cleaned since 1922."

The portraits of the Stockers, like those of the Rouverts by James Peale, were composed as a pair, each figure placed slightly to one side in its composition, so that when seen together the two portraits form a balanced grouping. Louise Stocker is seated in an interior on an upholstered Empire settee. Its curved arm is visible to the left. She is perched on the settee, her arms at her sides, holding an open book on her lap. She has a sweet, pert look, the corners of her mouth curved upward to form a delicate smile. Her dark brown hair is pulled back, and soft ringlets frame her heart-shaped face. She wears a white Empire-style gown, decorated with a soft lace border along its square-cut decolletage.

The pendant portrait of John Clements Stocker (fig. 1), now at the Newark Museum, shows a solid, prosperous merchant of more (apparent) physical substance. Stocker (1786–1833) was only twenty-eight years old when his portrait was painted. Yet he appears a well-established man of property, his glasses in hand, his signature seals dangling at his waist. His pose, arm draped over the back of an Empire-style side chair, and his arched eyebrows add to this image of studied prosperity.

Ellen G. Miles

Exhibitions

Philadelphia, The Pennsylvania Academy of Fine Arts, *Catalogue of the Memorial Exhibition of Portraits by Thomas Sully,* April 9–May 10, 1922, no. 7 (lent by a granddaughter, Mrs. Arthington Gilpin, Philadelphia), p. 13.
N.Y., The Knoedler Gallery, *Exhibition of American Portraits (1755–1815),* June 16–July 31, 1958, no. 16.
SBMA, *Two Hundred Years,* 1961, no. 10, repr., mentioned "Introduction," n.p.
SBMA, *American Portraits,* Apr. 6–May 8, 1966, no. 26, repr., n.p.
Tucson, University of Arizona Museum of Art, *First Flowers of Our Wilderness,* 1976, no. 62, Pl. 62, opened SBMA, Jan. 11–Feb. 15, 1976, traveled University of Arizona, Feb. 29–March 28, 1976, and to the following not listed in the catalogue, Kansas, Wichita State Museum, Apr. 11–May 9, 1976, Athens, The University of Georgia, Georgia Museum of Art, May 30–June 27, 1976.

References

Edward Biddle and Mantle Fielding, *The Life and Works of Thomas Sully* (Philadelphia, 1921; reprint; Charleston, South Carolina: Garnier and Co., 1969), p. 280, no. 1653.
Antiques, LXXII, no. 4 (Oct. 1957), repr. p. 307.

Notes
1. *Dictionary of American Biography* (New York: Charles Scribner's Sons, 1935–1936), part 2, pp. 202–205.
2. *Memorial Exhibition of Portraits by Thomas Sully,* Philadelphia, The Pennsylvania Academy of the Fine Arts, 1922, no. 13, p. 15.
3. Information on Stocker's parents comes from the Stocker-Lewis Bible Records at the Historical Society of Pennsylvania, courtesy of Peter Parker.
4. John Clements Stocker's portrait is no. 1652 in the register, as published by Edward Biddle and Mantle Fielding (see References). The portrait, measuring 36 x 28 in., was acquired by The Newark Museum in 1956.

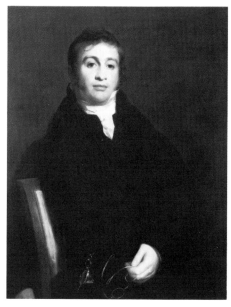

fig. 1 Thomas Sully, *Portrait of John Clements Stocker.* Reproduced by permission. Collection of the Newark Museum.

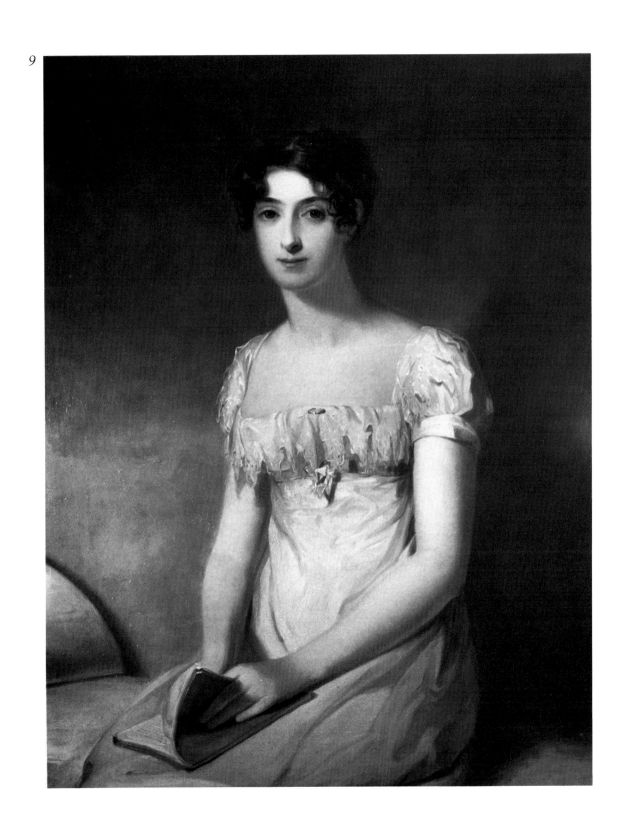

Nineteenth-Century Landscapes

Thomas Cole
1801-1848

Thomas Cole was born in 1801 in Bolton-le-Moor, one of the earliest industrial centers in England. His early experience with art was as an apprentice to a designer of calico prints and then as an engraver. In 1819 Cole and his family immigrated to the United States.

After his arrival in America, the young Cole supported himself as an itinerant portrait painter and engraver, working in the region of the Ohio Valley. As a young aspiring artist Cole was convinced that nature was his real master.

In 1825 Cole moved to New York City and traveled extensively in the Catskill Mountains and in New England. Around this time he began to receive recognition from fellow artists and was befriended by wealthy patrons such as Robert Gilmore, Jr., of Baltimore. Gilmore sponsored Cole on his first European trip in 1829. Even as a youthful artist Cole was interested in painting not only recognizable scenes of the American wilderness, which his patrons preferred, but also ideal historical compositions that allowed him to display his wide-ranging erudition and his technical virtuosity.

After his return from Europe during the 1830s, Cole at the height of his powers created a number of impressive allegorical compositions, including *The Course of Empire* (1836) and the immensely popular series *The Voyage of Life* (1839–1840 and 1842). These works established his fame and made him a recognized leader among the artists working in America.

In 1841–1842 Cole made a second trip to Europe, and upon his return, was increasingly preoccupied with religious subjects, a preoccupation that culminated in the series *The Cross and the World* and *The Meeting of the Waters.* During the last decade of his life Cole came to be regarded by his fellow artists as the leader of their small artistic community, and as its ideal example. Cole's tragic death in 1848 from pneumonia was unexpected and cut short his ambitious plans for completing *The Cross and the World* and the other religious works he was planning. Subsequently, Cole was elevated to the position of founder of the American school of landscape painting by his fellow artists and by the historian Henry Tuckerman.

J. Gray Sweeney

The Meeting of the Waters
(See color reproduction, page 36)

In its majestic, panoramic space and in its use of typological symbolism, *The Meeting of the Waters,* although unfinished, is one of Thomas Cole's key late paintings. These late works, especially those with overt religious content, in this century have been the least understood and appreciated of Cole's oeuvre. As recently as 1979, the noted scholar Milton Brown wrote: "Much of the revival of interest in Cole is a condescending appreciation of the imagination of his allegories, so prophetic of Surrealist hallucination, in preference for his more lasting contributions to landscape painting."[1] From an art historical perspective, however, *The Meeting of the Waters* offers a remarkable synthesis of the emblematic imagery used by Cole in his earlier popular series, *The Voyage of Life* (first version 1839–1840, Munson-Williams-Proctor Institute, Utica, N.Y.; second version 1842, National Gallery of Art, Washington, D.C., figs. 1–4; *Childhood* in the second series measures 52⅞ x 77⅞ in.,

10 The Meeting of the Waters

ca. 1847
Oil on canvas
51 x 75¾ in. (129.5 x 192.4 cm)
Not signed or dated
Gift of Suzette Morton Davidson
79.19

Provenance

Studio of the artist at his death, 1848; descendants of the artist until 1979; purchased from Hirschl & Adler by Suzette Morton Davidson for the PMC, 1979.

Condition and Technique

In 1981 examination by the BACC noted the painting had been lined with a wax-resin adhesive to a double-threaded, plain weave fabric (estimated linen). The original tacking margins had been preserved. There were some flake losses of paint and ground along the side and bottom edges and flaking of the upper paint layer along the edges, probably from contact with the frame rabbet. There was some overpaint covering scratches in the center of the sky and over a broad strip of 2 in. running the width of the painting along the top edge. Scattered smaller areas of overpaint throughout the sky suggested the possibility this area may have been extensively abraded, possibly from a vigorous earlier cleaning. There were also a few small areas of overpaint in the trees and landscape. There were residues of dirt and old varnish along the edges, and the surface coating was abraded along the edges from the rabbet. A toned varnish, possibly a synthetic polymer resin, was estimated to have been applied recently. The overall grey tonality of the sky may have been due to the toned varnish.

The support is a moderately light to medium weight, single-threaded plain weave fabric (estimated linen), and there may be a vertical seam at w. 41 in. The ground, light grey in tone, is moderately thin and appears to extend irregularly onto the tacking margins. It almost completely fills and smooths the fabric texture. The paint, estimated an oil type, a paste vehicular structure, has been applied in the sky in long sweeping horizontal brushstrokes with slight relief in the clouds, some dry scumbles and semi-transparent glazes in the rocks, and with soft fat globs of paste in the foliage.

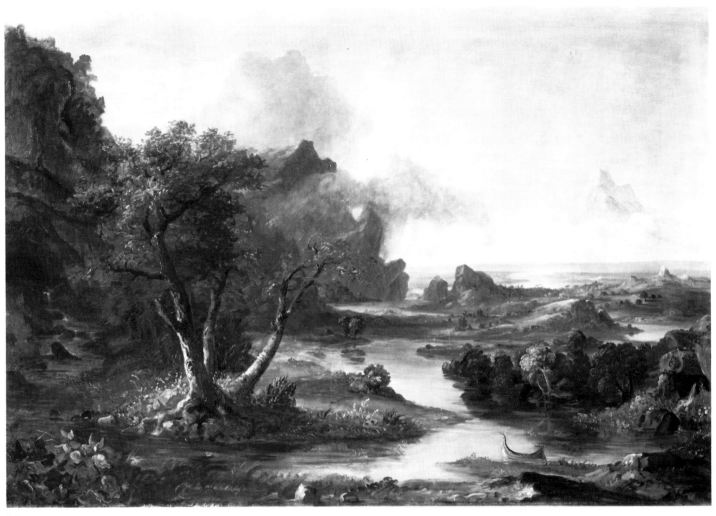

10

134.3 x 197.8 cm) and in his unfinished, ultimate series, *The Cross and the World* (figs. 5–7), which like *The Meeting of the Waters* was painted in the last year of Cole's life.

The composition of *The Meeting of the Waters* bears a strong resemblance to *Childhood* (fig. 1), the first panel of Cole's *Voyage of Life,* while its expansive vista recalls the beckoning landscape seen by the voyager in *Youth* (fig. 2). Incomplete at the time of Cole's unexpected death in February 1848, *The Meeting of the Waters* is still sketchy in execution and manifests none of the meticulously rendered details typical of his finished paintings. Viewed from any distance, however, the composition fuses into a unified whole and breathes spaciousness. The expansive breadth, the flowing succession of planes into infinite depth, the softly pervasive and all-suffusing light speak eloquently of the lessons Cole had learned over the two and a half decades of his brief career.

A narrow stream issuing from the cave in the left foreground turns and broadens into a river that winds through a vast prospect gradually to disappear at the horizon. Save for a momentary storm showering the mountain chasm in the middle distance, the light of the painting is clear as it bathes the river's gracefully varied and enticing course. The scene exudes a soothing and peaceful harmony, in contrast to the sublime histrionics of *The Pilgrim of the Cross on His Journey* (fig. 6) and *The Pilgrim of the Cross at the End of His Journey* (fig. 7), the enveloping, morbid gloom of *The Pilgrim of the World at the End of His Journey*, or the malevolent, gesticulating nature seething about the voyager in *Manhood* (fig. 3), the third scene in *The Voyage of Life.*[2]

The iconography of *The Meeting of the Waters* was created at the same time as *The Cross and the World,* which featured a double journey over land for the two pilgrims.[3] The subject matter of the Santa Barbara painting, a winding river inviting travel, was one Cole had already explored in *The Voyage of Life.* Both of these series portrayed landscapes abounding with "types" and "providences."[4] Providences were made manifest in the guise of supernatural phenomena, such as the guardian angel who watches over the traveler in *The Voyage of Life,* the devil's face emerging from the tree trunk in *Christ and the Tempter* (1843, Worcester Art Museum and Baltimore Museum of Art), and the radiant cross that appears repeatedly before the pilgrims in *The Cross and the World.*[5] Providential revelation of the supernatural premised a special category of typology that saw sermons in stone, and nature as Scripture.[6] Typology for Cole amounted to the belief that every fact and every event recorded in the great book of nature bore a meaning that could be perceived as revealing the Deity's plan. Typological revelation was integral to Cole's nature imagery, first appearing in early paintings such as *John the Baptist Preaching in the Wilderness* (1827, Wadsworth Atheneum, Hartford), and finally attaining its culmination in the latest of his *paysages moralisés, The Cross and the World* and *The Meeting of the Waters.*[7]

The Meeting of the Waters offers a universal representation of mortal existence in both Old and New Worlds — the "green pastures" and "still waters" of Canaan, and the "New Eden" of America. The painting is a complex, didactic work in which the soul's journey down the river of life with God's guidance is conveyed by the symbolism of the landscape, which to Cole's generation affirmed the belief that the voyage through life required only faith. This all-sufficient faith, moreover, would enable the voyager to read the signs and types engraved in the great book of nature.

At the far left, at the foot of a dark cliff a stream issues from the mouth of a cave; it recalls the source of human life portrayed by Cole in the first scene of *The Voyage of Life — Childhood.*[8] Emblematic of the beginnings of earthly existence, this narrow stream is destined ever to widen. Flowing toward the immediate foreground, the stream makes its

fig. 1 *(top left)* Thomas Cole, *Voyage of Life: Childhood.* Reproduced by permission of the National Gallery of Art, Washington, Ailsa Mellon Bruce Fund. fig. 2 *(top right)* Thomas Cole, *Voyage of Life: Youth.* Reproduced by permission of the National Gallery of Art, Washington, Ailsa Mellon Bruce Fund. fig. 3 *(middle left)* Thomas Cole, *Voyage of Life; Manhood.* Reproduced by permission of the National Gallery of Art, Washington, Ailsa Mellon Bruce Fund. fig. 4 *(middle right)* Thomas Cole, *Voyage of Life: Old Age.* Reproduced by permission of the National Gallery of Art, Washington, Ailsa Mellon Bruce Fund. fig. 5 *(bottom left)* Thomas Cole, *The Cross and the World: Two Youths Enter Upon a Pilgrimage—One to the Cross, the Other to the World.* Reproduced by permission. Courtesy of Wichita State University Art Collection, Edwin A. Ulrich Museum of Art, Wichita, Kansas. fig. 6 *(bottom left)* Thomas Cole, *The Pilgrim of the World on His Journey.* Reproduced by permission. Courtesy of Albany Institute of History and Art.

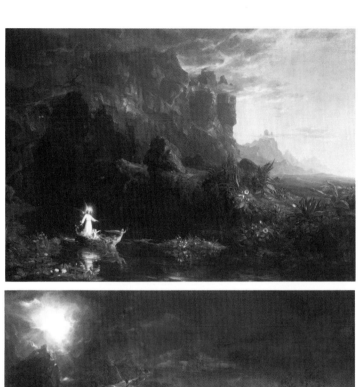

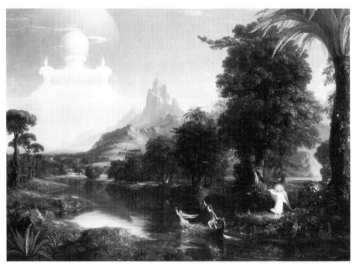

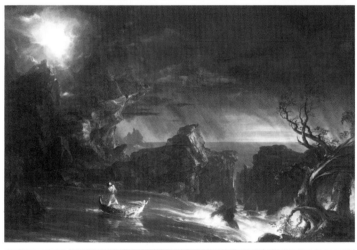

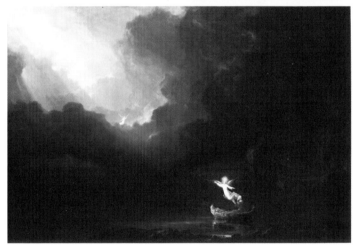

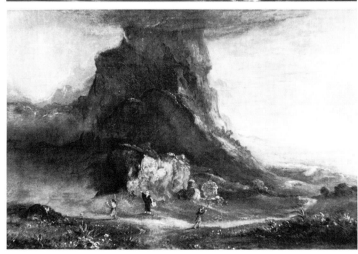

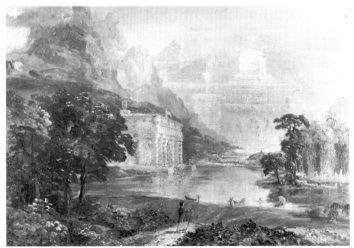

fig. 7 Thomas Cole, *Pilgrim of the Cross at the End of His Journey*. Reproduced by permission of the National Museum of American Art (formerly National Collection of Fine Arts), Smithsonian Institution; Museum purchase.

first turn by a clump of luxuriant vegetation, a passage emblematic, as in *Childhood* of *The Voyage of Life,* of the blissful, paradisiacal state of early life.

Following the river, the viewer successfully encounters forms whose "type" indicates the continual divine guidance proffered by nature.[9] An example of such guidance is expressed by the group of three trees at the center left, whose branches writhe and gesture as if animated by an inner force and energy. These three trees may well be emblematic of the three crosses of Calvary — wilderness prefigurations of the Christian's prospect of immortality. At the right is a fanciful vessel, a "shallop," similar to that used by the passenger in *The Voyage of Life.*[10] Perhaps Cole intended to complete the work with a figure or figures, or it may be that, in the absence of any figure, the spectator was meant to identify himself as the vessel's potential passenger and thus be vicariously drawn along into a moral pilgrimage.

The broad stream sweeps across the foreground and turns at the right, growing into a veritable river, as yet another fresh source of the waters of life issues from a spring. Beyond the bend at the right, the everwidening vista indicates, as in *Youth* of *The Voyage of Life,* the awareness that grows with the experience of years. In the middle distance, the river broadens, then turns twice to disappear, each time to reappear before entering a rocky, cloud-covered chasm. Signifying the torment and trouble that mark the period of "manhood," this chasm is a veritable "valley of the shadow of death," a psalmic passage. Cole here, however, does not dwell upon this trying ordeal, which is in contrast with the treatment of its counterparts in *The Voyage of Life* and in *The Cross and the World,* especially in the latter, in which the pilgrim of the world and the pilgrim of the cross each separately encounters a dark and ominous mountain abyss. In *The Meeting of the Waters* the rock face on the left side of the chasm has a benign mien.

In the far distance, the river flows into the vast, flat sea, for Cole the emblem of divinity.[11] Here, the individual merges with the universal, the infinite. Above the mountain chasm, at left, hovers a huge cloud, its upper profile beheld as a face looking

Notes

1. Milton Brown, *American Art* (New York: Abrams, Prentice-Hall, 1979), p. 195.
2. Cole's description of *The Pilgrim of the Cross on His Journey* reads: "A wild mountain region now opens upon the beholder. It is an hour of tempest. Black clouds envelope the surrounding summits. A swollen torrent rushes by, and plunges into the abyss. The storm, sweeping down through terrific chasms, flings aside the angry cataract and deepens the horror of the scene below. The Pilgrim, now in the vigor of manhood, pursues his way on the edge of a frightful precipice. It is a moment of imminent danger. But gleams of light from the shining cross break through the storm, and shed fresh brightness along his perilous and narrow path. With steadfast look and renewed courage, the lone traveler holds on his heavenly pilgrimage. The whole symbolizes the trials of faith." *Memorial Exhibition,* 1848, p. 11.
3. For the most in-depth study of the series, especially the study for *Two Youths Enter Upon a Pilgrimage — One to the Cross, The Other to the World,* see James C. Moore, "Thomas Cole, *The Cross and the World:* Recent Findings," *The American Art Journal,* V, no. 2 (Nov. 1973), pp. 50–60. Additionally, Howard Merritt, *Thomas Cole* (exhibition catalogue), Memorial Art Gallery of the University of Rochester, 1969, discusses *The Pilgrim of the World on His Journey* (no. 59) and *The Pilgrim of the Cross at the End of His Journey* (no. 60). According to the catalogue of the *Memorial Exhibition* of Thomas Cole at the American Art Union in 1848, four of the original canvases, each measuring 96 x 64 in., were exhibited along with five studies. Today only three of the studies are extant (*The Cross and the World: Two Youths Enter Upon a Pilgrimage — One to the Cross,*

heavenward as though to guide the voyager to his maker.[12] Far off, looming over the horizon and rising from the clouds that encircle its base, is a vast white monolithic mountain, the sublime emblem of natural divinity.[13] (Its craggy features recall the impassive façade of the peak in *The Course of Empire.*)

Expressive of serenity, *The Meeting of the Waters* may have been in part Cole's answer to the criticism that in *The Voyage of Life* he had been too gloomy in portraying the traits of *Manhood,* or that in *The Cross and the World* he had bared too darkly the ordeals of the pilgrims. Regarding the two series, Cole's biographer and friend, the Reverend Louis Noble observed: ". . . both works are as twin children, born of the same poetic state of mind, of one and the same pure religious passion."[14] In concluding his discussion of Cole's life and work, in a strangely garbled passage, Noble alludes to a final work painted simultaneously with *The Cross and the World,* intended by Cole to be a culmination of his whole artistic life, and based on the opening lines of the twenty-third Psalm:

> The Lord is my shepherd: I shall not want.
> He maketh me to lie down in green pastures:
> He leadeth me beside the still waters.

Noble attributes some of the tranquility of the painting to the verses of the Psalmist. The present author proposes that Noble was referring to *The Meeting of the Waters,* through the "green pastures" and "still waters" of which we are shepherded. Noble concludes his discussion by turning, as if in apostrophe, to address the painting itself:

> So far, the picture is a divine song, expressive of the poet and the Christian. As a work of art, it evinces the pencil at home with excellence, and used to the most precious grace and beauty. While it is the mirror of a mind sublime in the contemplation of immortal holiness and serenity, it shows a thorough knowledge of all the painter's proper means, and manifests a hand skillful as well in the most delicate, subtle touches as in all bolder ways and freer motions, and quickened by an imagination of the most singular purity and brilliance.[15]

The Meeting of the Waters is a late work of Cole's genius, but its genesis may go back two decades earlier, as suggested by a drawing from a sketchbook of about 1827 (The Detroit Institute of Arts, fig. 10). Although the scene in the drawing is much more excited and confined than the expansive calm of the painting, and its three peaked summit with

fig. 8 Thomas Cole, *Desolation* from *The Course of Empire.* Reproduced by permission. Courtesy of The New York Historical Society, New York City.

fig 10 Thomas Cole, drawing from sketchbook, circa 1827, possible study for *The Meeting of the Waters.* Reproduced by permission of The Detroit Institute of Arts, Founders Society Purchase, William H. Murphy Fund.

fig. 11 John Martin, *Adam and Eve—The Morning Hymn*, from *Paradise Lost* by John Milton, Book 5, pp. 160–161.

fig. 9 Thomas Cole, *Home in the Woods*. Reproduced by permission. Property of Reynolda House Museum of American Art.

The Other to the World, Wichita State University Art Collection, gift of Mr. Sam Bloomfield; *The Pilgrim of the World on His Journey*, Albany Institute of History and Art; *Pilgrim of the Cross at the End of His Journey* (National Museum of American Arts, Smithsonian Institution)), while a fourth *The Pilgrim of the World at the End of His Journey*, is known through a photograph in the possession of Ellwood C. Parry. Professor Parry's ground-breaking study of Cole's *The Course of Empire: A Study of the Serial Imagery* (Ph.D. Dissertation, Yale University, 1970) demonstrates the complexity and far-ranging erudition of Cole's serial paintings.
4. Sacvan Bercovitch, ed., *Typology and Early American Literature* (Amherst, Mass.: University of Massachusetts Press, 1972). Bercovitch's "Annotated Bibliography," pp. 245–337, lists works on all aspects of typology. George P. Landow's recent *William Holman Hunt and Typological Symbolism* (New Haven: Yale University Press, 1979) is a useful study indicating the widespread use of typology both in Hunt and the other members of the Pre-Raphaelite Circle. David C. Huntington's *Frederic Edwin Church* (New York: Braziller, 1966) offers many observations on Church's use of typology. Professor Huntington's essay "Church and Luminism: Light for America's Elect," in the catalogue for *American Light* (Washington, D.C., The National Gallery, 1980), provides an essential discussion of Church's and Cole's use of typology. I am indebted to Dr. Huntington for reading this essay and making many helpful comments.
5. For a pioneering study of Cole's religious paintings see: William Gerdts, "Cole's Painting: *After the Temptation*," in *Studies on Thomas Cole, an American Romanticist*, Baltimore Museum of Art, Annual II, 1967, pp. 103–111.
6. An invaluable study for the student of American art interested in the application of typology to landscape painting is James C. Moore, *The Storm and the Harvest: the Image of Nature in Mid-Nineteenth Century American Landscape* (Ph.D. Dissertation, Indiana University, 1974). Additionally, the reader is referred to Roger B. Stein, *John Ruskin and Aesthetic Thought in America, 1840–1900* (Cambridge, Mass.: Harvard University Press, 1967).

the radiating orb of the sun emphatically more dramatic than the mountain Cole painted in 1847, the principal elements in the drawing are similar to those in the painting, which compositionally reverses them — a mountainous landscape enframing on one side a deep reaching vista, a meandering river, and in the far distance, a mountain rising precipitously above a ring of clouds.

The drawing, in turn, is based in part on the popular illustrations by the English artist John Martin for Milton's *Paradise Lost*. One of Martin's mezzotints, the scene presenting *Adam and Eve — The Morning Hymn* (fig. 11),[16] is evoked by Cole's drawing. It is well established that Cole was much influenced by Martin's work, especially in his early religious paintings, such as *The Expulsion from the Garden of Eden*.[17]

The Santa Barbara painting was left untitled in the artist's studio, which he had built especially to accommodate it and other large canvases such as *The Cross and the World*. It was not shown publicly until 1964, when it was given the present title because of its resemblance to a description in an early, undated list of subjects once drawn up by Cole. His description read: "The Meeting of the Waters. The confluence of two rivers, one a rapid & broken stream the other placid & flowing gently — in the foreground two lovers — sitting on a flowery bank." The discrepancy between the description and the painting is apparent with only the "placid & flowing gently" river represented, while no figures are visible.[18] The verses of the twenty-third Psalm quoted by Noble also seem only partially to apply: Cole has placed a great emphasis on the spatial and moral progression of the voyager. It is understandable, however, that by 1847, when he was also working on paintings like *The Cross and the World*, the artist would have modified his original idea for a picture described as *The Meeting of the Waters*, and have added to the Psalm's imagery. In the light of the content of the painting discussed here, it seems reasonable to propose that a more appropriate title might be "The River of Life" — and to stress that the work should be seen in close relation to the contemporaneous *The Cross and the World* and the earlier *The Voyage*

of Life. Understood in this perspective, *The Meeting of the Waters* or "The River of Life" appears not like the prophecy of a "Surrealist hallucination" but as a uniquely significant work by Cole. The painting, when thus considered, reveals to the viewer more about Cole and his age than it does about our own.

J. Gray Sweeney

7. In a typological system, such as Cole developed, objects retain their natural significance as they simultaneously reveal spiritual meaning. For example, another masterpiece of 1847, *Home in the Woods* (fig. 9) may be seen as alluding through the portrayal of the different generations of this pioneer family — children, mother and father, grandmother — to the archetypal theme of "the stages of life", treated by Cole earlier in *The Voyage of Life.* In a similar vein, Cole's discreet introduction, beside the cabin, of a post and beam that in a seemingly fortuitous fashion form a cross may be interpreted, when one recalls the everpresent promise of the cross in *The Cross and the World,* as implicitly denoting, in the opinion of this author, a Christian home. (See J. Gray Sweeney, *Themes in American Painting* [exhibition catalogue], Grand Rapids Art Museum, 1977, pp. 72–73. Huntington discusses *Home in the Woods* in "Church and Luminism," pp. 163–164.)
Anthropomorphic form was indispensable to Cole as a means of endowing his landscapes with a naturalistically expressive iconography in which rocks, trees, mountains, and clouds were seen as emblems of divine revelation. (See Huntington, *Art and the Excited Spirit* [exhibition catalogue], Ann Arbor, Michigan, University of Michigan Museum of Art, 1972. Also important from the perspective of European art is Robert Rosenblum, *Modern Painting and the Northern Romantic Tradition* [New York: Harper & Row, 1975].) As Allan Wallach has shown, certain features of Cole's series, *The Voyage of Life* and *The Cross and the World,* "must be considered *sui generis,* without immediate precedent in their employment of well known traditions founded in the popular emblem books of the dissenting tradition of Protestantism (*The Ideal American Artist and the Dissenting Tradition: A Study of Thomas Cole's Popular Reputation* [unpublished Ph.D. Dissertation, Columbia University, 1973], p. 184; also by the same author, "The Voyage of Life as Popular Art," *Art Bulletin* LIX [June 1977], pp. 234–241.) In a recent study on the eighteenth- and early nineteenth-century taste for "The Rude Sublime," Barbara Stafford has shown the pervasive interest in anthropomorphic forms that persist in Cole's art ("The Rude Sublime: The Taste for Nature's Colossi during the late Eighteenth and early Nineteenth Centuries," *Gazette des Beaux-Arts,* LXXXVII [Apr. 1976], pp. 113–126.) Huntington has recently referred to Cole's art as "pervasively anthropomorphic. Even the way he applies pigment to the canvas is emotionally expressive" ("Church and Luminism," p. 165; see also pp. 155ff.). Cole used anthropomorphic forms throughout his career. The author is preparing a study entitled *Natural Divinity: Homage to Cole,* which will present the anthropomorphizing nature of Cole's art.
Because of the unfinished state of *The Meeting of the Waters,* one cannot point with any certainty or assurance to the conclusive presence of

anthropomorphic forms in its landscape. Nonetheless, indications of anthropomorphic typology are suggested in the adumbration of a visage etched by the dark horizontal fissures in the rock above the opening of the cave at the far left; in the semblances of a bearded face with open mouth, above the lowest branch of the first tree and just below its second branch to the left; and in the profile of the rock from which issues a spring at the far right foreground.
8. Cole's description of *Childhood* in the series *The Voyage of Life* applies, in part, to the cave at the left side of *The Meeting of the Waters.* It reads: "A stream is seen issuing from a deep cavern, in the side of a craggy and precipitous mountain. . . . The dark cavern is emblematic of our earthly origin, and the mysterious Past. The Boat . . . images the thought, that we are born on (it) down the Stream of Life. The rosy light of the morning, the luxuriant flowers and plants, are emblems of the joyousness of early life. The close banks and limited scope of the scene, indicate the narrow experience of Childhood, and nature of its pleasures and desires. The Egyptian Lotus in the foreground of the picture is symbolical of Human Life. Joyousness and wonder are the characteristic emotions of childhood." *Memorial Exhibition,* 1848, p. 6.
9. Huntington, *Art and the Excited Spirit,* pp. 12–15; see also footnote 7.
10. J. B. Waterbury in *The Voyage of Life Suggested by Cole's Celebrated Series* (Boston: Sabbath School Society, 1852), p. 13, calls the vessel a "fairy shallop." Discussing the nature of Cole's boat he states: "The fairy shallop is stranded on the flowery bank of its headwaters. How many have I seen coffined at this early age! How many soft eyelids have been closed forever over their once beautiful orbs: and the marble brow, so still to the sight, so cold to the touch, has told me that the voyage was ended almost as soon as it began!"
11. Cole describes the sea in which the aged voyager ends his journey in *The Voyage of Life* as "a vast and midnight Ocean. . . . The stream of life has now reached the Ocean, to which all life is tending. The world, to Old Age, is destitute of interest. There is no longer any green thing upon it. . . . The chains of corporeal existence are falling away; and already the mind has glimpses of Immortal Life." *Catalogue of Pictures* (exhibition catalogue, not dated, of *The Voyage of Life* and other pictures at the National Academy of Design).
12. The central question of personal immortality must have been very much on Cole's mind while he was painting *The Cross and the World* and *The Meeting of the Waters.* On April 6, 1846, Cole wrote: "'The Lord gave, and the Lord hath taken away.' Our infant daughter died yesterday afternoon. Its pilgrimage in this world has been short and sinless. God, in His great mercy, has taken it unto himself before the world could defile its spiritual garments." In September 1847 Cole visited

Niagara but found it wanting in sublimity. In a key passage that denotes not only his deepening religiosity as he completed the series *The Cross and the World,* but also his interest in luminous light such as found in *The Meeting of the Waters,* he wrote: "Not in action, but in deep repose, is the loftiest element of the sublime. With action waste and ultimate exhaustion are associated. In the pure blue sky is the highest sublime. There is the illimitable. When the soul essays to wing its flight into that awful profound, it returns tremblingly to its earthly rest. All is deep, unbroken repose up there — voiceless, motionless, without colours, light and shadows, and ever-changing draperies of the lower earth. There we look into the uncurtained, solemn serene — into the eternal, the infinite — toward the throne of the Almighty." Quoted in Louis Legrand Noble, *The Life and Works of Thomas Cole,* ed. Elliot S. Vesell (Cambridge, Mass.: Harvard University Press, 1964), pp. 281–282.
13. For a discussion of the sublime mountain and its meaning, the reader is referred to Marjorie Hope Nicholson's *Mountain Gloom and Mountain Glory* (Cornell University Press, 1959; reprint, W. W. Norton, Co., 1963). See also Samuel H. Monk, *The Sublime* (Ann Arbor: The University of Michigan Press, 1960).
14. Noble, p. 305.
15. Gerdts, p. 108.
16. John Martin, *Adam and Eve — The Morning Hymn,* mezzotint, illustration to John Milton, *Paradise Lost,* Book V, line 136 (London: Septimus Prowett, 1825).
17. Parry, pp. 14–20. This is an important discussion of Cole's practice of painting works in pairs, and his relationship to Martin.
18. Howard S. Merritt, "Thomas Cole's list 'Subjects for Pictures,'" in *Studies on Thomas Cole, an American Romanticist,* The Baltimore Museum of Art, Annual II, 1967, p. 99.

Exhibitions

N.Y., Kennedy Galleries, *An exhibition of paintings by Thomas Cole N.A. from the artist's studio, Catskill, New York,* Nov. 24–through Dec. 1964, p. 3, repr. cover.

N.Y., Memorial Art Gallery of the University of Rochester, *Thomas Cole* (catalogue by Howard S. Merritt), Feb. 14–March 23, 1969, no. 46, p. 37, repr. p. 95; traveled Utica, Munson-Williams-Proctor Institute, Apr. 7–May 4, 1969, Albany Institute of History and Art, May 9–June 20, 1969, Whitney Museum of American Art, June 30–Sept. 1, 1969.

References

Howard S. Merritt, "Studies on Thomas Cole, An American Romanticist," *Annual* II (1967), The Baltimore Museum of Art, p. 99, no. 119.

Katherine Mead, "Recent Acquisition," SBMA *Calendar,* June 1979, repr., n.p.

"Sweeney Opens CAS Series with Talk on Cole Painting," *Grand Valley Forum* (Grand Valley State Colleges), Nov. 12, 1979, repr., n.p.

SBMA, "Acquisitions of 1979," *Annual Report 1979,* p. 17, repr. p. 19.

Jasper Francis Cropsey
1823-1900

Jasper F. Cropsey, known primarily for his landscape paintings, initially trained as an architect. In 1837 at the age of thirteen, his skill as a draftsman earned him a diploma from the Mechanics Institute in New York and led to an apprenticeship with the New York architect Joseph Trench. Cropsey also began painting at an early age, and in 1844 the acceptance of one of his landscapes by the National Academy of Design secured his election as an Associate of the Academy and his reputation as an artist. Although his landscapes had prompted the encouragement of several established artists, including William Sidney Mount and Henry Inman, it was not until 1847 that Cropsey gave up architecture in order to devote his energies to painting.

His early paintings reflect the concerns of the Hudson River artists. Following the example of Asher B. Durand (1796–1886), Cropsey looked at nature with an exacting eye. His attitudes toward nature are recorded in several essays, such as "Natural Art," prepared for the Art Union in 1845, and his reverence for nature parallels the transcendental philosophy of the essayist Ralph Waldo Emerson.[1] Raw nature is seen as a worthy subject for the artist without need of conventional idealization. This fidelity to the natural scenery won for Cropsey the favor of the American critics prior to his first trip abroad in 1847.

After his marriage to Maria Cooley in 1847, the artist and his wife embarked on a two-year tour of Europe, which allowed for sketching excursions to Barbizon and Fontainebleau, and long stays in London and Rome. In Rome he occupied the Via del Babuino studio previously used by Thomas Cole. Although Cropsey had been cautioned before his departure for Europe not to compromise his style with European elements, works such as *Italian Campagna with the Claudian Aqueduct* (1848)[2] record his emotional response to the historic scenery of the Roman countryside and to the ideal landscapes of Claude Lorraine.

Cropsey's residence in London strengthened his early fondness for watercolors. His association with the English artist Edward Maury, with whom he studied during his years as apprentice to Joseph Trench, had introduced him to watercolor, a medium that proved important to his stylistic development. Maury, as representative of English artistic taste, used the watercolor sketch as a work of art in its own right. This attitude colored Cropsey's approach to painting, and his mastery of the watercolor medium is seen in works such as the marvelous *Hudson River near Hastings* (1886).[3] He continued to use watercolor throughout his career, and in 1867 he helped found the American Watercolor Society.

Upon their return to the United States in late 1849, the Cropseys settled in New York City, where they remained until 1856. During this second American period, despite Cropsey's continued verbal advocacy of pure nature as subject matter for painting, his landscapes varied between realistic transcriptions of local scenery and more romantic images dependent on the works of Thomas Cole. Such vacillation was not atypical of the Hudson River School at this time. During the early 1850s, probably in response to European models and again the example of Cole, Cropsey produced a number of allegorical paintings, such as the *Millennial Age* (1854).[4]

Returning to England in 1856, Cropsey installed his family at Kensington Gate, London, and established a circle of acquaintances that included, among others, the artists John Linnell and John Brett; Sir Charles Eastlake, the director of the National Gallery; Lord Lyndhurst, the son of John Singleton Copley; and most importantly, John Ruskin.[5] Ruskin's ideas, popularized in America through the *Crayon*, stressed fidelity to nature and appealed to Cropsey, as did the detailed approach of the Pre-Raphaelites. In turn, Cropsey's direct representations of the scenery of North America were of immediate interest to Victorian London, especially his autumnal scenes, which satisfied the current taste,

11 Janetta Falls, Passaic County, New Jersey

1846
Oil on canvas
22¼ (at highest point) x 18¾ in. (56.5 x 46.6 cm)
Signed and dated l.l.: J. F. Cropsey/Aug 9, 1846
Inscribed by the artist on reverse (fig. a): J M Falconer Esq/with Comp^mts/of the Artist./April 23rd 1847
Gift of Mrs. Sterling Morton
60.55

fig. a Jasper Francis Cropsey, *Janetta Falls, Passaic County, New Jersey*, detail of reverse. Preston Morton Collection, Santa Barbara Museum of Art.

Provenance

John M. Falconer, Brooklyn, N.Y., 1847; (John Falconer sale, Anderson Auction Company, N.Y., April 28, 1904, no. 432); (Gustav Klimann, Boston, by 1958); (purchased from Klimann by Vose Galleries, Boston, 1958); purchased from Vose by Mrs. Sterling Morton for the PMC, 1960.

Condition and Technique

In 1978 examination by the BACC noted extra tacking holes indicating the painting had been restretched after the priming layer was applied. The support had been retacked to a complex strainer shaped to fit the arched top and the margins were frayed. The painting had suffered losses around the edges, especially bottom l. with cleavage between the ground and fabric. The surface coating, a thin layer of natural resin varnish with a possible admixture of oil, had yellowed slightly and was grimy.

In 1980 the painting was treated by the BACC. The surface grime was removed with Calgon, 1.5% in water, followed by Benzine B264. The desic-

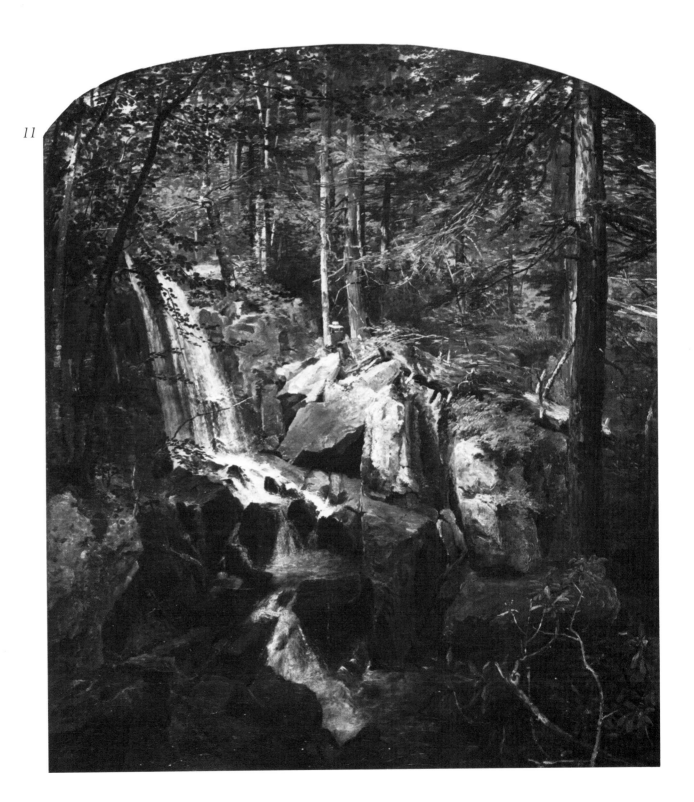

11

established by the Pre-Raphaelites, for a vibrant color scheme. Cropsey exhibited at the British Institute and the Royal Academy, winning special acclaim for his great *Autumn on the Hudson River* (1860).[6] This period proved the most successful yet in Cropsey's career, and public recognition reached its peak with his presentation to Queen Victoria in 1861.

Two years later the artist returned permanently to the United States, and became involved with the new tonal or luminist approach of the Hudson River School. During the next fifteen years Cropsey produced some of his finest paintings in this luminist mode. Examples such as *Shad Fishing on the Hudson* (1874)[7] exhibit a warm golden light reminiscent of the marine scenes of the Dutch artists of the seventeenth century.[7] At this time also he returned to his earlier vocation, accepting architectural commissions to supplement his painting. His best-known designs, for the Queen Anne-style Sixth Avenue Elevated Railroad Station in New York City, date from 1876.

Although during the last quarter of the century other leading American landscapists turned to the Barbizon style for a fresh approach to nature, Cropsey was content to rely on tried solutions to create a balance between the ideal landscape and the veracity of local scenery. Consequently his paintings were seen as outmoded, and his reputation declined before his death at Hastings-on-Hudson in 1900.

Lynn Federle Orr

Notes

1. William Talbot, *Jasper F. Cropsey 1823–1900* (exhibition catalogue), National Collection of Fine Arts, Smithsonian Institution, Washington, D.C., 1970, p. 17.
2. Collection: Brown Reinhardt, Newark, Delaware; Talbot, fig. 3, p. 21.
3. Collection: Mrs. John C. Newington; John Howat, *The Hudson River and Its Painters* (New York: Viking Press, 1972), Pl. 19.
4. Collection: Mrs. John C. Newington; Talbot, no. 19, repr. p. 76.
5. Talbot, p. 30.
6. National Gallery of Art; Talbot, no. 35, repr. p. 86.
7. Private collection; Howat, Pl. 10.

In 1980 the painting was treated by the BACC. The surface grime was removed with Calgon, 1.5% in water, followed by Benzine B264. The original fabric was desiccated and brittle. A new lining fabric of linen was then stretched and keyed out, and a layer of Rhoplex AC234 applied and sanded, followed by a second application of same, also sanded. PVA heat-seal adhesive was next applied and sanded and the operation repeated a second time. The painting was lined on a vacuum hot table, maximum surface temperature 140°, with vacuum pressure about 3½" Hg. The painting was restretched on the original rounded top stretcher and its edges set down with Ross wax. It was then keyed with four new keys made to replace the old ones. Flaking areas of paint around the edges were consolidated with Ross wax. After excess wax was removed from the surface, a brush coat of Soluvar 1:1 in benzine was applied and losses were filled in with gesso putty, consisting of gelatin, 1:10 in water, and calcium carbonate. Losses from flaking in l.l. corner were inpainted with dry pigments hand ground in Acryloid B72. Finally the painting was sprayed with a coat of B72, 10% in xylene.

The support is a fine linen. The ground is a cream-colored type applied in a thin, even layer and is covered with a priming layer of a brown oil type. The design layer consists of an oil-type paint ranging from thin glazes that allow the brown priming to show through as in the pools and boulders, to a thicker layer with moderate impasto in the waterfall and foliage.

Janetta Falls, Passaic County, New Jersey

Janetta Falls brings the viewer face to face with primeval American nature. We are taken deep into a forest, dense with trees and rocky obstacles, yet penetrated by a sunlight that gives vibrant life to the woods and to the water tumbling over a stony outcrop. Trees are distinct in bark and leaf, the rocks massively piled but detailed with clear contours and sharp edges.

In the very heart of this untouched and tangled forest an artist is working atop some boulders. He is sketching directly from nature, a practice central to the artistic philosophy of early nineteenth-century American landscape painters. In 1845 Cropsey himself wrote in "Natural Art," a short essay for the American Art Union, that the greatest works of art were produced by artists most attentive to nature.[1] In a letter to his future wife written less than four months after painting *Janetta Falls,* Cropsey criticized a painting by Asher B. Durand for being too general in its treatment of nature.

There are weeds painted but no particular kind, and so there are tree trunks and foliage and with but one or two instances as exceptions, no particular kind. It is a picture of general truths as our critics call it (which means no truths) — setting nature and her laws at defiance.[2]

A larger version of the Santa Barbara painting was exhibited at the American Art Union in 1847 as no. 2.[3] A reviewer in the *Literary World* called it a faithful transcript from nature and said:

We consider the rock painting in this picture far superior to anything of the kind in the gallery and almost equal to the best we have ever seen. Most of our landscape painters have a conventional manner of painting rocks, which they would find to be utterly false if they would study them as Mr. Cropsey has done these, direct from nature.[4]

An inscribed, precise date such as found in the Santa Barbara painting is rare in Cropsey's early oils, usually small-scale nature studies. It testifies that on a particular day the artist recorded this specific scene at first hand.[5] The Santa Barbara painting appeared in the 1858 annual exhibition of the National Academy of Design, no. 386, with the title *Janetta Falls, Passaic County, New Jersey.* Despite this apparently precise location, Janetta Falls cannot be found, nor is it known to the Passaic County Historical Society.[6] It is most likely a spot somewhere near the southern end of Greenwood Lake in New Jersey where the family of Isaac Cooley lived. Cropsey was wooing Maria Cooley at this time, and her father favored the match enough to offer him a permanent "painting room" at the lake by late 1845.

At the time it was exhibited in 1858, the *Crayon* briefly noted that "Cropsey is scarcely represented this season, — two small works — one Janetta Falls, an admirable study — being the only warrant for the mention of his name."[7] In *The Home Journal* the picture was thought "a fine specimen of close observation and faithful workmanship. It is one of the few very finely executed pictures of the exhibition".[8]

Cropsey's vigorous brushwork was a legacy from Thomas Cole, his close attention to details of nature the credo of his generation, the second to devote itself to native American landscape. John Kensett, Worthington Whittredge, Sanford Gifford, and George Inness were some of Cropsey's contemporaries. Each developed a distinctive mature style, but about mid-century they all tramped the forested mountains and valleys of America seeking spiritual and intellectual inspiration from nature's "exhaustless mine."[9] Untouched American nature was close to the Creation and its complexity, impressive grandeur, and potential for the young nation had moral and spiritual overtones keenly appreciated by the artists.

Cropsey's paintings of the 1860s and 1870s remained devoted to natural detail but became more panoramic in scope with autumn colors prominent, though there are a number of cool luminist landscapes also. In general a more distant vision using more yellow and red replaced the earlier predominantly brown and green, close-range views of nature of which the Santa Barbara picture is one of the finest examples.

The inscription on the back of the canvas indicates that Cropsey presented the painting to J. M. Falconer a few days before the artist was honored on April 27, 1847, at a private dinner by a group of friends including Falconer. The affair marked Cropsey's imminent departure for England, which took place in mid-May. When exhibited in 1858 the picture was loaned by Falconer. It later appeared in the 1904 sale of the Falconer collection "in massive round top gilt frame. . . ." John Falconer (1820–1903) was a fellow painter and dealer who did portraits, landscapes, and genre, working also in enamels, etchings, and watercolors. He was a close friend of our artist and corresponded with

Cropsey while he was in Rome during 1848.[10] Falconer's letters are full of news, gossip, and some rather detailed admonitions on painting. Falconer commented on the pictures Cropsey had sent back to America for sale, praising detail from nature, scolding any sacrifice of naturalism for pictorial effect, and lamenting poor figure drawing. Falconer mentioned efforts to sell Cropsey pictures sent from Rome and various successes.

Falconer's remarks range from comments on Cropsey's acquisition of studio props to possible landscape series on Epochs of Christianity and Religious Rites in Britain. In the sale of the Falconer collection in 1904 there were no fewer than fifteen oils and five watercolors by Cropsey dating from 1845 to 1865, yet there are no sales to Falconer recorded in Cropsey's accounts from 1845 to 1868. Falconer loaned at least four Cropsey paintings to exhibitions at the National Academy of Design (1850, 1858, 1860, 1873), in two cases while Cropsey was abroad from 1847 to 1849, and from 1856 to 1863, and three of these exhibited pictures remained in Falconer's collection until his death, some indication of his regard for our painter.

It seems most likely that the Falconer pictures were gifts or payments in kind for Falconer's services as a dealer. *Janetta Falls* is just the sort of fresh nature study highly prized by Falconer for the naturalism that was central to American landscape painting at mid-century.

William S. Talbot

Notes

1. The manuscript for "Natural Art" is in the collection of Cropsey descendants in Newark, Delaware. A typescript of the article is in the Print Room of the Museum of Fine Arts, Boston.
2. Letter to Maria, November 12, 1846, among Cropsey's papers in his studio at Hastings-on-Hudson, N.Y.
3. 62½ x 48¼ in., not signed or dated, The Baltimore Museum of Art.
4. *Literary World*, October 23, 1847.
5. Two drawings in the Cropsey studio at Hastings-on-Hudson mentioned in the 1970 Cropsey exhibition catalogue (see Exhibitions, The Cleveland Museum of Art) and in Talbot (1977) (see References), as related to the SBMA painting were cited in error. The drawings are of similar subject matter but not preliminary to the painting here catalogued.
6. Howard S. Merritt, "19th Century American Landscape Paintings," *The Baltimore Museum of Art News*, XXV, no. 2 (Winter 1962), p. 12.
7. *Crayon*, V, part v (May 1858), p. 147.
8. *The Home Journal*, May 8, 1858.
9. Thomas Cole, "Essay on American Scenery," 1836, in *American Art 1700–1960*, ed. John McCoubrey (Englewood Cliffs, N.J.: Prentice-Hall, 1965), p. 99.
10. The four letters from Falconer to Cropsey are in the studio at Hastings-on-Hudson and are dated February 24, September 4, October 3, and October 29, 1848.

Exhibitions

N.Y., National Academy of Design, *Annual Exhibition*, 1858, no. 386 (loaned by J. M. Falconer).
SBMA, *Two Hundred Years*, 1961, no. 24, repr., mentioned "Introduction," n.p.
Bloomington, Indiana University Art Museum, *The American Scene 1820–1900*, Jan. 18–Feb. 28, 1970, no. 30, p. 23.
The Cleveland Museum of Art, *Jasper F. Cropsey 1823–1900*, July 8–Aug. 16, 1970, no. 4, pp. 66–67, p. 17; traveled Utica, Munson-Williams-Proctor Institute, Sept. 14–Oct. 25, 1970, Washington, D.C., National Collection of Fine Arts, Smithsonian Institution, Nov. 23, 1970–Jan. 3, 1971.

References

"Sketchings: Exhibition of the National Academy of Design," *Crayon*, V, part v (May 1858), p. 147.
The Home Journal, May 8, 1858.
Catalogue of the Interesting and Valuable Collection of Oil Paintings, Water-Colors and Engravings formed by the late John M. Falconer, Brooklyn, N.Y., Anderson Auction Company, N.Y., 1904, no. 432.
Howard S. Merritt, "19th Century American Landscape Paintings," *The Baltimore Museum of Art News*, XXV, no. 2 (Winter 1962), pp. 14–15, repr. p. 13, fig. 9.
William S. Talbot, *Jasper F. Cropsey 1823–1900* (New York: Garland Publishing, Inc., 1977), pp. 34, 290, 337–38, 542, fig. 16.

John Frederick Kensett
1816-1872

John Frederick Kensett was one of the artists most beloved by his colleagues. His death in 1872 was widely lamented, and his great popularity indicated by the large sums paid for paintings included in the sale of the contents of his studio. Yet Kensett's beginnings were inconspicuous. He was born in Cheshire, Connecticut, the son of an immigrant English engraver. He learned to draw and engrave in his father's New Haven shop, and the influence of printmaking left an indelible impression on the artist. His paintings were noted for their detail and fidelity to fact. Kensett determined to become a painter when he successfully exhibited a painting at the National Academy of Design in 1838.

Kensett's opportunity came when he was able to join three other artists — Thomas P. Rossiter, John Casilear, and Asher B. Durand — in a grand tour of Europe. Kensett remained in Europe from 1840 to 1845, and the experience was transforming. He gave up engraving for painting, and his works showed the influence of Claude Lorraine and Thomas Cole. Unlike Cole, however, Kensett eschewed ideal compositions, history, and narrative; instead his topographically accurate views painted in a restricted palette are in contrast to the grandiose scenic panoramas of Bierstadt or Church. A tireless worker praised for his devotion to the easel, he was also a prolific painter who received steady patronage with compositions that included woodland interiors and many marines. Today he is properly regarded as one of the most interesting artists of the Hudson River School in its luminist phase. Kensett died unexpectedly of heart failure after contracting pneumonia while trying to save the drowning wife of the painter Vincent Colyer at Darien, Connecticut.

J. Gray Sweeney

View of the Beach at Beverly, Massachusetts
(See color reproduction, page 37)

John Frederick Kensett's *View of the Beach at Beverly, Massachusetts* (1860), one of the artist's finest marines, epitomizes the style and sentiment of Luminism. It represents the popular resort beach near the famous village of Salem. The seashore was one of the artist's favorite subjects, and Kensett is best known for his many marines painted around Newport, Rhode Island. The exhibition *American Light,* held in 1980 at the National Gallery of Art, featured Kensett's work as one of the major figures in the mid-nineteenth-century movement art historians of the twentieth century have termed Luminism.[1] One characteristic of Kensett's art is his concern with the nature of American light and his treatment of distinctively American subjects. Kensett handled the American landscape with great simplicity and with a severe naturalism, avoiding any flights of fancy or uncharacteristic, idealized effects like those of Cole's *The Meeting of the Waters.* In the self-effacement of the artist from the scene represented, in the contemplative mood the paintings evoke in the spectator, and in the transcendental implications of the all-suffusing light, Kensett's work is seen today as a classic example of the luminist mode.[2]

Kensett, like many American artists of his period, entered into landscape painting through engraving, and consequently, his paintings express a meticulous attention to detail and finish. Kensett was noted for his careful observation, and it was said that his

12 View of the Beach at Beverly, Massachusetts

1860
Oil on canvas
14¼ x 24¼ in. (48.8 x 61.6 cm)
Signed and dated l.r.: JFK '60
Gift of Mrs. Sterling Morton
60.68

Provenance

(American Art Galleries, Apr. 12, 1923?);[1] (Victor D. Spark, N.Y., by 1960); purchased from Spark by Mrs. Sterling Morton for the PMC, 1960.

1. An undated memorandum, probably from the time of the purchase, from Victor Spark notes: "There was a picture of Kensett of Beverly Beach — same size and title — sold at the American Art Galleries on April 12, 1923. I believe it must be this picture."

Condition

In 1977 examination by the LACMA Conservation Center noted that the painting was structurally stable with slight drawing at the corners and minor distortions in the canvas plane. The rabbet edges were generally repainted, and there was scattered spot retouching across the sky. The surface was coated with a moderately to heavily yellowed natural resin varnish.

In 1977 the painting was treated by the LACMA Conservation Center. The canvas was keyed-out slightly to reduce distortion of the surface plane. The surface was cleaned with tergitol and rinsed with water. The discolored varnish was removed with acetone without any solubility problems. Retouching was readily removed with the varnish. Some of the harder repainting and discoloration was removed from the edges using DMF. The surface was revarnished with an isolating layer of Acryloid B72 in toluene with 10% cellosolve. Inpainting was done with acrylic Magna colors. Although the raw rabbet edges required extensive inpainting, the painting is in generally excellent condition. The painting was given a final surface coating of Acryloid B72.

landscapes would please a scientist because of the verisimilitude with which they captured the particular traits of a place. A traveler, it was asserted, would recognize Kensett's localities at a glance. "But his fidelity to detail is but a single element of his success," wrote Henry T. Tuckerman in *The Book of the Artists* (1867). "His best pictures exhibit a rare purity of feeling, an accuracy and delicacy, and especially a harmonious treatment, perfectly adapted to the subject."[3] Kensett's emphasis on technique, however, was not merely a means of imitating nature but also of interpreting her, which, according to Tuckerman was, ". . . the most legitimate and holy task of the scenic limner."[4]

Tuckerman noted approvingly that Kensett's paintings with their devotion to local truth define the diversities of the New England coast: "We all feel that Newport scenery — even that of the sea — so apparently monotonous, differs from that of Beverly and its vicinage, but it would be hard to point out the individualities of the two; Kensett does it with his faithful and genial pencil."[5] *View of the Beach at Beverly* is a fine illustration of Kensett's fascination with the specific and the familiar revealed with truthfulness and a luminous clarity. The painter depicts this area of the coast bathed in clear sunlight with great simplicity and with a heightened awareness of its beauty. Truth to nature is evident in minute rendering of the observable, but Kensett subtly selects and manipulates elements of the scene. The presence of the artist's hand, his touch, is virtually eliminated. The perfection of the paint surface, almost like glass, serves to heighten the spectator's awareness of the topographical veracity of the view. The organization of space is controlled through the measured recession of parallel planes. The small accessory figures are far enough away that their presence in no way obtrudes on the quietness of the scene — indeed, they provide a human scale against which the panoramic breadth of the painting is emphasized. Kensett renders the scene with a clarifying light, almost as if the artist had viewed nature through Emerson's "transparent eye-ball."[6] Light is the medium through which the ordinary and the familiar are revealed — manifestations, as Barbara Novak has stressed, of the divinity of nature.[7]

Kensett's discreet placement in the right foreground of two pieces of driftwood that overlap to form a cross may likewise be interpreted as providing a sign, albeit unobtrusive, of the immanence of the divinity in this simple beach scene.[8] Cole had used in similar fashion a modest and seemingly fortuitously constructed cross in *Home in the Woods* (ca. 1846, Reynolda House, Inc.).[9] In keeping with his vision of the world, Kensett avoids any unnatural or strained symbolical effect. The driftwood cross takes its place on the beach as naturally as does the boat or the man with the oar.

Kensett imbues this seemingly unexceptional scene with a quiet but unforgettable beauty. As Tuckerman asserted, Kensett's greatness resulted from his "Never invoking the assistance of a great or sensational subject, but sedulously seeking for the simplest material, he has by his skill and feeling as a painter, taught us the beauty and poetry of subjects that have been called meager and devoid of interest."[10]

J. Gray Sweeney

Notes

1. *American Light: The Luminist Movement, 1850–1875* (exhibition catalogue, ed. John Wilmerding), National Gallery of Art, Washington, D.C., 1980. In the exhibition an entire gallery was devoted to the work of Kensett.
2. John I. H. Baur was the first historian of American art to recognize the qualities of Kensett's work as luminist in his pioneering article of 1947, "Trends in American Painting, 1815 to 1865," in *M. and M. Karolik Collection of American Painting, 1815 to 1865* (Cambridge, Mass.: Harvard University Press for The Museum of Fine Arts, Boston, 1949, XV–LVII). Subsequently, Barbara Novak in her study *American Painting of the Nineteenth Century: Realism, Idealism, and the American Experience* (New York: Praeger, 1969) extended these insights. As David Huntington observes in "Church and Luminism: Light for America's Elect," *American Light*, p. 155: ". . . from the vantage point of the present a luminist sensibility would seem to fit transcendentalism with almost elegant precision." In his "Introduction" to *American Light*, John Wilmerding provides an historiographical survey of the development of the term "Luminism" in recent scholarship.
3. *The Book of the Artists* (New York, 1867, reprinted by James F. Carr, 1966), p. 511. It is important to note that Tuckerman does not refer to Kensett as a "luminist"; indeed he does not use the term to designate any of the landscape painters he presents.
4. Tuckerman, p. 512.
5. Tuckerman, p. 514.
6. See Novak, *American Painting*, 1969, passim. See also Novak's recent study *Nature and Culture: American Landscape and Painting, 1825–1875*, (New York: Oxford, 1980), especially chapters II and III.
7. Novak, *Nature and Culture*, passim.
8. See J. Gray Sweeney, *Themes in American Painting* (exhibition catalogue), Grand Rapids Art Museum, Michigan, pp. 73–74; see also Huntington, "Church and Luminism," pp. 163–164, fig. 198.
9. Kensett was certainly aware of and influenced by the paintings of Thomas Cole, especially by his last series, *The Cross and The World*. These five paintings had created a sensation in the artistic community when they were first exhibited in 1848 at the American Art Union's *Memorial* to Cole. Kensett is known to have painted a *Reminiscence of Cole*, and perhaps not coincidentally three paintings from *The Cross and the World* were exhibited in 1874 at the Metropolitan Museum of Art's memorial to Kensett, *The Last Summer's Work* (for Cole paintings, see cat. no. 10, figs. 5–7).
10. Tuckerman, p. 512.

Exhibitions

SBMA, *Two Hundred Years*, no. 44, repr., mentioned "Introduction," n.p.

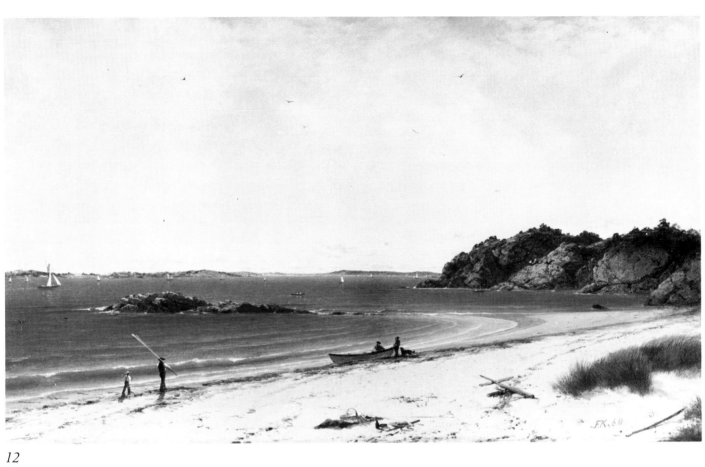

12

Thomas Worthington Whittredge
1820-1910

Thomas Worthington Whittredge, after leaving the family farm near Springfield, Ohio, arrived in Cincinnati in 1837 to become a house painter as the apprentice of his brother-in-law. This occupation was soon put aside for portrait painting and then landscape. In 1846 Whittredge submitted his first entry to the National Academy of Design, *View on the Kanawha, Morning*, which prompted the encouragement of Asher B. Durand, then President of the Academy, whose own landscape paintings would later play a determining role in Whittredge's stylistic development. Within the next few years Whittredge established his reputation as a landscapist in Cincinnati and secured enough commissions in advance to partially finance a trip to Europe in 1849.

Like other of his artistic contemporaries Whittredge went to Europe to experience European culture and its artistic heritage and to improve the technical foundation of his style. As Anthony Janson has pointed out, the active but provincial nature of Cincinnati's artistic community had limited Whittredge's early development.[1] Once in Europe, his exposure to a wide range of solutions for the staging and transcription of landscape helped Whittredge to progress quickly beyond the level of "competent craftsmanship" that had characterized his earliest paintings.

Whittredge stopped only briefly in Paris in 1849, and then went on to Düsseldorf, which he found better suited to his nature and purpose. During his seven-year stay in Düsseldorf, many foreign artists, including Americans such as Emmanuel Leutze (1816–1868) and Eastman Johnson (1824–1906), resided in the city, creating a truly international artistic atmosphere. In the Romanticism popular in Düsseldorf at the time, Whittredge found an approach similar to that which had attracted him to the paintings of Thomas Cole. Although he never actually attended the Düsseldorf Academy, he quickly absorbed some of its formal elements, which included a dramatic staging of the composition coupled with realistic details in the foreground.[2] Stylistically he aligned himself first with Andreas Achenbach (1815–1910) and then with Johann Wilhelm Schirmer (1807–1863), a leading exponent of the romantic landscape, whom he probably met through Leutze's friend, Karl Friedrich Lessing (1808–1880). Later in his autobiography, Whittredge suggested that his own protracted stay abroad had compromised the distinctly American character of his art and proved detrimental to his stylistic development.[3] Examination of the works produced by him in Düsseldorf and then in Rome, where he stayed from 1854 to 1857, reveals, however, that the basic tenets of the European landscape tradition were successfully assimilated into his personal style. Although Whittredge later rejected the romantic attitude toward nature, he continued to profit from the fundamentals of technique and composition that he had learned in Europe.

After his return to the United States in 1859, Whittredge's individual development mirrored the changes in the style of the Hudson River School as a whole. The paintings done shortly after his return respond to a new American aesthetic, epitomized by the poetry of William Cullen Bryant and the paintings of Asher B. Durand. This approach, based on a "national mythology which posits that nature determines America's character," affirmed nature's role as the teacher of moral truths.[4] During the 1850s Durand's landscapes became increasingly naturalistic in their construction and detail. In their use of a *plein air* approach his finished paintings, as well as his sketches, are characterized by a novel objectivity. After the example of Durand, Whittredge also turned away from the formulae of the ideal landscape and focused on the actual woodland scenery of the Eastern mountains and forests. In works such as *The Old Hunting Ground* (ca. 1864, Reynolda House), he found a specifically American form of expression that combined faithful

13 Scene on the Upper Delaware: State of New York, Autumn[1]

1876
Oil on canvas
17 x 23 in. (43.2 x 58.4 cm)
Signed l.r.: W. Whittredge
Not dated
Gift of Norman Hirschl
60.87

1. Formerly affixed to the stretcher, now lost but recorded, was a label in the artist's hand that read: Scene on the Upper Delaware/State of New York Autumn/Painted by W. Whittredge

Provenance

Early history unknown; (Terry DeLapp, Los Angeles); purchased from DeLapp by Norman Hirschl; from Norman Hirschl to the PMC, 1960.

Condition and Technique

In 1978 examination by the BACC noted the painting had been lined with an aqueous glue to a plain weave linen and the original tacking margins removed. The lining had crushed the brushmarkings in the clouds and foreground bottom l. The rabbet had caused slight abrasion along the r. and bottom r. edge. There was a small diagonal scratch c.l., and various small scuffs. The surface coating was a moderately thin, natural resin spirit varnish. The overall condition was secure.

The support, a moderately light-weight, tightly woven, plain-weave linen, is covered with a moderately thin, white ground that does not completely obscure the fabric texture. The paint, an oil-type, vehicular paste, ranges from thin smooth layers and slight scumbles to slight brushmarking in the clouds and bottom l. foreground. The fabric texture is apparent throughout the paint layers.

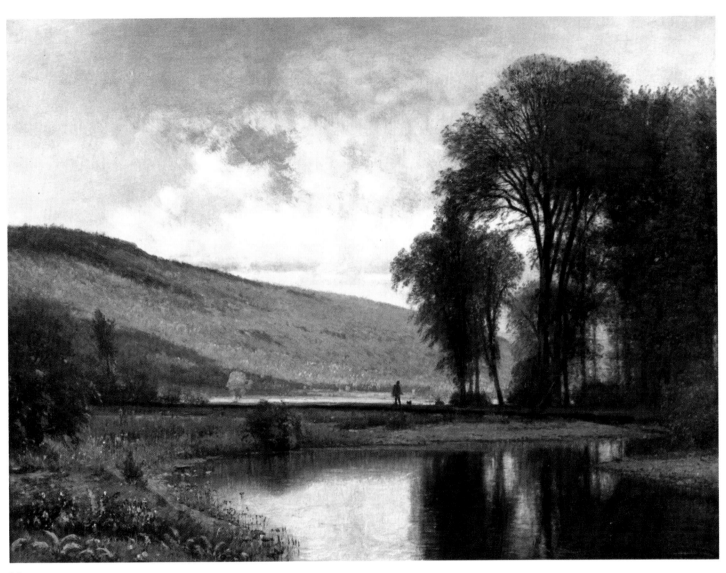

13

representation of the natural setting with personal sentiment.[5]

To impart his landscapes with a reflective mood, Whittredge became increasingly involved with what has subsequently been termed Luminism, a tendency in American painting that developed during the 1840s and 1850s. Whittredge's interest in this movement seems to coincide with his renewed friendship with Sanford Gifford.[6] Gifford and Albert Bierstadt (1830–1902) had been in Rome with Whittredge in 1856–1857. Together they had explored the Roman Campagna and painted pastoral landscapes in the style of Claude Lorraine. The works of Whittredge of that period, such as *Aqueducts of the Campagna* (1859, Cincinnati Art Museum), in their expansiveness and subtle nuances of color, light, and atmosphere, appear to look ahead to the paintings of his luminist phase.[7] Paintings such as *Indians Crossing the Platte* (1867, private collection) maintain the basic compositional format of the ideal landscapes of Whittredge's Roman period, now adapted to the American context.[8] The pervasive sentiment, created by the fading glow of the afternoon light, links this work to European depictions of Arcadia. However, at the same time the painting demonstrates a self-effacing approach that suppresses brushstrokes and details and a pronounced stratification of the landscape into flat elements arranged parallel to the pictorial surface, characteristic of American luminist art.

In 1866 Whittredge toured the Missouri Territory with General John Pope, and this experience signaled another shift in the artist's style. In numerous works over the next decade, Whittredge recorded his response to the expansive scenery of the American West. His approach became more direct, and he generally dispensed with the associations he had earlier imposed upon nature. The comparison between *Indians Crossing the Platte* (1867) and *Crossing the Ford* (1868–1879, Century Association, New York)[9] made by Janson illustrates this shift in the artist's interests.[10] Although the compositions are almost identical, in the later work the natural details are more accurately defined, while the brushstrokes are much freer; the much blonder colors, moreover, serve to dispel the earlier pensive quality.

By the mid-1870s Whittredge became completely detached from the luminist style. In his later works he, like many of his fellow Hudson River artists, turned to the Barbizon approach to the landscape. The various phases of Whittredge's oeuvre reflect in part the artist's search for stylistic modes suited to the changing attitudes toward nature in nineteenth-century America.

Lynn Federle Orr

Notes

1. Anthony Janson, "Worthington Whittredge: Two Early Landscapes," *Bulletin of the Detroit Institute of Arts,* LV, no. 4 (Winter 1977), p. 200.
2. Janson, p. 205.
3. Thomas W. Whittredge, *The Autobiography of Worthington Whittredge, 1820–1910,* ed. John Baur (New York: Arno Press, 1969), p. 33.
4. Janson, "Worthington Whittredge: The Development of a Hudson River Painter, 1860–1868," *The American Art Journal,* XI, no. 2 (Apr. 1979), p. 77.
5. Janson, "Development," fig. 5, p. 76; pp. 74, 77.
6. Janson, "Development," p. 80.
7. Janson, "The Western Landscapes of Worthington Whittredge," *American Art Review,* III, no. 6 (Nov.–Dec. 1976), repr. p. 61.
8. Janson, "Western Landscapes," repr. p. 59.
9. Janson, "Western Landscapes," repr. p. 59.
10. Janson, "Western Landscapes," p. 64.

Scene on the Upper Delaware: State of New York, Autumn

As a member of the Hudson River School, Worthington Whittredge mainly depicted the Catskills, although Newport and Colorado also figure prominently in his oeuvre.[1] *Scene on the Upper Delaware: State of New York, Autumn* is among only a handful of canvases, all done within a few years of each other, showing that region. The Santa Barbara Museum of Art formerly owned another such scene of the same title of a slightly earlier date (ca. 1872–1875), which is completely different in character (fig. 1).[2] The present painting is based on an oil sketch from nature (Cincinnati Art Museum), which

fig. 1 Thomas Worthington Whittredge, *Scene on the Upper Delaware: State of New York, Autumn*. Previously Preston Morton Collection, Santa Barbara Museum of Art.

was probably executed in the early summer of 1876 at an unidentified site along the river (fig. 2).[3] Except for the mountains, the composition adheres closely to the initial study. But the character of the landscape has been transformed by changing the season to the height of autumn and substituting the hunter with his dog for a herd of cattle in the water.

The picture can be identified with one that was exhibited at the National Academy of Design in 1876 and reviewed favorably in *The Art Journal:*

> "An Autumn on the Delaware" by Mr. Whittredge is very tenderly painted. The autumn tints are subdued yet forcible in effect, and the work is well kept together. Mr. Whittredge paints the brilliant phases of autumn foliage with charming taste.

Reflecting the prevailing taste for large, ostentatious paintings, the reviewer added that "although it is a creditable specimen of his work, it does not assume importance, owing to its small size." The canvas nevertheless bore a price of $700, twice what the artist normally asked for a picture of comparable size and quality at the time.[4] The unusually high fee reflects the exceptional importance Whittredge attached to this work, which is aesthetically and historically one of his most significant achievements.

Scene on the Upper Delaware was executed at the height of Whittredge's career. He had established himself as one of the foremost Hudson River painters and as a leader in New York art circles. During his two terms as its president from 1874 until 1876, Whittredge saved the National Academy from internal collapse and financial ruin. To raise money he participated in organizing the art exhibition at the Philadelphia Centennial for the benefit of both the Academy and the newly established Metropolitan Museum, which he had also helped to found. These duties kept the artist from his studio for long periods. The recently finished *Scene on the Upper Delaware* was evidently the only painting he had on hand that was worthy of inclusion in the Academy's annual exhibition that year, despite its small size.[5]

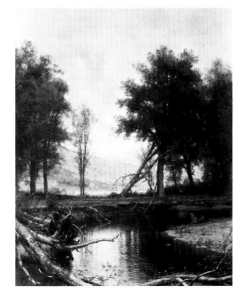

fig. 2 *(left)* Thomas Worthington Whittredge, *Sketch from Nature*. Reproduced by permission. Courtesy of the Cincinnati Art Museum, Gift of the Ohio Mechanics Institute.

fig. 3 *(below)* Thomas Worthington Whittredge, *Landscape with Stream and Deer*. Reproduced by permission of Hirschl & Adler Galleries.

At first glance, *Scene on the Upper Delaware* seems a typical example of Whittredge's mature landscapes. Compared to his earlier version (fig. 1), however, it marks a significant departure. While the foreground has a characteristic wealth of detail, the artist's previous delight in technical bravura and crisp highlights has given way to a more painterly approach as well as to a more subdued tonality. The abstract composition, moreover, has a new flatness. These subtle changes impose an elusive veil across the atmospheric landscape to evoke a broad range of associations beyond time and place. Although rooted in Whittredge's earlier paintings, the poetic reverie also shares the dreamlike vision of George Inness, the leader of the American Barbizon school. In fact, *Scene on the Upper Delaware* represents Whittredge's first, tentative exploration of such a subjective mood.

It is ironic that Barbizon influences began to appear in Whittredge's work at the very time he helped the Hudson River School achieve its greatest triumph. As chairman of the New York delegation, he helped pack the American paintings section of the Philadelphia Centennial with the work of his friends, who garnered most of the medals, and was largely responsible for systematically excluding American Barbizon artists from the exhibition.[6] Yet, as *Scene on the Upper Delaware* attests, the victory for the old guard was illusory.

The Centennial Exhibition as a whole had a major impact on the national consciousness. Perhaps its greatest effect was to force Americans to realize how much the United States had changed during Reconstruction. The Civil War shattered the mythology of America's Manifest Destiny. Moreover, because of the rapid industrial expansion that followed, the romantic vision of the United States as nature's nation was replaced by the twin ideals of civilization and progress. With the American ethos and its landscape style under further attack from philosophical and artistic currents imported from abroad,

nature was relegated from a teacher of moral truths to a purely personal experience. American painting in the Barbizon mood answered the need for a new kind of landscape to express the country's altered mentality. Adapting the French style to these changed conditions, it afforded the artist and viewer alike an unparalleled freedom to evoke poetic states of mind.[7]

Whittredge himself had been exposed to Barbizon art in 1849, when he left Cincinnati for Europe to improve his training. But in spite of the fact that he met Narcisse Diaz and admired the Barbizon painters as "genuine kickers," he found their style incompatible with the Anglo-American tradition from which he stemmed. However, he assimilated Barbizon elements at second hand in Düsseldorf through the school of Johann Schirmer, whose style he emulated throughout most of his decade in Europe.[8] While he struggled to purge his art of these foreign components upon his return to the United States in 1859, this experience abroad made Whittredge unusually susceptible to European influences. Moreover, he was often willing to investigate different styles as part of his continuing artistic growth. But above all, he was especially sensitive to changes in the cultural climate around him, which his paintings often reflect with remarkable fidelity.

This openness to new currents decisively altered the course of Whittredge's career after the Centennial. His experiment with Barbizon devices was extended further the following year. In a variant of *Scene on the Upper Delaware* (fig. 3), the execution has become inconsistent, the composition unbalanced. These are the first signs of a deep artistic crisis that began in 1877. That September he complained in a letter to Jervis McEntee that among other problems his sketching was going poorly.[9] For the next two or three years Whittredge's paintings deteriorated as he struggled to reconcile Barbizon and Hudson River painting. The conflict between these opposing tendencies was resolved in the early 1880s through the example provided by the Barbizon Realism of Charles-François Daubigny. In two large paintings of Seconnet Point (Amon Carter Museum of Western Art, Fort Worth, and National Collection of Fine Arts, Washington, D.C.), for example, he was able to unite the best features of both schools by using *plein air* naturalism to convey his refined poetic sensibility. This happy synthesis was unfortunately short-lived. Within a few years Whittredge entered a long fallow period from which he did not emerge until around 1890 under the rejuvenating influence of Impressionism.[10]

Anthony F. Janson

Exhibitions

N.Y., National Academy of Design, *Annual Exhibition*, 1876, no. 233 (as *Autumn on the Delaware*).
SBMA, *Two Hundred Years*, 1961, either no. 60 or no. 61.
Utica, N.Y., Munson-Williams-Proctor Institute, *Worthington Whittredge (1820–1910): A Retrospective Exhibition of an American Artist* (catalogue by Edward H. Dwight), Oct. 12–Nov. 16, 1969, no. 20; traveled N.Y., Albany Institute of History and Art, Dec. 2–Jan. 18, 1970, Ohio, Cincinnati Art Museum, Feb. 6–March 8, 1970.
Washington, D.C., The Corcoran Gallery, *The Delaware Water Gap*, July 11–Aug. 31, 1975, no. 2, repr. p. 18.

References

The Art Journal, 1876, p. 190.
M. Naylor, *National Academy of Design Exhibition Record, 1860–1900*, 2 vols. (New York: Tombstone, AZ, for Kennedy Galleries, Inc., 1973), II, p. 1025 (dated 1876).

Notes

1. See Edward H. Dwight, *Worthington Whittredge Retrospective*, Utica, Albany and Cincinnati, 1969–1970; Sadayishi Omoto, "Berkeley and Whittredge at Newport," *Art Quarterly*, XXVII, no. 1 (Spring 1964); Anthony Janson, "The Western Landscapes of Worthington Whittredge," *American Art Review*, III, no. 6 (Nov.–Dec. 1976).
2. Like the painting under discussion in this essay, this second painting was given by Norman Hirschl to the PMC (formerly 60.88). It was deaccessioned by the SBMA in 1971 as a partial trade toward J. G. Brown's *Pull for the Shore* (see present cat. no. 25). (Ed.) Besides those mentioned in this essay, there was yet another canvas bearing a similar title formerly in the Terry DeLapp Gallery, Los Angeles. See Anthony F. Janson, "The Paintings of Worthington Whittredge," Doctoral Dissertation, Harvard University, 1975.
3. The Cincinnati oil sketch bore an old label inscribed "an artist's sketch from nature/by Worthington Whitridge (my grand uncle) and given to/my father, by him, in July 1876/Bert L. Baldwin." Bert Baldwin was the grandson of Almon Baldwin, Whittredge's brother-in-law, from whom he received his initial art instruction in Cincinnati. See Anthony F. Janson, "Worthington Whittredge: Two Early Landscapes," *Bulletin of the Detroit Institute of Arts*, LV, no. 4 (Winter 1977).
4. See *The Art Journal* for 1876, p. 190, and M. Naylor, *National Academy of Design Exhibition Record, 1860–1900*, 2 vols. (New York: Tombstone, AZ, for Kennedy Galleries, Inc., 1973), II, p. 1025.
5. Naylor, p. 1025; Eliot Clark, *History of the National Academy of Design, 1825–1953* (New York: Columbia University Press, 1954); Worthington Whittredge, *The Autobiography of Worthington Whittredge*, ed. John Baur (Brooklyn: Arno Press, 1942), p. 44.
6. Whittredge, pp. 43–44; *U.S. Centennial Commission, International Exhibition, 1876, Reports and Awards, Groups, XXVIII*, vol. III, Washington, 1880. Whittredge won a bronze medal.
7. See Janson, "Western Landscapes," and Peter Bermingham, *American Art in the Barbizon Mood* (Washington, D.C.: National Collection of Fine Arts, 1975).
8. Whittredge, p. 21, and Janson, "Two Early Landscapes."
9. Entries of September 2 and 5, 1877, *The Diaries of Jervis McEntee*, 5 vols., Archives of American Art, Washington. The decline is manifest in *Evening in the Woods* (Metropolitan Museum of Art, N.Y.), Whittredge's major entry in the National Academy's 1877 exhibition, which compares unfavorably with his earlier forest scenes.
10. See Janson, "Paintings," pp. 129–131. Compare Richard Boyle, *American Impressionism* (Boston: New York Graphic Society, 1974), esp. chs. IX–XI.

Albert Bierstadt
1830-1902

Albert Bierstadt was the principal artist of the "Rocky Mountain School," which specialized in large, grandiloquent paintings of the natural wonders of the American West. This school may be seen as spanning the period from 1859, the year of Bierstadt's first western trip, to 1889, when changing tastes clearly left him behind. These were years when the exploration and settlement of the West were almost as much on American minds as the events and consequences of the Civil War. Painters of the Rocky Mountain School such as Bierstadt were deeply influenced by the landscape artists of Düsseldorf. German art and thought had become popular in America, and American painters going to Europe to study particularly favored the academies and ateliers of Düsseldorf.

Bierstadt's own ties with Düsseldorf were reinforced by family circumstances. His family came from that area, and Bierstadt was born in Solingen near Düsseldorf. The family of seven emigrated in 1831 and established itself in New Bedford, Massachusetts, where Bierstadt attended public school and may first have learned to draw. He continued his art out of school, taught art classes, and in 1851 and 1853 exhibited in Boston. Since Bierstadt could not afford the expense of going to Düsseldorf, several art patrons contributed the cost of his going there to study under his mother's cousin, Johann Hasenclever, whose genre and landscape works were well known. Bierstadt arrived in Düsseldorf in 1853 only to find Hasenclever had just died. On the funds he had, Bierstadt improvised an art education as best he could. He rented studio living quarters in the same building with the American artists Emanuel Leutze and Worthington Whittredge, older than he and already established. Although they and other artists allowed him to copy their studies and criticized his work for him, Bierstadt was to a large degree self-taught. During the next four years, Bierstadt also traveled on foot through the Hartz Mountains, the Swiss and Italian Alps, making sketches of the mountain scenery that he later worked into studio oils. He regularly sent these home for sale, which earned him enough money to continue his study abroad and also brought him something of a reputation before his return home in 1857, as evidenced by articles in New England newspapers.[1] Bierstadt traveled and painted around home for a while, but his yearning for conquests farther afield led to his travels west and to the evolution of his mature style and work.

In 1859 Bierstadt went west for the first time with Colonel Lander's expedition. Bierstadt made sketches in pencil and in oil on paper or board and also took photographs, including stereographs, as material from which to work up paintings in the studio on his return. In the vast expanse of the plains and the stone architecture of the mountains, peopled by an exotic native race, Bierstadt found his principal subject and began moving toward the climax of his career.

Bierstadt's views of the Far West began in an era when grandiose landscapes of natural wonders by American painters were reaching a new height of popular interest. Frederick Edwin Church had achieved remarkable acclaim for his *Niagara Falls* (1857), and his tropical subjects such as *Heart of the Andes* (1859) had received "[a] popular and critical success that was unprecedented in the history of American art."[2] Choosing the Rocky Mountains as his territory, Bierstadt, four years younger than Church, set out to rival him.

After his return, in 1863, Bierstadt painted one of his most ambitious works, the famous canvas *The Rocky Mountains, Lander's Peak* (now in the Metropolitan Museum). The public response was such that Bierstadt succeeded in rivalling Church's preeminence. In 1864 (after his return from his second trip west but before the works resulting from it received significant public notice) Bierstadt's *Rocky Mountains* and Church's *Heart of the*

14 Mirror Lake, Yosemite Valley
1864
Oil on canvas
21¾ x 30⅛ in. (55.2 x 76.5 cm)
Signed and dated l.r.: Bierstadt 1864
Gift of Mrs. Sterling Morton
60.51

Provenance

Early history unknown; (John Nicholson Gallery, by 1959); purchased from Nicholson by Mrs. Sterling Morton for the PMC, 1960.

Condition and Technique

In 1978 examination by the BACC noted the painting had been lined with an aqueous adhesive and the tacking margins of the support had been cut. The support was in good condition. The paint layers, however, were seriously endangered by incipient flaking of the paint, including blind cleavage and lifting corners of paint flakes in localized areas, viz. in bottom r. corner, along the top edge in the sky and in the water, especially just to the l. of the boat. There was a small paint loss already in the bottom r. quadrant, and three small old losses to the r. of c. at the top edge, and scattered inpainted gouges and scratches, the longest being a horizontal scratch 3–4 in. long above the center mountain and a vertical scratch near and parallel to the end of the r. edge. The surface coating, which was not the original one, had yellowed enough to muddy the cool grey tones of the painting.

In 1979 the painting was treated by the BACC. The surface coating was removed with acetone and the cleavage set down with PVA emulsion and heat. The old fills were removed with a scalpel from over the original paint, and residues of varnish and old overpaints were removed with acetone. A layer of Elvacite 2044 in benzine was brushed on and two layers of Japanese tissue and Elvacite in benzine applied as facing. The painting was removed from the stretcher by cutting the tacking margin of the lining fabric (original tacking margin previously lost). The old lining fabric was removed and the glue on the back of the original support was scraped and sanded. The reverse was vacuumed and wax-resin adhesive applied. The facing tissue was removed with benzine. The adhesion between paint and ground appeared fragile. A lining fabric of fine linen was infused with Ross wax and the painting lined face up on the hot table, with vacuum at 5" Hg., heat up

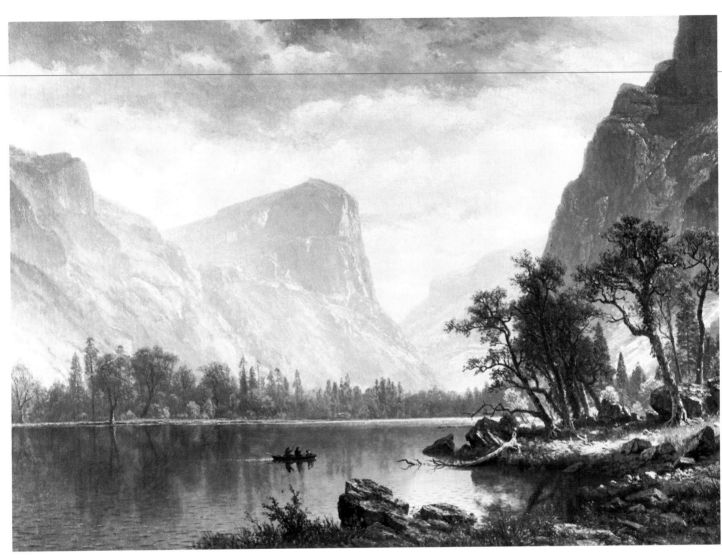

14

Andes were exhibited opposite each other in the elaborate Art Gallery of the New York Sanitary Fair, like two cinerama spectaculars on a double bill. (If that were not enough, also on display in the same room was Emanuel Leutze's popular-history classic, *Washington Crossing the Delaware*.) The debts these three works owed to the styles of the academies in Düsseldorf, to native genius or to the inspiration of the American wilderness were much discussed at the time.

On his second trip west in 1863, Bierstadt went all the way to the Pacific. He was accompanied by Fitz Hugh Ludlow, a writer six years younger who wrote with a Victorian eloquence on art, the wonders of nature, and "Hasheesh." Ludlow's book, *The Hasheesh Eater*, published in 1859, had made him a celebrity, and he and his particularly beautiful wife, Rosalie, were ornaments of the New York society in which Bierstadt was becoming established. Ludlow's ways eventually led to his decline, and Rosalie Ludlow subsequently became Bierstadt's wife. However, as they started westward, Ludlow and Bierstadt were two young adventurers out to explore and capture the wonders of the West with pen and brush.

Bierstadt's later career was marked by spectacular success followed by an ultimate fall from favor. The apogee of his public acclaim began in 1864, the year *Mirror Lake, Yosemite Valley* in the Preston Morton Collection was painted and the year of the great acclaim given to his *The Rocky Mountains, Lander's Peak* at the New York Sanitary Fair. In 1866 he married Rosalie Osborne Ludlow and built a lavish stone villa and studio, Malkasten, on the Hudson River. He made a second, longer visit to California in 1871–1873, and a third in 1884. In Europe, collectors and crowned heads bought his works and bedecked him with medals; the United States Congress in 1878 commissioned two large pictures for the Capitol. Before long, however, he was struggling with adversities. Malkasten burned in 1882. When art styles changed, his work was no longer as widely favored; the American jury for the Paris Exposition of 1889 rejected his *The Last of the Buffalo*. Rosalie died in 1893. Bierstadt married again the next year and remained an urbane and dapper figure in spite of altered circumstances. He died in New York City in 1902.

What has been called "the first retrospective exhibition" of his art was *Albert Bierstadt, 1830–1902: A Retrospective Exhibition*,[3] a pioneering effort in the restudy of nineteenth-century American art, organized by Thomas Leavitt, then director at the Santa Barbara Museum of Art, in 1964.

Paul Chadbourne Mills

Notes

1. The outline of Bierstadt's career follows that of Lewis Ferbraché, *The Yosemite Valley by Albert Bierstadt N.A.* (exhibition catalogue, The Oakland Museum, Oakland, Calif., 1964) and Gordon Hendricks, *Albert Bierstadt, Painter of the American West* (New York: Harry N. Abrams in association with the Amon Carter Museum of Western Art, 1974).
2. Hendricks, p. 140.
3. Exhibition catalogue, Santa Barbara Museum of Art, Aug. 5–Sept. 13, 1964.

to 155° F. The painting was rolled during heating. There were some irregularities in the plane after lining, so the painting was placed face down on Mylar and three layers of newsprint, vacuum at 3″ Hg., heat up to 140° F. Residual wax was removed from surface with Benzine B264. One coat of Acryloid B72, 10% in xylene was applied. The losses were filled with a wax-resin mixture pigmented with titanium dioxide; the fills were isolated with PVA-AYAF, 10% in ethyl alcohol. Inpainting was done with a palette of B67/B72 and xylene. Two spray coats of B72, 10% in xylene were applied, followed by two more spray coats of same.

The support consists of a fine, rather loosely woven, single-threaded plain weave fabric with approximately 18 warp and weft threads per centimeter. The ground layer, of medium thickness, is white and smooth and hides almost completely the fabric texture. The oil-type paint is applied as a rich vehicular paste with some pigmented pellicular glazing in the foliage and the water. Broad bristle brushstroke texture is evident in the mountains and sky, but in general the paint has been applied with fine, small brushstrokes with overall fine, low impasto and evidence of stippling in the background.

Mirror Lake, Yosemite Valley

The Yosemite Valley was discovered in 1855, and artists doing popular lithographs and woodblock illustrations for periodicals quickly made its natural wonders famous throughout the world. Albert Bierstadt, however, was the first well-known painter to depict this marvelous valley.

Mirror Lake, Yosemite Valley was painted as a result of Bierstadt's second trip west in 1863.[1] Besides Bierstadt and the writer Fitz Hugh Ludlow, the party which traveled to Yosemite consisted of Dr. John Newton, a scientist, and two capable artists from California, Virgil Williams, director of the San Francisco School of Design, whom Bierstadt had known in Rome, and Enoch Wood Perry, with whom he had studied in Düsseldorf. On their way to Yosemite from San Francisco at the beginning of August, they stopped at the Mariposa Redwood Grove, where Bierstadt first saw the forest giants. The five traveled into the Valley by way of Inspiration Point, which Ludlow described in his typical prose style.

> That name (Inspiration Point) had appeared pedantic, but we found it only the spontaneous expression of our own feelings on the spot. We did not so much seem to be seeing from that crag of vision a new scene on the old familiar globe as a new heaven and a new earth into which the creative spirit had just been breathed. I hesitate now, as I did then, at the attempt to give my vision utterance. Never were words so beggared for an abridged translation of any Scripture of Nature.[2]

Mirror Lake, Yosemite Valley is dated 1864, the year following Bierstadt's return to New York and the year of his public success with *The Rocky Mountains, Lander's Peak* at the New York Sanitary Fair. A very small *Valley of the Yosemite*, also dated 1864 (Karolik Collection, Museum of Fine Arts, Boston), had been sold for the benefit of the Fair and was probably Bierstadt's first Yosemite work to be exhibited. A *New York Evening Post* writer who visited Bierstadt's studio predicted that the large Yosemite paintings resulting from the trip would be among the artist's best works.[3] Bierstadt's paintings played a role in encouraging sufficient public awareness of the Valley to lead to its creation as a National Park. In his extensive account of their stay in Yosemite, Ludlow mentions their camping near Mirror Lake, which he described as follows:

> One of the loveliest places in the Valley is the shore of Lake Ah-wi-yah — a crystal pond of several acres in extent, fed by the north fork of the Valley stream, and lying right at the mouth of the narrow strait between the North and South Domes. By this tranquil water we pitched our third camp, and when the rising sun began to shine through the mighty cleft before us, the play of color and chiaroscuro on its rugged walls was something for which an artist apt to oversleep might have sat up all night.[4]

Shortly after Yosemite's discovery, nearly every waterfall, peak, lake, and stream was given a descriptive or poetic title. The special attraction of Mirror Lake lay in its reflection of the dramatic upsurge of the rock called Half Dome, which was thus seen doubled.[5] Bierstadt, however, chose to depict Mirror Lake not in its classic manner, reflecting Half Dome, but from the southwestern bank instead. In fact, if the band of Yosemite Cliffs in the background were removed, the painting could be a depiction of a pastoral scene in New England or of many other rural places. The tree-covered peninsula on the right, and especially the serene little fishing boat at the left, are stock characters in Bierstadt's oeuvre. On the whole the painting looks backward to the Hudson River and Luminist styles rather than forward to the dramatic Düsseldorf manner Bierstadt was then embarking upon, and was to use in many other Yosemite works.

The lake as depicted by Bierstadt is larger than it is today, and one could wonder if Bierstadt were taking artistic license and exaggerating its size to give more of a "Hudson River" look to the painting. This is not the case, however; the lake was actually larger then.[6]

Some note should be made of Mount Watkins which is depicted in the center of the painting, of the celebrated Valley photographs of Carlton E. Watkins, and of any possible relation — or lack thereof — between Watkins's work and the painting. Although the peak in the center of the painting is indeed now known at Mount Watkins, in 1865 and 1868 it was called Pine Mountain.[7] Watkins was in the Valley in 1861 and 1864, and anyone concerned as was Bierstadt with the pictorial aspects of the Valley would have been aware of Watkins's photographs. Bierstadt was very interested in photography, undoubtedly partly because his brother, Edward, was a pioneer in the art of landscape photography. Bierstadt had involved himself with photography on the Lander expedition and worked from photographs. He clearly used a Watkins photograph as the basis for his painting of the "Giant Grizzly" tree in Mariposa Grove, *California Redwoods*, and some of his Yosemite paintings appear to have derived a varying amount of information from Watkins's photographs. On his 1872 visit to the Valley, Bierstadt and the photographer Eadweard Muybridge traveled in the Valley together, which indicates it would have been likely for Bierstadt to have tried to establish an open, working contact with Watkins on this earlier trip had Watkins been there, but there is no evidence that he was.[8] There are indeed photographs of Mirror Lake by Watkins, but none that could have provided the source for the Santa Barbara painting, and one could wonder if our painting had perhaps been painted especially to depict the mountain named for the photographer, but the mountain was not given the name "Mount Watkins" until 1870, well after Bierstadt's visit.

The selection of *Mirror Lake* for the Preston Morton Collection in itself is a fact of art historical interest. From the time Bierstadt's work started to become outmoded, as new styles in landscape pushed it into the background, his grandest works were the most totally neglected. When in the 1950s the revival of interest in long-neglected phases of American nineteenth-century art began, it was Bierstadt's oil sketches and more modest paintings that were first allowed back through the door — his larger, grandiloquent canvases were still seen as "calendar art." *Mirror Lake* was acquired for the Preston Morton Collection in 1960. Although not one of Bierstadt's sketches, it is unpretentious in scale and intent. In later years, had one been selecting a single work to represent Bierstadt, it would more likely have been a more typical Rocky Mountain School view, grander and more theatrical. Notwithstanding changing tastes and scholarly revisions affecting present-day perspectives of nineteenth-century American painting, Bierstadt's *Mirror Lake* represents the artist in a particularly agreeable moment.

Paul Chadbourne Mills

Notes

1. Gordon Hendricks in "The First Three Western Journeys of Albert Bierstadt," *The Art Bulletin*, XLVI, no. 3 (Sept. 1964), p. 334, 365, lists fourteen paintings including the present work, here titled *Yosemite Valley with Mirror Lake in the Foreground* (no. 89, fig. 18) for which he feels evidence is "strong to conclusive" they resulted from the 1863 trip and one painting as "probable." See also Hendricks's major work on this subject, *Albert Bierstadt: Painter of the American West* (New York: Harry N. Abrams, Inc., in association with the Amon Carter Museum of Western Art, 1974), CL-22 (now titled *Mirror Lake, Yosemite Valley*), in which he notes the painting formed the basis for an engraving for the frontispiece of an edition, not specified, of Fitz Hugh Ludlow's *The Heart of the Continent*.
2. Ludlow, *The Heart of the Continent: A Record of Travel Across the Plains and in Oregon, with an Examination of the Mormon Principle* (New York: Hard and Houghton, 1870), p. 421; quoted in Hendricks, *Bierstadt*, p. 130.
3. May 24, 1864; quoted in Hendricks, *Bierstadt*, p. 155.
4. Ludlow, Fitz Hugh, *The Heart of the Continent*, from unpaged typed copy in Oakland Museum. There is no known translation for Ludlow's "Lake Ah-wi-yah," "except perhaps in the minds of some Caucasian linguist of the time," according to Jack Gyer (Curator, Research Library, The Yosemite Collections, National Park Service). Gyer points out that Indian culture and language in the Valley suffered traumatic changes, and that when Indians now in the Valley are asked what the name means, they "smile and say they don't know" (telephone call, Dec. 19, 1980).
5. The name Mirror Lake had been given by the party of the editor and publisher James Hutchings during its 1855 visit to Yosemite. (See Hutchings, *Heart of the Sierras*, San Francisco, 1886, p. 91). Hutchings's early publication *Picturesque California* was influential in encouraging popular interest in Yosemite.
6. According to a telephone conversation with Dan Card of the Yosemite National Park Service (Sept. 14, 1979), Mirror Lake was created by the receding of the glaciers. Over the years it has been filling up with silt and eroded deposits from Tenaya Canyon. In order to keep Mirror Lake in accordance with its descriptive name, it used to be dredged out periodically. The current practice of the National Park Service, however, is not to interfere with the processes of nature, with the result that the lake is gradually filling up and therefore far smaller than it was when Bierstadt painted it.
7. As stated in the Whitney Survey Books, according to Craig Bates, Assistant Curator, Research Library, The Yosemite Collections, National Park Service, in a telephone call of Dec. 29, 1980.
8. Marjorie Arkelian, *The Kahn Collection of Nineteenth Century Paintings by Artists in California*, The Oakland Museum Art Department, 1975, p. 11. See also Pauline Grenbeaux, "Before Yosemite Art Gallery: Watkins' Early Career," pp. 220–229, and Nanette Sexton, "The Yosemite Views," *California History*, LVII, no. 3 (Fall 1978), pp. 236–241.

Exhibitions

N.Y., John Nicholson Gallery, *The John Nicholson Gallery Presents New Acquisitions of American, English and French Paintings*. n.d. [ca. 1959], listed (as *Yosemite Valley With Mirror Lake in the Foreground*), n.p.

SBMA, *Two Hundred Years*, 1961, no. 14, repr., mentioned "Introduction," n.p.

SBMA, *Albert Bierstadt 1830–1902: A Retrospective Exhibition*, Aug. 5–Sept. 13, 1964, no. 25 (as *View in Yosemite Valley*), repr. color, n.p.

Calif., Crocker-Citizens National Bank, *A Century of California Painting, 1870–1970: An Exhibition Sponsored by Crocker-Citizens National Bank In Commemoration of Its One Hundredth Anniversary*, June 1, 1970–Jan. 10, 1971, no. 1, p. 22, opened Los Angeles, Crocker-Citizens Plaza, June 1–30, 1970; traveled Fresno Art Center, July 6–26, 1970, SBMA, Aug. 3–Sept. 3, 1970, San Francisco, California Palace of the Legion of Honor, Sept. 11–Oct. 8, 1970, University of Santa Clara, deSaisset Gallery, Oct. 13–Nov. 5, 1970, Sacramento, E.B. Crocker Art Gallery, Nov. 10–Dec. 10, 1970, Oakland Museum, Dec. 15, 1970–Jan. 10, 1971.

Dallas Museum of Fine Arts, *The Romantic Vision in America*, Oct. 9–Nov. 28, 1971, no. 47 (as *View in Yosemite Valley*), repr., mentioned, n.p.

Washington, D.C., National Collection of Fine Arts, Smithsonian Institution, *National Parks of the United States*, June 23–Aug. 27, 1972, no. 77, repr. p. 110; traveled Arizona, Phoenix Art Museum, Oct. 7–Nov. 27, 1972.

Houston, Texas, Meredith Long & Company, *Tradition and Innovation: American Paintings 1860–1870, A Loan Exhibition of The Houston Museum of Fine Arts*, Jan. 10–25, 1974, no. 1, repr. p. 13.

The Vatican Museums, Braccio di Carlo Magno, *A Mirror of Creation: 150 Years of American Nature Painting / Uno Specchio della Creazione: 150 Anni di Pittura Americana della Natura*, Sept. 24–Nov. 23, 1980, no. 6, repr., and also shown at the following not listed in the catalogue, Evanston, Ill., Terra Museum of American Art, Jan.–Feb. 1981.

References

Fitz Hugh Ludlow, *The Heart of the Continent* (New York: Hard and Houghton, 1870), repr. frontispiece, engraved by V. Balch, in another printing of the same book, repr. fig. 1 (as *Camping in Yosemite*).

Gordon Hendricks, "The First Three Journeys of Albert Bierstadt," *The Art Bulletin*, XLVI, no. 3 (Sept. 1964), no. 89, p. 357, repr. p. 333, mentioned p. 346.

Gordon Hendricks, *Albert Bierstadt: Painter of the American West* (New York: Harry N. Abrams, Inc., in association with the Amon Carter Museum of Western Art, 1974), no. CL-22, repr.

George Inness
1825-1894

George Inness was born May 1, 1825, on a farm near Newburgh, New York. He was the fourth son and the sixth of thirteen children born to Clarissa Baldwin and John Inness, a successful Scottish grocer-merchant. Young Inness, a frail and sensitive child, was given to lapses of "melancholy" and poor health. He suffered from an undisclosed illness, probably epilepsy, all of his life, and it is likely for this reason he chose to live most of his life in the country rather than the city.

After living briefly in New York City, the Inness family moved to Newark, New Jersey, when George was four years old. As just a young boy Inness happened upon an artist painting a pastoral landscape. He decided to become an artist, and although his father did not encourage him in this career he accepted his son's choice when, at the age of fourteen, George failed in his own grocery business. During this period Inness received a limited education, including some art lessons from a local artist named Barker. After his business failure Inness went to New York to serve an apprenticeship with Sherman and Smith Engravers and, while in that city, also took a few lessons in painting from Régis Gignoux, a former pupil of Paul Delaroche. His first public showing was at the National Academy of Design in 1844.

In 1846 Inness was discovered by Ogden Haggerty, New York auctioneer and art dealer, who became his mentor and first patron. Two years later Inness married Delia Miller. She died within six months after their wedding, and almost nothing is known about her.[1] In 1850 Inness married Elizabeth "Lizzie" Hart, who became his lifelong companion, assistant, and protectress.

The Innesses went to Europe on a combined honeymoon and extended painting trip with the financial help of Haggerty.[2] They spent the bulk of their time in Italy, returning through Paris for the Salon of 1852. Their first child, Elizabeth, was born in Florence, where Inness maintained a studio directly over the one used by American artist William Page, who later became Inness's agent. Apparently at this time there was no contact, or very limited contact, between them. Of his work during this first trip abroad Inness commented in a letter to Ripley Hitchcock, "Our traditions were English, and French art — particularly landscape, had made but little impression on us. Several years before I went to Europe however I had begun to see that elabourateness in detail did not gain me meaning."[3] The paintings done in the first Italian visit are few and do not differ substantially from the American paintings of the same period. They follow the old masters closely in both color and composition.[4]

Inness returned to Europe in 1853, this time to Paris. In 1859 he settled near Boston in Medfield, Massachusetts, where he completed his renowned *Peace and Plenty* (1865). While in Medfield he also worked as a partisan Union supporter and abolitionist. By 1865 he had moved his family to Eagleswood, New Jersey, where he took a few painting students, including William Comfort Tiffany. In 1867 he moved again, this time to Brooklyn.

His restlessness took him back to Italy in 1870, where he lived in Perugia (1870–1871); Albano (1872), and Pieve de Cadore (1873). It is from this period that the most dramatic change is seen in Inness's work.

By 1875 Inness had moved his family to New York, and then to Montclair, New Jersey. Over the next few years he visited Chicago and California. In 1881 he turned away from landscape to figure painting. He told his wife he expected figures "to take the place of landscape altogether in his art."[5] But he soon abandoned the idea and returned to his favored scenery.

15 The Sun Shower

1847
Oil on canvas
29¾ x 41¾ in. (75.6 x 106 cm)
Signed and dated l.c.r.: G. Inness 1847
Gift of Mrs. Sterling Morton
60.65

Provenance

R. S. Codman, Boston; (purchased from Codman by Vose Galleries, Boston, 1921); purchased from Vose by E. C. Donnelly, Boston, 1926; (purchased from Donnelly family of Commonwealth Avenue, Boston, by Vose, 1960); purchased from Vose by Mrs. Sterling Morton for the PMC, 1960.

Condition and Technique

In 1968, on the occasion of the loan of the painting to The Baltimore Museum of Art, flaking paint and small losses were noted by that institution, and treatment by its conservation department was authorized. According to a letter of Feb. 3, 1969, from the Registrar at Baltimore to the SBMA, a paint loss was suffered during the return transit to Santa Barbara.

In 1978 examination by the BACC noted the painting was lined at an unknown date with an aqueous adhesive. The support was dry, brittle, and quite fragile, and beginning to tear at the stretcher corners. Its tacking margins had been cut. There was poor adhesion between the ground/paint layers and the support, resulting in scattered cleavage, raised edges of paint, and slight paint losses. The worst areas were in the sky along the r. and top edge, and in the area of the signature and the seated figure. Actual paint loss had occurred only in the sky at the right edge. A large area of wrinkled paint in the sky and landscape was probably caused during the earlier lining procedure, when much of the impasto had been flattened or surrounded by moating. An approximately 1 in. wide strip of overpaint covered all edges of the painting.

In 1978–1979 the painting was treated by the BACC. The yellowed surface coating, a natural resin varnish, was removed, acetone, MEK and EDC being used. After the painting was faced, the old lining canvas and adhesive were removed. Abrasions on the reverse, caused by the removal of adhesive with a cartilage knife, were filled in with chalk-gelatin filling material with thymol added as disinfectant. The reverse was infused with wax-

15

Inness was, if not erratic, at least highly idiosyncratic about his painting. He often changed the names of works, sometimes the dates, and, much to the exasperation of the buyer, would occasionally overpaint on a canvas after it was sold. He is known to have done as many as twenty-five works on one canvas. His son George Inness, Jr., a minor painter himself, reports that when his father worked it was a complete immersion in his craft.

> When he painted he painted at white heat. Passionate, dynamic in his force, I have seen him sometimes like a madman, stripped to the waist, perspiration rolling like a mill-race from his face, with some tremendous idea struggling to expression. After a picture was complete it lost all value for him. He had no interest in it. What was his masterpiece one day would be "dish-water" and "twaddle" the next. He would take a canvas before the paint was really dry, and being seized with another inspiration, would paint over it.[6]

His strong intellect led him to constant theorizing about art, but most of his ideas were used only by him, as a platform for argument with others. His dedication to painting is best expressed in his own words, "Let us believe in art . . . because it is the handmaid of the Spiritual life of the age."

Inness and his wife returned to Europe in 1890 for health reasons, and on August 3, 1894, George Inness died at Bridge-of-Allan, Scotland.

Kathleen Monaghan

Notes

1. Nicolai Cikovsky, *The Life and Works of George Inness* (New York: Garland Publishing, Inc., 1977), p. 15. There is some discrepancy between sources on all dates; those cited here are from Cikovsky.
2. Cikovsky, *George Inness*, pp. 17–18.
3. Elizabeth McCausland, *George Inness, An American Landscape Painter* (New York: American Artists Group, Inc., 1946), p. 18.
4. Cikovsky, *George Inness*, pp. 159–165.
5. Cikovsky, *The Edward Butler Collection of Paintings by George Inness (1825–1894)* (Chicago: Art Institute of Chicago, 1930), p. 59.
6. Cikovsky, *Edward Butler Collection*, p. 61; quoted from George Inness, Jr., *Life, Art and Letters of George Inness* (New York: Plenum Publishing Corp., 1917), p. 117.

The Sun Shower
Morning, Catskill Valley
(See color reproduction, page 38)

George Inness's development is astonishing when one considers the range of his stylistic language and ability. The distance he traveled from his beginnings to his maturity is perfectly represented by the two paintings in the Preston Morton Collection. One was painted during Inness's first years of professional activity, the other in the last year of his life. They are literally poles apart. The early painting, *The Sun Shower* (1847), is painstaking and at times awkward in its handling, rich in incidental details, and earnestly observes the conventions of landscape painting. The later *Morning, Catskill Valley*[1] (1894) is broadly conceived, executed with fluency and assurance, dispenses with any incidental or narrative detail, and, in a style distilled from a lifetime of thought and experience, transcends the conventions of landscape art. They differ so, in every way, that without the assistance of signatures one might think they were painted by different artists. Yet in spite of their

resin lining adhesive consisting of beeswax (4 parts), microcrystalline wax (2 parts), paraffin (1½ parts) and Zonarez polyterpene resin (1½ parts). The infused support fabric was lined with the infused lining fabric on the vacuum hot table, with pressure brought to 3" Hg, heat to 155–160° F on the surface of the covering rubber membrane, and heat turned off. Due to two slight diagonal indentations in the paint surface caused by wrinkles in the rubber cushioning layer under it, the lined painting was placed face down directly on the hot table without cushioning on the same Mylar used before, and the table heated up again to temperature of approximately 150° F when turned off, pressure constant at 10" Hg. After the painting was mounted on the stretcher, the sheet of .002 Mylar from the lining was left on the reverse as a moisture barrier. Wax and varnish residues were removed from the paint surface and an isolating layer of Acryloid B72, 10% xylene, was brushed on. The losses were filled in with a wax putty mixture of beeswax and dry pigments. The fills were isolated with PVA-AYAA, 10% in ethyl alcohol. Inpainting was done with dried pigments ground in Acryloid B72 and B67, 3:1 with xylene as solvent and Acryloid B72 as medium. Two spray coats of Acryloid B72 were applied as protective surface coating.

The support, a medium-weight, single-threaded plain weave fabric, is covered by a moderately thick white ground. The oil-type paint ranges from pigmented pellicular glazes to a rich vehicular paste, applied extensively wet into wet. Extensive use of the small brush is apparent in the foliage and landscape, with fine impasto of medium height throughout these areas. The use of glazing over a lighter base is apparent in the darks of the foreground and the green ground in the middle landscape.

apparently vast differences both paintings are enactments of an artistic will that remained remarkably constant during the nearly half-century separating them. The beliefs that shaped and guided Inness's art, most completely and effortlessly expressed in his late paintings, were discernible even in his earliest ones. His art, which seemed to contemporaries "wildly unequal and eccentric,"[2] and impetuously to assume different forms, was in its foundation of one piece; although he may have changed his manner, Inness never fundamentally altered the convictions he held at the outset of his artistic life.

Painted in 1847 when Inness was twenty-two, *The Sun Shower* comes from Inness's earliest period. Before this he had received only a fragmentary artistic education — it was too irregular and undisciplined to be called training — from an itinerant painter in Newark, New Jersey, probably in 1841, and from the accomplished French-born artist, Régis Gignoux in New York, probably in 1843. In all, evidently because of poor health, he spent no more than a few months with his two instructors. Inness was not a precociously gifted artist, and he learned only rudimentary skills during his brief study. As a result, early works such as *The Sun Shower* show unmistakable signs of technical uncertainty. The human and animal figures, which verge on being malformed, are clumsily painted and betray Inness's lack of rigorous formal training. So, too, does his inability to unify the parts of his painting. The relationship of the figures to their settings is uncertain, and within the quadrants of the painting there are slight but disturbing anomalies and inconsistencies of scale. These quadrants moreover, do not hold their position in space. To be sure, parts of the landscape, particularly the central tree and sky, are confidently, if somewhat stiffly, painted. The close resemblance of Inness's method of rendering leaves and clouds to the representational formulae commonplace in old master landscape paintings suggests the reason for this confidence: Inness had, in some unknown form and degree, such examples available to him for study and imitation.

There is little in the awkwardness and imitativeness of *The Sun Shower* and other early works to foretell the absolute technical mastery of later paintings like *Morning, Catskill Valley*. There are, however, two essential ingredients of his fully mature art already present in his early paintings. One of them is his devotion to color as the major instrument of pictorial form and expression. Despite its shortcomings, *The Sun Shower* is an impressive painting largely because of color. It is color that gives the painting what the other components fail to provide: harmony and unity, convincing spatial depth, energy and compelling beauty. Inness's deficiencies in technique may be attributable in part to his early affinity for color, an affinity that made other pictorial means appear less appealing and less important.

Inness's early work also shows that he had clearly formulated what he believed art should be and how it should be made. He began exhibiting professionally at the National Academy of Design in 1844. He was soon noticed by critics, who looked upon him as a "young artist of good promise."[3] But however promising or exceptional they found him, his critics were regularly disturbed and puzzled by the tendency of his art. In 1847 (the year of *The Sun Shower*), his Academy paintings were said to "lack truth of color and composition."[4] In 1848 a critic wrote, "We fear that he is beginning to lose sight of Nature in the 'Old Masters,'" and accused him of actually imitating Claude.[5] In 1852 a critic felt his "pictures have become shallow affectations of that which is at best superficial to Art — the accomplishment, not the substance. What the condition of that mind can be which will resign not only all nature but even all that is most valuable in art, to a tone of color, we cannot conceive. . . . What, then, is he who contents himself with studio concoctions as

blank and wanting in the truths of nature as the canvas they are painted on?"[6] What disturbed his critics, and what they could not understand, was Inness's attraction to other art and to the artifices of color, composition and handling — "studio concoctions" — instead of to the truthful imitation of nature.

It would seem perfectly normal that a young artist, particularly one like Inness deprived of a thorough artistic education, would consult the art of the past for inspiration and guidance. But in the 1840s American artists were urged to follow a quite different course. Asher B. Durand described it best in the following decade in his 1855 "Letters on Landscape Painting" in the.*Crayon*: "Go first to Nature to learn to paint landscape, and when you shall have learnt to imitate her, you may then study the pictures of great artists with benefit.... True Art teaches the use of the embellishments which Nature herself furnishes, it never creates them. All the fascination of treatment in light, and dark, and color, are seen in Nature; they are the luxuries of her store-house, and must be used with intelligence and discrimination to be wholesome and invigorating."[7] Time and again American artists received the same advice and admonishment. Inness could hardly have avoided it, if only because it appeared in reviews of his own work. Yet he obviously did not follow it. For as his critics, unable to comprehend a "condition of mind" to them so perverted, noticed, he was not nature's humble communicant or faithful transcriber, nor did he believe that art's treasures reposed in nature's storehouse. On the contrary, he clearly found the conventions of art, which he persisted in emulating despite constant critical disapproval, at least as important as the truths of nature, and, reversing Durand's procedure, he went first to art, not to nature.[8] Inness was a formalist in an age of realism, a votary of Art in an age of Nature.

Inness also expressed his artistic position by the subjects he preferred. *The Sun Shower*, for example, is not an image of undefiled wilderness, of the kind painted by so many of his contemporaries under the influence of Thomas Cole; it is, on the contrary, with its road, cottage, and fenced fields, an image of nature transformed by civilization. Lest one miss this, Inness provided, in the prominently placed reaper and shepherdess, unmistakable emblems of cultivation. Thirty years later he would avow his predilection for "civilized landscape,"[9] yet, as *The Sun Shower* clearly shows, it was already formed at the beginning of his career. Inness liked civilized landscape, he said, because "Every act of man . . . marks itself wherever it has been." He also preferred it to "that which is savage and untamed" because, shaped by the formative and creative powers of man, it was a metaphorical counterpart of his determination to transform nature into art, to impress his will upon nature for his own expressive and aesthetic purposes, and not, as his American contemporaries were urged to do, be used by it.

Inness's critics accused him of being untruthful to nature because to them he mixed invention with observation to an intolerable degree. This mixture is visible in *The Sun Shower*: the central tree and distant landscape, because of their irregularity and individuality, seem to have been studied from nature, but accessories like the shepherdess, cottage, roadway, and hay wagon, are standard items of *staffage* appropriated from art. Without knowing what the site looked like, however, it is impossible to say how greatly and in what ways he transformed it. For this reason, an early painting recently acquired by the Santa Barbara Museum (fig. 1), heretofore unknown and unpublished, assumes a special importance. It is an untitled landscape that Inness presented to his brother James, of Pottsville, Pennsylvania, on the occasion of his wedding. In a document affixed to it James Inness testified: "The group of trees and rocks in the foreground were taken from the Sharp

16 Morning, Catskill Valley[1]

(also titled *The Red Oaks*)
1894
Oil on canvas
35⅜ x 53¾ in. (89.8 x 136.5 cm)
Signed l.r.: G. Inness 1894
Gift of Mrs. Sterling Morton
60.66

1. Formerly affixed to the stretcher, now lost but recorded by Knoedler, was a label in the artist's hand that read: Morning Catskill Valley Leeds Geo. Inness.

Provenance

(Fifth Avenue Art Gallery, N.Y., *Inness Executor's Sale*, Feb. 12–14, 1895, no. 239, as *The Red Oaks*); Charles E. Clarke, 1895, still in collection by 1908 (see References); William S. Skinner, N.Y.; Robert Steward Kilborne (or Kilburn); (purchased from Kilborne by Knoedler and Co., Inc., N.Y., Aug. 27, 1959);[1] purchased from Knoedler by Mrs. Sterling Morton for the PMC, 1960.

1. The provenance follows essentially the one given in Ireland, *The Works of George Inness*, 1965, no. 1504 (see References). The reference to Knoedler, however, according to a letter of Dec. 26, 1979, from Nancy C. Little, Librarian, Knoedler, is out of sequence in Ireland as there is no record of the painting having been with the gallery before 1959. Ireland lists, moreover, Mrs. Robert S. Kilborne, while the Knoedler records refer either to R. Steward Kilburn or Robert S. Kilborne.

Condition and Technique

In 1978 examination by the BACC noted the painting had been lined with wax resin to a fiberglass fabric. The tacking margins were extant. Wide-mouthed traction crackle in the sky along the top and in the central red tree was apparent. The painting had suffered slight losses along the edges, probably from lining. The design area may have been slightly extended in lining. The moderately matt surface coating was estimated a thin recent coating of synthetic polymer resin. The overall condition of the painting was good.

The support, a medium-weight, plain weave linen, is covered with a thin neutral grey ground, which fills the fabric weave and partially obscures its texture. The ground extends to the edge of the tacking margins, l. and r. The paint, an oil-type vehicular paste, ranges from thin scumbles to heavy-bodied brushmarked pastes. The latest paint layers end within present stretcher size at top, l. and r.

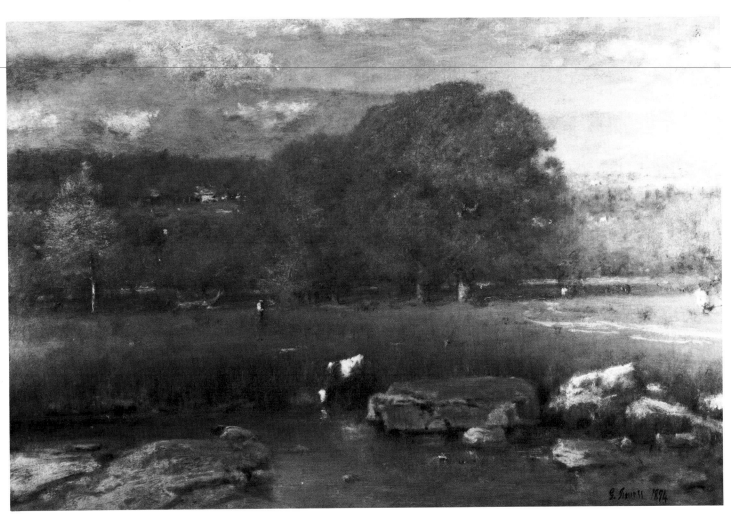

16

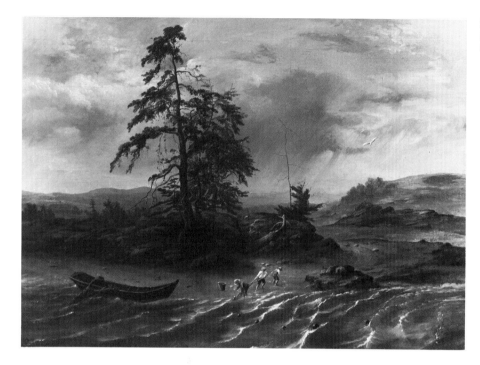

fig. 1 George Inness, *Landscape with Fishermen*.
Collection of the Santa Barbara Museum of Art,
Gift of Mrs. Tracy W. Buckingham.

Mountain in the Borough of Pottsville, Pennsylvania AD 1844." Part of the painting, then, originated in nature. But the rest of it, we can in this case be quite sure, did not, for no body of water of the kind Inness shows exists in the vicinity of Sharp Mountain.[10] This may be an extreme case — and a very early one — of the license Inness allowed himself; its very extremity, however, shows how little he felt bound to the configuration of nature.

Inness's artistic understanding was therefore extraordinarily complete at the beginning of his career. And as the 1894 *Morning, Catskill Valley* shows, it was fundamentally unchanged at its end. In it, placement, pattern, rhythm, order, and variation are carefully and sensitively plotted; colors have an intensity that exceeds the norms of nature and simple descriptive truth; and brushwork is self-assertively evident in its variety and energy. It is clear from traits such as these that the painting is as much an invention as a transcription; that its great beauty comes as much from artifice as from imitation; and that it is "civilized" as much by having been subjected to the refining and reforming discipline of art and a forceful artistic personality as it is by being simply inhabited.

The affinities, however, between Inness's early and late works should not give the false impression that they are connected by a direct and unbroken line of descent. Many experiences intervened between *The Sun Shower* and *Morning, Catskill Valley*, but two in particular were critical in causing the change in the mode and content of Inness's artistic language that differentiates these two pictures (and others early and late). The first was his discovery of Barbizon landscape painting in France in 1853. This experience so impressed Inness that it produced an abrupt change of stylistic allegiance. He discarded the conventions of old master landscape painting upon which he had patterned his earlier art, and adopted instead the looser, more suggestive handling, brighter and fresher colors, and more informal compositional arrangements of Barbizon art. All of Inness's later art would observe its principles. He was hardly alone in falling under the Barbizon spell. But unlike

most of the artists of the later nineteenth century who did so, passively imitating its style and subjects, Inness transformed them into a mode unmistakably his own.[11]

The second critical experience for Inness was his exposure in the 1860s, through the agency of the painter William Page, to the doctrines of Emanuel Swedenborg. For the remainder of his life Inness was a dedicated student of Swedenborg's teachings. Nowhere does he say that his art was influenced by them, nor do any of his paintings irresistibly demand a Swedenborgian explanation of their subject or form. It is unthinkable, however, that an abiding concern of thirty years would not inform his art without visible effect. In works of the last decade of his life, such as *Morning, Catskill Valley*, it would appear to have done so.

Inness's late paintings are always convincingly real. They always possess those basic attributes of reality that Inness listed as "color, distance, air, space [and] *chiaroscuro*."[12] At the same time, one finds in them conditions that normal experience does not supply: colors that are more lovely, configurations that are more orderly, and a peculiar softness and stillness. Swedenborg claimed actual experience of the spiritual world and his writings are filled with accounts of it. The spiritual world that Swedenborg described was in many respects completely believable — coherently structured and filled with familiar objects and beings — but in essential ways it differed from the material world. For example, things in it were soft and yielding, spatial relations were not fixed and constant but could be changed and varied, and the splendor and refulgence of its colors were beyond comparison to those of the material world. In Inness's late paintings like *Morning, Catskill Valley*, though earthly nature is depicted in entirely plausible ways, the conditions of atmosphere, substance, space, and color seem closely to reflect Swedenborg's descriptions of the spiritual world. In this way they provide credible intimations of that higher realm.

It is possible, of course, to admire Inness's late paintings without knowing of his Swedenborgian affiliation; it is, in fact, impossible to point to a specifically Swedenborgian subject matter or symbolic language in them. A work like *Morning, Catskill Valley*, because of its formal authority and coloristic beauty, is much greater than the myriad "tonalist" and Barbizon-inspired landscapes of the late nineteenth century that seem to resemble it. At the same time the painting is also greater because of the presence of meaning that, however arcane and personal, suffuses its subjects and forms and invests them with a conviction and purpose that are ultimately expressed as pictorial quality.

Nicolai Cikovsky

Notes

1. Inness's titles are usually vague and unreliable. Many were supplied by others, such as his wife, son and dealers, who thought — as he did not — that his paintings needed the help of colorful or poetic titles. But a title in use during Inness's lifetime, as *Morning, Catskill Valley* was in the 1894 National Academy of Design exhibition, has some claim, however faint, to Inness's approval, and its continued use can prevent confusion in identifying his paintings. For these reasons, *Morning, Catskill Valley* is preferable to *Red Oaks*, and this rule might helpfully be followed in other similar situations.
2. James Jackson Jarves, *The Art Idea* (1864; reprint, Cambridge, Mass.: Belknap Press, 1960), p. 195.
3. *Literary World*, I (1847), p. 347.
4. *Literary World*, I, p. 304.
5. *Literary World*, III (1848), p. 328.
6. *Literary World*, X (1852), p. 332.
7. *Crayon*, I (January 3, 1855), p. 2.
8. Jasper Cropsey's 1846 *Janetta Falls* in the PMC (present cat. no. 11), depicting an artist at work embedded in wilderness nature, may be regarded as a pictorial manifesto of Cropsey's adherence to the American pedagogy Durand prescribed. And it was Cropsey, when Inness called upon him in 1845, who "directed his attention to the study of nature" (letter to John P. Ridner, August 24, 1845, Boston Public Library).
9. "A Painter on Painting," *Harper's New Monthly Magazine*, LVI (1878), p. 461.
10. Mr. Reginald Rix, Curator, The Historical Society of Schuylkill County, Pottsville, Pennsylvania, wrote that "the fisherman, boat and water is [sic] not of this county. We have no large body of water around here" (letter of Sept. 22, 1978).
11. For Barbizon influence in America, see Peter Bermingham, *American Art in the Barbizon Mood* (exhibition catalogue), National Collection of Fine Arts, Smithsonian Institution, Washington, D.C., 1975.
12. "Mr. Inness on Art-Matters," *The Art Journal*, New York, n.s. V (1879), p. 375.

Exhibitions

The Sun Shower:

N.Y., The Buffalo Fine Arts Academy, Albright Art Gallery, *George Inness: Centennial Exhibition, 1825–1925*, Oct. 30–Nov. 30, 1925, no. 51.

SBMA, *Two Hundred Years*, 1961, no. 37, repr., mentioned "Introduction," n.p.

Austin, University of Texas, University Art Museum, *The Paintings of George Inness (1844–94)*, Dec. 12, 1965–Jan. 30, 1966, no. 4, p. 14, repr. p. 5, mentioned p. 3.

The Baltimore Museum of Art, *From El Greco to Pollock: Early and Late Works by European and American Artists*, Oct. 22–Dec. 8, 1968, no. 73, repr. and mentioned p. 94.

Exhibitions

Morning, Catskill Valley

N.Y., National Academy of Design, *69th Annual Exhibition*, Apr. 2–May 12, 1894, no. 235 (as *Morning, Catskill Valley*), repr.

N.Y., American Fine Arts Society, Fine Arts Building, *Exhibition of the Paintings Left by the Late George Inness*, opening Dec. 27, 1894, no. 208.

N.Y., Fifth Avenue Art Gallery, *Inness Executor's Sale*, Feb. 12–14, 1895, no. 239 (as *The Red Oaks*).

SBMA, *Two Hundred Years*, 1961, no. 39, repr., mentioned "Introduction," n.p.

Calif., Fresno Arts Center, *200 Years of American Painting*, Nov. 20–Dec. 30, 1977, no. 14, p. 21, repr. in color p. 5, Pl. 3.

Calif., Oakland Museum, *George Inness Landscapes: His Signature Years 1884–1894*, Nov. 28, 1978–Jan. 28, 1979, cat. p. 61, repr. in color p. 51 (as *The Red Oaks* [*Morning, Catskill Valley*]); traveled SBMA, Feb. 10–April 15, 1979.

Seattle, University of Washington, Henry Gallery, *American Impressionism* (catalogue by William H. Gerdts), Jan. 3–March 2, 1980, cat. p. 133, repr. in color p. 20; traveled to Los Angeles, University of California, The Frederick S. Wight Art Gallery, March 9–May 4, 1980, Illinois, Evanston, The Terra Museum of American Art, May 16–June 22, 1980, Boston, The Institute of Contemporary Art, July 1–Aug. 31, 1980.

References

The Sun Shower:

Le Roy Ireland, *The Works of George Inness; An Illustrated Catalogue Raisonné*, (Austin: University of Texas Press, 1965), no. 22, p. 9, repr. p. 10.

Nicolai Cikovsky, *The Life and Works of George Inness* (New York: Garland Publishing, 1977), fig. 8.

Morning, Catskill Valley

Inness Executor's Sale, Fifth Avenue Art Gallery, N.Y., Feb. 12–14, 1895, no. 239, as (*The Red Oaks*).

New York Herald, Feb. 15, 1895, mentioned (information provided by Knoedler).

E. Daingerfield, "A Reminiscence of George Inness," *Monthly Illustrator*, New York (March 1895), repr. p. 266.

Masters in Art, "Inness," Boston, Bates and Guild Co., IX (June 1908), p. 253 (as in Clarke Collection), p. 41.

LeRoy Ireland, *The Works of George Inness: An Illustrated Catalogue Raisonné* (Austin: The University of Texas Press, 1965), no. 1504, repr. p. 395 (as *Morning, Catskill Valley* or *The Red Oaks*).

Nicolai Cikovsky, *George Inness* (New York: Praeger, 1971), no. 93 (as *The Red Oaks*).

Alfred Werner, *Inness Landscapes* (New York: Watson-Guptill Publications, 1973), p. 84, repr. in color p. 85, Pl. 32 and on jacket (as *The Red Oaks*).

Nineteenth Century
(1840s to 1880s)

George Peter Alexander Healy
1813-1894

Born in Boston, G. P. A. Healy painted his first portraits when he was seventeen. Encouraged by patrons and by Thomas Sully and Jane Stuart to study in Europe, Healy went to Paris in 1834, where he worked for a year in the studio of Baron Gros. Moving to London after a trip to Italy, Healy soon began his long career of painting portraits of politically and socially prominent sitters. A major series of commissions developed from his introduction in 1838 to Lewis Cass, American Ambassador to France. This led to Healy's portrait of King Louis Philippe of France, and the King's commission of a series of portraits of American statesmen and presidents, painted in the 1840s. For this series, Healy returned to the United States for the first time since 1834.

After Louis Philippe's overthrow in 1848, Healy remained in Europe. By this time he was well-known on both sides of the Atlantic. In 1855 William B. Ogden convinced Healy to move back to the United States, to Chicago, where he lived until after the Civil War. In 1867 he returned to Europe, living in Paris until 1892, two years before his death.

Healy's best portraits were painted in the period from the 1830s to the 1860s. His work of this period has a light touch and a clarity that makes the portraits seem freshly painted. Healy was a rapid painter. His more notable sitters included Abraham Lincoln, Henry Clay, Andrew Jackson, Henry Wadsworth Longfellow, Franz Liszt, and Jenny Lind.

Ellen G. Miles

Study for the Portrait of François Pierre Guillaume Guizot

Healy's *Study for the Portrait of François Pierre Guillaume Guizot* was painted in Paris in 1841 as a preparatory essay for the full-length portrait of Guizot (fig. 1) now in the National Museum of American Art (Smithsonian Institution, Washington, D.C.).[1] The finished portrait was one of the most important early works of Healy's long career as a portrait painter. Its commission and subsequent gift to the United States were closely intertwined with Healy's rapid rise to fame. Painted when Healy was twenty-seven, it portrays King Louis Philippe's Minister of Foreign Affairs, the King's prime minister and advisor from 1840 until Louis Philippe's overthrow in 1848. Equally significant, it portrays the stern intellectual whose essay on George Washington brought him the gratitude and admiration of many Frenchmen and Americans.

The full-length portrait of Guizot was commissioned in 1841 by a committee of twenty-five Americans living in Paris. Guizot (1787–1874), a much-admired French historian, was a proponent of constitutional monarchy. He had served as Louis Philippe's Minister of Education from 1832 to 1837. In 1840 he became, briefly, French Ambassador to England and then, in October, was made Foreign Minister. The portrait, however, was intended to celebrate a different achievement, Guizot's publication in 1840 of his *Vie, correspondance et écrits de Washington,* the French edition of Jared Sparks' *The Writings of George Washington* (1834–1837). In particular, the portrait honored Guizot for his preface, an essay on Washington that read in part, "If ever a cause was just and had a right to succeed, it is that of the English colonies which rose up to become the United States of America." This essay was published in English the same year as an *Essay on the character and influence of Washington in the Revolution of the United States of America.*

17 Study for the Portrait of François Pierre Guillaume Guizot

1841
Oil on canvas
32⅛ x 21 in. (81.6 x 53.3 cm)
Signed and dated l.r. on cross bar of chair: Geo. P. A. Healy pinxt/1841
Inscribed on scroll held in Guizot's right hand: Washington-/Au Val Richer - Septembre 1839
Inscribed to r. of red seal on second sheet below Guizot's right hand: Fait à Paris/Par le Roi
Inscribed in ink across reverse: Ceci est la copie du grand portrait de M. Guizot,/qui a été commandé en 1841 à M. Healy par un/comité américain et qui a été placé à Washington dans la/bibliothèque du Congrès.
Stenciled on reverse of original fabric: BOULEVARD MONTMARTRE DE FORGE, M^D deCouleurs, A Paris
Gift of Abraham Adler
60.86

Provenance

Previous history unknown; from Abraham Adler to the PMC, 1960.

Condition and Technique

The painting was lined at an unknown date with animal glue (estimated) to a coarse fabric, possibly jute. The tacking edges had been cut off leaving no margins. The background revealed irregular areas of darkened paint from overpainting to repair old damage and losses. The painting had suffered small losses in the figure.

In 1971 the painting was treated by Helmer Ericson, Santa Barbara, for flaking paint on the upper portion of the lion-footed leg of the chair. In 1976 the coarse lining was removed by Sherman White, Santa Barbara.

In 1977 the painting was treated by the BACC. The degraded surface coating was removed with a solution of acetone (10%), diacetone alcohol (10%), and petroleum ether (80%). The overpainting in the background was removed with morphaline. The painting was sprayed with an isolation layer of PVA and the desiccated lining adhesive on the reverse removed with instru-

The letter written by the American committee to Guizot on February 1, 1841, asking for sittings for the portrait, makes the purpose of the commission clear:

> Sir, The undersigned, citizens of the United States of America, sojourners in Paris, being deeply impressed with the friendly spirit and general excellence of the introduction to your valuable edition of the Life and Writings of Washington, have united for the purpose of soliciting you to sit for your picture to an American artist who has earned a high reputation in his profession. Our ulterior purpose is to transmit the portrait to the speakers of our Congress, and to request for its place in the library of that body, as a permanent memorial of the profound respect which we entertain for your personal character and intellectual trophies, and, in particular, of the gratitude which all Americans should feel for your liberal agency in exhibiting anew to Europe the true nature of their Revolution and the distinctive preeminence of its hero.[2]

Healy, then twenty-seven, was the "American artist who has earned a high reputation in his profession." Living in London, Healy had come to Paris several times since 1838, to paint General Lewis Cass, American Minister to France, Mrs. Cass, King Louis Philippe, and the French Minister of War, Maréchal Nicholas Jean de Dieu Soult. The portrait of Mrs. Cass won a third-class medal at the Paris Salon of 1840.

Healy later discussed the portrait of Guizot in his autobiography, *Reminiscences of a Portrait Painter.* He noted his impressions of the stern minister:

> Cold in manner, exquisitely polite, he was inflexible when he thought himself to be in the right.... He was a grandson, on both sides, of Protestant ministers, and had inherited some of their austere and cold eloquence.... Guizot, who was a highly respected professor ... in private life was not only a man of pure and high principles, but full of tenderness and delicacy. ... Guizot was then a man of about fifty-five, in the full strength and vigor of his long life.... The head was remarkably fine and delicate, the head of a scholar and of a perfect gentleman.[3]

For the commission, Healy began by painting a small sketch, described in his *Reminiscences:*

> Before beginning the large portrait I made a careful drawing on a canvas, just rubbed in here and there with a little color. This was considered so successful that I left it in an unfinished state, and have kept it ever since.[4]

This sketch appears to be the small study now in the Preston Morton collection. Its subsequent history is unclear. It may be the study for the portrait of M. Guizot that Healy lent to the Paris Salon of 1889.[5] The inscription in French on the reverse of the canvas reads in translation: "This is a copy of the large portrait representing M. Guizot, commissioned in 1841 from Mr. Healy by a committee of Americans. The painting is in the Library of Congress in Washington." The information on the reverse is only partially correct. The large portrait was sent to Washington, D.C., in 1842 and became a gift to the newly founded National Institution for the Promotion of Science, forerunner of the Smithsonian Institution.[6]

The small study is remarkable for its kinship with the finished portrait, with which it agrees in every detail of composition and coloring. Guizot in both paintings is shown in a black suit, wearing the badge, star, and sash of the Legion of Honor. He holds a scroll inscribed *Washington au Val Richer — Septembre 1839,* a reference to Guizot's essay on Washington, written at Guizot's country estate, Val Richer, in September 1839. Elsewhere in both paintings we see a black robe thrown over a red Empire side chair, and a table, draped in green, with several large documents. One bears a red seal and is inscribed *Fait à Paris/Par le Roi.* This may be the document containing Guizot's appointment as Foreign Minister. On the flowered carpet in the foreground are several large volumes, probably some of Guizot's publications on representative government, the history of France, and the history of Europe.

ments, and punctures in the support were luted with gesso. The support was infused with a microcrystalline wax and resin mixture. A double lining was attached with a microcrystalline wax-resin mixture. The painting was spray coated with an isolating layer of B72 in xylene and toluene and inpainting done with acrylic. Final sprays of B72 in xylene were applied.

The support, a light-weight, plain weave linen of excellent quality, is covered with a white ground sufficiently thick to hide the fabric texture. The oil-type paint is handled as a diluted paste and is slightly transparent. It is uniformly thin and smooth except in details of tassels, jewel, and furniture, where a stiffer paste is handled with some relief as design accents.

fig. 1 George Healy, *Portrait of François Pierre Guillaume Guizot.* Reproduced by permission of the National Museum of American Art (formerly National Collection of Fine Arts), Smithsonian Institution. Transfer from the National Institute.

The oil study of Guizot differs markedly from the only other known studies for Healy's portraits. The first, almost contemporary with this portrait, was for his full-length of Maréchal Soult, painted in Paris in 1840. The study, oil on wood panel, is very loosely painted. It is a study intended to mark the main compositional and color elements of the painting.[7] The second, a drawing on paper, is dated 1872 and was made for one of the portraits of Prince Charles of Roumania.[8] In its greater detail, this study is closer to that of Guizot, but as a drawing it lacks the element of color. It shows, however, particularly in the face, that Healy in his studies could be as thorough as he would be in the finished portrait.

Like the full-length of Guizot, Healy arrived in Washington, D.C., in May 1842, sent by King Louis Philippe to copy the full-length Lansdowne portrait of George Washington by Gilbert Stuart, which hung at the White House. Both Healy and the portrait of Guizot were praised in newspaper editorials as tributes to American genius in the fine arts. The portrait was soon placed on public view in the new Patent Office Building, whose third floor gallery served as the exhibition hall for the portrait's new owner, the National Institution for the Promotion of Science. It hangs today in a nearby gallery, in the National Museum of American Art.

Ellen G. Miles

Notes

1. The full-length portrait, 94 x 56 in., is signed and dated *G. P. A. Healy pinxt. Paris 1841.*
2. The original letter, written in English, was published as Appendix XV, p. 478, in Guizot's *Mémoires pour servir à l'histoire de Mon Temps,* Vol. IV (Paris, 1861). One of its signers was Jared Sparks. Guizot discusses the portrait on pp. 320–321.
3. G. P. A. Healy, *Reminiscences of a Portrait Painter* (Chicago: A. C. McClurg and Co., 1894), pp. 174-178. The portrait of Guizot is also discussed in *Healy's Sitters* (exhibition catalogue), Virginia Museum of Fine Arts, Richmond, 1950, pp. 20–21, and in Marie de Mare's *G. P. A. Healy, American Artist* (New York, 1954), pp. 88, 102, and 107.
4. Healy, *Reminiscences,* p. 178.
5. *Explication des ouvrages . . . exposés au Palais des Champs Elysées, le 1er Mai 1889,* no. 3324, "Portrait de M. Guizot, étude 1889 D." This study was exhibited in the drawings section of the Salon. My thanks are to Lois Fink for this reference.
6. Joshua C. Taylor, *National Collection of Fine Arts, Smithsonian Institution* (Washington, D.C., 1978), pp. 6–11. The portrait of Guizot is illustrated on p. 11. Considerable information about the gift of this portrait to the National Institution and its transfer to the Smithsonian Institution is also available in the files of the Curatorial and Registrar's Offices, National Museum of American Art.
7. This study measures 21¾ x 14 in., smaller than the study of Guizot. It belongs to the Columbus Gallery of Fine Arts, Columbus, Ohio. See The Louisiana State Museum exhibition catalogue, *G. P. A. Healy: Famous Figures and Louisiana Patrons,* 1976–1977, pp. 14–15, no. 4, repr.
8. Louisiana State Museum catalogue, pp. 66–67, no. 29, repr. This drawing measures 30½ x 24½ in., framed. The drawing is in a private collection.

Exhibitions

N.Y., Hirschl & Adler, *Selections from the Collection of Hirschl & Adler Galleries,* II, 1960, no. 17, repr.
SBMA, *Two Hundred Years,* 1961, no. 33.

References

Believed to be the study kept by the artist, and referred to in G. P. A. Healy, *Reminiscences of a Portrait Painter* (Chicago: A. C. McClurg and Co., 1894), p. 178.

William Morris Hunt
1824-1879

William Morris Hunt was Boston's finest portrait painter and teacher during the third quarter of the nineteenth century, a collector and promoter for modern French and American art, an intimate in all the most lively literary circles of the city, and a witty, caustic critic of the status quo. And yet, withal, a curiously incomplete artist was Hunt. He died a hopelessly depressed man, certain that his legacy would fall far short of his lofty aspirations.

Hunt was the second child born to Jonathan Hunt, III, and his wife Jane, in Brattleboro, Vermont. The father was a lawyer and member of the State Legislature (later a congressman), the mother an amateur artist and daughter of a Connecticut judge. After his father died in Washington in 1832, Jane Hunt began in earnest the artistic education of her children, moving them first to New Haven and later, in 1838 to Boston. Hunt's rather dilettantish early life included some drawing lessons in New Haven with an Italian artist named Gambardella, a few classes in a sculptor's studio in Boston, followed by a rather indifferent performance as a student at Harvard.

In the fall of 1843, the entire Hunt family left for the Grand Tour of Europe. After lessons with Henry Kirke Brown, an American expatriate sculptor in Rome, young William scrapped his plans for a return to Harvard and traveled to Greece, Turkey, and Switzerland, and finally, in the winter of 1845, to the famous Düsseldorf Art Academy in Westphalia.

Hunt disliked the "grinding methodical process" of Düsseldorf training and perhaps on the advice of his younger brother, Richard (later an architect of considerable renown), went to Paris, where late in 1846 he enrolled as a student of Thomas Couture. A great favorite with American students for many years, Couture taught an accessible recipe for painting that included a combination of simple light and dark patterns developed first through thin sepia washes, slightly thicker glazes added to half tones and darks with heavier, often exaggerated impastos reserved for the light areas. It was all very "French" in its dash and spontaneity, and Hunt thoroughly enjoyed his exposure to the Couture method. Hunt exhibited at the Paris Salon of 1852 while still a disciple of Couture but shifted his allegiance in the same year to Jean-François Millet, then a resident of Barbizon and soon to be the idol of Hunt for the rest of his career.

Millet and the peasants of Barbizon combined to offer Hunt an ingredient lacking in his previous work, a sincerity based on genuinely humanistic ideals. With Millet, Hunt "felt the infinitude of art . . . with Couture there was a limit."

Hunt bought Millet's most famous painting, *The Sower,* for only 300 francs and began then a personal crusade on behalf of Barbizon art that he spread to his own pupils and friends after his return to Boston in 1855. There, in the same year, he carved a comfortable niche for himself in Boston's social register with his marriage to Louisa Perkins. He built a spacious residence and studio in Newport, Rhode Island, where, in addition to several important portrait commissions, he took on a few pupils for informal instruction. Among his early students were William and Henry James, John Bancroft, and two future professional artists, Edward Wheelwright and John LaFarge.

Hunt moved from his Newport retreat in 1862 to take up quarters first in the Roxbury section of Boston and later at the Studio Building on Tremont Street. By 1864, he moved into a new, large studio in the Mercantile Building on Summer Street. In 1865, Hunt was elected the first President of the Allston Club, which, along with his affiliation with the Boston Athenaeum, the Boston Art Club, and the National Academy of Design in New York, provided him with additional opportunities for exhibiting his work, this time

18 Portrait of a Child in Fancy Costume

(previously titled *Head* and *Child's Head*)
ca. 1854
Oil on canvas
20¼ x 15⁷/₁₆ in. (51.5 x 39.3 cm)
Signed, dated, and inscribed on reverse (fig. a): W.M.H. May 8 1854 [84?]/ to F.H.S. [F.M.S.?]
Gift of Mr. and Mrs. Victor D. Spark
61.6

fig. a William Morris Hunt, *Portrait of a Child in Fancy Costume,* detail of reverse. Preston Morton Collection, Santa Barbara Museum of Art.

Provenance

(Miliken Sale, N.Y., 1902, no. 3); Colonel C. E. S. Wood, possibly of San Francisco; (Victor D. Spark, N.Y.); from Mr. and Mrs. Victor D. Spark to the PMC, 1961.

Condition and Technique

Prior to its being sent in 1961 to the SBMA, the painting was lined (letter from Spark of Jan. 4, 1961), with an aqueous adhesive to a single weave fabric. The inscription on the reverse was covered by the lining and is known from the photograph taken at the time.

In 1978 examination by the BACC noted the tacking margins had been cut. Both ground and paint appeared secure despite raised edges of paint in cupping, especially in the forehead and the l. side of the brown background. The surface coating, a glossy, natural resin (estimated), showed abrasion along the edges from the rabbet.

The support consists of a fine, light-weight, loosely woven fabric. The ground, a greyish layer of medium thickness, does not hide the weave texture. The paint, an oil type, varies from thick impasto and marked brushstrokes in the light areas to thinner, smoothly modeled passages in the dark areas.

along with those of his favorite French contemporaries including the Barbizon group. In 1866, Hunt began his long interest in charcoal drawing during a trip with his wife and three daughters to France, England, Holland, and Italy. He returned in April of 1868.

On his return to Boston, Hunt opened his studio to forty women pupils for classes in charcoal drawing. One of his students, Helen Knowlton, later adapted her notes from these classes into a book called *Talks on Art*. Hunt's wit and charm, unencumbered by fear of contradiction, stimulated not only aspiring artists but also future patrons. (Many of the major benefactors of the Museum of Fine Arts in Boston had their taste first honed under Hunt's direction.)

In 1872, Hunt separated from his family and suffered a disastrous fire in his Summer Street studio. During a trip to Florida in 1873, he started to study landscape painting in earnest, all but giving up entirely on portraiture. Trips to Cuba and Mexico followed, along with several excursions to the Massachusetts countryside where, in 1877, he built a studio in Magnolia.

In 1878, Hunt was awarded the commission for two lunettes in the dome of the new capitol building in Albany, New York. *Anahita (The Flight of Night)* and *Columbus (The Discoverer)* were finished by December of that year amidst very favorable critical response. The drain on Hunt's energy was considerable, however, and his spirits were darkened further when an appropriation for more work was vetoed in the state legislature. Faults in the construction of the dome were also discovered, forcing the builders of the capitol to cover both of Hunt's murals.

A lack of sales of his recent landscapes, the continued separation from his family, and the death of his mother extracted an additional toll. In the late summer of 1879, Hunt visited his friend, the poetess Celia Thaxter at Appledore, New Hampshire, on the Isle of Shoals. On September 9, after he failed to return from a walk in the rain, he was found dead in a small reservoir behind Celia's house. His death, at first thought to have been a suicide, was probably caused by a sudden stroke, hints of which were already present prior to Hunt's sojourn at Appledore.

In November of 1879, the Museum of Fine Arts, Boston, mounted a large Memorial Exhibition of Hunt's work which included 200 oils, 110 charcoal drawings, 3 sculptures, and even a patchwork quilt made when Hunt was a schoolboy in Brattleboro. A sale following the exhibition netted $63,877, a record at that time for sales in Boston.

Peter Bermingham

Portrait of a Child in Fancy Costume

This small portrait is closely related to a slightly smaller (18 x 14 in.) but quite similar undated painting, *Head of a Child,* in the Museum of Fine Arts, Boston. That painting was donated by the Bartol family in Boston, which included Elizabeth Bartol, one of Hunt's students in the 1870s. The Santa Barbara painting is dated and inscribed on the reverse. But that inscription, "W.M.H. May 8 1854/ to F.H.S. [F.M.S.?]" may have been a posthumous inscription with the nearly illegible date actually reading "1884" and referring to a sale of the work five years after Hunt's death.

Who exactly the F.H.S. or F.M.S. might be is no less of a puzzle. Hunt scholar Martha Hoppin has suggested that it might refer to Frank Hill Smith, an artist friend of Hunt's from the 1870s, or possibly to a member of the family of Quincy Adams Shaw, Millet's most important patron in America and a friend of Hunt.

However cloudy evidence on the reverse of this canvas may be, a date of about 1854, shortly before Hunt's return from Paris, does seem fairly secure although this painting lacks in the face much of that artfully contrived spontaneity that Hunt learned from Couture (and which is present to a slightly greater degree in the Boston painting). Ideal figure subjects dominated most of Hunt's publicly displayed work during his association with both Couture and Millet in Paris. His first exhibited paintings in Paris, *The Fortune Teller* and *La Marguerite,* shown at the Salon of 1852, are in this genre, as are *The Hurdy Gurdy*[1] and *Bohemian Girl,* shown at the Boston Athenaeum in the same year. The more directly conceived *Portrait of a Child in Fancy Costume* does seem to display some of the contradictions in Hunt's approach that we might expect to find at this still early stage of his career. The boldly painted sleeves, for example, seem to be a rather dashing gratuity compared to the paste-like quality in the firmly constructed face. On the one hand, Hunt has apparently tried to retain important features of the sketch — a keystone of Couture's teaching — while providing a measure of balance in the strong features of the child's head.

Hunt's oft-stated goal of breadth and simplicity, his weapons in the battle against a more photographic portraiture, is only partially realized in this fairly modest work from the early years of his professional life.

Peter Bermingham

Notes
1. All three paintings are in the collection of the Museum of Fine Arts, Boston.

Exhibitions
Chicago Exposition, 1885.[1]
San Francisco Art Association (unknown date).[1]
SBMA, *Two Hundred Years,* 1961, no. 36, mentioned "Introduction," n.p.
SBMA, *American Portraits,* 1966, no. 42, repr., n.p.

1. From information provided by Victor D. Spark in a letter of Jan. 4, 1961 to James W. Foster, Director, SBMA.

Randolph Rogers
1825-1892

Randolph Rogers was a member of the second generation of American expatriate sculptors to live and work in Italy in the nineteenth century. Like many successful Americans of his time, he rose to prominence from a humble background.

Born in Waterloo, New York, in 1825, Rogers moved with his family to Ann Arbor, Michigan, at a young age. After a brief period of schooling, he was apprenticed in a bakery, and a few years later became a dry goods clerk. Eventually, he moved to New York City, where he continued in the same work until his employers discovered that he had a gift for modeling in clay, which he had been pursuing in his spare time. Financed by these farsighted businessmen, Rogers set off for Italy to study sculpture.

Study in Italy, leading to a career as an expatriate there, was typical for American sculptors of Rogers's time. Much of the world's great sculpture, from virtually every age, was to be found in Italy, while in America little other than plaster casts of the original works were available for study. Furthermore, in Italy the sculptor found a plentiful supply of suitable marble, along with a large work force of skilled marble carvers. As it was customary for sculptors of that time to execute their work in clay models, which were then realized in marble through reproduction by hired craftsmen, the Italian marble-carving industry was virtually indispensable to the success of sculptors such as Rogers.

In addition to these practical assets, the expatriate sculptor's life in Italy had a romantic appeal heightened by the glamorous accounts of the "art life" by writers such as Hawthorne, Henry James, and the Brownings[1] who knew the colonies of expatriate artists in Florence and Rome.

The migration of American sculptors to Italy began when Horatio Greenough settled in Florence in 1825. This first generation of expatriate artists also included Hiram Powers and Thomas Crawford. Rogers was one of a younger group of artists who arrived in the late 1840s and 1850s, most of whom eventually gravitated to Rome. To this second generation likewise belonged William Wetmore Story, Edward Bartholomew, Paul Akers, Chauncey B. Ives, and Harriet Hosmer. The vogue for neoclassical sculpture as produced in Italy gradually subsided after the American Civil War, and by the 1890s the center of artistic life had finally shifted to Paris, where a new school of realist sculpture identified with Rodin had emerged.

Rogers arrived in Florence in 1848, to begin three years of study with the neoclassical sculptor, Lorenzo Bartolini. Following a move to Rome in 1851, Rogers soon produced two sculptures that were to secure his reputation in America: the "ideal" figures of *Ruth Gleaning* and *Nydia, the Blind Girl of Pompeii*. Both of these works were based on literary sources. The *Nydia* depicts the blind heroine of Edward Bulwer-Lytton's novel *The Last Days of Pompeii* (1834), as she gropes her way to safety through the lava fields. Both statues were extremely popular, and dozens of replicas were ordered by wealthy travelers visiting Rome on the Grand Tour. The sale of these statues provided Rogers with a steady income and the means of repaying his original benefactors. As a result of the popularity of these sculptures, Rogers received a commission for a life-size figure of John Adams to stand in a chapel at Mount Auburn Cemetery in Cambridge, Massachusetts. For this commission Rogers returned briefly to America in 1855, a successful sculptor at the age of thirty.

Rogers's career was greatly assisted at this time by the friendship and patronage of Professor Henry Simmons Frieze (1817–1882), who was later to become President of the University of Michigan. Through his urging, a group at the University raised the money to buy an early copy of the *Nydia*. Due to Frieze's influence, Rogers bequeathed several examples of his work and his entire collection of casts to the University of Michigan.

19 *Ruth Gleaning*

(reduced version)
1861
Marble
H. 34¾ in. (80.83 cm), including circular base
Signed, inscribed and dated on back of base: Randolph Rogers, Rome 1861.
Museum purchase with funds provided by Mrs. Sterling Morton for the purpose of securing a statue for the niche in the Preston Morton Gallery
69.9

Provenance

Previous history unknown; (according to a letter of Aug. 23, 1980, from Spark to P. Knowles, purchased from "a dealer in the Boston area" by Spark); purchased from Spark by the SBMA for the PMC, 1969.

Condition

Prior to its acquisition in 1969 by the SBMA the statue, "discolored by dirt and grime," was cleaned, according to a letter of Oct. 11, 1968 from Spark to Goldthwaite H. Dorr III, then Director, SBMA.

In the Spring of 1977 the little finger of Ruth's right hand was broken off at the joint of the hand and lost.

In 1977 examination by the LACMA Conservation Center noted overall surface dirt and grease, with several inclusions and pits in the marble. Treatment was completed Sept. 1977 by the LACMA Conservation Center. The statue was cleaned with water, Basic Hand Basic I by Shackley, and Wyandotte Detergent by Vermarco in the more soiled areas. The surface was spray coated with B72, 3% in toluene. The missing proper right little finger was modeled after the version owned by Mr. and Mrs. Julian Ganz, which is of a different scale. The finger was made out of hydrostone, PVA, no. 9 glass beads and powdered pigment in ochre and white. The finger was attached to the sculpture with PVA emulsion, then coated with liquitex polymer and acrylic paints, and given a final coat of B72, 8% in toluene.

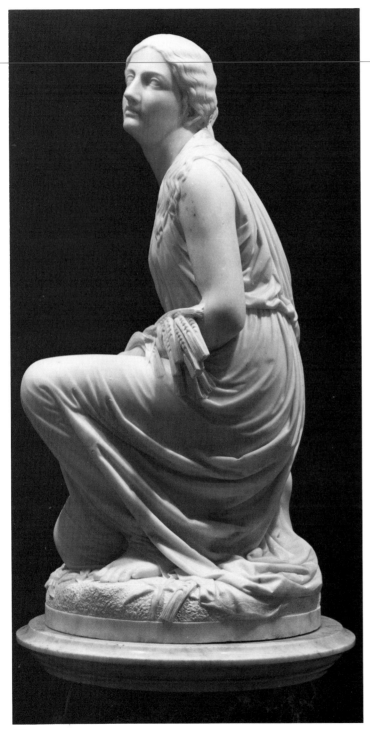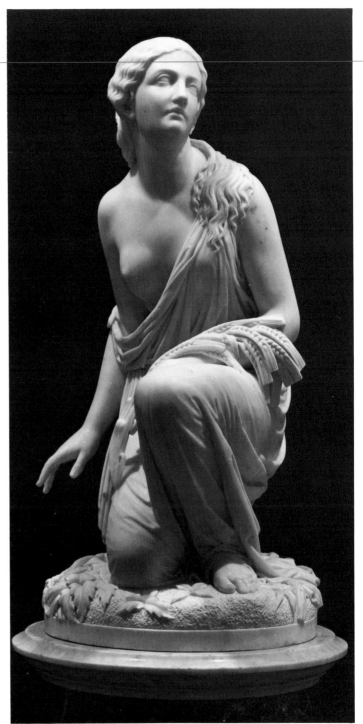

19

Unfortunately, because of their neglect for many years in inadequate storage facilities, only three of these casts have survived.

American officials were eager to embellish the republic with monuments that would rival those of Europe, and Rogers was successful in obtaining many governmental commissions. The first of these was a set of bronze doors for the Rotunda of the Capitol in Washington, D.C., completed in 1859. Inspired by Ghiberti's doors in Florence, Rogers's panels represented scenes from the life of Columbus. At about this time, Rogers was also commissioned to complete the Washington Memorial in Richmond, Virginia, which had originally been designed by Thomas Crawford and was left unfinished at the latter's death in 1857.

After the Civil War, Rogers was kept busy designing various memorials. Some, like the *Angel of Resurrection* for the Colt Funerary Monument in Hartford, Connecticut (1863–1864) and the *Sentinel (Soldier of the Line)* for the Cincinnati Memorial (1864–1865), involved single figures. Others, such as the *Soldiers' and Sailors' Monuments* for the cities of Providence (1871), Detroit (1873) and Worcester (1874), were grandiose confections of allegorical figures in marble and bronze arrayed on a stepped base, and capped by a single figure. For each of these projects, Rogers was paid from $50,000 to $75,000.[2]

Although Rogers executed portrait busts for private collectors, most of these have disappeared. His colossal bronze statue of Lincoln for Fairmount Park, Philadelphia (1871) and a similar seated bronze of William Seward in Madison Square Garden, New York (1876), executed during his declining years, were portraits of state heroes rather than living individuals. Other late works were the *Lost Pleiad* (1874–1875), which was exhibited, along with copies of *Ruth Gleaning* and the *Nydia* in the Philadelphia Centennial Exhibit in 1876, and the Nike-like statue, *The Genius of Connecticut* (1877), crowning the dome of the state capitol in Hartford.

Due to increasing paralysis, Rogers was less active during the last ten years of his life. He died in Rome in 1892.

By contemporary standards of fame and fortune, Rogers's career as a sculptor was a success. He was not only knighted by King Umberto of Italy, but was the first American ever to be elected a member of Rome's prestigious Accademia di San Luca.

James Jackson Jarves, a critic of the period, astutely identified the shortcomings of American neoclassical sculpture, particularly in its attempt to impress through sheer size or technical tour de force, but conceded that as pioneers of monumental sculpture in America, these artists had played a vital role: "No nation, in so brief a period, has produced better work, or developed a wider range of motives. From nothing, sculpture has risen to be a popular want."[3] Through his enormous body of work and the considerable popularity of statues like *Ruth Gleaning,* Randolph Rogers contributed to the changing attitude on the part of the American public. By catering to the popular taste for the sentimental and anecdotal, Rogers succeeded in creating an interest and a market for sculpture in America, thus paving the way for its achievement in the twentieth century.

Penny Knowles

Notes

1. Cf. Nathaniel Hawthorne, *The Marble Faun* (Boston: Ticknor and Fields, 1860); Henry James, *William Wetmore Story and His Friends* (Boston: Houghton and Mifflin and Co., 1903).
2. Millard F. Rogers, Jr., *Randolph Rogers: American Sculptor in Rome* (Amherst, Mass.: University of Massachusetts Press, 1971), pp. 107–112.
3. James Jackson Jarves, *The Art-Idea* (1864;rev. ed. Benjamin Rowland, Jr., Harvard University Press, 1960), p. 226.

Ruth Gleaning

Ruth Gleaning is reputedly Randolph Rogers's earliest "ideal" work. The original was probably modeled in 1853, two years after Rogers took up residence in Rome. The first reference to it is in a short article in the *Charleston Courier* of September 22, 1853, which states, "Mr. Randolph Rogers, sculptor, from the U. States, who has been studying in Italy for several years, has exhibited a statue, Ruth, in the house of Mr. Dudley Selsen in Paris. This work is said to be well done, and reflects great credit upon the artist."[1] *Ruth Gleaning* is also mentioned in an article for the *Art Journal* by one Florentia who visited Rogers's studio in the Piazza Barberini in the spring of 1854.[2]

The statue soon became one of Rogers's most popular works, surpassed in repute only by *Nydia, The Blind Girl of Pompeii,* modeled in 1855. Rogers himself promoted the popularity of these sculptures by submitting both to the International Exposition in London in 1862 and the Philadelphia Centennial in 1876.

We know that many replicas of *Ruth Gleaning* were ordered, and that Rogers entrusted their manufacture, according to contemporary practice, to skilled Italian marble carvers. Using a cast made from Rogers's original clay model, the carvers transferred the dimensions to white Carrara marble, with the help of a pointing machine.[3] Although this mass production method, decried by discriminating contemporaries, led to a certain lifelessness and uniformity in the sculpture, it was accepted practice and extremely profitable.[4] Because Rogers did not keep a journal until 1867, it is not known exactly how many copies of *Ruth* were commissioned. Entries in Rogers's *Journal* record the sales of ten copies of the original life-size version, and twenty-one of the three-quarters-size reduction, but there must have been many more, perhaps fifty in all.[5] Rogers's biographer, Millard F. Rogers, Jr., has identified twelve surviving *Ruths* in private and public collections, of which five predate the Journal entries.[6] Among these is the one purchased for the Preston Morton Collection in 1969; one of the reduced versions, the statue is inscribed and dated "Rome, 1861." Its original owner and subsequent history are not known.

Like much other neoclassical sculpture of the period, the subject of *Ruth Gleaning* comes from a literary source. Ruth is depicted as described in the Bible (Ruth 11:1–13) gleaning wheat in the fields of Boaz, at the moment she encounters her future benefactor and husband. Rogers has portrayed her as a crouching figure, loosely clad with one bared breast, her face upturned in an expression described as "hesitating between hope and fear."[7] The sheaf of wheat draped over her forearm and thigh and the vegetation under her feet are her identifying attributes.

Since Rogers wrote very little about either his artistic beliefs or the subject matter of his art, we can only speculate on what this figure meant to him and his contemporaries.[8] We know that Ruth was a fairly popular subject at mid-century with both artists and writers. Florentia, who visited Rogers in 1854, refers to a "Ruth fever," comparing the vogue for depictions of Ruth to an epidemic of measles, and calls Rogers's *Ruth* "not remarkably different from its countless fellows to be found in the studios of all nations."[9] In citing several depictions of Ruth by nineteenth-century sculptors, William H. Gerdts concludes that "the subject seems to have had special appeal to Americans who may have felt that they, too, were toiling in an alien land."[10]

Ruth as a figure in nineteenth-century literature appears, for example, in Keats's *Ode to a Nightingale:* "Through the sad heart of Ruth,/when, sick for home/she stood in tears amid the alien corn . . ."; in Thomas Hood's poem, *Ruth:* "she stood breast high amid the corn/ clasped by the golden light of morn,/ like the sweetheart of the sun/ who many a

glowing kiss has won. . . ." It is tempting, however, to connect Rogers's *Ruth* with George William Curtis's *The Howadji in Syria,* a fictionalized account of the author's travels in the Near East and the Holy Land, which had been published in 1852 and was a best seller at the time. Curtis was also an American and had earlier lived in Rome, where he had associated with other expatriate writers and artists, including Hawthorne. Curtis, in the *Howadji,* mentions Ruth twice, once in connection with religious painting, another with his impressions of Nazareth and memories of childhood sermons, saying, "In that calm Syrian afternoon, memory, a pensive Ruth, went gleaning the silent fields of childhood, and found the scattered grain still golden, the morning sunlight yet fresh and fair."[11]

Rogers's *Ruth Gleaning* differs from contemporary versions of the subject he might have seen and from the verbal descriptions of Keats and Hood, as she is not represented standing. Her crouching pose may have been suggested by an antique statue such as the *Kneeling Aphrodite* in the Vatican Museum, although the alignment of the arm and tilt of the head are slightly different.[12]

Unlike the Hellenistic model, however, *Ruth* is not completely nude. Her partial undress provides, in fact, a clue to the ambivalent content of the work: a mixture of innocence and sexuality. To the Victorian, nudity was synonymous with eroticism.[13] With their Protestant background, Americans in particular found nudity in art, however appealing, hard to accept, unless presented in the guise of Christian virtue, as in the case of Hiram Powers's *Greek Slave,* or Erastus Dow Palmer's *White Captive.* Possibly this was what Rogers had in mind when he cast his heroine as the Biblical Ruth, for, although her relationship with Boaz is suggestive, her virtue was beyond reproach. The essential innocence of Ruth is also alluded to in Curtis's reference to her childlike quality in *The Howadji in Syria.* The message conveyed by Rogers's *Ruth* seems as contradictory as Victorian mores themselves. Her virginal innocence has definite erotic appeal, made explicit by her immodest costume and languorous expression. The surface of the marble, too, is both seductive and coldly impersonal.

The style of *Ruth,* which combines literally rendered details with idealized form, is characteristic of the statues of American sculptors working in Italy at mid-century. Because of its simple sculptural forms, *Ruth* has been regarded as "the most pleasing of all [Rogers's]" works."[14] It is certainly more serene and self-contained, more classical in its simplicity of outlines, than Rogers's subsequent production. *Nydia,* executed two years later, and *Lost Pleiad* (1874–1875) by comparison are almost baroque in the complex treatment of drapery folds and the depiction of movement and extreme emotion. In *Ruth,* on the other hand, the curves of arm and drapery enfold the figure, leading the eye in a gentle spiral toward the head, while such precise details as the strands of hair cascading down the shoulder and the undulating stalks of wheat across the thigh repeat these large rhythms rather than interrupting them.

Ruth Gleaning was one of Rogers's first triumphs. It was not only a popular work at the time, but in retrospect, considered one of his best. While there is a certain theatricality about Ruth's pose, and the content may seem maudlin to modern sensibilities, Rogers's sculpture of Ruth must be viewed as an honest attempt of a young impressionable artist to embody the taste of his time. It typifies the taste of the period for literary subjects carved in pure white marble, derived from classical prototypes, romanticized in expression and "literal" in the careful rendering of accessories. As a more recent addition and as its only sculpture, *Ruth Gleaning* fills an important gap in the Preston Morton Collection.

Penny Knowles

Notes

1. Millard F. Rogers, Jr., *Randolph Rogers: American Sculptor in Rome* (Amherst: University of Massachusetts Press, 1971), p. 198. Wayne Craven, *Sculpture in America* (New York: Thomas Y. Crowell Co., 1968), p. 313, says, "the statue was not put into marble until 1855," but he does not indicate the source of his information.

2. Florentia, "A Walk Through the Studios of Rome," *Art Journal,* June 1,1854.

3. The original plaster cast listed as no. 140 in Martin L. D'Ooge's *Catalogue of the Gallery of Art and Archaeology,* University of Michigan, Ann Arbor, 1892, has since disappeared.

4. The mechanical reproduction of statues like Ruth was ridiculed by Hawthorne in the *Marble Faun* (New American Library Edition, 1961, pp. 88–90); James Jackson Jarves, *The Art Idea,* (1864; reprint, Cambridge, Mass.: Belknap Press, 1960), p. 211, commented derogatorially that sculptors "manufacture statuary on the same principle that they would make patent blacking, founding their standard of success on the amount of their sales." A visitor to Rogers's studio reported that he saw there "seven *Nydias,* all in a row, all listening, all groping, and seven marble cutters at work, cutting them out. It was a gruesome sight!" (D. H. Armstrong, *Day Before Yesterday,* 1920).

5. For the complete list of Journal entries recording commissions for replicas of *Ruth,* see Rogers, *Randolph Rogers,* pp. 198–199.

6. Rogers, pp. 197–198.

7. William J. Clark, Jr., *Great American Sculptures* (Philadelphia: Gebbie & Barrie, 1877), p. 75.

8. A reporter for the *Michigan Argus* (Dec. 6, 1867) quotes Rogers as being of the opinion that "henceforth there will be fewer Cupids, Pucks, Venuses, and subjects from mythology than there have been; that the public taste is satiated; that the Bible, instead of heathen mythology, will henceforth be the textbook of artists." Quoted by Rogers, p. 18.

9. Florentia, "A Walk."

10. William H. Gerdts, *American Neo-Classic Sculpture: The Marble Resurrection* (New York: Viking, 1973), p. 69.

11. George William Curtis, *The Howadji in Syria* (New York: Harper and Brothers, 1877), p. 262.

12. The resemblance was noted by Rogers, p. 15 (fig. 3). Use of ancient prototypes was common practice, and it is thought that *Nydia* was modeled on similar antique models.

13. Rogers, p. 18; Gerdts, pp. 20–22; Albert Ten Eyck Gardner, *Yankee Stonecutters* (published for the Metropolitan Museum of Art by Columbia University Press, 1945), p. 14.

14. Lorado Taft, *The History of American Sculpture* (1903; new ed., New York: MacMillan Co., 1925), p. 161.

Severin Roesen
ca. 1815–ca. 1872

Severin Roesen is today the best known of the still-life specialists working in the United States during the middle of the nineteenth century, yet the details of his life remain uncertain, despite the efforts of a number of scholars who have investigated his career.[1] Roesen's place and date of birth are not known, but it has been suggested that he was born about 1815, and that he was a German Rhinelander who exhibited a flower painting at the local art club in Cologne in 1847. He and his future wife, Wilhelmina Ludwig, were among the many immigrants who left Europe in the wake of the mostly unsuccessful liberal revolutions of 1848. They settled in New York City and married shortly thereafter; the first of their three children, all born in New York, was Louisa Roesen, born in 1851.

Roesen was active as a still-life painter in New York City, exhibiting his work with the American Art-Union in 1848, 1849, and 1850, and one of his pictures was sold in the Art-Union sale in 1852. About 1857, Roesen appears to have abandoned his family and left New York, perhaps due to the economic depression of the times, or to the growing disenchantment with the Düsseldorf style of painting from which his art derived. Roesen went to Pennsylvania, first to Philadelphia and then to Harrisburg, where he was active in 1859. By the following year he was in Huntington in that state, and by 1862 he had settled in the then prosperous community of Williamsport, where he remained for about a decade and established a local reputation. Like his date of birth, Roesen's death date is unknown, though a dated painting of 1872 clearly disproves previous suggestions and local traditions that he died in a Philadelphia almshouse in 1871. Tradition also has suggested that Roesen did finally leave Williamsport, probably in 1872, perhaps retracing his route back to his family in New York City, but his place of death is likewise unrecorded.

William H. Gerdts

Notes

1. Lois Goldreich Marcus, *Severin Roesen: A Chronology* (Williamsport, Pa.: Lycoming County Historical Society and Museum, 1976) is the most recent and thorough study of Roesen's art and career; see also the slightly earlier articles of the late Professor Maurice A. Mook listed in the Selected Bibliography. All recent Roesen scholars have been assisted by Roesen's descendant, Mrs. Edna Haseltine, New York City.

Still Life

Severin Roesen produced the largest body of high Victorian still-life painting in America, largest both in number of located works and in the scale and content of such pictures. Probably about three hundred to four hundred still lifes by him have come to light, and this is probably only a fraction of his total production during his approximately twenty-four years of activity in America. All the local pictures are still lifes, though he is supposed to have painted portraits also, at least in Williamsport.[1] Although some of these are relatively small pictures and a few are quite frugal in their content, most of them contain quantities of pieces of fruit or a multitude of different flowers, and a good many of them combine fruit and flowers, often in great proliferation. Roesen often left no area of his paintings unfilled with fruit, flowers, birds, nests, and man-made decorative objects of ceramic and glass, sometimes piled onto a double-tiered table, the better to accomodate the proliferation. Although such abundance was previously interpreted as standard Victorian *horror vacui*, his pictures are now seen as the ultimate embodiment of mid-century optimism in American still-life painting. They represent and proffer the richness of the

20 Still Life

Oil on canvas
25 x 35 in. (63.5 x 88.9 cm)
Signed l.r.: S. Roesen
Not dated
Gift of Mrs. Sterling Morton
60.79

Provenance

Early history unknown; (county auction in Connecticut?);[1] private collection?;[1] Paul Magriel; Mrs. Paul Magriel?;[1] (acquired from Mrs. Magriel?[1] by M. Knoedler and Co., Inc., May 1955); purchased from Knoedler by Mrs. Sterling Morton for the PMC, 1960.

1. From information provided by Nancy C. Little, Librarian, Knoedler, in a letter of Oct. 13, 1980 to the editor: "A6003 [Knoedler stock number] came in from Mrs. Paul Magriel according to all our records. In fact we have made a note in our files that Paul Magriel got it from someone who got it at a county auction in Connecticut. This was purchased from Mrs. Magriel in May 1955 and sold in 1960 to Mrs. Sterling Morton."
This letter reiterated in essence the Magriel provenance provided the SBMA by Knoedler at the time of the acquisition of the painting. William H. Gerdts, however, checked the provenance with Paul Magriel who stated that "he never owned this painting, [nor did] Mrs. Magriel . . ." (letter of Aug. 3, 1980 from Gerdts to the editor). Mr. Magriel in turn informed the editor that he "really [did not] remember."

Condition and Technique

In 1978 examination by the BACC noted the painting had been lined at an unknown date with an aqueous adhesive to a single weave fabric. The tacking margins of the support had been cut. There were scattered small losses with matt and discolored overpaint visible in the r. background, and some fine horizontal tenting along the top edge. The surface coating was matt over inpainting. The general condition was secure.

The support, a fine medium-weight, single and plain weave fabric, is covered with a thin, white ground that does not hide the weave texture. The oil-type paint is applied generally smoothly as a vehicular paste, with white scumbles over the darker colors and some fine impasto.

land, the profusion of God's bounty in the New World, or the bountifulness of Nature as symbolic of God's handiwork and his blessing upon the American Eden. Indeed, the title frequently bestowed upon Roesen's pictures (often perhaps in modern times rather than by the artist himself), *Nature's Bounty*, emphasizes this exuberance. Roesen's pictures were not infrequently painted as pairs, sometimes balancing fruit and flower subjects to underscore their decorative purpose as "dining room pictures," as such were termed in their own day.

Roesen's methodology was never recorded in his lifetime, but it is an extremely synthetic one. Although he may have worked, in part, from actual fruit and flowers — "from nature" — such elements could at best have been only additive to larger, preconceived compositional schemes. Every element in a Roesen still life can be found repeated in other works by him, sometimes many times over; at times the repetition involved individual flowers or pieces of fruit, at others, whole groups of fruit or a bouquet of flowers. These repeated elements indicate that the artist worked either from a large group of templates of individual elements or from a group of "master compositions" he may have kept with him, borrowing separate features for the paintings he created either on order or on speculation, rearranging those elements in different patterns to create unique works, which were often only variations on others already painted. Thus, in the Santa Barbara still life, the flower arrangement at the left is nearly identical to one in a New York private collection (fig. 1), though the fruit and flower below the glass holding the bouquet are different, and the New York painting is *in toto* only the equivalent of the right-hand side of the Santa Barbara picture. Likewise, that same bouquet is identical to a small bouquet in a private collection still in Williamsport, likewise a vertical picture without the added display of fruit at the right, which is in turn duplicated in other of Roesen's paintings. In the Williamsport painting, the same rose substitutes as in the New York example, for the fruit in the lower left, while Roesen added a tulip to the right of the dominant calla lily in the bouquet itself.

The other proof of Roesen's synthetic methodology is his introduction of fruits and flowers that bloom at different seasons of the year, indicating that the composition was not based upon a natural arrangement. Temporal considerations emerge in yet another context in the bouquet of the Santa Barbara painting, where Roesen has introduced the morning glory, a flower of extreme temporal brevity, often introduced symbolically in art to indicate brevity of life. There is no indication, however, that Roesen was concerned in his pictures with flower symbolism, which enjoyed great literary popularity in America and elsewhere in the 1820s, 30s, and 40s — the red rose as symbol of love, the hollyhock, symbol of ambition, etc.

Although Roesen's repertory of fruits and flowers was more extensive than that of any of the other leading specialists of the period in America, such as George Hall, John F. Francis, and others, his basic format was traditional. Despite their new popularity he eschewed natural settings for his subjects, an approach derived from the writings of the English critic and aesthetician, John Ruskin, wherein flowers and particularly fruit were placed, or "replaced," in nature, on the ground and often within grassy nooks, rather than following the traditional and more formal tabletop arrangement.[2] George Hall, William Mason Brown, Paul Lacroix, and others of the period utilized this alternate approach extensively, but the only concession to it that Roesen made was the occasional introduction of a mountainous landscape background behind his arrangements, in place of the more typical, totally neutral background. While George Hall preferred a polished wood

fig. 1 Severin Roesen, *Flowers in a Glass.*
Reproduced by permission. Collection, Nancy Koenigsberg, New York City.

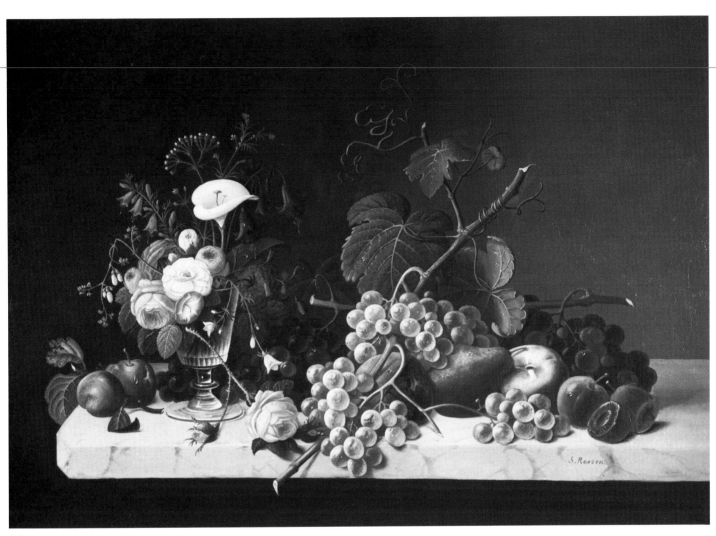

20

"support" beneath his displays of fruit and flowers, and John F. Francis invariably introduced a white tablecloth, Roesen's inevitable choice was richly grained marble — all of these supports, of course, more sumptuous and more pictorially active than the very neutral and almost unidentifiable surfaces preferred earlier in the century by James and Raphaelle Peale.

Analysis of Roesen's compositional formats leads directly to a consideration of Roesen's chronology and a possible date for the Santa Barbara painting. Roesen's style is quite distinctive in America, for it constitutes the most direct transmission of the hard, bright, linear approach to painting practised in the then flourishing art center of Düsseldorf in Germany, near Roesen's early residence in Cologne. Roesen was not the only still-life specialist to immigrate to America from Germany at the time — Werner Hunzinger, George Hetzel were among the others — but he was to become the most noted and appears to have had the greatest influence, one that may have been transmitted in New York where his works were on public display.[3] His influence likewise may have been felt in Huntington and Williamsport, Pennsylvania, where he is known to have had pupils. Both his style and theme were much enjoyed there and in neither place does he seem to have had any competition. While his compositions can be traced back to Dutch prototypes, particularly the works of artists of the late seventeenth and early eighteenth centuries in Holland, such as Jan van Huysum and Rachel Ruysch, whose still lifes offered greater profusion than earlier, more classic Dutch masters, this approach was reinterpreted in Düsseldorf by artists such as George Lehnen and especially Johann Preyer, in harder, more wiry terms. The bright colors, gleaming droplets of moisture, and the sinuous grape stems

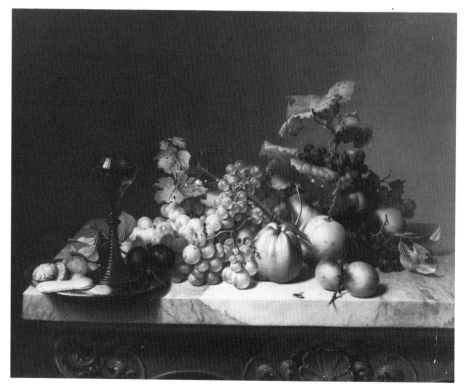

fig. 2 Johann Wilhelm Preyer, *Still Life*.
Reproduced by permission of M. Newman Ltd.,
London.

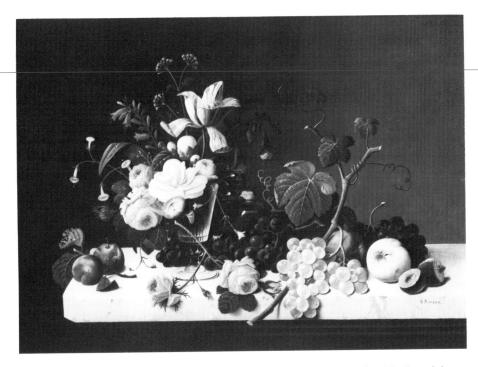

fig. 3 Severin Roesen, *Still Life*. Reproduced by permission of Coe Kerr Gallery.

often found in Roesen's pictures are directly taken from Preyer's Düsseldorf models.

Likewise taken from Preyer is the white marble slab on which the fruit and flower bouquet rest in the Santa Barbara painting (fig. 2). The great majority of Roesen's compositions utilize a grey marble support; only a small number of them introduce white marble, which provides a brighter if somewhat less stately ambiance. It can be estimated that only one out of fifteen or twenty of Roesen's located works contain the white marble support; one of those so far identified uses double-tiered white marble, while another double-tiered arrangement contrasts one white marble slab with a grey slab. None of the white marble paintings has a landscape background.

Yet the landscape background and the white marble support, separately, seem to relate to Roesen's Williamsport period, rather than his earlier, New York years. Although only a handful of Roesen's known works are dated — little more than two dozen out of his hundreds of still lifes — a general attempt at chronology does not seem to sustain the criteria presented by some of the earlier writers on Roesen, who posited either a gradual development from simpler to more complicated compositions, or a deterioration in the overall quality of his work.[4] The landscape background, however, seems to appear only in those paintings dated as done in Williamsport, and this background element can be related to his activity in a more rural, isolated setting. The only two dated works, moreover, in which Roesen introduced the white marble support were painted in 1870 and 1872, toward the end of his Williamsport stay. Furthermore, almost all of his known marble pictures have either remained in Williamsport or can be traced back to a Williamsport provenance. Even the white marble slab itself is standardized in Roesen's work; it is always lightly grained, with a beveled corner, and always continues beyond the picture's edge at the right, but ends suspended at the left (fig. 3); only one located work, an all-flower composition recently on the New York auction market, reverses this scheme.

The actual quality of the workmanship in Roesen's paintings differs enormously from picture to picture; colors can be beautiful or garish; forms can be convincing or grotesquely distorted; and compositions can be ordered or chaotic. Since about half his known or accepted work is unsigned and since the existence of imitators, copyists, and pupils has been recorded or can be proven, the attribution of Roesen's work has become a difficult and complex matter, made more so by the artist's prolific output and by the rising values of his paintings in today's market. The Santa Barbara picture nonetheless is one of the finer of those so far to come to light.

William H. Gerdts

Exhibitions

Greensburg, Pa., The Westmoreland County Museum of Art, *Two Hundred and Fifty Years of Art in Pennsylvania*, 1959, no. 108, Pl. 53 (information provided by Knoedler).

SBMA, *Two Hundred Years*, 1961, no. 54, repr., mentioned "Introduction," n.p.

Los Angeles, University of Southern California, The University Galleries, *Reality and Deception*, Oct. 16–Nov. 24, 1974, no. 6, repr., mentioned in text n.p., traveled Seattle Art Museum, Dec. 4, 1974–Jan. 12, 1975, Honolulu Academy of Art, Jan. 23–Feb. 23, 1975, SBMA, March 13–Apr. 20, 1975.

Honolulu Academy of Arts, *Vignettes of American Art and Life*, Sept. 10–Nov. 7, 1976, no. 1, p. 16.

Notes

1. Richard B. Stone in his "Not Quite Forgotten: A Study of the Williamsport Painter, S. Roesen," *Lycoming Historical Society Proceedings and Papers*, no. 9 (Nov. 1951) records the tradition of Roesen's portraiture. A figure piece of a boy with a profuse still life in the Butler Art Institute in Youngstown, Ohio, has been attributed to Roesen, but this appears to be rather by the little-known Charles Baum, also a German immigrant painter working primarily in Egg Harbor City, New Jersey, and occasionally in Philadelphia, whose history and career seem extraordinarily similar to Roesen's.

2. See William H. Gerdts, "The Influence of Ruskin and Pre-Raphaelitism on American Still-Life Painting," *The American Art Journal*, I, no. 2 (Fall 1969), pp. 80–97.

3. Some of the works of Paul Lacroix, particularly, suggest an extremely close adaptation of Roesen's style and motifs, even including identical items of the decorative arts. Lacroix's life, however, is even less well documented than Roesen's, though he appears to have been active primarily as a still-life painter in New York City and later in Hoboken, New Jersey, about 1858, just after Roesen's departure from the metropolitan area. Lacroix died in 1869.

4. Lois Goldreich Marcus, *Severin Roesen: A Chronology* (Williamsport, Pa.: Lycoming County Historical Society and Museum, 1976) deals specifically with the problem of establishing a chronology of Roesen's work and illustrates most of the located dated pictures.

William Michael Harnett
1848-1892

As the Peale family had dominated the early development of the American still-life tradition, so did William M. Harnett mold its character during the last quarter of the nineteenth century. The importance of Harnett has finally been recognized in the research of Alfred Frankenstein.[1] For generations the Peales lived in Philadelphia, and it is there that Harnett grew up, his family having moved from Clonakilty, County Cork, Ireland, a year after his birth in 1848. His early works seem to reflect the artistic solutions of the Peales, especially of Raphaelle Peale (1774–1825). However, the direct influences on his style have still not been satisfactorily defined, as scholars disagree on what artistic models, whether European, particularly Dutch seventeenth-century, or indigenous examples, might have been accessible to him.[2]

In 1867 Harnett embarked on his formal art education, entering the Philadelphia Academy of Fine Arts. He moved to New York in 1871, working as a silverware engraver during the day, and furthering his studies at night.[3] He attended classes at the Cooper Union and the National Academy of Design, where he began to exhibit in 1875. Although financial hardship occasionally forced him to give up his course work, he followed the traditional studio curriculum, which included drawing from plaster casts of antique sculpture. Just such an exercise is the *Head of Minerva* (1874),[4] in which Harnett's special talent — convincing the viewer that it is the object itself that confronts the eye and not its two-dimensional representation — is already apparent.

Perhaps on account of his poverty, which in all likelihood prevented him from hiring models, Harnett restricted himself to painting primarily still lifes. His friend James E. Kelly described his impoverished situation:

> At 104 East 11th Street, Harnett, the still life painter, lived, worked and almost starved. His works were wonderful in their realism; he used to paint pictures such as *Jack's Supper* — a sausage, rye loaf, an orange, etc.; Harnett said that he differed from most artists, for after painting them, he could eat his models. . . . He generally started the eatable part of the subject first, it thereby answering the double purpose of a model and a meal.[5]

Harnett had begun to specialize in still lifes before his return to Philadelphia in 1876. Once more he became involved at the Pennsylvania Academy of Fine Arts, establishing a circle of friends that included his artistic alter ego, John F. Peto. He continued painting fruit pieces, some of which, such as *A Wooden Basket of Catawba Grapes* (1876, Charles and Emma Frye Museum, Seattle)[6] have a rather naive quality, reminiscent of early seventeenth-century painters such as Louise Moillon. Other subjects, such as *Morality and Immorality* (1876, Wichita Art Museum),[7] demonstrate not only a more sophisticated iconography, but also a much more complex compositional arrangement. At this stage, as Frankenstein has pointed out, Harnett began to enrich the American still-life tradition by popularizing a number of novel still-life types: the smoking scene, the writing table, the bank-note picture, the rack picture, and the "bric-a-brac" picture.[8] He painted numerous representations of well-loved objects, including a mug and a pipe, in infinite recombinations.

Of the new motifs, the bank-note is of particular interest. In works such as *Shinplaster* (1879, Philadelphia Museum of Art), Harnett's skill as a *trompe l'oeil* painter is fully developed — "the object of these paintings is to produce the closest possible facsimile of the original."[9] Throughout the rest of his career, Harnett worked at perfecting this skill, as exemplified by the great painting of his European period, *After the Hunt*.[10] Even after his departure for Europe in 1880, when his paintings grow in complexity, Harnett's approach is always the same: the objects are precisely detailed, as if seen in a vacuum without the interference of atmosphere.

21 The Secretary's Table

1870
Oil on canvas
14 x 20 in. (35.6 x 50.8 cm)
Signed and dated l.r.: 〽 ARNETT/1870
Inscribed recto on writing pad l.r.: June
 28/see Mr Clarke/at St George Hotel
Gift of Mrs. Sterling Morton
60.60

Provenance

Early history unknown; (Victor D. Spark, N.Y., by 1945 or 1946); purchased from Spark by an unknown buyer; (repurchased by Spark, early 1950s, definitely by 1953); purchased from Spark by a second unknown buyer; (repurchased from a third unknown source by Spark);[1] purchased from Spark by Mrs. Sterling Morton for the PMC, 1960.

1. Provenance as given by Spark in a letter of Jan. 5, 1960 to James W. Foster, Jr., Director, SBMA. An information sheet, probably dating from the time of purchase from Spark, suggests that one of the unknown owners of the painting was the collector Joseph Katz of Baltimore: "V.S. Spark sold to Mr. Joseph Katz/resold the painting to a private collector — re-purchased the painting — in possession of V. Spark when the book [Alfred Frankenstein, *After the Hunt*, 1953] was published on Harnett." The credit in Frankenstein's catalogue (no. 51) lists Victor D. Spark. A letter of Dec. 12, 1979 from Spark to the editor also indicates that the painting at one time belonged to Katz but does not clarify the period of ownership: "I have no way of ascertaining the date I purchased the Wm. M. Harnett. . . . It definitely once belonged to Joseph Katz but I was never informed how long he had owned it."

Condition

Prior to its entering the SBMA in 1960, the painting was sent by Spark to Shar-Shisto to be wax-lined. The painting at the time was not cleaned but did receive a light coat of varnish. Despite the mottled appearance of the background, Spark felt certain the painting was in "its original state" (letter of Jan. 15, 1960). At the time the painting was lent in 1968 to the Maxwell Galleries (see Exhibitions), a pinhead loss, 1 in. above the bottom edge and 8 in. from the r. edge was noted. The area r. of the candlestick and below the stationery box appeared either cloudy in the varnish or dirty. In 1976 inspection by Sherman White, conservator, Santa Barbara, indicated a layer of dirt beneath the varnish.

In 1976 examination by the LACMA Conservation Center noted the painting had been partially cleaned recently. The major problem con-

Harnett spent most of his time in Europe in Munich, going to Paris only in 1885 and exhibiting at the Salon that year. There is disagreement regarding the specific influences on his style during his stay in Europe. Frankenstein maintains that the works of the French painter Meissonier were of primary importance, while Gerdts and Burke suggest that a group of German still-life artists, including Johann Hasenclever and Ludwig Knauss, provided the important models.[11] During his stay abroad, Harnett's compositions at first became more cluttered, but by the time he returned to the United States in 1886, they had reverted to a more austere presentation.

As a result of his declining health Harnett completed only a few additional works before his death in 1892. His paintings were, however, widely known, especially after Theodore Stewart purchased the fourth version of *After the Hunt* and hung it over the bar in his New York City saloon. In response to his popularity, the *New York News,* in 1889 or 1890, ran a long interview with Harnett that has been a major source of information about his early life and interest in painting.[12]

Still-life painting was a favored subject in nineteenth-century American art, despite its low esteem in academic circles, where prejudice against still life was based on belief that there is little "art" in the mere imitation of unimproved nature. *Trompe l'oeil* was further condemned as facile deception. Today, earlier prejudices discarded, the consummate skill, or magic, of artists such as William M. Harnett is fully acknowledged and appreciated.

Lynn Federle Orr

Notes

1. Alfred Frankenstein, *After the Hunt: William Harnett and Other American Still Life Painters 1870–1900,* (2nd ed., Los Angeles: University of California Press, 1969). This is the essential source for information regarding Harnett and his circle.
2. Frankenstein maintains that the paintings of the Peale tradition were of primary importance for the development of Harnett's style in Philadelphia. Gerdts and Burke propose that the painters Hall, Brown, and Heade would have been most readily accessible to the artist during his early period in New York, and later in Philadelphia the works of Lambdin and Levi Wells Prentice. Frankenstein, pp. 31–32; William Gerdts and Russell Burke, *American Still Life Painting* (New York: Praeger, 1971), p. 134.
3. Frankenstein, p. 36.
4. Frankenstein, Pl. 26; a lost work known only from a photograph.
5. These excerpts from the unpublished memoirs of James E. Kelly are quoted in Frankenstein, p. 38.
6. Frankenstein, fig. 32.
7. Frankenstein, fig. 31.
8. Frankenstein, p. 43.
9. Frankenstein, p. 43. So convincing were his recreations of paper money that in 1886 Harnett supposedly found himself threatened with arrest for counterfeiting; Gerdts, p. 135.
10. Frankenstein, frontispiece. This work is known in four versions, including one at the California Palace of the Legion of Honor, San Francisco.
11. Frankenstein, pp. 58–64; Gerdts, p. 142.
12. Frankenstein, pp. 29, 55–56.

sisted in the extremely irregular and disfiguring appearance of the background resulting from the application of both reglazing and some type of hard resin coating. The coating was unevenly brushed over the background and some of it extended down the l. side and across the dark bottom of the table. Traces also extended over the cover of the inkwell, pencil, seal, and lettercase into the sealing wax. Whether it extended over other areas before the recent cleaning was not ascertainable. There was evidence of the loss of shadow areas on the table on the right. The high impasto on the candlestick, especially the red wax, had been badly crushed by either the recent or an older lining.

In 1978 the painting was treated by the LACMA Conservation Center. The painting was recleaned with acetone. The r. side of the painting was cleaned repeatedly with a mixture of acetone and toluene, DMF being used occasionally but not generally. The same procedure was followed over the darker background, where considerable repaint was removed. Other solvents were tried, but toluene-acetone was the most controllable. At the request of Katherine Mead, Curator of Collections, SBMA, further cleaning of the darkest background was done, but in the areas where the overpaint was more or less completely removed, the paint beneath was unacceptably damaged, so cleaning was stopped. An isolating layer of Acryloid B72 in toluene with 10% diacetone alcohol was applied. Inpainting was done with acrylic Magna colors, and natural resin varnish colors were used for the transparent darks. It was decided to "spot" the background as opposed to broad reglazing or reworking with an air brush. A final protective coat of Acryloid B72 was applied.

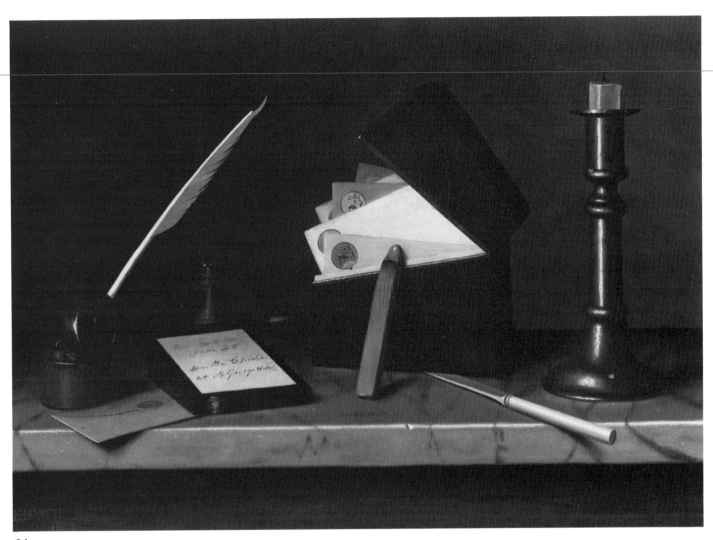

21

The Secretary's Table

(See color reproduction, page 39)

Note

Alfred Frankenstein died June 22, 1981, just as this catalogue was going to press. Lively and opinionated till the end, he was a remarkable crusader for American art, an unforgettable ally of all those whom he helped learn to love it.

P. C. Mills

Harnett's precisionism is not so much a product of science as of craft. His family were all humble craftspeople. His father was a shoemaker, his brother a saddle maker, and his sister a seamstress, while the artist himself began as an engraver on table silver. He took to painting in 1874, and his artistic career fell into three six-year periods: 1874 to 1880, mostly in Philadelphia but with recurrent periods of study in New York; 1880 to 1886, in Europe, mostly in Munich; and 1886 to his death in 1892, once again in New York.

The Harnett in the Preston Morton Collection is one of the last works of the artist's first period. Throughout these six years Harnett produced many pictures of tabletops supporting either beer mugs and pipes or letters, pens, and writing equipment of other kinds. *The Secretary's Table* is a most unusual example of the latter type, with its brilliant contrast of the red sealing wax and the green leather case containing fresh sheets of letter paper stamped with a circular Japanese fan adorned with a crane and sheets of bamboo. The candle, the candlestick, the knife, and the quill pen are regular Harnett *dramatis personae* of this period. The note on the writing pad — "June 28/see Mr Clarke/at St George Hotel" — probably refers to Thomas B. Clarke, an enthusiastic collector of American art for whom this picture might well have been painted.

Alfred Frankenstein

Exhibitions

SBMA, *Two Hundred Years*, 1961, no. 29, repr., mentioned "Introduction," n.p.

St. Petersburg, Fla., Museum of Fine Arts, *Inaugural Exhibition*, Feb. 7–March 7, 1965, no. 14, repr., n.p.

Calif., La Jolla Museum of Art, *The Reminiscent Object: Paintings by William Harnett, John Frederick Peto and John Haberle*, July 11–Sept. 19, 1965, no. 8, repr., traveled SBMA, Sept. 28–Oct. 31, 1965.

San Francisco, Maxwell Galleries, *American Art Since 1850*, Aug. 2–31, 1968, no. 122, repr.

Berkeley, University Art Museum, *The Reality of Appearance: The Trompe l'oeil Tradition in American Painting* (catalogue by Alfred Frankenstein, pub. by New York Graphic Society Ltd.), 1970, no. 31, repr. p. 67, opened Washington, D.C., National Gallery of Art, March 21–May 3, 1970, traveled Whitney Museum of American Art, May 19–July 5, 1970, Berkeley, University Art Museum and San Francisco, California Palace of the Legion of Honor, July 15–Aug. 31, 1970, The Detroit Institute of Arts, Sept. 15–Oct. 31, 1970.

References

Alfred Frankenstein, *After the Hunt: William Harnett and Other American Still Life Painters, 1870–1900* (Berkeley: University of California Press, 1953, 2nd. ed., Los Angeles, 1969), no. 51, p. 167.

John Frederick Peto
1854-1907

The resurrection and delineation of the artistic personality of John F. Peto is the result of the art-historical investigations of Alfred Frankenstein. His initial interest in the development of the American still-life tradition and in particular the paintings of William M. Harnett, led him to uncover not only the available details of Harnett's career, but also the previously undetected hands of about ten additional artists.[1] The major obstacle to identifying the personal style of John F. Peto proved to be a scarcity of information about his life, and the not accidental confusion between his autograph works and the paintings of Harnett. Peto, born in 1854 the son of a picture frame dealer and gilder, outlived Harnett by fifteen years, and because of the relative closeness of their styles and subject matter, coupled with the obscurity of Peto and the popularity of Harnett, Peto's works were often attributed to Harnett.

During the late 1870s both artists lived in Philadelphia and were involved with the Pennsylvania Academy of Fine Arts; however, the particulars of Peto's association with the Academy are unclear. At that time the two painters knew each other well, and Peto's respect for Harnett is borne out by his own work. At first glance there is a remarkable similarity between the paintings of the two, and the confusion between the two hands came partly from their both utilizing the same motifs. It appears that Harnett generally introduced motifs novel to the American still life, and that Peto then borrowed the new subjects with only slight adjustments. This is especially evident in works such as Peto's *Mug, Pipe, and Newspaper* (1887, collection of Mrs. J. Barnes, New York), which is a reworking of Harnett's mug and pipe compositions.[2] The rack motif alone, representing a flat board criss-crossed with tape into which are tucked oddments of paper such as scraps of letters and old envelopes, seems to have been a Peto innovation.[3] Peto's earliest known rack painting is dated just shortly before Harnett's extant painting of the subject. However, the wider popularity of even this motif is probably due to Harnett's use of it.[4]

Although Peto's dependence upon Harnett for a large portion of his subject matter might suggest that he was basically an imitator, Peto, in his handling of paint and in his approach, established his own distinct artistic identity. By isolating idiosyncratic features in works such as *Still Life with Lanterns* (Brooklyn Museum),[5] Frankenstein was led to differentiate the works of Peto and Harnett. One key to distinguishing the two hands is the different lighting and atmospheric effects in the two. Harnett's works epitomize the *trompe l'oeil* tradition, in which the artist recreates the individual objects with such clarity that the viewer is deceived, convinced that the objects themselves are before him. Peto's mature style represents the objects as they appear from a distance, with the colors, outlines, and details softened to suggest the intervention of light and atmosphere. Thus, even when using a Harnettian motif, such as a door with objects hanging on it (as in *Still Life with Lanterns*), Peto establishes his own artistic idiom: the arrangement of the rustic objects is more random than in any Harnett model; the integrity of the outlines is frequently obscured by the sharp contrasts of light and dark; the differentiation of the surface textures is only summary; and the brushwork is relatively loose. The result is an image unified by light and atmosphere and a granular texture, unlike Harnett's carefully arranged, but independently viewed objects.

As with his years in Philadelphia, little documentary evidence exists to fill in the details of Peto's later life in Island Heights, where he moved in 1889. Unlike many of his contemporaries, including Harnett, Peto never went to Europe, and the lack of information about his New Jersey years is particularly frustrating in regard to his possible exposure to current developments in European art. Late works such as his *Self-portrait with Rack*

22 My Studio Door

(previously titled *Things to Adore: My Studio Door*)

1895
Oil on canvas
49⅜ x 29½ in. (125.4 x 74.9 cm)
Signed and dated l.r.: John F. Peto/1895
Inscribed and dated on reverse: MY STUDIO DOOR/ J.F. Peto/ 95/ ISLAND HEIGHTS/ N.J.
Gift of Mrs. Sterling Morton
60.76

Provenance

Emery A. Barton, Cincinnati?,[1] the painting hung at "Sunrise," home of former governor of West Virginia, William MacCorkle, Charlestown, W. Va., from ca. 1910 until his death, 1931;[2] J. B. Harper, Charlestown, W. Va.; (purchased from Harper by M. Knoedler and Co., Inc., 1958); purchased from Knoedler by Mrs. Sterling Morton for the PMC, 1960.

1. On the reverse of the stretcher is nailed a small, torn card, which had been formerly more fully transcribed: EMERY H. BARTON-/[REMOV]ED TO [] 2 WEST FOURTH STREET/CINCINNATI.
2. From information provided by Knoedler; according to information from the McCorkle Estate available to Knoedler, MacCorkle is thought to have acquired the painting in 1910 in New York.

Condition and Technique

In 1978 examination by the BACC noted the painting had been lined with an aqueous adhesive to a single weave fabric and the tacking margins of the support cut. The inscription on the reverse of the original canvas, visible through the lining, was transcribed on the reverse of the lining. Lining probably caused the extensive areas of secure wrinkled paint. There were scattered small repairs, a diagonal scratch at c. of l. edge, and discolored lines of overpaint in grey u.l. quadrant, and elsewhere in c. The surface coating was estimated a natural resin varnish. The general condition was secure.

The support, a medium-weight, plain and single-weave fabric, is covered with a thin white ground that reveals the canvas texture. The paint, an oil type, has been generally applied finely and smoothly except for the browns over the hinges, which are thickly applied with slight impasto.

Picture (collection of Mrs. J. Bejarano, Rochester, N.Y.), with its broad, impressionistic handling, suggest at least an empathy with contemporary painting.[6] In his mature period Peto shows himself the most individual of Harnett's followers. Although perhaps not the Vermeer of America, as suggested by some writers, his works infused the American still-life tradition with the ambience of Luminism, which had characterized American landscape painting of the mid-nineteenth century.[7]

Lynn Federle Orr

My Studio Door

John Frederick Peto achieved the unique distinction of turning still life into a tragic form of expression. In his work, American still life, mostly associated with the kitchen, the dining room, or the flowery Victorian parlor, takes on a somber tone, beautifully exemplified here in the dark, richly highlighted color, which has strong parallels to that of Albert Ryder, Thomas Eakins, and the late work of Winslow Homer. All these artists were isolates cut off from the mainstream of American life in their time either through force of circumstances or by their own volition, and this isolation has everything to do with the dark tone and tragic character of their work.

Peto was born in Philadelphia, was trained at the Peales' Pennsylvania Academy of the Fine Arts along with Harnett, and spent difficult years in his native city trying to make a go of things as an artist and as a musician. Eventually he gave up, and accepted a job playing the cornet to lead the singing in the camp-meeting town of Island Heights, New Jersey. Ironically enough, the eighteen years in Island Heights were the most fruitful of his career so far as painting was concerned, but because he had completely dropped out of the art world, he became an easy target for dishonest dealers. They acquired his work in devious ways and forged Harnett's name to it; for a long time Harnett's celebrity was based on pictures actually painted by Peto, and the artist of Island Heights has come into his own only in recent years.

My Studio Door employs a compositional formula many American still-life painters of the nineteenth century exploited. The eye is stopped in its backward progress by a door painted on the picture plane, and the objects hung from that door come forward into the spectator's space. Like all great still-life painters, Peto uses a very small repertoire of models: the lantern, the pistol, the keyed bugle, the powder horn, the rusty hinges, and the address plate appear over and over again in other works of his. The bone-handled bowie knife toward the upper left is, according to the Peto family tradition, a souvenir of the battle of Gettysburg, in which the artist's father participated.

Alfred Frankenstein

Notes

1. Alfred Frankenstein remains the leading scholar on Peto, his *After the Hunt: William Harnett and Other American Still Life Painters 1870–1900* (Berkeley: University of California Press, 1953, rev. ed. Los Angeles, 1969) is the essential source for information regarding Harnett and artists in his circle.
2. Frankenstein, fig. 86.
3. Frankenstein, p. 101.
4. Frequently these rack pictures were used by Peto's patrons as office signboards, the artist incorporating among the bits of paper items referring to the services offered by that business establishment. See, for example, the rack picture of 1888, painted for Dr. B. M. Goldberg, now in the Metropolitan Museum of Art, New York.
5. Frankenstein, fig. 89.
6. Frankenstein, fig. 90.
7. William Gerdts and Russell Burke, *American Still-Life Painting* (New York; Praeger Publishers, 1971), p. 144.

Exhibitions

Ohio, Cincinnati Art Museum, *Two Centuries of American Painting*, Oct. 4–Nov. 4, 1958, no. 33.

SBMA, *Two Hundred Years*, 1961, No. 51 (as *Things to Adore: My Studio Door*), repr., mentioned "Introduction," n.p.

Calif., La Jolla Museum of Art, *The Reminiscent Object: Paintings by William Michael Harnett, John Frederick Peto and John Haberle*, July 11–Sept. 19, 1965, no. 45; traveled SBMA, Sept. 28–Oct. 21, 1965.

Calif., The Oakland Museum, *Art Treasures in California*, Nov. 29–Dec. 31, 1969, repr., n.p.

Los Angeles, University of Southern California, The University Galleries, *Reality and Deception*, Oct. 16–Nov. 24, 1974, no. 55, repr., traveled Seattle Art Museum, Dec. 4, 1974–Jan. 12, 1975, Honolulu Academy of Art, Jan. 23–Feb. 23, 1975, SBMA, March 13–April 20, 1975.

Calif., Fresno Arts Center, *200 Years of American Painting*, Nov. 20–Dec. 30, 1977, no. 22, repr. fig. 12, p. 24.

Edward Lamson Henry
1841-1919

Edward Lamson Henry[1] was born in Charleston, South Carolina, in 1841, but at the age of seven moved to New York, the city with which he is chiefly associated. His talent revealed itself at an early age, and he studied at the Pennsylvania Academy of the Fine Arts in Philadelphia, and later with Charles Gleyre (1806–1874) in Paris, while in Europe in the years 1860–1862. He saw service briefly during the Civil War and used this experience as the background for several successful paintings. He achieved early success with these and his two other favorite subjects, old houses and costumes, and forms of transportation. He was elected an associate of the National Academy of Design in 1867, and in 1869 became an Academician. Henry traveled in Europe in 1871 and again in 1875, following his marriage to Frances Livingston Wells, and in 1881 and 1882. During the early 1880s, Henry became associated with the emerging artists' colony at Cragsmoor, in rural southeastern New York. He built a house there in 1884, his principal residence, although he retained a studio in New York City. He continued to enjoy a successful career as a genre painter until his death in 1919.

Michael A. Quick

Notes

1. The standard biography of E. L. Henry is Elizabeth McCausland, *The Life and Work of Edward Lamson Henry N.A., 1841–1919,* New York State Museum, *Bulletin,* no. 339, Albany, N.Y., 1945.

Passion Play, Oberammergau

The Passion Play at Oberammergau, in the foothills of the Bavarian Alps, is a rare survival of the medieval "miracle play," or dramatization of scriptural events. In gratitude for deliverance from the Black Death in 1633, the villagers pledged to perform the events of the Passion every ten years, which they have continued to do up until the present. Because of the disruption of the Franco-Prussian War in 1870, however, the performance was postponed until the following year, when E. L. Henry, visiting Europe, saw the play and recorded his experience in the Santa Barbara painting, dating from 1872.

Every tenth year, the theatre, a temporary wooden structure, was re-erected on a site marked by two rows of poplars, visible in the painting.[1] Since the play was performed during the summer, the theatre could be open to the sky. The boxes on the sides were shaded by a projecting awning, and were therefore more expensive than the central pit. The play, its scenes of Holy Week alternating with Old Testament tableaux, lasted from eight o'clock in the morning until the intermission at one o'clock, and then resumed between two and five or six o'clock in the evening. The scene in the painting, the Crucifixion, the graphically portrayed climax of the spectacle, would have been seen in the late afternoon.[2]

The play and the piety of its peasant actors, attracted spectators to the village from throughout the Christian world, among them artists drawn by the picturesqueness of the village and its alpine setting. Eliza Greatorex (1820–1897), E. L. Henry's future neighbor at Cragsmoor, also visited Oberammergau during the summer of 1871, and recorded clusters of artists painting before every notable house in the village.[3] If few paintings of the Passion Play itself are known today, that may be because the authorities discouraged painting within the theatre, as a distraction from the sacred and devotional intention of the performance. According to the recollections of the artist's widow, an exception was made

23 Passion Play, Oberammergau

ca. 1872
Oil on canvas
20⁹/₁₆ x 34¾ in. (52.3 x 88.2 cm)
Not signed or dated
Anonymous gift
61.11

Provenance

Collection of the artist; (Ortgies Auction Rooms, Ortgies and Co., N.Y., March 2, 1887, no. 60); (John Levy Galleries, N.Y.); (purchased from Levy by M. Knoedler and Co., Inc., 1952); from Knoedler to the PMC, 1961.

Condition and Technique

In 1978 examination by the BACC noted that the painting had been lined at an unknown date with an aqueous glue to a linen fabric, in turn lined to another linen fabric. Its original tacking margins had been removed and slight losses had been suffered along edges from trimming during lining and at c.l. from frame abrasion. The losses had been overpainted.

In 1979 the painting was treated by the BACC. The discolored, yellowed surface coating and the overpainting were removed first by rolling ethyl alcohol over the area, and then removing the swollen varnish with acetone. One brush coat of Acryloid B72, 10% in xylene was applied as an isolating layer. Losses were filled with dry pigments in wax-resin mixtures as filling putty. The fills were isolated with PVA-AYAA 10% in ethyl alcohol brushed on locally. Losses were inpainted with dry pigments ground in Acryloid B72. Two spray coats of Acryloid B72, 10% in xylene were applied as final surface coating. After some more inpainting, two spray coats of PVA-AYAA, 10% in ethanol were applied.

The support, a light-weight, tightly woven, plain weave, single-threaded fabric like linen, is covered with a moderately thin (approximately 0.5 mm thickness) white, smooth ground that conceals the fabric texture. The oil-type paint is applied as a rich vehicular paste, with thinner, pigmented pellicular application of the lower layers in the darks, which is visible in the architectural details and shadows. The paint is applied in a very detailed fashion with fine brushes and fine, small strokes, generally smoothly, although there is thicker application and bristle brush stroke texture in the sky and the fine highlights. A very fine, rather uneven fracture crackle pattern is present in the paint layers.

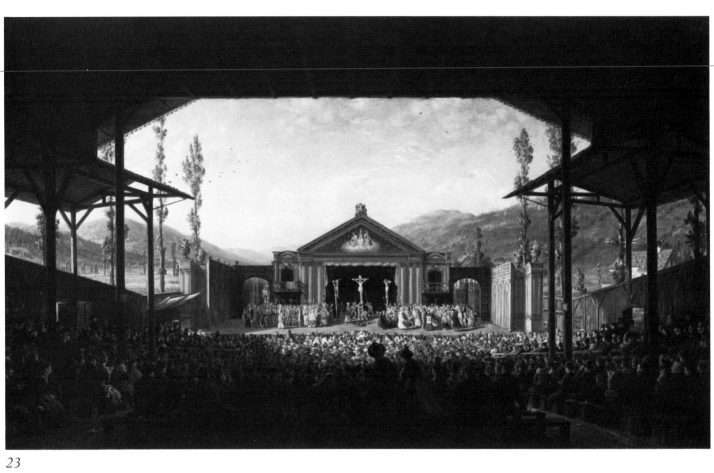

23

for E. L. Henry, who portrayed himself sketching very discreetly in the very rear of the theatre, on the left.[4]

At the same time, the artist's choice of the vantage-point of the painting also reflects Henry's taste for crowds and panoramas. His Civil War subjects, such as *City Point, Virginia* (1865–1872, Addison Gallery of American Art, Andover, Mass.), and railroad station subjects, such as *The 9:45 A.M. Accommodation, Stratford, Connecticut* (1867, Metropolitan Museum of Art, New York), usually are painted from a relatively distant point of view that takes in a large number of figures and much activity. The necessarily small-scale figures give Henry's paintings an effect of miniaturistic precision of detail. None, however, have nearly so many figures as the Santa Barbara painting, each figure somewhat differentiated. Henry generally introduces into his crowd scenes some dominant element, such as a train station and tracks, to establish perspective and suggest scale. The playhouse, of course, provides the firmest of perspective frameworks, and its high awnings dwarf the spectacle, making the figures seem even more numerous and minute. This effect of looking from an interior into a daylight exterior scene also recalls similar window motifs in early nineteenth-century paintings of the Dresden school, which Henry may have seen while in Germany. However, this same interest in effects of daylight had been noticeable in Henry's paintings since the mid-1860s. Interiors generally depend upon illumination from a window or door, which is carefully observed in terms of reflections and shadows. In fact, in 1866 Henry painted a view into a landscape from a verandah,[5] which is comparable to the effect of daylight and contrasting obscurity in *The Passion Play, Oberammergau.* His interest in effects of daylight may have been stimulated by Henry's use of photography to document his subjects as early as 1865.[6]

In any case, the dramatic enframing element in the Santa Barbara painting draws attention to two of the most distinctive qualities of E. L. Henry's art, his daylight color and his highly detailed finish. The painting must be acknowledged as one of the most successful of his early artistic maturity.

Michael A. Quick

Exhibitions

Philadelphia, Bailey, Banks and Biddle Company, date unknown (mentioned in McCausland, p. 165; see References).

SBMA, *Two Hundred Years*, 1961, no. 33a.

References

Ortgies and Co., *Catalog of the Collection of Mr. E. L. Henry . . ., Wednesday afternoon and evening, March 2, 1887,* no. 60, p. 21.

Elizabeth McCausland, *The Life and Work of Edward Lamson Henry, N.A., 1841–1919,* New York State Museum, *Bulletin* no. 339, Albany, N.Y., 1945, no. 99, pp. 32, 165, 327; reprinted by Kennedy Graphics, 1970.

Notes

1. An account of this playhouse and the performance in 1850, as seen by an artist, is given by Anna Mary Howitt in *An Art Student in Munich* (Boston: Ticknor, Reed, and Fields, 1854), pp. 59–66.

2. Howitt, p. 65, describes the Crucifixion scene as follows: "Then came the crucifixion; and as the chorus sang of the great agony, you heard from behind the curtain the strokes of the hammer as the huge nails were driven into the cross, and, as your imagination believed, through his poor pale hands and feet; and then, as the curtain slowly rose to the dying tones of the chorus, you beheld him hanging on the cross between the two crucified thieves.

"Both myself and my companion turned away from this spectacle sick with horror. They divided his garment at the foot of the cross; they pierced his side, and blood flowed apparently from the wound and from his martyred hands and feet. The Virgin and Mary Magdalene, and the disciples, lamented round the foot of the cross, in groups and attitudes such as we see in the old pictures."

3. Eliza Greatorex, *The Homes of Ober-Ammergau* (Munich: Joseph Albert, 1872). The volume contains twenty etchings, but a view of the interior of the theatre is not among them.

4. Elizabeth McCausland, *The Life and Work of Edward Lamson Henry N.A., 1841–1919,* New York State Museum, *Bulletin,* no. 339, Albany, N.Y., 1945.

5. *Porch Scene, Newport, R.I.* (no. 61, fig. 37 in McCausland's catalogue).

6. McCausland, pp. 98–100.

Winslow Homer
1836-1910

Winslow Homer was born in Boston on February 24, 1836. At the time, his parents were living in the heart of the city very near Quincy Market and historic Faneuil Hall. In 1842 the family moved to rural Cambridge, Massachusetts. It was here, at the age of ten, that Winslow produced his first known works, very possibly inspired by his mother, a competent artist in her own right. His professional career began in 1854, when he was apprenticed to the Boston lithographic firm of John Bufford & Sons. When, on his twenty-first birthday, his apprenticeship with Bufford was concluded, he did free-lance work and very quickly established himself as a leading illustrator for periodicals, first with *Ballou's Pictorial Drawing-Room Companion*, and then becoming the foremost contributor to *Harper's Weekly*, including assignment as an artist-correspondent during the Civil War.

Not until 1861 did Homer begin to paint. His efforts, however, soon met with critical success, and in 1866, as the result of his painting *Prisoners from the Front*, he achieved the status of Academician at the National Academy. During 1866 and 1867 he went to France, spending ten months in Paris before returning to New York. In the summer of 1873, during one of his typical summer outings at Gloucester, Massachusetts, Homer began devoting himself to watercolor painting. In 1881–1882, he visited and worked at Tynemouth, Northumberland, England. Upon his return, he established his home at Prout's Neck, Maine, where he resided until his death. He continued, however, his habit of taking lengthy painting excursions, including trips to Cuba, Florida, Nassau, the Bahamas, Canada, and the Adirondacks. He died at Prout's Neck on September 29, 1910, one of the most formidable figures in the history of American art.

Michael W. Schantz

Woman in Autumn Woods

At the time Winslow Homer painted *Woman in Autumn Woods*, most likely during the fall of 1877, he had established his studio in the famous Tenth Street Studio Building, 51 West Tenth Street, New York City. It was a popular location for artists, and some of the fellow renters included Eastman Johnson, Homer Dodge Martin, and J. G. Brown. The painting in the Preston Morton Collection, however, is the result of one of Homer's many excursions to escape the gloom of New York's brownstones for the freshness and color of the countryside. It was very possibly done at Houghton Farm, the country retreat of Lawson Valentine, located at Mountainville, New York. Winslow's brother, Charles, was Valentine's business partner and long-time friend. The painter frequently accompanied Charles and his sister-in-law, Martha French (or Mattie as Winslow called her), to the Valentine country estate. It was here that Homer produced a flood of rural scenes.[1]

The model for this work may well be one of the neighbors at Houghton Farm known to have posed for Homer on numerous occasions. The exact identity of this young woman, however, is relatively unimportant. The artist was well known for his impatience with patrons, critics, and the general public for reading too much into his paintings and for desiring satisfying explanations for pictorial actions.[2] Characteristically, Homer's genre scenes are not imbued with the sentiment or story-telling quality of a J. G. Brown or an Eastman Johnson. He produced works with an underlying detachment that disclosed interests as much formal and technical as they were narrative. Indeed, this detachment

24 Woman in Autumn Woods

ca. 1877
Oil on canvas
35⅛ x 24 in. (89.2 x 61 cm)
Not signed or dated
Gift of Mrs. Sterling Morton
60.63

Provenance

Given by the artist's sister-in-law, Mrs. Charles S. Homer to the Carnegie Institute, Pittsburgh, ca. 1915;[1] Mrs. Edith Halpert;[2] (acquired jointly by the Milch Galleries and the Babcock Galleries, 1941);[2] (consigned to Hirschl & Adler, 1960);[2] purchased from Hirschl & Adler by Mrs. Sterling Morton for the PMC, 1960.

1. The author is grateful to Lloyd Goodrich and to Mrs. Goodrich for this information sent in October 1980.
2. From information provided by Michael St. Clair of Babcock Galleries, in a letter to the editor, Jan. 14, 1981. The information supplements and accords basically with that provided by Goodrich. According to M. P. Naud of Hirschl & Adler in a letter of Nov. 7, 1980, to the editor, the painting "was back and forth several times between ourselves and Milch Galleries from September 1958 until February 1960."

Condition and Technique

In 1978 examination by the BACC noted the painting had been lined with an aqueous adhesive to a single weave fabric. The tacking margins of the support had been cut. There was a stretcher crease at center and paint movement along the edge of the fabric at the l. edge in the bottom l. corner. The thin and even surface coating, probably synthetic, had received a superficial scratch at l. edge, c. The overall condition was good.

The support, a medium-weight, loosely woven, plain and single-weave fabric, is covered with a thin, dark ground that is not easily visible. The oil-type paint shows a rich vehicular-pigmented pellicular application, the brushstrokes visible in the fast application, areas of heavy impasto in the leaves, which contrast with the smooth blending in other areas. There is extensive glazing in the drapery.

was characteristic of his life in general.

The uncertain identity of the woman in this painting is analogous to the character-less faces that populate many of his other works. This is in large measure a reflection of his years as an illustrator, when Homer reduced modeling to the bare minimum. The now famous (and often quoted) passage by Henry James on Homer's art speaks partly to this point. James considered many of the artist's productions " . . . almost barbarously simple, and to our eye, . . . horribly ugly. . . ."[3]

Compositions with a lone figure within an intimate, close-up landscape, as in *Woman in Autumn Woods*, were a common occurrence in Homer's art at this time. Other paintings of similar motif and chronology include *Butterflies* (New Britain, Conn., Museum of American Art), and *Gathering Autumn Leaves* (Cooper-Hewitt Museum, Smithsonian Institution).[4] Each, however, is a more finished and less spontaneous product than the Santa Barbara painting. It is also during this period that Winslow Homer produced an outpouring of lone shepherdesses, tending their flocks and often garbed in eighteenth-century finery. The artist would, in coming years, abandon such bucolic confections for the more robust images of the sea.

Perhaps the most appealing and striking aspect of this painting is the wooded backdrop. It is here that the viewer is greeted with the suggestion of impressionistic handling of color, with its loose application and distinct patches of pure color. Such manipulation of paint raises the question of Homer's relationship to Impressionism. In this artist's case, however, any interpretation or speculation concerning possible influence is, for the time being, unanswerable because Homer kept very much to himself. He diligently protected his privacy and was uncommunicative about his art and any influences or sources that may have inspired his approach to painting. Since *Woman in Autumn Woods* was painted after his trip to Paris in 1866–1867, it would perhaps be natural to ascribe such impressionistic passages to contemporaneous events in the Parisian art community. Even in his own day he was linked by critics to the "new-fangled Impressionists."[5] Any suggestion, nevertheless, of influence through direct contact is tenuous. What is certain, however, is that years before Homer went abroad, he already possessed some of the main ingredients that helped spawn French Impressionism. In fact, rather than suggest that he imitated artistic activities in France, it is more tempting to postulate that he developed his own impressionistic traits through independent investigation and experimentation.

Experimentation is precisely what *Woman in Autumn Woods* represents. It is an essay exploring color relationships and contrasts. Most evident here is Homer's interest in the interplay of darkest green with rust red, epitomized by the loose rendering of the tartan plaid shawl. This interest reflects his awareness of the latest trends in color theory. As early as 1860, his brother Charles presented him with a copy of Michel E. Chevreul's *The Laws of Contrast of Colours*.[6] This was one of the most influential tomes in the development of full-blown Impressionism and provided an exhaustive analysis of the effects colors have on one another.

Another ingredient at Homer's command was his exposure to Japanese prints, important sources of inventive compositional arrangements and decorative color usage. Again this experience antedates his trip to Europe. In this regard, his close friendship with John La Farge was most helpful. The latter artist was acquainted with and owned such prints, to which Homer no doubt had access, as early as the late 1850s.[7] Homer possessed yet another element that was endemic to much impressionistic painting — a natural

regard for the picture plane. As an illustrator, Homer utilized an analogous tendency toward flatness.

The artist took these various ingredients and blended them in a unique way, with a direction different from the path of European development. The most one can say about Winslow Homer is that he foreshadows American efforts at Impressionism. He himself was never an Impressionist; he never succumbed to the dissolution of line and form typical of mature Impressionism. Instead, the process always remained an adjunct (and an adjective) in Homer's work and is used in contrast, as it is here in *Woman in Autumn Woods*, to figures more solidly grounded in reality. Above all else, this painting represents an important document of Winslow Homer's constant experimentation with color, light, and composition.

Michael W. Schantz

Exhibitions

Oklahoma City, Oklahoma Art Center, *Inaugural Exhibition*, Dec. 1958–Jan. 1959, no. 52 (as *Woman in the Autumn Woods*), lent by Babcock Galleries.
SBMA, *Two Hundred Years*, 1961, no. 34, repr., mentioned "Introduction," n.p.

References

Forbes Watson, *Winslow Homer* (New York: Crown Publishers, 1942), repr. p. 112.
"Galleries: '52-'53 Flashback; Babcock," *Art Digest*, XXVII, no. 17 (June 1953), repr. p. 19.
Melinda Dempster Davis, *Winslow Homer: An Annotated Bibliography of Periodical Literature* (Metuchen, N.J.: The Scarecrow Press, Inc., 1975), no. 1044, p. 117.
Gordon Hendricks, *The Life and Work of Winslow Homer*, (New York: Harry N. Abrams, 1979) p. 133, CL-15, p. 279.

Notes

1. For discussions of Homer's Houghton Farm experiences, see Lloyd Goodrich, *Winslow Homer* (New York: The MacMillan Company, 1944), pp. 62–64, and Gordon Hendricks, *The Life and Work of Winslow Homer* (New York: Harry N. Abrams, Inc., 1979), pp. 122–140.
2. Two classic examples of Homer's response to an overly curious public occur as a result of his paintings the *Gulf Stream* and *Promenade on the Beach*. For the first, see Goodrich, p. 162; for the second, see Hendricks, p. 140.
3. Henry James's comments originally appeared in the July 1875 issue of *Galaxy* magazine. They are quoted at length both in Hendricks, pp. 115–117, and Goodrich, pp. 53-54.
4. Hendricks, p. 133; CL-22, p. 279; fig. 191, p. 127; CL-452, p. 310.
5. Hendricks, p. 138.
6. This was the 1859 edition translated by John Spanton and published in London by Routledge, Warnes and Routledge. See David Tatham, "Winslow Homer's Library," *The American Art Journal*, May 1977, pp. 92–98.
7. For La Farge's relationship to Japanese prints, see Henry Adams, "A Fish by John La Farge," *The Art Bulletin*, LXII, no. 2 (June 1980), pp. 269–280.

John George Brown
1831-1913

J. G. Brown was born and trained in England in the trade of glass-working as well as in painting. By 1853 he had settled in Brooklyn, where he was at first employed in the former occupation. Around 1855, however, Brown set himself up as a portrait painter. His particular adeptness with children stimulated the artist to develop a specialty in juvenile genre subjects. Success as a painter prompted a move in 1860 to the Tenth Street Studio Building in New York, where Brown discovered what was to be an even more popular theme — the city's bootblacks and newspaper boys, for which he is best known today. Although largely dismissed now as sentimental potboilers, the tremendous popularity of these subjects during the span of Brown's long career made him both a famous artist and a wealthy man. In fact, an investigation of Brown's oeuvre reveals that his range as a painter was considerably wider than is generally acknowledged, including a continuing interest in portraiture, activity as a landscape painter, and an interest in documenting both urban and rural adult working types such as those in the Santa Barbara painting.

Linda S. Ferber

Pull for the Shore

Pull for the Shore depicts eight figures in a boat, seven men and a young boy. The term "pulling" means to work an oar, and six men are rowing while a seventh handles the rudder and the boy sits high up on the prow looking to the right. They are on the open sea, the prow pointing toward a distant coastline on the horizon to the left, while white sails are barely visible on the ocean to the right. Brown treated this subject in several versions and variants. This particular painting is a version of a larger work, *Pulling for Shore* (34¼ x 56⅛ in.) in The Chrysler Museum, Norfolk, dated 1878, which must be *Pull for the Shore* exhibited at the National Academy of Design that same year (fig. 1).[1] The figures are virtually identical except the young boy, who turns to the left. A more detailed headland with a lighthouse is seen at the left and a number of closer, more detailed sailing vessels are silhouetted on the horizon at the right. The Santa Barbara painting appears to be the smaller undated work of this title included in Brown's studio sale of 1892.[2] Efforts to trace what appears to be a third version, close to the Santa Barbara type, known only through a newspaper clipping have so far been unsuccessful.[3] An undated variation on the theme similar in size and handling to the Santa Barbara picture is the painting *Lost in the Fog* (Collection of William A. Lucking, Jr., Ojai, California), sold in the 1892 studio sale (fig. 2).[4]

It has been suggested that *Pull for the Shore* "appears to be a group portrait of a fishing party."[5] There is ample precedent among American painters of the second half of the nineteenth century for the informal outdoor group portrait taken while engaged in sporting activity. A parallel might be drawn with the work of Junius Brutus Stearns (1810–1885), who painted *Charles Loring Elliott and His Friends Fishing* (1857, private collection) as well as *A Fishing Party off Long Island* (1860, Minneapolis Institute), which has been said to depict the artist's own closest friends.[6] Brown's own *Claiming the Shot — A Group of Portraits after the Hunt in the Adirondacks* (1865, Detroit Institute) is said to document a party including members of the Astor family at ease after the hunt in a mountain landscape.[7] One must point out, however, that the Norfolk painting was not

25 Pull for the Shore

(also titled *Pulling for Shore*)
Oil on canvas
23¹⁵/₁₆ x 39¾ in. (60.8 x 101.1 cm)
Signed l.l.: J. G. Brown N.A.
Not dated
Museum exchange; acquired through the Estate of Mrs. Stanley McCormick through Norman Hirschl and funds from the American Federation of Arts; transferred to the Preston Morton Collection in 1978
71.18

Provenance

The artist; (studio sale, Fifth Avenue Art Galleries, Ortgies & Co., N.Y., Jan. 27, 1892, no. 137, as *Pull for the Shore*); Walter P. Chrysler by 1930; Chrysler Museum, Provincetown, Mass.; (Warren J. Adelson and Jack Tanzer, Museum Art Exchange, Inc.); acquired from Adelson and Tanzer by the SBMA, 1971; transferred to the PMC, 1978.

Condition and Technique

Examination in 1980 by the BACC noted that the painting had been lined at an unknown date with an aqueous adhesive, like glue. The tacking margins were missing on all sides, and the edges had been cut somewhat unevenly. An interleaf of thick, blotter-like white paper was visible between the support and the lining fabric. The support was found to be exceedingly dry and brittle, tearing easily. There was a small vertical tear and a crease from flexing the original fabric in the l.r. corner. A small piece of the support in the u.l. corner had been torn away and reattached in a past restoration, and a small section along the top edge had also been torn, probably in an earlier stretching, and reattached. A small loss of the original fabric in the u.r. corner was likewise noted. Slight stretcher creases were visible on both side edges. The bond between the ground and support appeared secure. There was a broad linear vertical fracture crackle pattern with a very narrow aperture scattered throughout. No cleavage was evident, although there was slight to moderate cupping throughout. Small paint/ground losses were visible in the u.r. corner, on the r. side of the sky near the top edge, along the tear in the bottom r. corner, and along the bottom edge. Tiny holes were apparent in the paint film on the face of the man in the white shirt. The figures and the foreground had suffered slight

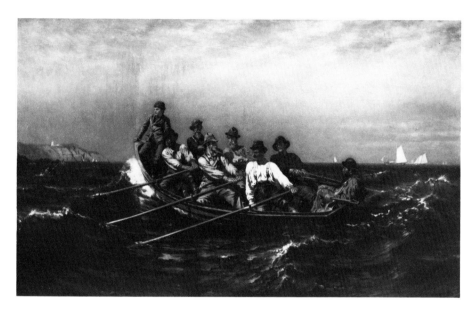

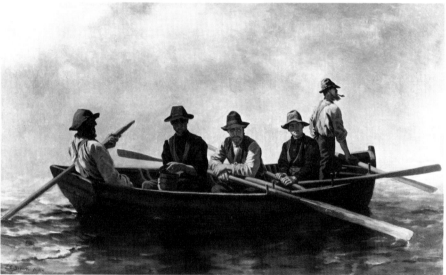

fig. 1 *(top)* J. G. Brown, *Pulling for Shore*.
Reproduced by permission of The Chrysler
Museum, Gift of Walter P. Chrysler, Jr. fig. 2
(bottom) J. G. Brown, *Lost in the Fog*. Collection
of William A. Lucking, Jr., Ojai, California.

abrasion and the edges, moderate abrasion, probably from the rabbet. Optical and ultraviolet excited/ visible fluorescence examinations indicated small areas of overpaint along the top and l. edges and on the face of the man in the white shirt. Impressions of fabric texture from lining were visible in the paint film. The paint film was covered with a thin layer of grime; and there were scattered small spots of an unidentified dark brown substance on the figures. The surface coating, a natural resin varnish (estimated), had yellowed and was moderately disfiguring. There were also residues of old discolored varnish in the interstices of the brushmarks in the more thickly painted areas.

In 1980 the painting was treated by the BACC. The yellowed varnish and surface grime was removed with acetone. Beneath this varnish layer, another layer was found that swelled and then crystallized on the surface upon exposure to acetone. The lower layer of varnish and overpaint was removed with acetone. In the l.r. quadrant, the paint reacted by swelling, so it was unsafe to take off the gelled varnish. After it had dried, most of the varnish was removed by rolling with the fingertips. The painting was given a coat of Soluvar, 15% in Benzine B264. A second coat of Soluvar, 15% in Benzine was applied. The lining was removed. Next the thick blotter adhered to the back of the canvas with a water-soluble adhesive was removed. The small tear in l.r. corner was repaired with PVA emulsion and Japanese tissue, and the several small holes in the canvas were filled with gesso putty. The painting was lined with two layers of satin weave fiberglass lining fabric using Ross Wax adhesive, on vacuum hot table, with vacuum pressure at 3″ Hg, heat at maximum 150° F on top of painting. An isolating layer of Acryloid B72, 10% in xylene was applied, and losses were filled with gesso putty. Inpainting was done with dry pigments ground in Acryloid B67/ B72 (1:3). More inpainting was executed and a spray varnish coating of Bakelite PVA-AYAA, 10% in ethyl alcohol applied.

The support is a moderately fine, plain weave linen (estimated) with some irregular threads. The ground, a white oil type, is a single layer of moderate thickness that conceals most of the fabric texture. It was probably applied by the artist. Small lumps, visibly scattered throughout the surface, appear to be part of the ground layer and may be caused by large particles. The oil-type paint (estimated) is generally of moderate thickness and ranges from a thin fluid to a thick soft paste with slight relief. Some preliminary drawing is visible on the figures. The paint in the foreground water is

identified as a group portrait when exhibited in 1878, as was the case with the work of 1865. One must also point out that these figures are not fishing; nor is any fishing equipment visible in the boat. While each man's features are highly individualized, they are also at least partially obscured by dark shadows cast by hat brims, unlike the clearly visible, evenly lit visages of Stearns's fishermen and Brown's own Adirondack group. A closer kinship might be found in a comparison of *Pull for the Shore* with Winslow Homer's

25

(1836–1910) *Breezing Up* (1876, National Gallery of Art, fig. 3). The close parallels in subject are, of course, obvious. There is also the interesting visual parallel in the figures of the young boys who sit up silhouetted against the sky. It is more than likely that Brown knew Homer's painting, which had been exhibited as *A Fair Wind* at the National Academy in 1876 and was a great success.[8] Brown and Homer were both at the Tenth Street Studio during these years, and Brown's admiration for Homer at this time is documented in Sheldon's *American Painters* (1879), where he refers to him as "one of our truest and most accomplished artists."[9] It would seem logical, then, to trace certain parallels in these paintings to the artists' common interest not in portrait characterization but in depicting figures in action on open water and subject to the play of strong outdoor light and shadow.

The occupants of the boat in *Pull for the Shore,* while not identified portrait figures, are carefully observed adult male types, a contrast to Brown's by then stock subject of winsome street urchins. The theme of adult males in a group seems to have interested the artist around this time, for in 1879, he exhibited *The German Band* (unlocated), which *Harper's Weekly* illustrated, commenting that the "several members of the band are well individualized."[10] In 1880, he exhibited his well-known *The Longshoremen's Noon* (1879, Corcoran Gallery), a group of stevedores at rest. *The Art Journal* noted that their "moral, and physiognomic characters are reproduced deftly enough," referring to Brown as "a realist of the first water."[11] The question arises, then, who are the types depicted so carefully in *Pull for the Shore* and its variants? The answer may be found, I believe, among the studies Brown gathered on his trips in 1877 and 1878 to Grand Manan Island off the coast of Maine.[12] This isolated spot (variously referred to as Grand Manan and Grand Menan in the nineteenth century) was described by S. G. W. Benjamin in an article on Brown in 1882: "a long narrow tableland elevated hundreds of feet above the sea, and surrounded by a wall of precipices. It lies in one of the most tempestuous parts of the coast of North America. In winter it is beaten by tremendous surges, and in summer it is often shut out from the world by dense fogs. It is only reached by sailing craft which are accustomed to cross the strait in almost all weathers, being manned by a sturdy class of seadogs, who are born amid the roar of breakers and are never out of sight of the ocean."[13] It is this "sturdy class of seadogs," I suggest, that is depicted in *Pull for the Shore.* Brown himself told Sheldon of his intention to paint the fisherfolk there: "I desired to paint some Grand Menan fishermen, and I went to Grand Menan and painted them from the life — their fish, their clothes, their boats."[14] Benjamin recorded that after Brown overcame the initial reluctance of the inhabitants to pose "all opportunities [to make oil studies] were offered him. In consequence, he produced a number of vivid and characteristic scenes, which are also artistically effective."[15] Six of these studies were exhibited at the National Academy in 1879, the year after he exhibited the large Norfolk composition.[16] A number of these oil studies are known, and all depict fishermen of similar mien and dress to those in *Pull for the Shore.*[17] One, *Grand Manan Fisherman Bringing Home His Oars* (George Arden, New York, fig. 4) appears to record the features and distinctive hat of the oarsmen at the front right in the Santa Barbara painting.

Despite the convincing visual and documentary evidence linking these boating subjects to Grand Manan, a problem arises from Brown's own statement of 1880 about his Grand Manan sketches exhibited at the National Academy in 1879: "The critics spoke in praise of my sketches when the latter were on exhibition, but I have yet to receive a commission to paint a picture from one of those sketches."[18] Sheldon reiterated this point

moderately thin and semi-transparent and was applied in a wet into wet technique. The figures and boat were done with a thick opaque brushmarked soft paste for the light tones and thin transparent fluid paint for modelling and dark tones.

Notes

1. No. 529. *Pull for the Shore,* $1,500.00. J. G. Brown, N.A.

2. Fifth Avenue Art Galleries. Ortgies & Co., N.Y., "J. G. Brown, N.A. Sale," Jan. 26 and 27, 1892, no. 137, *Pull for the Shore,* 40 x 27.

3. This clipping from the *New York Sun,* March 6, 1937, shows a version very close to the SBMA picture but with slight differences in the body of the boat and in the configuration of the water. The painting was scheduled to be sold at the Wise Auction Galleries, N.Y., the following week. (Artists' File, Art and Architecture Division, New York Public Library.)

4. No. 68, *Lost in the Fog,* 40 x 24. This work was also included in American Art Galleries, N.Y., "George A. Hearn Sale," Feb.–March 1918, no. 49, *Lost in the Fog,* 24½ x 39¾. Sold to Alfred Lueking [sic] $320.

5. Donelson Hoopes and Nancy Wall Moure, "American Narrative Painting," Los Angeles County Museum of Art, 1974, p. 139.

6. Millard F. Rogers, Jr., "Fishing Subjects by Junius Brutus Stearns," *Antiques,* XCVIII (August 1970), p. 249.

7. Graham Hood, Nancy Rivard, and Kathleen Pyne, "American Paintings Acquired During the Last Decade," *Bulletin of the Detroit Institute of Arts,* LV (1977), p. 94.

8. John Wilmerding, *Winslow Homer* (New York: Praeger Publishers, 1972), p. 92.

9. G. W. Sheldon, *American Painters* (New York: D. Appleton, 1879), p. 143.

10. "The Academy," *Harper's Weekly,* XXIII (Apr. 26, 1879), p. 325.

11. "Sketches And Studies. IV. From the Portfolios of J. G. Brown, Gungengigl [sic], and Samuel Colman," *The Art Journal* no. 6 (July 1880), p. 193.

12. Sheldon noted: "Mr. Brown made several trips to Grand Menan, and it was on the second of these excursions, in the summer of 1878, that he gathered the large number of studies," *Hours with Art and Artists* (New York: D. Appleton and Company, 1882, p. 151). His first trip seems to have been made in 1877, since a study, *Lighthouse, Grand Menan* (1877) was included in Brown's 1914 estate sale (no. 7). It was on this 1877 trip that the studies for *Pull for the Shore* and its progeny would have been made.

13. S. G. W. Benjamin, "A Painter of the Streets," *The Magazine of Art,* V (1882), p. 267.

14. Sheldon, *American Painters,* p. 141.

15. Benjamin, p. 268.

16. 1879: Nos. 74 to 79. *A Series of six studies made on the Island of Grand Manan, N.B.,* J. G. Brown, N.A.

17. Sheldon illustrated a "capital oil study" of *Captain Stanley of Stanley Beach* in *Hours with Art and Artists,* p. 151. In the 1892 sale were: no. 80, *Grand Menan Fisherman Going for Bait,* 15 x 23 in.; no. 91, *The Coming Squall,* 20 x 30 in., repr. p. 25; no. 98, *Grand Menan Fisherman Bringing Home His Oars,* 20 x 30 in., repr. p. 17; no. 118, *Grand Menan Fisherman, Southampton,* 15 x 20 in. In the 1914 sale were: no. 7, *Lighthouse, Grand*

in his *Hours with Art and Artists* (1882), discussing Brown's Grand Manan excursions at length and concluding: "It is an interesting if not curious fact that, of all the fishermen-studies made by Mr. Brown at Grand Menan, not one has ever been wrought out into a picture in his studio . . . they are now stored in a corner of his studio. Mr. Brown himself would enjoy nothing more than to carry out upon canvas the ideas and facts which they contain or suggest, but he has too much successful work underway to waste his strength upon that for which there seemed to be no demand."[19] What, then, are we to make of the large painting of 1878 exhibited "For Sale" at the National Academy and its variants? Moreover, Brown's obituary in the *New York Times* made intriguing reference to a "Grand Menan Fishermen Pulling for the Shore" as among "the best known of Mr. Brown's pictures"[20] — a reference surely to a finished composition rather than an oil study. It is very possible and even probable that Brown returned to his Grand Manan sketches after Sheldon's interview of 1882 and that the undated version and variants were painted after that date. This dates our painting between 1882 and about 1891, for it was included in Brown's studio sale early in 1892, a range compatible stylistically with the slightly broader handling in the Santa Barbara painting than in the work of 1878. While final resolution of this curious contradiction awaits further research and documentation, I believe we are secure in identifying the hearty oarsmen in *Pull for the Shore* as the fishermen of Grand Manan, "manful, daring, and independent as Vikings."[21]

Linda S. Ferber

Exhibitions
N.Y., Fifth Avenue Art Galleries, Ortgies & Co., Jan. 26–27, 1892, no. 137.
Los Angeles County Museum of Art, *American Narrative Painting* (catalogue notes by Nancy Wall Moure, essay by Donelson F. Hoopes, published in association with Praeger Publishers, Inc.), Oct. 1–Nov. 17, 1974, no. 65, p. 139 (as *Pulling for Shore* with incorrect measurements 32½ x 48½ in.), repr. p. 138, mentioned pp. 19, 20.
Calif., Fresno Art Gallery, *200 Years of American Painting*, Nov. 20–Dec. 30, 1977, no. 19, fig. 10.

References
Ronald Kuchta, "Recent Acquisition" (dated ca. 1878 as *Pulling for the Shore* and with incorrect measurements 37½ x 48½ in.), *Calendar*, Santa Barbara Museum of Art, June 1971.
Pierce Rice, "J. G. Brown: The Bootblack Raphael," *American Arts & Antiques*, II, no. 3 (May–June 1979), mentioned p. 94, repr. p. 95 (as *Pulling for Shore* with incorrect measurements 32½ x 48½ in.).

Menan, 1877, 17 x 11 in.; no. 88, *Grand Manan Fisherman*, 23½ x 15 in. Other studies in all likelihood depicting Grand Manan subjects are: Parke-Bernet, sale 241, Oct. 10, 1940, no. 47, *Casting the Nets*, 14½ x 23 in.; Parke-Bernet, sale 1253, May 10–11, 1951, no. 64, *Fisherman*, 22½ x 17 in.; Parke-Bernet, sale 2290, June 17–19, 1964, no. 230, *A New England Fisherman*, 1878, repr. (this figure appears at the stern in *Lost in the Fog*); Parke-Bernet, sale 2385, Nov. 24, 1965, no. 13, *Casting Nets*, 11 x 16 in.
18. "John G. Brown," *Harper's Weekly*, XIV (June 12, 1880), p. 373.
19. Sheldon, p. 152.
20. "J. G. Brown, Painter of Street Boys, dies," *New York Times*, Feb. 9, 1913.
21. Benjamin, p. 268.

fig. 3 Winslow Homer, *Breezing Up*. Reproduced by permission of the National Gallery of Art, Gift of the W. L. and May T. Mellon Foundation.

fig. 4 J. G. Brown, *Grand Manan Fisherman*. Reproduced by permission of George Arden.

Frederic Sackrider Remington
1861-1909

Frederic Remington was America's quintessential chronicler of the Old West. He worked from his own experiences and depicted the lifestyle of cowboys and Indians, Mounties, Rangers, and Cavalrymen in battle and at leisure. Remington was a prodigious worker and an orotund personality, prone to bombastic and sometimes pompous statements. He was fiercely nationalistic and dedicated to artistic preservation of the frontier, which he saw disappearing. At nineteen he knew "the wild riders and the vacant land were about to vanish forever . . . and the more I considered the subject, the bigger the forever loomed. Without knowing exactly how to do it, I began to try to record some fact around me, and the more I looked the more the panorama unfolded."[1]

Remington was the only child of Seth Pierre Remington and Clara Bascomb Sackrider. His father was a colonel in the Union Army, and later, the co-owner of the *St. Lawrence Plaindealer* newspaper. This background provided Remington with an early exposure to military life and its accoutrements as well as to the illustrative side of journalism.

He attended a parochial boy's school in Burlington, Vermont, Highland Military Academy in Massachusetts, and entered Yale in 1878 as a student in the new Art School, which had been founded in 1875. After his father's death in 1880, Remington left school to devote himself to his art, using his small inheritance to support himself. In the same year he met Eva Adele Caten, who succeeded in overcoming Remington's misogynistic attitude (which remained steadfast throughout his life where most other women were concerned). After an unsuccessful attempt at making his fortune in the West, Remington returned home in 1884 to marry "Missie" Caten; they made their new home in Kansas.[2] The artist sent an unknown number of illustrations to magazines in the East during the first months of his marriage, but only one is recorded as published. ("Ejecting an Oklahoma Bloomer," *Harper's Weekly*, March 28, 1885). As their financial situation steadily worsened, the newlyweds decided to try a new course of action. "Missie" returned to her father's home in New York, and Frederic became a vagabond artist traveling throughout New Mexico, Arizona, northern Texas, and back to Kansas. With no success in Kansas, he took the train to New York City, arriving there with three dollars in his pocket and a bulging portfolio. "Missie" joined him and they embarked on a determined program to sell his pictures of the West. Within a few months Remington had sold a cover illustration to *Harper's* with a full credit to him (January 9, 1886). From this point on the story of Remington's success is in the best of "rags to riches" tradition. In less than four years Remington had won the Hallgarten and Clark prizes, exhibited at the American Water Color Society and the National Academy. By 1890, when he was twenty-nine years old, he had purchased a mansion in New Rochelle to suit his expansive personality and his expensive tastes. (It is an interesting bit of American artistic folklore that Remington's studio was later used by another well-known illustrator, Norman Rockwell.)

Remington's output was commensurate with his unrepressed appetite. He produced two thousand and seven hundred paintings and drawings, twenty-three bronze figures (starting with "The Bucking Bronco"), illustrated one hundred and forty-two books, and contributed to more than forty different magazines. He authored several short stories and wrote a Broadway play. He remained essentially a private person with an "impelling taste for the good things of life,"[3] which must have included good food, as he eventually weighed over three hundred pounds! He avoided the New York art scene, keeping himself free from dealers, galleries, and museums whenever possible. At the time

26 Bull Fight in Mexico

(also titled *Corrida*)
1889
Oil on canvas
24 x 32 in. (61 x 81.3 cm)
Signed, inscribed, and dated l.r.: FREDERIC REMINGTON/City of MEXICO '89
Gift of Sterling Morton
60.78

Provenance

(John Nicholson Galleries, New York, 1950, as *Death in the Afternoon*);[1] Levison Collection?;[2] (Hirschl & Adler, Sept. 1959); purchased from Hirschl & Adler by Sterling Morton for the PMC, 1960.

1. From information provided by Maria Naylor.
2. From information provided by Hirschl & Adler; according to a letter of Nov. 7, 1980, of M. P. Naud of Hirschl & Adler to the editor: "In September 1959 we acquired this painting from a private collection . . . We have no further information on this painting."

Condition and Technique

In 1978 inspection by the BACC noted the painting had been lined with aqueous glue to a medium weight, double threaded, plain weave linen, and the original tacking margins had been removed. The original fabric was found to be brittle but the lining strong and secure. Some of the impasto had been crushed in lining. The painting had suffered some flake loss, which had been inpainted c.l. The edges had been overpainted for about ¼ in. at l. and bottom edges, especially the bottom l. corner. The paint was secure. Residues of old varnish in the interstices of paint in the bottom center foreground had yellowed. There was also a stroke of color over the varnish at c.l. between the horse's legs, and gold from the frame at c.r. The surface coating was estimated a natural resin spirit varnish.

The white ground, of moderately thin application, enhances the fabric texture. The paint, an oil type of lean vehicular structure, is applied in thin smooth even layers with brushmarking and slight impasto in the bottom foreground.

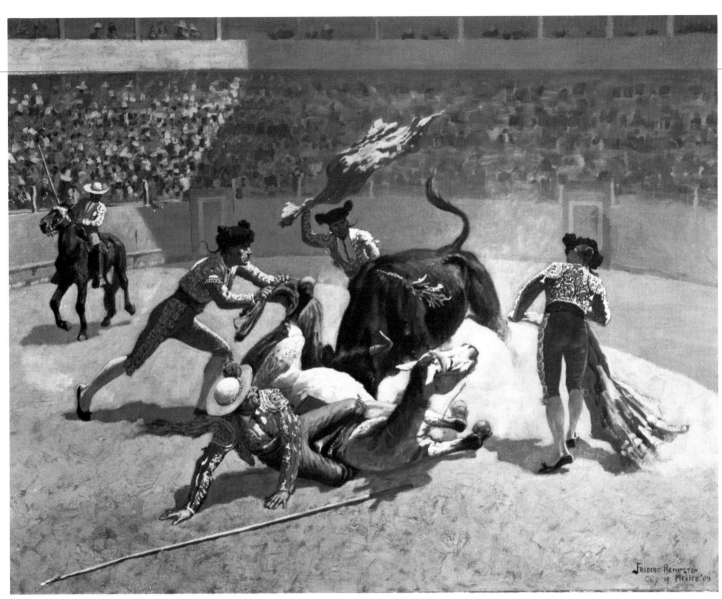

26

of his death the only member of the art world to attend his funeral was his long-time friend Childe Hassam. A recorder of actual events and always faithful to realistic reportage, Remington remains an expressive and authentic chronicler of the West.

Kathleen Monaghan

Notes

1. Harold McCracken, *The Frederic Remington Book* (Garden City, N.Y.: Doubleday & Company, 1966), p. 14.
2. McCracken, *Frederic Remington, Artist of the Old West* (Philadelphia: J. B. Lippincott Company, 1947), ch. III, passim, for details.
3. McCracken, *Frederic Remington*, p. 37.

Bull Fight in Mexico

When a series of articles on Mexico appeared in *Harper's Weekly*, written by Thomas Allibone Janvier and illustrated by Frederic Remington (fig 1),[1] very probably both publisher and reading public considered the artist the lesser partner in the production. Although a Remington drawing of a Mexican subject had appeared in *Harper's Weekly* as early as 1886,[2] Thomas Janvier was an acknowledged authority on Mexico and the author of a guidebook to the country that was reprinted over a period of some years.[3] Time has severely altered this case; today, Janvier's work as a journalist and writer of fiction is largely forgotten, as is his reputation as an authority on subjects as diverse as old New York and the literature of Provence, while Remington's popularity with the public and the collector seems capable, like inflation, only of increase.

"On the whole, bull fighting is the closest link that united our partially civilized present with our wholly barbaric past," Janvier wrote of the contest he described and Remington painted. "The bull always is killed, the horse usually is killed, and the man is killed with sufficient frequency to enliven each round of the performance with pleasingly exciting possibilities."[4] Archaeological discoveries, many of them subsequent to Janvier's day, have corroborated his statement about the great age of the conflicts between man and bovine and have documented the transitions in the nature of these encounters, from that between hunter and quarry to that of worshipper and his god, and ultimately to that of opposing sides in an athletic spectacle.[5]

A bullfight figures in one of the earliest painted scenes known to art history — a composition showing a scene of apparently mutual slaughter between man and bull from the caves of Lascaux, in the Dordogne Valley, France. Considering the antiquity of the type, bullfights are nonetheless rare subjects in art. So long as bulls were objects of worship, they were frequently also subjects for art, though apparently the human attitude toward them was too reverent to make them also an occasion for sport. The Cretan depictions of bull-leaping record what was evidently more a religious ceremony than an athletic contest, as was the Mithraic slaughter of beasts for the initiation of the cult's worshippers. It remained for the Romans, those masterminds of mass entertainments, to establish the *tauromachia* as a spectacular amusement, one that would survive the eventual death of Mithraism and other pagan animal cults and their supplantation by Christianity.[6] Both Mithraism and the *corrida* as a sport came to the Spanish peninsula with Roman rule, and by the time that rudimentary bullfights were depicted in miniatures in Spanish illuminated manuscripts of the middle ages[7] only the sport survived. Although paintings exist of bullfights that are not Spanish, such as the *Bullfight in the Campo San Polo of Venice* by Joseph Heintz the Younger (1648, Museo Civico, Venice), by early modern times a bullfight came to symbolize Spain. One early artist who depicted an early seventeenth-century (1635) protean Spanish bullfight was Jan Cornelisz de Haarlem.[8] By

fig. 1 Frederic Remington, *Corrida*, from *Harper's Weekly*, XXXIII, (January-June 1889), pp. 432, 433.

the end of the eighteenth century, the techniques of the bullring had advanced to the point that several series of prints were published whose principal objectives were to educate the public in matters of standards of performance by matadors and toreadors.[9] Contemporary with these series of prints, the paintings, etchings, and lithographs of Francisco Goya turned the tragicomic drama of the *corrida* into art; for Goya, all the history of his native land could be depicted through the *tauromachia.*

Probably far more effective in making the images of the bullfight accessible to those outside Spain were prints after sketches by artists of the early nineteenth century, whose travel notebooks furnished the material for albums of lithographs. As Spain fell further and further behind the rest of Western Europe during the advance and progress of the Industrial Revolution, it became increasingly attractive to artists of the "picturesque," such as David Roberts and John Frederick Lewis.[10] From the middle of the century, the illustrated periodical, with its multiple woodcuts, took over from more costly portfolios the task of acquainting an even wider public with the appearance and customs of foreign peoples and exotic lands. Few publications of the period fulfilled this task more zestfully or for a longer stretch of years than did *Harper's Weekly*; and from the end of the 1880s, few artists contributed more copiously to the American illustrated press than did Frederic Remington.

The authority Remington brought to his renderings of scenes of which he had been an eyewitness was well-suited to the reportorial intentions of the articles he illustrated. His approach to the violence and death of the bullring was more direct and matter-of-fact than that of one American predecessor in the depiction of the sport, Robert Blum, whose images seem more balletic than bloody.[11] The central violence of the *corrida* is not merely not avoided; it occupies the very heart of the composition. When Manet severed the figure of

the *Dead Toreador* from the bullfight sequence in the upper half of the original canvas, he altered the image instantly from a violent to a serene death.[12] Such a mitigation of the truth of the scene would have been foreign to Remington's nature and tastes. Janvier noted of the Mexico City bullrings that it was sometimes the practice to put blinders on the horses ridden; the rider would then cause the horse to rear to meet the bull's charge on his unprotected belly, while he himself leaped to safety from his mount's back. "In the better form of the sport," Janvier observed, "when the horse is not to be killed, this blinder is not used. When the game is conducted on the horse killing principle, the regular order of things is to permit two horses to be killed by each bull."[13] The effects of this wanton slaughter of horses on Remington, who was a lover of the animals as well as a connoisseur of their form, may well be imagined. The fact that *Bull Fight in Mexico* shows the rider paying for his past sacrifices may be due to faithful reportage, or to wishful thinking.

This work of 1889 shows the young Remington not yet fully master of his art but already possessed of a powerful facility for depicting men and animals in violent action. In contrast to the rather heavy-handed *grisaille* commonly employed for the illustrations of this period, the artist has here made use of a restrained but highly effective palette in which the predominating tawny ochre of the bullring is punctuated by dashes of blacks and brilliant reds and yellows. The complex intertwinings of the central group of bull, horses, and men are typical of Remington's work, which made it seem very fresh, and above all, very "real" to contemporary viewers, especially by comparison with the typical works of other illustrators of the time; the veracity of such renderings must have seemed almost overpowering. Although they had many of the very elements that appealed to Remington as subjects for his art — colorful costumes, strenuous action, undeniable skill, and picturesque carnage — bullfights seem to have exercised little hold upon his imagination, for he never returned to the subject after these early commissions. Possibly he found their action and violence too contrived and unnecessary.

Maria Naylor

Exhibitions

N.Y., Schneider-Gabriel Galleries, 1946.[1]
N.Y., Knoedler Galleries, *Remington Exhibition*, 1954.[1]
SBMA, *Two Hundred Years*, 1961, no. 53, repr.

1. Information provided by Hirschl & Adler.

References

Harper's Weekly, XXXIII, no. 1693 (June 1, 1889), repr. pp. 432-433, wood engraving (as: A BULL FIGHT IN MEXICO/Drawn by Frederic Remington; woodcut signed, inscribed, and dated l.r.: FREDERIC REMINGTON/MEXICO '89).
Benjamin Lowe, *The Beauty of Sport: A Cross-Disciplinary Inquiry* (Englewood Cliffs, N.J.: Prentice-Hall, Inc., 1977), p. 135, Pl. 24a, p. 162.

Notes

1. The present painting was reproduced in *Harper's Weekly*, XXXIII, no. 1693 (June 1, 1889) pp. 432–433 as an illustration for "Bull-Fighting in Mexico," published in the same issue, pp. 441, 444–446. Other articles on Mexico on which Remington and Thomas A. Janvier collaborated for *Harper's Weekly* were "Silver Mining in Zacatecas," on Oct. 19 and "Mexican Burros" on Nov. 30 of the same year, and "Mexican Doorways" on July 25, 1891. Remington also illustrated a work of fiction by Janvier set in Mexico, *The Aztec Treasure House*, which ran in the same periodical from Dec. 21, 1889, to Apr. 26, 1890. This was subsequently published as a book by Harper & Brothers in 1890.
2. "Mexican Troops in Sonora," *Harper's Weekly*, XXX (Aug. 7, 1886).
3. Thomas A. Janvier, *A Guidebook to Mexico* (New York: Charles Scribner's Sons, first ed. 1886). It went through more than half a dozen editions between 1886 and 1900.
4. *Harper's Weekly* (June 1, 1889), p. 441.
5. Jack Randolph Conrad, *The Sword and The Horn* (New York: E. P. Dutton, Inc., 1957), passim.
6. Conrad, passim.
7. *La Arte en las Tauromachia* (Madrid: Sociedad Español de los amigos del Arte, 1918), nos. 198, 165.
8. *La Arte*, no. 172.
9. Antonio Cavnicero, *Colección de las principales suertas de una Corrida de Toros*. The 1790 edition was published with a series of plates, variously twelve or thirteen in number.

Luis Fernandez Noseret published circa 1792 or 1798 a work of the same title as the above. José Delgado y Galvez (1754–1801), a toreador known professionally as Pepe-Hillo, wrote a work entitled *La Tauromachia*, published in 1790, illustrated with a frontispiece. The 1796 edition was enlarged by the addition of thirty-two plates known in several states. (This information courtesy of George Smith, Los Angeles, past president of the Society of Taurine Bibliophiles.)
10. David Roberts, *Sketches of Spanish Scenes and Architecture*, 1833(?), n.p., John Frederick Lewis, *Lewis's Sketches of Spain and Spanish Character made during his Tour in that Country in 1833–4. Drawn on stone from his Original Sketches* (London: G. F. Moon, 1836).
11. Illustration for Charles Dudley Warner, "The Bullfight at Madrid," *Century Magazine*, XXVII, no. 1 (Nov. 1883), pp. 3–13.
12. Anne Coffin Hansen, *Manet and the Modern Tradition* (New Haven and London: The Yale University Press, 1977), pp. 82 ff.
13. *Harper's Weekly* (June 1, 1889), p. 441.

Late Nineteenth and Early Twentieth Centuries

Thomas Eakins
1844-1916

Thomas Eakins was born and raised in Philadelphia. His father was a teacher of penmanship in the Quaker schools of the city. In high school he received good training in draftsmanship and drawing, and after graduation he became a student at the Pennsylvania Academy of Fine Arts in Philadelphia. In 1866 he left America for the only time in his life to study at the École des Beaux-Arts in Paris. J. L. Gérôme permitted him to enter his atelier at the École as a special student — that is, a student not preparing for the Prix de Rome contest. Gérôme was at the height of his fame and powers; he had just been appointed to the École as Professor by Nieuwerkerke, the Minister of Education, as part of a reform of the École. From Nieuwerkerke's point of view, Gérôme was a good appointment, very fashionable as a realist, and extremely rigorous and conscientious as a teacher. Gérôme fulfilled Nieuwerkerke's expectations. He visited his classes regularly, even coming in from the countryside during vacation; he revived parts of the École routine that had gone into neglect, such as requiring his students to study sculpture and to attend dissections at the medical school of the Sorbonne. He was rigorous in his teaching of drawing and perspective. Drawing he thought to be "the grammar of painting." Eakins stayed with him for two years and then spent another six months in the atelier of Gérôme's young friend, the Realist portrait painter Léon Bonnat. Perhaps Gérôme, in sending Eakins to Bonnat, sensed that the young American would probably have to support himself by portraiture once he returned to America. The result of the stay with Bonnat is that although Eakins's ideas about art and teaching came from Gérôme, his loose facture, dark palette, and way of posing portrait sitters came from Bonnat.

Eakins's pictures in the first few decades after he returned from Paris are his most interesting. He painted genre scenes of American life as well as many portraits. His greatest picture, however, *The Gross Clinic* (1876), after an initial *succès de scandale*, was soon forgotten, and through neglect, almost disintegrated. In 1876 Eakins began teaching at the Pennsylvania Academy and instituted many reforms and very vigorous teaching in imitation of his Parisian masters. He soon became a professor, but lost his position, either — depending upon one's bias — through the prudery of the school board or his own lack of tact. Later he taught at the American Academy of Design in New York. Gradually he exhibited less and less, retired into the company of his students and friends and became almost forgotten as a personality. When Sargent visited Philadelphia in the 1880s, asked by his host to meet Eakins, he answered, "Who's Eakins?" This lack of professional stimulation and critical attention must have led to the decline of his later style.

Sadly, Thomas Eakins left only a small number of masterpieces upon which to hang a reputation. Nonetheless, the adulation of Eakins as the "greatest American painter" has obfuscated a correct estimation of his intense, serious, and somewhat tragic personality, and may keep us from recognizing what Pierce Rice has called his greatest contribution to American art, not his painting, but his high ethical standards: the great intellectual and moral responsibility to the craft of painting that he as a teacher instilled in several generations of American artists at a time when virtuosity and chic were conquering the artistic world. His independence from late nineteenth-century avant-garde movements — such as Impressionism or Symbolism — is dramatized by some art historians as the grand isolation of an American original genius. Consequently Eakins has been robbed of his proper intellectual company, the late Realists of Europe: his teachers Gérôme and Bonnat, Menzel, Leibl, Luigi Nono, Mŏretti, Fildes, Gervex, Bastien-Lepage, Repin, and others. Only in this company can he be fully understood and evaluated.

Gerald M. Ackerman

164

27 Portrait of Master Douty

1906
Oil on canvas
20 x 16¹/₁₆ in. (50.8 x 40.8 cm)
Not signed or dated
Inscribed by the artist on reverse: TO/ MRS.
 NICHOLAS DOUTY/ FROM HER FRIEND/
 THOMAS EAKINS/ 1906
Gift of Mrs. Sterling Morton
60.56

fig. a. Thomas Eakins, *Portrait of Master Douty*, detail of reverse. Preston Morton Collection, Santa Barbara Museum of Art.

Provenance

Mrs. Nicholas Douty, 1907 until sale to Wildenstein sometime before Jan. 6, 1955; (Wildenstein, by 1955); purchased from Wildenstein by Mrs. Sterling Morton for the PMC, 1960.

Condition and Technique

In 1978 examination by the BACC noted the support to be extremely brittle, dry and slack. In the u.r. corner of the reverse several heavy globs of dark paint (probably slopped on by the artist when writing the inscription) had stained the reverse. There appeared to have been a continuing problem of poor adhesion between support and ground in the drapery areas resulting in the overall loss of tiny flakes of paint, especially in the white below the neck area and at the center near the bottom edge. The tiny paint losses had been overpainted and there were scattered small areas of overpaint throughout the white drapery which had darkened. The surface coating had moderately yellowed, dulling the crisp, cool tones, especially in the drapery area of the painting. There was severe local blanching in the shadow of the boy's nose.

In 1978–1979 the painting was treated by the

Portrait of Master Douty

In 1930, the young art historian Lloyd Goodrich was putting together the first major book on the life and work of Thomas Eakins for the Whitney Museum of American Art.[1] An important part of the project was the visit he made to Mr. and Mrs. Nicholas Douty, in Elkins Park, a suburb of Philadelphia. Eakins had painted a portrait of their son, Alfred,[2] aged seven, and given it to Mrs. Douty as a Christmas present in 1907.[3] In 1910, Eakins painted her portrait, as a "surprise" gift to Nicholas Douty.[4] The couple were "close friends of Eakins, who loved music and had a number of musical friends, and painted several portraits of them. Nicholas Douty was a tenor, well-known as a Bach interpreter, a frequent soloist for the Bethlehem Bach Choir, also a teacher, composer and writer on music; a friend of the singer Weda Cook[5] (model for Eakins's *The Concert Singer*), and appeared with her in several recitals. His wife, nee Frieda Schloss, was a musicologist, editor of the *Musical Survey and Directory of Philadelphia*. . . . they were a pleasant warm-hearted couple, genuinely fond of Eakins, and with many memories of him."[6]

Goodrich considers this portrait the best of Eakins's "few portraits of children, which were as honest and unflattering as his portraits of adults."[7] Although the inscription is dated 1906, it was not until the following Christmas that Eakins gave Frieda Douty the gift, as is evident from an affectionate letter she sent to Eakins on December 22, 1907.[8]

By the time Eakins had painted the portrait of the young Douty, he had abandoned outdoor painting and his more ambitious themes using multiple figures and was restricting himself, for the most part, to individual poses. Fame and honor had come to him, but few sales of his works. He made many gifts to his sitters. In 1889, *The Agnew Clinic* was a commission for $750.[9] None of his earlier portraits was commissioned; when the Jefferson Medical College bought *The Gross Clinic* in 1878, the price was $200.[10] However, in 1914, when Eakins was in tragically failing health, Dr. Albert C. Barnes bought a study of *The Agnew Clinic* for many thousands of dollars.[11] In the memorial exhibitions of Eakins's paintings held at the Metropolitan Museum of Art in New York and at the Pennsylvania Academy of the Fine Arts in 1917, more than half of the paintings were credited "lent by Mrs. Thomas Eakins."[12]

Young Douty posed for Eakins wearing a white sailor suit with a blue collar and blue band on his left sleeve. He sits against a brown background. His dark blond hair falls mostly in shadow; it is neatly trimmed and the bangs echo the curves of shadow and neckline below. He is turned slightly left of full face, a pose quite similar to that of Ruth Harding, whose portrait Eakins had painted in 1903 (White House Collection).[13] The head of the boy is carefully and delicately brushed, a drawing with the brush of outline, shadow, and reflection that defines the volumes of his face and features with consummate realism. The garment, on the other hand, is freely painted, giving the whole painting the vigor and vitality of a momentary pause. The reflection along the jawline on the right side of the painting also adds to the liveliness of the picture. This device of using white garments to reflect on facial outlines Eakins also used in the White House portrait.

No photograph of Alfred Douty exists to indicate that Eakins followed his frequent practice of using photographs as *aides-mémoire*. There is documentation, however, stating Douty's somber aspect was frequent in Eakins's youthful sitters, who would naturally wish to be elsewhere and whose expressions reflect seriousness and restraint.[14] The interchangeable concepts of *thinking* and *feeling* taught and practiced by Eakins are visible

BACC. The surface coating was removed with acetone. The adhesion between the paint layers was found so poor due to crumbly ground that it was impossible to clean before infusion from reverse with wax. The reverse was cleaned with a scalpel and the globs of paint were removed. The reverse was infused with Ross wax, applying it molten with a brush. The painting was placed face up on the vacuum hot table, and temperature brought up to 150°F, pressure at 3" Hg. The excess molten adhesive was rolled out. The painting was cleaned with acetone in the lights and with xylene-toluene in the background and dark greys. It was not possible to remove all of the varnish from the red background which was slightly sensitive to toluene after infusion. A plain weave fiberglass fabric was infused with Ross wax, and the support lined with the fiberglass on the hot table, temperatures up to ca. 148°F, pressure at ca. 3" Hg. The painting was placed on an ICA SM-4 spring stretcher. Wax was removed from the front with xylene and one brush coat of Acryloid B72 was applied as an isolating layer. Tiny paint losses wre filled with filling material consisting of lining adhesives and dry pigment mixed in for hardness and color. PVA-AYAA, 10% in ethyl alcohol was applied over the wax-resin fills as an isolating layer. Losses were inpainted with a palette consisting of dry pigments, ground in Acryloid B67 and B72, 1:3, with xylene as solvent and B72 as additional medium. Two spray coats of Acryloid B72, 10% in xylene were applied, followed by two more coats of same as final protective surface coating.

The support, a medium weight, plain and single-threaded weave fabric, is covered by a thin, white ground, probably applied by the artist, which does not hide the texture. The oil type paint is applied as a rich vehicular paste, in broad, fluid brushstrokes, wet into wet, and ranges from medium impasto to very thin application.

in this sensitive portrait. In many ways, they belie the youth of the sitter.

Young Douty went on to become a chemical engineer, abandoning his parents' hope that he might have a musical career. He was a lifelong friend of the son of Weda Cook, thus keeping his link to Eakins. Both Douty and his wife were quite distressed when his mother decided to sell the portrait. At the end of his life, in 1971, however, he was grateful to know it was in a respected public collection.[15]

Ruth Bowman

Exhibitions

SBMA, *Two Hundred Years*, 1961, no. 28, repr., mentioned "Introduction," n.p.
SBMA, *American Portraits*, 1966, no. 47, repr.

References

Alan Burroughs, "Catalogue of Works by Thomas Eakins 1869–1916," *The Arts*, no. 5 (June 1924), p. 322.
Lloyd Goodrich, *Thomas Eakins: His Life and Work* (New York: Whitney Museum of Art, 1933; reprint, New York: AMS Press, 1970), no. 436, p. 202.
Dorothy Adlow, "The Home Forum," *Christian Science Monitor*, Jan. 6, 1955, p. 8, repr. (by courtesy of the Wildenstein Galleries, New York).
Gordon Hendricks, *The Life and Work of Thomas Eakins*, (New York: Viking, 1974), no. 7, p. 316, repr. (as *Portrait of Alfred Douty*).

Notes

1. Lloyd Goodrich, *Thomas Eakins: His Life and Work* (New York: Whitney Museum of American Art, 1933).
2. Born March 2, 1899; died August 1971.
3. Goodrich, letter to Katherine Mead, Sept. 1980.
4. Goodrich, letter.
5. Weda Cook became Mrs. Stanley Addicks. Her portrait of 1892 is in the Philadelphia Museum of Art.
6. Goodrich, letter.
7. Goodrich, letter.
8. To be published in vol. II of Goodrich, *Thomas Eakins* (Cambridge, Mass.: Harvard University Press, 1981).
9. Goodrich, *Thomas Eakins* (New York: Praeger, 1970), p. 26.
10. Goodrich (1970), p. 13.
11. Goodrich (1970), p. 32.
12. The Metropolitan Museum of Art, New York, Nov. 5–Dec. 3, 1917, *Loan Exhibition of the Works of Thomas Eakins*; and Pennsylvania Academy of the Fine Arts, Philadelphia, Dec. 23, 1917 to Jan. 13, 1918, *Memorial Exhibition of the Works of the Late Thomas Eakins*.
13. Phyllis D. Rosenzweig, *The Thomas Eakins Collection of the Hirshhorn Museum and Sculpture Garden* (Washington, D.C.: Smithsonian Institution Press, 1977), no. 103, p. 87.
14. Rosenzweig, p. 188.
15. Conversation of author with the widow of Alfred Douty, Nov. 1980.

William Merritt Chase
1849-1916

William Merritt Chase was born in Nineveh, Indiana, near Indianapolis, in 1849. Because he showed an early talent for art, his father, a harnessmaker, let him study with a local portrait painter. At the age of twenty he went to New York and entered the National Academy of Design. The successes of two still-life paintings in the National Academy Exhibition of 1871 won him a group of patrons who financed a trip to Munich, where he enrolled in the Bavarian Royal Academy in 1872. There he studied under the history painter Piloty and the Realist peasant and portrait painter Wilhelm Leibl. In Munich he shared a room with the young Cincinnati painter Frank Duveneck. They both picked up the virtuosic, bituminous *facture* of Leibl's loose style, and became experts at it. They brought the style back to America, where they received quick acclaim. Chase won a medal at the Philadelphia Centennial Exhibition in 1876 and critical attention at the National Academy of Design Exhibition in 1878. He could have stayed in Europe for, although his command of German was never very great, he was offered a professorship at the Bavarian Royal Academy, which he declined in 1877. In America he quickly made his name and a fortune through many exhibitions (he was very prolific) and through teaching. He continued the dark Munich style until Arthur Stevens, visiting his studio in 1881, asked him, "Why do you want all of your works to look like old masters?"[1] After thinking over the implied criticism of the remark, Chase brightened his palette, and became one of the lightest and most French of American painters. Later he was to assimilate the brushstroke of Sargent into his work. He and Sargent were good friends, and painted each other's portraits; Sargent's portrait of Chase is in the Metropolitan Museum of Art.

The immediacy of Chase's style with its dazzling bright colors and startlingly free handling attracted students to him. His knowledge of techniques from every era — he was a lifelong student of old painters — kept them with him. Most of his life he taught in one American institution or the other, including the New York School of Art in Manhattan, which he had founded as The Chase School in 1895. In 1891 he taught his first summer school at Shinnecock, Long Island. He liked the location so well that he had a large summer house built for him there by McKim, Mead and White. He taught there until 1906. In 1903 he started taking groups of American students for summer study to Europe. At various times he instructed them in Bruges, Venice, Granada, Munich, on Hampstead Heath, and in Florence. He bought a villa in Florence in 1907. His last summer course was in Carmel, California, in 1914.

Chase trained several generations of American painters and had a considerable influence on the development of the American school of painting. He taught his students to choose simple, modest subject matter, to paint from life, and to use a loose *facture* that emphasized gorgeous and vivid brushstrokes as much as or even more than the accurate transcription of values. The resulting cheerful Realist style became standard in America. For several generations young American artists looked to Chase's example for the American alternative to the tauter Academic Realism that Thomas Eakins had brought back from the École des Beaux-Arts in Paris, to the seeming artificiality of Impressionism, and to the intellectualizing of the Symbolists and the Aesthetes. Nonetheless, his influence on his students was less specific. They seemed to develop with great individuality. One has only to review the names of some of his more famous American students to see that he did not hinder personal development with doctrinaire teachings. Strong personal styles are brought to mind by the names of Gifford Beal, Guy Pène du Bois, Charles Demuth, Marsden Hartley, Edward Hopper, Rockwell Kent, Alfred H. Maurer, Hayes Miller, Georgia O'Keeffe, and Charles Sheeler, all students of Chase.

28 Dorothy in Pink

Oil on canvas
42½ x 38½ in. (108 x 97.8 cm)
Signed u.l.: Wm. M. Chase
Not dated
Gift of Mrs. Sterling Morton
60.53

Provenance

Alice Chase, wife of the artist; given by Alice Chase to her daughter, Dorothy Chase; purchased from Dorothy Chase by William H. Thomson, by 1928; Joseph Katz, Baltimore, by 1949; (purchased from the Katz estate by Hirschl & Adler Galleries, N.Y., Apr. 2, 1959); purchased from Hirschl & Adler by Mrs. Sterling Morton for the PMC, 1960.

Condition and Technique

In 1978 examination by the BACC noted the painting had been lined with an aqueous adhesive to a plain weave fabric. The tacking margins had been cut. The lining fabric in turn had been backed by a plain weave fabric. The surface coating, a natural resin varnish (estimated), had moderately but not disfiguringly yellowed and had suffered severe abrasion around the edges from the rabbet.

The support, a very fine, light-weight, tightly woven, plain and single weave fabric, is covered with a very thin, white ground that reveals the fabric texture. The paint, an oil type, is applied as a rich vehicular paste in broad, fast brushstrokes, and texture is very apparent. There is some very heavy impasto, especially in the jewelry to catch the light.

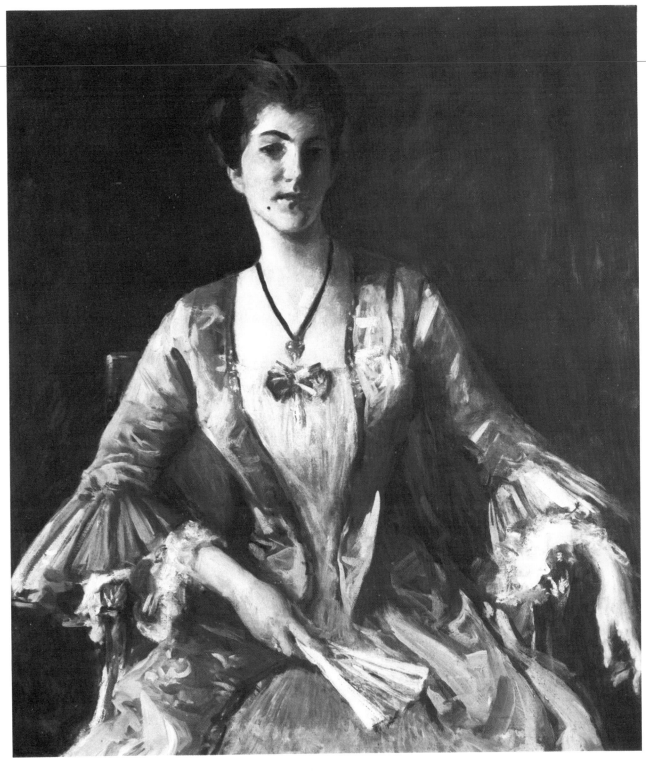

For over a decade, from about 1883 to 1895, Chase held open house on Saturdays in his Tenth Street Manhattan studio. The studio was set up like a private museum, filled with his paintings and the brilliant artifacts (antiques and curios) he had bought on his travels. This comfortably stuffed interior is well known from photographs and as the background or subject of many of his paintings. The entertainment at his open house (food, service, music, and guests) was elegant.

The brilliance of Chase's salons helped to raise the social status of the painter in America. It was an American parallel to the receptions given by Leighton in London, Piloty in Munich, and Meissonier in Paris. Since the Renaissance, artists and writers had argued that painting was not a craft but a liberal art, and that painters were or could be gentlemen, far above the artisan position generally accorded them. For a brief period around 1875 the question was moot; painters like Chase, Piloty, Leighton, and Meissonier were accepted at court and in society and lived like gentlemen. This triumph did not last very long. The activities of bohemian artists soon brought painters down a notch or two lower in the public estimation than they had ever been placed as artisans.

Chase went from one success to another, although his repertoire of subjects, like that of most fashionable Realists, was rather limited and repetitive. When he died in 1916, the critic Kenyon Cox said, "I can't imagine that he would have added anything to his reputation had he lived longer."

Gerald M. Ackerman

Notes

1. Katherine Metcalf Roof, *The Life and Art of William Merritt Chase* (New York: Charles Scribner's Sons, 1917), p. 95.

Dorothy in Pink

Dorothy in Pink is a portrait of Chase's third child of eight children. Dorothy Bremond Chase was born around 1890–1892. She much resembled her mother, and this picture might have been painted as a pendant to a slightly larger, earlier portrait of the mother, *Mrs. Chase in Pink* in the Davenport (Ohio) Municipal Art Gallery (fig. 1).[1] Both are kneepieces of approximately the same size, and the poses are similar. Both pictures belonged to Mrs. Chase and did not leave the family until after her death.

Dorothy's childhood may be followed in a series of portraits of herself alone and with her brothers and sisters.[2] She also appears as a model in several of Chase's genre scenes. Here she seems at least eighteen years old if not a bit older, so the picture was probably painted around 1910, when Chase was in his early sixties. The canvas is quickly and boldly painted. The accurate transcription of optical values has materialized as strong, individual brushstrokes. Chase's very loose *sprezzatura* technique might seem either the result of years of practice or of the infirmity of old age had we not recognized it as a type of handling popular at the time. The same effects can be recognized in the late portraits of Boldini and Sargent. Chase's emphasis on the autonomy of individual brushstrokes is part of the general abstracting tendency of the time.

Gerald M. Ackerman

Notes

1. Oil on canvas, 47¾ x 37¾ in. (121.5 x 96 cm), signed, not dated.
2. Eleven portraits of and including Dorothy are listed in the "Checklist of known works of William Merritt Chase," *Chase Centennial Exhibition*, Indianapolis, Indiana, John Herron Art Museum, 1949, n.p. Of these works, only two are in public collections, *Dorothy* (1911, Herron Art Museum), and *My little daughter Dorothy* (1891, Detroit Art Institute).

Exhibitions

N.Y., Montross Galleries, *Ten American Painters*, 1914.[1]

London, Shepherd's Bush, *Anglo-American Exhibition*, 1914.[1]

N.Y., The Metropolitan Museum of Art, *Loan Exhibition of Paintings by William M. Chase*, Feb. 19–March 18, 1917, no. 41 (as *Dorothy B. Chase*), lent by Mrs. William M. Chase.[1]

St. Louis, New House Galleries, *Paintings by William Merritt Chase*, N.A., LL.D., 1927, no. 46 (with sight measurements 40½ x 36 in.).

N.Y., American Academy of Arts and Letters, *Exhibition of The Works of William Merritt Chase*, Apr. 26–July 15, 1928, no. 39, lent by William H. Thomson.

Indianapolis, John Herron Art Museum, *Chase Centennial Exhibition*, "Checklist of Known Works by William M. Chase" (by Wilbur Peat), Nov. 1–Dec. 11, 1949 (as *Dorothy in Pink* [Dorothy Chase]: Lady in Pink (B), o/c, 42½ x 38½ in.; s.u.l., 1914. Joseph Katz, Baltimore Md.).[1]

SBMA, *Two Hundred Years*, 1961, no. 20, repr., mentioned "Introduction," n.p.

SBMA, *American Portraits*, 1966, no. 31, repr., n.p.

Calif., Fresno Arts Center, *200 Years of American Painting*, Nov. 20–Dec. 30, 1977, no. 37, color Pl. 7.

1. The editor is grateful to Ronald G. Pisano, Director, The Parish Art Museum, Southhampton, N.Y., for providing this information.

References

J. B. T., "'The Ten's' Annual Show," *American Art News*, XII (March 21, 1914), p. 3, repr. p. 1 (as *Portrait*, in the exhibition *Ten American Painters*, at the Montross Galleries).[1]

"Studio Talk," *International Studio*, LIV, no. 213 (Nov. 1914), p. 49 (as *Portrait of Miss C.*, review of Anglo American Exhibition, Shepherd's Bush), repr. p. 46.[1]

1. The editor is grateful to Ronald G. Pisano, Director, The Parish Art Museum, Southhampton, N.Y., for providing this information.

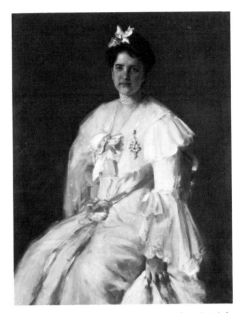

fig. 1 William Merritt Chase, *Mrs. Chase in Pink*. Reproduced by permission of Davenport Municipal Art Gallery, Gift of the Friends of Art.

John Singer Sargent
1856-1925

Although John Singer Sargent was born abroad, his parents were American, and he retained his United States citizenship throughout his life. His parents were Fitzwilliam Sargent and Mary Newbold Singer. Upon their marriage, Mrs. Sargent prevailed upon her husband, a physician, to give up his practice; together they took up residence abroad, where they lived in modest circumstances on the income from an annuity inherited by Mrs. Sargent. John Sargent was the eldest of three children; his sister Emily was born in 1857 and another sister, Violet, in 1870. Between 1856 and 1874, the year Sargent committed himself to a career in art, he traveled extensively in western Europe with his family. In 1876 Sargent made his first trip to the United States to establish his citizenship.

Between 1874 and 1878, Sargent studied at the École des Beaux-Arts in Paris and also with the well-known portrait painter, Charles Émile Carolus-Duran. In that last year as a student, he won an honorable mention at the Salon for his *Oyster Gatherers of Cancale* (Corcoran Gallery of Art, Washington, D.C.) and quickly went on to establish himself as a young major talent. His *El Jaleo* (Isabella Stewart Gardner Museum, Boston) in the Salon of 1882 and *The Boit Children* (Museum of Fine Arts, Boston), submitted to the Salon of the following year, won him much favorable critical attention. His career in Paris came to an abrupt end in 1885, as a consequence of the scandal attending the exhibition of his *Portrait of Mme. X* (Metropolitan Museum of Art, New York) in the Salon of 1884. Its daring realism shocked the public, effectively discouraged prospective clients, and obliged him to move to London, which became his permanent residence.

His first years in England were marked by an interest in Impressionism, and he completed his major genre painting of the period, *Carnation, Lily, Lily, Rose* (The Tate Gallery, London), which was shown at the Royal Academy in 1887. That year also brought him several commissions for portraits from American clients, and Sargent spent the winter of 1887–1888 in Boston, where he painted his *Portrait of Isabella Stewart Gardner* (I. S. Gardner Museum, Boston). Sargent was a frequent visitor to Boston thereafter; in 1890 he was commissioned to provide a mural decoration for the Boston Public Library, a project that would continue throughout the following twenty-nine years.

During the decade of the 1890s, Sargent became the foremost portrait painter in England, completing almost 150 commissions. Among his sitters numbered members of the English peerage, men of letters and science, prominent actors and actresses, and merchant princes. In the first years of the new century, he continued to be sought out as a portrait painter, but by 1907 he was becoming dissatisfied with this aspect of his career. It is from about this time that Sargent began to show much interest in watercolor painting, and he made extensive trips throughout the Mediterranean area, where he employed the medium with great effect.

The last twenty years of his life were largely focused on his mural projects for the Boston Public Library and the Museum of Fine Arts, Boston. During the First World War, he served in France as official war artist for the Imperial War Museum, London. Sargent received many honors during his lifetime: in 1897 he was elected to the National Academy of Design, New York, and the Royal Academy of Arts, London, and made an Officier, Légion d'Honneur. Honorary degrees were given to him in recognition of his work by major universities: University of Pennsylvania (LL.D., 1903), Oxford University (D.C.L., 1904), Cambridge University (LL.D., 1909), Yale University (LL.D., 1916), and Harvard University (Art D., 1916). Sargent won prizes and honors for his paintings in all of the major international art exhibitions, and his work is represented in the principal art museums in Paris, London, and the United States.

Donelson F. Hoopes

29 Statue of Perseus by Night

(also titled *Statue of Perseus in Florence*)
ca. 1907
Oil on canvas
50¾ x 36⅜ in. (128.9 x 92.4 cm)
Signed u.l.: John S. Sargent
Not dated
Gift of Mrs. Sterling Morton
60.80

Provenance

Mrs. Charles Hunter; (purchased from Mrs. Hunter by M. Knoedler and Co., Inc., N.Y., 1928); purchased from Knoedler by Mrs. Sterling Morton for the PMC, 1960.

Condition and Technique

Prior to sending the painting to the SBMA, Knoedler, at the request of James W. Foster, Jr., Director, SBMA (letter from Foster, Jan. 28, 1960), had the painting lined with a wax-resin adhesive to a fiberglass fabric.

In 1978 examination by the BACC noted in the ground and paint layers several areas of wide-mouthed traction crackle and slight fracture crackle that had developed due to the heavy and uneven layers of paint. Numerous drips of a white, opaque, water-soluble material were scattered over the surface coating (estimated a synthetic polymer resin) down the left edge of the painting.

In 1979 the painting was treated by the BACC. The splatters were removed with a cotton swab slightly moistened with deionized water. The surface coating was estimated to be a recent application of synthetic polymer resin. The painting was in good condition.

The support, a thin, light-weight, single-threaded plain weave fabric, is covered with a thick layer of pink-beige ground that extends onto all of the original tacking margins. The oil-type paint has been heavily and quickly applied wet into wet with extensive impasto. The painted design area stops about 1 in. from the edges on all sides (slightly less along the top edge) to expose a 1 in. wide surface of the ground, forming a margin along all sides.

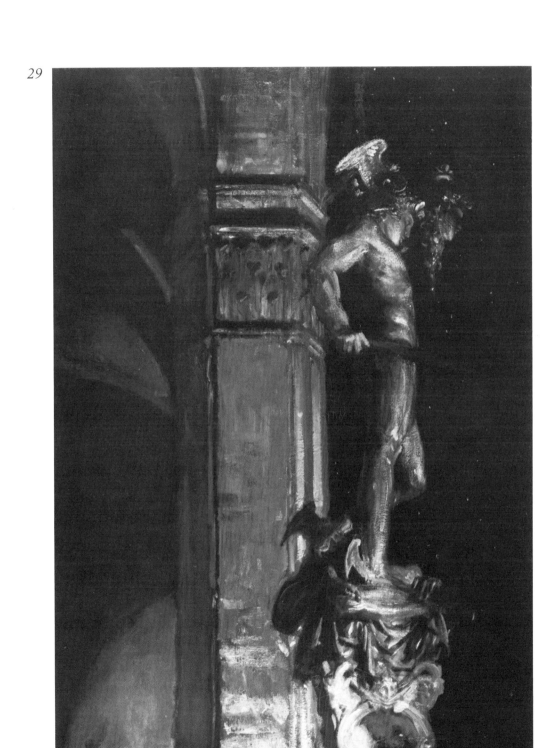

Statue of Perseus by Night

Sargent's painting *Statue of Perseus by Night* is a tour de force and one of the most curious and accomplished works of his long and varied career. Curious because it does not relate easily to the artist's oeuvre; there is only one other work, *The Spanish Dance* (The Hispanic Society of America, New York) painted in 1880, that employs the same mysterious nighttime darkness against which the figurative element is modeled in half-light. This picture is the product of the artist's maturity and substantiates what has been said of him, that his "... eye saw the physical presence of the world more directly, and his mind resolved that presence into pictorial realism more trenchantly than any other artist of his time."[1]

Assigning a date to the creation of this painting has been problematical. Neither of Sargent's first two biographers, William Howe Downes (1925) and Evan Charteris (1927), cared to estimate a probable date for it. When the painting was included in the exhibition, *The Private World of John Singer Sargent,* organized by The Corcoran Gallery of Art in Washington, D.C., in 1964, the date 1907 was accepted as probably correct, based upon the stylistic evidence presented by the painting itself, and the known itinerary of Sargent's travels in Italy from 1900–1913. During that time, only the years 1900 and 1907 securely place him in Florence; the later date for *Perseus* seems more appropriate. Sargent's manner of working certain passages of paint with a chalky scumbling technique manifested itself, notably in portraits, more toward the end of the decade. This technique is quite pronounced on the figure of Perseus and the architectural element behind the statue. It is certain that the picture could not have been painted later than 1913. The following year Sargent traveled in Switzerland and Austria, and with the outbreak of the First World War, never again made painting trips to the Continent.

While the genesis of this painting must lie partly in Sargent's profound interest in the effects of reflected and diminished light, another impulse is at work in the Perseus subject. Beginning in 1890, Sargent had been engrossed in a project to create a large mural decoration for the Boston Public Library. It required almost twenty-five years to complete his design, and during this time Sargent became a frequent visitor to Boston. He looked upon the Library murals as the crowning achievement of his career, surpassing even his accomplishments in portrait painting. Indeed the Library murals were hailed as the Sistine Chapel of American art when the final sections were installed in 1919. It was quite natural, therefore, that when the trustees of the Museum of Fine Arts in Boston determined to construct a new building, they should call upon Sargent to provide mural decorations for it, as he had for the Library. While firm contractual arrangements for the Museum decorations were not drawn up until 1916, informal negotiations must have been in progress for several years, perhaps even prior to the building's construction in 1909.

The architect of the new Museum building was Guy Lowell, who had determined to design a studiously correct neoclassical structure. In keeping with this architectural idiom, Sargent chose subjects from Greek mythology as themes for his decorations. As with his previous work for the Boston Public Library, Sargent approached the Museum assignment with great thoroughness and historical accuracy. His search for precedents for the Perseus subject led him quite naturally to Benvenuto Cellini's famous bronze of 1548.

It is not known if Sargent had any specific program in mind for the Perseus theme in connection with the Museum mural project at the time he painted this picture; however,

the unusual choice of a nighttime view of the Cellini bronze, rather than the more expected daylight rendition of it, suggests that he was working out, at least tentatively, a lighting problem connected with the murals. The first set of decorations for the Museum included both paintings and bas-relief sculptures. As with the Library commission, Sargent found that much of the illumination falling upon the upper portions of the walls and the ceilings in both projects was reflected light, bouncing off the floor, rather than direct illumination from the skylights in both spaces. The Perseus theme was not used for the first set of Museum decorations after all, but found final resolution in the second set, which was commissioned in 1921 and delivered to the Museum in 1925, after Sargent's death. The scheme of this last set, which included *Perseus,* provided for eight other Classical subjects: *The Danaïdes, Apollo in His Chariot with the Hours, The Four Winds, Atlas and the Hesperides, Chiron and Achilles, Orestes and the Furies, The Fall of Phaeton* and *Hercules Slaying the Hydra.*[2] Sargent did not use Cellini's version of the Perseus story, with the hero standing in triumph over the slain figure of Medusa; instead Sargent chose to portray Perseus astride the winged horse, Pegasus, handing the severed head of the monster to Athena. Indeed Sargent's composition bears no resemblance at all to that of Cellini, except in one detail; in the twisted, headless figure of Medusa, Sargent seems to have derived his concept rather directly from Cellini.

The provenance for Sargent's *Perseus* in the Preston Morton Collection shows that it was originally owned by Mrs. Charles Hunter. Sargent painted Mrs. Hunter's portrait in 1898 (The Tate Gallery, London) and formed a very close friendship with her. He was a frequent visitor at the Hunter's country estate, Hill Hall, near Epping. Evan Charteris characterized it as being "furnished and decorated in the Italian style and in admirable taste by Mrs. Hunter, who, herself keenly interested in the arts, had the faculty of gathering within the fold of her generous hospitality rising and risen lights of the literary and artistic world."[3] The novelist Henry James was often a guest at Hill Hall, as were the composer Percy Grainger and the critic George Moore, among other luminaries. Whether Sargent gave this painting to Mrs. Hunter or whether she bought it from him is not known. As it was his custom to inscribe a dedication on works intended as gifts, the absence of such an inscription suggests the latter possibility.

Donelson F. Hoopes

Notes

1. Donelson F. Hoopes, *The Private World of John Singer Sargent* (exhibition catalogue), The Corcoran Gallery of Art, 1964, p. 24.
2. *The Decorations of John Singer Sargent: History and Description with Plan* (Boston: Museum of Fine Arts, 1925).
3. The Hon. Evan Charteris, K.C., *John Sargent* (New York: Scribner's, 1927), p. 168.

Exhibitions

San Diego, Balboa Park, The Palace of Fine Arts, *Official Art Exhibition: California Pacific International Exposition,* Feb. 12–Sept. 9, 1936, no. 327 (as *Perseus*).

Michigan, The Detroit Institute of Arts, *The Age of Impressionism and Objective Realism: Loan Exhibition of Paintings,* May 3–June 2, 1940 (catalogue published in *Art News,* XXXVIII, no. 31, May 4, 1940), no. 75 (as *Perseus*).

SBMA, *Two Hundred Years,* 1961, no. 55 (as *Statue of Perseus in Florence,* dated ca. 1898), repr., mentioned "Introduction," n.p.

Washington, D.C., Corcoran Gallery of Art, *The Private World of John Singer Sargent* (catalogue by Donelson F. Hoopes), April 18–June 14, 1964, no. 74.

References

William Howe Downes, *John Singer Sargent: His Life and Work* (Boston: Little, Brown, and Co., 1925), p. 271 (as *Perseus By Night*).

Evan Charteris, *John Sargent* (New York: Scribner's, 1927), p. 296 (as undated oil).

Charles S. Kessler, *Arts,* XXXV, no. 7 (April 1961), p. 19, repr.

Charles Merrill Mount, *John Singer Sargent: A Biography* (New York: W. W. Norton & Co., 1955), no. K0710, p. 449 (as *Statue of Perseus By Night,* 1907).

Walter Gay
1856-1937

One of the numerous American expatriates active in Paris around the turn of the century, Walter Gay worked almost exclusively in Europe. As the major artistic center during the nineteenth century, Paris drew to her many young artists seeking simultaneously academic training and exposure to contemporary movements; consequently American artists journeyed to Paris in almost unbroken succession.

Walter Gay was born on January 22, 1856, in Hingham, Massachusetts, where he spent his early years close to his uncle, the painter Winckworth Allan Gay (1821–1910), who had himself sojourned in Paris in the late 1840s as a member of the studio of Constant Troyon. It has recently been observed that stylistically little, if anything, in the younger Gay's works can be attributed to the influence of his uncle.[1] In his memoirs, however, Walter Gay suggests the importance of his uncle as a role model: "[my uncle] was a landscape painter of note, who had lived much abroad. He had gone to Paris in 1848, and I learned much from him, sitting by his side while he painted and hearing him talk about France, whither I longed to go."[2]

From Hingham the family moved to Boston, and it is there in 1873 that Walter Gay began his studio training, attending a night class at the Lowell Institute for Drawing and becoming a member of the Tremont Street studio of William Morris Hunt (1824–1879).[3] Hunt, a friend of W. A. Gay, had also traveled with him to Europe, and there joined the *atelier* of Thomas Couture in Paris. Not surprisingly therefore, the young Gay, encouraged by both Hunt and his uncle, left Boston in 1876 to continue his studies abroad. This departure signaled the end of the first phase of Gay's development, for once in Europe both his style and subject matter changed. In Boston he had become an accomplished painter of flower still lifes and successfully exhibited at the gallery of Williams and Everett.[4] After his arrival in Paris, perhaps as a result of the French academic disdain for still life, Gay's preoccupation with flower motifs was eventually replaced by his interest in the narrative possibilities of the human figure.

During his early career it is known that he also painted landscapes, an interest shared by Hunt and W. A. Gay, who had both worked near Fontainebleau with Barbizon artists such as Corot, Millet, and Daubigny. After his own installation in Paris, Gay visited the countryside near Auvers-sur-Oise where he and his companions frequently painted in the presence of Daubigny.[5] At that time, and later when he went on to Barbizon, he must have painted many landscapes. None of the early landscape paintings, however, have yet been identified, and his sketchbooks provide our only indication of his interest in nature.[6] While at Barbizon, Gay made the acquaintance of another of his uncle's friends, William P. Babcock, who introduced him formally to the French peasant as a subject worthy of the artist's attention.

Back in Paris Gay sought admittance to the studio of Léon Bonnat (1833–1922), where he studied for the next three years. A figure painter with a distinguished reputation, Bonnat was sought out by young American artists, including previously, among others, Eakins and Sargent.[7] Training in this studio assisted Gay in making the transition from the tight, detailed description of botanical subjects to a more broad, painterly style well suited to his new subject matter. At Bonnat's suggestion, Gay, as Sargent had done before, went to Spain in 1878 to study the free brushstroke of Velazquez's mature style. This exposure proved to be a determining factor in the development of Walter Gay, as it has been for other American expatriates.

Initially Gay painted historical genre such as *Une Leçon d'escrime* (A Fencing Lesson), his first entry in the Salon of 1879; but following the example of Millet and of

30 *Interior of His Brother's House in Boston*

(also titled *Interior of the House of the Brother of the Artist in Boston*)
ca. 1902
Oil on canvas
20 x 24⅞ in. (50.8 x 63.2 cm)
Signed l.r.: Walter Gay
Not dated
Anonymous gift
61.12

Provenance

Given by the artist to Lucien Guitry, ca. 1905;[1] Sacha Guitry by 1925?;[2] (purchased from S. Guitry by Knoedler, 1930); from Knoedler to the PMC, 1960.

1. According to the notation made by Knoedler at the time the gallery acquired the painting in 1930: "This picture was given by the artist to Lucien Guitry about twenty-five years ago." The date of ca. 1905 is also proposed by Nancy C. Little, Librarian for Knoedler, in a letter of Oct. 13, 1980, to the editor.
2. Lucien Guitry, the father of Sacha Guitry, died June 1, 1925.

Condition and Technique

In 1978 inspection by the BACC noted that the painting had been lined at an unknown date. There was a crack along the seam at the top edge, some overpaint and many tiny areas of cleavage, especially at top r. The surface coating, a natural resin (estimated), had slightly yellowed.

In 1980 the painting was treated by the BACC. The loose paint was set down with a dilute proprietary PVA emulsion and Tergitol. Losses were filled with Ross Wax and pigment. The fills were isolated with Bakelite PVA-AYAA, 30% in ethyl alcohol. Inpainting was done with dry pigments hand ground in Acryloid B67/Acryloid B72, 1:3 in xylene. An overall spray coat of B72, 10% in xylene was applied.

The support, a medium-weight, plain and single-weave fabric, is covered with a white layer, probably comercially applied, of medium thickness that slightly obscures the weave texture. The paint, a rich vehicular paste-pigmented pellicular oil type, was applied wet into wet, with brushstrokes evident and some very high impasto in the highlights.

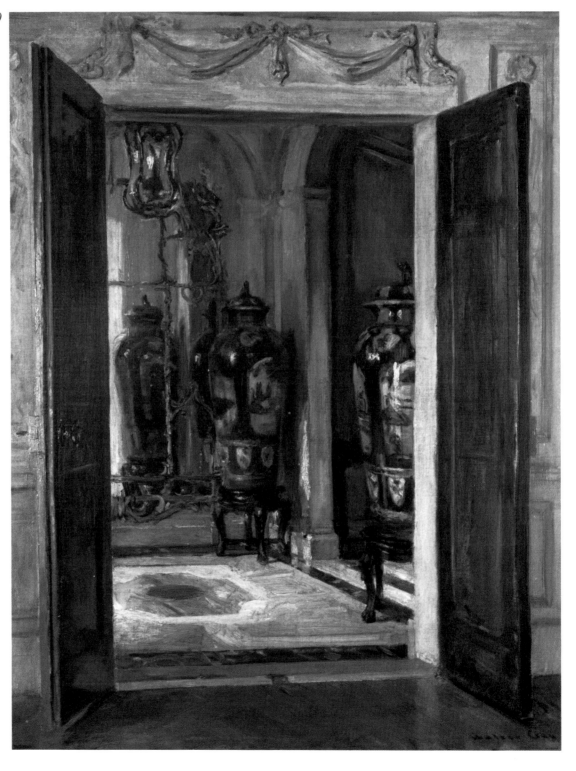

Bastien-Lepage he gradually turned to more sober depictions of the French lower classes. In keeping with the serious nature of his subjects in those years, his palette is restrained. In works such as *Charity* (Manney Collection),[8] the color scheme, limited to a subtle range of tones from mid-gray to mid-brown, relieved only by gray-greens and a small area of muted red, displays none of the flickering contrasts of the pure colors of the Impressionists. Gay's use, however, of a wide range of values for each color creates a sensation of silvery light and demonstrates his interest in light as it qualifies colors and forms.

By the 1890s Gay's artistic reputation was secure, and he counted among his friends Sargent, Cassatt, Whistler, Mortimer, and Degas. He and his wife, Matilde Travers, moreover, circulated in an international circle, which included not only artists, but writers such as Henry James and Gabriel de Mun, wealthy Americans such as Sarah Cooper Hewitt, and members of the French aristocracy such as the Comtesse de Gramont. It was from her in 1907 that Gay purchased the Château de Bréau, which served jointly as a luxurious environment in which to entertain and as a source for many of his paintings of interiors. Beginning in the mid 1890s until Gay's death in 1937, the rooms of the lower classes were replaced by the rich furnishings of the eighteenth-century salon.

Despite his current lack of renown, Walter Gay's paintings were well enough known during his lifetime to prompt imitation,[9] and wealthy patrons from Europe and America, such as the Fricks, sought him out, asking him to paint portraits of favorite rooms in their residences. From 1879 on, he exhibited internationally, winning honors at the Salon and attaining the distinction of Commander of the Legion of Honor. After his death at Le Bréau on July 13, 1937, the Metropolitan Museum in New York held a retrospective exhibition of his work. Gay subsequently slipped into relative obscurity, from which he and his paintings have been recently rescued through the retrospective of his paintings at the Grey Art Gallery.[10]

Lynn Federle Orr

Interior of His Brother's House in Boston

Interior of His Brother's House in Boston offers a characteristic example of the numerous interiors Walter Gay painted from the mid 1890s until the end of his career. During this last and longest period, Gay limited himself almost entirely to representing unoccupied interiors. His motivation for painting them is clearly set forth in a letter of April 29, 1917, to Frederic F. Sherman:

> It was at this time c. 1895 that I went to live in the country in an old chateau, and surrounded as I was by the past, I imbibed perhaps some of the atmosphere. At all events, it was then that I began painting interiors giving the spirit of rooms that are unoccupied.[1]

Gay's "peopleless interiors," Gary A. Reynolds has written, "had no direct precedents in either European or American art. Before his interest in this subject matter, most empty interior paintings were done as studies for larger figural compositions."[2] Prior to those of Gay, examples of empty interiors painted for themselves are extremely rare, the notable exceptions being provided in the nineteenth century by Menzel and by Turner.[3]

Despite the documentary aspect of Gay's interiors, in which objects and furniture

Notes
1. Gary Reynolds, *Walter Gay: A Retrospective* (exhibition catalogue), Grey Art Gallery, New York University, September 1980, p. 15.
2. Walter Gay, *Memoirs of Walter Gay* (New York: William Edwin Rudge, 1930), p. 12.
3. Gay, p. 37.
4. Reynolds, p. 16.
5. Gay, p. 41.
6. See, for example, the drawings of the French countryside in the *Sketchbook* of 1882 (Archives of American Art, Smithsonian Institution).
7. Reynolds, p. 21.
8. Repr., Reynolds, Pl. 21.
9. The imitations included outright forgeries as attested by his letter of June 7, 1917, to Frederic F. Sherman: "Many thanks for your letter of May 22nd with its enclosure of photographs from your collection. Among the latter, I was much surprised and shocked to find photos of two pictures of mine, not being in my style at all, but are frank forgeries . . . the one signed is a subject I never attempted and the other is quite unlike me in treatment." (Letter in the collection of the Philadelphia Museum of Art.)
10. See Reynolds.

are faithfully depicted, his main concern, as Reynolds has indicated, "was to capture the personality of a room — or in the artist's own words — 'getting the subject of the room and its decoration — giving personality to objects and furniture.'"[4]

Most of the rooms Gay painted are imbued with the spirit of the eighteenth century, a period that enjoyed a revival in France during the second half of the nineteenth century, and one that Gay, along with Edith Wharton and Elsie de Wolfe (both friends of his), did much to advance in America during the last years of the nineteenth and early years of the twentieth century.[5] His interiors are preponderantly French, some of them from historical buildings such as the Palace of Fontainebleau.[6] It was in the interiors of houses inhabited by friends, family, and himself, however, that Gay captured their essence and suggested the unseen presence of past and present owners. "He portrays apartments; he studies the physiognomy of vestibules with their marble tilings," Henri Lavedan wrote in 1913, ". . . He is unequalled in the realistic rendering of woodwork, and even expresses a thought in the rendering of a light parquet flooring or the checkered inlay of a flagstone pavement."[7]

Gay rarely attempted to give a thorough description of a room. He preferred instead to study one corner, focusing on one or two lovely pieces of furniture or other decorative forms; or, as in the Santa Barbara painting, to show one room opening onto another, delighting in the partial vistas and in the passage from a shadowed space to one animated by light.

Gay's interiors were by no means exclusively European. In the course of return visits to the United States he depicted several New England interiors,[8] including some from his native Boston. *Interior of His Brother's House in Boston* is an undated work that was probably painted on the occasion of his trip to America in 1902, when he painted *Interior, Boston,* inscribed and dated "Boston 1902," which also represents an interior of the house of William Gay, the artist's brother, at 169 Beacon Street.[9] In both works the view is from one rather dark room through an opened (or partially opened) door into a light filtered space, and in both Gay encompasses only a few decorative pieces.

As seen in the Preston Morton painting, Gay is a master of *facture:* his paint varies from a thick impasto in the highlights, to very thin passages that allow the underpainting to show through. His brushstroke, loose but controlled, blurs precise details, such as the designs on the Chinese vase, yet respects the integrity of the outlines of the various forms. In this respect Gay's technique, like that of other American expatriate artists, differs from that of the French Impressionists, where the brushstrokes dissolve the solidity of the forms. Analogous to the concerns of the Impressionists, on the other hand, is Gay's mastery in rendering the seduction of light as it filters onto the landing — caressing the glazed surfaces of the porcelains, glinting in the crystal walls of the chandeliers, or quietly resting behind the curtained windows reflected in the mirror.

Gay's gift for evoking an era and for revealing the character of a house and the quality of the life within it is beautifully exemplified by the two blue-and-white Chinese vases, those ubiquitous emblems of cultivated estheticism during the declining years of the last century, and whose presence on the landing bespeaks a household assured in its quiet yet luxurious elegance.

Lynn Federle Orr

Notes
1. Quoted in William Gerdts, "The Empty Room," *Allen Memorial Art Museum Bulletin,* XXXIII, no. 2 (1975–1976), p. 74.
2. Gary Reynolds, *Walter Gay: A Retrospective* (exhibition catalogue), Grey Art Gallery, New York University, September 1980, p. 70; see also Gerdts, p. 72–88.
3. Reynolds, p. 70.
4. Reynolds, p. 71, and no. 12.
5. Reynolds, pp. 81–82.
6. Reynolds, no. 40, p. 62, repr.
7. Quoted in Reynolds, p. 64.
8. Reynolds, nos. 34–37, pp. 59–60, repr.
9. Reynolds, no. 34, p. 59; repr. in color p. 83.

Childe Hassam
1859-1935

Childe Hassam was born in Dorchester, Massachusetts, in 1859. While still in his teens he was apprenticed to a wood engraver and worked as a free-lance illustrator. 1878 found him attending evening classes at the Boston Art Club, and a little later he studied with a Boston painter, I. M. Gaugengigl. His first trip to Europe took place in 1883. The following year he married and first visited the island of Appledore off the coast of New Hampshire, where Celia Thaxter, a writer and poet, had formed a summer colony of artists and writers. She encouraged Hassam and bought some of his watercolors. During the winters, for the next few years, Hassam painted street scenes of Boston, characterized by a tonalist approach and a predilection for rainy weather and deep perspectives.

In 1886, Hassam made his second trip to Europe, where he stayed for three years and studied briefly at the Académie Julian. As exemplified by *Le Jour de Grand Prix* (1887, Museum of Fine Arts, Boston), Hassam began to leave behind the rain-soaked views of his Boston years to adopt the sunlit palette, accentuated brushstrokes, and asymmetrical placements of French Impressionism. His work met with considerable success at the Paris Salons of 1887 and 1888, as well as at the International Exposition of 1889, where he won a bronze medal. In the fall of 1889 Hassam returned to New York, where he established a studio at 95 Fifth Avenue. One of the best interpreters of New York's city life, Hassam at the time believed that an important artist "paints his own time and the scenes of every-day life around him." His *Three Cities*, published in 1899, summarizes this phase of his art.

Once more during the summers he visited Appledore, painting some of his most engaging pictures there, and in 1894 he illustrated Celia Thaxter's *An Island Garden*. After a third visit to Europe in 1897 and upon his return to New York, he resigned from the Society of American Artists and helped found The Ten American Painters, who held their first exhibition in 1898. They exhibited regularly for twenty years. During all of this time Hassam continued to win medals at various art exhibitions, and in 1902 he was elected an Associate at the National Academy of Design and finally an Academician in 1906.

In the early years of the twentieth century Hassam experimented with new themes. He painted street scenes with working-class people that predate those by the "Ashcan" School. He traveled to California and Oregon in 1908, painting the scenery there. A few years later he began the "Window" series, which features interiors with figures. Included at the Panama-Pacific International Exhibition, Hassam visited San Francisco in 1914 and painted at Carmel. In 1915 he took up etching in a major way, exhibiting seventy-five etchings and drypoints the following year in New York.

In 1917 Hassam began his *Flag Series* of Fifth Avenue, which reached its climax in the scenes celebrating the end of the World War. In these compositions the flags receive the major attention as the city recedes in the background, and the paintings dispense with the detailed record of a social period that his New York paintings of the 1890s had conveyed.

Hassam continued to garner honors and awards. In 1919, a major retrospective exhibition of his paintings was held at the Macbeth Gallery, and in 1920 he was elected to the American Academy of Arts and Letters. That same year he established a permanent summer home and studio at East Hampton, New York, which inspired many of his finest etchings. His *Etchings and Drypoints* was published in 1925. More retrospective exhibitions followed in 1926 and 1927. A few months after his death at East Hampton in 1935, a posthumous exhibition of his paintings was held at the Milch Gallery, New York.

Patricia Gardner Cleek

31 The Manhattan Club

(also titled *The Stewart Mansion, New York City*)
ca. 1891
Oil on canvas
18¼ x 22⅛ in. (46.4 x 56.2 cm)
Signed l.r.: Childe Hassam N.Y.
Not dated
Gift of Sterling Morton
60.62

Provenance

(American Art Association, N.Y., Auction Catalogue, Childe Hassam, Feb. 6–7, 1896, no. 92, as *The Manhattan Club*); private collector; (to Parke Bernet, N.Y., *French and Other Modern Paintings*, May 6, 1959, no. 92, repr.); (purchased from Parke Bernet by E. & A. Milch, Inc., N.Y.); (to Hirschl & Adler Galleries, Inc., N.Y., May 1959–Jan. 22, 1960); purchased from Hirschl & Adler by Sterling Morton for the PMC, 1960.

Condition and Technique

In 1979 examination by the BACC noted the painting had been lined at an unknown date with a wax-resin adhesive to a light-weight, single-threaded, plain weave fiberglass fabric. The original tacking margins were preserved. To hide the dark line of a scratch in the paint and ground layers, there was a light vertical streak of discolored white overpaint 5¾ in. long and ⅛–¼ in. wide running on an almost vertical line from behind the woman crossing with the top-hatted man to r., down to the bottom edge. The overall condition was good.

In 1979 the painting was treated by the BACC. The discolored overpaint was removed with acetone and toluene. The area was inpainted with dry pigments ground in B67/B72 (1:3) and xylene. An overall spray coat of B72, 10% in xylene was applied to even out gloss between inpainted and original areas.

The support, a very fine, light-weight fabric, single-threaded and with plain weave, is covered with a white ground thinly applied that does not hide the fine fabric texture. The paint is applied in sketchy, short strokes as a rich vehicular paste and leaves the ground exposed in many areas around the forms as an additional white tone. The paint ranges in texture from very thin smooth glazes to fine high impasto with extensive brushstroking visible. Lines of a light sketch in blue are visible below the paint.

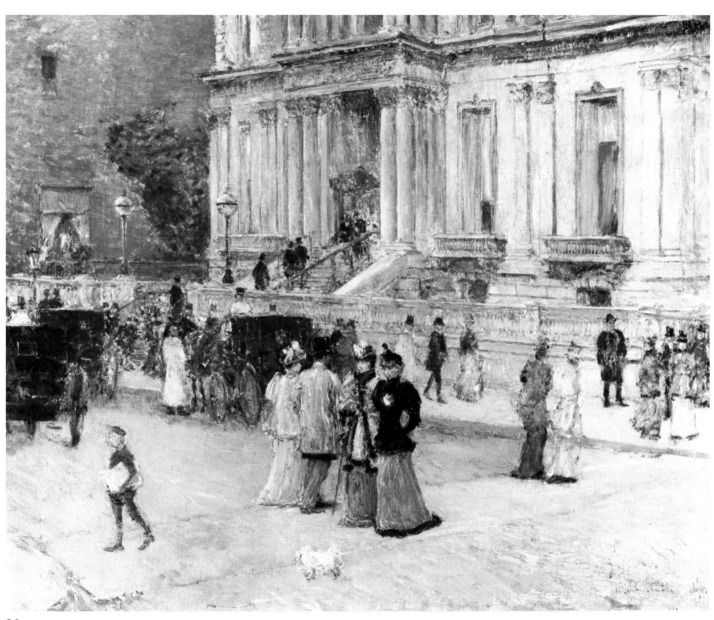

31

The Manhattan Club

(See color reproduction on cover)

Childe Hassam, a former Bostonian, on his return from France in 1889 settled in New York and in a short period of time became known for his street scenes of New York painted in an Impressionist style. Although he had previously done some *plein air* painting around Boston, it was during his three years in Paris (1886–1889) that his earlier interest in depicting city parks and boulevards asserted itself as a dominant theme.

Upon his return to New York, Hassam found a studio apartment on Fifth Avenue at Seventeenth Street, not far from the squares and other picturesque spots of the city, and quickly established himself as the painter of the fashionable places of New York. On the occasion of the 1890 fall exhibition of the National Academy of Design, *The Critic* praised Hassam's painting of Union Square and another of Broadway and Madison Square. As a former illustrator Hassam would have been familiar with numerous representations of various parts of the city, then appearing in periodicals such as *Harper's Weekly,* that frequently represented places where "congregate the beauty and fashion of the city." Hassam limited his scenes to the narrow strip of fashionable New York along Fifth and Madison Avenues.

In the next few years Hassam continued to receive praise for his paintings of street scenes. Reviewing the exhibition of the American Water-Color Society in 1891, *Harper's Weekly* wrote: " 'Fifth Avenue,' by Childe Hassam, is one of the artist's street scenes that we are getting to know and like so well, a picture of fine ladies and gentlemen, walking on the favorite promenade of New York. There is . . . no lack of fine raiment."[1] M. G. Van Rensselaer, an art critic and writer on architecture, in her article "Picturesque New York," written for *Century Magazine,* stated: "Some of our young artists are beginning to draw and to etch and to paint New York, and here and there they find corners and vistas of delightfully novel flavor."[2] Several of the picturesque spots she singled out had already been or soon would be painted by Hassam. An article of a year later, "Fifth Avenue" by the same author, was illustrated with engravings of Hassam's paintings and included *The Manhattan Club House.* In Mrs. Van Rensselaer's opinion, Fifth Avenue above Madison Square was particularly picturesque and interesting: "Few streets in the world are gayer, brighter, more attractive than is this part of our best street when it is seen at its best. To begin with, it has such a wonderful atmosphere, such a crystalline splendor of thin, bright air, and brilliant light, such a canopy of transparent sapphire." The writer goes on to describe the street traffic of "stately steeds and satisfying gowns. . . . And certainly the now ubiquitous hansom adds greater picturesqueness to a street panorama than the low open cabs of Paris and Vienna."[3]

The Manhattan Club represents an animated and elegant slice of life on Fifth Avenue at 34th Street. The painting depicts the "Palace," so referred to by contemporary newspapers, which belonged to one of the greatest "Merchant Princes" of the nineteenth century, Alexander Turney Stewart (1803–1876), a retail store magnate. Crowning his successful career, in 1869 he built his mansion on Fifth Avenue, which was considered one of the most splendid in America (fig. 1). It was built of the finest white Carrara marble, with the interior decorated by Italian artisans. Stewart was an art collector and one of the early patrons of the Metropolitan Museum of Art. After Stewart's death in 1876, his house remained vacant for many years until it was taken over by the Manhattan Club in December 1890 and kept until 1899.

fig. 1 *A. T. Stewart House*, photograph, 1894. Reproduced by permission of Museum of the City of New York.

Hassam's method of painting in the early 1890s was described by A. E. Ives in *The Art Amateur* of 1892:

"I paint from cabs a good deal," said Mr. Childe Hassam, when asked how he got his spirited sketches of street life. "I select my point of view and set up my canvas or wooden panel, on the little seat in front of me, which forms an admirable easel. I paint from a cab window when I want to be on a level with the people on the street and wish to get comparatively near views of them, as you would see them if walking in the street."[7]

This method of sketching from cabs had been previously used in Paris by Jean Béraud and Giuseppe de Nittis, who were noted for Paris street scenes shown at the French Salon. Hassam was often compared to Béraud and de Nittis at this time in his use of subject matter. They too painted the fashionable city residential sections and were well known in the last quarter of the nineteenth century. Hassam's painting may be compared to Béraud's *The Church of St. Philippe du Roule, Paris* (fig. 2), which was first shown at the Paris Salon in 1877 and was bought in 1888 at a New York sale by Samuel P. Avery, a prominent New York art dealer.[8] He was also secretary of the art committee of the Union League Club and one of the founders of the Metropolitan Museum of Art.

Like Hassam's, Béraud's painting represents figures on the stairs of a monumental porticoed entrance and people walking along the sidewalk and the street, the latter with its complement of cabs. Although the spatial recession of each differs — Béraud's street plunges deeply — both show a partial view of the main architectural element viewed on a diagonal.

Hassam's *The Manhattan Club* was mentioned in "Gossip of the Studios . . . Something About Childe Hassam's Methods," published in the *New York Recorder*, a clipping of which is preserved by the American Academy of Arts and Letters:

In the van of the genuine impressionists native to the soil is Childe Hassam whose later pictures were recently exhibited at the Blakeslee Galleries. Of late Mr. Hassam has been doing much work in pastel. . . . Among the most important of Mr. Hassam's productions are *Turquoise and Sapphires* and *April Shower — Paris,* a sparkling view of the *Manhattan Club* and a clever canvas depicting coachmen under an electric light. . . . Mr. Hassam has not been long in New York — Boston having been his former home — but he can rest assured that wherever he stakes his tent there will be found those who will admit his talent and enjoy his work.[4]

Although the date has been cut from the clipping, internal evidence points to a date in May 1891, inasmuch as *Electric Light*, referred to in the article, is probably the painting shown at the Society of American Artists in that month.[5] Since the Preston Morton picture appears to have been consistently called at the time *The Manhattan Club*,[6] a date between December 1890, when the Club took over the Stewart Mansion, and May 1891 seems likely, with Mrs. Van Rensselaer's article of November 1893 providing an absolute terminal date.

Béraud's painting was exhibited in the Fine Arts Society Building, New York, in 1893 but may have also been shown earlier at such a place as the Union League Club, where many art exhibitions were held.[8] On the other hand, Hassam may have as easily derived the idea of emphasizing a particular building from street scenes in contemporary American periodicals. Hassam used this approach in other illustrations and paintings he did in the early 1890s.

Hassam's quick sketching ability, learned as an illustrator, certainly helped him in his Impressionist style. A. E. Ives, in the same article of 1892, described Hassam's method of painting: at the beginning, "at the near view some of the figures were the merest suggestions of men and women, more like odd, little hieroglyphs than anything else."[9]

fig. 2 Jean Béraud, *The Church of St. Philippe du Roule, Paris.* Reproduced by permission of The Metropolitan Museum of Art, Gift of Mr. and Mrs. William B. Jaffe, 1955.

Subsequently the figures would be elaborated slightly with a few strokes of the brush, and the work considered finished.

The Manhattan Club was painted in the heyday of American Impressionism. In the period from 1890 to 1893 American Impressionists were receiving prizes and acclaim. In reviewing the exhibition of the Society of American Artists in 1892, M. G. Van Rensselaer said: "Those methods of decomposing colors, of rendering one tint to the eye by the association of many tints, which are called impressionistic methods, have formed so many adherents that we may say an American impressionistic school now exists."[10] Hassam figured prominently in this group. Beginning in the early 1890s, he began sending his paintings quite regularly to the National Academy of Design, the Society of American Artists, and to exhibitions across the country. He also began winning important medals, receiving a gold medal in the World's Columbian Exposition at Chicago in 1893. This Exposition represented a climax in the success of American Impressionists. In *Crumbling Idols* (1893), Hamlin Garland said, "If the [Chicago] Exposition had been held five years ago, scarcely a trace of the blue shadow idea would have been seen outside the work of Claude Monet, Pissarro and a few others."[11]

Hassam was represented in the prestigious collection assembled by Thomas B. Clarke. Mr. Clarke gave an annual prize at the National Academy of Design and was chairman of the art committee of the Union League Club, where he planned many small exhibitions of American painting open to the public. Hassam's work was shown there in 1891, in three exhibitions of 1894, and possibly on other occasions. The Manhattan Club also held small loan exhibitions of painting during its residency at the Stewart Mansion.

At the turn of the century, Hassam was still receiving praise for his views of New York: "He is one of the very few artists who have found beauty in the teeming busy streets

of New York and have produced pictures of street scenes that have value apart from local associations."[12] By 1906, critics were recognizing other subjects: "Of late Hassam paints street scenes less frequently than he did in former years. . . . There was a time when we really could not associate his name with anything else."[13] Although he continued painting Fifth Avenue, culminating in the *Flag Series* of 1916–1919, city scenes no longer represented the most important theme in his work.

Patricia Gardner Cleek

Exhibitions

N.Y., Blakeslee Galleries, May 1891? (as *The Manhattan Club*).

SBMA, *Two Hundred Years*, 1961, no. 32 (as *The Stewart Mansion, New York City*), repr., mentioned "Introduction," n.p.

N.Y., Hirschl & Adler Galleries, *Childe Hassam, 1859–1935*, Feb. 18–March 7, 1964, no. 17 (as *A. T. Stewart Mansion*, dated 1893), repr.

Tucson, The University of Arizona, Museum of Art, *Childe Hassam Retrospective*, Feb. 5–March 5, 1972, no. 74, p. 138, repr. color p. 25, traveled SBMA, March 26–April 30, 1972.

Calif., The Oakland Museum, *The Painters of America: Rural and Urban Life*, Feb. 10–March 30, 1975 (shown only at Oakland; not in the exhibition at the Whitney Museum of American Art and not included in the catalogue).

Seattle, University of Washington, Henry Art Gallery, *American Impressionism*, Jan. 3–March 2, 1980, p. 131, repr. p. 145 (as *The Stewart Mansion, New York City, 1893*); traveled Los Angeles, University of California, Frederick S. Wight Art Gallery, March 9–May 4, Evanston, Ill., Terra Museum of American Art, May 16–June 22, Boston, The Institute of Contemporary Art, July 1–Aug. 31.

References

"Gossip of the Studios . . . Something about Childe Hassam's Methods" (*New York Recorder*, May ?, 1891?, see note 4).

M. G. Van Rensselaer, "Fifth Avenue," *The Century Magazine*, XLVI (Nov. 1893), repr. p. 14 (as *The Manhattan Club-House*, engraved by E. H. Del'Orme).

Norman A. Graebner, Gilbert C. Fite and Philip L. White, *A History of the American People* (New York: McGraw Hill Book Co., 1970), II, repr. p. 283 (as *The Stewart Mansion, New York City*).

Ralph K. Andrist, ed., *The American Heritage History of the Confident Years* (narrative by Francis Russell) (New York: American Heritage Publishing Co., Inc., 1969), repr. pp. 176–177.

MD The Medical News Magazine (Nov. 1975?)[1]

MD En Español (Oct. 1977), repr. p. 80 (as *La mansión de Stewart, Nueva York*).

1. Information from a request of Aug. 15, 1975 from *MD*.

Notes

1. "Exhibition of the American Water-Color Society," *Harper's Weekly*, XXXVI, no. 1847 (Feb. 7, 1891), p. 107.
2. M. G. Van Rensselaer, "Picturesque New York," *The Century Magazine*, XLV (Dec. 1892), pp. 168–169.
3. Van Rensselaer, "Fifth Avenue," *The Century Magazine*, XLVI (Nov. 1893), pp. 14–15.
4. Microfilm, Archives of American Art, American Academy of Art and Letters, NAA-1, frame 487. Although the name and date of the newspaper are cut off in the clipping, the article was identified by Roger Mohovich of The New York Historical Society as coming from the *New York Recorder*. Subsequent efforts to find complete runs of this paper were not successful. Both the Library of Congress and the American Antiquarian Society have disposed of their holdings of the *Recorder*. The file held by The State Historical Society of Wisconsin (the only institution known to still have issues of this daily paper) runs only from November 1891 to June 1894. The article was not found in any of these issues. (Ed.)
5. See *The Critic*, May 1891, p. 243.
6. It is as *The Manhattan Club* that it is listed in the Childe Hassam auction catalogue, American Art Association, Feb. 6–7, 1896, no. 92.
7. A. E. Ives, "Mr. Childe Hassam on Painting Street Scenes," in *The Art Amateur*, Oct. 1892, p. 116.
8. *French Paintings — A Catalogue of the Collection of the Metropolitan Museum of Art*, Metropolitan Museum of Art, New York, 1966 (distributed by New York Graphic Society, Greenwich, Conn.), p. 216, repr.
9. Ives, p. 116.
10. Van Rensselaer, in *Harper's Weekly*, XXXV (May 14, 1892), p. 468.
11. Hamlin Garland, *Crumbling Idols* (Chicago and Cambridge, Mass.: Stone & Kimball, 1894), p. 121.
12. Frederick W. Morton, "Childe Hassam," *Brush and Pencil*, VIII (June 1901), p. 147.
13. *International Studio*, XXIX (Sept. 1906), p. 269.

Twentieth Century—
The Urban and Rural Scene

Maurice Prendergast
1859-1924

"The love you liberate in your work is the only love you keep."
Maurice Prendergast[1]

Maurice Brazil Prendergast was unique among early modernists in America. He "seemed to expand like a blossom under a summer sky, and like the proverbial sundial, he chose to record only the smiling hours: out of his abstemious life came a sort of Franciscan hymn to the sun and his fellow creatures."[2] His painting of figures in landscapes, and still lifes, nudes, and seashore scenes synthesized French Post-Impressionist modes with the glitter and dignity of Venetian mosaics and a fresh native American response to the out-of-doors.

He was born on October 10, 1859, in St. John's, Newfoundland.[3] His mother was a Bostonian of French Huguenot ancestry and his father, of Irish descent. When Maurice was two, his family moved to Boston, where his younger brother, Charles, was born in 1869. The family was poor; his "life was as constricted and difficult as Ryder's."[4] Leaving school at fifteen, he went to work in a dry-goods store where he also painted show-cards. He apprenticed himself to a sign-painter and began spending his spare time sketching and painting in watercolor.

From youth to the time of Maurice's death, the Prendergast brothers were very close, working, traveling together and sharing living quarters. In 1886, they worked their way to England on a cattle boat, visiting Wales and Paris. The following year, they returned and settled in Winchester, near Boston, and several miles from Revere Beach, to which the artist frequently walked in order to paint. Later, when Charles set up a framing business, Maurice assisted him. Charles was a diligent craftsman, best known for his carved, incised, and gilded frames and gessoed, painted panels and decorative chests depicting naive, simplified pre-Raphaelite scenes.

In 1891, Maurice made his first monoprint, showing the influence of Bonnard. Soon, however, these vigorous, translucently brushed prints became Prendergast's own triumphant personal statement. By that same year, he had saved enough money ($1000) to return to Europe to study — with Courtois at Colarossi's and with Joseph Blanc, Benjamin Constant, and Jean Paul Laurens at the Académie Julian. He traveled with several of his fellow students, including Canadian James Wilson Morrice, visiting Dieppe, St. Malo, and Dinard. His vision and style gravitated to the work of the Nabis and the post-Impressionists.

Returning to the United States in 1895, Prendergast sent watercolors and monoprints to the annual exhibition of the Pennsylvania Academy of the Fine Arts. At this time, too, he met Philadelphian artists William Glackens and Robert Henri. He began showing his work nationally, and a few sales were made. In Boston, he was commissioned to illustrate several books, including a novel by Sir Hall Caine and *My Lady Nicotine* by Sir James Matthew Barrie.

Prendergast attracted patrons. The artist-collector Sarah Choate Sears (Mrs. J. Montgomery Sears) financed his third trip to Europe. In Paris, he was dazzled by the work of Cézanne. He returned to the French beaches, painting many watercolors at St. Malo. In Italy, Prendergast visited Siena, Florence, Rome, Capri, and Venice. He painted along the canals and in the Piazza San Marco. He was particularly intrigued by the Carpaccio panels in San Giorgio degli Schiavoni.

Back in Boston, in 1899, he was given his first one-man show at the Chase Galleries. In 1900, he showed jointly with a Boston friend, Hermann Dudley Murphy, at the Art Institute of Chicago. Through Arthur B. Davies, he exhibited watercolors and

32 Summer in the Park

ca. 1905–1907
Oil on canvas
15½ x 20¼ in. (39.4 x 51.4 cm)
Signed l.r.: Prendergast
Not dated
Gift of Mr. and Mrs. Sterling Morton
59.52

Provenance

Estate of Maurice Prendergast; willed to his brother Charles Prendergast; Mrs. Charles Prendergast, at death of Charles Prendergast, 1948; (Kraushaar Galleries); purchased from Kraushaar by Mr. and Mrs. Sterling Morton for the PMC, 1959.

Condition and Technique

In 1978 examination by the BACC noted the painting had been lined with an aqueous glud and the original tacking margins removed. The impasto had been crushed during lining. The very thin recent surface coating (estimated synthetic polymer resin) had some slight grime along the bottom edge.

The support is a moderately light-weight, plain weave fabric (estimated linen). The ground, light grey in tone, is moderately thin and does not hide the fabric texture. The paint, an oil-type, vehicular paste structure, ranges from thin diluted washes to vigorous strokes of brushmarked pastes and slight impasto. The ground tone is visible in much of the design.

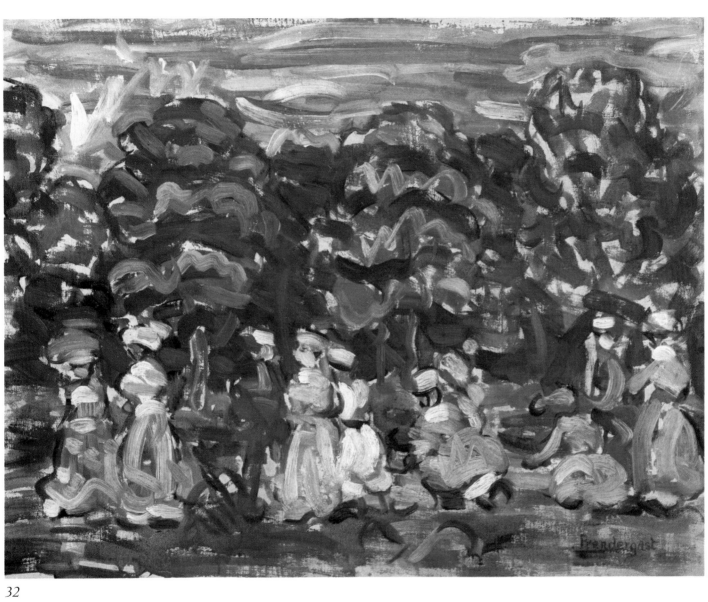

32

monotypes at the Macbeth Gallery in New York. At this time he began making regular trips to New York, painting a series of Central Park watercolors. In 1901, he was awarded a Bronze Medal at the Buffalo Pan-American Exposition. His paintings were shown that year at the Cincinnati Art Museum. In 1903, he moved with Charles to a studio on Mt. Vernon Street in Boston, spending summers for several years at Nahant, Ipswich, Marblehead, and Gloucester. He began transcribing his watercolors to oil in his studio.

In 1904, the National Arts Club annual exhibition included Maurice Prendergast along with such artists as Davies, Glackens, Henri, George Luks, and John Sloan.[5] He was included in the 1908 Macbeth Gallery show of "The Eight," famed for its pyrotechnical color and brushwork. This exhibition traveled to nine American cities, establishing a basis for the welcome Prendergast's entries received nationally when he continued to enter major exhibitions throughout the nation.

Prendergast made three more trips to Europe before World War I. His seventh and last trip was financed by Lillie Bliss[6] and collector-lawyer John Quinn. In 1913, Prendergast showed seven paintings in the International Exhibition of Modern Art, the "Armory Show." The following year he succeeded Davies as president of the Association of American Painters and Sculptors. It was at this time that he and Charles moved to 50 Washington Square South, above the studio of Glackens.

In 1915, he showed two mural-sized paintings at the Montross Gallery. John Quinn bought them both. Gertrude Käsebier photographed Prendergast for *Vanity Fair*, which "nominated" him for the "Hall of Fame."[7]

Duncan Phillips was an early Prendergast collector and patron. He was attracted by his "technical innovations" and "bold bright patterns." Phillips wrote that Prendergast was "an original, whimsical lyricist with tubes of color for language," using a ''weaving stroke," "infinite variations in the color schemes, the textures, the alterations of the perpetual arabesque."[8]

With the help of Frederick William Howald, Dr. Albert Barnes began buying Prendergast oils and watercolors. These three patrons endowed museums with fine representations of Prendergast's work in Washington, D.C., Columbus, Ohio, and Marion, Pennsylvania.

Just before his death on February 1, 1924, Prendergast was awarded the third William A. Clark Prize and the Bronze Medal in Washington's Corcoran Gallery Ninth Biennial Exhibition. His ashes were placed in a cemetery in Norwalk, Connecticut.

Ruth Bowman

Notes

1. As quoted by Perry T. Rathbone in Foreword to centennial catalogue, *Maurice Prendergast, 1859–1924*, Museum of Fine Arts, Boston, 1960.
2. Lewis Mumford, *New Yorker*, April 22, 1933, filed at the Whitney Museum of American Art.
3. With a twin sister, who died at the age of seventeen.
4. Mumford, *New Yorker*.
5. Sloan, in the etching *Anshutz on Anatomy*, 1912, depicted a class at Henri's school in New York, in 1905, showing all of the group plus many other men and women.
6. Later a founder, in 1929, of the Museum of Modern Art in New York.
7. *Vanity Fair*, November 1915, p. 56.
8. Duncan Phillips, *The Artist Sees Differently*, The Phillips Publications no. 6, vol. 1 (New York: E. Weyhe, 1931).

Summer in the Park

(See color reproduction, page 40)

Summer in the Park is typical of the method of Maurice Prendergast oil paintings, being painted originally on loosely stretched very fine linen canvas. This flexibility of surface and response to the laden brush of Prendergast's oils added vitality to his strokes of paint. The Centennial Exhibition catalogue dated the painting 1905–1907. Antoinette Kraushaar thought it was done later, in 1910–1912. There is no doubt, however, that this work was done at the peak of Prendergast's painterly powers and that it reflected his willingness to free his brush, loaded informally with barely mixed pigment, to move with the energy and speed so readily seen in his monotypes. This immediacy gives *Summer in the Park* a freedom seldom seen even in the brightest of his more structured compositions.

Summer titles are frequently seen in Prendergast exhibition catalogues. The ease and informality, the openness and vigor of this composition are far from the "cool, low tones of the early impressionistic work . . . the precision of definition of the carefully patterned Venetian scenes gives way to the freedom of expression, the richness of glowing color, the highly individual interpretation of design that is so triumphantly asserted in his later works."[1]

Prendergast was reserved both in his person and in his work, but never impersonal. His painting reflects an "interest in pageantry, crowds, scenery, the passing scene."[2] Subject matter for Prendergast was confined to topics that could be caught in suspended animation: seashores, riders, park promenades, bathers, fishing boats, rain scenes in the city, and vivid fruit or flowers — all seen framed and from a removed position. There stood the artist, "making patterns of joyous color," giving evidence to the world that for all time he will always be "one of the men who has been consistently and thoroughly modern."[3]

Ruth Bowman

Notes

1. Margaret Breuning, *New York Evening Post*, February 24, 1934, files of the Whitney Museum of American Art.
2. Dorothy Adlow, *Christian Science Monitor*, Boston, September 27, 1938.
3. William Glackens, as quoted by Hedley Howell Rhys, in centennial catalogue, *Maurice Prendergast, 1859–1924*, Museum of Fine Arts, Boston, 1960.

Exhibitions

Boston, Museum of Fine Arts, *Maurice Prendergast 1859–1924* (catalogue by Hedley Howell Rhys), Oct. 26–Dec. 4, 1960, no. 14, p. 69, repr. in color p. 45; traveled only to San Francisco, California Palace of the Legion of Honor, Apr. 22–June 3, 1961, Cleveland Museum of Art, June 20–July 30, 1961.

SBMA, *Two Hundred Years*, 1961, no. 52, mentioned "Introduction," n.p.

Albuquerque, University of New Mexico Art Gallery, *Impressionism in America*, Feb. 9–March 14, 1965, no. 39, p. 42, p. 15, repr. in color p. 43; traveled San Francisco, M. H. DeYoung Memorial Museum, March 30–May 5, 1965.

Tulsa, Okla., Philbrook Art Center, *French and American Impressionism*, Oct. 2–Nov. 26, 1967, no. 50, p. 18.

Calif., San Jose Museum of Art, *The United States and the Impressionist Era*, Nov. 17, 1979–Jan. 9, 1980, listed, n.p.

Washington, D.C., National Gallery of Art, *Post Impressionism: Cross Currents in European and American Painting 1880–1906*, May 25–Sept. 1, 1980, no. 272, repr. p. 239.

Gifford Beal
1879-1956

If a realist painter's oeuvre can be viewed as a diary of where he has been, then we might conclude that Gifford Beal never had much use for umbrellas. Mostly he walked where the sun shone — in New York's Central Park, at the garden parties tossed by New England's *haut monde,* and on the docks of the harbor in Newport, Massachusetts, where the air was filled with the stench of fish and the cries of seagulls. Like all of us, he must have known days that were stormy and gray, but these he escaped by going to the circus or theater.

Life was good to him, and, a contented man, he mostly saw goodness and beauty in the world about him. He was born in New York City in 1879 to William and Eleanor Beal. His father, an official with a light company, took pride in the artistic talent young Beal started to show when he was a pupil at the Barnard Military School in Harlem. The senior Beal wanted his son to get the best art training available. When Gifford Beal was twelve, he began taking part-time instruction from William Merritt Chase at Chase's Tenth Street studio. Beal entered Princeton University in 1896, but continued his studies with Chase by commuting from New Jersey to New York City on weekends. Throughout his university years, Beal attended the summer school Chase established in Shinnecock, Long Island. After graduating from Princeton in 1900, Beal carried on his art studies for two more years at the Art Students League in New York. (He was to serve as president of the League from 1914 through 1929, holding the office longer than anyone else in the school's history.)

Beal had but one job in his life, and it was the only one he ever wanted. He began establishing himself as a professional artist immediately upon leaving the Art Students League. He was not yet twenty-five when he started to collect prizes and place his paintings in important juried shows. The awards were to keep coming in throughout his life, including six from the National Academy of Design. Many major museums acquired his paintings, among them the Metropolitan Museum of Art and the Whitney Museum of American Art in New York City, the Art Institute of Chicago, the Detroit Institute of Art, and the Philips Collection in Washington, D.C. In 1920, Beal was given a solo exhibition at the Kraushaar Galleries, which ever since have mounted almost yearly shows of Beal's work, and in 1950 a Beal retrospective was organized by the Century Association in New York.

Beal painted in several different manners, ranging from a diffuse impressionist style to sharp-focus realism, but his pictures were freighted with only one message and it was a simple one: beauty and the joys of living are as worthy of the painter's attention as are ugliness and sadness. We might call him a romantic realist. Beal died in New York City in 1956. If he painted few great pictures, he painted fewer bad ones. His work should be better known today. It is as if the artist who spent so many of his days in the sunshine had gone deeply into the shade soon after death.

Dean Jensen

33 Sideshow

1910
Oil on canvas
28⅛ x 36⅛ in. (71.4 x 91.8 cm)
Signed and dated l.l.c.: GIFFORD BEAL.10
Gift of Mr. and Mrs. Sterling Morton
59.66

Provenance

(Grant Galleries, N.Y.); (Terry DeLapp, Pasadena, Calif., 1949); purchased from Terry De-Lapp, Los Angeles, by Mr. and Mrs. Sterling Morton for the PMC, 1959.

Condition and Technique

In 1978 examination by the BACC noted some localized areas of crackle in the paint. The surface coating, a natural resin, had slightly yellowed. The overall condition was good.

The support, a rather tightly woven medium-weight, plain and single-weave fabric is covered with a white ground of medium thickness, possibly commercially prepared. The oil-type paint is applied as a rich vehicular paste, with some areas of extremely heavy impasto in the lights creating islands of paint in high relief.

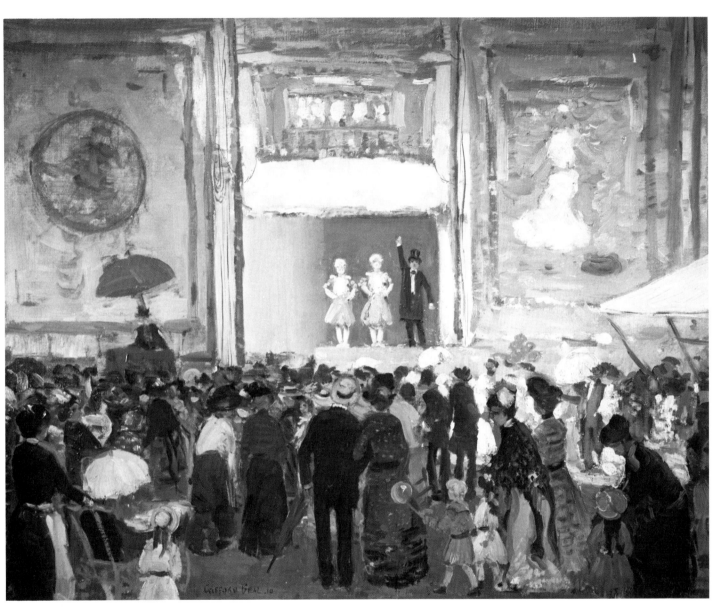

33

Sideshow

(See color reproduction, page 41)

Gifford Beal painted an amazing number of good pictures in a career that spanned more than a half century, but *Sideshow* reveals the artist in one of his finest hours.[1]

Like Daumier, Seurat, Toulouse-Lautrec, Picasso, and a multitude of other great artists, Beal was an unrepentant circus enthusiast. Whenever one of the sawdust spectacles was in his neighborhood — in New York's Madison Square Garden, in Provincetown, Massachusetts, or in Newburgh-on-the-Hudson, New York, which may be the setting for the Preston Morton painting — he was likely to be on hand with a sketchbook. Beal painted perhaps a hundred circus pictures. It may be that no American was better than Beal at getting down in paint the magic of what went on under the canvas.

In the day of this painting, virtually every circus had a tented annex with fire-eaters, sword-swallowers, and snake-charmers. Sideshows are pretty much a thing of the past. Some now say that the days of the circus are numbered. If the day comes when these gypsy caravans end their peregrinations to tank towns hidden away in the cornstalks and the great metropolises, it will be a time lamented not just by schoolboys, but by artists. With its peculiar blend of beauty and freakish hideousness and its silk peddler's inventory of colors, the circus has bewitched the artist as has no other spectacle. In Beal's *Sideshow,* the enchantment of yesterday's circus lives on.

Walt Kuhn, a far more hard-boiled artist than Beal, took us backstage at the circus. Kuhn showed us that the smile of the clown was just so much greasepaint and that the radiant expression of the equestrienne dissolved the instant she stepped outside the tanbark ring. Beal never looked that probingly at these wanderers of never-contented will. He saw the circus' dramatis personae as does the child, with eyes filled with wonder. He seems to have been drawn to the setting of *Sideshow* as just another member of the crowd who fell under the hypnotic spell of the "talker," as sideshow pitchmen are called in the circus.

What is the top-hatted figure on the sideshow's bally platform crowing about? We can only guess, but we do know that the Barnum & Bailey Circus of 1910 advertised such attractions in its Congress of Human Wonders as Jean Libberra, "the man with two bodies, four hands and four feet," Krao, "the missing link in the chain of evolution," Rosa Winsted, "the Giantess," and Norman Green, "the living skeleton." In a paraphrasing of the phosphorescent language used by the sideshow talkers of old, such human curiosities were "all real, all alive," and a ticket to see them all could be purchased for a mere twenty-five cents.

We cannot be certain, but there is reason to believe that the sideshow depicted was part of the Barnum & Bailey colossus and that the place is Newburgh-on-the-Hudson. Beal was living in New York in 1910, when the painting is dated, but his parents, William and Eleanor Beal, made their home in Newburgh during this period. Young Beal made regular trips to Newburgh to visit them. Barnum's *Greatest Show On Earth* played Newburgh on May 19, 1910. Since Beal was never known to waste time in translating his sketches into paintings, it is likely that he completed this work in the same year he saw the circus. One thing is certain. Even in the golden age of the big top when this painting was done, there were very few circuses that featured sideshows as large as the one depicted here. These included the Barnum & Bailey show and the Ringling Bros., with which it later merged. There is yet another reason to believe that we are looking at the Barnum

sideshow of 1910. The costumed figures on the stage are attired in raiment similar to that worn by members of the Bayrooty Troupe of Oriental Dancers, a popular attraction of the Barnum sideshow at the time.

Beal did paintings of the circus as a young man and in his final years, but it cannot be said that his impressionistic handling of the scene here was typical of his painting style. Beal did not paint in one manner, but in perhaps a half dozen styles. He sometimes summered on the coast of Maine. There he did paintings of the sea and fisherfolk that in their raw drama and bold draftsmanship recall the pictures of Winslow Homer, who had covered the same place and people earlier. Most of Beal's circus paintings are aglow with color, but in their execution they can be highly finished, almost photorealistic at the one extreme, or hurried and broadly brushed at the other. *Sideshow* — a painting in which Beal appears to have worked at a middle point in his stylistic extremes — is a tour de force for the artist. Its magic-lantern show of color and light, the sense of life emanating from the sideshow professor and the towners he has under his spell, capture well the holiday mood of the occasion and the rodomontade of the circus. We are reminded, too, that maybe only Reginald Marsh was as good as Beal in showing us that a crowd of one hundred is comprised of one hundred individuals who are distinct from one another. Beal may have pushed the balloon-carrying boy in the Little Lord Fauntleroy suit into the picture purely for sentimental effect. But look at the straw-hatted man with his head cocked ever so slightly toward the woman at his side. He has been individually observed, as have the others in the throng. There is little doubt that Beal rubbed elbows with all of them on a sunny, carefree, long-ago day at the circus.

Dean Jensen

Notes

1. The following sources were used for this essay: Interview with William Beal (son of the artist), Rockport, Mass., Nov. 11, 1980; interview with Gifford Beal, Jr. (son of the artist), Highland, N.Y., Nov. 11, 1980; Barnum and Bailey Circus route book of 1907, compiled and published by Charles Andress; *Billboard Magazine,* April 23, 1910, p. 33; March 18, 1911, p. 46; Nov. 23, 1912, p. 27; Ringling Bros. and Barnum & Bailey Circus route book of 1945.

Exhibitions

SBMA, *Two Hundred Years,* 1961, no. 65, repr., mentioned "Introduction," n.p.

Ernest Lawson
1873-1939

Ernest Lawson was born in Halifax, Nova Scotia, on March 22, 1873, to Dr. Archibald Lawson, a physician, and Anna E. Mitchell. His parents moved to Kansas City, Missouri, in 1883, leaving their son with his uncle and aunt, Dr. and Mrs. George Munro Grant in Kingston, Ontario, where Dr. Grant was president of Queen's University. The young Lawson took a great interest in drawing, a pursuit considered of little promise in a family so involved in scholarship. (Lawson's father considered a profession in art a "drifting and lazy position.")[1] Joining his parents in 1888, Lawson apprenticed in a shop stippling designs on cloth and copying "the dogs of Rosa Bonheur on a blotting cloth."[2] While in Missouri, he also studied at the Kansas City Art Institute with Ella Holman, whom he later married. In 1890, Lawson and his family moved to Mexico City, where he worked as a draftsman for an English engineering firm and studied in the evenings at the Academy of San Carlos.

Lawson came to New York in 1891 to study at the Art Students League. It was not until 1892, however, when he enrolled in the summer school established by John Twachtman and J. Alden Weir in Cos Cob, Connecticut, that Lawson adopted the Impressionist style he was to pursue with variations for the remainder of his career.

During his first visit in 1893 to Paris, Lawson studied at the Académie Julian under Jean-Paul Laurens and Benjamin Constant. At Moret-sur-Loing, just outside Paris, he met Alfred Sisley, an Impressionist whose style coupled with that of Twachtman profoundly influenced the work of the young American. Two of Lawson's paintings were accepted in the Salon des Artistes Français in 1894. Upon his return to the States that same year he married Ella Holman, after which they sailed to France, where their first daughter, Margaret, was born in 1896.

After a short stay in Canada, Lawson accepted a teaching position in Columbus, Georgia. A second daughter, Dorothy, was born in 1897. The following year, the family settled in the Washington Heights region of New York City, where they were to remain for eight years. Margaret Lawson Bensco recalls those years as happy ones with her father, who was a devoted family man during this period.

By the turn of the century, Lawson's subject matter largely confined itself to this upper Manhattan neighborhood bounded by the confluence of the Hudson and Harlem Rivers. Now densely settled with large apartment buildings, the region at that time consisted of forested areas surrounding small farms. After the move to Greenwich Village in 1906, Lawson continued to journey to these former haunts, carrying his painting equipment on the Sixth Avenue El. According to his daughter, he loved nature and always started his work out-of-doors. More prolific in the summer, "in the winter, he studied and improved works he did in the summer."[3] Rather than making preliminary drawings, Lawson painted directly onto the canvas, often doing an entire outline of the composition in red.

Living in Greenwich Village gave Lawson the opportunity to meet William Glackens, with whom he formed a lifelong friendship. He was befriended as well by George Luks, John Sloan, and Everett Shinn, who along with Glackens were friends since their earlier days on the *Philadelphia Press*. Together with Robert Henri, Arthur Davies, and Maurice Prendergast, the group formed "The Eight" as an alternative to the conservatism of the National Academy of Design, and in 1908 exhibited together at the Macbeth Gallery.[4] Unlike other members of "The Eight" (with the exception of Davies), Lawson was not drawn to the streets and the human vignettes of the urban scene, but continued instead to paint landscapes. Lawson also participated in the exhibition of the Society of

34 Royal Gorge, Colorado

Oil on canvas
25 x 30 in. (63.5 x 76.2 cm)
Signed l.r.: E. Lawson
Not dated
Gift of Mrs. Sterling Morton
60.70

Provenance

Samuel T. Shaw; (Samuel Shaw Sale, Sotheby Parke Bernet, N.Y., 1945, no. 87); James E. Shaw, Orleans, Mass.; (purchased from Shaw by the Vose Galleries, Boston, Oct. 7, 1952); (purchased from Vose by the Babcock Galleries, Dec. 4, 1954); purchased from Babcock by Mrs. Sterling Morton for the PMC, 1960.

Condition and Technique

In 1978 examination by the BACC noted the painting had been lined with an aqueous adhesive to a piece of kraft paper (estimated) in turn lined to a tightly woven fabric, in turn lined to a similar piece of fabric. The tacking margins of the support and of the first lining had been cut. The impasto revealed extensive flattening. Yellowed remnants of a natural resin coating were caught in the hollows of the impasto. The condition of the ground and paint was secure.

The thin white ground, possibly applied commercially, has been left exposed in many areas. The oil-type paint, heavily applied in impasto to form areas of high relief, has been scored in straight parallel lines by a tool (palette knife?).

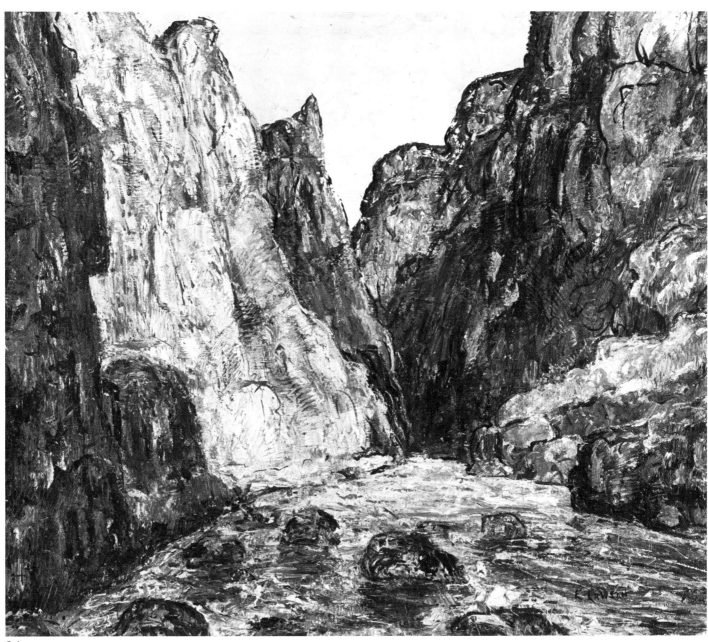

34

Independent Artists in 1910, the first "no jury, no prizes" show to be held in America. He was likewise involved in the Armory show of 1913 — serving on the Committee of Foreign Exhibits and exhibiting three of his works. In July 1914 Lawson had a successful show at the Galerie Levesque in Paris.

A $1,500 prize from the Corcoran Gallery allowed Lawson to take his family to Spain in 1916, where he painted in the regions around Toledo and Segovia. The landscapes of this period, bathed in bright light and colors, reflect a new palette different from that of earlier canvases. Despite the unfavorable reaction in the States to this new style when he returned in 1917, Lawson persisted with it for several years.

In 1917, Lawson was elected to full membership at the National Academy and in June 1919 journeyed to his native province after the Nova Scotia Museum of Art offered him an exhibition. The Lawson family spent its last summers together in New Hampshire in 1919 and 1920. Despite his winning several prizes in 1920 and 1921, the artist continued to be poorly received by critics and this, coupled with personal problems, caused him to drink heavily.[5]

Lawson painted at Peggy's Cove, Nova Scotia, in 1924 and then in New York. He taught at the Kansas City Art Institute in 1927, and in that same year moved to Colorado Springs to accept a faculty position at the Broadmoor Art Academy.

Except for a brief visit to Nova Scotia in 1928 for his mother's funeral, Lawson remained in Colorado for three years. While there, he befriended one of his students, Katherine Powell, who, together with her husband Royce, played an important role during the last decade of the artist's life and gave him much-needed support and encouragement. In 1931, Lawson accepted their offer to visit them in Coral Gables, Florida. He returned to Florida annually until 1936, when he moved permanently to Coral Gables.

Despondency over his work was temporarily halted when the Metropolitan Museum bought his painting *The Beach, Miami* in 1937. That same year, he also received a commission to execute a mural for the Federal Arts Project in the Short Hills, New Jersey, Post Office (since demolished), which, begun in the summer of 1939, was installed in 1940.

The final years of Lawson's life were marked by ill health, financial distress, and discouragement. In a letter to his wife and daughter of December 18, 1939, Lawson wrote of his depressed state.[6] That same day, his body was found on the beach at Miami, the cause of his death attributed to a heart attack perhaps following a robbery, since his wallet was missing. In the obituary of the *New York Herald Tribune* of December 20, his close friend and fellow artist, Guy Pène du Bois, wrote: "He was a lover of nature who knew the language of his art so well that he could render all the richness he saw in her and all the joys she made him feel."

Adeline Lee Karpiscak

Notes

1. Lee Karpiscak, Interview with Mrs. Margaret Lawson Bensco, April 11, 1977.
2. Frederic Newlin-Price, *Ernest Lawson, Canadian-American*, (New York: Ferargil Gallery, Inc., 1930), n.p.
3. Paul Karlstrom, interview with Mrs. Margaret Lawson Bensco, Archives of American Art, Smithsonian Institution, San Francisco, Sept. 7, 1976.
4. Lawson sold one work, *Winter on the River*, to Mrs. Gertrude Whitney.
5. During these two years, Lawson won the Temple Gold Medal at the Pennsylvania Academy, the Altman Prize from the National Academy, and the First Prize at the Pittsburgh International Exposition.
6. Excerpts from this final letter in the Archives of American Art, Smithsonian Institution, San Francisco, read as follows:

All I can send you to get two simple things for yourselves is $10.00. . . . However, I expect to sell a picture here this week. Pray for it. . . . However, we are better off than others and I have no debts. I hate the season of hysterical giving back and forth. . . . Hope you and Margaret are not uncomfortable. Do write me. I must admit — I am depressed. . . . Oh, the farce of Christmas. This is not a cheerful Christmas letter but I cannot write in a gay mood when I don't feel gay. At least, we can pray and hope that the next year will be better than the last. Do your best to get some enjoyment. I am desolated that I cannot contribute to it. Please forgive me. I ought to have more money but I have not. . . . Oh, how I wish peace and comfort for you both.
Ernest

Royal Gorge, Colorado

In 1927, Ernest Lawson received a teaching assignment at the Broadmoor Academy in Colorado Springs, Colorado (presently the Colorado Springs Fine Arts Center). Frederic Newlin-Price, president of the Ferargil Galleries, New York, and a supporter of Lawson and his works, relates in a 1930 essay an account told by the artist during his residence in Colorado Springs "of a collector sent by a friend, who looked at [Lawson's] paintings and then looked at him, and walked out with the statement: 'You'll live for years, you're no investment.'" Newlin-Price continues, "Money was low, and Colorado was fine for his health [Lawson was suffering from rheumatoid arthritis]; soon he was painting the golden aspens and the rocky portals to the desert."[1]

During his three years in Colorado, Lawson concentrated on its forested mountains and canyons, and the houses, churches, and mines nestled among them. These landscapes, as exemplified by *Royal Gorge, Colorado*, form a logical transition between his Spanish paintings of 1916–1917, with their intense light and bold palette, and the energetic brushstrokes and somber colors of his Florida paintings of the 1930s. The earlier Twachtmanesque mode of Lawson's views of New York, with their gentle, ethereal quality often enhanced by snow-covered hills and ice-encased waterways, is forgotten. Rather his Colorado paintings manifest a predilection for a pictorial structure that may reflect the influence of Cézanne, with whose works Lawson was undoubtedly acquainted from the 1913 Armory Show.

In *Royal Gorge, Colorado*, one of the finest examples of Lawson's work during these years, the subject matter, in conjunction with a new palette, creates a massive and dramatic buildup of forms. The Royal Gorge of the Arkansas River, just west of Cañon City, Colorado, is approximately twenty-five miles southwest of Colorado Springs. The canyon narrows to thirty feet, while its sheer cliffs rise to twelve hundred feet. In the Santa Barbara painting, these craggy, shadowy cliffs form solid rock walls that parallel the meandering river. Lawson expresses their rugged quality by strongly outlining them and by actually "scoring" the paint surface to form a rough texture.

In an interview of 1931, Lawson told Arthur Strawn: "I'm trying to get a little more solidity in some of my masses, even if the paintings might seem less charming. I'm not sure yet if I'm succeeding at it."[2] This sense of solidity is already a paramount feature in Lawson's Colorado canvases, as exemplified by *Royal Gorge* and another masterpiece of these years, *Goldmining, Cripple Creek* (fig. 1, National Museum of American Art, Washington, D.C.) for which he was awarded the Saltus Gold Medal at the National Academy in 1930.

Despite awards, Lawson's Colorado paintings were not a success at the time either with the critics or with the public. Both the exhibition of twenty-four paintings Lawson organized in Colorado Springs in 1928 and the subsequent one held at the Ferargil Galleries in New York met with reviews that failed to appreciate their force and vigor.

Adeline Lee Karpiscak

fig. 1 Ernest Lawson, *Gold Mining, Cripple Creek.* Reproduced by permission of National Museum of American Art (formerly National Collection of Fine Arts), Smithsonian Institution; Bequest of Henry Ward Ranger through National Academy of Design.

Notes
1. Frederic Newlin-Price, *Ernest Lawson, Canadian-American* (New York: Ferargil Gallery, Inc., 1930), n.p.
2. Arthur Strawn, "Ernest Lawson," *Outlook*, CLVII (April 22, 1931), p. 573.

Exhibitions

Alabama, Birmingham Museum of Art, May 31– July 1956 (information provided by Babcock Galleries).
Iowa, Des Moines Art Center, *Art Today: Its Range of Styles and Its Sources* (exhibition of works for sale), Feb. 2–March 2, 1958, no cat.
SBMA, *Two Hundred Years*, 1961, no. 106, mentioned "Introduction," n.p.
Tucson, University of Arizona Museum of Art, *Ernest Lawson, 1873–1939: a retrospective exhibition of his paintings* (catalogue by Adeline Lee Karpiscak), Feb. 11–March 8, 1979, no. 46, repr. p. 66, p. 29, fig. 28.

Robert Henri
1865-1929

"[A] man of enormous personal magnetism,"[1] Robert Henri contributed to American art as much by his personal éclat as by his artistic example. Henri was the leader of the "Gang," a group of independent artists who after their much-publicized exhibition of 1908 at the Macbeth Gallery in New York came to be known as "The Eight." Five of them — Henri, Sloan, Luks, Shinn, and Glackens — formed the core of the so-called "Ashcan" School.

A brilliant and effective teacher, proselytizer, and organizer, Henri acted as the chief champion of these independent artists who, until the Armory Show of 1913 (organized largely by members of Henri's circle), constituted the most conspicuous modern movement in this country. In defiance of the Academic canons, the "Ashcan" artists painted in broad, bold strokes, eschewing "finish" and imparting to their canvas the spontaneity of the sketch. They turned to what was most contemporary in American society and reveled in its urban, industrial, and proletarian aspects.

Trained at the Academy of Fine Arts in Philadelphia, Henri absorbed from his teacher Anshutz the creed of uncompromising realism formerly taught and practiced at the Academy by Eakins. While learning from European art, past and present, Henri believed in American Art nourished from "the nation's soul." Already during the 1890s in Philadelphia, where Sloan, Glackens, Luks, and Shinn worked as newspaper illustrators, Henri — older and recognized as a teacher and artist — preached the gospel of "art for life" and inspired these young men to take up painting as a serious profession. The artist, in Henri's credo, should seize life in its most vital and revealing aspects and create his work out of his individual response to a freely chosen subject.

Henri was born in Cincinnati, Ohio, on June 24, 1865, the younger son of Theresa Gatewood and John Jackson Cozad. His ancestors were pioneering families of Welsh, English, and French descent. Henri's father had left the family home in Allenville, Ohio, when he was only twelve years old to become an enterprising vagabond. While working on the Mississippi as a cabin boy, he learned to play cards, becoming an unbeatable faro player. When Cozad met and married Theresa Gatewood of Virginia in 1857, he gave up his riverboat life in favor of a stable, happy family life. However, he never gave up his proclivity for gambling. The seduction of risk proved irresistible to the senior Cozad, who in 1872 went West to found the town of Cozad, Nebraska, on the Platte River, where he turned his entrepreneurial talents to real estate development. At home Theresa Gatewood encouraged her two sons John A. and Robert Henry (as the name was then spelled) to expand their horizons through literature, music, and painting. During this period of his life Henri was encouraged to draw, to write, and to keep a personal diary. Because of his mother's interest in history, Henri has left us with invaluable documentation of his life and the period in which he lived. Young John and Robert attended school in Cincinnati during the winters but traveled West again each summer. Speaking about his own development as an artist, Henri said of this life of variety, "the stimulating influences of my mother who had a natural love for books and painting and the constructive enthusiasms of my father counted favorably against an environment — the far West, cowboys, etc., etc., in which there was no association with artists."[2] Unfortunately, John Jackson Cozad found himself the target of growing animosity from a segment of the cattle-ranching population in Cozad. The central figure in a frontier drama, he fatally shot, in self-defense, a disgruntled farmer. Cozad moved his family first to Denver and then to New York and, in order to remove any stigma, changed all of the family names. Theresa and John became Mr. and Mrs. Richard Lee, John A. became Frank Southrn and

35 Derricks on the North River

(also titled *Summer Evening, North River*)
1902
Oil on canvas
26 x 32 in. (66 x 81.3 cm)
Signed l.r.: Robert Henri
Not dated
Inscribed by artist on reverse u.l. (fig. a):
 223/A/1
Inscribed and signed by artist on reverse u.r.
 (fig. a): SUMMER EVENING/ NORTH
 RIVER/ Robert Henri
Museum purchase for the Preston Morton
 Collection with income from the
 Chalifoux Fund
77.45

fig. a Robert Henri, *Derricks on the North River*, detail of reverse. Preston Morton Collection, Santa Barbara Museum of Art.

Provenance

Robert Henri;[1] Marjorie Organ (Mrs. Robert Henri), widow of the artist;[1] Violet Organ, sister-in-law of the artist;[1] John C. LeClair, nephew of Violet Organ;[1] (consigned to Hirschl & Adler Galleries, N.Y., 1954);[2] returned by Hirschl & Adler to the Organ estate, Jan. 1961;[2] (Noah Goldowski, Inc., N.Y., jointly with Zabriskie Gallery, N.Y., 1967–1969);[1] Andrew J. Crispo, N.Y., by May 1969;[1] Jack Kartee, Coral Gables, 1971; purchased from Kartee (through the ACA Galleries, N.Y.) by the SBMA with income from the Chalifoux Fund for the PMC, 1977.

1. From information provided by William Innes Homer.
2. According to M. P. Naud of Hirschl & Adler in a letter of Nov. 7, 1980, to the editor, "This was consigned to us for sale by Miss Organ in March 1954, and was returned by us to the Organ estate in 1961."

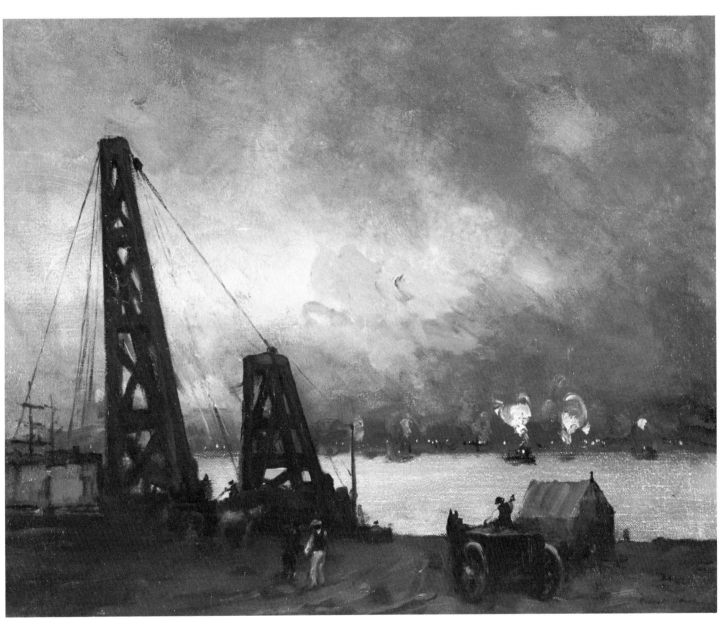

35

Robert adopted his own middle name as a surname. Proud of his French background — but equally proud of his American heritage, Robert adamantly insisted his name be pronounced in the American vernacular (Hen'rye) all of his life.

After studying with Anshutz, Robert Henri spent several years in Paris before returning to Philadelphia in 1891 to teach at the Academy. In 1904 he began his own art school in the westside bohemian district of New York where his classes "became the rallying ground for eager youth."[3] As Lloyd Goodrich has written, "Under Henri's leadership, they fought for artistic independence, the artist's right to say what he thought and to get his work before the public. In doing so they effected a revolution from which all American art since their day has benefitted."[4]

Kathleen Monaghan and Katherine H. Mead

Notes
1. Helen Appleton Read, *Robert Henri and Five of His Pupils: George Bellows, Eugene Speicher, Guy Pène DuBois, Rockwell Kent, Edward Hopper*, Loan Exhibition, The Century Association, Libraries Press, Freeport, N.Y., 1946, n.p.
2. William Innes Homer, *Robert Henri and His Circle* (Ithaca, N.Y.: Cornell University Press, 1969), p. 13.
3. Read, *Henri*.
4. Lloyd Goodrich and John I. H. Baur, *American Art of Our Century* (New York: Whitney Museum and Praeger, 1961), pp. 20, 28.

Derricks on the North River

Robert Henri practiced many different styles throughout his career as an artist, but he is best known historically as the founder and mentor of the so-called Ashcan School (more correctly called New York Realists).[1] A group of young enthusiastic painters who moved to New York from Philadelphia around the turn of the century — Sloan, Shinn, Glackens, and Luks — followed his example in directing their attention to lively, un-idealized scenes of city life. In adopting this approach, Henri and his friends abandoned the polished techniques and polite subjects popular with the academicians of their time, and they turned instead to common people and ordinary urban themes, just as Walt Whitman had done earlier in his prose and poetry. In *Derricks on the North River* (1902)[2] Henri demonstrated his own ability to paint as an "Ashcan" artist; clearly evident are his command of the Realist style and his ability to paint sympathetically an urban industrial subject.

When Henri moved from Philadelphia to New York in 1900, he settled in an old brownstone on East 58th Street, a house with a view on the East River. His wife Linda described it as an "ideal place . . . and out of both the front and back windows that river is fine — busy little boats hurrying by — and big white river steamers."[3] The large number of river scenes he painted in the first decade of the century bears witness to his fondness for these subjects. *Derricks on the North River*,[4] in particular, testifies to the excitement that Henri felt when confronting river subjects near his newly adopted home. The painting has a vigor and conviction that is not easily matched in his oeuvre before or after this time.

In this period — the opening years of the century — Henri painted with a dark, subdued palette, and the tonality of his work is much in the tradition of the early Manet or the Dutch Realist masters of the seventeenth century. Henri wished to find a terse,

Condition and Technique

In 1979 examination by the BACC revealed the original fabric support to be very brittle and easily breaking away in crumbling pieces, with several pieces missing along the tacking margins and with tears at the corners. The water area had been carefully overpainted to cover abrasion along the tops of the threads. There were only a few scattered losses, all of them overpainted. A faint traction crackle in the center of the painting in the thickly applied paint of the mist was noted. The thick surface coating had yellowed considerably.

In 1980 the painting was treated by the BACC. The yellowed surface coating and overpainting was removed with acetone, sometimes MEK and EDC. Removal of the overpaint revealed that the artist had deliberately abraded the river area. Also more extensive overpaint than originally thought was noted around the bottom and l. edges. The painting was removed from the stretcher, the reverse cleaned, and the tacking margins flattened using heat, moisture, and pressure. The reverse was infused with Vance wax. The painting was lined to a fiberglass lining fabric infused with molten Vance wax on a hot table, with temperature up to 130° F (as measured on the surface of the rubber membrane over the painting) after bringing vacuum pressure up to 2" Hg. The wax was cleaned from the front with Benzine B264. One brush coat of Acryloid B72, 10% in xylene was applied as isolating layer. Losses were inpainted with dry pigments handground in Acryloid B72. Two spray coats of Acryloid B72, 10% in xylene were applied as final protective surface coating and inpainting was adjusted in two small spots.

The original support is a medium- to heavy-weight, loosely woven fabric, single-threaded and with plain weave, coarse in texture and reddish brown in color. The greyish-white ground of medium thickness does not conceal the fabric texture. The oil-type paint is thickly applied, wet into wet, as a rich vehicular paste, with fluid brushstroke texture visible overall and soft round impasto of medium height in the lighter areas. The surface of the water area has been deliberately abraded, revealing the ground and creating highlights.

compelling style for city subjects, themes he saw in dramatic terms — and he therefore turned to the sombre, muted palette and heavy, fluid brushwork that became his trademark at this time. Henri and his friends were reacting against the higher-keyed colors of Impressionism and the accompanying deterioration of that style into a kind of academic formula. In a sense, Henri's style represents a kind of Post-Impressionism, rejecting, as it does, the superficial surface appearances of Impressionism. Like the French Symbolists and their American followers, Henri placed considerable emphasis on the mood and spirit of the subject he was representing. Although he has often been called a Realist, his work represents something more than a merely factual description of nature. For example, while his subject matter in *Derricks on the North River* is taken from the everyday world in one of its more "ugly" aspects, his Realism was tempered by attention to the mood and feeling suggested by the subject.

Very few American artists before Henri had painted industrial subject matter in such a straightforward, unidealized fashion. It was this directness of approach that made Henri and his colleagues distinctly different from earlier artists in this country. Because they maintained close personal and artistic ties with each other, Henri, Sloan, Shinn, Glackens, and Luks formed a kind of unofficial "school," and each painted New York City subjects similar to *Derricks on the North River* at one time or another. The work of Henri and his friends, in turn, established unidealized treatment of urban subject matter as an acceptable art form and therefore paved the way for ensuing currents of Realism in twentieth-century painting; following most directly in this wake were the Realist and Regional schools of the 1920s and 1930s.

Henri had the courage to portray the American scene without sentimental frills and with a certain Whitmanesque optimism. To Henri, New York was an exciting and beautiful spectacle, and one senses, in paintings like *Derricks on the North River*, his urgent desire to capture the spirit and mood of the city. This canvas and others he painted of similar subjects are records of the city at the turn of the century, telling of incidents long past. But this work maintains its relevance and importance to us today because Henri transmuted this sector of the city he loved into an image that has lasting aesthetic and emotional appeal.

William Innes Homer

Notes

1. The term "Ashcan School" was not used at the time *Derricks on the North River* was painted. The label came into general use only in the 1930s to refer to the group of American Realist painters (chiefly Henri and his friends) who portrayed the uglier aspects of city life in the first decade of the century. Five such members of the group belonged to "The Eight," an informal association of like-minded painters whose work was shown in a controversial exhibition at the Macbeth Galleries, N.Y., in 1908.
2. In Henri's own unpublished Record Book of his paintings, the following entry appears for his catalogue number A-223/1: "Derricks on the North River.' Dec. 1902. No 25 [refers to the size of the canvas: 26" x 32"] hot evening effect/ smoke & glow in sky./ some blue towards left upper corner/ figures & wagons. X. In hands of Macbeth Feb. 1903. In my hands 1905."
 On the back of the canvas Henri wrote "Summer Evening, North River" with his name and an indication also of his own catalogue number for the work: 223/A/1 (fig. a)
 His Record Book also mentions the existence of an oil sketch, 8 x 10 in., for this work. Its present location is unknown.
 Evidently Henri changed his mind about the title of the work when he sent it out for exhibition. Therefore, the two titles just cited should be considered equally valid.
3. Quoted in William Innes Homer, *Robert Henri and His Circle* (Ithaca, N.Y.: Cornell University Press, 1969), p. 99.
4. In *Derricks on the North River* one looks across the North (or Hudson) River toward the Palisades.—(Ed.)

Exhibitions

N.Y., Hirschl & Adler Galleries, *Robert Henri*, Feb. 3–28, 1958, no. 14 (as *Summer Evening—North River*).

Washington, D.C., Corcoran Gallery of Art, *American Muse*, Apr. 4–May 17, 1959, no. 20 (lent by Hirschl & Adler).

Lincoln, University of Nebraska, Sheldon Memorial Art Gallery, *Robert Henri, 1865–1965*, Oct. 12–Nov. 7, 1965.

New York Cultural Center, 2 Columbus Circle, in association with Fairleigh Dickinson University, *Robert Henri Exhibition* (lent by ACA Galleries).[1]

1. Incomplete information from a partially torn label on the reverse of the stretcher.

References

William Innes Homer, *Robert Henri and His Circle* (Ithaca, N.Y.: Cornell University Press, 1969), p. 229, fig. 47 (as in Andrew Crispo Collection, N.Y.).

Katherine Harper Mead, "Recent Acquisition: Robert Henri's *Summer Evening, North River*," *Gallery Notes*, SBMA, Sept. 1977.

Portrait of Mrs. Edward H. (Catherine) Bennett

(See color reproduction, page 42)

Before any painting by Robert Henri, whatever its subject, we are immediately made aware of the transforming power of his art. Indeed, the epithet "Ashcan" bestowed on Henri and his "black gang" belies the acute sense of style informing many of his portraits. Henri's "art for life" with its explicit challenge to the "art for art's sake" aesthetic of the late nineteenth century in no way attacked art itself. Nor did Henri's sympathy for the "people" — workmen, urchins, country folk — obtrude upon his ability to rival Sargent or Boldini in the realm of fashionable portraiture.

Portrait of Mrs. Edward H. Bennett combines firm modeling of the figure and dazzling pyrotechnics of color and brushwork to create an image at once formal in its dignity yet alive with spontaneity and exemplifies Henri's portraiture at its finest. Painted early in the 1920s,[1] during Henri's "third and final period,"[2] it displays the strong abstracting tendencies of his late oeuvre.[3] The planes of Mrs. Bennett's face are simplified; a crown of hair molds the perfect dome of her head. Brows, eyes, and mouth are rendered as flawless arcs; the bridge of her nose continues unbroken from the line of her brow. Set against a background resonant with touches of green and royal blue, and above the pink of the dress, the sitter's head and shoulders emerge from a foil of charged color. A black border brushed down over the pink recalls the "rose et noir" noted by Baudelaire in the work of Edouard Manet, an artist of major importance to Henri.

Henri painted Catherine Bennett in Lake Forest shortly after finishing two portraits of her son Edward, who some fifty years later donated this portrait of his mother in remembrance of the years she spent in Santa Barbara. As recounted by Edward Bennett, Catherine's father, David Jones, built the Mediterranean-style house designed by David Adler on Pepper Hill in about 1916. Catherine, the second of five children, "was born in 1885." Only Gwethalyn (her oldest sister), who helped their father find the Pepper Hill site, "riding out with him from the Old Potter Hotel," and Catherine were "interested in the place...."[4] Her husband, Edward H. Bennett, who was associated with the architectural firm of Daniel Burnham in Chicago, planned the magnificent terraced gardens.[5] Catherine Bennett "died of scarlet fever and subsequent peritonitis"[6] in 1925, only a few years after the completion of Henri's portrait, now one of the ornaments of the Preston Morton Collection.

Katherine Harper Mead

36 Portrait of Mrs. Edward H. (Catherine) Bennett

Oil on canvas
32 x 26 in. (81.3 x 66 cm)
Signed l.l.: Robert Henri
Gift of Mr. and Mrs. Edward H. Bennett, Jr.
79.4

Provenance

Edward H. Bennett, Jr., son of Catherine Bennett. Gift of Mr. and Mrs. Edward H. Bennett, Jr. for the PMC, 1979.

Condition and Technique

In 1979 examination by the BACC noted the painting had been wax-resin lined to a plain-weave linen and the original tacking margins preserved. The surface coating, a thin spray of synthetic polymer resin (estimated) was slightly matt overall.

The support is a medium-weight, plain-weave fabric (estimated linen). The ground, off-white in tone, is moderately thin and extends evenly onto all the tacking margins; it may have been commercially applied. The oil-type paint, lean vehicular pastes, is thinly applied and ranges from dry scumbles to slight brushstroking. The fabric texture is very evident, and there is some ground exposed. The overall condition is good.

Notes

1. Letter of January 6, 1978, from Edward H. Bennett, Jr., to the author.
2. See William Innes Homer, *Robert Henri and His Circle* (Ithaca, N.Y.: Cornell University Press, 1969), p. 247.
3. Homer, p. 160.
4. Bennett letter.
5. Bennett letter; and from information kindly provided by Elizabeth de Forest in a conversation of March 1981 with the author. The splendid ensemble of house and Renaissance-style gardens was torn down in the late 1950s and early 1960s to make room for a real estate development.
6. Bennett letter.

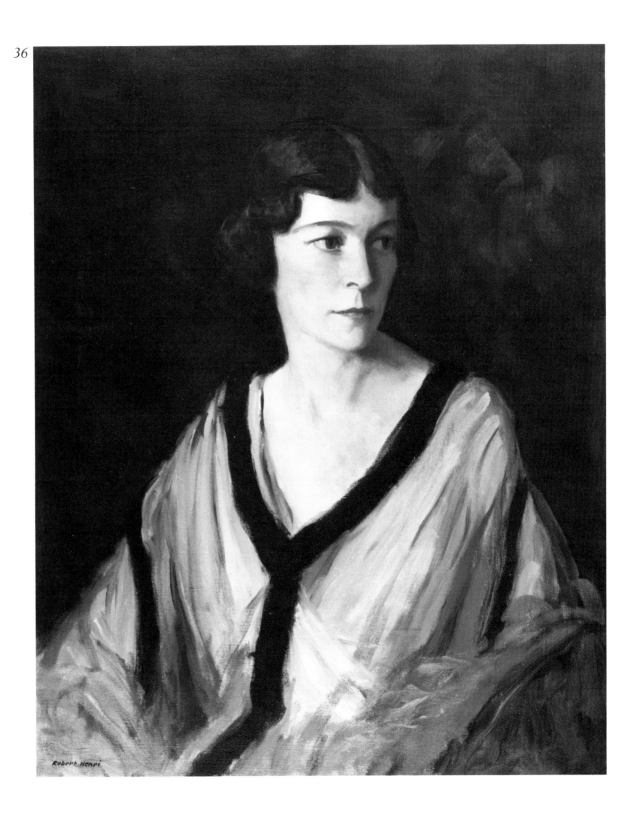

William J. Glackens
1870-1938

William James Glackens was born in Philadelphia on March 13, 1870. He attended the city's highly respected Central High School, where he was a classmate of John Sloan and Albert Barnes, later a noted collector of European and American paintings. Glackens graduated from Central in 1889 and, shortly thereafter, began his professional career as a reporter-illustrator for the *Philadelphia Record*. Later, he worked in a similar capacity for the *Philadelphia Press* and *Public Ledger*. Glackens also began to attend night drawing classes at the Pennsylvania Academy of the Fine Arts. At the Academy, he studied under Thomas Anshutz, who had been the classroom monitor for the renowned Thomas Eakins. Glackens's fellow art students included George Luks, Everett Shinn, and John Sloan. In 1892, he met Robert Henri, whose enthusiasm for art and impassioned pleas on behalf of painting in America had a dramatic impact on Glackens's life and art. Henri encouraged Glackens, and the other young Philadelphia artist-reporters, to reject the artificial manner of the Academy and the Genteel Tradition. Sloan summed up this early influence:

> We were all young, knew very little about art and had no idea of becoming 'painters.' Henri came back from Europe and took over the leadership. He had a studio at 806 Walnut Street where we used to gather once a week to talk and listen to his ideas about painting, and what it meant to be an artist, and why it was worth dedicating one's life to the single purpose of working to suit oneself rather than the critic or public or contemporary success. . . .
>
> We were all for Henri, who came like a breath of fresh air into the studio atmosphere and said 'forget about Art — paint pictures of what interests you in *life* — paint with honesty not cleverness.'[1]

Glackens and Henri shared a studio in Philadelphia and traveled together in Europe in 1895. Upon his return to America in 1896, Glackens moved to New York City. He was a confirmed advocate and practitioner of Henri's approach to art and, like his mentor, painted daily city life, admired the tonal canvases of Velasquez and Whistler, and adopted the broad, fluent brushstrokes of Hals and Manet. Indeed, the mood, tone, and viewpoint of Glackens's 1902 painting *East River from Brooklyn*, one of the major pictures in the Preston Morton Collection, pays direct tribute to the influence of his dear friend, Henri.

Glackens not only exhibited in many of the progressive art exhibitions of the day, but he also participated in many of the liberal art movements as well. He exhibited, for example, at the show of "The Eight" in 1908, at the first Exhibition of Independent Artists in 1910, and at the 1913 Armory Show, the epoch-making exhibition that introduced modern European art to America. Furthermore, Glackens helped organize the Armory Show, was elected the first president of the Society of Independent Artists, and helped assemble, for his old high school friend Dr. Albert C. Barnes, one of the notable collections of modern painting in America (The Barnes Foundation in Merion, Pennsylvania).

William Glackens, like his Philadelphia compatriots, brought a new vigor and independent spirit to American art. He rejected current fashion and fought for the expression of new ideas in art. His early paintings, such as *East River from Brooklyn*, broke new ground as they captured the spirit of urban America. A reserved and gentle man, William Glackens was an active participant in many of the dynamic and noteworthy art events of the early years of the twentieth century.

Grant Holcomb III

Notes
1. "John Sloan Discussing Robert Henri," in *John Sloan/Robert Henri, Their Philadelphia Years (1886–1904)* (exhibition catalogue), Moore College of Art Gallery, Philadelphia, Oct. 1–Nov. 12, 1976, pp. 20, 23.

37 East River from Brooklyn

(also titled *View of the East River from Brooklyn*)
1902
Oil on canvas
25⅛ x 30 in. (63.8 x 76.2 cm)
Not signed or dated
Gift of Mrs. Sterling Morton
60.57

Provenance

Mrs. William J. Glackens; given by Mrs. Glackens to Charles Henry; (Hirschl & Adler Galleries, N.Y., 1945); Mr. and Mrs. William Poplack; (purchased from Poplack by Hirschl & Adler, 1959); purchased from Hirschl & Adler by Mrs. Sterling Morton for the PMC, 1960.[1]

1. The provenance for the painting prior to its acquisition in 1945 by Hirschl & Adler follows the one given by Ira Glackens in letters of Nov. 19, 22, and Dec. 2, 1980 to the editor. According to the records of Hirschl & Adler (letter of Nov. 7, 1980 from M. P. Naud), the gallery acquired the painting from Mrs. William J. Glackens on March 8, 1945, but this information is not substantiated by Ira Glackens, as Mrs. Glackens "never sold *East River from Brooklyn* to Hirschl & Adler, nor to anyone else. She never sold any painting to anyone [. . .] Mother gave the painting in question to Charles Henry. (He was an expert lighter and lighted the shows of father's work which she put on in her house for ten years — 1940–1950)" (letter of Nov. 19). The information regarding Mr. and Mrs. Poplack was provided by M. P. Naud.

An inscription in pencil on the reverse of the stretcher: *V. Spark*, moreover, suggests that possibly the painting at one time was held by Spark. It has not been possible to resolve this question.

Condition and Technique

At an unknown date the painting was lined with aqueous glue and the original tacking margins removed. In 1978 and 1980 examination by the BACC noted extensive overpaint scattered across the design area, including the widemouth traction crackle c. and bottom c., the water, the vertical blue at c.r., the sky at top c., and top c.l., and the small areas of cleavage, c.r. and near the c. of the r. edge. Some of the overpaint had been done by the artist. The painting also appeared to have suffered from slight abrasion, which had been covered with overpaint. There was slight tenting of the paint in the vertical blue at c.r., to r. of the overpaint. Lining had depressed the brushmarkings and caused marked moating around them. The surface coating, a thin natural resin spirit varnish over residues of a previous coating incompletely removed, had yellowed extensively.

37

East River from Brooklyn

"Ah, what can ever be more stately and admirable to me/than mast-hemm'd Manhattan?"[1] So wrote Walt Whitman in 1856. Approximately fifty years later, William Glackens painted *East River from Brooklyn*, a part of the broad spectacle and drama of urban life that had intrigued Whitman in the mid-nineteenth century and inspired members of the "Ashcan" School in the twentieth century. Glackens's painting of the flow of river life, from the naked "river rats" in the foreground to the activity on the river and "mast-hemm'd Manhattan" beyond, fully illustrates the city realists' absorption of the Whitmanesque vision and subsequent rejection of the prevailing Genteel Tradition in art. In his autobiography, artist-critic Guy Pène du Bois summed up the revolution of Glackens and the "Ashcan" School:

> Here, before their eyes, was the untouched panorama of life, an unlimited field, an art bonanza. Here in the Alligator Cafe on the Bowery, the Haymarket on Sixth Avenue, the ferryboats, the lower East Side, in any number of cheap red-ink restaurants, one found subjects as undefiled by good taste or etiquette or behaviour — that national hypocrisy — as a new-born babe. Here was life in the raw. . . .[2]

The rivers that encircle New York City provided ample and sufficient material for the artists of the "Ashcan" School. George Bellows painted young boys frolicking in the river to escape the heat of summer (*Forty-Two Kids*, 1907, The Corcoran Gallery of Art, Washington, D.C.); Jerome Myers recorded the quiet evening gatherings of the poor on the city's piers that bordered the rivers (*East River Pier*, ca. 1915, private collection); John Sloan captured the solitude that a city dweller in crowded Manhattan found on the deck of a ferryboat (*Wake of the Ferry, no. 2,* 1907, The Phillips Collection, Washington, D.C.); and Robert Henri painted panoramic vistas of the East River from Fifty-eighth Street (*Derricks on the North River*, 1902, present cat. no. 35; *The East River — New York*, ca. 1900–1905, private collection). Glackens's *East River from Brooklyn* is a veritable synopsis of these views of river life, as it combines Henri's breadth of vision with Myers's and Bellows's glimpses of life at the banks of the rivers.

Illustrative views of city life often shocked the academically oriented public. To many critics, the limited palette and the broad, active brushstrokes in such paintings as *East River from Brooklyn* were equally scandalous, and they referred to Glackens and the other city realists as "the black gang" and "the apostles of ugliness." Certainly, *East River from Brooklyn* is not a radical picture when compared to contemporary art in Europe. Indeed, Glackens's Santa Barbara picture recalls his close adherence to the practices of the nineteenth-century French painter Edouard Manet. The subdued palette, the *alla prima* technique, the flat, painterly brushstroke, and even the silhouette effect indicate the influence of the French master. Revolutionary in theme, it is, nonetheless, conservative in technique. Yet, in the end, the picture reveals the expansiveness and peculiarities of what Whitman described as the "most ample, picturesque bay and estuary surroundings in the world."[3] Like Whitman's verse, *East River from Brooklyn* sings the praises of the "City of hurried and sparkling waters:/city of piers and masts:/City nested in bays!/my city!"[4]

Grant Holcomb III

In 1980 the painting was treated by the BACC. The yellowed varnish and the restorer's overpaints were removed with acetone, MEK, and ethylene dichloride. The overpaint by the artist was kept. The cleavage was set down locally from the front using Ross Wax and a tacking iron. One brush coat of Acryloid B72, 10% in xylene was applied as an isolating layer. The losses were filled with putty consisting of Ross Wax and dry pigments. The fills were isolated locally with Bakelite PVA-AYAA, 10% in ethyl alcohol. The losses were inpainted with dry pigments ground in B72. Two spray coats of B72, 10% in xylene were applied. Inpainting was complete, and one final spray coat of B72, 10% in xylene was applied as protective surface coating.

The support, a moderately light weight, relatively loosely woven, plain weave and single-threaded fabric, is covered with a white ground applied moderately thinly that does not hide the fabric texture. The oil-type paint (estimated) has been applied wet into wet as a fluid paste structure, ranging from dilute, slightly transparent washes to softly brushmarked pastes. A thin grey wash covers much of the ground prior to the application of the thicker paint. The highest impasto is in the foreground and in the clouds at u.c. Cleaning revealed that the dark grey strokes of paint over the sails of the ship and over the sky above the tug are by the artist. The artist likewise appears to have painted over the traction crackle, which must have formed very early in the history of the painting.

Notes

1. Walt Whitman, from "Crossing Brooklyn Ferry," *Leaves of Grass* (New York: The Viking Portable Library Edition, 1973), p. 154.
2. Guy Pène du Bois, *Artists Say the Silliest Things* (New York: American Artists Group, 1940), p. 82.
3. Whitman, "New York — The Bay — The Old Name," in *Complete Prose Works, Walt Whitman* (Philadelphia: 1897), p. 501.
4. Whitman, from "Mannahatta," *Calumus* (New York: The Viking Portable Library Edition, 1973), p. 207.

Exhibitions

N.Y., Whitney Museum of Art, *William Glackens Memorial Exhibition*, Dec. 1938–Jan. 1939, no. 3 (as *East River from Brooklyn*, lent by Mrs. Glackens), circulated by the American Federation of Arts; traveled San Francisco Museum of Art, Sept. 3–24, 1939, Missouri: City Art Museum of St. Louis.

San Francisco, Palace of Fine Arts, *Golden Gate International Exposition*, 1940, no. 1231 (as *The East River from Brooklyn*, 1902, lent by Mrs. William J. Glackens), repr. p. 141.

The New York Scene, 1944, no. 23.[1]

SBMA, *Two Hundred Years*, 1961, no. 88 (as *View of the East River from Brooklyn*), repr., mentioned "Introduction," n.p.

Missouri, City Art Museum of St. Louis, *William Glackens in Retrospect*, Nov. 18–Dec. 31, 1966, no. 8, repr.; traveled Washington, D.C., National Collection of Fine Arts, Feb. 1–Apr. 2, 1967, New York, Whitney Museum of American Art, Apr. 25–June 11, 1967.

N.Y., The Brooklyn Museum, *The Triumph of Realism: An Exhibition of European and American Realist Paintings, 1850–1910*, Oct. 3–Nov. 19, 1967, no. 94, repr. p. 175; traveled Richmond, Virginia Museum of Fine Arts, Dec. 11, 1967–Jan. 14, 1968, San Francisco, California Palace of the Legion of Honor, Feb. 17–March 31, 1968.

Washington, Tacoma Art Museum, *The American Eight*, Nov. 15–Dec. 30, 1979, no. 21, repr.

1. No more information on this exhibition was available.

References

Ira Glackens, *William Glackens and the Ashcan Group: The Emergence of Realism in American Art* (New York: Crown Publishers, 1957), repr. following p. 50 (as *East River from Brooklyn*).

Matthew Baigell, *A History of American Painting* (New York: Frederic A. Praeger, 1971), repr. no. 9–15, mentioned p. 190.

John Sloan
1871-1951

John Sloan, called the "American Hogarth" and "Dean of American Painters" during his lifetime, is one of the major realists in the history of American art. Rejecting the academic tradition, Sloan brought to American painting a robust realism that influenced several generations of artists and marked a new epoch in the development of art in this country. He probed the commonplace and the unheroic in urban America and, like the poet Walt Whitman, gazed with "loving and thirsting eyes, in the house or street or public assembly."[1]

John Sloan was born in Lock Haven, Pennsylvania, a small community situated on the West Branch of the Susquehanna River. He moved to Philadelphia with his family in 1876 and began his formal education in the public schools. His study of art began at the Spring Garden Institute in 1890. Two years later, while working as an artist-reporter on the *Philadelphia Inquirer*, Sloan enrolled in classes at the Pennsylvania Academy of the Fine Arts, where he studied under Thomas Anshutz, a former pupil and assistant of Thomas Eakins. In 1892 Sloan also met Robert Henri, a gifted painter and inspired teacher who encouraged the younger artist to pursue a career in art. "It was Robert Henri," Sloan wrote, "who set me to painting seriously; without his inspiring friendship and guidance I probably might never have thought of it at all."[2] From the beginning, Henri urged Sloan (and the other Philadelphia newspaper artists who gathered about him) to observe and paint the beauty and the nobility of the common man. Their essential motive for art was life. "Guts! Guts! Life! Life! That's my technique," exclaimed George Luks.[3]

Sloan moved to New York City in 1904 and there joined his old Philadelphia friends Robert Henri, George Luks, William Glackens, and Everett Shinn, all of whom had moved to the city earlier. The decision to settle in New York was critical to Sloan's creative development. Lloyd Goodrich has written:

> In every way the move to New York was a turning point. It meant definitely giving up newspaper work on a salary, the substitution of free-lance magazine illustration, and his increasing commitment to creative work as a painter and etcher. He did not find himself as an artist until he came.[4]

Sloan observed and absorbed the unique flavor of city life: "It is all the world . . . Work, play, love, sorrow, vanity."[5] And he responded to this new stimuli with an outpouring of creative energy. Works such as *Dust Storm, Fifth Avenue* (1906, The Metropolitan Museum of Art, New York), *The Wake of the Ferry, no. 2* (1907, The Phillips Collection, Washington, D.C.), *South Beach Bathers* (1907–1908, Walker Art Center, Minneapolis) are all truly representative of the finest painting produced in America at that time. Less familiar, however, are the artist's early landscape paintings of Pennsylvania, New York, and New Jersey, many of which were painted concurrently with his genre masterpieces. Though not as monumental as his Gloucester and Santa Fe landscapes of later years, these early efforts in landscape painting represent an estimable, yet relatively unknown, phase in Sloan's oeuvre.

John Sloan painted the landscape for over fifty years, a fact that may startle many students of American art who have studied Sloan merely as a painter of New York city life. Certainly his city genre scenes are brilliant achievements in American art. Yet Sloan was also a keen and sensitive observer of natural fact. From the Palisades of Coytesville, New Jersey, to the rocky shores of Gloucester, Massachusetts, and the red earth and blue skies of Santa Fe, New Mexico, Sloan painted the landscape with vigor, joy, understanding, and integrity.

Grant Holcomb III

38 City from the Palisades

1908
Oil on canvas
26¹/₁₆ x 32¹/₁₆ in. (66.1 x 81.5 cm)
Signed and dated l.r.: 1908/John Sloan
Inscribed on top tacking margin: City from
 Palisades
Gift of Mrs. Sterling Morton
60.82

Provenance

Purchased (from the Kraushaar Galleries, N.Y., representing the Sloan Estate) by Mrs. Sterling Morton for the PMC, 1960.

Condition and Technique

In 1978 and 1980 examination by the BACC noted the painting was lined with a wax-resin adhesive and the tacking margins were all present. There were numerous small areas of old paint losses in the central portion of the sky as well as small losses throughout the sky and clouds near the right edge. The painting had also suffered from tiny flake losses and moderate abrasion along the edge from the rabbet, and several small scratches in the paint layer were visible in the u.r. portion of the sky. There was a fine, netlike traction crackle pattern in the foreground and middleground as well as a few areas of fine linear fracture crackle pattern scattered throughout. The surface coating had yellowed slightly, and had lifted away from the paint film in the l.r. corner. Superficial scratches were visible in the lower portion of the l. edge, around the signature in l.r. corner, and in the u.r. portion of the sky. The thin surface coating was estimated a synthetic resin.

In 1980 the painting was treated by the BACC. The tacking margins of the support were reattached to the lining fabric with Ross Wax. The surface was cleaned with a swab and moisture, and the scratches reformed with a brush and xylene. The losses were filled with dry pigment in wax resin putty and the filling isolated with Bakelite PVA-AYAA in ethyl alcohol. Two spray coats of Soluvar in Benzine B264 were applied. Inpainting was done with dry pigments ground in Acryloid B72. A protective layer of two spray coats of Soluvar in Benzine was applied.

The support, a medium-weight, plain-weave fabric (estimated linen), is covered with a greyish-white ground of moderate thickness, probably commercially applied, that does not con-

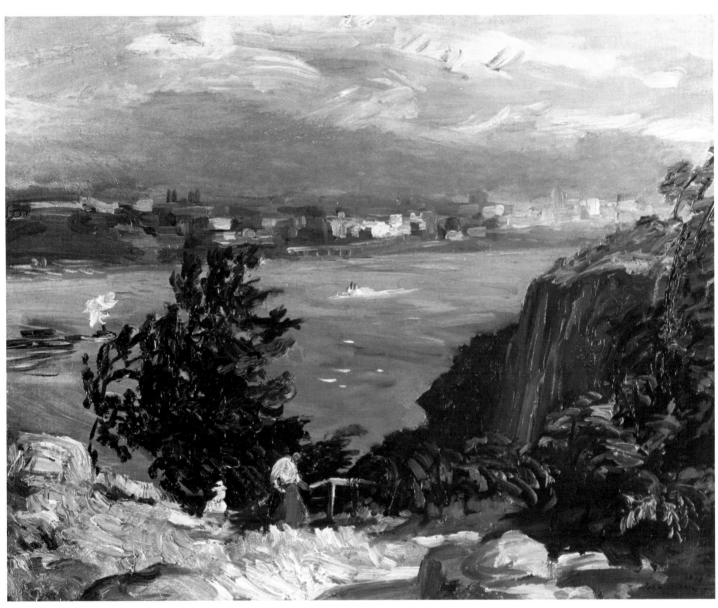

38

Notes

1. Walt Whitman, from "Crossing Brooklyn Ferry," *Leaves of Grass* (reprint, New York: Modern Library, 1950), p. 132.
2. John Sloan, *Gist of Art* (New York: American Artists Group, Inc., 1939), p. 3.
3. Bennard Perlman, *The Immortal Eight: American Painting from Eakins to the Armory Show, 1870-1913* (New York: Exposition Press, 1962).
4. Lloyd Goodrich, *John Sloan* (New York: The MacMillan Company, 1952), p. 17.
5. Mary Fanton Roberts, "John Sloan, His Art and Inspiration," *Touchstone*, IV (Feb. 1919), p. 362.

ceal the fabric texture. The oil-type paint (estimated) is generally thick and opaque, ranging from a thick fluid to a stiff paste with impasto. The foreground landscape, figures, and trees were boldly applied in a wet into wet technique using a thick stiff paste with brush marks and moderate impasto.

City from the Palisades
(See color reproduction, page 43)

Sloan's first landscapes in oil were painted in 1906, when the artist sketched the countryside around the Sloan family home in Fort Washington, Pennsylvania. He began his first continuous series of landscapes during the summer of 1908, when he traveled across the Hudson River to visit friends in Coytesville, New Jersey. Within hours of his arrival, Sloan commenced painting directly from nature:

> This morning the weather was clear, the sky filled with big clouds. I made a first sketch from the top of the Palisades looking down at an apron of ground. . . . After lunch, the sky was quite cleared and the sun out brightly. I made another panel much better than the first, looking through an opening among the trees at a glimpse of New York City to the south.[1]

Though the majority of these Coytesville landscapes are small, nine-by-eleven-inch sketches painted on a fine-grained Belgian linen and mounted on cardboard, Sloan did paint two large (32 x 26 in.) canvases: *Hudson Sky* (Wichita Art Museum) and *City from the Palisades*, also known as *Hudson from the Palisades*. Apparently they were painted toward the end of Sloan's two-week visit. On July 2, the day before departing from Coytesville, the artist noted in his diary: "In the afternoon, I made a large canvas sketch, did not finish it however as I started late."[2] Both pictures were started from nature, or "on the spot," as Sloan noted.[3] However, they were not completed until the following month in the artist's New York studio. At that time, Sloan may have referred to one, or more, of the smaller panels in order to complete the compositions, as a comparison between *City from the Palisades* and *Coytesville, New Jersey* (fig. 1) suggests. The scenes and general compositions of the two pictures are similar: trees at the left and the cliffs of the Palisades at the right frame the Hudson River below while, in the distance, the skyline of Manhattan is dissolved by the haze of a summer afternoon. Each picture was vigorously painted with a limited palette based upon the earth colors, ultramarine blue, and viridian.

In many ways the similarities between *City from the Palisades* and *Coytesville, New Jersey* are striking. Yet several important compositional adjustments by the artist made *City from the Palisades* a more powerful and dramatic landscape composition. First, Sloan reduced the scale (as well as the number) of figures at the left, thereby eliminating any anecdotal quality in the larger picture. The cliffs and banks were then enlarged and, with a long, slashing diagonal, given a more prominent place in the composition. Finally, *City from the Palisades* shows a more decisive handling of the skyline; loose, summary brushwork in the small sketch gives way to a firm, architectonic structuring of form in the Santa Barbara painting. All of these compositional modifications enabled Sloan to subordinate human activity and focus directly upon the major forms within the landscape. As a result *City from the Palisades* is a painting of breadth and immediacy.

City from the Palisades was the first landscape submitted for exhibition by Sloan. On

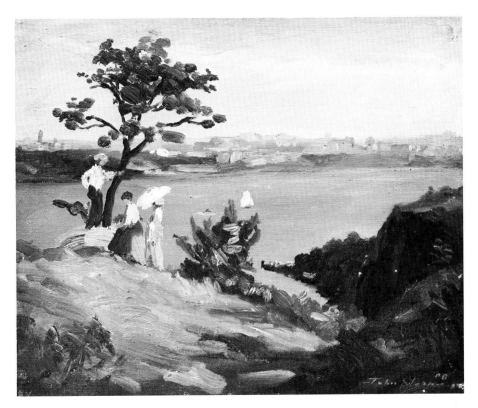

fig. 1 John Sloan, *Coytesville, New Jersey*.
Reproduced by permission. Courtesy of the John
Sloan Trust.

Notes

1. Bruce St. John (ed.), *John Sloan's New York Scenes: From the Diaries, Notes and Correspondence 1906–1913* (New York: Harper and Row, 1965), pp. 226–227.
2. St. John, p. 228.
3. Mrs. Rafael Naras Papers, Archives of American Art, Washington, D.C.
4. Mary Fanton Roberts Papers, Archives of American Art, Washington, D.C.
5. Lloyd Goodrich, *John Sloan* (New York: The Macmillan Company, 1952), p. 33.

Exhibitions

N.Y., MacDowell Club, Jan. 1912 (group exhibition).
N.Y., Kraushaar Galleries, *Landscapes of John Sloan*, Apr. 10–May 6, 1939, no. 1.
Philadelphia, Wanamaker Galleries, *Retrospective Exhibition: John Sloan Paintings, Etchings and Drawings*, Jan.–Feb. 1940, no. 1.
Santa Fe, Museum of New Mexico, 1941.
New York, American Academy of Arts and Letters, 1958 (group exhibition).
Lincoln, University of Nebraska, 1959.
South Carolina, Columbia Museum of Art, 1959.
SBMA, *Two Hundred Years*, 1961, no. 126, repr., mentioned "Introduction," n.p.
Washington, Tacoma Art Museum, *The American Eight*, Nov. 15–Dec. 30, 1979, no. 62, repr.

References

New York Evening Post, Apr. 15, 1939.
New York Sun, Apr. 15, 1939.
Brooklyn Eagle, Apr. 16, 1939.
New York Times, Apr. 16, 1939, section X, p. 9.
New York Herald Tribune, Apr. 16, 1939, section VI, p. 5.
New Yorker, XVC (Apr. 29, 1939), p. 89.
Bruce St. John (ed.), *John Sloan's New York Scenes* (New York: Harper and Row, 1965), pp. 228, 233, 258, 265, 269, 278, 279, 597.

Information for Exhibitions and References provided by the author.

November 24, 1908, the artist sent the picture to the National Academy of Design but, within two weeks, had been notified that the painting had been rejected by the jury. This was not an uncommon situation for Sloan and other progressive painters in America, whose work was often excluded from the conservative annual exhibitions. Sloan's paintings were not accepted by the Academy until 1906, and only half of those submitted by the artist after that date were approved for exhibition. If the paintings were exhibited at all, they were usually skied. For example, *Chinese Restaurant* (Memorial Art Gallery, University of Rochester), a major city picture, was hung at the National Academy in 1909, but as Sloan wrote to a friend, "That you found it in the N.A.D. Exhibition speaks well for your eyesight — or did your foresight prompt you to tour the show with a ladder?"[4] Sloan verbally attacked the "puny puppy minds of the jury"[5] and actively participated in several radical art organizations that challenged the narrow exhibition policies of the Academy. Thus, in its own small way, the rejection of *City from the Palisades* by the National Academy helped set in motion a series of activities and events that resulted in three progressive and highly significant art exhibitions: the 1908 show of "The Eight," the 1910 Exhibition of Independent Artists, and the 1913 Armory Show.

Grant Holcomb III

Everett Shinn
1876-1953

In 1891 at the age of fifteen Everett Shinn left his native town of Woodstown, on the southern tip of New Jersey, for Philadelphia. There he studied mechanical drawing and worked briefly designing light fixtures for the Thackery Gas Fixture Works. In 1893 he began classes at the Pennsylvania Academy of Fine Arts, studying under Thomas Anshutz. He soon became friends with fellow students Ira Glackens and John Sloan. In the same year, he started work as a staff artist for the newspaper *Philadelphia Press.* George Luks was already on the staff, and by 1895 the two were joined by Glackens and Sloan. All four came under the influence of Robert Henri.

In 1895 Shinn moved to New York City to work at the *New York World,* where by 1904 he was joined by his three Philadelphia newspaper-artist friends. It was in the early New York years that Shinn began to receive public attention. His first one-man exhibition was held in January of 1899 at the Pennsylvania Academy of Fine Arts, exhibited were forty-eight pastels. These same works were exhibited a year later, in 1900, in New York at the Boussard Valadon Gallery, where ten were sold. Shortly after the opening, Shinn made his only visit to Europe, spending time in London and Paris. In 1901 he held his second exhibition in New York at the same gallery, showing pastels and drawings of Europe. From then until 1911 he exhibited widely.

Shinn, in the purplest of prose, wrote in 1944 of the New York art world in the first decade of the century:

> It [was in] a state of staggering decrepitude. . . . It was disciplined in an order of sameness, effete, delicate, and supinely refined. It revealed its pale countenance with the elegance of plush-lined shadow boxes in shrines and gilt grottos. Art galleries of that time were more like funeral parlors wherein the cadavers were displayed in their sumptuous coffins. One day an incredulous stare came into its imported plate-glass eye which had for a decade mirrored only lorgnettes and fawning patrons. For there on its velvet lawn stood a bedraggled group of invaders. The Eight had wandered in. The interlopers paused and removed their hats. The solemnity of death had caught at their scant respect. The Eight had journeyed out to see life and found themselves in a morgue.[1]

In reaction to the "cadavers" of contemporary painting, the four former Philadelphia artists with Robert Henri, then too in New York, and Ernest Lawson formed in April 1907 the nucleus of "The Eight" or "Ashcan School." They were soon joined by Arthur B. Davies and Maurice Prendergast. In February of 1908 "The Eight" opened an exhibition at the William Macbeth Gallery. Greeted with derision in New York, the exhibition traveled to good reviews in Philadelphia, Chicago, Buffalo, and Toledo.

During the years that Shinn and his friends were attacking the established art world, he was also dabbling in theatricals. He built a small theater in his studio and established a group he called, after his address, "The Waverly Street Players." Shinn was the impresario playwright, director, and producer as well as scene painter. Among the plays produced were *Lucy Moore or The Prune Hater's Daughter, Ethel Clayton or Wronged from the Start,* and *Hazel Weston or More Sinned Against Than Usual.*

By 1912 Shinn had become more and more preoccupied with his career as a decorator. He had met in 1899, the year of his first one-man exhibition, Clyde Fitch, the playwright, and Elsie de Wolfe, the decorator. Through them he met David Belasco and Stanford White, for whom he was soon painting murals and decorations. Shinn's specialty became murals in the manner of Louis XV, and his style was referred to ironically by his friends as "rococo revivalism." Indicative of Shinn's artistic goals by 1913 is the fact that when asked to participate in the Armory Show, he never even answered.

In 1912 Shinn was divorced in a widely publicized suit by his first wife (he was to be married four times). A year earlier, he had served as a model for the bohemian painter-hero

39 Sixth Avenue Shoppers

Pastel and watercolor on board
21 x 26½ in. (53.3 x 67.3 cm)
Signed, l.r.: E. Shinn
Not dated
Inscribed by artist on reverse (fig. a): glass on all/Frame in close/after trimming/E. Shinn
Gift of Mrs. Sterling Morton
60.81

fig. a Everett Shinn, *Sixth Avenue Shoppers*, detail of reverse. Preston Morton Collection, Santa Barbara Museum of Art.

Provenance

Everett Shinn; (acquired from the artist by the Graham Gallery probably shortly before the artist's death, 1953);[1] purchased from Graham by Mrs. Sterling Morton for the PMC, 1960.

1. Letter of Jan. 2, 1980, from Elizabeth Dailey, Graham Gallery.

Condition

The pastel has been slightly rubbed on all four edges by the rabbet.

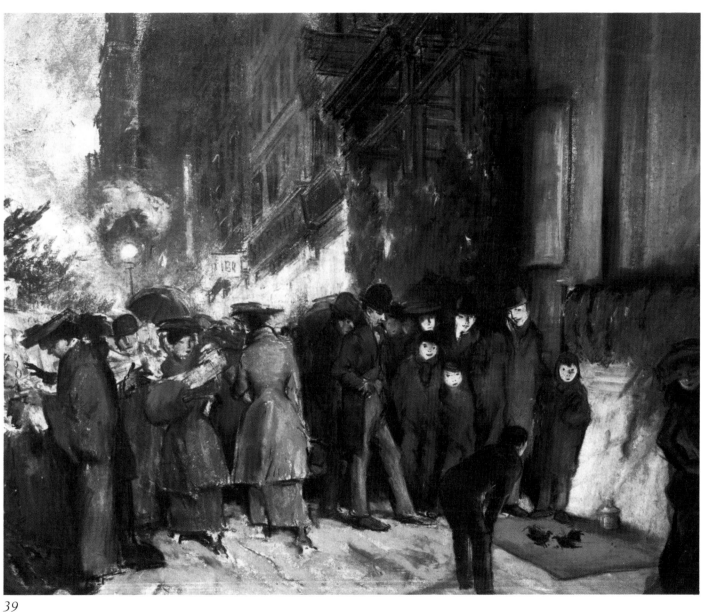

39

of Theodore Dreiser's novel *The Genius*, a book in which contemporary gossip said the author had used Sloan's paintings, Shinn's studio, and Dreiser's life. The two men had known each other through Shinn's work as an illustrator for several magazines of which Dreiser was the editor.

Shinn's work for magazines began in 1900, when he succeeded in having a pastel used for a double spread in *Harper's Weekly*. From then onwards, he was a prolific illustrator, altering his style to meet the demands of a changing public. In the 1920s and 1930s, for example, his figures became elongated with a bloodless sophistication. In 1917 he branched out into the new movie business, becoming art director for Goldwyn Pictures in New York. He worked actively for studios until he grew tired of producer William Randolph Hearst's constant interference while he was working on *Janice Meredith*, a vehicle for Marion Davies.

In the late 1930s and 1940s Shinn returned after a twenty-year hiatus to his original "Ashcan" subjects — scenes from the active life on New York streets. His most famous works from this period are the murals in the Men's Bar of the Plaza Hotel of Central Park. These works, however, lack the early empathy with people and their surroundings.

David W. Steadman

Sixth Avenue Shoppers

(See color reproduction, page 44)

Sixth Avenue Shoppers shows the crowded sidewalk of one of New York's major shopping avenues in the soft, late-afternoon light of a winter's day. At the left, women peruse merchandise at sidewalk stands; shoppers with bundles walk in the center; and a crowd of men and boys watch birds fight by the light of a simple lantern.

Early critics of Shinn's pastels praised his fluidity of line but also noted how facile the pastels could be, often finished neither in conception nor in execution. A story — probably apocryphal — is told about his major break into magazine illustration in late 1899 with a pastel of the Metropolitan Opera House in a snowstorm: after months of trying to have a drawing accepted for the center two-page spread in *Harper's Weekly*, Shinn finally left a portfolio. Upon his return the editor, Colonel Harvey, asked to see him.

> "You have here such a variety of New York street scenes," the editor began, "that I was wondering if you have in your collection a large color drawing of the Metropolitan Opera House and Broadway in a snowstorm." Shinn glanced out of the window at the falling snow which would soon create the desired effect. "I think I have," he replied. "Good," snapped Harvey, "have it here at ten tomorrow morning."
> Shinn had his evening's work cut out for him. On his way home he purchased a fifty-cent box of pastels, then hurried to the Metropolitan Opera House to observe the architectural detail of its facade. Once home, he began to toy with the pastels . . . a medium he had not employed since his student days at the Pennsylvania Academy.
> Shinn worked through the early hours of the morning. Shaky and pale he delivered the finished drawing at the appointed deadline. Colonel Harvey stared at the artwork in silence. He scrutinized the lights twinkling dimly through the swirling snow, the dashing hansom cabs, the scurrying ladies hoisting their voluminous skirts. "We have to decide on a price," Harvey finally announced. "How about four hundred dollars and you own the original?"[1]

Shinn had actually been producing pastels in New York before this. In early 1899, months before this episode, he had exhibited forty-eight pastels in his first one-man

Notes

1. Written on the occasion of the exhibition held by the Brooklyn Museum, *The Eight*, Nov. 24, 1943–Jan. 16, 1944, as quoted in Edith de Shazo, *Everett Shinn 1876–1953: A Figure in His Time* (New York: Clarkson N. Potter, Inc., 1974), p. 64.

exhibition at the Pennsylvania Academy of Fine Arts, including pastels of New York scenes. The most accurate part of the *Harper's Weekly* story is Shinn's ability to make quick perceptions and to record them in his memory. Both traits had been developed during his years as an artist for newspapers. Staff artists would accompany reporters on assignments and would have to be able to turn in quick, accurate drawings for reproduction.

Just as Shinn had a remarkable memory for details, so too did he have a fine color sense. In *Sixth Avenue Shoppers* he effectively creates an asymmetrical balance in an essentially frieze-like composition of figures in dark clothing through the use of one bright splash of vivid red in the dress of the woman with a muff. Moreover, he conveys the coldness of the atmosphere by liberally using light blue highlights on the snow-covered sidewalk. His method of using pastels was unusual and necessitated a complete balance already worked out in his mind before he began to draw. Edith de Shazo describes it well:

> He took paper mounted on a heavy backing board and soaked it completely in a tub of water, removing excess water with his hand or a sponge. Then, with the final color composition completely in his mind, he began laying on patches of color. When these colors struck the wet ground, they turned immediately to a dark tone, losing their original coloration. Shinn worked swiftly and continued to build up his design until he had covered the whole surface. As the picture dried, the original color would return, but unlike the usual quality of pastel with its delicate, dustlike surface, evaporation of water caused the pigment to dry hard, producing brilliant color with a tempera-like quality.[2]

It is difficult to date Shinn's pastels precisely. His most brilliant ones are all from the period 1898–1911. In these early years he was recording the activities of the bustling life of New York. He particularly loved the special effects of weather or light, and night scenes are among his most telling works. Although it was dated in 1959 by Shinn's dealer as circa 1925, the costumes of the women in *Sixth Avenue Shoppers* would date it between 1905 and 1910.

David W. Steadman

Notes

1. Bennard Perlman, *The Immortal Eight* (New York: Exposition Press, 1962), pp. 104–105.
2. *Everett Shinn, 1876–1953* (exhibition catalogue), Trenton, New Jersey State Museum, 1974, p. 157.

Exhibitions

Art Institute of Chicago, *Twelfth International Watercolor Exhibition,* March 31–May 30, 1932, no. 461 (as *Lower Sixth Avenue*).

University of Pittsburgh, Henry Clay Frick Fine Arts Department, *Everett Shinn: An Exhibition of His Work,* March 1959, no. 51 (dated ca. 1925).

SBMA, *Two Hundred Years,* 1961, no. 125 (measurements as 20⅛ x 25¾ in.), repr., mentioned "Introduction," n.p.

Oklahoma City, Oklahoma Art Center, *Everett Shinn, 1876–1953,* n.d., no. 69 (measurements as 20⅛ x 25¾ in.).

Trenton, New Jersey State Museum, *Everett Shinn: 1876–1953,* organized in cooperation with the Delaware Art Museum and the Munson-Williams-Proctor Institute, Sept. 15–Nov. 25, 1973, no. 70 (measurements as 20⅛ x 25¾ in.); traveled to Wilmington, Delaware Art Museum, Dec. 14, 1973–Feb. 17, 1974, Utica, Munson-Williams-Proctor Institute, March 10–July 12, 1974.

Calif., Claremont, Pomona College, Montgomery Art Gallery, *Works on Paper 1900–1960 From Southern California Collections,* Sept. 18–Oct. 27, 1977, no. 71 (measurements as 20⅛ x 25¾ in.), pp. 62–63, repr. p. 69; traveled to San Francisco, M. H. de Young Memorial Museum, Nov. 11–Dec. 31, 1977.

References

David W. Steadman, *Works on Paper 1900–1960 From Southern California Collections* (exhibition catalogue), Galleries of the Claremont Colleges, Pomona College, Scripps College, 1977, no. 71, pp. 62–63, repr. p. 69.

George Wesley Bellows
1882-1925

George Wesley Bellows was born on August 12, 1882, in Columbus, Ohio, where he was raised.[1] Showing an early talent and interest in the career of an artist, he nevertheless attended Ohio State University before dropping out at the end of his junior year. In 1904 he moved to New York City, where he enrolled in the New York School of Art, studying with Robert Henri. In 1907 his painting *River Rats*, depicting boys swimming in a New York river, was accepted for the Spring exhibition of the National Academy of Design and favorably received. The following years brought Bellows numerous honors, including election as an associate of the National Academy of Design in 1909, and an Academician in 1913. During these years he achieved a reputation both for landscapes and for his vigorously painted scenes of urban life, including his boxing subjects. He married in 1910 and saw the birth of daughters in 1911 and in 1915. Highly successful, he remained active in progressive art circles, helping to organize the Armory Show in 1913 and the New Society of American Artists in 1918. In 1916 he took up lithography, opening another productive phase of his career. He died following a sudden illness in 1925.

Michael A. Quick

Notes

1. The best biography of George Bellows is Charles H. Morgan, *George Bellows, Painter of America* (New York: Reynal and Co., 1965).

Steaming Streets

While studying under Robert Henri (1865–1929) at the New York School of Art, George Bellows learned much from the elder artist's approach to art. Henri represented a potent progressive force in the American art world, advocating freedom from conventional technique, and a direct response to the subject matter to be found in urban settings. He urged his students to find an individually expressive style of their own through which to interpret contemporary life.

As a particularly promising student, Bellows was invited to attend Henri's "Tuesday Evenings," where he became better acquainted with John Sloan (1871–1951), George Luks (1867–1933), William Glackens (1870–1938), and Everett Shinn (1873–1954), four of Henri's pupils whom he had taught in Philadelphia. They formed the nucleus of the exhibiting group named "The Eight," organized by Henri in 1907, in defiance of the National Academy of Design, which had declined to exhibit their work because of its lower-class subject matter and sketchy technique.[1]

The four Philadelphians had worked as illustrators for the press, developing through the experience their ability to remember and record quickly momentary actions in the world about them. In *Steaming Streets*, Bellows came closest to this aspect of the work of The Eight, with whom he was then closely associated. Although his paintings often showed small figures in the customary motions of their daily lives, they very rarely represented momentary action subjects. A team of horses, barely restrained by their driver, has bolted into the crowded city street, where a horse-drawn streetcar approaches. Before a perspective of shop signs, a group of children follows the excitement from the sidewalk.

The title of the painting refers to the then-novel urban phenomenon of steam

40 Steaming Streets

March 1908
Oil on canvas
38⅜ x 30¼ in. (97.5 x 76.8 cm)
Signed l.l.: G. Bellows
Not dated
Inscribed on reverse: STEAMING STREETS/
 GEO BELLOWS/ 146 E 19th/ NY.
Gift of Mrs. Sterling Morton
60.50

Provenance

Estate of Mrs. Emma S. Bellows; (H. V. Allison & Co., Inc.); purchased from Allison by Mrs. Sterling Morton for the PMC, 1960.

Condition and Technique

In 1978 examination by the BACC noted the painting had been lined, probably with a wax-resin adhesive to a single-weave fabric. The support, ground, and paint were in good condition, the surface coating moderately yellowed and uneven.

The support is a rather coarse, medium-weight, plain and single-weave fabric. The ground, light grey in tone (?), is of medium thickness. The paint, an oil type, is applied as a rich vehicular paste, with heavy impasto and strong brushstroke marking.

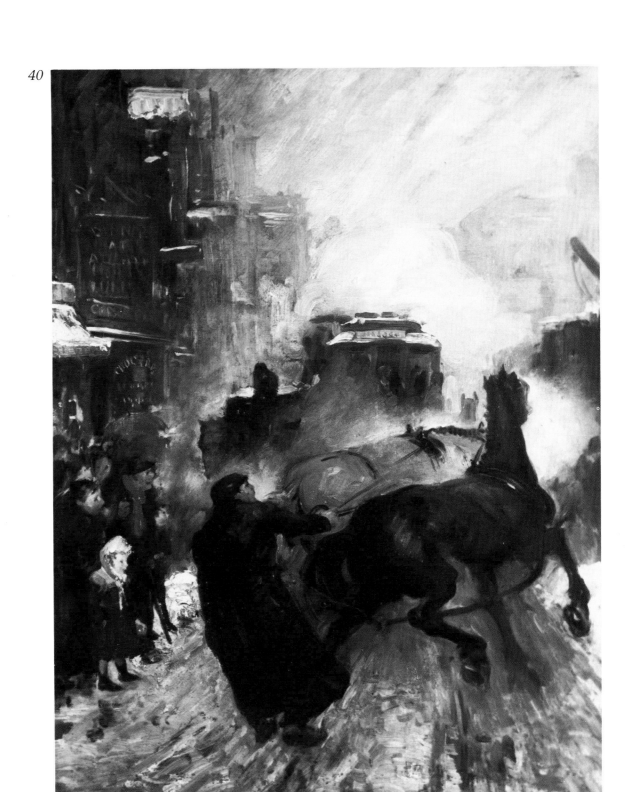

issuing from vents of the steam heat system laid under the streets, made all the more striking with snow on the ground. The artists of Bellows's circle frequently included steam clouds in their paintings, finding them highly picturesque, as well as suggestive of the city itself as a modern machine.[2] The painting thus thematically represents a meeting of the new and old orders, the new world of steam and machinery that during just those years was replacing horse-drawn streetcars and wagons on the streets of New York.

In terms of the formal interests of The Eight, the whites and greys of steam contrasted crisply with the strong blacks preferred by Henri. In *Steaming Streets* these whites, shading into steely blue greys, form a light background against which Bellows blocks in black silhouettes, in the bold strokes of his instinctive draughtsmanship. The same conspicuously direct painting continues in the swirling, soft curves of the rising steam. The painting presents a sketcher's shorthand of contrasting graphic textures, in the best spirit of The Eight's direct response to experience. But *Steaming Streets* is not a page in a sketchbook; it is an impressively large painting, the very size of which proclaims it to be an important statement, an exhibition piece, epitomizing the realists' joy in painting and their defiance of the merely conventional.

Michael A. Quick

Notes

1. For a fuller discussion of The Eight, see William Innes Homer, *Robert Henri and his Circle* (Ithaca, N.Y.: Cornell University Press, 1969). For a different point of view see Amy Goldin, "The Eight's Laissez Faire Revolution," *Art in America*, LXI, no. 4 (July–Aug. 1973), pp. 42–49.
2. Wanda Corn discusses the motif of steam and the artists' celebration of modernity in "The New New York," *Art in America*, LXI, no. 4 (July-Aug. 1973), pp. 59–65.

References

Recorded in Bellows' private Painting Book A, p. 45. Emma Louise Story Bellows, comp., *The Paintings of George Bellows*, (New York: Alfred A. Knopf, 1929), repr. p. 10.

Art News, XXXV (Feb. 13, 1937), repr. p. 13.

Charles H. Morgan, *George Bellows: Painter of America* (New York: Reynal & Co., 1965), p. 85, repr. p. 316.

Today's Art, XIV (April 1, 1966), repr. p. 17.

Harold Hayden, *Great Art Treasures in America's Smaller Museums* (New York: G. P. Putnam's Sons, 1967), p. 190, repr.

Mahonri Sharp Young, *The Paintings of George Bellows* (New York: Watson-Guptill Publications, 1973), p. 36, repr. color p. 37.

Exhibitions

Dallas, *State Fair of Texas: Art Department*, Oct. 17–Nov. 1, 1908, no. 12.

The St. Louis Society of Artists, The Gallery of McCaughen & Burr, *First Annual Exhibition of Paintings by American Artists*, Oct. 4–23, 1909, no. 8.

Detroit Institute of Arts, *Circuit Exhibition of Contemporary Art of the National Arts Club*, Feb. 11–March 10, 1911, no. 2; traveled Worcester Art Museum (as *Circuit Exhibition of Paintings by Artist Life Members of The National Arts Club, New York*), Feb. 11–March 10, 1911, no. 2, possibly Providence, Rhode Island School of Design (as *Exhibition of Contemporary Art*), April 21–May 10, 1911, no. 2.

Ohio, Art Students League of Columbus at The Public Library, *A Catalogue of Paintings by George Bellows*, Nov. 16–Nov. 26, 1912?[1]

N.Y., Whitney Museum of American Art, *New York Realists 1900–1914: Robert Henri, George Luks, John Sloan, William Glackens, Ernest Lawson, George Bellows, Everett Shinn, Glenn O. Coleman, and Guy Pène duBois*, Feb. 9–March 5, 1937, no. 9 (lent by Emma S. Bellows).

N.Y., Gallery of Modern Art (including the Huntington Hartford Collection), *George Bellows: Paintings, Drawings, Lithographs*, March 15–May 1, 1966, no. 11, repr. p. 15.

The Brooklyn Museum, *The Triumph of Realism: An Exhibition of European and American Realist Paintings 1850–1910*, Oct. 3–Nov. 19, 1967, no. 98, repr. p. 179; traveled Richmond, The Virginia Museum of Fine Arts, Dec. 11, 1967–Jan. 14, 1968, San Francisco, California Palace of the Legion of Honor, Feb. 17–March 31, 1968.

Bloomington, Indiana University Art Museum, *The American Scene 1900–1970*, April 6–May 17, 1970, no. 9, repr., mentioned pp. 12, 14.

Michigan, Grand Rapids Art Museum, *Themes in American Painting*, Oct. 1–Nov. 30, 1977, no. 70, p. 146, repr. p. 147.

1. From information provided by H. V. Allison & Co., Inc. The title, *Steaming Streets*, however, does not appear in the catalogue. The painting may have been exhibited under another title.

Jerome Myers
1867-1940

Jerome Myers is best known for his paintings of New York City life during the opening decades of the twentieth century.[1] Described as "the gentle poet of the slums,"[2] Myers found beauty and a poetic grandeur in the simple, ordinary life of the common man. He was, in fact, one of the first artists to explore and subsequently paint the life of the urban poor in this country. Robert Henri, the noted city realist and leader of the "Ashcan School," echoed Emerson's nineteenth-century challenge to American artists when he stated, "There is only one reason for the development of art in America, and that is that the people of America learn the means of expressing themselves in their own time and in their own land . . . what we do need is art that expresses the spirit of the people of today."[3] Myers firmly adhered to this philosophy and painted canvases that revealed his deep and abiding respect for the unpretentious life of the masses. From the frenetic activity of the marketplace on New York's Lower East Side to the restful moments spent at the end of the city's numerous piers, and from the multifarious joys of childhood to the quiet dignity of old age, Jerome Myers captured the low, the familiar, and the common in urban American life. Myers's contribution to the history of American art was significant. While pioneering new thematic materials in American art, Myers also actively participated in several progressive art organizations that helped encourage and develop new directions in American art. He was, for example, one of the four original founders of the 1913 Armory Show, considered to be the most significant art exhibition ever held in this country.

Born in Petersburg, Virginia, in 1867, Myers lived in Philadelphia, Baltimore, and New Orleans before he established residence in New York City in 1886. Within a year, he had enrolled in his first formal art courses at Cooper Union and, shortly thereafter, the Art Students League, where he studied with George de Forest Brush and Kenyon Cox, both competent and learned academicians. However valuable the technical training and discipline, the young artist questioned the highly structured, conservative nature of these institutions. According to Myers, his instructors frowned upon his interest in city life. "Brush did not believe in doing the crowd," he wrote, "but to me the importance of group life became a guiding star."[4] Responding to this impulse, Myers set out to interpret the life of the city for himself: "If ever I was to create beauty I know that it would not be by imitating the classical Greeks or Michael Angelo but by expressing what was in me, as they had expressed themselves."[5]

Travels to Europe in 1896 and 1914 reaffirmed the artist's conviction that only the city life of New York could furnish the material for his life's work. He painted and sketched genre scenes in London and Paris but always preferred the immigrant life of New York City. He stated, "When they merge here with New York something happens that gives them vibrancy I didn't get in any other place."[6] It should be noted that Myers's arrival in New York in 1886 coincided with the immigration of thousands of East Europeans to America. New York's Lower East Side became a haven for the newly-arrived immigrant, and Myers developed, almost immediately, a keen sensitivity toward the poor and the dispossessed of the city. His vision of ghetto life seldom, if ever, evoked a sense of wretchedness. "Others saw ugliness and degradation there," he wrote, "I saw poetry and beauty."[7]

Grant Holcomb III

41 Children

1926
Oil on canvas
20 x 24¹/₁₆ in. (50.8 x 61.1 cm)
Signed and dated l.r.: JEROME MYERS 1926
Gift of Mrs. Sterling Morton
60.72

Provenance

Joseph Katz, Baltimore; (Victor D. Spark, N.Y.); purchased from Spark by Mrs. Sterling Morton for the PMC, 1960.

Condition and Technique

In 1978 examination by the BACC revealed a small tear in the extremely fragile fabric at the bottom l. corner and in two places on the r. edge near the bottom corner. It noted an uneven, overall pattern of fracture crackle. The surface coating, estimated a natural resin spirit varnish, had darkened moderately and had been abraded along the edges by the rabbet. The stretcher appeared to be the original, as there was no complete set of empty tack holes along the tacking margins.

In 1980 the painting was treated by the BACC. The yellowed varnish was removed with MEK, followed by EDC. The fabric was then lined with fiberglass infused with three coats of PVA. The vacuum was pulled to 2" Hg, and the temperature was immediately cooled upon reaching 145°. A spray coated isolating layer of Acryloid B72, 10% in xylene was applied and the cleaning tests inpainted with dry pigments ground in Acryloid B72. The painting was again spray coated with Acryloid B72, 10% in xylene.

The support consists of a medium-weight fabric. There is no apparent ground and the oil-type (estimated) paint has been applied directly, wet into wet, on the fabric, with washes of pigmented pellicular application in the upper layers. In the more thinly applied opaque areas, the paint enhances the fabric texture, whereas in general the thickly applied paint shows extensive brushstroked texture and a pebbly surface with impasto of low to medium height. The design in many areas does not conform to the structure of the impasto.

Notes

1. See Grant Holcomb, "The Forgotten Legacy of Jerome Myers (1867–1940): Painter of New York's Lower East Side," *The American Art Journal,* IX (May 1977), pp. 78–91.

2. Lloyd Goodrich and John I. H. Baur, *American Art of Our Century* (New York: Praeger, 1961), p. 10.

3. Robert Henri, "The New York Exhibition of Independent Artists," *The Craftsman,* XVIII (May 1910), p. 161.

4. Jerome Myers, *Artist in Manhattan* (New York: American Artists Group, Inc., 1940), p. 19.

5. *New York Globe,* Sept. 28, 1922.

6. *New York World-Telegram,* Feb. 22, 1940.

7. *A Memorial Exhibition of the Work of Jerome Myers, Virginia-born Master* (exhibition catalogue), Virginia Museum of Fine Arts, 1942, p. 9.

Children

Jerome Myers found the poetic and the beautiful best expressed in the lives of New York City's children. Indeed, it appears that the joys of childhood, a dominant theme in his work, somehow sheltered the artist from the more sordid aspects of life on the Lower East Side. As he once noted, "the happiness of children, their number, and their well-being, amply made up for the parents' privation."[1] *Children* focuses on the joys of childhood yet represents a slight departure from Myers's primary interest in city life. Beginning in 1915, the Myers family spent the summer months at Carmel, New York, a rural community approximately sixty miles north of New York City. Though *Children* may have been painted in one of the numerous city parks, it was, most likely, painted at Carmel. Certainly, the gently sloping terrain and the densely wooded area depicted in the painting are reminiscent of this part of upper New York state. In any case, Myers rarely turned to the landscape for compositional motifs. "It is not that I am insensible to landscape," he wrote, "but that I could not commit myself to it sufficiently while carrying on my studies in the city." He concluded, ". . . artistically, I could not do justice to both places at once."[2] This perhaps explains why Myers covered the windows in his Carmel studio with brown draperies. Such a device prevented the brilliant greens of the summer landscape from disrupting the muted palette he used while working on his city scenes in the country. Furthermore, the tonal nuances of the draperies would better simulate the pervading neutral tones found in an urban environment.

Young boys and girls were perpetual sources of inspiration for the artist, whether they cavorted on the streets of New York City or played with one another in the bucolic setting of Carmel. In *Children,* they engage in various activities and play without any conspicuous parental restraint. In this respect, Myers felt that "all adult direction or supervision or bossing in any way is fatal and tyrannically impertinent . . . [children] have something they can only lose in contact with adults."[3] Although adults are found in the Santa Barbara painting, the children are absorbed in their respective pursuits and, alone, are responsible for the festive spirit.

The composition of *Children* is typical of the artist's work. A strong horizontal foreground plane contains the major activity and is, in turn, balanced by the dominant verticals of the trees at the lateral edges of the canvas. Myers repeatedly utilized this simple yet stable compositional formula throughout his career. Flickering brushwork and the bright color notes of the children's costumes and toys enliven the composition and recall Myers's contention that the gaily dressed children were the "little jewels that sprinkled my pictures."[4] His remark may account for the "picture-book" quality often found in his work. Whether Myers painted children in the dingy tenement districts of New York or in the wooded environs of the countryside, he clad them in splendid, colorful garments.

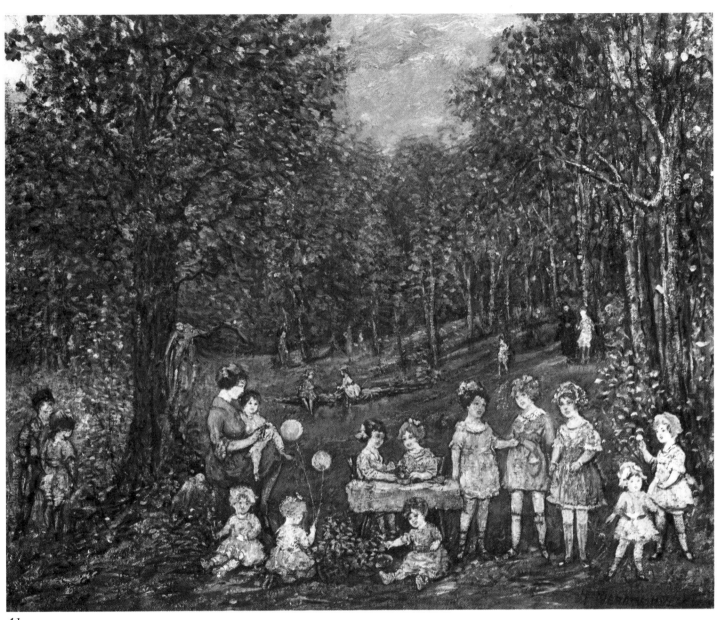

41

Such pictorial characterizations recall the illustrations found in nineteenth-century children's books, especially those illustrated by Kate Greenaway, who also depicted youngsters in fashionable, festive dress. Greenaway's use of flat, unmodeled forms and delicate coloring likewise corresponds to many of the stylistic traits found in Myers's depictions of children. *Children* characteristically expresses the tenderness and joy Myers found in the world around him.

Grant Holcomb III

Notes

1. Jerome Myers Papers, on deposit at the Delaware Art Museum, Wilmington, Delaware.
2. Jerome Myers, *Artist in Manhattan* (New York: American Artists Group, Inc., 1940), p. 59.
3. Myers Papers.
4. Myers Papers.

Exhibitions

SBMA, *Two Hundred Years*, 1961, no. 116, repr., mentioned "Introduction," n.p.

Edward Hopper
1882-1967

Edward Hopper was born July 22, 1882, in Nyack, New York, to Elizabeth Griffiths Smith and Garrett Henry Hopper. After studying illustration in New York, Hopper, between 1906 and 1910, traveled on three different occasions to Europe, where it was Impressionism and not the more recent avant-garde movements that had the greater effect on his art.[1] He was enthralled by the quality of light he found in Impressionist works. As he later commented: "I've always been interested in light — more than most contemporary painters."[2]

Until 1924 Hopper earned his living as a commercial illustrator for books and by publishing in periodicals such as *Sunday Magazine, Adventure,* and *Scribners'*. His 1918 poster *Smash the Hun,* completed as a competition piece for the United States Shipping Board, won Hopper a first prize and his first national acclaim as an artist. He also did posters for the movies and the American Red Cross.[3]

Hopper exhibited in the Armory Show of 1913 and sold his first painting, an oil, for $250. It was soon after this that Hopper moved into his Washington Square North studio. In 1915 a friend and fellow illustrator, Martin Lewis, taught Hopper how to etch, and until 1928 Hopper did very little painting. Instead, he produced over sixty prints in what Goodrich describes as his "fully mature style" where "within the limits of black and white, he finally found himself."[4] Works from this period like *Evening Wind* (1921) or *American Landscape* (1920) exemplify Hopper's intense vision and confrontation of subject. Zigrosser compares Hopper to Robert Frost or Thomas Eakins in his "clear sighted vision . . . integrity of character and tenacity of purpose."[5] In 1924 Hopper married the painter Josephine Verstile. They led a quiet, solitary life devoted to work, dividing their time between New England summers and New York winters, with one trip to Mexico in the l940s.

Hopper depicted the American scene in a direct yet unique way. Throughout his career he repeatedly turned to representations of single figures, barren settings, and bleak architectural prospects.[6] His concern for the poignancy of American life — especially the loneliness experienced in the American city — remained constant. The paintings of the 1950s and 1960s look much like the paintings done in the 1920s, but instead of becoming banal through repetition Hopper's view becomes one of clarity. By paring down to essentials Hopper imbues his scenes with a quality that is at once emotional and physical.

As William Seitz has written: "No portrayal in art of a nation as vast and diverse as the United States can be anything but fragmentary, ... Hopper's images ring so true because they reflect personal conviction and feeling rather than a program of social comment. The truth to which one responds is that of art distilled from life."[7]

Kathleen Monaghan

Notes

1. Lloyd Goodrich, "Edward Hopper," in *São Paulo 9* (Washington, D.C.: National Collection of Fine Arts, Smithsonian Institution Press, 1967), pp. 7–8.
2. Goodrich, *Edward Hopper: Selections from the Hopper Bequest to the Whitney Museum of American Art* (New York: Whitney Museum of American Art, 1971), pp. 7–8.
3. Gail Levin, *Edward Hopper: The Art and the Artist* (New York: W. W. Norton & Company in association with the Whitney Museum of American Art, 1980), pp. 34–35. See also Levin, *Edward Hopper as Illustrator* (New York: W. W. Norton & Company in association with the Whitney Museum of American Art, 1979).
4. Goodrich, 1971, pp. 7–8.
5. Carl Zigrosser, "The Complete Graphic Works of Edward Hopper," in *Prints,* ed. by Carl Zigrosser (New York: Holt, Reinhart and Winston, 1962), n.p. See also Levin, *Edward Hopper: The Complete Prints* (New York: W. W. Norton & Company in association with the Whitney Museum of American Art, 1979).

42 November, Washington Square

Begun ca. 1932, completed 1959
Oil on canvas
34⅛ x 50¼ in. (86.7 x 127.6 cm)
Signed l.l.: EDWARD HOPPER
Not dated
Gift of Mrs. Sterling Morton
60.64

Provenance

Edward Hopper; purchased (through Frank K. M. Rehn, Inc., N.Y., agent for Hopper) by Mrs. Sterling Morton for the PMC, 1960.

Condition and Technique

In 1978 and 1980 examination by the BACC revealed that the support was only slightly fragile but weak at all four corners where the stretcher had been expanded. There were small tears in the fabric at the bottom two corners caused by the stretcher angles. The stretcher may not have been the original as there was an empty set of tack holes in the tacking margins. There were also small convex bulges in the fabric near the upper left edge and marked vertical stretcher crease lines over the central stretcher bar. Both the paint and ground layers were in excellent condition with no age crackle and no abrasion apparent. The surface coating had been unevenly applied and had yellowed considerably. There had been cleaning tests especially one in the u.l corner which was quite large.

In 1980 the painting was treated by the BACC. The yellowed natural resin (estimated) coating was removed with acetone. Two isolating coats of Rhoplex AC-234 followed by two coats of PVA heat seal were applied to the linen lining fabric. The painting was removed from the stretcher and the tacking margins were flattened with a hot spatula and moisture. The painting was lined with the heat seal method, with pressure pulled up to 3" Hg and the temperature raised up to 140°, as measured on top of the lining fabric covered by a sheet of Mylar, and then immediately cooled down. The painting was mounted on a new stretcher. One brush coat of Acryloid B72 was applied as a protective isolating layer. Inpainting was done with dry pigments ground in Acryloid B72. Two spray coats of Acryloid B72, 10% in xylene were applied as final protective surface coating.

The support is a plain and single weave,

6. Levin, *Hopper* (1980), passim.
7. William C. Seitz, "Edward Hopper — Realist, Classicist, Existentialist," in *São Paulo 9*, pp. 19–20.

November, Washington Square

(See color reproduction, page 45)

Edward Hopper is known primarily as a realist painter of his surroundings. He first rented his New York studio at 3 Washington Square North in late December 1913, and, although he later took over additional space on the floor, he remained there until his death in 1967. Thus, his painting *November, Washington Square,* begun in 1932, represents a view he knew intimately — the view directly across from his studio on the south side of Washington Square Park.

In 1899, after graduating from high school in his hometown of Nyack, New York, Hopper commuted daily to New York City to study illustration, which his parents insisted offered a more secure income than painting.[1] The next year he enrolled at the New York School of Art, where he eventually studied painting with William Merritt Chase, Kenneth Hayes Miller, and Robert Henri.

Hopper traveled to Europe in October 1906 in order to study the great masters. Upon his return the following August, he worked for an advertising agency three days a week to support himself while painting. After two additional trips abroad in 1909 and 1910, he took a studio in New York, but continued to live with his parents and sister in Nyack commuting daily for the next several years.

When Hopper's new neighbor Walter Tittle returned from a Christmas visit home to Ohio in January 1914, he learned that the adjoining studio was occupied by his former classmate, who, like himself, was now a struggling artist and illustrator. Tittle, recalling that Hopper was then preoccupied with French subject matter and style, noted of Hopper: "for a considerable period his principle product consisted of occasional caricatures in a style smacking of both Degas and Forain, and drawn from memories of his beloved Paris."[2]

By February 1915, when he exhibited in a group show at the MacDowell Club of New York, the negative critical reception that his monumental painting *Soir Bleu* of about 1914 had received as a French "fantasy" contrasted with the praise his *New York Corner* (well known today as *Corner Saloon*) received as "a perfect visualization of New York atmosphere."[3] The growing tide of cultural nationalism encouraged Hopper to turn to his immediate surroundings for his subject matter. By the late 1920s, he was repeatedly praised for the "Americanness" of his paintings.[4]

Hopper noted in his ledger that *November, Washington Square* was "Painted in New York studio about 1932 or 1934" and that the "Sky [was] added in June 1959"; he also indicated "Colors and canvas unknown, probably zinc white."[5] The delay in finishing painting the sky, caused by Hopper's anxiety about ruining a picture, happened more often with his watercolors. Sometimes, as in his watercolor *Cabin, Charleston, South Carolina* (1929), included in the Hopper Bequest to the Whitney Museum of American Art, he failed to find either the courage or the time to complete the sky.

Until the end of his life, even after much success, Hopper remained vulnerable to critical evaluations of his work. Comments less than enthusiastic probably provoked lingering feelings of self-doubt left over from years of struggling for recognition. Late in

tightly woven, medium to heavy weight fabric like linen with approximately 10 to 14 threads/cm in warp and weft directions. The ground is white, smooth and thin, and appears to be commercially applied. The oil-type paint (estimated) is applied as a rich vehicular paste, wet into wet, and in many areas is very thinly applied, allowing the tops of the ground-covered fabric to show through. There are areas of thicker application, especially in the whites in the foreground, which appear to have been applied with a palette-knife type of tool and have some low impasto.

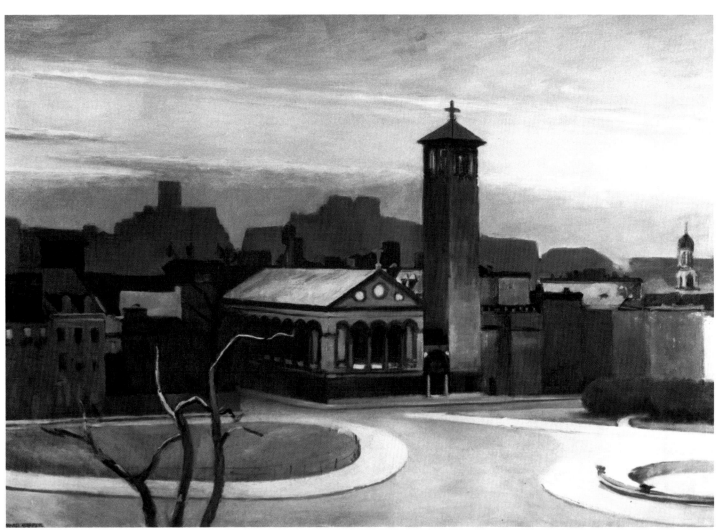

42

fig. 1 Edward Hopper, *Town Square (Washington Square and Judson Tower)*. Reproduced by permission of University of Nebraska Art Galleries, Lincoln, Nebraska, J.M. Hall Collection.

life, Hopper remarked of artists: "Ninety per cent of them are forgotten after they're dead."[6]

Although there is not a group of preparatory sketches for *November, Washington Square,* there is one closely related drawing entitled *Washington Square and Judson Towers* (fig. 1),[7] which Hopper liked well enough to give to his friend Mrs. John O. Blanchard. On the back of a reproduction of this drawing from the Nebraska Art Association Annual Exhibition catalogue of 1959, Jo Hopper noted "This drawing done from Wash. Sq. N. roof."[8] Thus, the similar view in the painting could also be seen from the roof of the Hoppers' home. In 1932, the year Hopper remembered beginning this canvas, he and Jo took over additional space on their floor in 3 Washington Square North.

The view from his roof, and from two windows in his apartment, is down across Washington Square Park to the Judson Memorial Church, built during the last decade of the nineteenth century. Hopper depicted the church's square bell tower topped with a cross dramatically silhouetted against the sky. In the foreground of his painting, a tree, left bare by winter, provides a striking counterpoint on the lower left of the composition. Hopper made the composition of this painting more effective than that of his related drawing by eliminating the distracting edge of the roof and its protruberances and focusing directly on the view itself. He often painted views from his roof in the city, and occasionally made watercolors from rooftops while traveling, such as those in Saltillo, Mexico, painted in 1946.

Hopper especially liked painting architectural forms and capturing the drama of light and shadow. He stated that he had disliked having to illustrate because he had to draw people "grimacing and posturing" when "What I wanted to do was to paint sunlight on the side of a house."[9]

The Hoppers were proud to be living under the same roof where so many celebrated figures had passed, including Ernest Lawson and William Glackens of The Eight, e.e. cummings, John Dos Passos, Rockwell Kent, and Thomas Eakins.[10] All of these

feelings must have gone into Hopper's thoughts when he chose to paint this view from his house. He chose November, the month he and Jo usually returned from a long summer spent on Cape Cod. His decision to present this busy city square deserted indicated his preference for the quiet calm of early morning when introspective thoughts could best be entertained.

Gail Levin

Exhibitions

SBMA, *Two Hundred Years,* 1961, no. 101, repr., mentioned ''Introduction,'' n.p.

Calif., Newport Harbor Art Museum, *Edward Hopper,* Jan. 12–Feb. 20, 1972, traveled Pasadena Art Museum, March 6–Apr. 30, 1972.

Salt Lake City, The University of Utah, Utah Museum of Fine Arts, *Edward Hopper Retrospective,* Oct. 19–Nov. 16, 1975 (not included in the catalogue of the Whitney Museum's Hopper Exhibition).

N.Y., Whitney Museum of American Art, *Edward Hopper: The Art and the Artist* (catalogue by Gail Levin), Sept. 16, 1980–Jan. 18, 1981, Pl. 51 in color p. 98 (as 1932 and 1959); traveled Amsterdam, Stedelijk Museum, Apr. 22–June 17, 1981, Düsseldorf, Stadtische Kunsthalle, July 8–Sept. 2, 1981 (did not travel to The Art Institute of Chicago or San Francisco Museum of Modern Art).

References

J. Morse, ''Interview with Edward Hopper,'' *Art in America,* XLVIII, no. 1 (Spring 1960), p. 60, repr. p. 62.

Lloyd Goodrich, *Edward Hopper* (New York: Harry N. Abrams, 1971), repr. p. 138.

Gail Levin, *Edward Hopper: The Art and the Artist* (New York: W. W. Norton & Company in association with the Whitney Museum of Art, 1980), repr. p. 98.

Notes

1. For an account of Hopper's career as an illustrator, see Gail Levin, *Edward Hopper as Illustrator* (New York: W. W. Norton & Company in association with the Whitney Museum of American Art, 1979). For a detailed chronology of his life, see Levin, *Edward Hopper: The Complete Prints* (New York: W. W. Norton and Company, in association with the Whitney Museum of American Art, 1979).

2. Walter Tittle, ''The Pursuit of Happiness,'' unpublished autobiography (before 1949, revised version 1949), Wittenberg University Library, Springfield, Ohio, chap. 22, p. 2. For a discussion of Hopper's interest in French art and culture, see Levin, ''Edward Hopper, Francophile,'' *Arts Magazine,* LIII (June 1979), pp. 114–121.

3. ''Shows and Sales. Mr. Bellows Paints Cross-Eyed Boy,'' *New York Herald,* February 13, 1915.

4. For examples, see ''America Today,'' *New York American,* March 1926, and Lloyd Goodrich, ''The Paintings of Edward Hopper,'' *The Arts,* VII (March 1927), p. 136. For an analysis of this attitude, see Levin, *Edward Hopper: The Art and the Artist* (New York: W. W. Norton & Company in association with the Whitney Museum of American Art, 1980).

5. Hopper's ledgers, bequeathed to Lloyd Goodrich, are on deposit at the Whitney Museum of American Art. They were kept by the artist and his wife. Hopper's record sketch of *November, Washington Square* accompanies his entry in Volume III.

6. Quoted in Brian O'Doherty, ''Portrait: Edward Hopper,'' *Art in America,* LII (Dec. 1964), p. 69.

7. *Washington Square and Judson Tower* was known as *The Town Square* prior to an unpublished letter, April 18, 1962, from Edward Hopper to Norman A. Geske, University of Nebraska.

8. This reproduction was placed in Volume V of Hopper's ledger.

9. Quoted in Lloyd Goodrich, *Edward Hopper* (New York: Harry N. Abrams, 1976), p. 31.

10. See Brian O'Doherty, *American Masters: The Voice and The Myth,* (New York: Random House, 1973), p. 13. For years the Hoppers fought eviction from their building, threatened by New York University, which wanted use of the building.

Charles Burchfield
1893-1967

Charles Burchfield was the product of a small town in midwestern America and the countryside that surrounded it. A native of Salem, Ohio, he became so fascinated with changes in weather that as a child he drew symbols of these changes — particularly the dramatic summer thunderstorms — on the family calendar.

From 1912 to 1916 he studied at the Cleveland School of Art, where his genius for pattern was quickly recognized. An exhibition of Chinese scrolls in 1914 stimulated Burchfield to execute in continuous form "all-day sketches," in which he included sunrise, mid-morning clouds, afternoon thunderstorms, sunsets, and moonrise.

In the fall of 1916 he moved to New York to study at the National Academy of Design. He spent one day attending classes, lingered about a month in the city which bewildered him, and then returned home to Salem depressed. Within two days he resumed working in the cost department of Mullins Company, a firm for which he had worked during summers since 1911. In his paintings of that winter and the following two years, he evoked childhood memories of nature. Just as romantic landscape painters had before him, Burchfield felt mysterious forces emanating from nature. He even attempted to capture nature's moods by codifying them into about twenty notations which he called "Conventions for Abstract Thoughts." He was attuned as well to sounds, and throughout his career he attempted to capture the fleeting and haunting sounds of nature, giving works such titles as *Song of the Wood Thrush*, *Cicada Song in September*, and *Song of the Red Bird*.

Indicative of Burchfield's approach to nature are his comments on some of his drawings. He said, "I have already mentioned 'idea notes.' These are the most casual and fragmentary of drawings. They may be merely motifs, such as the song of a bird, heat, wind, or cold, even the adaptation of a doodle as an abstract motif. I have hundreds of such notes filed away under seasonal headings, with subheadings such as mood, wind, fantasy and weather."[1]

In 1918 and 1919 Burchfield served in the army, working in the camouflage section. In 1921 he lost his job at Mullins Company in Salem and moved to Buffalo, New York, to join M. H. Birge and Sons as a designer of wallpaper, a job he held until 1929, when he began to live entirely on the sale of his paintings.

By 1920 Burchfield began to make paintings of houses, which like his landscapes are devoid of people. He created an excited emotional mood by charging the wooden buildings with anthropomorphic pathos, painting the windows as if they were huge eyes.

In the early 1920s his work became more realistic. It was in this decade that he was called "The Sinclair Lewis of the Paintbrush" for his paintings of midwestern towns. The 1920s was the period of the Revolt from the Village in literature, with Sherwood Anderson, Edgar Lee Masters, and Sinclair Lewis. They wanted to destroy the myth that the American small towns were the place of innocence and virtue. It was Burchfield who captured in his watercolors the inwardness of small towns, usually those already decaying, having been bypassed by progress.

In the 1930s his palette became more subdued but with a concomitant new interest in textures. By the late 1930s and early 1940s he seemed to be taking inventory, trying to reassess his career.

In 1943 there was a dramatic change in his work brought about by his return to his early works for inspiration. He completed old studies from the teens or elaborated those already finished from the same period, increasing them in size by literally adding sections of paper to the older works. Whenever possible, he left the early paintings untouched and

43 Early Winter Twilight

(also titled *Early Morning Twilight/Buffalo*)
1943–1959
Watercolor on five joined pieces of paper laid on board
42 x 56 in. (106.6 x 142.2 cm) total composition
 (A) 12⁹/₁₆ x 56 in. (32.2 x 142.2 cm)
 (B) 29⁷/₁₆ x 17⁵/₁₆ in. (74.4 x 44 cm)
 (C) 22¹²/₁₆ x 28¹³/₁₆ in. (57.8 x 73.2 cm)
 (D) 6¹⁰/₁₆ x 28¹³/₁₆ in. (16.8 x 73.2 cm)
 (E) 29⁷/₁₆ x 9¹¹/₁₆ in. (24.6 x 74.7 cm)

Monogrammed and dated l.r.:
1943–1959
Gift of Mrs. Sterling Morton
60.52

Provenance

Charles Burchfield; purchased (through Frank K. M. Rehn, Inc., agent for Burchfield) by Mrs. Sterling Morton for the PMC, 1960.

Condition

In April 1963, at the time of its shipment to The State University College at Buffalo (see Exhibitions), the work suffered u.c. a break of about ¾ in. from broken glass. According to an exchange of telegrams and letters between the SUCB and the SBMA, Charles Burchfield was to repair the damage, and his having done so is testified by a bill dated May 24 for $50 from the artist to SUCB, "to repair damage to the water-color 'Early Morning Twilight,'" and by a letter of Nov. 7 to James W. Foster, Jr., Director, SBMA, from D. Kenneth Winnebrenner of SUCB, who quotes Burchfield as saying: "I don't want anybody else monkeying with my painting." The repaired area is clearly visible. There is also slight tear and loss in the l.r. corner.

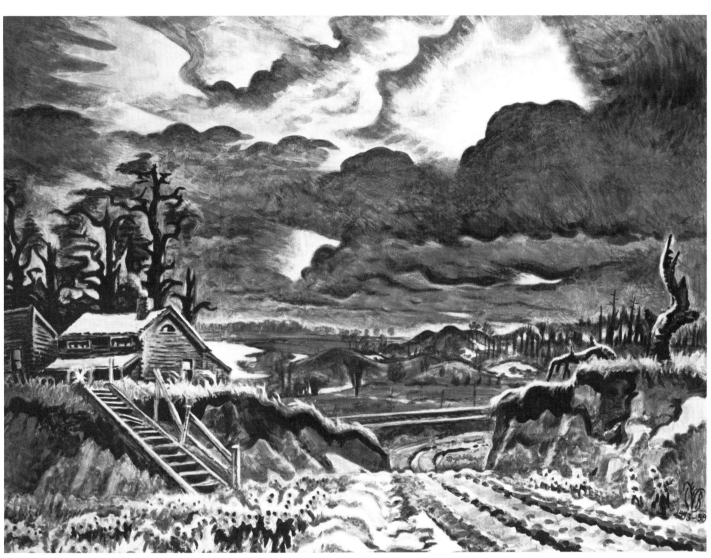

43

added in a similar style new elements around the edges. The first work to be thus expanded was *Coming of Spring*.

One of the major problems Burchfield faced in these new enlarged paintings was that of scale. He resolved the problem by using conventions as he had in his early paintings to express moods, but now simplifying shapes to strong linear outlines and using jagged yellow lines for pulsating light. He likewise maintained the use of small brushstrokes, which gave both movement and unity to the surface. In these later works, which extended to his death in 1967, he desired to evoke nature, rather than describe it. He struggled to develop a language in which everything is symbol realized in pattern. Part of this stylization may have been the result of his inability, for reasons of health, to spend much time outdoors.

In 1959 Burchfield was given cortisone therapy for his failing health. The improvement resulted in one of the best years of his entire career. He said that solutions became immediately apparent for every unfinished picture he took from his files.

David W. Steadman

Early Winter Twilight
(See color reproduction, page 48)

Burchfield was a very articulate artist. In his journals, which will eventually be published, he commented upon works in progress, and he discussed individual paintings in several exhibition catalogues.[1] Of *Early Winter Twilight* he wrote in 1963: "The stark drama of the onset of winter in earlier times. The vast array of clouds seems about to engulf the lonely little farmhouse, which is flanked by a group of brooding black locusts. Dead goldenrod and asters, lining the road, are lit up by the cold pale light from the sun."[2] A number of important aspects of Burchfield's work becomes clear in this statement. The time of year depicted is transitional — the icy, cold days of late fall and early winter. It was the periods of growth and imminent change between seasons that fascinated Burchfield most. He once said that he wanted to embody March in life and in art.[3] This scene takes place "in earlier times" not in 1959, when the painting was completed. The artist is nostalgically looking back to recreate anew the drama. Like many of Burchfield's paintings, this one revels in the pathetic fallacy. Nature is seen as a dramatic conflict between the powerful forces of the sky and the tall, brooding trees against the lonely farmhouse. Man implicitly is dwarfed in the face of an animate nature. Finally, light is a major protagonist in this drama, for it is "the cold, pale light" that sets the somber mood of the painting.

In an interview with a reporter for *Time* magazine in 1960, Burchfield explained the painting in a slightly different way. Then he said, "The sky is the leading actor. I was trying to express the threat of winter coming. There is a single light in the farmhouse window, showing that somebody is preparing supper or that they had supper."[4] Burchfield here uses the metaphor of the theater. The sky is "the leading actor" in a drama in which man stays indoors, prosaically eating supper while the true drama among the great forces of nature takes place around him. In both descriptions, an underlying attitude is present. A painting is a narrative we "read." Details slowly accumulate to fill out our comprehension of the dramatic protagonists.

Notes
1. Charles Burchfield, "The Place of Drawings in an Artist's Work," *The Drawings of Charles Burchfield*, ed. Edith H. Jones (New York: Praeger, 1968), p. 8.

The painting is built around a small watercolor painted in 1943 north of Attica, New York.[5] Burchfield expanded and completed it during the very fruitful year 1959. In that year, as a result of cortisone therapy, Burchfield's stamina returned, and he completed a number of paintings begun earlier. *Early Winter Twilight* is one of the largest of his watercolors, being made of five sheets of paper. He achieved a unity on this scale by the use of short, highly rhythmical brushstrokes throughout the painting, with a resultant feeling of pulsating energy in every part of the painting. Likewise, there is a unifying silver-gray tonality that intensifies the pure black lines, the whites (which are painted on the paper, not the paper showing through), yellows, and oranges.

Typical of Burchfield's later watercolors is his flattening of the space in the painting. He does not emphasize recession into depth, be it of the sky or of the landscape. Rather, he strengthens the foreground and the sky equally through the force of heavy lines in both, creating a strong surface pattern. Similarly, he emphasizes the horizontality of clouds and foreground landscape.

Burchfield struggled with the composition, and there are many changes visible in the watercolor. He first did compositional sketches, one of which, a pencil sketch measuring 11 x 21¾ in., is in the Charles Burchfield Center, Buffalo, New York. The entire composition was laid out first in pencil, with the paints added later. It was primarily in the placement of some of the trees that Burchfield changed his mind. The pentimenti are visible at the right side in both a deleted branch from the stump at the far right and one from the tree at its left. Both changes were obviously made to reduce the verticality of the foreground in order to allow clearer visibility of the horizontal hills beyond. At the left of the painting, a large branch was deleted from the second tree from the left and a large tree from the background hill, in shape like that of the single tree behind the railroad tracks. In all of these changes Burchfield scraped off the paint (the paper is slightly abraded in these areas) and painted over the passages.

David W. Steadman

Notes

1. Burchfield's journals, the editing of which has just begun, are on deposit at the Charles Burchfield Center, Buffalo, New York.
2. As quoted in *Charles Burchfield: Recent Paintings* (exhibition catalogue), The State University College at Buffalo, 1963, no. 21.
3. Matthew Baigell, *Charles Burchfield* (New York: Watson-Guptill Publishers, 1976), p. 25.
4. *Time*, January 18, 1960, p. 66.
5. In his entry notes on the painting as quoted in *Charles Burchfield: Recent Paintings*, no. 21.

Exhibitions

N.Y., Whitney Museum of American Art, *1959 Annual Exhibition of Contemporary American Painting*, Dec. 9, 1959–Jan. 31, 1960, no. 18.
SBMA, *Two Hundred Years*, 1961, no. 70, repr., mentioned "Introduction," n.p.
N.Y., The State University College at Buffalo, Upton Hall Gallery, *Charles Burchfield: Recent Paintings*, April 24–May 15, 1963, no. 21, repr. p. 9.
Tucson, The University of Arizona Art Gallery, *CB: His Golden Years: A Retrospective Exhibition of Watercolors, Oils and Graphics by Charles Burchfield*, Nov. 14, 1965–Jan. 9, 1966, no. 117, repr. p. 110.
Utica, N.Y., Munson-Williams-Proctor Institute, Museum of Art, *The Nature of Charles Burchfield: A Memorial Exhibition*, Apr. 9–May 31, 1970, no. 254 (checklist). For the catalogue by Joseph S. Trovato published on the occasion of the exhibition, see References.
Los Angeles, Occidental College, Thorne Hall, *Charles E. Burchfield: Watercolors*, Feb. 12–March 15, 1979, no. 17, repr. p. 22.

References

"Music in Landscape," *Time*, VII, no. 3 (Jan. 18, 1960), p. 66, repr.
Joseph S. Trovato, *Charles Burchfield: Catalogue of Paintings in Public and Private Collections* (Utica, N.Y.: Museum of Art, Munson-Williams-Proctor Institute, 1970), no. 1182 (as *Early Winter Twilight/Buffalo*).

Twentieth Century—
Modern Currents

Alfred Henry Maurer
1868-1932

Alfred Henry Maurer (pronounced Morer) was born in New York City, April 21, 1868. His father, Louis, born in Germany, arrived in America in 1815, and was employed as an artist for Currier and Ives. After leaving that firm, about 1872 or 1874, he opened a lithographic business that he ran until his retirement in 1884. That same year Alfred received his first art instruction in the family business. He also began studying with Edgar Ward at the National Academy of Design and attended Ward's Sunday classes at the famous Tenth Street Studio Building. The few pictures surviving from this time demonstrate that Maurer was talented, but not extraordinary.

Like so many young American artists, Alfred felt the need to go to Europe to study and to imbibe the artistic atmosphere of Paris. Before he sailed for France in November of 1897, Maurer had been perceived as a promising young artist. Upon arriving in Paris he enrolled for a week or two at the Académie Julian. After this brief stint as a student, he set himself up as an independent artist, with some success as indicated by his acceptance at the official Salons of 1889, 1900, 1903, and 1904, as well as at many other exhibitions. During this period, Maurer's loosely painted, realistic subjects — female portraits and genre scenes such as *Le Bal Bullier* (ca. 1901–1903, Smith College) — were based on the work of Whistler, Sargent, and Manet and reflected a manner then flourishing in Europe and America. Outstanding examples from this period are his *Self-Portrait* (1897, University of Minnesota) and the Corcoran Gallery's delicate *Young Woman in Kimono* (ca. 1901).[1]

Recognition came not only from Europe but also from the art establishment in the United States. In 1901, an oil on cardboard, *An Arrangement* (Whitney Museum of American Art), received the then enormous first prize of $1,000, plus a gold medal, at the Carnegie International. Rewarded handsomely, basking in the admiration of family and friends, Maurer's path to fulfillment seemed assured. Then something happened. He discovered Matisse and other Fauves, most likely at Salon d'Automne of 1905, in which he was also represented. No longer truly young and throwing off recognition at home, financial security, and family approval, he abandoned his fashionable mode around 1906 and allied himself with the radical movement.

His old chum, the sculptor Mahonri Young, recalled that on Maurer's thirty-sixth birthday (probably a little later) he suddenly: "... before our very eyes changed to a middle-aged man. He was never the light-hearted gay Alfie we had known."[2] Until the First World War forced him home, he executed a series of energetic, impressive, brilliantly colored, Matisse-like paintings, mostly landscapes. Leaving behind old ways and old friends, Maurer moved in the "Charmed Circle" of Gertrude and Leo Stein, and came into personal contact with Matisse, Picasso, and other leaders of the School of Paris. In the meantime, it is persistently rumored, he had a long-standing love affair with a Frenchwoman. Comfortable with his life and art, he undoubtedly intended to remain in France.

While Maurer was still abroad, an important event occurred in New York that could have promised great artistic rewards. He was invited to exhibit in 1909 with John Marin (another American in Paris) at 291 Fifth Avenue by Edward Steichen and Alfred Stieglitz. Marin's subsequent close association with Stieglitz brought him recognition and strong moral support. But unlike Marin, who returned from Europe in 1910 or 1911, Maurer remained abroad. Perhaps it was distance that caused it, but upon his return to New York in 1914, Maurer was unable to re-establish a working relationship with 291 and never again enjoyed the sponsorship of Stieglitz.

Critics, friend and foe alike, responded negatively to the 1909 exhibition, stunned

44 Still Life with Two Pears

Oil on board
18¹/₁₆ x 21¹³/₁₆ in. (45.9 x 55.4 cm)
Signed u.r.: A.H. Maurer
Not dated
Gift of Mr. and Mrs. Sterling Morton
59.54

Provenance

(Bertha Schaefer Gallery, N.Y.); (purchased from Schaefer by Esther Robles Gallery, Los Angeles, 1959); purchased from Robles by Mr. and Mrs. Sterling Morton for the PMC, 1959.

Condition and Technique

In 1978 examination by the BACC noted that the edges of the board were chipped and dog-eared and beginning to delaminate. The vulnerable edges have suffered paint losses. Traction crackle in the central yellow-green and orange-red, and also in the dark green bottom r., revealed the ground. The surface coating, a very thin natural resin (estimated), had yellowed slightly.

The support, a pressed wood pulp paper board, has a wide-mesh screen pattern impressed into the reverse and a somewhat finer texture impressed on the front. The thin white ground allows the impressed texture to show through. The paint, an oil-type, vehicular paste structure, ranges from dilute washes to heavy-bodied brush-marked pastes, with slight daubs and ridges of soft impasto. The impasto was flattened while the paint was drying.

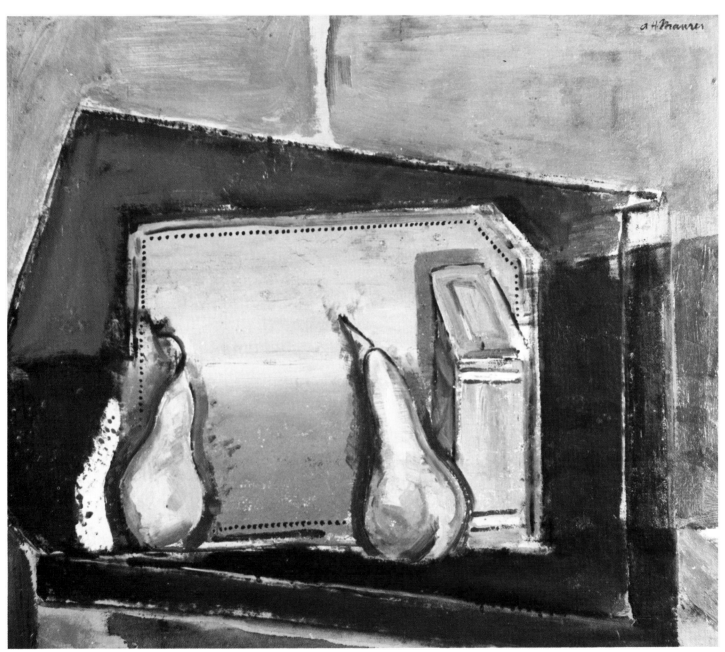

44

by what seemed Maurer's deliberate leap into a style that appeared to have no saving graces. Mahonri Young simply felt that Alfie had "gone off his rocker";[3] James Huneker called Maurer the "Knight of the Burning Pestle";[4] while J. F. Chamberlain just gave up: "But his pictures! There is no understanding them."[5]

Maurer's return to the United States, which he had thought would be for the interval of the war, turned out to be permanent. Despite numerous exhibitions before his tragic suicide, Maurer, increasingly isolated from the moving figures of modernism, lived in a world of neglect or hostility. He had lost most of his early Fauve pictures that he had stored in his studio to which he had fully intended to return;[6] lost too a lover; and he lived with a father who looked askance at his strange paintings. Not even the champions he found among the literati (especially Sherwood Anderson) and his close friendship with Arthur and Reds Dove were sufficient to break this sense of isolation. His idiosyncratic pictures of long-necked, wide-eyed young women, which he began painting about 1920, lacked all of the niceties of style and evoked, even from those sympathetic to modernism, cautious and reserved comment. His still lifes, readily associated with aspects of American Cubism, were well received, but, coming late in his career, were insufficient to rescue him from despair. Still living in the family house, his health failing, Alfred Maurer took his life by hanging, August 4, 1932.

Sheldon Reich

Notes
1. As exemplified by Elizabeth McCausland, Maurer's biographer and a staunch defender of avant-garde art, a later generation of critics viewed his early efforts as "academic." This approach has been eloquently refuted by Lloyd Goodrich (see Sheldon Reich, *Alfred H. Maurer*, Smithsonian Press, 1973, p. 19).
2. Quoted in Elizabeth McCausland, *A.H. Maurer* (New York: A. A. Wyn, 1951), pp. 85–86.
3. Reich, p. 31.
4. *New York Sun*, April 7, 1909.
5. *New York Evening Mail*, April 3, 1909.
6. These were recovered in about 1972 by Charles Sterling for the Bernard Dannenberg Gallery.

Still Life with Two Pears

(See color reproduction, page 46)

Sometime around 1920, Alfred Henry Maurer began painting a series of still lifes depicting pears and assorted objects on a tabletop. Influenced by Synthetic Cubism, these paintings evince a tendency toward decorativeness not found in his portraits or landscapes of the same period. Toward the latter part of the decade, Maurer made his still lifes more complicated and intricate by breaking up the planes and introducing collage. Earlier in the 1920s, however, he created simple, powerful, and stark images of fruit on a rectilinear tabletop, and it is to these works that *Still Life with Two Pears* belongs.

In fact, the Santa Barbara painting compares favorably with *Yellow Pear and a Roll*, dated about 1920, in the collection of the University of Minnesota (fig 1). Both share a taste for organizing shapes at right angles and for spatial ambiguity (the tabletop is tipped up and forward, while other forms — such as the book in the Santa Barbara painting — are treated three-dimensionally). Both likewise display a disregard for finesse and a predilection for strong primary and secondary colors that recall Maurer's conversion and allegiance to Fauvism. In *Still Life with Two Pears*, for example, the combination of the strident and aggressive greens of the background with the glowing orange of the book recalls the coloristic dissonances used by Matisse between 1905 and 1907, based on strong juxtapositions of complementary colors.

Unlike Maurer's enigmatic renditions of sad-eyed and long-necked women, which puzzled critics and the art public alike, still lifes of the type exemplified by the Santa Barbara one elicited enthusiastic response from those sympathetic to modern art. When a few such pictures were shown in a 1926 exhibition at Weyhe Gallery in New York, a

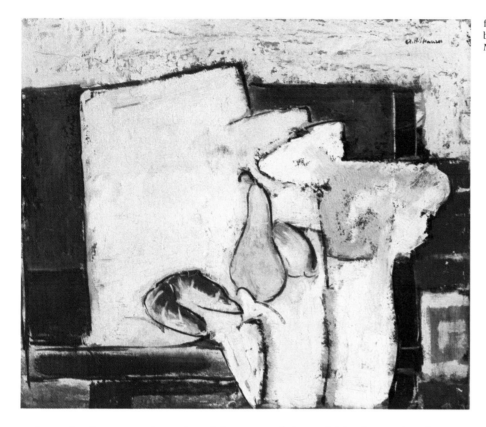

fig. 1 Alfred Maurer, *Yellow Pear and a Roll*. Lent by University Gallery, University of Minnesota, Minneapolis.

reviewer for the *New York Sun* found that some of them "fairly glow with radiance."[1] Responding to a 1931 display, the *Herald-Tribune* recorded that "A number of new still life designs mark the principal development in the last year in the work of Alfred Maurer. . . . These venture farther in the direction of pure abstraction than Mr. Maurer has yet progressed and reveal in their best form a new sensitiveness toward color as well."[2]

Yet exhibitions were relatively few, and although E. Weyhe purchased the contents of Maurer's studio in 1926, sales were even fewer. Weyhe's purchase represents perhaps the brightest event in Maurer's career.[3] In a letter to Sherwood Anderson, he wrote that such a thing had never before happened in America.[4] Most likely, it is from this acquisition that *Still Life with Two Pears* originally came.

Sheldon Reich

Notes

1. Quoted in Elizabeth McCausland, *A.H. Maurer* (New York: A.A. Wyn, 1951), p. 179.
2. January 8, 1931.
3. In 1941 the late Hudson Walker purchased the Maurer estate from the artist's sister — over 400 pictures for $1,500.
4. Maurer to Sherwood Anderson, about Jan. 1924; McCausland Papers, Archives of American Art.

Exhibitions

Esther Robles Gallery, Summer Group Show, July–mid August 1958, no cat.
SBMA, *Two Hundred Years*, 1961, no. 115, mentioned "Introduction," n.p.
Washington, D.C., National Collection of Fine Arts, Smithsonian Institution, *Roots of Abstract Art in America 1910–1930*, Dec. 2, 1965–Jan. 9, 1966, no. 127.

Marsden Hartley
1877-1943

Marsden Hartley was born in Lewiston, Maine, in 1877. His mother died when he was a young boy, leaving him to be raised by older sisters. He left school at the age of fourteen, went to work for a shoe factory, and a year later joined the family, which had moved to Cleveland. There he studied art with several teachers and in 1898 was given a modest five-year stipend to study art in New York. He attended the Chase School and later the National Academy of Design, spending his summers in Maine.

In 1908 a friend took him to Alfred Stieglitz's Photo-Secession Gallery, known fondly as "291." Stieglitz agreed to show Hartley's paintings, giving him his first one-man exhibition in May 1909, thereby establishing an enduring association. Hartley continued to exhibit with Stieglitz until 1936, first at 291 and later at the Intimate and American Place galleries. In 1912 Stieglitz and Arthur B. Davies made it financially possible for Hartley to go for the first time to Europe, where he came into direct contact with the modernist revolutions in art. He met Gertrude Stein and attended several of her "evenings" at 27 rue de Fleurus. In 1913 he visited Berlin and Munich and met Kandinsky, Marc, and other members of the Blaue Reiter, with whom he was invited to exhibit. Hartley was immediately in tune with all things German and executed a series of vibrant expressionist, abstract paintings that were later shown in Berlin and at 291. World War I forced Hartley to return to the United States, and over the next few years he visited and painted in Bermuda, Provincetown, Maine, and New Mexico. He returned to Germany in 1921 and with intermittent trips home, spent the entire decade of the 1920s in Germany, Paris, and southern France, supported in part by a stipend in exchange for paintings from an American syndicate of businessmen. A significant turning point came in 1931 with his paintings of Dogtown Common, near Gloucester, Massachusetts. This was a period during which he reaffirmed his commitment to his native New England. Awarded, however, a Guggenheim Fellowship to work in Mexico, he lived there from 1932 to 1933. At the end of that year he went back to Germany one final time, to Hamburg and the Bavarian Alps. In 1934 he returned to New England and devoted the last decade of his life to become *the* painter of Maine.

Despite his long years abroad and his extended experimentation with many phases of European modernism, Hartley maintained his inherent "Americanness." Though his work felt the strong impact of Cézanne, the Cubists, the German Expressionists (especially in their mystical tendencies), and some of the older masters, his closest affinity was with the mystical New Englander Albert Pinkham Ryder, about whom Hartley — a gifted poet and essayist — wrote on more than one occasion. Hartley, along with his contemporaries in the Stieglitz circle — Georgia O'Keeffe, Charles Demuth, John Marin, and Arthur Dove — forged a new art for twentieth-century America, using distinctly individualistic and indigenous means. During the 1930s, when Regionalism and American Scene painting dominated the art of this country — depending largely on sentimental or political realism for its appeal — Hartley and the other Stieglitz artists persevered in their pioneering art forms. Hartley's painting is rugged and somber, like the hard, grey granite of his native Maine coast; but there are also moments of tenderness, particularly in his still lifes with dead birds, as well as an expansive humanism in his late figure paintings.

Gail R. Scott

45 Alspitz-Mittenwald Road

ca. Winter 1933–1934
Oil on paper board
17⅝ x 29¾ in. (44.8 x 75.6 cm)
Not signed or dated
Gift of Mrs. Sterling Morton
60.61

Provenance

Estate of the artist, no. 224; (Paul Rosenberg and Co., N.Y., by 1945); (purchased from Rosenberg by Babcock Galleries, N.Y., Dec. 31, 1959); purchased from Babcock by Mrs. Sterling Morton for the PMC, Jan. 22, 1960.

Condition and Technique

In 1978 examination by the BACC noted a small hole in each of the four corners of the paper board support, indicating it was once pinned or nailed to a surface and that the pressed wood pulp board to which it is adhered may be a later addition. The board had been slightly crushed at all four corners, and there was some abrasion of the paint layer from the rabbet as well as slight paint loss at the corners due to local abrasion. Some of the impasto had been flattened. The surface coating, an even layer of probably natural resin, had yellowed. The overall condition was good.

In 1980 the painting was treated by the BACC. The discolored surface coating was removed and the painting cleaned, the highlights and sky with isopropyl alcohol and the darker part with ethylene dichloride. An isolating brush coat of Acryloid B72, 10% in xylene was applied, and the slight paint losses in the corners and edges were inpainted with dry pigments ground in Acryloid B72. Two spray coats of Acryloid B72, 10% in xylene were applied, followed by two spray coats of Bakelite PVA-AYAA as final protective coating.

The support consists of a pressed paper pulp type board, approximately ⅛ in. thick, adhered to a pressed wood pulp board. The surface of the paper board has an imitation canvas texture pressed into it. As there is no ground layer and the support is exposed in many areas, the tonality of the painting assumes the dark grey-brown, oil-infused color of the support. The oil-type paint (estimated) is applied wet into wet directly onto the support in a fluid vehicular paste with some transparent and scumbled application over the dark support and some localized impasto in the white highlights.

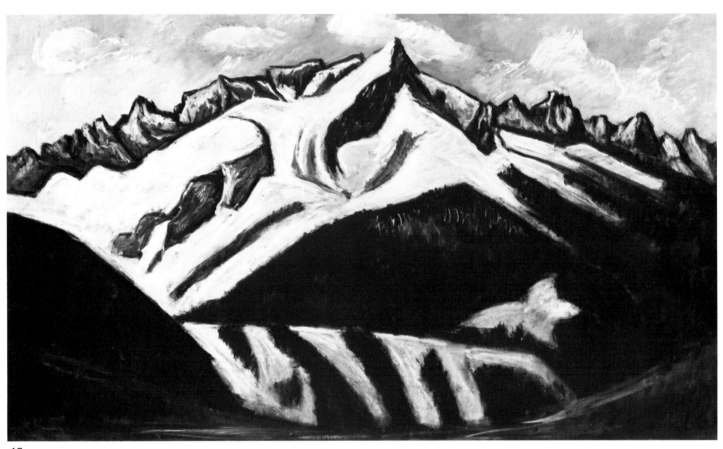

45

Alspitz-Mittenwald Road

Hartley executed *Alspitz-Mittenwald Road* in the winter of 1933–1934 while living in the alpine town of Garmisch-Partenkirchen, Germany, near the Austrian border. The painting belongs to a larger thematic series of mountain pictures that had absorbed Hartley since the start of his career and would continue until the end of his life.[1] He was intrigued with the problem of capturing the essential *idea* of the mountain, and to do so he tackled in paint such peaks as Mt. Popocateptl in Mexico, Mt. Katahdin in Maine, Mont Ste. Victoire in Aix-en-Provence, and, most challenging of all, these awesome Bavarian Alps.

In the summer of 1933 he arrived in Hamburg from Mexico, where he had spent a year on a Guggenheim Fellowship. He had not liked Mexico. He found it a land of volcanic fire — the fire of destruction and death, and he wanted to purge that experience with the cool of the northern countries. He predicted that if he could "live with a few Alps at a time . . . it could mean the making of a new life" — a prophecy that was indeed fulfilled. He determined to live *in* the Alps, to face them every day and have them "enlarge his vision and spirit."[2]

After arriving there in the early autumn, Hartley related in a letter that he had to walk great distances to get at his subjects and find the best perspectives. He sought not only to view the mass of mountains, but also to know the inside of them as well as their profile by climbing in and through them. He became intimately familiar with these majestic forms and with what he called the "language" of mountains.[3]

He commented in another letter to the same friend, ". . . there is no distance here to excite extravagance of eye or lose 'eye thinking.'"[4] Hartley's "eye thinking" produced many careful drawings in which he sought exactitude of information. One of these pen and sepia drawings (in a sketchbook in the Hartley Memorial Collection at the Treat Gallery, Bates College, Lewiston, Maine), dated October 28, 1933, renders the same view as the oil in the Preston Morton Collection and is undoubtedly a preliminary sketch for it (fig. 1).

When the snow came, the sky clouded over, and conditions became too difficult for exploring the area on foot, Hartley retreated, as he related in his letters, to his room in the town, where for the next few months he worked on paintings from sketches he had made at the scene. In these same letters he also noted the lack of color in the alpine winter vistas. His paintings, he commented, would look "sober" to the viewer and "offer no shade of prettiness," but would be true to the facts of the scene.[5]

Alpine climatic and topographical features suited his proclivity for monochrome and rugged natural forms. He had always felt that the greatest painting — from cave drawings, to Coptic embroideries, to Rembrandt — was done basically in monochrome and that the great artists "understood how to swell their crescendos out of dark surroundings. . . . [D]eparting from black and white, rising in the scale of umbers, the siennas, the ochres and blue, you already have a sonorous gamut, with a chromatic vibrancy all its own."[6] From Cézanne, whom he had devotedly studied during his 1925–1929 period in Aix-en-Provence, Hartley had learned that from the perfect harmonizing of color comes precise design, and in *Alspitz-Mittenwald Road* we see the fruits of this lesson. The mountain emerges from just this monochromatic sense of color-form. The somber tonality allows the architectonics of the mountain-as-form to dominate. The viewer is not overwhelmed with a picturesque alpine vista but is embraced in the shadow of its presence.

There are many small inclusions of dirt and paintbrush hairs in the paint layers, and the texture of the support is visible over much of the paint surface.

fig. 1 Marsden Hartley, *Alspitz*. Reproduced by permission of The M. H. Memorial Collection, Treat Gallery, Bates College, Lewiston, Maine.

Also to be noted are unpainted areas of bare ground or composition board — another lesson from Cézanne. Hartley had observed, especially in Cézanne's watercolors, that with a thorough organization of tonal values, the bare spaces function to unify the whole. Hartley's own success in this practice is evident in *Alspitz-Mittenwald Road*, where, by allowing the dark, oil-infused board to show through, the unpainted patches contribute to the tonal unity of the painting.

Hartley expressed satisfaction with the pictures he was producing during these months in the Alps. He felt he had been able to convey the inner effect as well as the essential identity of the surrounding mountains, so that by looking at one of his paintings, a native of the region might be able to identify specific peaks by name.[7]

At the same time, his work — both mental and artistic — during this time had even broader implications than the rendering of a certain landscape. He had been reading Plotinus and Christian metaphysics throughout his stay and realized that, for the first time in his life, he had achieved a degree of mental quietude. He was fond of quoting the Belgian mystic Jan van Ruysbroeck, ''Perfect stillness, perfect fecundity,'' and these mountains had certainly given him an inner stillness and were also to be the beginning of the most fecund period of his career — the last decade of his life. He returned home in March of 1934 with renewed vigor. The sense of strength and peace the mountains symbolized became, in turn, the very qualities that were to characterize his late great paintings.

Gail R. Scott

Exhibitions

N.Y., The Museum of Modern Art, *Lyonel Feininger/Marsden Hartley,* Oct. 24, 1944–Jan. 14, 1945, p. 92.

Chicago, Renaissance Society at the University of Chicago, *Exhibition of Coptic Art and Paintings by Marsden Hartley and Max Weber,* Oct.–Dec. 1945, no. 1.[1]

N.Y., University of Rochester, Memorial Art Gallery, *Five Modern Americans: Avery, Hartley, Knaths, Rattner, and Weber,* organized by Paul Rosenberg and Co., June–Aug. 1946 (no cat.); traveled Ohio, The Dayton Art Institute, Dec. 1946–Jan. 31 (?) or March (?), 1947, Springfield, Mass., Museum of Fine Arts.[2]

Boston, Institute of Contemporary Art, *Hartley, Chaney, Cutler Memorial Retrospective,* Sept.–Nov. 1947.[1]

Bloomington, Indiana University Art Museum, June–Aug. 1948.[1]

The Arts Club of Chicago, *Marsden Hartley/Edward Hopper/Walt Kuhn/John Sloan,* May 8–June 15, 1956, no. 9 (lent by Paul Rosenberg and Co., N.Y.)

N.Y., The Brearley School, May 1957?.[3]

SBMA, *Two Hundred Years,* 1961, no. 96, repr.

Calif., La Jolla Museum of Art, *Marsden Hartley/John Marin,* Feb. 12–March 27, 1966, no. 17.

Los Angeles, University of Southern California, The University Galleries, *Marsden Hartley: Painter/Poet 1877–1943,* Nov. 20–Dec. 20, 1968, no. 79, repr.; traveled Arizona, Tucson Art Center, Jan. 10–Feb. 16, 1969, Austin, University of Texas, University Art Museum, March 10–Apr. 27, 1969.

N.Y., Bernard Danenberg Galleries Inc., *Marsden Hartley: A Retrospective Exhibition,* Sept. 11–Oct. 4, 1969, no. 25 (dated 1933), repr. p. 18, p. 7.

Lawrence, University of Kansas Museum of Art, *Marsden Hartley: Lithographs and Related Works,* March 19–April 16, 1972, no. 28.

1. From information provided by Michael St. Clair, Babcock Galleries in a letter of July 3, 1979, to Gail R. Scott.
2. From information provided by Helen L. Pinkney of The Dayton Art Institute in a letter of Nov. 7, 1980, to the editor, and by Michael St. Clair.
3. From information provided by Michael St. Clair. There is no record of the paintings being shown at The Brearley School, and it may have been a loan (letter of Nov. 17, 1980, from Barbara Huggins).

Notes

1. For recent discussion of the works executed from Garmisch-Partenkirchen, see Barbara Haskell, *Marsden Hartley* (exhibition catalogue), Whitney Museum of American Art, New York University Press, 1980, pp. 94–95; Babcock Galleries, *Marsden Hartley 1877–1943, Paintings from 1910 to 1942 and a Bavarian Sketchbook of Silverpoint Drawings,* 1933 (essay by James R. Mellow), New York, March 1980. —(Ed.)
2. Letter from Hartley to Adelaide Kuntz, July 12, 1933, from Hamburg (Archives of American Art, Smithsonian Institution, Washington, D.C.; hereafter AAA).
3. Letter to Adelaide Kuntz, October 16, 1933, from Partenkirchen (AAA).
4. Letter to Adelaide Kuntz, December 22, 1933, from Partenkirchen (AAA).
5. Letter to Adelaide Kuntz, December 1, 1933, from Partenkirchen (AAA).
6. ''On the Persistence of the Imagination, the Painting of Milton Avery,'' unpublished manuscript essay, Yale Collection of American Literature, Beinecke Rare Book and Manuscript Library, Yale University.
7. Letter to Adelaide Kuntz, December 1, 1933 (AAA).

John Marin
1870-1953

Born in Rutherford, New Jersey, John Marin was reared by his aunts. During his early twenties, he worked in architects' offices and did a brief stint as a free-lance architect. In his free time he painted. At the age of twenty-eight he attended the Pennsylvania Academy of Fine Arts for two years and in 1904 studied briefly at the Art Students League in New York. In 1905, he went to Europe, staying in Paris. Influenced by Impressionism, he did engravings and watercolors of the city and provinces. Although Marin stayed in Europe for five years at a period when new and revolutionary styles were bursting upon the scene, his work then did not reflect the new ideas. Edward Steichen discovered Marin's work and sent to Alfred Stieglitz in New York a few of his watercolors, which were hung at the 291 Gallery in March 1909. In February 1910 Stieglitz gave Marin his first one-man show. This act of confidence sparked Marin's painting career. Stieglitz would remain for the rest of his life the artist's great friend and supporter.

In the next few years Marin began developing his abstract approach to landscape painting. He returned to Europe in 1910, coming home for good in the spring of 1911. He married in 1912 and the next year moved permanently to Cliffside, New Jersey, for the winters. The modern European art Marin saw at Stieglitz's gallery undoubtedly influenced his work. He saw "great forces at work" in New York and his images of that city reflect knowledge of Delaunay and the Futurists. There were hints of Cubism in his Maine watercolors of 1914, which became more pronounced in his work done at Small Point, Maine, the following summer. In Maine, he developed a special kinship with nature, and, as a rugged outdoorsman, he pursued his subject matter of sea and coastline by hiking, swimming, boating, and fishing. The summer of 1919 he spent at Stonington, to which he would return, as well as to Small Point and other places on the east coast, for the next nine years. In 1925, Stieglitz opened his new Intimate Gallery in New York with a group of Marin's pictures. When he opened An American Place in 1929, Stieglitz again honored Marin with an exhibition, and it was with a retrospective of Marin's oil paintings that he later closed the gallery.

After an interlude of two summers in Taos, New Mexico, in the summer of 1931, Marin came back to Small Point, Maine, where he turned to oil painting with great enthusiasm and determination. He discovered Cape Split on the Maine coast in 1933. The following year Marin bought a house at Cape Split and for the rest of his life spent the summers there. In 1936 he wrote to Stieglitz: "Here the sea is so damned insistent that houses and land things won't appear much in my pictures."[1] In his later years, Marin was disappointed that his oils were not as appreciated as his watercolors.

National recognition came in 1936, when the Museum of Modern Art held a Marin retrospective. Other retrospective exhibitions occurred at the Institute of Contemporary Art, Boston, in 1947 and on the west coast in 1949 at the Los Angeles County Museum of Art and at the Santa Barbara Museum of Art. Marin died in 1953 at his beloved Cape Split, Maine.

Patricia Gardner Cleek

Notes

1. Dorothy Norman (ed.), *The Selected Writings of John Marin* (New York: Pellegrini and Cudahy, 1949), p. 171.

46 *Composition, Cape Split, Maine, No. 3*

1933
Oil on canvas
22 x 28 in (55.9 x 71.1 cm)
Signed l.r.: Marin 33
Sketch in charcoal on reverse (fig. a)
Gift of Mrs. Sterling Morton
60.71

fig. a John Marin, *Composition, Cape Split, Maine, No. 3*, detail of reverse. Preston Morton Collection, Santa Barbara Museum of Art.

Provenance

(Downtown Gallery); purchased from Downtown by Mrs. Sterling Morton for the PMC, 1960.

Condition and Technique

In 1978 examination by the BACC noted the thickest paint had developed minute fracture crackle pattern. The brittle dry paint had begun to separate and flake away from the ground, and small losses had occurred in the thick paint in the r. half of the bottom l. quadrant. Several of the highest peaks of impasto had been flattened, probably before the paint was completely dry, but most survived intact. Many of the darker areas of the paint were veiled by a whitish "blanching," probably caused by the extreme leanness of the paint and possible exposure to humidity. There was no surface coating.

In 1979 the painting was treated by the BACC. The surface dust and grime was removed with a soft brush. Jade PVA emulsion was applied to the crackle, allowed to dry, and set down with a warm tacking iron. An overall spray coat of B72, 10% in xylene was applied to eliminate blanching

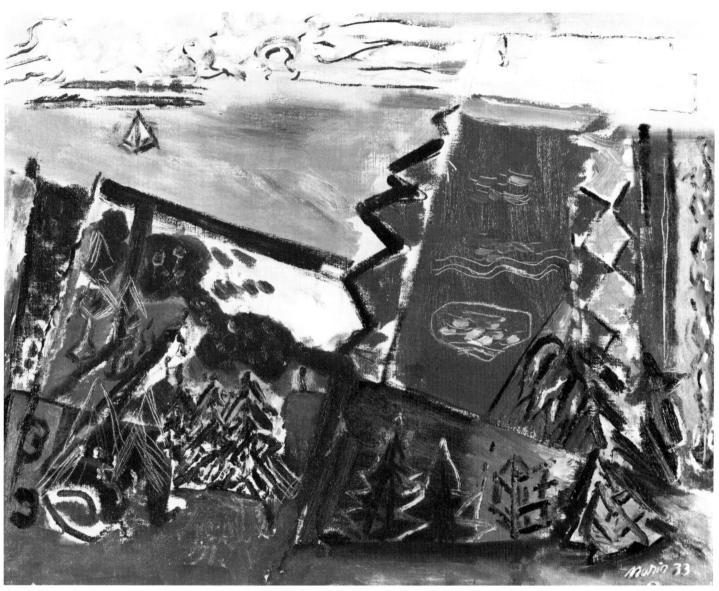

46

Composition, Cape Split, Maine, No. 3

(See color reproduction, page 47)

Marin had worked sporadically in oil throughout his life, but it was not until the summer of 1931 that he forcefully turned to painting in that medium, which in the following years would become as important to him as his work in watercolor. When he first exhibited his thickly painted canvases in the fall of 1931 at An American Place, most of the critics were stunned. Ralph Flint, however, wrote perceptively for *Art News* of Marin's "new trend": "the new oils are carrying the long-established Marin tradition into new latitudes.... Marin is at the beginning of a new era in his painting career."[1] His new experiments also affected his watercolors, which Flint described as "magnificent in their new ruggedness." In the catalogue of the major Marin retrospective held at The Museum of Modern Art in 1936, E. M. Benson wrote: "The most important single factor in the course of Marin's development since 1925 was his return to oil painting."[2]

It was in response to the Maine coast and to the sea that Marin felt the need for a greater ruggedness in his works, compelling him to use a rough and heavy impasto in his oils. John Marin first discovered the Maine coast in the summer of 1914 at Small Point, where he developed his symbols for trees, waves, and rocks. With the exception of two interludes in the summers of 1929 and 1930, when he went to Taos, New Mexico, Marin returned to Maine every summer. In 1931 he returned to Small Point, and in a letter of July 20, 1931 to Stieglitz he wrote of reaching the essence of things as they exist in flux: "to get down what's ahead of you — water you paint the way water moves — Rocks and soil you paint the way they were worked for their formation — Trees you paint the way trees grow ... You'll paint and paint — and when you get through your paint builds itself up — moulds itself — piles itself up — as does that rock."[3]

Marin first summered at Cape Split, Addison, Maine, in 1933. He was so taken with this location that the following year he bought a house "so close to the water I almost feel at times that I am on a boat."[4] Here he would return for the next twenty years until the end of his life, mainly painting the sea and calling himself the "Ancient Mariner." MacKinley Helm has observed that the change from Small Point to Cape Split was "not revolutionary. Marin was therefore able to 'play around' with his motifs almost at once, producing 'quite a batch' of new paintings.... This area has provided him ... an ideal pattern for his habit of work — the constant and manifold elaboration of familiar themes, the production of several versions and treatments of a particular motif in a quick series of 'sittings' or over a succession of seasons."[5]

Composition, Cape Split, Maine, No. 3 is one of three canvases (all 22 x 28 in.) executed during Marin's first summer at Cape Split. *No. 2* (fig. 1) and *No. 3* seem to be variations of the same view. Sheldon Reich suggests that Marin carried a few small oil panels around with him in the same way he carried sketching material, in this way directly confronting his scene.[6]

In the versatility of technique ranging from thick pigment to transparent washes and in its design, *Composition, Cape Split, No. 2* has been singled out as an exceptional painting. *No. 3* likewise exhibits a richness of texture and design and, very likely, represents the same view as *No. 2*, with the land and sea more flattened and the forms (trees and island) smaller in the Santa Barbara painting, for which the artist appears to have placed

and to isolate surface. Losses were filled with a wax-resin mixture, isolated with PVA-AYAF, 30% in ethanol, and inpainted with B67/B72 palette and xylene. An overall spray coat of B72, 10% in xylene was applied as final coating.

The support, a medium-weight, plain weave, single-threaded fabric like linen with many uneven, irregular threads, is tacked to its original stretcher. The moderately thin white ground penetrates the fabric slightly and is visible on the reverse. The oil-type paint, of lean vehicular structure, ranges from translucent scumbles and thin, dry opaque layers to fat wedges, ridges, and blobs of high impasto. Much of the ground is visible between the brushstrokes and is exposed where the "sgraffito" technique has been used, scratching through the paint layers to reveal the white ground below.

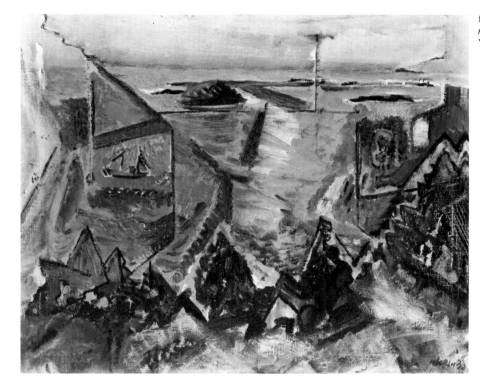

fig. 1 John Marin, *Composition, Cape Split, Maine, no. 2*. Courtesy of Kennedy Galleries, Inc., New York.

himself at a higher point farther back from the coast line. In both paintings there is to the right a serrated border against the water. In *No. 2* the area is colored green, suggesting a grove of pine.[7] The shoreline on the right in *No. 3* , a bold zigzag in blue, is more dominant and abstractly rendered. The land to the right of the border is also blue with heavy outlining in black, and this area is divided into vertical bands, one of these bands carrying a pronounced diamond design.

The use of bands or planes with interior linear designs found in *No. 3* can be seen in Marin's watercolors and oils of New Mexico of 1929 and 1939 and also in his watercolors and oils of New York streets of the late 1920s and early 1930s. This style, which began for Marin in the mid-1920s, Sheldon Reich believes may have been derived from his knowledge of the work of the Immaculates or Precisionists Charles Demuth and Georgia O'Keeffe, central figures in the Stieglitz circle, who were painting in the Precisionist manner from about 1925 to 1930. O'Keeffe, moreover, was in New Mexico at the same time as Marin. *No. 3* uses the same simplified composition of two tilted and staggered planes as O'Keeffe's *Storm Over Taos, New Mexico* (1930), in which there is also a suggestion of parallel banding that is, however, placed horizontally.

In his use of bands with interior designs, Marin may have been influenced by Indian jewelry and blankets. As early as 1919, Marin in a letter to Stieglitz praised the "symbolic and abstract expression" of Indian jewelry.[8] In another letter to Stieglitz from the fall of 1929 Marin mentioned bringing home two blankets and some jewelry from New Mexico, which seemed to share a "funny" quality with his paintings done that summer.[9] At this period Marin declared himself as "hating everything foreign [and being] a shouting spread-eagled American."[10] During these two summers in the West he would

have had every opportunity to look at Indian crafts. He stayed at Mabel Dodge Luhan's ranch in Taos, where she had a collection of Indian blankets. Marin's old friend, Andrew Dasburg, whom he had known in New York, moreover, ever since coming to Taos in 1916, where he spent a part of every year, had become an avid collector of Indian blankets. In *Edge of Taos Desert*, Mabel Dodge Luhan describes the rare ancient blankets they both collected including "beautiful old blue and white serapes, dyed with indigo."[11] The unusual diamond pattern, the zigzag treatment and parallel bands in the right hand plane of *Cape Split, No. 3* could very well have been inspired by Navajo blankets of the type called the serape style produced in the nineteenth century. Elaborate in style, they could be blue and white or red, white and blue.[12] Marin would certainly have been interested and inspired by this native American art with its flat and abstract shapes.

Indian art was very much in the air in the early 1930s. John Sloan, who had spent his summers in Santa Fe since 1918 and who also acquired Indian blankets, was in charge of the large exposition of Indian Tribal Arts at the Grand Central Galleries in New York in the fall of 1931. This traveled for two years to major art centers in the United States and because of its uniqueness then, received many important notices from the art critics. When Ralph Flint reviewed Marin's watercolors of New Mexico at An American Place in the fall of 1931, he remarked that "Marin in some way or another manages to get a curious hieroglyphic something into his shapes that is largely Indian." He also singled out a watercolor "with a series of angular patterns that might have come off some early Indian rug or pottery."[13]

Whatever their source, the museum's oil painting by Marin uses geometric and linear devices that the artist had been using previously. Sheldon Reich points out that Marin's oils of the sea from early 1930 until about 1941 are concerned with the flattening of shapes against the picture plane and the patterning of forms. *Cape Split, No. 3* is a fine example of this mature period of Marin's art.

Patricia Gardner Cleek

Notes

1. Ralph Flint, "Marin 1932 Show Has New Trend," *Art News*, XXXI, no. 7 (Nov. 12, 1932), p. 11.
2. E. M. Benson, *John Marin: Watercolors, Oil Paintings, Etchings* (exhibition catalogue), The Museum of Modern Art, New York, 1936, p. 32.
3. Dorothy Norman (ed.), *The Selected Writings of John Marin* (New York: Pellegrini & Cudahy, 1949), pp. 139–140.
4. Letter of Aug. 18, 1935, to Stieglitz; Norman, p. 67.
5. MacKinley Helm, *John Marin* (Boston: Pellegrini & Cudahy in association with The Institute of Contemporary Art, Boston, 1948), pp. 70–71.
6. Sheldon Reich, *John Marin: A Stylistic Analysis and Catalogue Raisonné*, Part I (Tucson: University of Arizona Press, 1970), p. 203.
7. *No. 2* also has a linear framing in black of a type typical of Marin's work beginning at Stonington and Deer Isle in about 1921. See also *Maine Islands* (1922, Phillips Gallery, Washington, D.C.).
8. Norman, p. 51.
9. Norman, p. 134.
10. Letter of Aug. 21, 1927, to Stieglitz; Norman, p. 115.
11. Mabel Dodge Luhan, *Edge of Taos Desert* (New York: Harcourt Brace, 1933 and 1937), p. 139.
12. Mary Hunt Kahlenberg and Anthony Berlant, *The Navaho Blanket* (exhibition catalogue, pub. by Praeger Publishers, Inc., New York, in association with the Los Angeles County Museum of Art, 1979), p. 16.
13. Ralph Flint, "Recent Work by Marin seen at An American Place," *Art News*, XXX, no. 3 (Oct. 17, 1931), p. 5.

Exhibitions

N.Y., An American Place, *John Marin*, Dec. 20, 1933–Feb. 1, 1934, no. 21.
N.Y., The Museum of Modern Art, *John Marin: Watercolors, Oil Paintings, Etchings*, 1936 (reprinted 1966 for MOMA by Arno Press), no. 174 (as *Composition, III, Cape Split, Maine*), p. 75.
Washington, D.C., Studio House, *John Marin*, Feb. 3–21, 1937, no. 18.
SMBA, *Two Hundred Years*, 1961, no. 114 (as *Composition, Cape Split, Maine*), mentioned "Introduction," n.p.
Calif., La Jolla Museum of Art, *Marsden Hartley/John Marin*, Feb. 12–March 27, 1966, no. 25, mentioned text, n.p.
Los Angeles County Museum of Art, *John Marin/1870–1953*, July 7–Aug. 30, 1970, no. 93, p. 16; traveled San Francisco, M. H. de Young Memorial Museum, Sept. 20–Nov. 7, 1970, The Fine Arts Gallery of San Diego, Nov. 28, 1970–Jan. 3, 1971, Whitney Museum of American Art, Feb. 18–March 28, 1971, Washington, D.C., National Collection of Fine Arts, Smithsonian Institution, Apr. 23–June 6, 1971.

References

Sheldon Reich, *John Marin: A Stylistic Analysis and Catalogue Raisonné*, (Tucson: University of Arizona Press, 1970), I, p. 203, repr. fig. 178; II, no. 33–35, repr. p. 653.

Abraham Rattner
1895-1978

For Abraham Rattner, art was never primarily an aesthetic activity, but rather a means of expressing what he called "livingness" and his search for the divine in man.[1] Deeply religious, though unorthodox by nature, Rattner's passionate attitude toward painting demanded the "courage to go beyond the reality as I've experienced it, seeking that greater reality of nature created by God."[2] Believing that painting could glorify the entire range of human feeling and experience through organized formal structure, Rattner integrated figurative and abstract elements into compelling personal visions.

Born in New York in 1895, the son of a rabbinical student from Czarist Russia, Rattner was vividly aware of his Russian-Jewish heritage. In his hometown of Poughkeepsie, New York, he suffered poverty and the indignations of anti-Semitism. Painting became an important outlet for the frustrations and angers of the young man. While attending George Washington University in Washington, D.C., he studied architecture but became more interested in painting through night courses at the Corcoran School of Art. Following brief study at the Pennsylvania Academy of the Fine Arts in 1916–1917, Rattner served in World War I, with a camouflage section and the artillery in France. The experience of war deeply affected the young artist.

After the war, a traveling fellowship enabled Rattner to return to France in 1920, where he lived for twenty years, primarily in Paris. As a member of the Minotaure group, which included Picasso, Miró, Dali, Giacometti, and Le Corbusier, he became an active part of the avant-garde circle. During the mid-1920s, Cubism and Futurism were major influences on his work, but between 1925 and 1930, Rattner returned to representation in order to express more intense emotionalism. In the 1930s, his figurative style incorporated brilliant colors and heavy, sinuous contours. His first one-man shows were held in Paris and New York in 1935 and 1936. Following Hitler's entry into Paris, Rattner escaped to the United States in 1940.

The Second World War plunged Rattner into deep anguish, eliciting symbolic themes in his work to portray the prevailing "stupidities, bestialities and grotesqueries" of men.[3] He sought in his representation of universal symbols, such as the cross, to take us beyond the negative forces of modern times toward a realization of man's potential to rise above himself. Even after the war, when his paintings became less agonized, Rattner continued the symbolic content of his work to express many levels of commonplace and transcendent realities.

Melinda Lorenz

Notes
1. John I. H. Baur, "Abraham Rattner," *Four American Expressionists: Doris Caesar, Chaim Gross, Karl Knaths, Abraham Rattner* (exhibition catalogue), Whitney Museum of American Art, 1959, p. 39.
2. Baur, p. 40.
3. Allen Leepa, *Abraham Rattner* (New York: Harry N. Abrams, Inc., 1974), p. 36.

47 Crucifixion in Blue (Composition II)

1953
Oil on masonite board
35¼ x 45¾ in. (89.5 x 116.2 cm)
Signed l.l.: Rattner
Signed and dated by artist on reverse:
 Rattner/1953
Inscribed below signature and date on
 reverse: Composition II/1953/Crucifixion
 in BLUE
Gift of Mrs. Sterling Morton
60.77

Provenance

(Downtown Gallery, by 1959);[1] purchased from Downtown by Mrs. Sterling Morton for the PMC, 1960.

1. It has not been possible to ascertain whether the painting at one time was in the possession of Paul Rosenberg and Co. On the reverse of the frame is a chalk inscription: ROSENBERG and a torn gallery label. No answer regarding the possibility of provenance and/or exhibition was received from Rosenberg.

Condition and Technique

In 1979 examination by the BACC noted the painting had suffered slight abrasion in the u.r. corner. The painting was in good condition.

The support, a ⅛ in.-thick masonite board, its textured side on the reverse, is covered on the recto with a thin white ground of medium thickness. The paint surface, of an oil type, shows extensive use of a very high impasto consisting of crumpled and wrinkled masses of paint like pieces of paper covered with paint, in turn painted over; some of the paint is directly squeezed from the tube; extensive brush texture and linear applications are also evident.

Crucifixion in Blue (Composition II)

The theme of the Crucifixion in Rattner's work arose as a consequence of the moral torment the artist experienced during the years of World War II, and it continued as a major subject for him in the years following. In the Crucifixion, Rattner personalized the message of man's inhumanity to man by stating it was himself on the cross.[1]

Crucifixion in Blue was painted in 1953 when Rattner's style became, and remained, much more abstract. Following a period of more classic formalism from 1950 to 1953, he achieved an intense expressionist mode in which formal equivalents conveyed emotional tension, conflict, and resolution. The development of Abstract Expressionism during the late 1940s and early 1950s encouraged this tendency in Rattner's painting. Comparing *Crucifixion in Blue* to an earlier work on the same theme, *Study for Crucifixion* (1950, Des Moines Art Center, fig. 1), the increased expressionist abstraction is apparent in the later work. Specific details, evident in the earlier piece, such as the moon, candles, lances, and figures, are fragmented, held together by a tense structural network of dynamic lines and vibrating color planes. An even greater degree of almost frenzied abstraction appears in *Crucifixion in Yellow,* painted a year later in 1954, with similar dimensions (45¾ x 35 in.), but on a vertical axis.[2]

In these works, linear structure anchors the richly painted, glazed and scumbled colors in dominant hues of blue and yellow, respectively. Line and color served different purposes for Rattner, who felt that line was more analytical, color more emotional. Exploratory drawings preceded a major work, but it was through painting and repainting that final decisions were made, providing full emotional content and specific symbolism.

His work recalls that of Georges Rouault, which Rattner attributes not to influence, but to their mutual admiration of Gothic stained glass. Rattner lived near Chartres Cathedral for several summers and spent many hours studying the windows. In 1953, the year of *Crucifixion in Blue,* he executed his first stained glass designs, leading to the 1957 commission of a large window for the new Chicago Loop Synagogue.

Related iconographically and stylistically to the Cruxifixion is Rattner's *Window Cleaner* series. A single figure with outstretched arms is poised on a ladder or scaffolding, recalling Christ's posture on the cross. It has been suggested that the Window Cleaner is a symbolic counterpart to Christ in commonplace experience.[3]

Through the Crucifixion and related themes, Rattner was able to express a profound spiritual meaning that embraced the literal and the symbolic, the personal and the universal.

Melinda Lorenz

Notes

1. Allen Leepa, *Abraham Rattner* (New York: Harry N. Abrams, Inc., 1974), p. 36.
2. John I. H. Baur, "Abraham Rattner," *Four American Expressionists: Doris Caesar, Chaim Gross, Karl Knaths, Abraham Rattner* (exhibition catalogue), Whitney Museum of American Art, 1959, repr. p. 49.
3. Baur, p. 46, and Frank Getlein, *Abraham Rattner* (New York: Kennedy Galleries, Inc., 1969), p. 11.

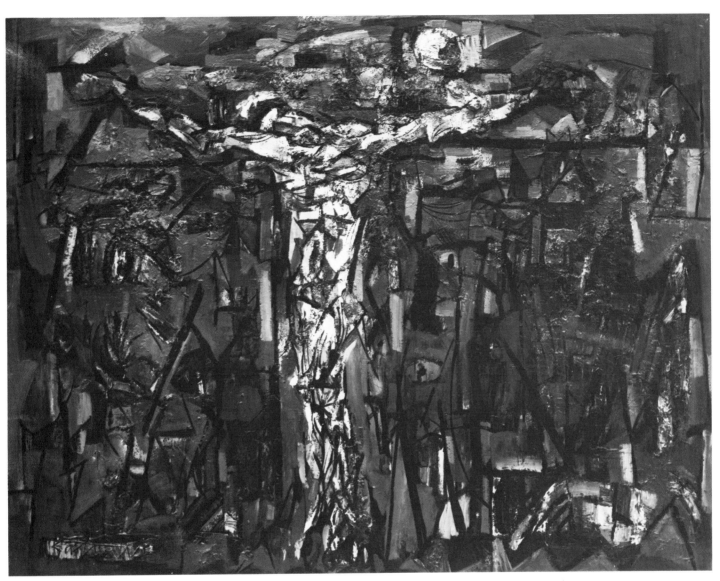

47

fig. 1 Abraham Rattner, *Crucifixion*. Reproduced by permission of Des Moines Art Center, James D. Edmundson Fund, 1952.

Exhibitions

N.Y., The American Federation of Arts, *God and Man in Art,* circulated March 1958–March 1959, no. 9 (as *Cruxifixion in Blue*), lent by Downtown Gallery.

SBMA, *Two Hundred Years,* 1961, no. 175.

Missouri, City Art Museum of St. Louis, *Ecclesiastical Art,* Oct. 9–Nov. 1, 1963, cat. (copies of the catalogue have not been found; according to a letter of Dec. 1, 1964, from Charles E. Buckley: "The Church Federation was in charge of catalogues . . . and the few that were available were given away and quickly disappeared").

Los Angeles, Loyola Marymount University Art Gallery, *Faces of Jesus,* Nov. 28–Dec. 20, 1978, no. 37, mentioned in text, n.p.

References

Allen Leepa, *Abraham Rattner* (New York: Harry N. Abrams, Inc., 1974), repr. p. 161, Pl. 134.

Karl Knaths
1891-1971

Born in Eau Claire, Wisconsin, in 1891, Karl Knaths attended commercial art school in 1909 and studied at the Art Institute of Chicago from 1912 to 1916. During this period, the Armory Show of 1913, particularly the work of Cézanne, dramatically affected Knaths's aesthetics. Characteristic of the first generation of American modernists, Knaths felt free to select from a variety of modern styles. In addition to Cézanne, Braque and the other Cubists were important to him. His painting theory developed from an extensive knowledge of the works and writings of Klee, Mondrian, Kandinsky, and Severini. Although Knaths never visited Europe, an unusual phenomenon among this first group of modernists, his need for exposure to European ideas was satisfied through reading and the accounts of other artists who had traveled there.

Intensely private and independent, Knaths spent the better part of every year beginning in 1919 in Provincetown, Massachusetts. This environment, with its community of artists and natural beauty, allowed him to work undistracted and to lead the simple life he desired.

In 1926, Duncan Phillips bought the first painting Knaths ever sold, initiating a lifelong friendship and professional association that included Knaths's teaching every winter between 1938 and 1950 at the Phillips Gallery in Washington, D.C. Knaths joined the New York gallery of Paul Rosenberg in 1945, which, representing him until his death in 1971, gave him twenty-two one-man shows. During the 1950s and 1960s, Knaths was the recipient of numerous honors, prizes, and retrospective exhibitions.

Melinda Lorenz

Violin

Violin, painted in 1959 during his most abstract period, expresses Knaths's primary concern for balancing pure, pictorial design and recognizable subject matter. Within the abstract linear network of *Violin* are present the essential shapes and rhythms of the instrument. The exceptional degree of abstraction in the painting corresponds to his other work from the late 1950s. Indeed, 1959 was the apex of his abstract tendency, which increased during the decade of Abstract Expressionism. Although not associated with its artists, Knaths shared their intuitive, even mystical response to natural phenomena conveyed through autographic, pictorial abstraction.[1] Like many Abstract Expressionists, he combined Cubist linear structure with a painterly approach to pigment and color. He remained, however, more concerned with traditional subject matter, such as still life and landscape, and with a smaller format.

Music, both as subject matter and compositional theory, played an important role in Knaths's life and painting. His wife, Helen Weinrich, was a pianist, and her grandfather was a violinist. Many evenings at home were spent making and listening to music. While on the WPA between 1934 and 1935, Knaths painted a mural illustrating the history of music, including the development of the instruments. Beginning in the 1930s, the violin became a recurring image in his still-life paintings and was consistently presented resting upright on its side on a tabletop. Often accompanying the violin was a bottle and a piece of fruit, both seen in the Santa Barbara painting (above the scroll and below the middle of the violin, respectively).

48 Violin

1959
Oil on canvas
24 x 48 in. (61 x 121.9 cm)
Signed u.r.: Karl Knaths
Inscribed by the artist in pencil on reverse of right half of upper member stretcher bar: Shiva Rembrambt [sic] windsor [sic] newton oil colors/not varnished — if needed use only thinned mat [sic] varnish
Inscribed and dated in black crayon on reverse of left half of upper stretcher member:
KARL-KNATHS-P-TOWN-1959-24 x 48
Gift of Mrs. Sterling Morton
60.59

Provenance

(Acquired from the artist by Paul Rosenberg and Co., N.Y., 1959); purchased from Rosenberg by Mrs. Sterling Morton for the PMC, 1960.

Condition and Technique

In 1979 examination by the BACC noted some slight traction crackle in the dark c.l. The overall condition was good.

The medium-weight, loosely woven, plain weave fabric is covered with a thin white ground, visible in many areas, that allows the fabric texture to show through. The paint, an oil type (according to artist's writing on reverse of stretcher: Shiva, Rembrandt, Winsor, Newton oil paints) varies from a very thin, matt application to some low dry impasto.

Believing that there were measurable correspondences between musical intervals and spatial proportions, Knaths developed a chart showing musical ratios in graphic form, as numbered lines radiating from a common center. In composing a picture, he used these ratios to determine the major directional lines and spatial proportions.

Color intervals and relationships were also precisely selected from color charts. In 1959, he used a color system from the dye industry based on Wilhelm Ostwald's classification of thirty-seven colors with about twenty-eight hues each, amounting to almost a thousand hues on separate, removable metal chips. For each painting, Knaths mixed the pigments to match the colors selected from this system and strictly adhered to its logic, never varying the preselected colors while painting. He felt that this method provided certain and unique chromatic harmony in each work, since he never duplicated his selection of hues or pigments from one painting to the next. "Systems are only bricks and lumber — of themselves they cannot encompass the immeasurable spiritual qualities that go into a successful picture."[2]

After having mixed his colors and measured his proportions, Knaths often began a painting by placing a rectangle on the left side of the composition, balancing it with other rectangular elements. This approach is evident in *Violin,* in which rectilinear, spatial intervals underlie an open network of gestural lines and scumbled patches of paint. The large rectangle at the left may represent a window through which buildings are visible. Literal transparency is evident where outlines of former shapes show through the overpainting, adding to the linear complexity and surface richness. Unusual color tonalities of gold, umber, and lavender evoke a subdued mood of resonant intensity, suggesting the memory of languid echoes rather than acute awareness of actual music.

Incorporating an underlying rectilinear structure, precise proportional and color relationships, painterly surface, and subtle color modulations, Knaths achieved a synthesis of repeatable method and personal expression. His work becomes a modern fusion of classical construction and romantic inventiveness and lyricism.

Melinda Lorenz

Notes

1. Knaths stated: "If I have been concerned with the purely plastic problems of painting it is because I hoped that through a better understanding of pictorial composition I could bring out what I felt in living." Quoted in Paul Mocsanyi, *Karl Knaths,* The Phillips Gallery, 1957, p. 45.

2. Lloyd Goodrich, "Karl Knaths," *Four American Expressionists: Doris Caesar, Chaim Gross, Karl Knaths, Abraham Rattner* (exhibition catalogue), Whitney Museum of American Art, 1959, p. 18.

Exhibitions

SBMA, *Two Hundred Years,* 1961, no. 103, mentioned "Introduction," n.p.

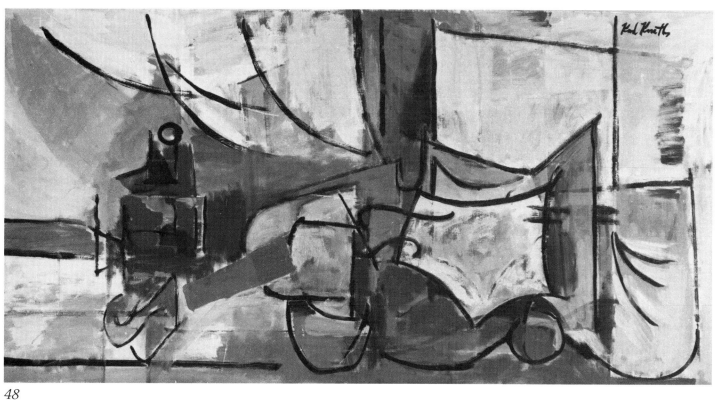

48

Appendix

As a result in part of work on the present catalogue, the attributions formerly carried by two paintings in the Preston Morton Collection have been called into question. One of them, *The Greeks' Departure from Troy*, as it had been previously titled, may definitely be removed from its position — one that was never secure — in the oeuvre of Thomas Cole. The other, acquired with the title, *The Baby Carriage*, and an Eastman Johnson attribution, is a copy, but whether it is a copy by the American artist or by another nineteenth-century hand, possibly a French one, remains as yet unanswered. Since both works are "authentic" as to their period, the nineteenth century, and since the problems both of them raise are of substantial interest, it was decided to include them, unattributed as they are at the present moment, in the catalogue. They are, moreover, in their different ways, both works of considerable charm. Since, however, not only their authorship but also their nationality is being questioned, their placement in an appendix seemed appropriate. The possibility exists that their presence in the Preston Morton Collection, one devoted exclusively to American art, may be somewhat of an anomaly, as the presentations that follow indicate.

The editor is grateful to Professors Corlette Walker and Patricia Hills for their willingness to pursue the problems surrounding the two paintings, the so-called Cole and Johnson respectively, even though neither one of them believed they would be able to provide definitive answers. It was our shared opinion, however, that stating the problems was a necessary step and one which we hoped would lead to further scholarly discussion and thereby contribute to the knowledge of nineteenth-century painting in this country and abroad.

Editor's Note

Unknown Artist

The Embarcation of Regulus

At the time of its acquisition for the Preston Morton Collection, the painting was attributed to Thomas Cole and entitled *The Greeks' Departure from Troy*. The dealer from whom it was acquired, James Coats, was unable to give any information on its provenance beyond the fact that a sketch for it had been seen on the art market in New York around the time that it was purchased. The attribution to Thomas Cole no doubt came about because, in America at least, classical scenes such as this were associated with his name, and the painting had a superficial resemblance to Cole's *Course of Empire: Destruction* (1830–1833) in the New York Historical Society. This is the view of Howard Merritt, the Cole scholar, who, while he felt the Cole attribution does not hold up, could not say who he thought might have painted it.[1] The chances of discovering exactly who did this work are very slim, and one would have to discover another work by the same hand in order to make the attribution a firm one. If the work had resembled a known Cole in both composition and subject matter, it might have been possible to call this painting "follower of," as was the case in a recent discovery of a Cole follower by M. Betty Blum discussed in the February 1981 issue of *Antiques*.[2] The Santa Barbara painting does not, however, conform directly to any known Thomas Cole in either subject or style.

Certainly the style of this painting does not resemble that of the two paintings *Consummation of Empire* and *Destruction* from *The Course of Empire Series* or that of Cole's other architectural masterpiece *The Architect's Dream* (The Toledo Museum of Art). As exemplified in these works, Cole's perspective in most of his architectural paintings is on eye level. Where he used the downward-looking or panoramic view, as in *The Ox Bow* (1836, The Metropolitan Museum of Art) or *View of Florence from San Miniato* (1837, Cleveland Museum of Art), the intention seems to be definitely topographical rather than imaginary or historical. In his historical works Cole never combined this downward-looking view with architecture as the *repoussoir* framing the central prospect — a device often used in English painting of the period. More telling, however, is the incorrect, almost naive perspective drawing of the architecture. The disparity between the two sides suggests that the artist has used an engraving, perhaps more than one, for his painting. The hard, linear character of the treatment of the architecture contrasts with that of the foliage and the distant city, once again suggesting a multiple origin for the composition. This method of working from engravings was, of course, standard practice in America, since there were relatively few academies or exhibitions where the artist might have painted from his imagination or copied. Even such elements as the *staffage* are difficult to place stylistically, as in the early nineteenth century there were many drawing manuals that printed examples of *staffage* for every type of painting.

The work is an attractive painting done in the genre of historical landscape, a genre popular in both England and America in the 1830s, when this painting was probably painted. A date around this period is supported by the conservation report on the analysis of the pigments in the painting. The presence of chrome yellow, which was found in several areas of the painting, means that it cannot have been done before 1818, when the pigment became available to artists. Furthermore, the presence in the painting of smalt, the earliest of the blue cobalt pigments, the use of which was discontinued by most artists in the early nineteenth century, would indicate that the painting cannot be much later than the mid-1830s. These physical facts conform generally with the style of the painting and indicate that it is contemporary with the work of Thomas Cole.

49 The Embarcation of Regulus
(previously attributed to Thomas Cole and titled *The Greeks' Departure from Troy*)
Oil on canvas
22⅜ x 30 in. (57.5 x 76.2 cm)
Not signed or dated
Gift of Mrs. Suzette Morton Zurcher
60.32

Provenance

Early history unknown; (James Coats); purchased from Coats by Mrs. Suzette Morton Zurcher for the PMC, 1960.

Condition and Technique

In 1960 upon its acquisition by the SBMA the painting was given a light cleaning and varnished.

In 1978 and 1979 examination by the BACC noted the painting had been lined with an aqueous adhesive and the tacking margins of the support cut. Both the lining and support fabrics were fragile. The paint had suffered one loss caused by abrasion from the vertical side of the rabbet ca. 1 in. from the bottom corner on the r. side. There was a fine pattern of crackle and an area of discolored overpaint over the fracture crackle in the sky to the l. of the tree branches. In 1979 the BACC, using a stereo microscope, took minute samples of paint in seven representative color areas for purposes of pigment analysis (see *Summary and Discussion of Pigment Analysis* following).

In 1980 the painting was treated by the BACC. The old lining fabric was removed. The painting and new lining fabric were infused with Ross Wax. The vacuum pressure on the hot table was pulled up to 4" Hg, temperature to 145° F and immediately cooled down. Losses were filled with pigment wax putty, and inpainting was done with dry pigments hand ground in Acryloid B72. Two spray coats of Acryloid B72, 10% in xylene were applied as final protective surface coating. The painting was subsequently returned to the BACC to correct blistered varnish. After blisters had been flattened, three spray coats of Acryloid B72, 10% in xylene were applied.

The support consists of a fine- to medium-weight, plain and single-threaded fabric. The ground, creamy beige-white in color, is of medium thickness and smoothly applied. The pencil lines outlining the architecture are visible around some of the buildings. The paint ranges from a rich vehicular paste to pigmented pellicular glazes and is

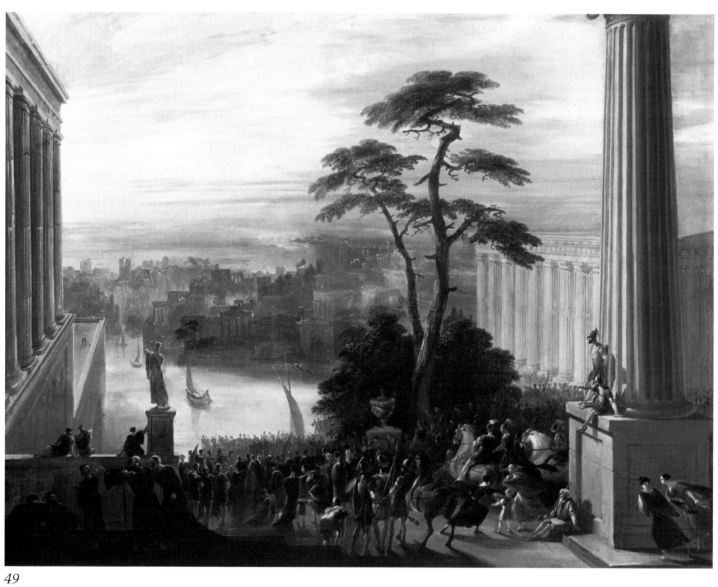

49

Although documentable attribution of this painting either as to school or to any other known artist may escape solution, this does not mean that we cannot discover more about it than is now known. Thomas Cole was not the only painter to work in this genre. Indeed, in both England and America many artists, both known and unknown, painted similar paintings, and these works were often engraved. When I first examined this painting, it suggested certain embarcation scenes done by J. M. W. Turner, the greatest English painter of this era and one of the creators of this type of landscape. In a recent telephone conversation with Andrew Wilton, the Keeper in charge of the Turner Bequest at the British Museum, Mr. Wilton disagreed with me. He said that undoubtedly the Santa Barbara artist had had Claude Lorraine in mind. This great seventeenth-century French landscape painter had a resurgence of influence in early nineteenth-century Great Britain. The appearance in this period of the Angerstein Claudes — *The Embarcation of the Queen of Sheba*, and *The Embarcation of St. Ursula*, both in the National Gallery, London — stimulated Turner's competitive spirit, and he painted a series of Claudian seaports related to his own *Destruction of the Carthaginian Empire* (Tate Gallery). The painter of the Santa Barbara painting, however, need not have emulated Turner. The taste for Claude could have provided sufficient motivation for him to paint his own version of an embarcation. Dr. Wilton felt, furthermore, that even though the background of the city in the sunset had vague Turneresque qualities, the hard finish of the architecture and the tight handling of the tree in the foreground were characteristic of much early nineteenth-century American painting. Dr. Wilton did, however, suggest a resemblance between this work and those of a contemporary English artist, Samuel Colman (work 1816–1840), a member of the provincial Bristol school. It is true that a work such as *The Temple of Flor* (Tate Gallery)[3] shows certain similarities to the Santa Barbara picture in its slightly askew architecture and in the style and treatment of the figures. Colman was noted for his eclecticism, and it is known that he took his treatment of trees from several sources, so the fact that the foliage in the Santa Barbara painting does not resemble Colman's need not be significant. English provincial art shared some of the characteristics of the American school in its lack of sophistication and its hard linear style. It should be noted that there is nothing strange in a painting of the Bristol school being thought of as American, as there was a strong connection between this city and American painting in the early nineteenth century. In the decades just before this work was painted, both Washington Allston and Samuel Morse had been in Bristol — Allston had a one-man show there in 1814. In other words, a traveling American or even an American artist in England might have viewed Bristol art favorably, or a Bristol painting might have been purchased and brought back to America.

Whether the style and conception of this work are English or American can only be a matter of speculation, but the subject of the work, again according to Dr. Wilton, cannot have been *The Greeks' Departure from Troy*. He pointed out that if indeed the painting depicted the victorious Greeks leaving Troy, the city would have been in flames, the population dying and enslaved. The activity in this painting does not seem to suggest a disaster of this magnitude. The horsemen, the figures reclining against the column, the crowds watching the ships leave the harbor suggest rather a festive occasion, filled with excitement, even anxiety but not the ravages of war. I wondered if the painting might not portray a scene from the beginning of the Trojan War — *The Embarcation of the Greeks for Troy*. The fact, however, that there are no prototypes for this subject has led me to accept another suggestion of Dr. Wilton's — that this is another embarcation scene that was well known at the time. This is the subject of Turner's *Embarcation of Regulus* (painted in 1828 as

generally applied with fine brushstrokes, and there is fine low impasto in all the highlights.

Summary and Discussion of Pigment Analysis, BACC, May 1979

Minute samples taken from this painting were analyzed under the polarizing light microscope. Among the pigments present, several are interesting, and one is very important in answering the question of whether the painting was executed in the nineteenth or the twentieth century.

Coloring materials from animal, vegetable, and mineral sources were sought by man as early as remote prehistoric times. Many were easily procured, and among these some were found suitable for making pictures and have found constant use from ancient times to the present. Most of the pigments used in this painting are of this type, such as vermilion, yellow and brown iron oxides, organic red lake, and bone black.

Artificial pigments came to be made almost from the beginning of written history. Lead white was known in ancient times and was one of the first artificially produced pigments. Another example from this painting, Prussian blue, is interesting because it is the first of the artificial pigments with an established date of first preparation. Prussian blue was first made in Berlin in 1704 by a dyer and color maker named Diesbach. It is still in use today.

Since it has been documented that chrome yellow, which is present in several areas of this painting, was not available to artists until 1818, the painting cannot have been created before this time. The positive identification of another pigment, smalt, is even more critical. Smalt was the earliest of the blue cobalt pigments, made by reducing to a powder a potash silicate strongly colored with cobalt oxide. Its origin is obscure, but its use in European painting has not been documented prior to 1475, although it may have been used earlier to color molten glass. Such early occurrences are rare, however, and smalt seems to have had its general beginnings as a painter's pigment by the middle to late sixteenth century. It is generally agreed that the use of smalt as an artist's pigment was discontinued around the beginning of the nineteenth century, because of its several shortcomings and because its place was taken by the more satisfactory cobalt aluminate (cobalt blue) and by artificial ultramarine.

Smalt can be recognized easily by its characteristic microscopic appearance, and its presence in this painting in original layers of paint, together

part of his series on the destruction of Carthage, Tate Gallery). Instead of Troy, Regulus is leaving Carthage for his native Rome. Subjects from the Punic Wars were popular with both Englishmen and Americans during this period. Identification by them with the struggle between the Romans and the Carthaginians was suggested by the long struggle between the French and the English, which had only ended in 1815. John Vanderlyn, an American painter, won a gold medal at the Paris Salon in 1807 for his *Marius in the Ruins of Carthage* — a subject also done by Benjamin West. Regulus, like Marius, represented an *exemplum virtutis*, a virtuous example. Marcus Atilius Regulus was a Roman general and Consul in the first Punic war, 256 B.C. Captured by the Carthaginians, he was imprisoned for five years. At last, after a Carthaginian defeat, he was sent on his parole to negotiate peace and an exchange of prisoners. On his arrival in Rome, he urged the Senate to refuse both proposals. He kept his word and returned to Carthage, to a terrible death by torture. As in the Turner painting, which was engraved with the title *Ancient Carthage, the Embarcation of Regulus*, we see the same reference to the Claudian seaport viewed in the setting sun. In both paintings, agitated crowds on the shore watch the ships depart. As in most historical landscapes, the figures are too small to tell us much about the story, and there has been argument about the whereabouts of Regulus in the Turner painting. Likewise in the Santa Barbara painting there does not seem to be a figure that could be identified as Regulus. But as Dr. Wilton has written in his recent monograph on Turner,[4] Turner (and historical landscape painters in general) suggested the content of the painting through the unifying effects of light. Although less dazzling and overwhelming than in the Turner, light in the Santa Barbara painting is the element that draws together all the disparate details — the ancient city suffused in sunset light, the milling figures, the ships setting out on some high, noble quest.

In conclusion, while we can propose with reasonable certainty that the painting was executed ca. 1830, and that its probable subject is *The Embarcation of Regulus*, we cannot be certain whether it is British or American. Although it resembles the work of the Bristol painter Samuel Colman, the likelihood nonetheless exists that it is American, painted by someone acquainted with the Bristol school or with engravings of works by the Bristol school.[5] It may be a unique conception, or it may be a pastiche garnered from several works. Neither a copy after nor a pastiche of Turner, it falls nonetheless into the general sphere of influence of the British school of Turner, John Martin, and Francis Danby, into what is nowadays often called the School of Cataclysmic Sublime. Thomas Cole himself was influenced by this school in England, but on his return to America, Cole and the Sublime landscapists who came after him transformed the traditional literary subject matter of Greco-Roman history into a uniquely American subject. In Cole's *Course of Empire* the savage state and the wilderness bracket the scenes of civilization. The artist of this painting has not sought a uniquely American point of view, and, like the Groombridge painting (cat. no. 5), this work is more allied with English taste than American.

Corlette Walker

with chrome yellow, clearly establishes a very strong probability that the painting was created sometime after 1818 but early in the nineteenth century.

Notes

1. Letter from Howard Merritt to editor, 6 Sept. 1977.
2. Collector's notes, ed. by Karen Jones, "Charles Baker, painter 'after Cole,'" *Antiques*, CXIX, (Feb. 1981).
3. *The Bristol School of Artists: Francis Danby and Paintings in Bristol 1810–1840* (exhibition catalogue), City Art Gallery, Bristol, 1973.
4. Andrew Wilton, *J. M. W. Turner, His Art and Life* (New York: Rizzoli, 1979).
5. There were one or two other American artists who painted historical landscapes in the 1830s. Thomas Doughty comes to mind, with such a painting as *Romantic Landscape with a Temple* (1834, Museum of Fine Arts, Boston). Doughty's landscape tended, however, more to what Joseph Burke, the author of *English Art 1714–1800*, has called "modesty of nature" picturesque, while the Santa Barbara painting falls more easily into his definition of the "grand picturesque" or the Sublime. For this reason I hesitate to associate him and the other American landscapists working in this genre in the 1830s with this painting.

Exhibitions

SBMA, *Two Hundred Years*, 1961, no. 22 (as *The Greeks' Departure from Troy*, by Thomas Cole), mentioned "Introduction," n.p.
Florida, St. Petersburg, Museum of Fine Arts, *Inaugural Exhibition*, Feb. 7–March 7, 1965, no. 11 (as *The Greeks' Departure from Troy*, by Thomas Cole).
Calif., Oakland Museum, *Art Treasures in California*, Nov. 29–Dec. 31, 1969 (no cat.).

Unknown Artist

In July 1980 I asked Patricia Hills if she would write the essay on the painting that had come to the Santa Barbara Museum of Art in 1960 with the title *The Baby Carriage* and that ever since its acquisition had been displayed and lent in all good faith as by Eastman Johnson. Professor Hills agreed to tackle the assignment despite reservations she had about the painting, which, as I recall her saying, she found "puzzling."

One key to the puzzle, which neither Hills nor I could foresee, rested in the damage the painting had received in the summer of 1976 when it had been vandalized with a blunt instrument and most of the plant in the lower right section, scarred down to the canvas, had been destroyed (see Condition, fig. a). Sent to The Conservation Center of the Los Angeles County Museum of Art, the painting was found to have at an unknown date been folded over its present stretcher for a width of about three inches on all four sides. Despite severe losses suffered by the folded edges, it was decided to open up the composition fully to its extant size. Enough remained of the paint surface along the edges to allow for some discreet inpainting, which although not aesthetically distracting, was kept clearly evident to the naked eye. Since the painting presented an interesting example of conservation work, before and after conservation photographs of the painting were featured in the Santa Barbara Museum of Art's *Annual Report* of 1979.

On November 12, 1980, Carol Taylor, wife of a Santa Barbara Museum trustee, passed on to me information Richard Wattenmaker had included in a recent letter to her. Wattenmaker wrote:

> The enclosed photographs are of a painting by Jules Breton, *Le Départ pour les champs*, dated 1857, 25 x 37", which was recently on the market in London. . . . Your museum has a canvas entitled *The Baby Carriage* which is a direct copy of the Breton. I saw it reproduced in your 1979 *Annual Report*. What a coincidence.

Knowledge of the Breton was in turn immediately communicated by me to Patricia Hills who has submitted the report that follows.

Editor's Note

Copy after *Le Départ pour les champs*

TO: Preston Morton Catalogue, Santa Barbara Museum of Art

FROM: Patricia Hills

RE: *The Baby Carriage*, attributed to Eastman Johnson

Because of the nature of my conclusions, I cannot write a scholarly essay on the painting, as requested by Katherine Mead in her letter to me of July 28, 1980. Instead I submit the following report.

I. *Background*

 A. *Provenance*

 The painting was purchased by Mrs. Preston Morton from Hirschl & Adler Galleries, New York, in 1960. At the time the painting was passed among three galleries — Hirschl & Adler, Knoedler, and Kennedy Galleries — all three might have owned it together.[1] I made inquiries at all three

50 Copy after Jules Breton, *Le Départ pour les champs*

(The painting was previously considered an original composition by Eastman Johnson and titled *The Baby Carriage*)
(The Breton painting is dated 1857, oil on canvas, 25 x 37 in. (27.5 x 94 cm))
Oil on canvas
23⅜ x 33⅞ in. (63.5 x 86 cm) after restoration
20 x 30 in. (50.8 x 76.2 cm) before restoration
Not signed or dated
Gift of Mrs. Sterling Morton
60.87

Provenance

 Joseph Friedman Collection, N.Y. (according to information provided by Hirschl & Adler at the time of the SBMA acquisition); (held jointly by Knoedler, Kennedy Galleries, and Hirschl & Adler, purchase of Oct. 1958); purchased from Hirschl & Adler by Mrs. Sterling Morton for the PMC, 1960.

Condition

 In the summer of 1976, the painting was vandalized with a blunt instrument, possibly a pencil. A portion of the paint surface and ground of the flowering plant in the l.r. section was destroyed and the canvas suffered a puncture in this area (fig. a).

 In Aug. 1976 the painting was sent to the LACMA Conservation Center. Examination noted the painting had been glue-lined and pressed hard in the lining process. Besides the damage incurred by the vandalism, a vertical scratch was noted near the right edge just below the center. The painted

fig. a

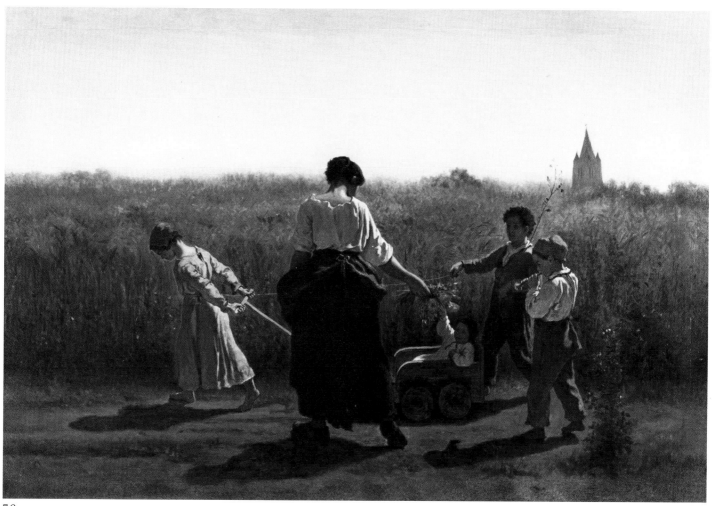

50

Le Départ pour les champs, Jules Breton.
Courtesy of Richard Green, London.

galleries and discovered that it was Rudolf Wunderlich of Kennedy who first bought the painting in 1958. Cynthia Seibels, the present Librarian, wrote to me on December 11, 1980:

> In regard to the painting "The Baby Carriage," by Eastman Johnson, . . . Rudy Wunderlich . . . recalled that our source for the painting, Joseph Friedman, had some connection with the Johnson family, either as a descendant of Eastman Johnson or a friend of the family.
>
> The picture was acquired from Mr. Friedman together with "The Wounded Drummer Boy," which is now in the collection of Mrs. McCook Knox, and a third painting by Johnson, the title of which Mr. Wunderlich was unable to recall.
>
> Unfortunately, our files contain no documentary material on any of these works. I hope that this vague information [is] helpful to you.

I have been unable to find a Mr. Joseph Friedman, nor do my own Eastman Johnson records reveal what the third painting might have been. I have also spoken with John I. H. Baur, who made the first extensive study of Johnson's work in the late 1930s, and who does not recall the name of Joseph Friedman.

B. *Examination*

In the spring of 1975 I visited the Santa Barbara Museum of Art and was shown the painting in the storeroom. I recall noting to myself that the style was very similar to Eastman Johnson's paintings of the early 1870s, particularly the way the light fell along the shoulders and arms of the woman and the children. (Note the similarity to the studies for *The Cranberry Harvest*.) Moreover, the general sensibility — "cute" children playing "horse" and "coachman" was certainly similar to Eastman Johnson's *The Old Stage Coach*. However, the clothing of the figures and the landscape clearly locates the scene in Europe, and I know of no other oil painting by Johnson of European figures in an outdoor setting.

II. *New Information: The appearance of Jules Breton's signed and dated 1857 painting titled* Le Départ pour les champs.

The appearance of this painting on the European art market (dealer: Richard Green, 44 Dover Street, London W1X4JQ) casts new doubts as to the Johnson attribution of the Santa Barbara painting. Both the transparency and the photograph were sent to me by Katherine H. Mead on November 14, 1980. The Green painting, according to the caption on the transparency, measures 25 x 37 inches, whereas the Santa Barbara painting measures 23⅜ x 33⅞ inches. However, there still seem to be several inches around the perimeter of the main scene on the Green painting which are not there on the Santa Barbara work.[2] My guess is that the figures themselves probably measure the same size in each.[3] One is perhaps a fairly exact copy of the other with minor deviations. I would suggest that the Santa Barbara painting is the copy since there is a certain mechanical quality to passages in the painting compared to the Green painting. Note the stalks of wheat behind the figures: the Green painting shows the stalks bending to the right and left with flecks of paint suggesting a variety of grasses, whereas the Santa Barbara painting treats the same area mechanically. Also, in the Santa Barbara painting, the grass and plants along the bottom edge seem to be missing (perhaps overcleaning or the artist-copiest made the decision not to include these details).[4] Also, in the Santa Barbara painting the distant church seems not to be rendered as faithfully as in the Green painting.

III. *Options regarding the attributions:*

1. *Both by Breton*
2. *Copy by Johnson after Breton*
3. *Copy by someone else after Breton*
4. *Both by Johnson*
5. *Copy by Johnson after someone else*
6. *Copy by someone else after Johnson*
7. *Neither by Johnson nor Breton*

264

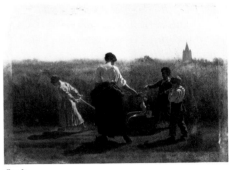

fig. b

edges at an unknown date had been folded over the present stretcher bars twice and stapled, i.e., at the obverse and reverse edges of the bars. Extensive paint loss had occurred along the edges. Beneath the moderately discolored natural resin varnish, there was a second, hard-resin or oil layer (possibly an original rubbed-in-oil coating), which had discolored significantly. This second layer had also collected some dirt, augmenting its dulling effect. Ultraviolet examination clearly revealed a few areas of scattered retouching, mostly along the edges.

In 1978 treatment on the painting was completed by the LACMA Conservation Center. The old discolored varnish was removed with acetone and the old overpaint partly scraped off. The two rows of staples that held the painting to the stretcher were removed. The painting was stretched to a strainer in the Dutch method with brown paper (fig. b). The old glue lining was removed. A new linen was inserted to the area of loss in the l.r. The painting was lined on a vacuum hot table with wax resin and attached to a new expansion-bolt stretcher. Losses were filled with colored wax gesso and the fills smoothed and also structured with linen. More overpaint and the disfiguring linseed oil film were removed with dimethyl formamide. Inpainting was done with Magna Acrylic colors. Several spray coats of Acryloid B72 were applied to the surface.

Option 1—Both by Breton

After discussing the problem with Albert Boime at the University of California, Los Angeles, and T. J. Clark of Harvard University, and at their suggestion, I telephoned and then mailed both transparencies and black and white photographs to Gabriel P. Weisberg, Curator of Art History & Education at the Cleveland Museum of Art. On November 27, 1980, Weisberg wrote to me as follows:

> There are several aspects that need consideration. First, Jules Breton was often capable and able of completing replicas of a whole composition or figures from larger compositions. These were often done throughout his career as he returned to an image or theme which had proven popular. However, Breton almost invariably signed all his works (even replicas) and the fact that the Santa Barbara work is unsigned makes one wonder whether it was a work by Jules himself lessening the possibility of a replica theory.
>
> Second, the more mechanical quality of the Santa Barbara version (as you note) does suggest another hand and indeed another artist but would that artist necessarily be Eastman Johnson? Jules Breton did have a daughter who painted (Virginie) and a brother (Emile) although it is unknown whether they ever exactly copied a work by Jules. It could be another possibility and one very difficult to pursue since their works are lost or hidden.
>
> Third, the fact that the Jules Breton painting has just surfaced (after many years of obscurity) on the art market is difficult to decipher. The London art dealer, whom I questioned about this work in Paris (where the work was shown in October) refused to disclose any provenance other than saying the work had come from a very small private English collection. The work may be Breton's lost *Return from the Fields* although likely it is an unknown work not exhibited at the Paris Salons and possibly done for private consumption in England in the 1850s.

When I spoke with Weisberg on the telephone he gave me no reason to believe that the Green painting was not by Jules Breton. But were the signature and date placed on the painting by Breton in 1857?[5]

Option 2—Copy by Johnson after Breton

Weisberg continued his letter as follows:

> Since Eastman Johnson did work in Paris in the late 1850s, and this painting could have been available, the possibility of a relationship is indeed there as it is in some other early Bretons. It would be interesting to see if you could trace the attribution of the Santa Barbara painting back to see who gave it first to Eastman Johnson.
>
> The qualities of light found in early Eastman Johnson compositions and those of early paintings by Jules Breton do suggest something further. Since Breton was an emerging, well-known young painter of rustic life in Paris his fame may have led Eastman Johnson to seek him out. I shall inquire from the Breton descendants, with whom I am preparing a book on Breton, whether they know of any letters between Jules Breton and Eastman Johnson which could cement this relationship further than on the visual possibilities we have before us.

Certainly the stylistic qualities — the light falling along the sides of the figures, the face of the boy holding the reins, the relationship of the underpainting to the final touches, and the outlining around the figures — suggest the Eastman Johnson possibility. As we know, in the early 1850s Johnson made a copy after Leutze's *Washington Crossing the Delaware*, a copy well documented in the nineteenth-century literature. (See my 1973 PhD Dissertation, published by Garland Publishing Company in 1977, *The Genre Painting of Eastman Johnson: The Sources and Development of His Style and Themes.*)

Option 3—Copy by someone else after Breton

Aside from the stylistic similarities, a strong argument could be made that the Santa Barbara painting was done by someone other than Johnson. The Breton painting is dated 1857. According to my records, Johnson went to Paris in the spring or early summer of 1855 to study with Couture. In the fall of 1855 he abruptly left Paris to return to America because of the death of his mother. He returned to the family home in Washington, D.C. In the summers of 1856 and 1857 he spent time with his sister in Duluth, painting portraits and the Chippewa Indians. He seems to have moved to New York in

April 1858; his name appears on the rent rolls of the University Building for that month.

If Johnson painted the copy, he either: (1) would have copied it in the fall of 1855 while he was still in Paris, or (2) painted it much later, assuming that the painting was later available for him to paint.

Arguing that he copied it in 1855 means that Breton would have painted his work in 1855 or before, given it to Johnson to copy and then in 1857 signed it. That somehow seems unlikely to me, although I do not know Breton's habits for signing his paintings. The next option is that Johnson somehow got hold of the painting and copied it some time after 1857. This would mean that the Breton painting came to America for Johnson to copy, or that Johnson copied it on a subsequent trip to Europe. I know of no copies so exact as this which were done by Johnson after another painter after the 1850s.

Even though Wunderlich of Kennedy Galleries recalls that all three paintings coming from Joseph Friedman were by Johnson, there are many instances when such circumstances do not make for such facts. On the visual evidence, one can understand why in 1960 — before we knew much of Breton or French academic painting — Wunderlich would not have questioned the Johnson attribution.

Option 4—Both by Johnson

Johnson often made very exact copies of his own work, but always the copy (or what seems to be the copy) has the same mechanical quality in the "unimportant" passages, as we see in the Santa Barbara painting. (Note the two versions of *The Peep*.) However, I cannot find any mention of paintings such as these French scenes in my records of Johnson. Nor can I speculate as to why he would have painted not one, but two paintings of such a subject.

Options 5, 6 and 7

Although these, too, seem to be possibilities, it seems fruitless to pursue them at this time.

IV. My Conclusion

As of this moment I cannot marshall enough evidence to give a solid Johnson attribution to the Santa Barbara painting. If indeed the Green painting was painted in 1857 by Breton, I cannot speculate that Johnson made such an exact painting after that date. By 1859, when he had painted and exhibited *Life at the South (Old Kentucky Home)*, he was just too much of a major figure in American genre painting to have made such an exact copy, although he no doubt admired Breton's work. In my *Eastman Johnson* (the catalogue for the Whitney Museum exhibition, 1972) I noted the similarity of the motif of the standing woman in Breton's *The Weeders* of 1868, with the standing woman in Johnson's *The Cranberry Harvest* of 1880 (Timkin Gallery, San Diego).

Further investigation may lie with determining whether the Green painting is indeed correctly dated. If the Breton were painted earlier, if Joseph Friedman could be found to give more evidence about the Johnson attribution, if we could discover more Johnson copies, then perhaps I could revise my decision.

I realize this is a conservative decision; however, I am a scholar and not a dealer. I prefer an ambiguous attribution, since the evidence is not yet strong enough to support a Johnson attribution. On the other hand, I think the Santa Barbara Museum of Art should keep alive the possibility of its painting being by Eastman Johnson or by another American. I would hope that in the meantime other scholars and myself continue to pursue new clues.

I think that the catalogue entry might read as follows: "Copy after Jules Breton."

Notes

1. According to a letter of Nov. 7, 1980, from M. P. Naud, of Hirschl & Adler, to the editor: "We owned this jointly with both Kennedy and Knoedler, purchasing it in October 1958. We sold it to Mrs. Morton in January 1960. We have no other information on this picture in our records." In a letter of April 27, 1960, Norman Hirschl wrote to Gertrude R. Egner, then registrar at the SBMA: "With regard to the Eastman Johnson, this painting came from the Joseph Friedman Collection in New York. They had been a family of jewelers." (Ed.)
2. As mentioned earlier by the editor and as noted in the condition report, the composition of the SBMA painting had been folded over the stretcher on all four sides and may therefore have been also reduced otherwise in format. (Ed.)
3. The woman in the SBMA painting measures 12¾ in. (32.4 cm) from the heel of her left, forward foot to the top of her hair. (Ed.)
4. The bottom edge, like all three others, suffered severe losses from the folding (see fig. b under Condition), and its present appearance is due in part to inpainting executed by the LACMA Conservation Center. (Ed.)
5. I spoke with Gabriel Weisberg on March 18, 1981, who assured me the signature was authentic (Hills).

Exhibitions

SBMA, *Two Hundred Years*, 1961, no. 41 (as Eastman Johnson, *The Baby Carriage*), repr., mentioned "Introduction," n.p.

San Francisco, Maxwell Galleries, *American Art Since 1850*, Aug. 2–31, 1968, no. 174 (as Eastman Johnson, *The Baby Carriage*).

References

SBMA, *Annual Report*, 1979, repr. p. 36.

Selected Bibliography

Beal, Gifford

Art Students League News, March 1956.

Beal, William, *Gifford Beal Retrospective Exhibition* (catalogue), Phillips Collection, Washington, D.C., 1971.

DuBois, Guy Pène, *Paintings and Watercolors by Gifford Beal* (exhibition catalogue), C. W. Kraushaar Galleries, New York, 1923.

Faulkner, Barry, *Memorial Exhibition of Paintings by Gifford Beal, 1879–1956* (catalogue), American Academy of Arts and Letters, New York, 1957.

Young, Mahonri, *Gifford Beal* (exhibiton catalogue), C. W. Kraushaar Galleries, New York, 1921.

Bellows, George Wesley

Morgan, Charles H., *George Bellows, Painter of America* (New York: Reynal, 1965).

Bierstadt, Albert

Arkelian, Marjorie, *The Kahn Collection of Nineteenth-Century Paintings by Artists in California* (Oakland, Calif.: The Oakland Museum Art Department, 1975).

Baur, John I. H., "American Luminism, A Neglected Aspect of the Realist Movement in Nineteenth-Century American Painting," *Perspectives, U.S.A.*, 9 (Autumn 1954), pp. 90–95.

Bierstadt file, Archives of California Art, Oakland Museum, Oakland, Calif.

Ferbraché, Lewis, *"The Yosemite Valley" by Albert Bierstadt, N.A.* (Oakland, Calif.: The Oakland Art Museum, 1964).

Hendricks, Gordon, *Albert Bierstadt, Painter of the American West* (New York: Harry N. Abrams, Inc., in association with the Amon Carter Museum of Western Art, 1974).

——————, "The First Three Western Journeys of Albert Bierstadt," *The Art Bulletin*, XLVI, no. 3 (Sept. 1964), pp. 334–365.

The John Nicholson Gallery Presents New Acquisitions of American, English and French Paintings (exhibition catalogue), New York, 1959.

Ludlow, Fitz Hugh, *The Heart of the Continent* (New York: Hurd and Houghton, 1870).

Novak, Barbara, *American Painting of the Nineteenth Century: Realism, Idealism, and the American Experience* (New York: Praeger Publications, 1969).

Strong, Donald S., "Albert Bierstadt, Painter of the American West," [book review] *American Art Review*, II, no. 6 (Nov.–Dec. 1975), pp. 132–144.

Tuckerman, Henry R., *Book of the Artists: American Artist Life* (New York: 1867, reprinted by James F. Carr, 1966).

Wilmerding, John, ed., *American Light: The Luminist Movement, 1850–1875* (exhibition catalogue), National Gallery of Art, Washington, D.C., 1980.

Brown, John George

Benjamin, S. G. W., "A Painter of the Streets," *The Magazine of Art*, V (1882), pp. 265–270.

"John G. Brown," *Harper's Weekly*, June 12, 1880, pp. 372–374.

Marshall, James T., Jr., "Brown, John George," in *Dictionary of American Biography*, 1946 ed.

Sheldon, G. W., *American Painters* (New York: D. Appleton Publishers, 1879), pp. 141–144.

Williams, Hermann Warner, Jr., *Mirror to the American Past* (Greenwich, Conn.: New York Graphic Society, 1973), pp. 178–180.

Burchfield, Charles E.

Albright Art Gallery, *Charles Burchfield: A Retrospective Exhibition of Watercolor and Oils, 1916–1943* (catalogue), Buffalo Fine Arts Academy, Buffalo, N.Y., 1944.

Baigell, Matthew, *Charles Burchfield* (New York: Watson-Guptill Publications, 1976).

Baur, John I. H., *Charles Burchfield* (New York: Macmillan Co. for the Whitney Museum of American Art, 1956).

Burchfield, Charles, ed. by Edith H. Jones, *The Drawings of Charles Burchfield* (New York: Praeger Publishers, 1968).

Trovato, Joseph S., *Charles Burchfield: Catalogue of Paintings in Public and Private Collections* (exhibition catalogue), Museum of Art, Munson-Williams-Proctor Institute, Utica, New York, 1970.

Chase, William Merritt

Cortissoz, Royal, *American Artists* (New York: Charles Scribner's Sons, 1923).

Cox, Kenyon, "William M. Chase, Painter," *Harper's Magazine*, LXXVIII (1889), pp. 549–557.

Roof, Katherine Metcalf, *The Life and Art of William Merritt Chase* (New York: Charles Scribner's Sons, 1917).

Story, Ala, *William Merritt Chase* (exhibition catalogue), University Art Galleries, University of California, Santa Barbara, 1964–1965 (with extensive bibliography).

Cole, Thomas

An Exhibition of Paintings by Thomas Cole, N.A., from the Artist's Studio, Catskill, New York (catalogue), Kennedy Galleries, Inc., New York, 1964.

Merritt, Howard S., *Thomas Cole* (exhibition catalogue), University of Rochester, Rochester, N.Y., 1969.

Moore, James C., "Thomas Cole's *The Cross and the World*," *The American Art Journal*, V, no. 2 (Nov. 1973), pp. 50–60.

Noble, Louis L., *The Life and Works of Thomas Cole*, (New York: 1853; ed. by Elliot S. Vessell (Cambridge, Mass.: Belknap Press of Harvard University Press, 1964).

Parry, Ellwood C., *Thomas Cole's "The Course of Empire": A Study in Serial Imagery*, unpublished Ph.D. Dissertation, Yale University, 1970.

Tuckerman, Henry T., *Book of the Artists: American Artist Life* (New York: 1867, reprinted by James F. Carr, 1966).

Wallach, Alan P., *The Ideal American Artist and the Dissenting Tradition: A Study of Thomas Cole's Popular Reputation*, unpublished Ph.D. Dissertation, Columbia University, New York, 1973.

Wilmerding, John, ed., *American Light: The Luminist Movement, 1850–1875* (exhibition catalogue), National Gallery of Art, Washington, D.C., 1980.

Copley, John Singleton

Belknap, Waldron Phoenix, Jr., *American Colonial Painting: Materials for a History* (Cambridge, Mass.: The Belknap Press of Harvard University Press, 1959).

Foote, Henry Wilder, *Robert Feke: Colonial Portrait Painter* (Cambridge, Mass.: Harvard University Press, 1930).

Frankenstein, Alfred, *The World of Copley, 1738–1815* (New York: Time Incorporated, 1970).

Prown, Jules David, *John Singleton Copley*, 2 vols. (Cambridge, Mass.: Harvard University Press, 1966).

Sellers, Charles Coleman, "Mezzotint Prototypes of Colonial Portraiture: A Survey Based on the Research of Waldron Phoenix Belknap, Jr.," *Art Quarterly*, XX (Winter 1957).

Waterhouse, Ellis, *Painting in Britain: 1530 to 1790* (Baltimore: Penguin Books Inc., 1953).

Webster, J. C., *The Journal of Joshua Winslow* (St. John, New Brunswick, 1936).

Wilson, J. G., and J. Fiske, eds., *Appleton's Cyclopaedia of American Biography* (New York: Appleton & Co., 1899).

Cropsey, Jasper Francis

Bermingham, Peter, *Jasper F. Cropsey 1823–1900, A Retrospective View of America's Painter of Autumn* (exhibition catalogue), College Park, University of Maryland Art Gallery, 1968.

Howat, John K., *The Hudson River and Its Painters* (New York: Viking Press, 1972).

Sears, Clara E., *Highlights among the Hudson River Artists* (Port Washington, N.Y.: Kennikat Press, Inc., 1968).

Talbot, William S., *Jasper F. Cropsey 1823–1900* (exhibition catalogue), National Collection of Fine Arts, Smithsonian Institution Press, 1970.

Eakins, Thomas

Burroughs, Alan, "Catalogue of Work by Thomas Eakins, 1869–1916," *The Arts* (June 1924).

Goodrich, Lloyd, *Thomas Eakins: His Life and Work* (New York: Whitney Museum of American Art, 1933).

——————, *Thomas Eakins* (New York: Praeger, 1970).

——————, *Thomas Eakins* (Cambridge, Mass.: Harvard University Press, vols. I & II, 1981; vol. III, catalogue raisonné, forthcoming).

Hendricks, Gordon, *The Life and Work of Thomas Eakins* (New York: Viking, 1974).

McHenry, Margaret, *Thomas Eakins Who Painted* (Privately printed for the Author, in Pennsylvania, 1946).

McKinney, Roland Joseph, *Thomas Eakins* (New York: Crown Publishers, 1942).

Porter, Fairfield, *Thomas Eakins* (New York: George Braziller, 1959).

Rosenzweig, Phyllis D., *The Thomas Eakins Collection of the Hirshhorn Museum and Sculpture Garden* (Washington, D.C.: Smithsonian Institution Press, 1977).

Schendler, Sylvan, *Eakins* (Boston: Little, Brown & Company, 1967).

Siegl, Theodor, *The Thomas Eakins Collection* (Philadelphia Museum of Art, 1978).

Gay, Walter

Allen, Josephine L., "A Memorial Exhibition of Paintings by Walter Gay," *Bulletin of the Metropolitan Museum of Art*, XXXIII (April 1938), pp. 100–102.

Gallatin, Albert E., ed., *Walter Gay: Paintings of French Interiors* (New York: E. P. Dutton & Co., 1920).

Gay, Walter, *Memoirs of Walter Gay* (New York: William Edwin Rudge, 1930).

Gerdts, William H., "The Empty Room," *The Allen Memorial Art Museum Bulletin*, XXXIII, no. 2 (1975–76), pp. 73–88.

Quick, Michael, *American Expatriate Painters of the Late Nineteenth Century* (exhibition catalogue), Dayton Art Institute, Dayton, Ohio, 1976.

Reynolds, Gary A., *Walter Gay: A Retrospective* (exhibition catalogue), Grey Art Gallery and Study Center, New York University, 1980.

Glackens, William

Glackens, Ira, *William Glackens and the Ashcan Group: The Emergence of Realism in American Art* (New York: Crown Publishers, 1957).

William Glackens Memorial Exhibition (exhibition catalogue, New York: Whitney Museum of Art, 1939).

William Glackens in Retrospect (exhibition catalogue, Missouri: City Art Museum of St. Louis, 1966).

Groombridge, William

Dunlap, William, *A History of the Rise and Progress of the Arts of Design in the United States* (1834); ed. by Rita Weiss (New York: Dover Publications, Inc., 1969), vol. II, pt. 1, p. 48.

Pleasants, J. Hall, *Four Late Eighteenth-Century Anglo-American Landscape Painters* (1942; reprint, Worcester, Mass.: American Antiquarian Society, 1943), pp. 31–41.

——————, *Two Hundred and Fifty Years of Painting in Maryland* (exhibition catalogue), Baltimore Museum of Art, 1945, pp. 26ff.

Gullager, Christian

Dresser, Louisa, "Christian Gullager: An Introduction to His Life and Some Representative Examples of His Work," *Art in America*, XXXVII, no. 3 (July 1949).

Sadik, Marvin, *Christian Gullager, Portrait Painter to Federal America* (exhibition catalogue), National Portrait Gallery, Smithsonian Institution, Washington, D.C., 1976.

Harnett, William Michael

Frankenstein, Alfred, *After the Hunt, William Michael Harnett and Other American Still Life Painters 1870–1900* (Berkeley: University of California Press, 1953; 2nd ed., Los Angeles: University of California Press, 1969).

——————, "Harnett True and False," *Art Bulletin*, XXXI (March 1949), pp. 38–56.

——————, "Mr. Hulings' Rack Picture," *Auction*, II, no. 6 (Feb. 1969), pp. 6–9.

——————, *The Reality of Appearance: The Trompe l'oeil Tradition in American Painting* (exhibition catalogue), National Gallery of Art, Smithsonian Institution, Washington, D.C., 1970.

——————, *The Reminiscent Object, Paintings by William Michael Harnett, John Frederick Peto, and John Haberle* (exhibition catalogue), La Jolla Museum of Art, 1965.

——————, Douglas MacAgy, and Jermayne MacAgy, *Illusionism and Trompe l'oeil* (exhibition catalogue), California Palace of the Legion of Honor, San Francisco, 1949.

Gerdts, William, *A Century of American Still-Life Painting, 1813–1913* (exhibition catalogue), The American Federation of the Arts, New York, 1966.

Harnett Centennial Exhibition (catalogue), The Downtown Gallery, New York, 1948.

Hartley, Marsden

Haskell, Barbara, *Marsden Hartley* (exhibition catalogue), Whitney Museum of American Art, New York University Press, 1980.

McCausland, Elizabeth, *Marsden Hartley* (Minneapolis: University of Minnesota Press, 1952).

Marsden Hartley 1877–1943: Paintings from 1910 to 1942 and a Bavarian Sketchbook of Silverpoint Drawings, 1933 (exhibition catalogue, essay by James R. Mellow), Babcock Galleries, New York, 1980.

Marsden Hartley Memorial Collection (exhibition catalogue), Treat Gallery, Bates College, Lewiston, Maine, 1978.

The Mountains of Marsden Hartley (exhibition catalogue), University Gallery, University of Minnesota, Minneapolis, 1979.

Hassam, Childe

Buckley, Charles E., *Childe Hassam: A Retrospective Exhibition* (catalogue), The Corcoran Gallery of Art, Washington, D.C., 1965.

Childe Hassam, 1859–1935 (exhibition catalogue), Hirschl & Adler Galleries, New York, 1964.

Cortissoz, Royal, *American Artists* (New York: Charles Scribner's Sons, 1923).

Gerdts, William H., *American Impressionism* (volume prepared in conjunction with an exhibition organized by the Henry Art Gallery; Seattle: The Henry Art Gallery, University of Washington, 1980), pp. 56–63.

Hassam, Childe, *Three Cities* (New York: R. H. Russell, 1899).

——————, "Twenty-Five Years of American Painting," *Art News*, XXVI (Apr. 14, 1928), pp. 22–28.

Norton, Frederick W., "Childe Hassam," *Brush & Pencil*, VIII, no. 3 (June 1901), pp. 141–150.

Steadman, William E., *Childe Hassam, 1859–1935* (exhibition catalogue), University of Arizona Museum of Art, 1972.

Van Rensselaer, M. G., "Fifth Avenue, With Pictures by Childe Hassam," *Century Magazine*, XLVI (Nov. 1893), pp. 5–18.

——————— , "Picturesque New York," *Century Magazine*, XLV, no. 2 (Dec. 1892), pp. 164–175.

Healy, George Peter Alexander

Leslie Cleek, *Healy's Sitters* (exhibition catalogue, Richmond: Virginia Museum of Fine Arts, 1950).

DeMare, Marie, *G. P. A. Healy, American Artist* (New York: McKay, 1954).

Healy, George P. A., *Reminiscences of a Portrait Painter* (Chicago: A. C. McClurg and Co., 1894).

Henri, Robert

Brown, Milton W., *American Painting from the Armory Show to the Depression* (Princeton, N.J.: Princeton University Press, 1955).

Henri, Robert, *The Art Spirit*, compiled by Margery Ryerson (Philadelphia: Lippincott, 1923).

Homer, William Innes, *Robert Henri and His Circle* (Ithaca, N.Y.: Cornell University Press, 1969).

Read, Helen Appleton, *Robert Henri and Five of His Pupils: George Bellows, Eugene Speicher, Guy Pène DuBois, Rockwell Kent, Edward Hopper*, Loan Exhibition, The Century Association, Libraries Press, Freeport, New York, 1946.

Sloan, John, *John Sloan/Robert Henri Their Philadelphia Years (1886–1904)* (exhibition catalogue), Moore College of Art Gallery, Philadelphia, 1976.

Yarrow, William, and Louis Bouché, eds., *Robert Henri: His Life and Works* (New York: Boni & Liveright, 1921).

Henry, Edward Lamson

McCausland, Elizabeth, *The Life and Works of Edward Lamson Henry, N.A., 1841–1919* (New York: Kennedy Graphics, 1970; reprint of 1945 edition).

Homer, Winslow

Adams, Henry, "A Fish by John LaFarge," *The Art Bulletin*, LXII, no. 2 (June 1980).

Boyle, Richard J., *American Impressionism* (Boston: New York Graphic Society, 1974).

Downes, William Howe, *The Life and Works of Winslow Homer* (Boston: Houghton Mifflin, 1911).

Flexner, James Thomas, *The World of Winslow Homer: 1836–1910* (New York: Time Incorporated, 1966).

Gerdts, William H., *American Impressionism* (Seattle: The Henry Art Gallery, University of Washington, 1980).

Goodrich, Lloyd, *Winslow Homer* (New York: The MacMillan Company, 1944).

Hendricks, Gordon, *The Life and Work of Winslow Homer* (New York: Harry N. Abrams, Inc., 1979).

Tatham, David, "Winslow Homer's Library," *The American Art Journal*, IX, no. 1 (May 1977).

Hopper, Edward

Barr, Alfred, *Edward Hopper: Retrospective Exhibition* (catalogue), The Museum of Modern Art, New York, 1933.

Brown, Milton, *American Painting from the Armory Show to the Depression* (Princeton, N.J.: Princeton University Press, 1955), pp. 12, 32, 173–176, 180–181.

Goodrich, Lloyd, *Edward Hopper Retrospective Exhibition* (catalogue), Whitney Museum of American Art, New York, 1950.

——————— , *Edward Hopper* (New York: Harry N. Abrams, 1971).

——————— , *Edward Hopper: Selections from the Hopper Bequest to the Whitney Museum of American Art* (catalogue), Whitney Museum of American Art, New York, 1971.

Levin, Gail, *Edward Hopper as Illustrator* (New York: W. W. Norton & Company in association with the Whitney Museum of American Art, 1979).

——————— , *Edward Hopper: The Complete Prints* (New York: W. W. Norton & Company in association with the Whitney Museum of American Art, 1979).

——————— , *Edward Hopper: The Art and the Artist* (New York: W. W. Norton & Company in association with the Whitney Museum of American Art, 1980).

Morse, John, "Interview with Edward Hopper," *Art in America*, XLVIII (March 1960), pp. 60–63.

Seitz, William C., "Edward Hopper," in *São Paulo 9* (exhibition catalogue, Museo de Arte Moderna, São Paulo, 1967–68; Washington, D.C.: Smithsonian Institution Press, 1967).

Zigrosser, Carl, "The Etchings of Edward Hopper" in *Prints* (New York: Holt, Rinehart and Winston, 1962), pp. 155–173.

Hunt, William Morris

Adams, Henry, and Martha J. Hoppin, *William Morris Hunt: A Memorial Exhibition* (catalogue), Museum of Fine Arts, Boston, 1979.

Bermingham, Peter, *American Art in the Barbizon Mood* (exhibition catalogue), National Collection of Fine Arts, Smithsonian Institution, Washington, D.C., 1975.

Danes, Gibson A., *A Biographical and Critical Study of William Morris Hunt; 1824–1879*, unpublished Ph.D. Dissertation, Yale University, 1949.

Hoppin, Martha J., *William Morris Hunt: Aspects of His Work*, unpublished Ph.D. Dissertation, Harvard University, 1974.

——————— , "William Morris Hunt and His Critics," *American Art Review*, II, no. 5 (Sept.–Oct. 1975), pp. 79–91.

Hunt, William Morris, *Talks about Art*, with a letter from J. E. Millais (Boston: 1875, 1883; London: Macmillan, 1885).

Knowlton, Helen Mary, *The Art-Life of William Morris Hunt* (Boston: Little, Brown & Co., 1899).

Landgren, Marchal E., and Sharman Wallace McGurn, *The Late Landscapes of William Morris Hunt* (exhibition catalogue), University of Maryland Art Gallery, 1976.

Inness, George

Cikovsky, Nikolai, *The Edward Butler Collection of Paintings by George Inness (1825–1894)* (exhibition catalogue), Art Institute of Chicago, 1930.

——————— , *The Life and Work of George Inness* (New York: Garland Publishing, Inc., 1977).

Ireland, LeRoy, *The Works of George Inness* (Austin: University Art Museum of the University of Texas, 1965).

McCausland, Elizabeth, *George Inness, An American Landscape Painter* (New York: American Artists Group, Inc., 1946).

——————— , *The Paintings of George Inness (1844–1894) at the University of Texas* (exhibition catalogue; preface by LeRoy Ireland, introduction by Nicolai Cikovsky, Jr.), University Art Museum of the University of Texas, Austin, 1965.

Werner, Alfred, *Inness Landscapes* (New York: Watson-Guptill, 1973).

Kensett, John Frederick

Howat, John, *John Frederick Kensett* (exhibition catalogue), The American Federation of Arts, New York, 1968.

Kettlewell, James, *John Frederick Kensett* (exhibition catalogue), Saratoga Springs, New York, 1967.

Tuckerman, Henry T., *The Book of the Artists: American Artist Life* (New York: 1867; reprinted by James F. Carr, 1966).

Wilmerding, John, ed., *American Light: The Luminist Movement, 1850–1875* (exhibition catalogue), National Gallery of Art, Washington, D.C., 1980.

Knaths, Karl

Goodrich, Lloyd, "Karl Knaths," *Four American Expressionists: Doris Caesar, Chaim Gross, Karl Knaths, Abraham Rattner* (exhibition catalogue), Whitney Museum of American Art, 1959.

Mocsanyi, Paul, *Karl Knaths*, The Phillips Gallery, 1957.

Lawson, Ernest

Anderson, Dennis, *Ernest Lawson Retrospective* (exhibition catalogue), ACA Galleries, New York, 1976.

Berry-Hill, Henry, and Sidney Berry-Hill, *Ernest Lawson, American Impressionist* (Leigh-on-Sea, England: F. Lewis, 1968).

Ernest Lawson Papers: personal letters from the artist to his wife, and daughter, Margaret, and from Mrs. Katherine Powell to Mrs. Lawson and daughter, Archives of American Art, Smithsonian Institution, gift of Mrs. Margaret Lawson Bensco, 1976.

Gallatin, A. E., "Ernest Lawson," *International Studio*, LIX (July 1916), pp. xiii–xv.

Karlstrom, Paul, Interview with Mrs. Margaret Lawson Bensco, Sept. 7, 1976, Archives of American Art, Smithsonian Institution, San Francisco.

Karpiscak, Adeline Lee, *Ernest Lawson 1873–1939* (exhibition catalogue), University of Arizona Museum of Art, Tucson, 1979.

Newlin-Price, Frederic, "Lawson of the Crushed Jewels," *International Studio*, LXXVIII (Feb. 1924), pp. 367–370.

O'Neal, Barbara, and Duncan Phillips, *Ernest Lawson* (exhibition catalogue), National Gallery of Canada, Ottawa, 1967.

Rihani, Ameen, "Landscape Painting in America —Ernest Lawson," *International Studio*, LXXII (Feb. 1921), pp. 114–117.

Strawn, Arthur, "Ernest Lawson," *Outlook*, CLVII (Apr. 22, 1931), p. 573.

Marin, John

Benson, E. M. et al., *John Marin: Watercolors, Oil Paintings, Etchings* (exhibition catalogue), The Museum of Modern Art, New York, 1936.

Coke, Van Deren, *Marin in New Mexico/1929 & 1930* (exhibition catalogue), University Art Museum, University of New Mexico, 1968.

Helm, MacKinley, *John Marin* (Boston: Pellegrini & Cudahy in association with The Institute of Contemporary Art, 1948; reprinted by Kennedy Graphics, 1970).

Homer, William Innes, *Stieglitz and the American Avant-Garde* (Boston: New York Graphic Society, 1977).

Norman, Dorothy, *The Selected Writings of John Marin* (New York: Pellegrini & Cudahy, 1949).

Reich, Sheldon, *John Marin: A Stylistic Analysis and Catalogue Raisonné*, 2 vols., (Tucson: University of Arizona Press, 1970).

Maurer, Alfred Henry

McCausland, Elizabeth, *A. H. Maurer* (exhibition catalogue), Walker Art Center and the Whitney Museum of American Art, 1949.

_____, *A. H. Maurer* (New York: A. A. Wyn for the Walker Art Center, 1951).

Reich, Sheldon, *Alfred H. Maurer* (exhibition catalogue), National Collection of Fine Arts, Smithsonian Press, Washington, D.C., 1973.

Myers, Jerome

Henri, Robert, "The New York Exhibition of Independent Artists," *The Craftsman*, XVIII (May 1910), p. 161.

Holcomb, Grant, "The Forgotten Legacy of Jerome Myers (1867–1940): Painter of New York's Lower East Side," *The American Art Journal* IX, no. 1 (May 1977), pp. 78–91.

Myers, Ethel, *A Memorial Exhibition of the Work of Jerome Myers, Virginia-born Master* (catalogue), Virginia Museum of Fine Arts, Richmond, 1942.

Myers, Jerome, *Artist in Manhattan* (New York: American Artists Group, Inc., 1940).

Peale, James

Bauer, John I. H., "The Peales and the Development of American Still Life," *The Art Quarterly*, III, no. 1 (Winter 1940), pp. 81–92.

Brockway, Jean Lambert, "The Miniatures of James Peale," *Antiques*, XXII, no. 4 (Oct. 1932), pp. 130–134.

Elam, Charles H., ed. *The Peale Family: Three Generations of American Art* (exhibition catalogue), The Detroit Institute of Arts, 1967.

Gerdts, William H., and Russell Burke, *American Still-Life Painting* (New York: Praeger Publishers, 1971).

James Peale and his Family (exhibition catalogue), Walker Galleries, New York, 1939.

Portraits by Charles Willson Peale and James Peale and Rembrandt Peale (exhibition catalogue), The Pennsylvania Academy of Fine Arts, Philadelphia, 1923.

Sellers, Charles Coleman, "Colonial and Federal Faces: A Note on Contrasts in the Portraits of Charles Willson, James and Rembrandt Peale," *The Art Quarterly*, II, no. 3 (Summer 1948), pp. 269–273.

_____, "James Peale: A Light in Shadow 1749–1831," in *Four Generations of Commissions: The Peale Collection of the Maryland Historical Society* (exhibition catalogue), Maryland Historical Society, Baltimore, 1975.

Sherman, Frederic Fairchild, "Heretofore Unpublished Miniatures by James Peale," *Art in America*, XXIV, no. 4 (Oct. 1936), pp. 162–164.

_____, "James Peale's Portrait Miniatures," *Art in America*, XIX, no. 3 (Aug. 1931), pp. 208–221.

_____, "Miniatures by James Peale and Edward Greene Malbone," *Art in America*, XIX, no. 1 (Feb. 1931), pp. 89–94.

_____, "Two Recently Discovered Portraits in Oil by James Peale," *Art in America*, XXI, no. 4 (Oct. 1933), pp. 114–121.

Peto, John Frederick

Baur, John, "Peto and the American Trompe l'oeil Tradition," *American Magazine of Art*, XLIII, no. 5 (May 1950), pp. 182–185.

Frankenstein, Alfred, "Harnett True and False," *Art Bulletin*, XXXI (March 1949), pp. 38–56.

_____, *John F. Peto* (exhibition catalogue), The Brooklyn Museum, Brooklyn Institute of Arts and Sciences, 1950.

_____, *The Reality of Appearance: The Trompe l'oeil Tradition in American Painting* (exhibition catalogue), National Gallery of Art, Smithsonian Institution, Washington, D.C., 1970.

_____, *The Reminiscent Object, Paintings by William Michael Harnett, John Frederick Peto, and John Haberle* (exhibition catalogue), La Jolla Museum of Art, 1965.

Gerdts, William H., *A Century of American Still-Life Painting, 1813–1913* (exhibition catalogue), The American Federation of the Arts, New York, 1966.

_____, and Russell Burke, *American Still-Life Painting* (New York: Praeger Publishers, 1971).

Thomas Carr Howe, Jr., Douglas MacAgy, and Jermayne MacAgy, *Illusionism and Trompe l'oeil* (exhibition catalogue), California Palace of the Legion of Honor, San Francisco, 1949.

Prendergast, William

Breuning, Margaret, *Maurice Prendergast*, American Artists Series (New York: Whitney Museum of American Art, 1931).

Langdale, Cecily, *The Monotypes of Maurice Prendergast* (New York: Davis and Long Company, 1979).

Rhys, Hedley Howell, *Maurice Prendergast, 1859–1924* (exhibition catalogue), Museum of Fine Arts, Boston, and Harvard University Press, 1960.

Sims, Patterson, *Maurice B. Prendergast, A Concentration of Works from the Permanent Collection* (exhibition catalogue: A 50th Anniversary Exhibition, Whitney Museum of American Art, Jan. 9–March 2, 1980), New York, Whitney Museum of American Art, 1979.

Wick, Peter A., "A Critical Note," in *Sketches by Maurice Prendergast, 1899* (a facsimile of watercolor notebook) (Cambridge, Mass.: Museum of Fine Arts, Boston, and Harvard University Press, 1960).

Rattner, Abraham

Baur, John I. H., "Abraham Rattner", *Four American Expressionists, Doris Caesar, Chaim Gross, Karl Knaths, Abraham Rattner* (exhibition catalogue), Whitney Museum of American Art, 1959.

Leepa, Allen, ed., *Abraham Rattner* (New York: Harry N. Abrams, Inc. 1974).

Weller, Allen S., "Rattner in Illinois," *Krannert Art Museum Bulletin*, University of Illinois, Urbana-Champaign, III, no. 1 (1977), pp. 12–23.

Remington, Frederic Sackrider

Frederic Remington, A Retrospective Exhibition of Paintings and Sculpture (catalogue), The Paine Art Center and Arboretum, Oshkosh, Wisc., 1967.

Hassrick, Peter H., *Frederic Remington* (exhibition catalogue), Amon Carter Museum, Fort Worth, Texas, 1973.

McCracken, Harold, *Frederic Remington, Artist of the Old West*, introduction by James Chillman, Jr. (Philadelphia: J. B. Lippincott Company, 1947).

——————, *The Frederic Remington Book* (Garden City, N.Y.: Doubleday & Company, Inc., 1966).

Remington, Frederic, *Frederic Remington's "Own Outdoors,"* ed. by Douglas Allen, introduction by Harold McCracken (New York: The Dial Press, 1964).

Roesen, Severin

"Among Recent Acquisitions," *City Art Museum of Saint Louis, Bulletin*, new series, VI, no. 2 (July–Aug. 1970), pp. 1–2.

"August Roesen, Artist: An Interesting Williamsport Genius Recalled by His Works," *Williamsport Sun and Banner*, June 27, 1895.

Born, Wolfgang, *Still-Life Painting in America* (New York: Oxford University Press, 1947).

Fisher, Mahlon L., "Four Who Knew Williamsport," *Williamsport Gazette and Bulletin*, Nov. 8, 1926.

Gerdts, William H., and Russell Burke, *American Still-Life Painting* (New York: Praeger Publishers, 1971).

Marcus, Lois Goldreich, *Severin Roesen: A Chronology* (Williamsport, Pa., Lycoming County Historical Society and Museum, 1976).

Mook, Maurice A., "S. Roesen, 'The Williamsport Painter,'" *Allentown* (Pa.) *Morning Call*, Dec. 3, 1955.

——————, "Severin Roesen, The Williamsport Painter," *Lycoming College Magazine*, XXV, no. 6 (June 1972), pp. 33–42.

——————, "Severin Roesen and His Family," *The Journal of the Lycoming County Historical Society*, VIII, no. 2 (Fall 1972), pp. 8–13.

——————, "Severin Roesen: Also the Huntington Painter," *Lycoming College Magazine*, XXVI, no. 6 (June 1973), pp. 13–16, 23–29.

"Recent Acquisitions Victorian Bouquet," *The Museum of Fine Arts, Houston, Bulletin*, new series, III, no. 4 (June 1972), pp. 42–45.

Stone, Richard B., "Not Quite Forgotten: A Study of the Williamsport Painter, S. Roesen," *Lycoming Historical Society Proceedings and Papers*, no. 9 (Nov. 1951).

Rogers, Randolph

Armstrong, D. M., *Day Before Yesterday; Reminiscences of a Varied Life by Maitland Armstrong, 1836–1918; ed. by his daughter Margaret Armstrong* (New York: C. Scribner's Sons, 1920).

Clark, William J., Jr., *Great American Sculptures* (Philadelphia: Gebbie & Barrie, 1877).

Craven, Wayne, *Sculpture in America* (New York: Thomas Y. Crowell, Co., 1968).

Florentia, "A Walk Through the Studios of Rome," *Art Journal*, Vol. 16, June 1, 1854, pp. 184–187.

Gardner, Albert Ten Eyck, *Yankee Stonecutters: The First American School of Sculpture 1800–1850* (New York: Columbia University Press for the Metropolitan Museum of Art, 1945). Biography, p. 71.

——————, "American Sculpture," *Catalogue of the Metropolitan Museum of Art*, 1965.

Gerdts, William H., *American Neo-Classic Sculpture: The Marble Resurrection* (New York: Viking Press, 1973).

Hawthorne, Nathaniel, *The Marble Faun* (reprint, New York: New American Library, 1961), especially chapters XIII–XIV.

Jarves, James Jackson, *The Art Idea*, ed. by Benjamin Rowland, Jr. (Cambridge, Mass.: Belknap Press of Harvard University, 1960).

Post, Chandler Rathfon, *A History of European and American Sculpture: From the Early Christian Period to the Present Day* (New York: Cooper Square Publishers, 1969), vol. II.

Rogers, Millard F., Jr., *Randolph Rogers, American Sculptor in Rome* (Amherst: University of Massachusetts Presss, 1971).

Taft, Lorado, *The History of American Sculpture* (1903; new edition, New York: MacMillan Co., 1925).

Thorp, Margaret Farrand, *The Literary Sculptors* (Durham, N.C.: Duke University Press, 1965).

Tuckerman, Henry T., *Book of the Artists: American Artist Life* (New York, 1867; reprinted by James F. Carr, 1966).

Sargent, John Singer

Charteris, Evan, *John Sargent* (New York: Scribner's, 1927).

Downes, William Howe, *John Singer Sargent: His Life and Work* (Boston: Little, Brown and Co., 1925).

Hoopes, Donelson F., *The Private World of John Singer Sargent* (exhibition catalogue), Corcoran Gallery of Art, Washington, D.C., 1964.

Mount, Charles Merrill, *John Singer Sargent: A Bibliography* (New York: W. W. Norton & Co., 1955).

Shinn, Everett

De Shazo, Edith, *Everett Shinn 1876–1953: A Figure in His Time* (New York: Clarkson N. Potter, Inc., 1974).

Everett Shinn—An Exhibition of His Work (catalogue), The Henry Clay Frick Fine Arts Department of the University of Pittsburgh, Pa., 1959.

Shinn, Everett, and John I. H. Baur, *The Eight* (exhibition catalogue), Brooklyn Museum, 1944.

Sloan, John

Beam, Philip C., *The Art of John Sloan, 1871–1951* (exhibition catalogue), Walker Art Museum, Bowdoin College, Brunswick, Maine, 1962.

Goodrich, Lloyd, *John Sloan* (New York: The Macmillan Company, 1952).

John Sloan Retrospective Exhibition (catalogue), Addison Gallery of American Art, Phillips Academy, Andover, 1938.

Perlman, Bennard, *The Immortal Eight: American Painting from Eakins to the Armory Show, 1870–1913* (New York: Exposition Press, 1962).

Sloan, John, and Helen Farr, *Gist of Art* (New York: American Artists Group, Inc., 1939).

Sully, Thomas

Biddle, Edward, and Mantle Fielding, *The Life and Works of Thomas Sully* (Philadelphia: 1921; reprint, Charleston, S.C.: Garnier and Co., 1969).

Memorial Exhibition of Portraits by Thomas Sully (catalogue), Pennsylvania Academy of Fine Arts, Philadelphia, 1922.

West, Benjamin

Alberts, Robert C., *Benjamin West: A Biography* (Boston: Houghton Mifflin Company, 1978).

Belknap, Waldron Phoenix, Jr., *American Colonial Painting: Materials for a History* (Cambridge, Mass.: The Belknap Press of Harvard University Press, 1959).

Evans, Dorinda, *Benjamin West and His American Students* (exhibition catalogue), National Portrait Gallery, Smithsonian Institution Press, 1980.

Foote, Henry Wilder, *Robert Feke: Colonial Portrait Painter* (Cambridge, Mass.: Harvard University Press, 1930).

Official Catalogue, International Exhibition 1876, part II (Philadelphia: United States Centennial Commission, 1876).

Sawitzky, William, "The American Work of Benjamin West," *The Pennsylvania Magazine of History and Biography*, LXII, no. 4 (Oct. 1938).

Sellers, Charles Coleman, "Mezzotint Prototypes of Colonial Portraiture: A Survey Based on the Research of Waldron Phoenix Belknap, Jr.," *Art Quarterly*, XX (Winter 1957).

Van Devanter, Ann C., "Benjamin West's *Death of Socrates*," *Antiques*, Sept. 1973.

Waterhouse, Ellis, *Painting in Britain: 1530–1790* (Baltimore: Penguin Books, Inc., 1953).

Wright, Nathalia, *The Life of Benjamin West by John Galt: A Facsimile Reproduction* (Gainesville, Fla.: Scholars' Facsimiles and Reprints, 1960).

Whittredge, Thomas Worthington

Baur, John, *Worthington Whittredge (1820–1910), A Retrospective Exhibition of an American Artist* (exhibition catalogue), Munson-Williams-Proctor Institute, Utica, N.Y., 1969.

Dwight, Edward H., ed., *Worthington Whittredge (1820–1910): A Retrospective Exhibition of an American Artist* (exhibition catalogue), Munson-Williams-Proctor Institute, Utica, N.Y., 1969.

Janson, Anthony F., *The Paintings of Worthington Whittredge*, Ph.D. Dissertation, Harvard University, 1975.

——————, "The Western Landscapes of Worthington Whittredge," *American Art Review*, III, no. 6 (Nov.–Dec. 1976), pp. 58–69.

——————, "Worthington Whittredge: Two Early Landscapes," *Bulletin of the Detroit Institute of Arts*, LV, no. 4 (Winter 1977), pp. 199–208.

——————, "Worthington Whittredge: The Development of a Hudson River Painter, 1860–1868," *American Art Journal*, XI, no. 2 (April 1979), pp. 71–84.

Whittredge, Thomas W., *The Autobiography of Worthington Whittredge, 1820–1910*, ed. John Baur (New York: Arno Press, 1969).